REFRAMING ABSTRACT EXPRESSIONISM

REFRAMING ABSTRACT EXPRESSIONISM

SUBJECTIVITY AND PAINTING IN THE 1940S

MICHAEL LEJA

YALE UNIVERSITY PRESS

NEW HAVEN AND LONDON

Published with assistance from the Mary
Cady Tew Memorial Fund.

The lyrics of "Dawn of a New Day" by
George and Ira Gershwin (© 1938 Chappell
& Co. [Renewed] All rights reserved) are
used by permission.

Designed by Nancy Ovedovitz and set in
Times Roman type by The Composing Room
of Michigan, Inc. Printed in the United States
of America by Thomson-Shore, Dexter,
Michigan.

Library of Congress
Cataloging-in-Publication Data
Leja, Michael, 1951–
 Reframing abstract expressionism :
 subjectivity and painting in the 1940s /
 Michael Leja.
 p. cm.
 Includes bibliographical references and
 index.
 ISBN 0-300-04461-5 (cloth)
 0-300-07082-9 (paper)
 1. Abstract expressionism—United
States. 2. Painting, Modern—20th
century—United States. 3. Subjectivity in
art. 4. Pollock, Jackson, 1912–1956—
Criticism and interpretation.
I. Title.
ND212.5.A25L45 1993
759.147′1′09044—dc20 92-32992
 CIP

A catalogue record for this book is available
from the British Library.

The paper in this book meets the guidelines
for permanence and durability of the
Committee on Production Guidelines for
Book Longevity of the Council on Library
Resources.

10 9 8 7 6 5 4 3 2

CONTENTS

ACKNOWLEDGMENTS

The germ of this book can be traced to a research paper written ten years ago for T. J. Clark's seminar on the New York School at Harvard University. The distance between that tentative beginning and the present volume is long (my 1988 doctoral dissertation stands somewhere near the midpoint), and I could never have come so far without the help of a great many people.

T. J. Clark, my dissertation advisor, offered invaluable support and counsel at every stage of the study. He—and his work—helped me shape the first outlines of the project, and his subsequent critical readings of the evolving chapters enriched them profoundly, beyond the ability of footnotes to convey. Through it all, his sustained enthusiasm and encouragement have been no less important than his insightful criticisms and suggestions.

Anna Chave, Ann Gibson, and Serge Guilbaut have been extraordinarily generous in offering sensitive critical responses to earlier drafts of the text. None have allowed their disagreements with some of my arguments (or my disagreements with theirs) to impede constructive intellectual exchange.

Many other colleagues and friends have made substantive contributions to the following pages: Carl Belz, Holly Clayson, John Czaplicka, Whitney Davis, Michael Fried, Reinhold Heller, Walter Hopps, Michael

Kimmelman, Susan Manning, Richard Meyer, John O'Brian, Larry Silver, Lisa Tickner, Nancy Troy, David Van Zanten, Anne Wagner, Karl Werckmeister, and Henri Zerner. Michael Auping, Serge Guilbaut, and Susan Witkie gave me valuable early opportunities to test some of the ideas in public forums. Graduate and undergraduate students in my New York School seminars at Northwestern University, Harvard, and MIT brought new energy and fresh perceptions to the subject and frequently led me to rethink my arguments.

My research at the Boston and Washington offices of the Archives of American Art was greatly facilitated by the assistance of Robert Brown, Erika Ell, and Cecilia Chin. The gracious hospitality of Glenn McMillan and Richard Desroche, Pauline McGuire, Tina Petra and Ken Wong, and Davia Temin enabled me to carry out research in New York and Washington. Yve-Alain Bois, Marie Foley, Helen Harrison, Jason McCoy, Nina Nielsen, Sanford Schwartz, and E. V. Thaw helped me gain access to important materials. Judy Metro and Cynthia Wells at Yale University Press patiently and capably directed the transformation of manuscript into book.

Financial support for research and writing was provided by the Getty Grant Program, the Center for Advanced Studies in the Visual Arts at the National Gallery in Washington, D.C., the Whiting Foundation, Harvard University, and Northwestern University's Office of Research and Sponsored Programs. A grant from the Center for Interdisciplinary Research in the Arts at Northwestern University helped to defray the costs of photographs and reproduction rights.

Over the decade I worked on this book, I drew heavily upon the unfailing encouragement, confidence, and moral support of my parents, Margaret and Stanley Leja, and my family, especially Suzanne Barnes. My gratitude to them is deeper than I can say.

Finally, Margaret Werth has had a profound influence on this study—more extensive, no doubt, than I realize. Her trenchant criticisms and energetic challenges repeatedly opened up my thinking and led me in new and productive directions. In the final stages of work, intellectual stimulation was only one of the many welcome effects of her daily presence.

INTRODUCTION

FRAMING ABSTRACT
EXPRESSIONISM

"Dreams and beasts," Emerson noted in
an early Journal, *"are the two keys by*
which we are to find out the secrets of our
own nature." That has proved an even
more penetrating intuition than he could
have guessed.
Lewis Mumford, *The*
Transformations of Man

Works of art are often sites where the issues
or questions a community or culture finds
urgent, fundamental, or troublesome are
elaborated and negotiated. In part, this is a
matter of what Nelson Goodman calls the
"cognitive efficacy" of visual representa-
tions: through representing or symbolizing
selected elements of "the world," experi-
ence is made susceptible to ordering and
rearrangement; the world can be more com-
pletely grasped, ordered, and illuminated.[1]
Visual representation is, consequently, a ve-
hicle for the increase of knowledge, both
scientific and nonscientific. But knowledge
is ideological: what passes for knowledge at
any given moment is radically conditioned
by a complex of regnant interests, values,
utilities. What may seem at first a pure dis-
covery, an objective truth emergent in visual
representation—linear perspective is a good
example—is later revealed as a culturally
specific, ideologically engaged, contingent
construction.[2]

Some works of art are especially successful in addressing the pressing concerns of a community and having some impact upon them, or at least seeming to do so. The metaphors and discourses articulated or extended by such works situate them at the very heart of cultural preoccupations, where they collide and compete with other representations issuing from and inflecting predominant cultural stresses. The success or failure of works of art in targeting cultural pressure points may be registered in the volume of attention they receive, whether approving or disapproving, or whether the reception is able at all to take the measure of the works' cultural resonance.

This book argues that the art of the New York School can claim precisely this sort of cultural and ideological pertinence for United States society in the 1940s and early 1950s. The preeminence secured by the paintings of Willem de Kooning, Adolph Gottlieb, Robert Motherwell, Barnett Newman, Jackson Pollock, Mark Rothko, and Clyfford Still over the past forty years is to be understood, it contends, as rooted in neither the sheer aesthetic achievement of the art nor its political utility as a weapon of United States cultural imperialism during the cold war, as the two dominant, conflicting histories of the New York School would have it. Rather, the highly effective promotion of this art on grounds of both artistic quality and national achievement was made possible and desirable by other of the paintings' engagements. Barbara Herrnstein Smith's view of the process by which works of art achieve the high canonical status of "classics" is relevant in this regard; as she puts it, elevation and endurance are the result "neither of the objectively (in the Marxist sense) conspiratorial force of establishment institutions nor of the continuous appreciation of the timeless virtues of a fixed object by succeeding generations of isolated readers but, rather, of a series of continuous interactions among a variably constituted object, emergent conditions, and mechanisms of cultural selection and transmission."[3] Embedded in the perception of artistic quality in this art, and prior (and prerequisite) to its promotion by such establishment institutions as the State Department and the Museum of Modern Art, was its ability to perform other specific necessary functions quite well for its particular audiences: it engaged urgent cultural concerns so directly and effectively that it became an especially privileged site for the production of knowledge with profound ideological importance. A defining feature of the school was its attempt to assimilate into visual representation relatively new knowledge about human nature, mind, and the human condition—knowledge gleaned from psychology, anthropology, and philosophy. It managed to adapt European modernist traditions to representation of and by a subjectivity—a model of the experiencing human individual— that was ascendant in U.S. culture. That is, the art enlisted in the cultural project articulated by Lewis Mumford in the epigraph to this chapter. But what seemed to be knowledge and discovery inscribed in New York School painting, namely, a new form of subjectivity riven and besieged, rife with "unconscious" and "primitive" instincts and impulses, was rather construction, with myriad ideological ramifications for the dominant culture in the United States in the 1940s and 1950s and since.

To attribute to Abstract Expressionism—the usual stylistic designation for the first and principal generation of New York School art, and the central focus of this study—a profound cultural and ideological pertinence is by no means to claim that it attracted a mass audience, or even that it was "understood" or appreciated by a significant proportion of the population. On the contrary it was frequently reviled and mocked by "mid-

dlebrow" audiences, to use a sketchy contemporary category of cultural differentiation.[4]

"Lowbrow" audiences were largely unaware of it. Only the "highbrows"—members of urban literary and artistic circles and certain adventurous patrons and followers from the social, economic, and political elites—demonstrated any interest in or support for this art, and even their interest was articulated in terms that were often quite esoteric.

Despite the facts that confusion and disagreement surrounded it and that its audience was small and select, New York School painting was an influential and effective arena for experimentation with crucial themes in United States culture in the World War II period and after. Its cultural influence was not contingent upon audience approval or sympathy; that it failed to attract hordes of devotees is less significant than its success in compelling media interest and attention, however critical or condescending. Here, for example, is an excerpt from a critical lamentation inspired by the work of Pollock and de Kooning and other modernists: "In fleeing from the machine and the terrors of the man-made world, we have plunged into the dimly lit corridors of man's own psyche. In a situation where art is used to explain the psyche, express the psyche, and heal the psyche of the modern man, criticism of art is pointless, and standards of art are non-existent. Every least gesture of the brush becomes a revelation, and our pessimism regarding the psyche is such that, the cruder the gesture, the greater the revelation."[5]

Even such negative glosses purveyed information about the art and its commitments: that it had some sort of investment in the psyche of modern man, that it held forms and gestures to be revelatory, that it was somehow responsive to the terrors of the man-made world, and so on. The information was not always reliable, but usually certain fundamental features were represented with a measure of accuracy, and gradually bits and pieces of information—especially about the new art's paradigm of the artist, its assumptions about the proper sources and subjects of artistic representation, and its premises about the shape and nature of those sources and subjects ("dimly lit corridors," "our pessimism is such," etc.)—filtered into the mass media and spoke to issues preoccupying the culture. The famous "*Life* Round Table on Modern Art," which reproduced works by de Kooning, Baziotes, Stamos, Gottlieb, and Pollock, concluded that "the troubles of modern art lead back into the troubles of the age. . . . The meaning of modern art is, that the artist of today is engaged in a tremendous individualistic struggle—a struggle to discover and to assert and to express himself."[6] *Time* picked up Sam Hunter's remark in the *New York Times* that Pollock "has carried the irrational quality of picture-making to one extremity," and specified parenthetically which extremity that was—"meaning, presumably, his foot."[7] Where Abstract Expressionism is concerned, dismissive comedy has always coexisted in the popular press with disturbed, sometimes uncontrolled outburst and earnest groping. A good example of excited outburst is the reaction of the senior critic of the *New York Times*, Howard Devree, to the reemergence of figuration in Pollock's work in 1951: "So far as these are intentionally representational elements they carry horrific suggestive power, turning the automatic emotional mazes into nightmarish expressionist visions as of half-glimpsed and enmeshed witches' sabbath, black mass and unholy groups of doomsday aspect, as if Rops or Munch had approached their themes nonobjectively."[8] The syntax falters in the effort to convey the rush of horror. As an example of earnest groping, another *New York Times* critic, Stuart Preston, writing about Pollock in 1955 will oblige:

In these revolutionary paintings are demonstrated his progressive abandonment of fore-thought; the way he leaves things to chance, the ruthless steps he has taken to shatter the conventions of art and introduce, for the first time in art, raw and naked, the elemental and largely subconscious promptings of his creative nature. No use looking for "beauty" or worrying about what socially relevant message is being communicated. Until psychology digs deeper into the workings of the creative act the spectator can only respond, in one way or another, to the gruff, turgid, sporadically vital reelings and writhings of Pollock's inner-directed art. Value judgments are difficult to make when dealing with what Sir Herbert Read, writing on Pollock, refers to as "an automatic register of the dimensions of the self."[9]

Through such coverage in the mass circulation press—coverage alternately be-mused, antagonistic, mocking, troubled, and appreciative—millions of nonspecialist readers learned that the strange work of the New York School artists was an effort at self-discovery in a troubled era. The visual language employed in these paintings—that of European high modernism—was abstruse, to be sure, but the work done to and with that language was conditioned by historically localized and specific interests, interests shared by many readers of *Life, Time, Newsweek,* the *New York Times,* and *Harper's Bazaar.* The extent to which this art engaged the concerns of the dominant culture—that is (to remain within the limited terms of this introduction), the culture of the middlebrow and highbrow constituencies taken broadly and together—has not been acknowledged or recognized by scholars and critics. Abstract though much of this art is, it sustained metaphors relevant and meaningful to audiences far broader than those captivated by the seductive but esoteric explanations offered by its most famous and compelling spokes-persons: Clement Greenberg, who painstakingly analyzed its progressive formal innova-tions, and Harold Rosenberg, who swathed the art in obscure, melodramatic, existential-ist rhetoric. It is the ambition of this book to demonstrate and analyze the extensive interdependence between New York School art and the culture in which it flourished.

Two different but related routes toward these ends will be charted here. One involves close comparison between the painting in question and contemporary cultural produc-tions of diverse sorts: popular philosophy, cultural criticism, Hollywood movies, jour-nalistic essays, and other materials. Abstract Expressionism had much more in common with the mainstream culture than some of its aggressively elitist defenders would allow. The second route involves constructing a broad historical account of the tensions within United States culture in that period, tensions related to social conflict and to cataclysmic historical events, national and international. In New York School painting, modernist artistic languages and forms were revealed as immensely useful for constituting fields or arenas for working through the issues upon which cultural tensions were focused. This confluence was an important reason why artistic modernism finally blossomed in the United States at this time.

To speak of New York School paintings as "fields" or "arenas" in the sense intended above involves a deliberate irony: these terms have figured prominently in the discursive apparatus that has insulated the art from the sort of social and cultural analysis to be undertaken here. Abstract Expressionist paintings will be treated in this study as histori-cally and ideologically engaged cultural artifacts. This is an approach to which the scholarship—both historical and critical—traditionally has been hostile. Even now that

the best of this art is more than forty years old, it is still fiercely protected from non-universalizing and de-idealizing treatments. As recently as December 1987, a *New York Times* article attempted to rescue Jackson Pollock from two types of alleged antagonists: art historians determined to expose the ideological character of his work—"which cannot be done anyway," since his paintings have an importance "independent of any ideology or moment"; and so-called "postmodern" American artists, whose turn "away from Pollock and everything he stood for" entails a great loss for art.[10] Pollock, and New York School art in general, may have begun to acquire a patina, but prominent institutions are not yet willing to see them treated as historical phenomena. The paintings are still widely cherished as objects of extraordinary beauty and universal expressive power; claims about historical and ideological components of their aesthetic stature are deflected.

A principal reason for this defensiveness is the exceptionally privileged position held by these artworks in the national culture. Their audience has expanded considerably by now, well beyond the highbrow elites and into the mainstream culture. Pollock, de Kooning, Motherwell, and company now qualify as subjects for "blockbuster" exhibitions. The cultural establishment—that segment of the upper and middle classes that takes the visual arts seriously enough to support institutions for promoting them—has constructed its self-image (presented as "America's" cultural identity) on bases provided in part by New York School art. Abstract Expressionism is taken to be a high-cultural correlate of the country's military, economic, and technological rise to preeminence in the Western Hemisphere during and after World War II. Not only is it believed to mark the coming to maturity and independence of the visual arts in the United States, but also it is generally interpreted as the quintessential artistic embodiment of the qualities and ideals that the nation's mainstream, middle-class culture holds dearest: individual freedom, boldness, ingenuity, grand ambition, expansiveness, confidence, power.

Nonetheless, the process of historical analysis has begun. For some art historians, Abstract Expressionism has come to seem the product of rather particular and contingent beliefs and ambitions, and its reception, promotion, and interpretation, if not always the art itself, are portrayed as deeply enmeshed in historical processes.[11] Most art historians have focused on the processes by which New York School painting came to serve certain purposes of postwar U.S. cultural imperialism, a development so widely recognized now that it requires no further comment from me. The principal focus of these studies, however, has been the *reception* of Abstract Expressionism—the interpretations it provoked, the support it garnered, the interests it came to serve. I share this concern and will take it up repeatedly and to somewhat different ends in the pages to follow, but I want to combine it with another, related but distinct: how was the *production* of New York School painting culturally and ideologically engaged? The *Times* reviewer will cringe at the suggestion that history and ideology inhabit the very ambitions, theories, and forms of Jackson Pollock and his contemporaries. But those places where ideology is said to be absent, as Louis Althusser reminds us, are often the sites of its most effective operations.[12]

The arguments presented in this book, in other words, will take some distance from the account codified and elaborated by Serge Guilbaut in *How New York Stole the Idea of*

Modern Art. That distance is not merely an effect of shifting attention to production as well as reception; more important, it concerns the way the crucial term *ideology* is defined. The distinction is significant, given that both Guilbaut's study and mine associate the New York School with an ideology by means of which the art's historical character and effects may be analyzed. For Guilbaut *ideology* designates an explicit, consciously held set of beliefs and commitments organized around a political affiliation. The ideologies that populate his study are those of the new liberalism, the conservative right, and the Communist left.[13] As used in the present study, however, *ideology* has little to do with consciously held beliefs or political affiliations. It is meant to designate rather an implicit structure of belief, assumption, and disposition—an array of basic propositions and attitudes about reality, self, and society embedded in representation and discourse and seemingly obviously true and natural. If not always beyond challenge or question, these propositions are incessantly restated, resecured, and naturalized; they are woven into the fabric of experience by virtue of their structuring all representation, including perception, analysis, argument, interpretation, and explanation. James Kavanagh's formulation is succinct and pithy:

> Ideology designates a rich "system of representations," worked up in specific material practices, which helps form individuals into social subjects who "freely" internalize an appropriate "picture" of their social world and their place in it. Ideology offers the social subject not a set of narrowly "political" ideas but a fundamental framework of assumptions that defines the parameters of the real and the self; it constitutes what Althusser calls the social subject's " 'lived' relation to the real."[14]

In this sense of the term, New York School paintings may be seen as representing "the real" and "the self" to a particular community in distinctive forms that are simultaneously rooted in and productive of ideology. A single ideology may cut across various political and intellectual alignments within a society, all of which may be shown to share fundamental assumptions about the world, self, and society. It is in this fundamental and primary sense that the "ideological" character and effects of Abstract Expressionism will be analyzed.

When the New York School painter tried to bring his art into some productive relation with beliefs about primitive residues in human nature or about unconscious contents of the mind—two of the ingredients most prominent in this school's artistic theories—he was engaging conceptual categories with rich and complex lives and roles in his own national culture. (I use the masculine possessive advisedly: nearly all the artists were male, and indeed, the subjectivity requisite for production of the art was male, as I shall argue.) This fact is overlooked by some art historians, who portray these concerns as retreats—as relatively unimaginative and insignificant substitutes for the political and social statements that had occupied some of the artists earlier but became too complicated, dangerous, or hopeless in the early 1940s. By this account, the aesthetic shift these artists underwent was motivated less by a compelling attraction to surrealism, myth, and primitivism than a repulsion from political art. The new interests camouflaged the "effacement" of the political and gave the artists a means to "cut themselves off from the historical reality of their own time."[15] I will contend that the appeal of the new interests was much greater and more culturally determined than this; far from cutting the artists off from their time, these interests went some way toward

securing their place in it. My point of departure will be a study of the complex cultural

lives and roles of the categories *the unconscious* and *the primitive* in order to construct or reconstruct some of the discursive fields within which New York School painting origi- nated and signified. By positioning the work and theories of certain painters in relation to these fields, it will become possible to determine with some precision the ideological valencies and operations of the art. This project entails contrasting the particular forms the artists gave the primitive and the unconscious with the forms they were given in other cultural realms. There will be readers who feel that the comparison of this painting with the likes of popular philosophy and *film noir* demeans the art. I hope to persuade at least some of them that the comparisons are warranted, that they contribute to an historical interpretation that illuminates the art, and that a measure of demythologization and demystification would be no bad thing for New York School studies.

Histories of Abstract Expressionism have often portrayed the artists' intellectual preoccupations as the products of artistic influences and of personal enthusiasms for distinguished thinkers. Such an approach makes causes of effects; moreover, it some- times overlooks the fact that the key preoccupations were general within the culture, not confined to a few individuals, while at other times it portrays the central ideas as having been simply "in the air." My purpose is to point to a discursive frame for the intellectual and artistic commitments of the Abstract Expressionists, a frame that preserves and highlights the individual and idiosyncratic aspects and colorings given those interests, but that also situates them in the cultural and social history that lends the ideas signifi- cance and utility. Fascination with primitivism and irrationality has been, of course, a familiar element in the history of artistic and literary modernism. Yet to whatever extent the sources in art history and intellectual history generated the interest of the New York School painters in primitive and unconscious forms, that interest intersected with wider contemporary preoccupations and absorbed their particular characteristics and ideologi- cal valences as a result. One does not have to look very far to find other contemporary cultural manifestations of fascination with the primitive and the irrational. They turn up repeatedly in Hollywood films, newspaper and magazine articles, radio programs, and books of all sorts. One kind of cultural production in particular gave these ideas center stage and treated them comprehensively: a type of popular nonfiction I will call Modern Man literature, since its focus was the nature, mind, and behavior of "modern man." This literature was a primary arena in which the problem-solving potential of concepts of the primitive and the unconscious—the two principal categories of "others" opposed to reason and common sense—was being worked out. A Modern Man discourse developed in and around the literature, mediating the cultural diffusion of the ideas. This discourse is defined by repetition of not only ideas, beliefs, and assumptions but also literary forms and figures: "a syntax which seems obligatory, a set of permitted modes of seeing and saying."[16] These features both define the discourse and, as T. J. Clark has noted, stand as signs of ideology. Examining the relation of New York School painting to Modern Man discourse and the dominant, middle-class ideology it forms and reforms will be the principal concerns of the pages to follow. My goal is a more historical—and a less purely art historical, idealistic, and individualistic—explanation for the interests that figured so prominently in the art and theory of the Abstract Expressionists. What were the specific historical conditions of the popularity of these concepts in the wartime and postwar

United States? The premise of this book is that Modern Man discourse offers a way of grounding, situating, giving form and substance to artistic concerns that are too often treated as either self-evidently compelling or hovering "in the air."

Another area of controversy into which my study necessarily enters concerns the problem of the subject of New York School art—"subject" in the sense more of subject matter than of the human subject, although my argument will deliberately conjoin the two. Some recent scholarship has tried to temper more formal analyses of Abstract Expressionism by reaffirming the art's involvement with "subject matter."[17] These efforts generally depart from the numerous statements of such interest by the artists themselves ("We assert that the subject is crucial"; "Abstract art, too, has a subject"; and so forth), frequently pointing to some sort of vestigial mimetic representation as the locus and boundary of a picture's vague emotional, religious, psychological, or philosophical content. Several such studies have come in for harsh criticism, some of it warranted.[18] The question of subject or meaning in these paintings is complex, it is true, but not so complex that it warrants enveloping the pictures in mystification or obscurity, or justifies the revival of untenable accounts of solely formal and expressive significance.[19] The task is to reconcile the artists' commitment to abstraction with their simultaneous commitment to expanding abstraction's possibilities for meaning. What sorts of premises about meaning's inherence in form underlie these paintings? It is important to keep in mind that the artists often said outright what many of their paintings clearly indicate: that is, in Rothko's words, "I do not believe that there was ever a question of being abstract or representational."[20] Generally they were much less worried about permitting figuration and mimetic reference a place in their work than they were about having their work read as pure formal decoration on one hand or as some kind of diagrammatic illustration on the other. The myth of pure abstraction—form freed from all mimesis and metaphor— was not one that particularly interested most of them, and their work reveals itself to be committed to devising an abstract art rich in complex, articulate metaphors. Modern Man discourse has, I believe, a capacity to illuminate some of that metaphorical complexity and articulateness. It can help us see the structures, operations, and premises that enabled essentially abstract formal arrangements to take on significance and meaning with *and* without recourse to mimesis. It can also help free us from absolute dependence upon idealistic and ahistorical interpretive schemata. While Rosalind Krauss's Hegelian-Saussurian reading of Pollock's subject ("the provisional unity of the identity of opposites . . . the operation of an abstract logic" emerging from a dialectical structure of difference) is descriptively rich and will intersect with my own reading, I agree with Paul Wood's criticism of her account: "The contradictions, tensions and scope of Pollock's work are defended against a variety of one-dimensional closures on argument, but then tied to an idealism, and a lack of concern for history, the very opposite of which is what makes Pollock as interesting and exemplary as he is."[21] An appropriately complex and historical treatment of the "subjects of the artist" is thus a goal of the present study.[22]

The second sense of the word *subject* mentioned above is inseparable from the first in my analysis. To anticipate a claim made in chapter 4, the subject of the artists was the artist as subject. Like Modern Man discourse generally, with which it shared crucial focal points, New York School painting was part of a process of reconfiguring human (to be precise, white heterosexual male) subjectivity. My project, consequently, amounts to

an effort to historicize subjectivity: to reconstruct from a selection of related representations, visual and literary, how an image of "self" was changing at a particular moment and under particular conditions. What defines and characterizes New York School art (its "subject") is its effort to devise a form of modernist visual representation that could accommodate and enrich developing models of the human individual, models that attributed new importance to irrational others within human being. These models were historically conditioned and ideologically charged: the Modern Man subject was largely a refurbishing of the culture's prevailing model of self as essentially autonomous, integral, rational, and effectual which was faltering under pressure from historical cataclysm and social conflict and change. Insofar as it participated in adjusting and resecuring the dominant ideology's model of subjectivity, New York School art engendered historical effects much less radical and progressive than its unconventional look and its stormy public reception might lead us at first to imagine. This idea would not be at all surprising if it did not go against the grain of so much scholarship. But as Barbara Herrnstein Smith has observed, canonization always requires some measure of reinforcement of establishment ideologies:

> However much canonical works may be seen to "question" secular vanities such as wealth, social position, and political power, "remind" their readers of more elevated values and virtues, and oblige them to "confront" such hard truths and harsh realities as their own mortality and the hidden griefs of obscure people, they would not be found to please long and well if they were seen *radically* to undercut establishment interests or *effectively* to subvert the ideologies that support them.[23]

How New York School painting specifically might have served establishment interests and ideologies has been suggested by T. J. Clark.

> What Pollock invented in 1947–50 was a set of forms in which previously disorganized aspects of self-representation—the wordless, the somatic, the wild, the self-risking, spontaneous, uncontrolled, "existential," the "beyond" or "before" the conscious activities of mind—could achieve a bit of clarity, get themselves a relatively stable set of signifiers. . . . These are aspects of experience that the culture wants represented now, wants to make use of, because capitalism at a certain stage of its development *needs* a more convincing account of the bodily, the sensual, the "free," in order to extend—perhaps to perfect—its colonization of everyday life.[24]

The questions I mean to address are "Why then?" and "What uses?" What specifically did the culture stand to gain at that particular moment from a new account of the wild, the spontaneous, the uncontrolled, the primitive, and the unconscious? And what made the account Pollock and his colleagues developed seem "convincing" and "organized"? I do not claim to be able to answer these questions completely and definitively; the cultural needs and uses served by Abstract Expressionism were more diverse and diffuse than a single study can demonstrate. But I do hope to make some substantial progress along the path.

Theorizing that the relation between New York School art and the dominant culture was one of deep interdependence obscured by superficial antagonism helps address an old problem. How is it that these avant-garde paintings became such effective vehicles for United States interests abroad during the cold war? Did the art turn at some point to embrace the views of the liberal political elite, or, rather, did that elite appropriate the art

via interpretations that capitalized upon its fundamental ambiguity? Its engagement with Modern Man discourse reveals that throughout the 1940s New York School painting was enmeshed in processes that helped to resecure the dominant ideology, despite the fact that the artists perceived and represented themselves as fundamentally resisting and opposing that ideology. Abstract Expressionism was a Trojan horse transporting a reconfigured older ideology into a new era.

This tension between resistance and complicity, a tension originating in the conflict between the oppositional intentions of the artists and the conservative momentum of discourses and ideologies, raises another explicit concern of this book: nuanced analysis of the relation between agency and structure in artistic production. The artist, as historical actor, is a subject constituted by cultural and symbolic systems and structures, which in turn are elaborated, developed, and revised by the activities of the artist. The artist's contributions are not determined by those systems; in the words of Anthony Giddens, "structure is not to be conceptualized as a barrier to action, but as essentially involved in its production." Giddens' point is clarified in Paul Smith's analysis of the problem. Smith argues that because the processes by which subjects are constituted are never complete and monolithic—that is, because interpellation engenders gaps, contradictions, and negativity as well as subjection to the dominant discourses and ideologies—agency may be understood as a necessary effect of subject formation. Smith locates within the subject "a tension which is the product of its having been called upon to adopt multifarious subject-positions. This is the process whereby the 'subject's' contradictory constitution is given over to the articulation of needs and self-interest." Smith's analysis, which originates in his study of recent feminist treatments of this problem, makes possible a notion of subject as simultaneously dominated by discourse and empowered to function as more than an "actor for the ideological script."[25] New York School studies generally have been impaired by an oversimplified handling of this dynamic. Many have perpetuated a modernist mythology of heroic individual artists for whom the decisive structures are artistic conventions. These conventions typically are handled willfully by the artists: boldly transcended or disregarded when they are stale or limited, brilliantly extended and enriched when they are vital and compelling. Those few art historians who have attempted to counter this portrayal have tended to render the artists mere dupes or instruments of larger political powers. I have tried to eschew both extremes by portraying the artists as agents making decisions within systems of constraints, namely, discourses and ideologies whose reshaping, development, and extension are determined in part by those decisions. The extent to which this art took subjectivity as its explicit subject matter makes it an especially valuable case study for cultural historians; it offers an exceptionally clear picture of the dialectic within which subjects, including cultural producers, are shaped by various discourses and representations they encounter in their culture, which they then go on as active agents to inflect, reshape, and (mis)represent.

My enterprise assumes that by restoring this art to the discursive matrices in which it was produced and received, something significant may be gained. Some of these anticipated gains have been mentioned already, foremost among them the replacement of insupportable models of relations between agent and structure, painting and ideology, subject (artist, critic, viewer) and object (motivation, influence, painting). My hope is that these will combine to yield a vivid sense of the paintings as imbricated in social,

historical, and ideological processes, or to put it another way, as warriors on the "battle-field of representations" that is society, in T. J. Clark's much quoted description.[26] Such a picture would have considerable explanatory power, not only with regard to the reception accorded the art, but also for the interpretation of individual works, as I hope to demonstrate. Another anticipated fruit of discursive analysis is richer and more precise description of distinctive features of the art, as well as plausible explanations for the cultural importance those features acquired.

Recently, historical discursive analysis as an interpretive and explanatory practice has come under attack. On one hand, its goals have been parodied as a desire to restore some imaginary ideal fullness to art—to discover a work's "true" meaning (either what it "meant" to its "original audience" or what the artist "intended") by recreating its "histori-cal context."[27] Such parodies do point to problems in some recent art-historical scholar-ship, but they ignore or misrepresent subtle and exemplary correctives to those problems. On the other hand, the critiques sometimes shrilly insist that since historical interpreta-tion cannot claim absolute, objective, noncontingent status, it has no justification what-soever: historical context is nothing more than a convenient fiction underpinning a partisan and ideological interpretation of a work of art. While the notion of historical context is deeply flawed, historical interpretation per se derives enhanced value and legitimacy from confronting those flaws.

Challenges to the notion of "historical context" have concentrated on two fronts.[28] The first concerns the assumption or implication that context is qualitatively different from text—that it may provide a fixed, solid, factual ground upon which the more delicate and unstable processes of interpretation can be based. On the contrary, critics argue, both context and text are constructed through interpretation. As Jonathan Culler puts it: "Context is not given but produced; what belongs to a context is determined by interpretive strategies; contexts are just as much in need of elucidation as events; and the meaning of a context is determined by events." Because it is deeply imbued with assumptions of priority and positivism differentiating it from text and interpretation, the term *historical context* should be replaced, Culler proposes, with the notion of "framing the sign." He recommends we ask, "How are signs constituted (framed) by various discursive practices, institutional arrangements, systems of value, semiotic mecha-nisms?"[29] This is a description of the course I have pursued in the present book. I have tried to construct a framework of contemporary cultural discourses in order to produce a more rigorous and comprehensive account of the process by which New York School painting became meaningful and important. What was found to be at stake in the paintings, and how did their forms acquire that significance? It is not my ambition to speak for or as the artist or some imaginary ideal viewer in 1950 but rather as an analyst in 1992 of a complex and distant—but not yet quite remote—historical dynamic.

The second challenge to the notion of historical context centers on its suggestion that text and context are separated and distinct. As various commentators have observed, the idea of a split between inside and outside, text and context, is highly misleading. "The so-called context of a work of art is . . . not a mere surrounding, separable from form; it is what the speaker or maker has most concretely to work with: context *is* text, the context is the medium."[30] Context permeates and constitutes the text, which in turn shapes context. To say the latter is not only to say that the work of art is an integral, constitutive,

active element shaping the society and culture in which it intervenes. It is also to say that the framework devised by the art historian in the interest of "situating" and analyzing the work has been generated itself from the work of art, from the subject matters it renders, the issues it raises, the concerns it articulates. In the present study, the interests and commitments of the New York School painters—the primitive, the unconscious, the subject—lead to the "discovery" of cultural discourses centered on these categories. To neglect the constitutive role of the art in the production of this "context" and to imply that the art might verify that this is the only proper context would be deceptive. There are many possible framings for the analysis and interpretation of a set of representations; no single one will exhaust the works. The conclusion to be drawn from this fact, however, is not that histories are either impossible or unnecessary but rather, to adapt a statement by Jacques Derrida, that although "no context permits saturation," nonetheless, "no meaning can be determined out of context."[31]

Of course, not all framings will be equally illuminating; there will be better and worse histories. The good ones will sift carefully and judiciously through broad fields of evidence, acknowledge contradictions and uncertainties, and attend carefully enough to the complexities and instabilities in the material to produce a convincing, nuanced, rich, complicated, self-critical picture of an historical moment intricately entangled with the artifacts it addresses. History both opens up and limits interpretation. The effort to construct history and art history simultaneously can produce resistances and complexities that restrain, minimize, or direct the appropriation that is an inevitable part of the interpretive process. Each effort must be judged on its own merit. The fact that none will ever deliver the "objective truth" should in no way lead to disappointment or condemnation. Hilary Putnam's essay "The Craving for Objectivity" throws just the right light on this issue; quoting John Austin, Putnam observes that where interpretation and history are concerned, "enough is enough, enough isn't everything."[32]

The significances I locate in New York School paintings are not to be construed as the "true" ones; nor do I believe that works of art have a "true meaning"—or indeed *any* meaning—indelibly inscribed within them. Works acquire meanings—along with salient properties and value—in the interaction with specific communities of viewers; meaning is transitive, constituted as much by the interpreting audience as by the work itself. For a work or movement that goes on to achieve canonical status, as Abstract Expressionism has, that process of meaning constitution is especially complex. Initial sets of meanings and values—which account for the works' original selection and valorization by a community of subjects—become overlain with other meanings and valuations constituted by subsequent audiences. As Barbara Herrnstein Smith has pointed out, canonization entails the suppression of the temporality of a work:

> Features that conflict intolerably with the interests and ideologies of subsequent subjects . . . will be repressed or rationalized, and there will be a tendency among humanistic scholars and academic critics to "save the text" by transferring the locus of its interest to more formal or structural features and/or by allegorizing its potentially alienating ideology to some more general ('universal') level where it becomes more tolerable and also more readily interpretable in terms of contemporary ideologies.[33]

I am interested in discovering, insofar as it is possible, what features and meanings located early on in Abstract Expressionist paintings by those communities of subjects

that first attributed value to them may have been repressed and rationalized in the inter-vening years. What necessary or desirable functions did the paintings serve for those sub-jects who discussed, defended, and villified them? What importance was attached to this obscure and difficult art? The issue is not the truth of particular meanings but their historical significance: the meanings that concern me are crucial, early components of the process by which Abstract Expressionism came to acquire profound cultural importance and to shape cultural identity. Several different, overlapping but distinct attributions of value and meaning to the pictures have collaborated in launching New York School painting into the topmost orbits of canonical high modernism. The more familiar and influential of those meanings (artistic "progress"; anxious, alienated freedom) and values (social distinction, national achievement) have obscured (repressed and rationalized) other, more obviously contingent and ideological cognitive values and meanings.

Such are the broad outlines of this study and of the problems and questions it seeks to address.

The structural logic of this book may require some clarification. Comparing New York School notions of "the primitive" and "the unconscious" (hereafter I will dispense with the quotation marks, although the problematizing they signify should be kept in mind) with other cultural representations of the same categories requires precision in definition and description; however, my early efforts to formulate the Abstract Expres-sionists' collective version of each idea met with failure and frustration. I was surprised at the degree of disparity among the artists concerning the shape and importance given to these dominant ideas. Precise description and general application came to seem mutually exclusive. This obstacle necessitated revision of my strategy: precision could be retained if I focused the discussion on small subgroupings of artists, or even upon individuals, but then the question of group coherence would have to be addressed. This is the subject of the first chapter. It attempts to ruffle the neat package that Abstract Expressionism has become. The premise is that there is something to be gained from getting clear right at the start just what kind of entity is "the New York School." Stylistically the paintings are highly diverse, the aesthetic programs articulated by the artists feature strikingly differ-ent emphases and priorities, and the artists themselves were unanimous in disavowing any connection to one another. By taking seriously the judgment that receives so much lip service in New York School literature—that these artists formed no coherent move-ment or school—I hope to open the work to fresh analysis and reorganization, less in terms of some diffuse group aesthetic and more in terms of the relations of particular individuals and subgroups to contemporary cultural preoccupations and productions. Hard as it may be to contain this collectivity, as the essentially monographic orientation of scholarship on the New York School indicates, the effort is essential, because there are, in the end, important reasons for grouping many of these artists. The varied interests articulated in their paintings and statements are part of a discrete formation of language and ideas—a discourse—thriving in wartime U.S. culture. The chapter aims to provide both a firmer basis for conceiving the collective enterprise in which many of the artists were engaged and a platform for a better view of the ideological processes in which this art was involved.

Whatever interest it may have on its own, the question of differences and disagree-

ments within the New York School will remain a secondary theme of this text. I have avoided as much as possible the impulse to explore fine distinctions among the various forms developed and interests pursued by the different artists. Only enough attention is devoted to internal relations, distinctions, and dynamics within the group to facilitate broader historical analysis. By isolating, for example, the specific and developed notion of the primitive that anchored the artistic theorizing and production of Gottlieb, Newman, and Rothko, it becomes possible to form a clearer picture of their construction of the category, to see what its attractions and values were, and to align it with other contemporary forms that can help elucidate its cultural resonance and functions. I do not mean to insist on a hard and fast split between these primitivizing artists and others in the New York School. Their emphases were different and distinctive but not fundamentally discontinuous with the constructions of the notion formed by their peers. It is possible, however, to speak of their carefully articulated sense of *the primitive* with a specificity not possible for the others. And if I isolate Pollock as an artist engaging deeply the notion of the unconscious, that is not to imply that his construction of the unconscious was necessarily fundamentally different from those formed by other Abstract Expressionists. The most important factor is that particularity is possible in his case to a far greater degree than for his contemporaries. Still, subtle distinctions can be observed and should be given due weight, as I hope chapters 2 and 3 will demonstrate. If Pollock's construction of the unconscious rendered it as, among other things, the locus of violent, mysterious, and dangerous impulses within the human mind—as, in other words, the opening into man's bestial core—Gottlieb, Newman, and Rothko, by contrast, construed it primarily as the individual's interface with the species and its past, the repository of primal experiences of tragedy and terror, the site of uncomplicated communication between the primitive artist and the modern viewer, or between the modern painter of abstract symbols and the viewer. The differences between them should be neither exaggerated nor underplayed. When, ultimately, these artists are reassembled in the subsequent sections of the book as a viable collectivity, differences such as this one will seem less crucial in the face of the broad general basis proposed for the grouping: mutual involvement in amalgamating artistic modernism with Modern Man subjectivity.

Modern Man discourse, like much New York School art, is, as I have indicated, distinguished in part by its accommodation of dual, overlapping categories of otherness within the human subject. The treatments of primitive and unconscious components of human nature are so profoundly interrelated and interdependent that they are, ideally, inseparable. The link crystallizes especially vividly in the period slang, which labeled psychiatrists and psychologists "witch doctors." I have resorted to the contrivance of treating these two categories in separate chapters simply to make the enterprise manageable. Slippage and similarity between the two chapters will be obvious throughout. I have tried to walk a fine line, acknowledging the deep overlap, on one hand, and minimizing repetition, on the other. In order to do this, the sections take opposing structural approaches to the material. Chapter 2 starts from a wide-angle view of the culture's wartime interest in anthropology and its views of primitivism. From an analysis of the ideological character and function of this knowledge, the focus narrows to a consideration of the theory and practice of Gottlieb, Newman, and Rothko and their place in this discursive field. Conversely, chapter 3 opens with a very narrow focus. It

traces the development and evolution of Pollock's interest in and beliefs about the unconscious, gradually widening to place his case in relation to dominant cultural constructions and operations of the category.

Similarly, different types of artistic evidence come under scrutiny in the two chapters. The chapter on primitivism makes use primarily of the theoretical and critical writings and statements of Gottlieb, Newman, and Rothko. Their texts offer a fuller and clearer formulation of their beliefs about the primitive than could be drawn from their paintings alone. Much of the thinking and theorizing of these artists took literary form, a form the artists themselves took very seriously. Questions regarding the relation of theory to practice will be raised by this approach, and I will address them with particular regard to the cases of these specific artists. In the case of Pollock and the unconscious, there is little textual evidence, so I have worked primarily from the paintings and drawings. Here the relevant pictorial cues are somewhat more specific and articulate than are the primitive elements in, especially, Rothko's and Gottlieb's paintings.

It has often been asserted that several of the interests of French modernist artists were taken up by the Abstract Expressionists and given a distinctly "American" inflection. (Throughout the text I have resisted as much as possible the convention of treating "America" as synonymous and coextensive with the United States. The gain in accuracy more than compensates for the sacrifice of mellifluous phrasing.) I hope to show that at least two of the key interests usually cited were categories already being articulated in and for United States culture well before the New York School artists addressed them. Efforts to historicize Abstract Expressionism have tended to focus on the late 1930s and the 1940s; I believe we need to begin in the 1920s—or even earlier, in the years during and immediately after World War I, when the shaping of the Modern Man subject gets underway. Recognition and analysis of the discursive fields taking form in this period may help us to characterize the art's distinctly national coloring and shape. I do not mean to underplay the significance of the Surrealists, Picasso, and other French modernists in the development of the New York artists' constructions of the primitive and the irrational. I have tried to give their influence due weight, but since these artistic sources have been thoroughly traced in the existing literature, I have set my focus elsewhere. This study is intended to complement, not supersede, the more strictly art historical accounts of the New York School's artistic and intellectual commitments. It aims, however, to move beyond those accounts by recognizing and describing the historical and ideological character of those commitments. This art's "Americanness" will be found to lie more in its ideological character than in some configuration of essential pictorial attributes such as size, energy, rawness, and intensity.

Chapter 4 sketches the origins and development of the subject called Modern Man and the discourse centered on him, beginning in the late nineteenth century and continuing through the post–World War II era. I am concerned with the overall shape and specificity of the construct principally within U.S. cultural history but also as a variant of the concept *man* traced by Michel Foucault to the turn of the nineteenth century in Europe. Each of the constituent terms in the subject's name, drawn from the discourse itself, is significant: *modern* serves to connect him to the phenomenon of modernity and distinguish him from earlier incarnations, although the comparison most common in the literature is with *primitive man; man* indicates that gender will likely play some role in

the character of this modern subject. Both topics are taken up in this chapter. In Modern Man discourse, modernity is defined by catastrophe. The texts themselves articulate their motivation for mining new knowledge in anthropology, psychology, and philosophy to formulate and advance a new understanding of human nature and mind as stemming from the conviction that older views had become inadequate in light of the tragedies of recent history. World war, socialist revolution, political corruption, social conflict, economic depression, the rise of fascism, genocide, the development and use of nuclear weapons—each and all of these twentieth-century phenomena prompted meditation upon the makeup and situation of the human (white male) individual and what precisely within or outside him accounted for these tragedies. Whether explanation centered on the tragic situation of modern man or his internal conflicts, the role of ideology is not difficult to discern, conditioning the forms taken by the questions as well as the answers offered. Claims about primitive impulses and unconscious drives in man functioned to naturalize, psychologize, and individualize the violence and brutality of modern experience. They undermined collectivist theories and explanations by displacing responsibility away from the political and economic orders and the nationalism, imperialism, and authoritarianism fostered by those orders. To put the argument baldly, Modern Man discourse enlisted the notions of the primitive and the unconscious in the cause of rescuing a dominant ideology, whose notion of subject was crumbling, from threats posed by its own historical effects. The existence of this discourse reveals that the plenary, centered, conscious subject was already problematic in the first half of the twentieth century, although the critique developed then would be not nearly as radical as the poststructuralist dismantlings by Foucault, Derrida, and Lacan. Working in the wake of these latter critics has helped considerably in discerning the outlines of the earlier project.

The chapter also addresses the involvement of New York School art and aesthetic theories in the constitution of Modern Man. These artists were themselves Modern Men, shaped by this powerful discourse and its model of subjectivity, which their art in turn reproduced, elaborated, developed, challenged, and promoted. A type of Modern Man subjectivity is at the very root of these painters' sense of self, and it characterizes their lives in various respects, ranging from their artistic theories and practices to their personal behavior and *film noir* personas. Their representations of their interior worlds or inner selves as dominated by particular primitive and unconscious components—the self as a site of heroic struggle between reason and unreason, control and uncontrol—helped to consolidate Modern Man subjectivity with its enlarged capacity for containing evil, destructive, and inexplicable behavior.

The place of woman in Modern Man discourse and in the New York School is also taken up in chapter 4. The gendered nature of the new subjectivity can help us understand both the marginalization of women artists in Abstract Expressionist circles and the representation of women in, for example, the work of de Kooning and Pollock. As do *film noir* and Modern Man discourse generally, Abstract Expressionism accords women privileged relations to the primitive (as earth mother) and the unconscious (as anima), but simultaneously engineers their exclusion from the subject position in which these very categories have primacy.

The final chapter proposes a reading of several of Pollock's paintings in order to

make vivid the implications of this study for the interpretation of New York School art. My analysis emphasizes the circulation of metaphor in Pollock's work and in its critical reception. First, the dynamics of control and uncontrol and figuration and abstraction that characterize Pollock's mature painting can be read as closely related to the forms and themes of Modern Man discourse. Second, the spatial metaphors in Pollock's abstract paintings, as articulated by contemporary critics—in particular, the suggestions of web, vortex, labyrinth, and ensnared or entrapped figures—are presented as resonating within Modern Man discourse, which lends cultural relevance or force to the paintings. I also chart the presence of similar forms and themes in contemporary *film noir*, extending a parallel developed throughout the study: Abstract Expressionism and *film noir* are portrayed as congruent in many respects, principally as analogous high-cultural and low-cultural graphic representations of Modern Man discourse. The convergence of elite and mass-cultural productions working over the same ideological materials is fascinating. It provides a striking exception to Fredric Jameson's generic distinction between forms of modernism and contemporary forms of mass culture:

> Both modernism and mass culture entertain relations of repression with the fundamental anxieties and concerns, hopes and blind spots, ideological antinomies and fantasies of disaster, which are their raw material; only where modernism tends to handle this material by producing compensatory structures of various kinds, mass culture represses them by the narrative construction of imaginary resolutions and by the projection of an optical illusion of social harmony.[34]

This formula simply does not fit Abstract Expressionism and *film noir:* both repress some anxieties, but give visual form to others; both produce compensatory structures; neither has much optimistic to offer in the line of imaginary resolutions or illusions of social harmony.

Using Pollock as a concluding case study, I hope to demonstrate that the historical framework constructed here elucidates New York School art and other contemporary cultural productions by enabling us to attend more closely and completely to their complex and diverse forms and themes and to their equally complex interactions with discourse and ideology.

O N E

THE FORMATION OF AN AVANT-GARDE IN NEW YORK

We must question those ready-made syntheses, those groupings that we normally accept before any examination, those links whose validity is recognized from the outset; we must oust those forms and obscure forces by which we usually link the discourse of one man with that of another; they must be driven out from the darkness in which they reign. And instead of according them unqualified, spontaneous value, we must accept, in the name of methodological rigour, that, in the first instance, they concern only a population of dispersed events.

Michel Foucault, *The Archaeology of Knowledge*

Foucault's injunction to historians quoted in the epigraph has immediate and literal relevance to the study of painting in New York during the 1940s. If we are in the midst of "redefining" or "reappraising" that art, as it has become fashionable to contend,[1] an examination of the conventional categories structuring our understanding of the period would seem a necessary part of that process. The central category is, of course, Abstract Expressionism, or the New York School. Redefinition notwithstanding, this category has remained unchallenged despite persistent signs of weakness. Surely it is odd

that an entity whose description and analysis are routinely padded with disclaimers and provisos ("although it was never a coherent movement," "no movement or school in any accepted sense," and so on) maintains a virtually unshakable status at the core of our conception of U.S. art history.

I see two reasons for this irony. One is the resistance of New York School art and its producers to affiliation. The other has to do with the place and nature of the concept of artistic collectivity in the history of modern art. Schools, groups, movements, and the like are the fundamental structural units in the analysis of the modern period. So central are they that one wonders whether such categories are an inescapable fact of artistic production in the dealer-critic institutional system or are, rather, structures of the modernist art historical mind, akin to space and time in Kantian epistemology.[2] Yet despite the centrality and indispensability of this structure, its shape is often unclear. What does it mean to say of certain artists that they constitute a collectivity? Different sorts of claims have tended to run together in establishing group identity, claims of three general types. First, evidence may be offered of significant social contact among the artists, who are shown to have worked together or met regularly. They may also have acknowledged common aesthetic commitments and beliefs and have striven to exhibit together. A second, alternative, focus is on similarities of style and/or subject matter, similarities not necessarily recognized by the artists themselves. Third, ideological congruences may be the grounds of a perceived unity, even if those congruences are largely a matter of what the artists agreed on opposing (an academy, for instance, or a prevailing set of beliefs and theories). These three types of arguments, usually in ambiguous combination, underpin the construction of most artistic collectivities. The New York School, prior to its celebration in the early 1950s, seems to depend on a curious amalgam of all three sorts. Which, if any, are justified by the historical evidence? How intricate and contrived a weaving of these three claims are we willing to tolerate in order to locate an avant-garde in post–World War II New York?

The canonization of this art has made invisible to us various obstacles to the formation of the New York School. Internal disagreements and differences in priorities have come to seem as insignificant in the final verdict as the stylistic dichotomy between "gestural" and "color-field" paintings, which has itself been so downplayed as to make of Abstract Expressionism a portmanteau painting style. The price, or should I say a condition, of stabilizing the group has been partiality and generality of analysis. It is no coincidence that its history has been written largely monographically: to attempt to speak with precision about beliefs and practices common to the New York School painters is to court frustration. Art historical scholarship has noted the disunity while treating the milieu with the abstractness and generality necessary to preserve coherence.

Part of the motivation for constructing a unity from the population of dispersed events that was the New York School has been a desire for these artists to be seen as a U.S. manifestation of European avant-gardism. This is partly a necessity, a requirement for success in the dealer-critic system, but it is also a matter of conformity to the modernist picture of artistic progress. While reconsideration of the New York School along the lines I have just begun to sketch will require several kinds of work—among them analysis of aesthetic and ideological differences and similarities among the artists, and analysis of the congruence and incongruence of their artistic developments—in this

chapter I will focus on the artists' attitudes towards group identity and avant-garde status. In what senses was the New York School an avant-garde? And how did its formation as an avant-garde take place? The process will be traced from the first tentative critical and curatorial initiatives of 1944–45, which ended in failure and fragmentation, to the successful, broad-based, artist-supported effort undertaken in 1948–49 in the face of an outburst of reactionary antimodernism.

THEORIES OF THE AVANT-GARDE

The conditions surrounding the formation of an avant-garde in New York during the 1940s have become a matter for dispute. On one hand we have a deep-rooted modernist account, the crucial claim of which is voiced by Clement Greenberg: "What happened . . . was that a certain cluster of challenges was encountered, separately yet almost simultaneously, by six or seven painters who had their first one-man shows at Peggy Guggenheim's Art of This Century gallery in New York between 1943 and 1946."[3] The challenges Greenberg has in mind are formal ones; for example, "loosening up the relatively delimited illusion of shallow depth that the three master Cubists— Picasso, Braque, Léger—had adhered to since the closing out of Synthetic Cubism," and loosening up also "that canon of rectilinear and curvilinear regularity in drawing and design which Cubism had imposed on almost all previous abstract art." In his view, then, the development of an avant-garde in New York during the final two years of World War II was an aesthetic phenomenon. Certainly, he would admit, there were nonaesthetic enabling conditions—the growth of the art institutions and market in New York, the arrival of prestigious European émigrés, the artistic professionalism produced by the WPA art project, and so on. But the essential fact was the simultaneous emergence of a group of individuals capable of and committed to engaging and extending the modernist tradition in roughly compatible ways.[4] Most histories of the New York School advance some version of this model, whether their emphasis falls upon matters of form or of subject matter.

An alternative view is implicit in the emerging historical materialist account of the New York School, one strand of which is outlined in Guilbaut's *How New York Stole the Idea of Modern Art*. Guilbaut's primary concern is to explain the national and international success of New York School painting in terms both of its embodiment of postwar United States liberal ideology and of its consequent role in the nation's cold war cultural imperialism. This he does with considerable force, but the direction of his interests leads him to elide the appearance and the success of the avant-garde in New York. Formation and promotion tend to be presented, without argument, as one process.[5] One can, though, infer from Guilbaut's argument a view of avant-garde formation in New York prior to its celebration in the late 1940s and early 1950s. As he sees it, a group of artists emerged from the political crises of the late 1930s with a certain set of strategies for coping with the difficult situation facing wartime artists. For example, "by using primitive imagery and myths to cut themselves off from the historical reality of their own time, they [the American avant-garde painters] hoped to protect themselves from the manipulation and disillusionment they had suffered previously." Furthermore, Guilbaut claims, this group adapted to subsequent shifts in the sociopolitical temper along common lines.

To illustrate, apropos of 1946: "The avant-garde artists took on both a prestigious past and an image of gravity and seriousness as well as a coherent native tradition, all the things that the new age required. The group thereby forged an 'American' image for itself, something that was becoming increasingly necessary for selling art in the United States."[6]

This instrumentalist view portrays the New York avant-garde as a group of artists who responded in unison, by developing their art along common lines, to the political, social, and economic forces shaping their historical situation. The avant-garde was that grouping of artists whose adaptations to these forces best matched, by coincidence or design, the needs of the liberal bourgeois elite claiming United States cultural supremacy in Europe.

These two versions of avant-garde formation in New York agree, surprisingly, on some fundamental points. Both consider the grouping of artists to have been a real one and to have had a substantial basis, whether formal or ideological. Both portray group formation as a product of related responses by individuals to problems encountered generally. Both assume that this initial instance of avant-gardism in the United States is fundamentally continuous with the European manifestations of the previous seventy-five years. Neither Greenberg nor Guilbaut is much interested in the actual process by which the New York School as an entity took form; indeed, my pressing their texts on this issue may seem overbearing. Greenberg is preoccupied with characterizing Abstract Expressionism's artistic achievements, Guilbaut with the basis of its participation in national cultural imperialism after the war. But as a result, both are content to work with convenient assumptions about the "movement's" character and formation.[7]

I want to argue that the process by which the avant-garde took form in New York was much more complex and particular than these explanations allow. Furthermore, certain aspects of the process throw into question some of the larger claims implicit in both Greenberg's and Guilbaut's accounts. One may, in the end, justly wonder whether the New York School qualifies in any meaningful sense as an avant-garde at all. Raising this question compels me to be clear about what precisely I take *avant-garde* to mean. This term has been subjected to considerable abuse—both by the critics of the 1940s, who often used it to refer to "that amorphous legion of the art world" experimenting with nonrealistic modes,[8] and more recently by theorists, notably Peter Bürger, whose attempt to appropriate it for a particular set of artistic objectives and a too specific historical moment deprives it of an important structural role in the history and sociology of modern art.[9]

I take *avant-garde* to designate a structural phenomenon of modern Western artistic production involving both a social organization and a broad aesthetic orientation. The social organization may be loose (the Impressionists) or tight (the Surrealists), but the members of an avant-garde maintain a sense of collective identity which distinguishes them from all nonmember contemporary artists.[10] Avant-gardes historically have displayed the difficulty involved in establishing a working equilibrium between claims to collective identity and demands for individual freedom and autonomy. This is in large part a function of the conflicting pressures exerted on the modern artist by the market, which the avant-garde structure serves to mediate: the demand for a unique, recognizable, personal style and the demand for a broader, supraindividual significance as part of

a movement, tendency, or school. It is often the case that in the early stages of an avant-garde, individual distinctions are suppressed as energies and resources are pooled in pursuit of shared aesthetic and professional objectives.[11] With success, however, comes disintegration of the group organization, as disagreements and tensions within the group assume significance at a rate inversely proportional to the level of the group's collective economic misery and political persecution.

About the aesthetic orientation I can be briefer; *avant-garde* generally denotes a set of progressive, experimental commitments, and such is the sense observed in this study. Opposition to prevailing artistic standards and procedures ("the academy") is registered by means of radical formal and technical innovation, widely perceived as extremist in nature. Beyond this, generalization is difficult and unnecessary for present purposes. As avant-gardism develops its own tradition in opposition to the classical academic tradition against which it arose, antitraditionalism *tout court* becomes an impossible and undesirable position for new avant-gardes. It becomes possible for a group to claim status as a *traditional* avant-garde, meaning that it sees itself as upholding the values and extending the work of prior avant-gardes. Artists so inclined would have at their disposal a full set of established behaviors and strategies capable of both securing an identity as avant-garde and facilitating success with existing institutions. At this stage, avant-gardism is really an alternative form of academicism, one demanding novelty and experimentation.

This paradox brings us to the first point to be made about the artists of the New York School: they found themselves, or placed themselves, in just the position I have described—seeking status as part of an avant-garde tradition. Their situation was complicated by the fact that New York and the United States offered no really strong academy against which an avant-garde could define itself. European vanguardism came to compensate for this lack by taking on the character of avant-garde academy. It played, in other words, both roles for the New York School artists; the European avant-garde constituted the tradition to which the New York artists desired to belong and the tradition from which they wanted to assert their independence. In the end, its identity as academy would come to the fore, and difference from it would be crucial (difference often exaggerated and questionable, as the writings of critics Clement Greenberg, Michael Fried, and William Rubin have indicated). But at the start, its status as model was preeminent. All the New York School artists were deeply impressed by the great European modernist tradition as they saw it portrayed and apotheosized in the Museum of Modern Art's exhibitions and publications.[12] MoMA's history of modern art presented the avant-garde structure as the mechanism by which innovation was achieved and promoted. Success, in that paradigm, seemed to demand affiliation; numbers conveyed legitimacy. It should come as no surprise that ambitious New York artists committed to modernism would practice self-conscious avant-gardism once they recognized its functional value within the network of institutions they aspired to enter.

One obvious strategy was to form artists' organizations, and most attempted this, with varying amounts of success. Adolph Gottlieb and Mark Rothko were undoubtedly the most inveterate joiners and organizers. Their inclination toward affiliation manifested itself first in 1935 with the Ten, a group of expressionistic modernists. That impulse peaked in the first half of 1943, when both exhibited as members of three different organizations—American Modern Artists, New York Artists Painters, and the

Federation of Modern Painters and Sculptors (hereafter, FMPS). Bradley Walker Tomlin

was also a member of the FMPS. David Smith and Ad Reinhardt belonged to the United
American Artists. Willem de Kooning, Smith, Arshile Gorky, Lee Krasner, and Rein-
hardt were all associated with the American Abstract Artists. Smith, Gorky, de Kooning,
and a few others formed a short-lived group in the mid-1930s.[13] William Baziotes,
Krasner, Robert Motherwell, and Jackson Pollock flirted with the idea of joining Matta's
proposed group of American surrealists, but the project failed to materialize.

None of the organizations catalogued above became anything like an avant-garde—
for various reasons, among the most important of which was their very loose aesthetic
character and program. Nor was this their sole, or, in some cases, even principal
purpose. Part of the motivation behind this organizing activity was no doubt simply
practical: participation in an organization made it easier for an artist to show her or his
work, to attract the attention of critics and curators, to meet new patrons, and to insure an
advantageous context for the viewing and interpretation of the work. Furthermore, it
offered a framework promoting mutual support and the constructive exchange of ideas
and methods.[14] Another part of the motivation for organizing was vestigial prounionism
and collectivism carried over from the 1930s. Some of the larger groups, especially,
functioned as artists' labor unions. But most of the organizations that promoted sympa-
thy for European modernism sought avant-garde status as well.

One way of gauging the level of this interest in avant-garde status is to look for the
use of strategies characteristic of the avant-garde, for example the production of mani-
festoes, public controversies, and protest exhibitions. Such devices became common-
place in New York in the early 1940s. Here, too, Gottlieb and Rothko were most prolific.
Gottlieb, as a chairman of the FMPS's cultural committee, began writing manifestoes and
protest letters for this organization in the early 1940s and continued in this capacity until
at least 1949.[15] Rothko was an author of the Ten's "Whitney Dissenters" manifesto in
1938. Each of the three organizations with which these two exhibited in early 1943
provided an overblown manifesto pinpointing some enemy which it portrayed as the
current academy. The FMPS alone, during a period of roughly two years between Novem-
ber 1941 and January 1944, launched protests against at least six major museum exhibi-
tions and succeeded in all but one case in getting its complaints published.[16] The
globalism controversy of mid-1943, produced by a letter to the *New York Times* from
Gottlieb, Rothko, and Newman, was the *succès de scandale* toward which all the earlier
efforts had aspired.[17] In years to come Gottlieb and Rothko continued to write to the
Times in hopes of repeating their triumph.

Although the strident, belligerent, and rhetorically grandiose tone of these mani-
festoes and the generally conspicuous behavior of the artists were recognizably and self-
consciously avant-gardist, the actual substance of their arguments and demands was
tame by European standards. The painters' sense of avant-gardism was traditional and,
for this reason, relatively conservative. It was also an avant-gardism adapted to the New
York situation, where American Scene painting and social realism still held sway. From
the early 1940s the New York modernists called for simple acceptance of abstract and
experimental modes and for artistic freedom. Beyond an often expressed antagonism to
prevailing realistic modes, their programs lacked the destructive, nihilistic component
characteristic of prior avant-gardes. They mounted no critique of the institutional frame-

work of art evaluation and promotion to which they were subject; their complaints were aimed at the aesthetic judgment of those in control of the existing institutions.[18] The artistic approach most of these artists favored was a synthetic one, uniting aspects of abstract and surrealist and, for some, even expressionist developments (although what they took these terms to designate, or took their significant aspects to be, varied widely). The manifestoes of the New York modernists constituted a kind of domesticated avant-gardism, one that had been largely purged of the radical and the rebarbative, and which came to cherish such convenient shibboleths as tradition, the liberal notion of individual freedom, bourgeois aesthetic mysticism, and universal humanism. And much as these manifestoes strove to adopt the style and tone of their European prototypes, they lacked both wit and the capacity to startle the reader. So much was noted by none other than the art critic of the staid *New York Times,* E. A. Jewell, who called attention to the exaggerated rhetorical vehemence of the catalogue essay for the second annual FMPS exhibition.[19] Unrelievedly serious, not to say pompous, and above all reasonable, these manifestoes seem to issue from the pulpit rather than bohemia. In the wake of the more radical and disturbing European Dada and Surrealist examples, they suggest a more securely bourgeois avant-gardism, in the sense that Impressionism may be so described.

A PROBLEM FOR CRITICS

Given that avant-gardism, albeit in a peculiar, self-conscious, and traditional form, was a real concern among these modernist artists, it comes as something of a surprise to find that a New York School avant-garde first took form without the collaboration of the artists involved. While expending considerable energy on behalf of other, aesthetically amorphous artists' groups, they made no effort to organize or promote the particular constellation that was beginning to take shape and would later become known as the New York School. In late 1944 and 1945, various critics and gallery operators began to suggest that a new movement was appearing. Yet none of the shrewd, ambitious artists identified in this group undertook any organizational activity to exploit this opportunity. Not only did they fail to take action on their own, but they impeded the efforts of critics and dealers to construct a platform for the group. The events surrounding the exhibition "A Problem for Critics," which was organized by Howard Putzel in May–June 1945, illustrate this point.

The title of the show was an obvious gimmick to attract the attention of the press. Putzel claimed to be exhibiting works representing a new movement, a movement that lacked a name; naming it was the problem posed to critics. Most of them recognized the ploy but took the bait anyway—that is, they reviewed the show (few proposed a name for the alleged tendency). Eleven artists were included: Gorky, Gottlieb, Hans Hofmann, Krasner, André Masson, Matta, Pollock, Richard Pousette-Dart, Rothko, Charles Seliger, and Rufino Tamayo.[20] This grouping was a selection from a new category being delineated by some critics, that of modernist artists who produced synthetic works— neither purely abstract, nor surrealist, nor expressionist, but some combination of these. Putzel's exhibition was the first in New York to be organized around artists in this category and to present them as a new school.[21] The landmark enterprise turned out to be more of a problem for the curator than for the critics.

The difficulty began when Putzel tried to articulate the grounds of the new move-

ment. From the very broad and vague basis upon which the category had been
established—part of the ordinary critical sorting of artists into convenient groups—
Putzel wanted to move to a narrower, more significant characterization. He chose to
build upon the idea of "metamorphism."

> During the past dozen years, and particularly since 1940, the tendency towards a new
> metamorphism was manifest in painting. However this may seem related with totemic im-
> ages, earliest Mediterranean art and other archaic material, it does not, on reexamination,
> appear to utilize any of these for direct inspirational sources. One discovers that the real
> forerunners of the new 'ism' were Arp and Miro. Some of Picasso's paintings fit in the same
> category, but the series he calls Metamorphoses is, in aspect, more sculptural than pictorial.[22]

Metamorphism derived in Putzel's view from Arp, Miró, and Picasso, all of whom were
included in the exhibition as "forerunners." But before this lineage could be proposed,
apparently, some misconceptions needed to be dispelled. Putzel felt it important to
distance the tendency from totemic, Mediterranean, and archaic imagery (and later in the
same statement, from Pre-Columbian art as well). The result is the odd passage above:
disclaimer rearing up unexpectedly, qualification intruding into the presentation even
before the most rudimentary definition of the phenomenon has begun. A reader is
prompted to wonder about the urgency of the point, and not without reason, as it turns out.

Putzel was invited by Jewell to clarify the meaning of metamorphism for the readers
of the *New York Times,* and his new text was published along with the first in Jewell's
review of the exhibition. In this appendix Putzel asserted that "abstraction from realism
ended with Mondrian" and that Arp pointed out the new direction.

> Dadaism, which commenced about 1916, constituted an action against the imagery of ab-
> straction. Arp, who was one of the leaders, used a kind of automatism: a deliberate start from
> a formless field of emotion or "inspiration," which he worked toward, but not into, direct
> resemblance to recognizably familiar things. It seems to me that Arp is a forerunner of, for
> example, Adolph Gottlieb, Hans Hofmann, Jackson Pollock and Mark Rothko, who also
> work toward rather than away from direct resemblances.[23]

Jewell made that final phrase the focus of his own remarks, which questioned the
existence of the purported new "ism." He found many of the works in the exhibition
nonobjective, pure and simple; and as for those that were not, he wondered, quite justly,
how one could tell which direction the painter was moving in. How is abstraction from
nature distinguishable from abstraction toward nature? He invited readers, as well as the
painters themselves, to contribute their thoughts on the "problem." Putzel's shrewd
packaging seemed to be working.

However, at the end of the month, after whatever excitement the controversy man-
aged to generate had dissipated, Rothko sent Jewell's review and subsequent clippings
from the *Times* to Newman, who was spending the summer in Provincetown. Rothko's
comment in the accompanying letter was morbid: "the corpse was never much alive and
is quite laid out by now."[24] This remark should be read as motivated by both disappoint-
ment and serious disagreement with Putzel's terms. The disappointment concerned the
failure of the issue to flare up the way the globalism controversy had just two summers
earlier. Jewell's solicitation of responses to the Putzel exhibition had indicated his own
interest in gauging the controversy-quotient of the event. Although Gottlieb and Rothko

did their part for the cause, the volume of letters was apparently small and the responses colorless, and Jewell let the issue die without further comment on his part.

The more serious criticism implicit in Rothko's letter to Newman had been made explicit in his own response to Jewell, published in the *Times* the week following Jewell's review. Rothko precisely reversed Putzel's analysis by downplaying the significance of metamorphism and the concomitant focus on issues of abstraction and realism, asserting instead the importance of archaic form and myth.

> It seems to me that to make this discussion hinge upon whether we are moving closer to or further away from natural appearances is somewhat misleading, because I do not believe that the paintings under discussion are concerned with that problem. . . . we are in a sense mythmakers and as such have no prejudices either for or against reality. Our paintings, like all myths, do not hesitate to combine shreds of reality with what is considered "unreal" and insist upon the validity of the merger.

> If there are resemblances between archaic forms and our own symbols, it is not because we are consciously derived from them but rather because we are concerned with similar states of consciousness and relationship to the world. With such an objective we must have inevitably hit upon a parallel condition for conceiving and creating our forms.

> If previous abstractions paralleled the scientific and objective preoccupations of our times, ours are finding a pictorial equivalent for man's new knowledge and consciousness of his more complex inner self.[25]

It was no wonder that Rothko, and later Gottlieb, objected to Putzel's description of the new tendency.[26] For two years they had been explaining their work primarily in relation to primitive and archaic motifs. Putzel's tense assertion that the "real" inspiration of the new tendency was not archaic material but the work of Arp, Miró, and Picasso flatly contradicted their published statements and seemed intent upon appropriating their work for another program, one conceived in terms of direct formal relation to European modernism. At this point it is important to recall that a year earlier Putzel had helped Pollock compose a self-interview for *Arts and Architecture* in which he said Picasso and Miró were the two painters he admired most.[27] Of all the artists in the exhibition, Pollock was probably the one closest to and most admired by Putzel, to judge by the correspondence from Putzel contained in the Pollock archive and by Putzel's efforts on Pollock's behalf. And it was through Pollock and Krasner (who was soon to marry Pollock) that Putzel met and became professionally involved with Hofmann, perhaps the most vocal exponent of European modernist painting in New York.[28] I am not proposing to construe Putzel as a spokesman for Pollock or Hofmann in this instance; his appraisal of the new tendency was idiosyncratic, and I doubt that any of the artists concerned would have embraced it. But his emphasis upon the connection to European modernism over archaic material was truer to the priorities of Pollock and Hofmann than to those of Rothko and Gottlieb.[29] It is, to underline the point, a matter of priorities. Rothko was not uninterested in Miró and Picasso, nor was Pollock neutral to primitive art—although the relation of his primitivism to Rothko's is a question that will have to be taken up further on. Nonetheless, Putzel's efforts backfired: instead of consolidating a new movement, he revealed in it a rift which the artists proceeded to widen. The exhibition, followed quickly by Putzel's untimely death, marked the end of the first wave of activity in the formation of the New York School avant-garde.

To return now to the question that provoked consideration of the "Problem for Critics" episode: Why did artists who ostensibly wanted to be part of an avant-garde fail to exploit the opportunities of 1945? Why, given the centripetal impulse, did centrifugal forces prevail within the collection of artists that contemporary observers felt had the best claim to the avant-garde mantle? Any satisfactory answer to this question will have to take several factors into account. First of all, as the preceding discussion has only suggested, aesthetic and conceptual differences within the group militated against affiliation. Arguments over the character of the alleged new tendency appear from the very beginning and reveal that certain apparent similarities in the paintings rested upon somewhat different sets of priorities, beliefs, and commitments. Seen from a vantage outside the group, the similarities dominate; however, from the inside, a stronger perception of difference may have thrown the whole notion of a group identity into question. Should attention to archaic form and myth have priority over the lessons of European abstraction? What is the unconscious like, and what is the character of its automatic imagery? Do these paintings express the experience of the modern age, or do they deny its premises? Such questions were controversial among the painters of the emerging tendency, and they were a source of difficulty where group identity was contemplated.

On the other hand, the fact that these artists shared certain general thematic and aesthetic interests may also have made organization problematic for them. The artists' organizations that they previously had participated in and promoted were very loose collections of individuals working in a broad range of styles; their programs were nothing more than vague and flimsy assertions of commonality based on quality, integrity, mutual respect, and individual artistic freedom. These loose federations offered no threat to any artist's sense of individuality or uniqueness. The importance of unmitigated individuality in this social world should not be underestimated. Even during the heyday of artistic collectivism in the U.S., Jewell left no doubt in the minds of his readers as to its significance.

> An organization may "agitate" and get results. It may champion a just cause and serve to set wrongs right. It may stimulate the artist, it may help the artist in many ways. An organization may accomplish much that is worth while. It cannot produce great art. To do that lies strictly within the province of the individual; the individual seeing for himself, feeling for himself, thinking things out for himself. Great art, true art, profoundly consequential art can come to us only from the artist who—however cooperatively—walks in an essential solitude.[30]

The wish to safeguard individuality conflicted with the desire to benefit from collective organization. A balance could be achieved in a loose federation, but any tighter organization posed a threat. And it this had been true in 1939, when Jewell wrote, how much more so it must have seemed in 1945, given the post-Depression, postwar resurgence of individualism in United States society at large.

A fascinating document from circa 1945 may stand as an emblem of the complicated relations among New York School artists at this moment: a photograph apparently intended to signify unity and collegiality among some of these painters (fig. 1). Formal portraits of Baziotes and Motherwell, facing in opposite directions, are superimposed upon the backdrop of a Pollock painting. The photographic artifice that forges this union is considerable and perplexing. The painting—a small, untitled multimedia work on paper dated 1945 (JP-CR 991)—is reversed (perhaps photographed in reflection) and

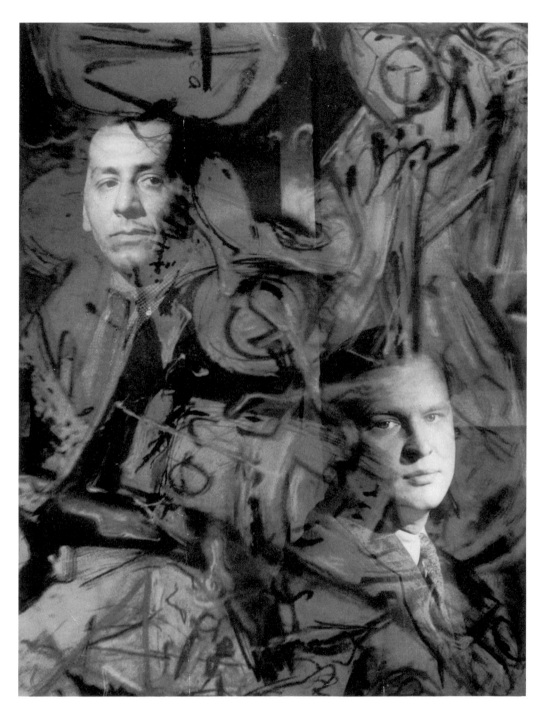

1. George Karger. Photograph of William
Baziotes, Robert Motherwell, and painting by
Jackson Pollock. *Ca. 1945. George Karger,*
Life *Magazine, © Time Warner Inc.*
Photograph courtesy of the Archives of
American Art, Smithsonian Institution.

greatly enlarged with respect to the portraits; the crossbars of a wooden stretcher-frame
float mysteriously between layers of the photograph, bisecting the image horizontally
and vertically and framing the portraits, which are set into diametrically opposed quad-
rants. If this photograph provides an image of connection, it is connection of a stiff and
artificial sort; it symbolizes the difficulty of producing the New York School artists as a
collectivity at this time.[31]

I mentioned above that the problem of balancing individual freedom and collective
identity was a problem of avant-gardes in general; in this respect the U.S. case should be
understood as different in degree, but not in kind, from that of most European avant-
gardes. Whether individualism was more extreme in the New York milieu than in its
European counterparts, or whether it was so strong because the formation of the Abstract
Expressionist avant-garde started only after most of the artists had begun individual
careers, a resistance to submerging the individual in the collective was overwhelming.
There is no moment in the history of the New York School at which the artists were
willing to work in concert to develop a set of stylistic features and formal innovations that
would serve as a basis for collective identity. Such moments are common in the history of
avant-gardism; one need only think of Monet, Renoir, and Sisley at Argenteuil, or of
Pissarro, Cézanne, and Guillaumin at Pontoise and Auvers, or of the Fauves or Der
Blaue Reiter. Perhaps the most extreme and celebrated example of such a situation is the
early stage of Cubism described by Braque, during which his collaboration with Picasso
approached the outer limits of male bonding:

> In the early days of Cubism, Pablo Picasso and I were engaged in what we felt was a search for
> the anonymous personality. We were inclined to efface our own personalities in order to find
> originality. Thus it often happened that amateurs mistook Picasso's painting for mine and
> mine for Picasso's.[32]

Such profound collaborations are not merely a way of establishing bonds within a group;
they are also a means of mutual instruction which escapes the established academic
curriculum. At the same time, they provide the opportunity for the collective develop-
ment of a program to which all the participating artists may feel that they have contrib-
uted. Each, therefore, has a direct and immediate interest in the advancement and
promotion of that mutual practice.

To be sure, individual difference continues to be cherished and sought, even in these
moments of collaboration. As I suggested at the outset, a great strength of the avant-
garde structure, a strength that no doubt accounts in part for its endurance in the history
of modernism, is its capacity to mediate between demands for individuality and for
supraindividual significance. In none of these cases of collaboration was the result a
bland uniformity. Quite the contrary: individual interests remained visible and signifi-
cant. In the case of the New York School, however, two differences are striking. First,
without the collective moment, the existence of a shared program remained always in
question, for the artists as well as for their viewers. And second, an exceptionally high
level of anxiety seems to have surrounded the matter of one's artistic individuality. The
New York School artists always guarded carefully their stylistic territory, being sure to
keep a respectable distance between their own work and that of their nearest neighbors.
The codes of their practice permitted borrowing, sometimes blatantly, from respected
European masters, such as Picasso, Miró, and Klee. But within the New York commu-

nity, forms and techniques were private property. I have encountered only one suggestion in the criticism of the 1940s that a substantial visual similarity existed between the works of two New York School artists, and the author of that observation felt no need to spell out the danger in such relations. Of Gottlieb's pictographs at the Kootz Gallery, Sam Hunter wrote in the *New York Times* that he detected "too close affinities to Baziotes and the development of an ingrown mode, more or less common to the Kootz group."[33]

The need to establish one's individuality and the competition for recognition combined to promote artistic radicalism, sometimes for its own sake. In the later 1940s, as the stakes became higher and the atmosphere overheated, outflanking one's colleagues in terms of formal extremism was increasingly seen as a necessary strategy. After Newman showed his first stripe painting, in a group show at Betty Parsons Gallery in October of 1949, Bradley Walker Tomlin wrote to him from Woodstock, "I heard reports of your astonishing canvas in the group show. Atta boy Barney up and at em—right straight up the middle."[34] Tomlin's congratulatory slap on the back indicates that Newman's success was in part a matter of having shocked his audience, including his fellow painters. The growing extremism of New York School painting at this time in two directions—the increasingly simplified field, on one hand, and the increasingly dramatic gesture, on the other—was partly a function of strategic maneuvering. The fact of stylistic polarization is, I think, evidence of an intent to establish distinctions of aesthetic interest and personal commitment. Can Newman's decision to pursue the formal path he did in 1948–49 be unrelated to the relative proximity of that path to the work of Rothko and Still and the relative distance of it from Pollock's work?

As one might expect of a milieu in which individuality was so highly valued and jealously guarded and in which competition was keen for a favorable position in the critical and commercial hierarchy, both personal and professional relationships were strained by the pressure. There is no shortage of evidence that the atmosphere among these artists was intense and sometimes ungenerous. Baziotes' letters to his brother, Christos, are the most poignant testimony: "It seems if you can't do anything materially for someone they never invite you to their place. Sometimes ten days go by and we don't see anyone. However, it is the general ambition and the love for being a 'character' that is peculiar to our time that causes this." Rothko revealed that he was exhausted by this situation: "We must find a way of living and working without the involvements that seem to have been destroying us one after another. I doubt whether any of us can bear much more of that kind of strain." Difficult interpersonal dynamics were likely another factor in the failure of the New York School artists to organize themselves into an avant-garde collective.[35]

The pressurized atmosphere, however, had both centripetal and centrifugal aspects. The urge to escape "involvements" coexisted with a consuming need for immersion in the overheated community politics. Perhaps the best way to illustrate this is to look at a letter of 10 August 1946 from Rothko, who was spending the summer months in East Hampton, to Newman, who was in Provincetown:

> I hope you have seen my missiles [missives?] to Adolph [Gottlieb] in which I have described the local scene. If you recall that we chose our present location to avoid the intrigues of the winter, rest assured that there is plenty here too! I guess our clamor is no longer escapable.[36]

Rothko's summer vacation, he reveals, was a calculated respite from the "intrigues" and "clamor" of the art season. But this respite was a sham. "I guess our clamor is no longer escapable"—an ironic complaint for one New York artist vacationing in East Hampton to be making to another in Provincetown. Did Rothko expect the intrigue and clamor to remain in New York while the art world transplanted itself to its two summer headquarters? His letter goes on to convey impressions of Motherwell, Baziotes, Pollock ("a self contained and sustained advertizing concern"), Rosenberg ("has one of the best brains that you are likely to encounter, full of wit, humaneness and a genius for getting things impeccably expressed. But I doubt that he will be of much use to us"), the painter Wolfgang Paalen, and the critic Jon Stroup. Rothko's choice that year of East Hampton over his usual destination, Provincetown, ought to be understood as having less to do with a desire to escape the clamor than with curiosity about another, less familiar segment of the art world. Hence the attention to "the panorama" in his letters to Gottlieb and Newman—like "the local scene," it has nothing to do with the dunes and bays.

In a sense, then, Rothko was right—the clamor and intrigue were inescapable insofar as they were so consuming, so mesmerizing that their subjects followed them even on holiday. Further evidence of this is the seemingly urgent need for gossip that punctuated the letters of those drawn away from the center. In the letter under discussion Rothko begs Newman for the news of Provincetown: "I thirst for gossip. Send it without delay." Tomlin, living in Woodstock in 1949, wrote to Newman that he was "starved" for gossip—"You know, just whether Mark has chewed Clem Greenberg's head off recently."[37] No doubt, in both these cases the irony is meant to be studied, but the gossip was retailed just the same. The desire to escape did constant battle against the desire for immersion; the latter usually won out.

SYNTHETIC MODERNISM

None of these obstacles to collective identity—aesthetic and conceptual differences, resolute individualism, difficult interpersonal dynamics—have necessarily prevented artists from forming and presenting themselves as an avant-garde. In other circumstances such obstacles have been overcome. But at least we can begin to see what it was that stood in the way of the New York School artists taking the initiative and behaving as avant-gardists. How, then, did they come to be perceived as such? As I have noted, the first tentative steps toward their constitution as a group, taken between late 1944 and early 1945, were the work of critics and dealers performing their routine duties—sorting out and labeling diverse objects circulating in the art world. Putzel's "Problem for Critics" group grew out of the "miscellaneous hybrid modernists" category that some of these critics were constructing, a category loose enough to contain the aesthetic and conceptual diversity that impeded the artists' own sense of fraternity. The process was a fitful one at this stage, marked by stumbling, groping, confusion, and contradiction. The driving force seems to have been the logic of the market, insatiable for new "tendencies" or "schools" around which dealers could focus their promotional energies and critics could demonstrate their grasp of the artistic panorama.

The constitution of the group may be said to have begun in December 1944, when Maude Riley proposed in the *Art Digest* that Pollock and Rothko might be starting a new

third party, between abstraction and Surrealism. A few weeks later, Robert Coates, in the *New Yorker,* described a new tendency distinguished by its synthesis of aspects of abstraction, Surrealism, and expressionism; Pollock, Baziotes, and Lee Hersch were named as part of this movement, but Rothko and David Smith were explicitly excluded. In an exhibition in Washington, D.C., in February 1945, David Porter assembled the work of thirty-five artists, including Baziotes, de Kooning, Gorky, Gottlieb, Hersch, Motherwell, Pollock, Pousette-Dart, Rothko, and Tomlin, on the grounds that they combined interests in abstraction and Romanticism-symbolism. James Johnson Sweeney, in *Partisan Review,* detected a trend toward imaginative expressionism linking the work of Gorky, Graves, Matta, and Pollock. His article testified to the growing momentum which the idea of a new tendency had acquired by this time; just a year earlier, he had written about the same four artists but had at that time structured his essay around the differences between them. And in May 1945, Putzel's exhibition served as the climax of these earliest gropings toward the constitution of a new tendency; after the minor controversy generated by this show, the idea of a new mode of painting with a corresponding avant-garde seems to have submerged for a time.[38]

One persistent thread in this initial campaign was the idea that the distinguishing feature of the new tendency was its synthesis of discrete modernist traditions. As a foundation for an alleged movement, such a synthesis was vague and shifting, but its elasticity made it viable. Even the artists could agree on this broad platform; the credos of several of them explicitly endorsed one form of the synthesis idea or another. Indeed, the basis for the new tendency articulated by Riley, Porter, Sweeney, and other critics may have been essentially an extrapolation from statements by several of the individual artists. The artists inevitably took pains to distinguish themselves in the end from the traditions they invoked; nonetheless, they generally were eager to acknowledge their indebtedness, as a pledge of allegiance to avant-garde principles. Rothko, for example, wrote in the catalogue for the David Porter exhibition, "I quarrel with surrealist and abstract art only as one quarrels with his father and mother, recognizing the inevitability and function of my roots, but insistent upon my dissension: I, being both they and an integral completely independent of them." The same point is implicit in Motherwell's article "The Modern Painter's World", published in *Dyn* in 1944, and in contemporary statements by Pollock. However, Newman's remarks (originally published in Spanish) seem best to express the feelings of many artists at this time.

> Both schools [abstraction and surrealism] have made important contributions to the plastic arts, the one by its purist functionalism, the other by its imaginative daring. It can be said that the art of the future may be a combination of or a compromise between these two schools. The art of the future will, it seems, be an art that is abstract yet full of feeling, capable of expressing the most abstruse philosophic thought.

Newman's contemporaries might have differed with him considerably over the sorts of results the merger ought to produce; the envisioned reconciliations ranged from demonstrating interest in both internal and external worlds to embracing simultaneous commitment to rational and irrational content. Nonetheless, that the marriage of modernist traditions—especially abstraction and surrealism—was full of promise at that moment seemed obvious to many of them.[39]

Besides being an imprecise foundation for a new movement, the synthesis idea had

an additional liability: synthesis was a familiar feature of earlier American modernism and its effort to come to terms with European prototypes. In the 1940s, historical accounts of the responses to European modernism by an earlier generation of New York artists credited a tendency to synthesis for not only sometimes derivative and "stylized" results, but also for the best of their work. John Marin, for example, in the words of Greenberg, had "taken cubism, married it to fauvist color and a bit of Winslow Homer, and of this made a personal instrument which has been surpassed on the score of sensitivity only by that of Klee among modern painters."[40] That the American artists galvanized by European formal experimentation in the early decades of the twentieth century would produce patently synthetic works is not surprising. They were exposed to more than they could properly assimilate or digest; their sheer appetite for the new and exciting ways of adapting form to structural and expressive purposes defined their work. The implications of this fact for articulating a new synthetic tendency in 1945 were several: the presence of synthesis per se would carry little definitive weight, so more would hinge on the particular components being synthesized; and synthesis would signify less something radically new than something characteristic of U.S. modernism, granting the provinciality that lineage implied.

Whatever the structural, theoretical, and historical limitations of synthesis as a proposed foundation for the new tendency, its importance in defining this art should not be underestimated. The dual commitment of much early Abstract Expressionist art to abstraction and Surrealism did not disappear even after the art assumed its various "classic," "homogenized," mature forms. The paintings of 1948–55 were not, it is true, the paintings of 1945. They had shed the overtly synthetic appearance and followed diverse paths that seemed to require less dialectical critical readings. But the two fundamental ingredients remained in play, as is indicated by the development and coexistence in the 1950s of two contradictory critical positions that isolated and advanced the opposing elements. Some of the most obvious failures in critical accounts of New York School art can be traced to inability or unwillingness to contend with the feature first isolated as distinctive to this art. This is not to imply that acknowledging its synthetic character would ever have solved the problem of giving coherent definition to the school; nonetheless, some of the confusion that enshrouds the phenomenon might have been dispelled.

Back in 1946 Clement Greenberg was among those who had described the intermingling of traditions as characteristic of the new tendency. Despite his general distrust of Surrealism and its influence upon these artists, Greenberg was compelled by the power of the results some of them had achieved to admit that Surrealism was fulfilling a useful purpose in their work. Speaking of Pollock, Gorky, and Baziotes, he wrote:

> French painting of the line Cezanne-Picasso-Miro had been for them a technical and formal discipline, but it did not furnish any emotional material. The example of surrealism inspired them to introduce into their pictures symbols and metaphors drawn from Freudian theory, archaeology, and anthropology. This literary apparatus has very little substance in itself and the content that the artists attribute to it appears to me illusory. But it contributed to steering them towards a painting of a Gothic genre, neo-expressionist and abstract, which is truer and more original than their imitations of Picasso and Miro. This work produces an elaborate baroque impression which recalls Poe and is full of a sadistic and scatological sensibility.

However, it is disciplined by formal ambitions and respects the majority of the constraints to which Matisse, Picasso, and Miro have submitted the illusion of depth.[41]

Greenberg would have liked more positivism and rationalism and less of the literary and esoteric, but if the price of the former was the latter, he was willing to pay it. Writing ten years later, however, in his most influential essay on the New York School, "American-Type Painting," Greenberg would begrudge Surrealism any significant part in the generation of Abstract Expressionism, giving rather to expressionism—presumably a less extreme vehicle of the literary and esoteric—the role opposite abstraction.

In part this position was a reaction against Harold Rosenberg's reading of this art, a reading which built upon and transformed the paintings' Surrealist components. Rosenberg portrayed the Abstract Expressionist artist as one who "gesticulates on canvas and watches for what each novelty would declare him and his art to be," one who participates in a process of self-discovery and self-creation through the process of painting. He held that aesthetic appreciation of the finished painting was utterly beside the point; reexperiencing the generative process and the decisions, discoveries, and actions that directed it was the proper object of viewer attention. Thus described, Abstract Expressionism, or "action painting" in Rosenberg's terminology, was not very far from Surrealist automatic writing: painting from the unconscious was not at all incompatible with self-discovery through the process of painting. Greenberg's account highlighted the commitment to formal abstraction in New York School art at the expense of its "literary" involvements; Rosenberg's inverted the imbalance. The distorting effects of this polarization of interpretation and, conversely, the importance of recognizing the art's synthetic character will become apparent in the pages to follow.

We might wonder that this principle of synthesis—which was simultaneously one of the few commitments many of the artists agreed upon at the start and the feature that figured most prominently in the early critical and commercial efforts to constitute an avant-garde in New York—was something the most influential critics and historians proved unable or unwilling to appreciate. This was a source of great frustration for the artists, who felt that their achievement was misrepresented by their critical supporters. Precisely this issue disposed Rothko (and Newman, and Still) to "chew Clem Greenberg's head off" now and then. In terms of practical success, however, the artists did not suffer from the polarity of the criticism. The two opposed readings managed to coexist in a strange hybrid account that was ultimately codified in the histories of the New York School.[42] Abstract Expressionism has been able, consequently, to have it both ways; it has stood convincingly for the formal and antiformal, ordered and spontaneous, traditional and revolutionary, contractive and expansive, national and international. This has made it especially amenable to political and ideological uses, but art historical scholarship has suffered through failing to observe the degree to which each pair of aspects represents two sides of a single coin.

The undialectical readings offered by Greenberg and Rosenberg obscured the fact that New York School painting, like U.S. artistic modernism generally, was always a two-sided enterprise—simultaneously spiritual and material, mystical and rational.[43] The spiritual aspect of the work of the Stieglitz group—the modernist artists who congregated and exhibited at Alfred Stieglitz's 291 Gallery between 1905 and 1917—spoiled their art for Greenberg. That they took more interest in the capacity of modern-

ism to convey emotional and spiritual content than in its application to rational, formal problem solving struck him as an egregious misunderstanding, making a travesty of modernism's true significance. He wrote of their art that it was "esoteric, excessively emotional, and the work of Cézanne, Picasso, and Braque [was] still slightly understood."[44] They didn't recognize, in other words, what Greenberg saw as the character and importance of the breakthroughs of Cézanne, Picasso, Braque, and their colleagues—that modernism was rational, scientific, material work on form.

Greenberg recognized that modernism had another side, the side explored in Kandinsky's *Concerning the Spiritual in Art,* but this element, he thought, should be dispensed with as a residue of Romanticism and Symbolism. The rational, material dimension to the modernist project was the side worth saving because it was what made modernism the expression of its own time.

> The first American modernists . . . read a certain amount of esotericism into the new art. Picasso's and Matisse's break with nature, the outcome of an absorption in the "physical" aspect of painting and, underneath everything, a reflection of the profoundest essence of contemporary society, seemed to them, rightly or wrongly, the signal for a new kind of hermetic literature with mystical overtones and a message—pantheism and pan-love and the repudiation of technics and rationalism, which were identified with the philistine economic world, against which the early American avant-garde was so much in revolt. Alfred Stieglitz . . . incarnated . . . the messianism which in the America of that time was identified with ultra-modern art.[45]

In other words, modernism as practiced by the Stieglitz circle set itself up in opposition to progressive rationalism because it associated the latter with the corrupt economic world. For these artists, rationalism was wrapped up in money and capitalism, from which they wanted to dissociate themselves and their work. Thus, they turned modernist art, the origins and foundations of which were rationalist and scientific, into an antirationalist, mystical enterprise, no longer part of the enlightenment project—the effort at rationalization of all of life. Greenberg found it ironic that modernism gained a foothold in the United States at that historic moment when reason was spreading through all the domains of life—that "moment in the history of the west," he wrote,

> when the stability of the society and the uninterrupted success of capitalism gave rise to the desire to explore all the domains of art. Materialism and radicalism, both full of confidence in man, served as a springboard for the spirits of intelligence and imagination.
>
> America had known since around 1900 this spiritual disposition, which was translated by the rise of socialism in politics, pragmatism in philosophy, and, in the domain of arts and letters, by the appearance of poets such as Eliot, Pound, Moore, and Stevens, and of painters such as Sloan, Glackens, and Prendergast.[46]

The early New York modernists had declined to participate in this spread of rationalism through society and culture by concerning themselves with varieties of mystical individual expressionism. That such an historic opportunity was wasted galled Greenberg; while he could not do anything to change the past course of events, he was relentless in his efforts to guide the production and interpretation of the 1940s variety of modernism along the proper path.

In Greenberg's analysis of Abstract Expressionism, the role Stieglitz had earlier played as purveyor of "a formless vapor of messianic emotion, esotericism, and carried-

away, irresponsible rhetoric having scarcely any relation to the art in question" was filled by Harold Rosenberg—a new, mystificating theorist and defender of modernist abstraction's origin and involvement in the individual soul, spirituality, and interiority.[47] Rosenberg had been involved in New York Surrealist circles since the early 1940s, and he was a regular contributor to *View,* the Surrealist magazine founded in 1940 by Parker Tyler and Charles Henri Ford. He participated in a dialogue with André Breton published in *View* in 1942, his own poetry was published and discussed in its pages, and he composed answers to Surrealist survey questions such as "What is the disappearing point of the unconscious?" and "What do you see in the stars?"[48] Rosenberg's later existentialist interpretation of New York School action painting was rooted in Surrealist principles: emphasis on the creative process, attention to what the work of art reveals of the artist's interior dynamics, and antiaestheticism, to name just a few.

Why then, was the synthesis attempted by Abstract Expressionism resisted so vehemently in the dominant critical interpretations? Was it Greenberg's and Rosenberg's personal, intractable aesthetic and theoretical commitments that prevented recognition of the dialectic operating in the art they championed? Or was there something about the literary medium that impeded the synthesis; was the amalgamation of abstraction and Surrealism something that could seem possible in paint at that moment, but not in words? Whatever the explanation, the two sides of modernist practice were closely interlocked in 1940s New York. Indeed, they became the means through which the art of the New York School forged its most distinctive and significant features: the enactment of conflict, the battle of control and uncontrol, the representation of division within subjectivity. It will be the argument of the pages to follow that an historical interpretation of the New York School requires a radical reintegration of these two aspects.

WE ARE MAKING CATHEDRALS OUT OF OURSELVES

A question persists: Why did this particular group of artists attract the interest and attention of critics and curators? Greenberg's answer, which points to the ingenuity and force of these artists' forms, is surely part of the story, but in crucial ways it begs the question. Why did these forms seem compelling? Guilbaut proposes that the ideology embodied in this art suited the specific needs of the marketplace, which sought both to fill the vacuum left by the lack of French imports during wartime and to find a national cultural identity to advance on the international stage. This is also part of the story, but again crucial questions remain about why and how this art came to satisfy those particular needs. One key step in the answer is the recognition of a different set of ideological underpinnings in the art from those Guilbaut describes, which will help to explain both the attention attracted by these artists and the recurrent claims for their relatedness.

This ideological force will be the primary subject of the subsequent chapters of this book. To pave the way for the arguments of those chapters it is necessary to underscore one more aspect of the artistic project being identified with the painters who would compose the New York School. Many of them were in general agreement concerning another feature of their art beyond its synthetic orientation: that its subject was, in significant part, the self. This may seem now, as perhaps it did then, a rather vague and

banal observation; I will argue that given careful attention this claim too, like the synthesis idea, can be crucially illuminating.

The inward direction of the artists' attention—upon the self, its mental contents and capacities (the unconscious, the ego), its individual and universal characteristics—was articulated in some of the earliest public statements by the future Abstract Expressionists. In February 1944 Pollock first publicly acknowledged his interest in making the unconscious the source of his art.[49] In the same year Robert Motherwell pointed to a general interest in self-exploration and explained it as a function of the modern artist's social isolation: "Empty of all save fugitive relations with other men, there are increased demands on the individual's own ego for the content of experience. We say that the individual withdraws into himself. Rather, he must draw from himself. If the external world does not provide experience's content, the ego must."[50] As Putzel's effort to assemble and rationalize an avant-garde began to crumble, one of the very hands wielding destruction proffered another ground of commonality. When he stepped back to compare the cultural significance of the alleged new tendency with that of other modern movements, Rothko found one point certain. "If previous abstractions paralleled the scientific and objective preoccupations of our time, ours are finding a pictorial equivalent for man's new knowledge and consciousness of his more complex inner self."[51] Rothko didn't present this observation as a basis for the new tendency; perhaps it seemed too broad and shapeless a foundation for a movement, or perhaps too obvious and mundane. Perhaps, also, it was unclear to him whether his own avenue into this larger project was taken by all the painters concerned. Nonetheless, his own belief was that the ultimate import, the cultural significance, of the work resided in its engagement with new, evolving notions of human nature and mind.

This view acquired some momentum over the next few years, as more artists articulated this interest and even followed Rothko in extending it to their colleagues. Barnett Newman's answer to the question of how it was possible to make a sublime art in a time without sublime legends or myths was that he and his associates were finding the sublime in themselves. "Instead of making *cathedrals* out of Christ, man, or 'life,' we are making it out of ourselves, out of our own feelings."[52] A year or two later, in the spring or early summer of 1950, Jackson Pollock concurred: "The thing that interests me is that today painters do not have to go to a subject matter outside of themselves. Most modern painters work from a different source. They work from within. . . . The modern artist, it seems to me, is working and expressing an inner world—in other words— expressing the energy, the motion, and other inner forces."[53] Jack Tworkov saw this inward orientation as the fundamental difference between the ancient and modern worlds. At the opening of an article on Soutine, he placed an epigraph from Whitehead: "The ancient world takes its stand upon the drama of the universe, the modern world upon the inward drama of the soul." Tworkov recalled in an interview in 1962, "It seemed to me that when I began painting in 1945, or earlier, 1944, I thought for the first time that I wanted to paint by means of search, by means of a kind of interior search for myself. I think in this connection . . . I wasn't unique."[54]

Again we must be sensitive to significant distinctions among these statements. When Newman speaks of finding "revelation" within himself, his words have a biblical

tone alien to Pollock's physicalist imagery. Newman saw the self as an avenue to the transcendental and the sublime, not as an end in itself: "The present painter is concerned not with his own feelings or with the mystery of his own personality but with the penetration into the world mystery."[55] In searching within themselves, these artists ranged over wide territory. In this sense the notion of inward focus is no less flimsy a basis for group identity than the others we have encountered; this is especially true given that so many other modernist artists outside the inchoate New York School would have subscribed to some version of the idea.

Flimsy though it might have been, this thesis too became the premise for an exhibition proposing to locate and define a new avant-garde in New York. "The Intrasubjectives" was organized in the fall of 1949 by Sam Kootz. Kootz was an enterprising dealer and art world impresario who had been making waves in the New York art community since 1931, when he asserted, in response to a *New York Times* review critical of his book *Modern American Painters,* that "there aren't ten first-rate painters in America." His dissatisfaction continued into the 1940s, when, in another infamous letter to the *Times,* he excoriated the community of contemporary artists in New York for failing to take advantage of new market opportunities opened by the decline of European imports during the war and for lacking imagination and a spirit of adventure in their work. His final paragraph was deliberately provocative:

> Money can be heard crinkling throughout the land. And all you have to do, boys and girls, is get a new approach, do some delving for a change. God knows you've had a long rest.[56]

By 1949 Kootz had identified a group of artists whose "delving" he and others were beginning to find convincing, and he undertook initiatives aimed at marketing those artists on the international block. In the pamphlet printed to accompany the widely publicized "Intrasubjectives" exhibition, he introduced the participating artists—including Baziotes, de Kooning, Gottlieb, Motherwell, Pollock, Rothko, and others—as drawing upon a "new realm of ideas" concerning the interior of the individual. He characterized their paintings as part of a "concerted effort to abandon the tyranny of the object and the sickness of naturalism and to enter within consciousness." What united the artists was the fact that they created "from an internal world rather than an external one. . . . each painting contains part of the artist's self." They shared, he wrote, a "point of view in painting, rather than an identical painting style," and the range of pictures in the show revealed that many sorts of images could be persuasive, even compelling, as representations of the modern self. I will come back to this exhibition and its critical reception in chapter 4, where their terms will resonate, I hope, in an enlarged frame of reference.[57]

This focus on the mind, the nature, and the "interior" of the modern self has been noted frequently by the artists involved and by critics and historians, although it has not been seen as lending unity and identity to the group. Newman reaffirmed his own interest in 1965: "The self, terrible and constant, is for me the subject matter of painting and sculpture." In 1967 Gottlieb recalled that in the 1940s "one had to dig into one's self, excavate whatever one could."[58] *Life*'s early effort to make sense for its readers of modern art in general, including the work of several New York School artists, came to this climactic conclusion: "The meaning of modern art is, that the artist of today is

engaged in a tremendous individualistic struggle—a struggle to discover and to assert and to express him*self."* The magazine quoted some of the panelists it had convened for a roundtable discussion of modern art. Meyer Schapiro noted that modern art demanded "a constant searching of oneself." H. W. Janson concurred: [The modern artist] is preserving something that is in great danger—namely, our ability to remain individuals." Schapiro later elaborated upon his point in relation specifically to Abstract Expressionism: "This art is deeply rooted, I believe, in the self and its relation to the surrounding world."[59] Harold Rosenberg's account of Abstract Expressionism as action painting made the drama of self-discovery the heart of its accomplishment. And unsympathetic critics too took self-exploration and inward focus as important distinguishing features of New York School art. In an essay from 1959 titled "Narcissus in Chaos," Cleve Gray challenged the assumption, which he associated with Abstract Expressionism, that the self and the unconscious were worthy subjects for ambitious art:

> This is a presumptuous program for an artist. It is presumptuous because it deliberately states that the visual declaration the artist makes is not about his conception of the visual world, but is only about his individuality. The artist assumes that his own ego and unconscious are worth contemplating, are more worthy of contemplation than the objective world. . . . [Such work] expresses no defensible or disputable assertion. The artist who is so attracted to himself that he is content with his private shorthand, and the group that enjoys the contemplation of his narcissism will, one hopes, be replaced by artists who have learned the importance of human relations.[60]

This assortment of statements is representative of a larger pool that identifies attention to self as a prominent feature of New York School art. However, the literature more commonly treats this commitment as not terribly revealing, as if in itself it offers little purchase on the art, little help in determining its distinctive profile. Inward focus is assumed to be a generic feature of modernism broadly; it is part of Abstract Expressionism's modernist credentials but for just that reason is relatively insignificant. Indeed, many of the artists' statements of this interest spill over into banal modernist tropes (for example, Pollock's remark, "Painting is self-discovery. Every good artist paints what he is."[61]). Inward focus fits the pattern set by the synthesis thesis: the loose, broad, shifting tenet, susceptible to highly individual coloring, is the sort able to compel general assent from this diverse and staunchly individualistic group of artists. I will want to argue that there is considerably more here to work with than there seems; the claim to be "finding a pictorial equivalent for man's new knowledge and consciousness of his more complex inner self" can take on substance and significance once the contemporary meanings and weights of the statement's terms are investigated and elaborated.

New York School art was involved in a broad cultural project—reconfiguring the individual (white heterosexual male) subject for a society whose dominant models of subjectivity were losing credibility. Narcissus was indeed in chaos, and these painters took that situation as thematic. Far from fulfilling some mythic role as intransigent opponent of bourgeois ideology and values, the New York School was deeply immersed in the reconstruction of that ideology. In some fundamental ways, New York School art went with, not against, the grain of wartime United States culture, and the character of this engagement provides what coherence the group can claim. It was that grouping of

artists whose adaptations of European modernism engaged a particular set of cultural preoccupations and performed a certain type of ideological work.

If, in the end, there was some sort of basis, however broad and ill-articulated, for group identity, it still permitted significant diversity—not only of ideas addressed, beliefs mobilized, and priorities established, but of visual imagery and style as well. Some painters might emphasize violence and the unconscious, others myth and tragedy; some might produce heavily impastoed works combining a tight formal syntax with a

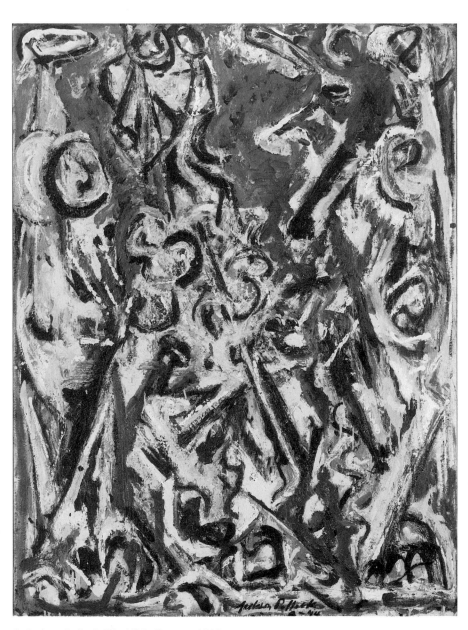

2. Jackson Pollock. The Night Dancer. *1944.*
Oil on canvas, 110 x 86 cm. Collection of
Jesse Philips. Included in the exhibition A
Problem for Critics, 1945. *Photograph by*
Rollyn Puterbaugh.

3. Mark Rothko. Watercolor. *Ca. 1944–45. Size and location unknown. © 1992 Kate Rothko-Prizel and Christopher Rothko/ARS, New York. Included in the exhibition* A Problem for Critics, *1945. Reproduced in* Art Digest *(1 June 1945): 12.*

paradoxically freehand manner—for example Pollock's *The Night Dancer* (fig. 2), shown in the "Problem for Critics" exhibition. Others could favor curious symbolic forms in conventional space, rendered in a thin, delicate, open, unlabored, and loosely structured style, as in Rothko's *Watercolor* (fig. 3), also shown in "A Problem for Critics." After the mid-1940s, visual differences among the artists became more pronounced as the most prominent of them moved toward gestural or color-field poles. Stuart Preston, reviewing the "Intrasubjectives" exhibition in the *New York Times,* found the paintings so diverse, he said, that the "portmanteau word" *Intrasubjectivism* failed to contain and explain them.[62] The immediate, obvious, and substantial differences among the works usually took precedence over broad, underlying similarities, especially for those observers closest to the artists. Perhaps by now we should not be surprised to find that the intimate observers were often the last or the most hesitant to affirm the existence of the new tendency.

NEWMAN AS CRITIC AND CURATOR

Barnett Newman's activities in this formative period are of particular interest here, because until 1947 his professional identity was in large part that of critic and occasional curator.[63] Like others in the art community, he was well aware of the ongoing efforts to constitute and name an avant-garde in New York, and he seems to have had mixed feelings about this enterprise. An important essay from 1945, unpublished until 1971, presents his views on Putzel's exhibition and on the situation of progressive, abstract painting in New York. In "The Plasmic Image," Newman applauded the recognition of the new movement, at the forefront of which he placed his friends Gottlieb and Rothko, but he proceeded quickly to qualify the claim for its organization and to warn about organized movements in general.

Mr. H. Putzel in his recent exhibition at his 67 Gallery, called *A Problem for Critics*, has shown the need of naming and perhaps explaining the new movement in painting that is taking place in America. That such a movement exists—although [it is not organized] in the way the surrealist and cubist movements were organized—is certain. . . . [It] is unmistakably a movement in the direction of "subjective abstraction." . . . Before we investigate what these painters are doing to entitle them to the classification of an art movement, it is important to understand that only a few of these men, who some believe are combining surrealism and abstract painting, stem from either movement. That is the danger of crystallized movements. Their limitations are binding, except in the very strong.[64]

Newman himself was one of those who had thought earlier that the combination of Surrealism and abstraction held the key to the future,[65] but now he, like Putzel and Rothko, wanted to align the amorphous new movement with his own artistic commitments. "If it were possible to define the essence of this new movement, one might say that it was an attempt to achieve feeling through intellectual content. The new pictures are therefore philosophic."[66] This interest in "philosophic painting" was a frequent theme of Newman's writing at the time, rooted in his intense personal involvement with philosophy;[67] the fact that he could enlist the new movement in support of this interest underscores the ambiguity of its commitments. Because there was no consensus concerning the movement's character and significance, it was open to appropriation into a wide variety of aesthetic programs. In 1947 Newman would undertake a curatorial initiative designed to substantiate his claim for intellectual content as the essential and distinguishing feature of the new movement.

Newman's promotional activities in the 1940s were directed narrowly, at first toward the Rothko-Gottlieb axis, and later toward an expanded subgroup containing these two plus Still and Newman himself. This subgroup was precisely the sort of entity that the New York School as a whole has come, mistakenly, to seem: a group whose members shared in some measure a sense of identity—the "small band of Myth Makers," as Rothko put it—based upon a real commonality of aesthetic belief and artistic practice.[68] This subgroup, however, was not coextensive with the New York School, nor did Newman try to make it so or make it seem so. When he undertook, in early 1947, to make the case definitively for the program he saw as distinguishing the subgroup, his presentation restricted itself to the stable of artists at the new Parsons Gallery. Around the core subgroup, minus Gottlieb, who was affiliated with Kootz, Newman assembled an array of satellites—Hofmann, Pietro Lazzari, Boris Margo, Reinhardt, and Theodoros Stamos—several of whom had little to do with the concerns of the core group. (Would Reinhardt, for example, have agreed that he was "not an abstract painter, although working in what is known as the abstract style"?[69]) It is possible that practical circumstances surrounding the exhibition, entitled "The Ideographic Picture," dictated this tactic; the show's primary purpose may have been to forge an identity for the new gallery rather than to present the new tendency in compelling and comprehensive form. Newman's words in the catalogue introduction are ambiguous: "Mrs. Betty Parsons has organized a representative showing of this work around the artists in her gallery who are its exponents. That all of them are associated with her gallery is not without significance."[70]

Is Newman distancing himself from the selection, perhaps because of his own inclusion? We don't know whether he would have wanted to include Baziotes, de

Kooning, Gorky, Motherwell, or Pollock, or whether he indeed thought them part of the

aesthetic tendency he was describing. According to the recollections of Richard Pousette-Dart, Newman intended to include Pollock and Pousette-Dart in the exhibition but was prevented from doing so by "contractual obligations."[71] In any case, the fact that Newman did not even mention the others makes the exhibition peripheral to the constitution of the New York School; it is less significant than the "Problem for Critics" and "Intrasubjectives" exhibitions. Its principal impact was the consolidation of a subgroup and the enlargement of that subgroup by one significant member—Newman himself.

Although Newman did not put Pollock or the sculptor David Smith into his exhibition, it may be revealing to imagine what the effects of such a gesture might have been. It would have been easy enough for him to designate their art as "plasmic" or "ideographic" in the broadest sense—that is, as works in which "the plastic elements of the art have been converted into mental plasma," and in which shape functions as "a vehicle for an abstract thought-complex."[72] Pollock's engagement with mental processes and (largely "unconscious") contents was a prominent feature of his paintings and his own public statements about them. Smith linked his own work (and abstract art in general) to the ideas of Einstein and Freud and the scientific analysis of the unconscious.[73] But here was the rub: to portray the new "subjective abstraction" as a visual equivalent for ideas and theories distinctive of modernity went against the grain of Mythmaker artistic theory. Newman associated a rather particular intellectual content with the new movement: "the idea-complex that makes contact with mystery—of life, of men, of nature, of the hard, black chaos that is death, or the grayer, softer chaos that is tragedy." He linked this content directly to the "primitive" artist and the "awesome feelings he felt before the terror of the unknowable." Their art was decidedly and deliberately out of step with the ideas and features that defined modern life. Still and Rothko explicitly agreed with Newman on this question. As Still put it, when he withdrew his paintings from the commercial market for a while in 1948:

> They [the paintings] deny so explicitly the premises on which our present scientific and commercial world is founded that they cannot perform the roll of social amenities required without emasculation of their most vital content.[74]

Pollock, by contrast, did see his art as an expression of the philosophy and technology of the modern age:

> Modern artists have found new ways and new means of making their statements. It seems to me that the modern painter cannot express this age, the airplane, the atom bomb, the radio, in the old forms of the Renaissance or of any other past culture.[75]

> Experience of our age in terms of painting—not an illustration of—(but *the equivalent.*)— Concentrated fluid[76]

Such ambitions apparently did not preclude "primitivist" commitments for Smith and Pollock; and conversely, antipathy toward and alienation from modernity did not prevent the Mythmakers from associating themselves with selected modern ideas, perhaps most explicitly in Rothko's characterization of the new tendency as "a pictorial equivalent for man's new knowledge and consciousness of his more complex inner self." Both positions entailed contradiction, and the difference between them is principally one of emphasis. But this difference in emphasis set Pollock and Smith in aesthetic territory

more congenial to Clement Greenberg, whose vehement desire for a positivist art (which excluded Freudian influences) I have already described.

Nearly a year after the "Ideographic Picture" exhibition, at the very end of 1947, Greenberg still considered the Mythmaker subgroup an entity unto itself. His description of the school and its "ideology" (the word and the scare quotes are Greenberg's own) contained no suggestion of connection with Pollock or other New York modernists. Furthermore, the reservations he had about its program—that is, his skepticism concerning the "symbolical or 'metaphysical' content of its art," which he saw as "half-baked and revivalist, in a familiar American way"—were different from his worries about, for example, Pollock's art, which he believed was narrowed by "its Gothic-ness, its paranoia and resentment."[77] Even here, however, one could glimpse the outline of his later position, which I introduced at the start of this chapter. His downplaying of the importance of programs was key: "But as long as this symbolism serves to stimulate ambitious and serious painting, differences of 'ideology' may be left aside for the time being. The test is in the art, not in the program."[78] In the following years, 1948 to 1951, Greenberg was to play a crucial role in the consolidation, promotion, and defense of the New York School avant-garde. But his construing these painters as a group required leaving aside certain ideological differences and establishing congruence on formal grounds. His willingness to dispense with consideration of their program was one cause of the hostility of the Mythmakers subgroup toward him. Other New York School artists—such as de Kooning, Motherwell, Pollock, and Smith—whose positions were somewhat closer to Greenberg's, seemed to have less difficulty with his strategy.

Greenberg, however, was a relative latecomer to a unified conception of the New York School painters. So too was the other critical voice closely associated with Abstract Expressionism, Harold Rosenberg. At this same moment, late 1947, he was asserting that painters such as Baziotes, Gottlieb, and Motherwell were "attached neither to a community nor to one another."[79] I take this as further evidence that the critics closest to the New York School artists were, prior to 1948, more sensitive to the differences—aesthetic, intellectual, and personal—among those artists than were more distant observers. While the very fact of their attention to this particular set of artists indicated a general recognition of connectedness, they saw real limits to that connection.

Other critics and dealers had been delineating a new avant-garde fully three years before this time, the initial flurry ending, more or less, with the controversy surrounding the "Problem for Critics" exhibition. When talk of the new tendency fell off, the artists involved seemed content to disperse into the broader modernist community and pursue their careers individually. By the following summer, when Reinhardt's comic tree diagram of the New York art world was published in the newspaper *PM* (fig. 4), the New York School artists appeared scattered throughout the three branches between the nonobjective painters and the realists.[80] The cartoon indicates that any new effort to attribute group status to these painters would have to start virtually from scratch, and this indeed is what happened in 1949–50. The new initiative began with Kootz' "Intrasubjectives" exhibition in late 1949; the old idea that synthesis of modernist modes was the source of the group's unity gave way first to the idea of the art's distinctive "interiority," and later to the idea of its special formal interests.

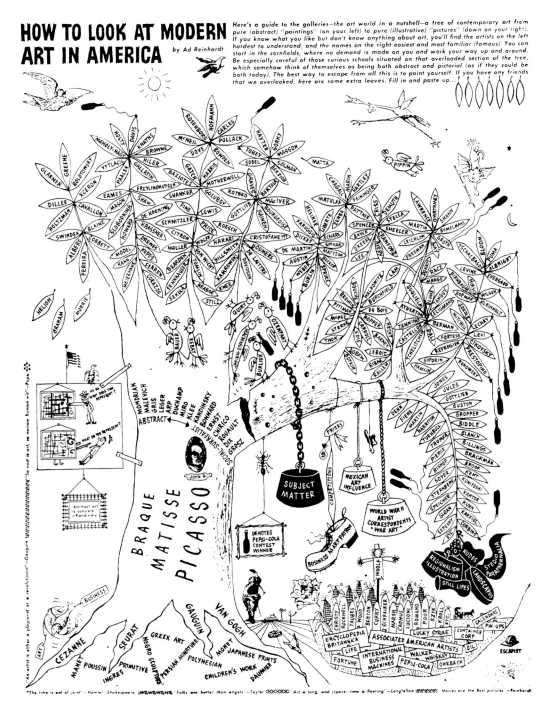

HOW TO LOOK AT MODERN ART IN AMERICA

by Ad Reinhardt

Here's a guide to the galleries—the art world in a nutshell—a tree of contemporary art from pure (abstract) "paintings" (on your left) to pure (illustrative) "pictures" (down on your right). If you know what you like but don't know anything about art, you'll find the artists on the left hardest to understand, and the names on the right easiest and most familiar (famous). You can start in the cornfields, where no demand is made on you and work your way up and around. Be especially careful of those curious schools situated on that overloaded section of the tree, which somehow think of themselves as being both abstract and pictorial (as if they could be both today). The best way to escape from all this is to paint yourself. If you have any friends that we overlooked, here are some extra leaves. Fill in and paste up...

4. *Ad Reinhardt.* How to Look at Modern Art
in America. *Published in* P.M., *2 June 1946,*
m13. © Anna Reinhardt.

THE NEW YORK SCHOOL AS BATTERING RAM

One question posed by these events concerns the relationship between the 1944–45 preview of the New York School avant-garde and its later flowering at the end of the decade. In the absence of evidence of professional affiliation among these artists, how should we view their reabsorption into the undifferentiated, amorphous modernist masses and their subsequent reemergence? Was the later reconstitution of the core group first assembled by Putzel a coincidence or contrivance, or was there a historical and developmental continuity between the two groups? It would be a mistake to assume that the more powerful reemergence took place on a more secure footing or involved a greater sense of group identity than the first appearance. Significant discontinuities and disagreements remained, but the atmosphere in the art world had changed dramatically.

The story of the outburst of antimodernism produced by the postwar forces of reaction in 1947–48 is well known by now.[81] In response to these attacks, the modernist sector of the art community organized to launch a counteroffensive in 1948. Many New York School artists participated in this activity, but they did not distinguish themselves as a subgroup within the larger modernist assembly, which covered a wide spectrum of progressive artistic interests. In the face of persecution, a sense of solidarity developed within the modernist community, although it was ad hoc, defensive, and founded only on extremely broad kinds of agreement. Nonetheless, progressive artists recognized the necessity for unity in a time of adversity and, consequently, became willing at least to consider sacrificing individualism for collective identity. Their change in attitude can be illustrated by looking first at the initial call to arms in early 1948. A letter from Tomlin, Paul Burlin, and Carl Holty proposed a protest against the growing reaction, and especially against the Boston Institute of Contemporary Art's antimodernist manifesto. The letter was explicit about the authors' worries. "We realize how difficult it is to assemble even for one meeting a group of serious artists, for they, being completely devoted to their effort as artists, are frequently inclined to wrongly estimate the calibre of their companions and fall into dissension on the point of who is the most gifted, the most important. Neglect and lack of proper appreciation has the tendency to warp the social side of the true artist and, for better or worse, he desires to be left alone."[82] But by 1950 this tendency had been tempered, as the popularity of artists' professional and social organizations, such as "The Club" and Studio 35, testifies.

The New York School artists shared in the largely tactical willingness to organize, and as they began to filter out again from the amorphous legion they seemed willing at least to consider the question of whether they constituted a community, had an identity, or merited a name. The Studio 35 discussions held in the spring of 1950—whose participants included most of what has come to be considered in retrospect the Abstract Expressionist extended family—consistently returned to these questions. None presented convincing affirmative answers to them, and several expressed grave doubts.

> HARE: I think this group activity, this gathering together, is a symptom of fear. . . .
>
> HOFMANN: There is nothing that is common to all of us except our creative urge. . . .
>
> NEWMAN: The thing that binds us together is that we consider painting to be a profession in an "ideal" society.[83]

Old habits died hard; in 1951 de Kooning remarked, "The group instinct could be a good

idea, but there is always some little dictator who wants to make his instinct the group instinct. There is no style of painting now. . . . Personally, I don't need a movement."[84]

If there was no more theoretical or stylistic unity among the artists at this moment than there had been in 1945, why did the effort to construct them as an avant-garde have such enduring effect the second time around? I think two differences are significant. The earlier attempt failed largely because of the inability of the critics and dealers to articulate for the purported group a platform that was powerful and specific and yet managed to conceal ideological and aesthetic diversity. For their part, the artists refused to accept the distortions involved in the process of producing a common denominator. The later attempt was able to succeed because both conditions had changed. The art had become susceptible to a form of criticism capable of obscuring its divisions and articulating a case for its coherence.[85] Under the pressure of persecution, the artists became more willing to see their commitments adjusted—or to adjust them themselves—to fit the mold. Alienation and freedom, flatness and literalness—these were largely peripheral to the interests that governed the production of New York School paintings in the 1940s; yet the painters became reconciled to, and perhaps came to believe in, such readings of their work's importance and congruence. There were, as I hope to demonstrate, unifying interests aligning these artists, interests indicating mutual engagement with pressing cultural problems. That feature went largely unarticulated although it figured—usually in fragmentary, implicit, and subtextual form—in critical writing on the art, and it helped underpin and stabilize the formal and political identities forged for the group. The formally progressive and politically liberal critical rationales developed for Abstract Expressionism were highly visible factors in its constitution and promotion, but they were grounded in and facilitated by largely unstated, shared, and fundamental cultural-historical engagements.

The relation of my argument to Guilbaut's on this issue warrants clarification. At times Guilbaut makes the following claim:

> The avant-garde artist who categorically refused to participate in political discourse and tried to isolate himself by accentuating his individuality was coopted by liberalism, which viewed the artist's individualism as an excellent weapon with which to combat Soviet authoritaria-nism. . . .
>
> Avant-garde radicalism did not really "sell out," it was borrowed for the anti-Communist cause.[86]

The position Guilbaut takes here conflicts with that argued in the passages from his text I quoted on pages 20–21. His book thus offers two different explanations for the success of New York School paintings. The harder of the two lines, which I juxtaposed with the Greenbergian view, argues that the New York School artists adapted their work to the same historical forces that were also producing the ideology of the powerful liberal bourgeois elite. The art, therefore, actually matched the ideology it came to serve. Guilbaut's softer line does not require such a matching. It holds that the sheer ambiguity of the paintings opened them to appropriation by those same powerful interests. In this view, the ideology the art came to serve was not necessarily the same as that (those)which figured in its production. The differences between Guilbaut's accounts of the process and my own will become clearer in the pages to follow. The process by which New York School art came to be enmeshed in the reconstruction of the dominant ideology is much

more complex and interesting than the opportunism alleged in Guilbaut's instrumentalist view. It is a telling instance of the hegemonic power of a dominant ideology. The congruence between the culture's dominant ideology and New York School art was deep and rooted in the preceding decade—the 1930s. It is not surprising that toward the end of the 1940s, as the fundamental compatibility began to emerge from beneath the superficial opposition, spokespersons for the ruling elite were able easily to find a way of construing the art that would take advantage of the congruences and obscure the conflicts.

The complexities and contradictions of the situation are visible in a letter written by Tomlin in which he reflects upon something Motherwell had said: "In talking to Bob in reference to his going back to Kootz he said (perhaps partly to alleviate his sense of guilt) that he felt that the fight was over for all of us—I think he said battle—and that at present each of us has to go about his own work. I know he means and in fact said that the bond between all of us is so strong that nothing can ever change it but that it is perhaps no longer necessary to think of ourselves as a group in somewhat the terms of a battering ram."[87] The letter was written in September of 1949, precisely the time that Kootz' "Intrasubjectives" exhibition seemed to be signaling the emergence of the Abstract Expressionist avant-garde. At all moments, apparently, this group seemed to be forming and breaking up at the same time. It was continually an unstable entity; in the process of forming it was always already self-destructing. The bonds between the artists were sometimes felt to be strong, yet the sense of a group identity was an inconvenience, tolerated at times for strategic purposes.

Can this strange phenomenon profitably be treated as a case of European-style avant-gardism? Have all avant-gardes been so brutally buffeted by centripetal and centrifugal forces issuing from both internal and external sources? Is the prominence of centrifugal forces in this case a peculiarity, attributable to factors particular to the New York milieu? In the end I am inclined to retain some aspects of the avant-garde paradigm and abandon others in the analysis of the New York School. But beyond that question there are wider lessons to be drawn. The evidence adduced here is meant to suggest that the old bases on which the synthesis "the New York School" rested are misleading and indeterminate; they cannot sustain close scrutiny, and they misdirect analytical attention. Foucault's advice is sound: questioning the received synthesis and recovering a sense of the population of dispersed events it represents illuminates its distortions, its partisan and ideological character. It portrays the New York School as having a family resemblance to the European avant-garde tradition, the better to legitimize its status as heir; and it necessitates a level of generality and abstractness in the thematic analysis of the art, the better to keep the work open to established ideological readings.

What remains is to articulate a new basis or core for the collectivity *the New York School*. The following chapters will develop the proposal that the new paradigm should be oriented around the artists' shared concern with adapting modernist artistic theory and practice to the discourse on "modern man" and human nature, which was the site of a broad-based cultural effort to reconfigure the human subject in the face of the events of twentieth-century history. This proposal is of necessity very broad, in order to contain real difference—not just individualism—among the artists. And it is historically specific, in an effort to place Abstract Expressionist art in dialogue with the culture and society in which it took form and acquired meaning.

T W O

THE MYTHMAKERS &
THE PRIMITIVE: GOTTLIEB,
NEWMAN, ROTHKO & STILL

Lose those cares and furrows.
Come, come where the five boroughs
Join to fulfill a dream,
Where all creeds and races
Meet with smiling faces,
Democracy reigns supreme.
Let the New York Fair proclaim her story,
Orange, blue and white beside Old Glory.

Sound the brass, roll the drum;
To the World of Tomorrow we come.
See the sun through the gray;
It's the dawn of a new day.

Here we come, young and old,
Come to watch all the wonders unfold,
And the tune that we play
Is the dawn of a new day.
Tell the wolf
At the door
That we don't want him around any more,
Better times
Here to stay
As we live and laugh the American way.
Listen one, listen all,
There can be no resisting the call.
Come, hail the dawn of a new day.
Ira Gershwin, *"Dawn of a New Day"*

The upbeat lyric by Ira Gershwin quoted in the epigraph, set to a bouncy, captivating melody recovered from the papers left by his recently deceased brother George, served as the official anthem of the 1939–40 New York World's Fair.[1] "Dawn of a New Day," like the fair itself, exemplified one sort of possible response to recent, worrisome historical events. Its metaphors were not very fresh—gray skies, the wolf at the door—but the message was none the less attractive for that. Perhaps the hard times were over; maybe the decade just ending was merely a bad dream, an aberration, an ultimately minor setback in the history of a blessed and resilient nation. Scientists, engineers, designers, and corporations were pooling their ingenuity and resources to develop the material utopia that would be the "World of Tomorrow." Inside the fair's eighteen-story Perisphere was one preview: Democracity, the "planned and integrated garden city" of the future, as the guidebook described it. In this "perfectly integrated, futuristic metropolis pulsing with life and rhythm and music," living, working, recreation, and shopping facilities were harmoniously interlinked. The General Motors Building contained another vision: Futurama, a sprawling scale model of the urban, suburban, and rural landscapes, laced with fancy new highways, as they were envisioned for 1960. Viewers sat in moving seats that took them around the display while they drank up its hopeful vision. The Depression and the misery and despair it brought, the strikes and strife, the radical critiques of the political, economic, and social orders (the various creeds and races had not been exchanging smiles lately)—perhaps all of these would be nothing but faint, dismal memories if science and the nation's corporations could make the World of Tomorrow a reality.

But however impressive the scientific and technological wonders on exhibit at the fair, the optimism they could generate was limited. At most, they might overshadow temporarily certain concerns about the darker sides of the new technology and mechanization—their effects on labor and warfare, for example. But as a staging of national accomplishment, the fair was missing something. The spectators' disappointment was sometimes expressed as a complaint about the fair's overemphasis on material values; the World of Tomorrow seemed to some visitors too much "an extension of the nervous, urban existence of today," oriented toward gadgets, speed, and comfort, with no thought given to what constitutes "a well-balanced way of life."[2] An opinion voiced with tiresome regularity in the cultural commentary of the period was that the real problem facing modern man was the gap between his knowledge of nature and his knowledge of himself. Unless the human sciences—anthropology, psychology, sociology—could be raised to the level of the material sciences, this refrain went, humanity might not be around long enough to enjoy the fruits of its technology; indeed, it might use that technology to destroy itself. If researchers did not develop convincing explanations for the growth and spread of violent, destructive, antisocial behavior—for bloody strikes and race riots, for the corruption of political leaders and the greed of the captains of industry, for the spread of gangsterism, crime and violence, for "the social and political disintegration now so markedly in progress in America"—humanity's days might be numbered.[3]

Of course, horrifying international developments were putting the lie to the fair's rosy picture even as Futurama was being constructed. Before the fair closed its doors, much of Western Europe had fallen under Fascist rule. Science and industry soon would be directing their attentions to the war effort, with results that would forever alter their

public image. During the war, utopian hopes turned to bitter disillusion. Worries that had

been building since the era of the First World War became resurgent; in the minds of many of its citizens, the United States once more (as it had in the wake of the Civil War) lost its privileged status outside history: instead of their own great, singular national destiny, many began to speak of the "human situation," often conceived as tragic. The problem, "man" himself, was one that the older, material sciences were not addressing, perhaps one no science could address. Among those who came to perceive the human situation as tragic, and science as part of the problem, were several of the New York School artists, whose art and writing will be the subject of this chapter. As they saw it, the experience of "modern man," his gadgets and highways notwithstanding, was essentially identical to—and illuminated by—the tragic and terrifying experience of "primitive man."

PRIMITIVISM, GENERIC AND SPECIFIC

In 1943 reference to the primitive and the archaic became a conspicuous feature of some controversial modernist painting in New York. In June of that year the globalism controversy raged in the art pages of the Sunday *New York Times,* caused in part by a letter from Rothko and Gottlieb that professed "spiritual kinship with primitive and archaic art" and described Rothko's *Syrian Bull* (fig. 10) as "a new interpretation of an archaic image."[4] In October the same two artists devoted nearly half of a program about their work broadcast over radio station WNYC to explaining the primitive and mythological character of their painting, reasserting their "kinship to the art of primitive men."[5] In the following month Jackson Pollock's first solo exhibition at Art of This Century featured paintings of moon women and a she-wolf among other primitivizing subjects.

Why did primitivism assume such prominence in U.S. modernism at this time? The primitive has been, of course, a recurrent preoccupation of modern artists since the late nineteenth century. To some extent 1943 has to be seen as beginning yet another stage in an ongoing process, for no doubt many of the same motivations felt by Gauguin, Picasso, Derain, Kirchner, Brancusi, Modigliani, Giacometti, and Masson were also felt by some of the New York school artists. Rothko certainly thought so. In his early drafts for the letter to the *Times* quoted above, before he began to collaborate on a response with Gottlieb and Newman, Rothko asserted the continuity between his interest in the primitive and the tradition of this interest in modern art history. He rephrased the same idea over and over.

> Why the most gifted painters of our time should be preoccupied with the forms of the archaic and the myths from which they have stemmed, why negro sculpture and archaic Greek [sculpture] should have been such potent catalyzers of our present day art, we can leave to historians and sociol [crossed out] psychologists.
>
> Our art seems inevitably to stem from African fetishes, the fetishes of a bygone day which our reason would banish as superstitious [and] no longer tenable within our time, and the archaic visions of the Aegean sea, and the Messopotamian plane [sic].
>
> The affinities between modern art and the archaic are too obvious to need proof. That the birth of this art should so often recall either the forms or the spirit of Negro Sculpture and the archaic Aegean civilization is too persistent [to be an] accident and too unremunerative to be affectation.[6]

Five times in all Rothko reworded this same point; it received more attention in his drafts than any other idea, and it nearly always marked a new beginning to the letter. It was, it seems, a fundamental claim in his defense of his new artistic identity.[7] Although he preferred to leave to the social sciences the problem of explaining the strong appeal so-called primitive forms held for himself and other modern artists, he felt no qualms about voicing his intuition that one set of causes applied to all.

Yet the very terms in which Rothko made this point raise doubts about its adequacy. Various idiosyncracies attending his conception and terminology distinguish his primitivism from earlier versions. For example, his determination to connect his own and earlier primitivisms is itself a mark of difference. By Rothko's time primitivism's place in the modern tradition was sufficiently established that it had become self-sustaining.[8] Artists who wanted to attach themselves to the great modern tradition being described and promoted by Alfred Barr and the Museum of Modern Art could signify that ambition through reference to primitivism. This is not to charge that Rothko or any of the other New York School artists embraced the primitive solely for this purpose; however, because primitivism had become thematized in U.S. modernism, Rothko's conception of and interest in this element were qualitatively different from those of artists for whom primitivism was virtually without tradition or pedigree.

Another distinctive feature of Rothko's statements is the apparent congruence of the categories *primitive* and *archaic*. African sculpture is treated as fundamentally continuous with Assyrian, Mesopotamian, and archaic Greek art. The difficulty of this position becomes explicit when Rothko describes the archaic: on one hand, we find him speaking of "that noble and austere formality which these archaic things possess"; on the other, the archaic is characterized by an "outward savagery and apparent ugliness and brutality."[9] This discrepancy is far from unique in the history of primitivism; in fact, it could be argued that some vacillation between such models inheres in most of primitivism's manifestations. Nonetheless, the particulars of Rothko's version of the opposition begin to give his primitivism a distinctive shape. Other features of his remarks take this process further: the configuration of preferred geographic references, the set of valorized attributes, even the untroubled disregard for consistency. And if we enlarge the discussion beyond the statements quoted above, other idiosyncracies emerge—for example, the "primordialism" some have found subsumed within the primitivism of Rothko and some of his colleagues,[10] or the emphasis on the place of terror in primitive expression—that further demarcate Rothko's position within the sprawling and murky domain that is modernist primitivism. The elasticity and inclusiveness of the category allow for a significant diversity of interests, so that Rothko and Max Ernst may both be primitivists, and yet their primitivisms have relatively little in common.[11]

My point, in short, is that although primitivism is a recurrent and persistent feature of modern art history, it is in no sense a monolithic one. In this respect, as in others, the history of modernist primitivism parallels the history of anthropological notions of "primitive society." Adam Kuper's study of the history of this idea demonstrates that a distinctive version "crystallized, with anthropology itself, in the 1860s and 1870s" and persisted through the next century and further. Over that period, the idea underwent various transformations and became aligned with radically different political and conceptual programs, and yet retained an essential identity and integrity. "The elements [of a

distinctive conception of primitive society] were generally stable, though one or another might be given special prominence; but these elements were reordered in every conceivable pattern, the relationships between them systematically transformed to produce a succession of prototypes, ideal types and models."[12]

In taking a narrow and particular focus on New York School primitivism, I do not want to obscure the ideological ties that bind it to the larger artistic, political, and cultural histories of primitivism. Primitive society has been a fundamental illusion, a pseudoscientific myth of origins fulfilling specific purposes in Western society. As Kuper has pointed out, "the term implies some historical point of reference . . . [and yet] there never was such a thing as 'primitive society.' . . . Certainly no such thing can be reconstructed now . . . [and] even if some very ancient social order could be reconstituted, one could not generalize it."[13] Although academic anthropology no longer takes this fiction as its object, the myth is deeply ingrained and self-sustaining. Its momentum derives largely from the ideological underpinnings it provides for certain modern institutions, including colonialism, nationalism, imperialism, racism, and the "third world." Modernist artistic primitivisms have been a prominent aspect of this larger ideological formation.[14] In every case, cross-cultural borrowing in which the borrowed culture is construed as primitive is part of a larger exercise of unequal power relations between the two cultures. Naming the other "primitive" is itself an exercise of power which historically has coincided with other forms of direct and indirect economic and political exploitation. Primitivism has also been consistently a component of identity production and self-analysis in Western cultures, processes which often depart from some construction of opposition to an other perceived as simpler, closer to nature, and historically anterior. The identity of both the culture as a whole and of the individuals who constitute it are shaped by notions of the primitive. "Our sense of the primitive impinges on our sense of our selves—it is bound up with the selves who act in the "real," political world. . . . We conceive of ourselves as at a crossroads between the civilized and the savage; we are formed by our conceptions of both these terms, conceived dialectically."[15] And beyond these functions, artistic primitivisms commonly have been a means by which Western culture industries are provided with revitalizing exotic materials. In all of these respects, New York School primitivism is unexceptional. My emphasis upon its particularity in no sense is intended to extract it from this larger history. Quite the contrary: my hope is that particularized analysis of this manifestation and close study of its immediate political, social, and ideological implications will illuminate the larger history of modernist primitivism and its deep embeddedness in intra- and inter-national power relations over the past century. "Primitivism, like the primitive, is in the details."[16]

One other preliminary word is necessary. Traditional scholarship on the New York School yields what might be considered an answer to one of the problems I have just posed, an answer which by force of familiarity may seem to some readers to be the obvious and correct one. Are not the idiosyncracies of New York School primitivism attributable to its specific and immediate sources—Surrealist primitivism and the anthropological work of Frazer and Boas, or the influential texts of Nietzsche and Jung? As I hope to demonstrate, this argument will not bear close scrutiny. No doubt all of these sources were influences, but it is far easier to find discrepancies between the attitudes of

the New York artists and these often-cited sources than it is to find similarities. While Surrealist influence on Abstract Expressionism was considerable, a fact made explicit in the paintings and writings of the New York artists, it primarily consisted in demonstrating the importance of and possibilities for engaging the unconscious in the production of art, of giving unconscious materials form through automatism and biomorphic fantasy. By the late 1930s the Surrealists' primitivism had degenerated to an interest in fantastic personages and exotic forms. But it had rather different emphases from most New York School primitivism even in its earlier, more radical manifestation as a vehicle for dislocating the conceptual and structural orders of modern French society and culture.[17] Likewise, the views of Frazer and Boas about primitive peoples, societies, and arts are in crucial ways at odds with those of these artists. Nietzsche and Jung present more complex problems but offer neither the only nor necessarily the best frames for the ideas in play.

Furthermore, these alleged sources of the interest are often presented as also probable *causes* of it. To hold that these images and ideas of the primitive captivated the Abstract Expressionists by virtue of some power residing within the images and ideas themselves—some inherent truth or rightness recognized by the artists—is ahistorical idealism. I believe it is possible to construct a more persuasive explanation by locating the significance and force of the images and ideas in particular historical conditions (conditions to which the artists themselves frequently pointed), by situating the artists' interests in primitivism in relation to contemporary cultural expressions of similar interests, and by attending as closely to what was ignored in influential sources as to what was taken up. In order to understand why primitivism attracted the attention of certain artists and observers of art in the wartime United States, it will be necessary to study the ways in which the primitive was invoked and applied in the culture at large. This is, in other words, to take up Rothko's cue, more or less, and restore to this particular manifestation of primitivism historical and psychological as well as sociological dimensions. Were there specific cultural questions to which primitivism seemed to offer answers?

ANTHROPOLOGY AND THE WAR

One way to begin is to look at the contexts in which anthropology was being tapped at this time in United States culture. The study of early humans had been acquiring growing cultural relevance since the end of World War I. By the time of World War II, anthropology was enjoying an intellectual vogue matched only by psychology. It seemed to have significance for a number of pressing problems and questions.

On a direct, practical level, anthropology was called upon to assist in the war effort. The war was bringing the United States and the Allied Nations into contact with alien cultures; anthropology and anthropologists were needed to mediate the collisions and to facilitate the accomplishment of military objectives in exotic lands. The *New York Times* reported that anthropology was "essential to victory," noting that handbooks prepared by anthropologists explained to the armed forces "the customs of other peoples and methods of dealing with them."[18] Charles R. Walker crowed in the *American Mercury,* "Not once, but several times a day, a knowledge of the natives and a knack at winning their loyalty—in Melanesia and in Polynesia—promotes victory for our arms in the Pa-

The popular press delighted in recounting anecdotes demonstrating that a little knowledge of an alien culture (knowing, for example, that coral was valued much more highly than U.S. currency in New Guinea, or that women were not to be addressed directly among certain South Pacific peoples) enabled the United States military to outsmart the Japanese in controlling native populations. To be sure, some anthropologists worried when they saw their work "prostituted to the service of exploitation and 'imperialism.'"[20] Besides violating professional codes concerning tampering with the object of study, such practices recalled unpleasant details about the origins of anthropological investigation in nineteenth-century Western colonialism.[21] Furthermore, the memory of the anthropological brouhaha following World War I, when Franz Boas accused four of his colleagues working in Central America of having "prostituted science by using it as a cover for their activities as spies," would have encouraged caution concerning military involvements.[22]

Another immediately practical service anthropologists were called upon to perform was the refutation of the specious racial theories emanating primarily, but by no means exclusively, from Germany. During the late 1930s and early 1940s the question of the existence of innate differences in the capacities for mental or cultural achievement among races and ethnic groups was the subject of a disproportionate amount of anthropological study and publication. Paul Radin, Herbert J. Seligmann, Ruth Benedict, and Ashley Montagu are only some of the better known of the many anthropologists who wrote books attacking the theories of Gobineau and his Nazi subscribers.[23] The popular interest in biological anthropology and eugenics was also related to this concern.

While these functions help us to understand the ubiquity of anthropological discussion in the mass-circulation magazines, they are of relatively little direct significance to the present study. There were, however, questions of another sort, questions equally urgent but perhaps even more complex and difficult, for which anthropology was being asked to provide insight if not answers. The anthropologist Ralph Linton felt the pressure, and it motivated him to edit in 1945 a collection of anthropological essays titled *The Science of Man in the World Crisis*. "In the past [man] has always turned to his gods for the explanation of present calamity and for advice on how to mitigate it. . . . Today he turns with the same blind faith to the new god, science, and expects from it everything that the old gods provided."[24] The image of interrogation that he conjured was not a literary effect; the popular press was indeed putting just such difficult questions to noted social scientists. The questions presented to Bronislaw Malinowski by the *New York Times Magazine* were typical.

> Cro-Magnon cave man crouched in rock shelters in prehistoric time. Now modern city dwellers crouch in caves of steel and concrete. The "progress" of civilization apparently has led merely from one cave to another. What is "civilization," and why, after centuries of growth, is it still so vulnerable? Must men forever wage war? What hope is there for our human future in the light of our precarious situation?[25]

The interviewer's image of cavemen crouching in rock shelters and her belief in the continuity of primitive and modern experience will become significant when, presently, particular conceptions of primitive life are drawn up and compared with the views of some artists. For now, however, the important point is that knowledge of primitive man was taken to have considerable bearing upon the condition and future of embattled

modern man. Malinowski obliged the *Times* interviewer by proposing certain "universals" in human behavior and society. "We must realize that from the very beginnings of culture the principle of "nationality" as well as that of the "political state" has existed. . . . Aggressiveness exists, certainly. Impulses to beat a wife or a husband or an antagonist are personally known to all of us. They are ethnographically universal and timeless."[26]

Paradoxically, there must have been something consoling in these disturbing assertions, in knowing that at their roots, present problems were nothing new. Such was the ideological service primitivism could perform. As another *New York Times Magazine* writer put it, apropos of postwar anxiety about atomic bombs: "That is one of the useful things about the study of human antiquity. If your teeth are chattering over the future, there is nothing like a little perspective."[27] The perspective anthropology offered was especially potent because it was both temporal and cross-cultural; it was believed to hold knowledge both of primal humanity and of the various courses of early development. Some pragmatic anthropologists tried to tap these perspectives for practical guidance. Margaret Mead, for example in a *New York Times Magazine* article published the week before the Japanese attack on Pearl Harbor, surveyed primitive cultures for viable attitudes toward violence and effective handling of aggression. She articulated the pressing questions for herself, in the name of worried citizens:

> "What has become of the fighting instinct?" ask worried citizens who realize that we are in a great crisis and notice that many young men seem uninterested in fighting. "Is there a fighting instinct which is ineradicable?" ask equally worried citizens with their eyes on the apparent speed with which German youth rallied to Hitlerism. . . . Questioners agree that the anthropologist ought to be able to give some sort of answer. Don't anthropologists spend years studying head-hunters and cannibals, people who still have the habits which we thought we were outgrowing, but to which we now see many men returning by choice, and others by necessity?[28]

Cultures, she argued, can cultivate the human drives for freedom and self-expression and thus produce individuals who shun violence but willingly take up arms when their freedom is threatened. Her article suggested that it was possible to choose a preferred behavioral pattern from an anthropological catalogue and develop that pattern in a given culture by emulating certain structural aspects of those cultures in which it predominated. She left open the question of how to determine which conditions are responsible for a particular set of behaviors.

Most uses of anthropological perspective, however, were addressed to more abstract and philosophical questions, significantly different in orientation from those that inspired Mead's article. Her faith in cultural engineering rested upon a belief in the plasticity of human "drives." In her view, these drives, which constituted something like a human nature, were shaped by cultural conditions. By emphasizing the formative role of culture, Mead's article minimized the determining effects of that drive-based human nature. It was far more common for articles on anthropology addressed to a general audience to reverse this formula and ask: What does the study of primitive peoples and cultures reveal human nature to be? And how are all cultures and societies marked by this nature? Malinowski's remarks quoted above were typical in this respect. They were directed to the universal in human cultures and they favored the temporal axis over the

cross-cultural. How are the situations and behaviors of primitive man and modern man

similar? How should we account for the similarities? Such concerns as these lay at the core of the general interest in anthropological knowledge, insofar as we may deduce that interest from the fare served up to feed it.

THE PRIMITIVE: ACADEMIC AND POPULAR

Although professional anthropologists were frequently interviewed and published as expert witnesses, most of the wisdom about so-called primitive behavior circulating in the wartime United States was not the work of professionals. The primary forum in which the nonspecialist—the general reader of magazines, newspapers, and popular literature—encountered talk of the primitive and its significance for the present was a genre of books and articles dealing with the nature and status of "modern man." The (white, heterosexual, middle-class, male) individual was posited in this discourse as the subject of reflection upon modernity and its problems, and anthropological knowledge was one of the primary materials fueling the enterprise. Modern Man discourse will be described and analyzed throughout the present study, and most comprehensively in chapter 4. At this point, it is important to note that Modern Man texts mobilized information of varying credibility from diverse sources—received ideas and prevailing assumptions merged with data imported from the social and natural sciences, especially anthropology and psychology—in an effort to understand or construct "human nature" and "the human condition." Where texts of such sweeping breadth are concerned, every writer is an amateur to some degree, and those most willing to navigate the waters are often those least cognizant of the rapids downstream. So it is not surprising to find the contributors to the genre displaying every sort and level of training and taking varied approaches. Anthropologists are less numerous among these Modern Man writers than journalists, fiction writers, philosophers, psychologists, social critics, moralists, and essayists. Nonetheless, a persistent and consistent feature of this diverse literature is concern with the relation between primitive and modern man and ways of accounting for this relation.

Texts in this genre generally presented themselves as amateur philosophy, scientific analysis, or popularization of newly developed knowledge, and often the line separating them from more straightforwardly academic studies became very fine. Nonetheless, it is important to distinguish between the characteristic notions of the primitive developed in Modern Man literature and those of contemporary scholarly anthropological discourse. The latter is the usual frame given to New York School painting, more for reasons of legitimation than elucidation; the former, however, as I hope to show, provides a much more appropriate and illuminating discursive context.

It is harder to generalize a concept of the primitive operating in academic anthropological texts than it is to sketch the Modern Man version.[29] This is partly because the anthropologists, usually treating specific manifestations of primitive society, sometimes questioned the possibility or reasonability of a generalized notion of the primitive. The growth of the ethnographic method in the early twentieth century contributed to a movement away from such sweeping theories.[30] Ruth Benedict, for example, wrote in *Patterns of Culture*, "The study of cultural behaviour, however, can no longer be handled

by equating particular local arrangements with the generic primitive. Anthropologists are turning from the study of primitive culture to that of primitive cultures, and the implications of this change from the singular to the plural are only just beginning to be evident" (p. 50). When treated with any specificity, the notions of "primitive man" and "primitive life" tended to collapse.

Another striking feature of the academic version is an emphasis on the alien nature of the primitive, especially by those anthropologists who had experienced it at first hand in field research. Boas and his students agreed on this with Frazer and Lévy-Bruhl, although they expressed it in different ways. Frazer's evolutionary view yielded a condescending picture of primitive peoples as ignorant and dull-witted, with behavior based on spurious and mistaken ideas; he placed them at a significant distance from superior, civilized man.

> In attempting to track his devious thought through the jungle of crass ignorance and blind fear, we must always remember that we are treading enchanted ground, and must beware of taking for solid realities the cloudy shapes that cross our path or hover and gibber at us through the gloom. We can never completely replace ourselves at the standpoint of primitive man, see things with his eyes, and feel our hearts beat with the emotions that stirred his.[31]

Lévy-Bruhl thought the distance so great that a different type of mind and thought were necessary to explain it. Some of those who disagreed with Lévy-Bruhl, including Boas, held that although the mind was the same, the set of mental practices and categories was so different that the primitive mind was no less difficult for us to fathom. Boas' cultural relativism aimed for liberal tolerance, yet it intersected Frazer's evolutionary anthropology on this point. And finally, Boas' emphasis on the differences between modern and primitive societies, differences so great that a primitive style of symbolic art was impossible for modern civilized man, further contributed to the sense of distance. "Expressionistic art requires a very firm and uniform cultural background, such as is possessed by many peoples of simple social structure, but that cannot exist in our complex society with its manifold intercrossing interests and its great variety of situations that create different emotional centers for each of its numerous strata."[32] The sense of the incommensurability of human experience and thought across millennia was given varying amounts of prominence in these texts, but it was almost always present in some measure.

On these points, the contrast with Modern Man literature could not be more extreme. Consider the following passage from Harvey Fergusson's *Modern Man: His Belief and Behavior:*

> What seems certain is that all primitive men are strikingly similar in cultural and psychological essentials. It appears sound to assume, therefore, that in studying contemporary primitive life we are studying the essentials of our own cultural background, and the social value of anthropology depends largely upon this fact. (P. 32.)

In writing of this sort, the generic primitive was not generally recognized as a problematic category. Furthermore, the essential continuity between primitive man and modern man was beyond question. An excerpt from Philip Wylie's *Generation of Vipers,* which spent six weeks in 1942 on the *New York Times* best-seller list, makes this clear.

> What an individual can do in a mob shows many things. It shows that we live, always, side by side with our brute ancestors, and that all they have done we can do, plus refinements we are

able to add by employing science. . . . It shows a need to reckon with ourselves on this bestial plane, collectively and individually, now and always. It shows that everything we call civilization, religion, enlightenment, modernity, knowledge, and hope is as thin as a one-molecule oil scum over the deep abyss of our instinctual nature. (P. 105.)

Wylie's shrill colloquial style contrasts with the sober certainty of Horace Carncross' *Escape from the Primitive* (1926), but the point is the same.

A study of primitive mentality and customs would show us the foundations for many of our beliefs and superstitions and attitudes, and again that these, now seemingly strange, were the necessary results of the primal tendencies of the human mind in its childhood. (P. 90)

All of these writers were convinced that a dangerous, dark, irrational nucleus lurked in the mind and nature of man (the conviction gained strength as the character of fascism became recognized), a nucleus untouched by the development of civilization and science, and most easily observed and studied in primitive life, where it ruled. For some, notably Carncross, the primitive and the unconscious were congruent.

Not only was the generic primitive accepted, but its boundaries seemed at times limitless, and always fluid. That the category was pure construction and highly charged ideologically is nowhere clearer than in the specific array of disparate peoples and societies it encompassed, including imaginary first humans, living in nature like apes; ancient small communities of nomadic hunters and gatherers or farmers (associated principally with African and Native American peoples); larger, prehistoric states spanning the world; and contemporary peoples of African and Native American descent. Wylie, for example, routinely conjoined the "savage bushman" with the peoples of ancient European civilizations and even with the barbarian invaders. In some passages, the primitive is so drastically extended that it becomes virtually incomprehensible. "For civilization is a subjective quantum, and our common people are not much more civilized today, in any important sense, than the Moors, or the Mongols, the Tartars, Huns, Etruscans, Mayans, or the Iroquois."[33] Even where less flamboyance is involved, Modern Man literature characteristically combines discussion of the enduring legacy of primitive man with the assessment of survivals from ancient, civilized man. This was part of a format made popular by James Harvey Robinson in a book called *The Mind in the Making,* published just after World War I. An intellectual historian, Robinson drew on research in psychology and anthropology in an attempt to uncover the vestiges in modern mental habits of outworn practices dating from previous periods of human history. The primitive, ancient, medieval, and Enlightenment contributions to the shaping of the "modern mind" were assessed and evaluated. One of Robinson's most important and influential claims was the following: "In general, those ideas which are still almost universally accepted in regard to man's nature, his proper conduct, and his relations to God and his fellows are far more ancient and far less critical than those which have to do with the movement of the stars, the stratification of the rocks and the life of plants and animals."[34] While Robinson was scrupulous about distinguishing between two categories—the primitive and the ancient—many of those who adopted his genetic format were not. In the broad terms and sweeping scope of this literature, the comparison was often between the conditions of modern life and those of "human antiquity"—a composite of the primitive and archaic categories.

Another important feature of the primitivism characteristic of Modern Man literature has already been mentioned. Eleanor Kittredge's question to Malinowski conjured the image of modern city dwellers cowering in caves of steel, just as cavemen did in rock shelters. This was a rather common conceit in United States popular culture in the early 1940s; it turned up even in popular Hollywood films. Frank Borzage's *Mortal Storm* (1939), for example, opened with a voice-over noting that just as early man was terrified by nature and killed his fellow men as sacrifices to appease the gods, so modern man still kills his fellow humans out of fear. Whether modern life induced a sense of terror as profound as that of primitive life was an open question, but many Modern Man texts were agreed in presenting fear as an essential characteristic of primitive man's condition. According to Carncross, "mankind has apparently always realized the precarious nature of its state, and, surrounded by obvious dangers, has allowed itself to be ruled largely by fear. Primitive man threaded his way through untold perils. Behind every bush or tree might lurk a danger."[35] Hyman Levy, in *A Philosophy for a Modern Man* (1938), accepted this view of primitive life but distinguished it from the modern. "In early savage days man may start up at every shadow, or fear the devil that he imagines resides in every stone; but as society develops, these fogs that have darkened his mind and confused his understanding gradually melt away."[36] After the bombing of Hiroshima, however, the belief in the equivalence of modern and primitive terror became conventional. The argument for the continuity of the primitive and the modern had a new component. Norman Cousins wrote in an article titled "Modern Man Is Obsolete" in the *Saturday Review of Literature:*

> The beginning of the Atomic Age has brought less hope than fear. It is a primitive fear, the fear of the unknown, the fear of forces man can neither channel nor comprehend. This fear is not new; in its classical form it is the fear of irrational death. But overnight it has become intensified, magnified. It has burst out of the subconscious and into the conscious, filling the mind with primordial apprehensions. (P. 5.)

Though the notion of primitive life as suffused with terror seemed secure in this literature, there was relatively little support for it in the contemporary anthropological research allegedly being consulted. It was, in other words, a received idea with diffuse origins and a strong ideological attractiveness.[37] This is not to say that Boas, Frazer, Benedict, and company denied the existence of fear in the cultures they studied—as counterevidence, one need only refer to the passage from Frazer above citing primitive man's blind fear. In general, however, these anthropologists did not cite it as a prominent motivation for significant behavior.[38] In some cases, for instance, with Boas and Benedict this difference from the Modern Man writers seems to be a function of the experience of direct contact with other cultures in field research. Sometimes it is related to an image of primitive man as bound to nature—so recently emerged from the bestial state that he still held a secure and stable place in the ecological order. Being as yet undetached from nature, primitive man could hardly have been terrified by it. For Frazer the difference turned on the character of primitive magic and religion as efforts to control the forces of nature more than to appease them. Primitive man had as much conviction in the efficacy of his magic and religion as modern man does in his science. Why should his fear have been any greater? As Frazer saw it, the religion that evolved from the early practice of magic did involve an enhanced recognition of human powerlessness before nature, but

religion never fully separated from magic; if prayers did not work, magic was invoked to secure the desired ends. In Frazer's views, terrified passivity before all-powerful gods is inadequate as description of the "natural human state"; it doesn't accommodate the evidence of priests threatening their gods to bring rain or else. "The savage fails to recognize those limitations to his power over nature which seems so obvious to us."[39]

Boas implicitly disputes the portrayal of primitive art as motivated by feelings of awe, terror, or agitation before nature. For Boas, primitive art is a source of simple pleasure in skillful ordering of visual materials, an expression of a natural urge to represent and structure the world, as well as a vehicle for communicating status. Notions of terror and awe are not at all part of his language or conception. Similarly, Ruth Bunzel's work on the Zuni led Ruth Benedict to observe that there are primitive societies that "do not culturally elaborate themes of terror and danger" at all. And Paul Radin commented upon the "refusal to be terrified" and the attitude of serene acceptance he found characteristic of primitive man.[40]

Here again the contrast with Modern Man literature is often dramatic. Some writers, such as Fergusson, argued that the function of primitive art was acknowledging or coping with terror. "Primitive and religious art are sometimes designed to comfort man, and sometimes, apparently, to terrify him."[41] Boas would have objected to more here than the emphasis on terror and its alleviation. Fergusson's implication that the content of primitive art was relatively clear and directly available to modern viewers goes completely against the grain of Boas' work. For Boas, primitive art can tell us of the material life of the society from which it comes—its social structure, kinship system, means of sustenance, and so on. But when it comes to ascertaining the content of primitive works, Boas is acutely sensitive to the difficulty of reading the imagery, not only for Western observers but even for the intended users and viewers of the objects. He presents evidence that the ordinary use of primitive art involved much reading into and projection onto the forms, and that this resulted in considerable variation in interpretation of the imagery and its significance. In Boas' view, the difficulty encountered by a member of the culture is enormously magnified for the alien observer. "The contents of primitive narrative, poetry and song are as varied as the cultural interests of the singers. It does not seem admissible to measure their literary value by the standards of the emotions that they release in us."[42] In part this view is connected to the larger argument about the alienness of the primitive. Alienness is not incommensurability; for Boas and his colleagues, understanding primitive art was not impossible for the foreign observer, but it was far from a matter of simple sensitivity.

For the Modern Man writers, terror was one corollary of primitive man's irrationality; he was afraid because he didn't understand the lawfulness of nature. There were, of course, also entirely rational bases for his terror, and these were not usually overlooked; they were, however, often portrayed as magnified by ignorance. Another corollary of primitive man's irrationality was his brutality and cruelty. These latter were perhaps the most widely accepted and unquestioned characteristics of the primitive in Modern Man literature. Their existence was implicit—unstated because understood—in many of the passages quoted above. There was no shortage of evidence in anthropological writing for this belief. *The Golden Bough*, for example, was a virtual compendium of brutal practices, encompassing cannibalism, human sacrifices, scapegoat rituals, and

punishments; among the latter was the penalty for peeling bark from a sacred tree. "The culprit's navel was to be cut out and nailed to the part of the tree which he had peeled, and he was to be driven round and round the tree till all his guts were wound about its trunk."[43] Such were the images that reinforced the Modern Man view of primitive life.

There are two points that ought to be made at this juncture. The first is that while terror and brutality were by far the predominant aspect of primitive irrationality for the Modern Man authors, there was also a brighter side. Primitive life allowed a space for the exercise and indulgence of man's nonrational dimensions. In this respect the comparison between primitive life and modern civilization favored the former. Modern life was so heavily weighted toward the rational, the material, science and technology that man's nonrational, spiritual side was seriously neglected. One of the reasons these writers advanced for the catastrophic events of modern life was the disregard for human spirit and instincts. Lewis Mumford, for example, described the internal crisis in Western civilization.

> The materialist creed by which a large part of humanity has sought to live during the last few centuries confused the needs of survival with the needs of fulfillment; whereas man's life requires both. . . . The most important needs from the standpoint of life-fulfillment are those that foster spiritual activity and promote spiritual growth: the needs for order, continuity, meaning, value, purpose, and design—needs out of which language and poesy and music and science and art and religion have grown.[44]

Such criticism of modern life sometimes erupted into explicit praise of the primitive. Two courses were common: either a call was made for systematic study of the impulses and instincts existing deep in the human mind and spirit; or recognition of the inadequacy of reason was demanded, and religious or mystical approaches were outlined. These patterns help to explain the immense popularity of Freud and, especially, Jung—along with Ouspensky, Tyrrel, and others—among the Modern Man writers.

There was another respect in which primitive life was sometimes explicitly commended. Its collective nature was favorably contrasted with the unmitigated individualism of modern civilization. Fergusson made this point and even extended it to the relations between the artist and his viewers. "It is true that this conflict between the artist and the common man appears to be purely a modern phenomenon. In primitive life every man is an artist sharing in a collective creative achievement which embodies values accepted by all. . . . What sets (primitive and religious art) apart from modern art is their complete domination by the collective consciousness."[45] Other features of Modern Man primitivism contradicted this description. For example, some texts, such as Susanne Langer's "The Lord of Creation," asserted a Hobbesian view of primitive life, which seemed to preclude such idyllic possibilities. In her view, "the war of each against all, which is the course of nature," gave way to primitive societies that were "almost entirely tyrannical, symbol-bound, coercive organizations."[46] Within the literature there were some sharply conflicting beliefs about the primitive; the notion was being called upon to do more than one sort of work, as I shall argue, and its ability to support on occasion either side of an argument contributed to its cultural utility. But this point needs to be qualified. The array of attributes carried by the primitive was stable, and even in cases of disagreement there was usually substantial common ground. Langer's vision may begin with ruthless individualism, but it modulates quickly into collectivity—one of primitiv-

ism's essential attributes. And furthermore, her negative gloss on that collectivity turns out, on closer examination, to be much closer to Fergusson's version than it appears. Fergusson's idyllic primitive community has another aspect elsewhere in his argument; he contrasts the restrictions and superstitions prevalent in primitive society with the more open, tolerant social organizations of modernity.[47] The widespread presence of this assertion in Modern Man discourse is another case of received ideas prevailing over recent research and argument. Malinowski's *Crime and Custom in Savage Society*, published in 1926, had done much to demolish the assumption among scholars "that in primitive societies the individual is completely dominated by the group—the horde, the clan or the tribe—that he obeys the commands of his community, its traditions, its public opinion, its decrees with a slavish, fascinated, passive obedience."[48]

Langer's anticommunal view brings us back to the depiction of primitive life as brutal and violent, and to the second point I wish to make. As I noted above, the Modern Man authors had solid anthropological evidence of primitive man's capacity for cruelty; there was, however, also considerable evidence to the contrary. The popular writers generally failed to notice or register the descriptions of primitive cultures in which violent behavior was virtually unknown, the cultures Benedict labeled "Apollonian."[49] Once again the borrowings of the Modern Man authors proved to be distinctly selective and partial.

The distinction between the primitivism of the Modern Man literature and that of more strictly anthropological writing has come to seem in the pages above perhaps a bit sharper than it should. After all, the former group of authors characteristically acknowledged Frazer, Boas, Lévy-Bruhl, Benedict, Malinowski, and others as the sources of their own accounts of the primitive, although they did not shrink from disagreeing with these experts when their own beliefs led them to a conflicting position. These are not two utterly distinct bodies of thought in conflict but two overlapping circles of interests and beliefs. Clearly it is not a question of a true and a false view of primitive society, since the very notion is a fiction. Both are ideological constructions. The value of contrasting these related and connected accounts lies in the insight each may offer into the ideological character and functioning of the other. The strong orientation in U.S. anthropology during this period toward applying the results of research and fieldwork to modern Western man becomes striking in the presence of Modern Man literature. The impulse demonstrated by Mead, Benedict, Radin, and others to contrast prominently their anthropological subjects with their own society reveals that academic anthropology was being shaped by some of the same cultural pressures that generated Modern Man literature.[50] For its part, the latter was comparatively unconstrained in catering to ideological expediency because of its willingness to borrow selectively from the scholarship it claimed to represent. In nearly every instance, Modern Man authors selected certain sorts of data while ignoring other, often opposing, sorts. Fieldwork and "empirical" comparative analysis did not provide escape from ideology, but occasionally they generated resistances and contradictions to its coherence and authority.

Like some of the New York School painters, the Modern Man authors came to anthropology with set assumptions about the primitive and with particular expectations for which they sought confirmation and elaboration. In their hands the primitive fit the words used by Edward Said to describe a similar category, "the Orient": "a collective

representation figuring a geographically and historically vague, but symbolically sharp exotic world." *The primitive,* like *the Orient,* was a term that "accrued itself to a wide field of meanings, associations, and connotations" that did not refer to any real people or condition but to "the field surrounding the word."[51] This field predetermined what sorts of anthropological data would be found to be significant and meaningful. So it is not surprising that the writers I am considering simply did not see the disconfirmatory or problematic evidence challenging the collective representation. In their quests for insight on and relief from pressing problems they gravitated toward information that preserved their structural assumptions while providing requisite alterations and amendments; in other words, they embraced the more convenient, useful, and immediately satisfying answers to their questions. The category of the primitive is not always used in quite this way; compare, for example, what James Clifford has called "ethnographic surrealism," which seeks in the primitive disorientation, surprise, and dislocation.[52] The latter approach is of course appropriative in its own way, but it is much more likely to attend closely to empirical data than the Modern Man attitude.

PRIMITIVISM, PROGRESS, AND FASCISM

By this point, the Modern Man construction of the primitive has begun to seem either deeply confused or self-contradictory. How can the primitive represent terror and brutality as well as spirituality and community? Why has this discourse chosen for itself these two particular focal points from the broad and complex range of available anthropological data and belief? In what sense are these particular aspects "convenient," as I put it just now?

Adam Kuper has pointed out that the idea of the primitive has often been a preferred idiom for debate about modern society; among the features responsible for this are its apparent neutrality and its immense ideological malleability. "The idea of primitive society provided an idiom which was ideally suited for debate about modern society, but in itself it was neutral. It could be used equally by right or left, reactionary or progressive, poet and politician."[53] As Marianna Torgovnick puts it, "The primitive does what we ask it to do. . . . It tells us what we want it to tell us."[54] This was certainly true of its manifestations in the United States between the wars and into the 1940s; talk of the primitive was generally connected with two different impulses. On one side it was frequently cited in expressions of worry or disapproval concerning the "progress" of modern life and society. These anxieties were familiar ones in the history of industrialization and capitalism. To the increasing materialism, selfishness, and scientism characteristic of modern life were counterposed the spirituality, transcendence, and organic community allegedly exemplified by primitive societies. According to this view, although primitive societies were not utopias, at least they allowed space for the development of these human capacities and, in doing so, attested to the "naturalness" of the need for such development. Conservatives and liberal humanists alike could assume this position; indeed, it was on just such common ground—widespread dissatisfaction with the effects of industrialization and the consolidation of capital—that some of the demagogues of the 1930s, notably Huey Long and Father Coughlin, constructed their political platforms.[55]

The second impulse routinely involved in recourse to talk of the primitive was the

effort to comprehend the barbarism of twentieth-century history. As noted above, widespread U.S. cultural interest in the primitive developed in the wake of World War I. In the late 1930s and early 1940s, as Fascist terror and brutality began to become widely known, the discourse on primitivism became one receptacle in which Fascism was contained and analyzed. One obvious sign of this is the frequency with which Nazis were represented as primitives in the political commentary of the period (fig. 5). The anthropologist Ralph Linton noted that the social sciences, and anthropology in particular, were being asked to account for Fascism. He was skeptical that the young science would be able to do the job.

> Only the naïve believe that our present troubles are due to Fascist aggression and that, once it has been stamped out, everything will automatically return to the good old days. The thoughtful recognize Fascism for what it is, a symptom of a deeper disorder, and are eager to know what this disorder may be and how it can be cured. . . . There is a fine irony in the fact that those sciences whose services are most urgently needed in the present crisis are the youngest and least developed of all.[56]

The Modern Man writers were less cautious than Linton; their faith that the secret lay in current research on the primitive and the unconscious was unquestioned. An infusion of urgency, even panic, marked their writing in this period—Wylie's *Generation of Vipers* is a quintessential example—and Nazism became an explicit subject.

At the end of the war, when the horrors of the death camps came fully to light, Nazism as modern primitivism became an indispensable trope in journalism and cultural commentary. Two statements by the influential journalist and radio commentator Dorothy Thompson, written in 1945 just after she had visited Dachau, are representative.

> If only one could say, and dismiss it with that, "These people are savages." They are—but they are a new and terrifying kind of savage. . . . When civilized man, with his science, his

5. *Bernard Partridge*. Brought to Bay. *From* New York Times Magazine, *3 Sept. 1944, 5. Courtesy Northwestern University Library.*

technique, his organization, his power, loses his soul, he becomes the most terrible monster the world has ever seen. He is not the savage of the jungle; the wildest cannibals of the South Seas kill only to assuage a hunger they cannot otherwise still. But the modern savage—the twentieth-century savage—understands the most intimate secrets of nature.[57]

Hitlerism is not a unique, isolated phenomenon, but a terrible example and warning. It is a symptom of universal moral crisis which even in cries for revenge and reprisal emits the animal-like cries of Nazism itself.[58]

Only the language of primitivism was adequate to convey the brutality of recent historical events and to contain and frame the analysis of the moral crisis those events engendered.

The primitive was construed as the mirror image of the modern on the other side of the civilizing process. The "we" and "they" in this discourse—the binary opposition that structures all primitivisms, defining civilized self by comparison with and contrast to the primitive other, while unifying and homogenizing each category of subjects—moved closer together. The primitive served as a form or container for conceiving the irrational, the barbaric, the evil of which modern man was showing himself capable. Likewise, it was a screen upon which he could project his own feelings, behavior, and situation, and study their configuration and implications. Modern man's traditional beliefs about himself and his condition could not fully accommodate these new behaviors; they needed to be mapped elsewhere. Primitivism helped to preserve fundamental components of the dominant bourgeois ideology—human goodness, individual autonomy, free will, the advance of civilization, scientific progress, and so forth—which were being challenged by global events. By finding in the primitive the source or the type of modern evil and irrationality, Modern Man could partially alleviate his guilt and, arguably, recover his optimism by establishing a new agenda for himself, a new domain for science to conquer, corrections to be made to his social order, rearrangement of his priorities, or the like. Nothing less than a reconstruction of the bourgeois notion of human nature was required and under way. These arguments are stated baldly here, I realize; I shall return to them in greater detail in what follows.

That these two intellectual operations, the critique of progress and the analysis of Fascism, shared the concept of the primitive—or, to put it another way, that the discourse on the primitive comprised two related cultural projects—begins to account for the complexities and peculiarities of Modern Man primitivism. The primitive was both the antithesis and the mirror image of the modern. It showed modern man his opposite and his essence. The concept helped to define the shape of human nature by extending it upward and downward: it showed modern man both sides of the irrational in his nature, the brutal and the spiritual. Explanations of what was going wrong in modern life were derived from versions of primitive behavior and tested on them for credibility. Contemporary writers were using the primitive to conceive the modern—to cope with the magnitude of evil in their recent history. Formulating possible strategies of redemption also seemed to require coming to terms with the primitive.

In *The Nature and Destiny of Man* Reinhold Niebuhr made this last point explicitly, delineating the duality of the primitive ("natural man" in his terminology) to which I have been pointing. But by attributing the discrepancies to different points of view he oversimplified the story and missed the complexity of the interrelations.

If modern culture conceives man primarily in terms of the uniqueness of his rational faculties,
it finds the root of his evil in his involvement in natural impulses and natural necessities from
which it hopes to free him by the increase of his rational faculties. . . . On the other hand, if it
conceives of man primarily in terms of his relation to nature, it hopes to rescue man from the
daemonic chaos in which his spiritual life is involved by beguiling him back to the harmony,
serenity and harmless unity of nature. . . . Either the rational man or the natural man is
conceived as essentially good, and it is only necessary for man either to rise from the chaos of
nature to the harmony of mind or to descend from the chaos of spirit to the harmony of nature
in order to be saved. The very fact that the strategies of redemption are in such complete
contradiction to each other proves how far modern man is from solving the problem of evil in
his life.[59]

There is another important dimension to the way the discourse deals with modern
brutality, and here once again I introduce an argument to be developed more fully later
on. These writers represented the tragedies of twentieth-century history in a way that
attributed causal responsibility to the tragic, fateful, human situation and to the nature
and mind of individuals, rife with vestiges of primitive barbarism. In so doing, they
implicitly absolved from responsibility and guilt conscious human agency and the politi-
cal order. As a result Fascism was both dehistoricized and psychologized. It and the other
horrors of modern history were removed from the realm of politics, nationalism, modern
state capitalism, and historical political or economic relations *tout court* and placed in a
continuum of inevitable circumstances, regressions, aberrations, and departures from
the progress of civilization. Indeed, to the extent it was possible, the problem of history
was marginalized, and Fascism and other contemporary crises seemed not to be histori-
cal formations at all. Such forms of explanation would hold obvious advantages for those
individuals in power and for others hopeful of maintaining the political and economic
status quo—advantages that would compensate for the distress caused by the simul-
taneous undermining of cherished beliefs about human nature and the human situation.

These effects made this body of writing on primitivism an especially important and
influential construction. While it seemed to have a critical, resistant edge, insofar as it
participated in reformist critiques of modernity and of received ideas about human
nature, it deflected attention from other analyses, including more rigorous ones that
seemed, and were, more threatening to the political and economic order. Some danger-
ous questions were obscured, rendered difficult to formulate. This is not to say that such
positions did not get articulated. In 1944, for example, Dorothy Thompson argued that
"flaws in the social and political structure of the Allied nations, as well as Germany, . . .
brought on the war."[60] This comment led to her being branded soft on Germany by those
who favored the theory that innate German racial characteristics accounted for the war
and who advocated revenge on the defeated nation. Although both Thompson's and her
critics' explanations are localized—addressed only to the most recent of the catastrophes
of modern history—neither fits the Modern Man mold. They belong to forms of resis-
tance to and reaction against the tendencies I have isolated in Modern Man discourse.[61] It
was alongside and against such alternative assessments of the causes and solutions of
contemporary problems that the Modern Man discourse developed. Its advantage was
the seeming obviousness and common sense of its solutions, which is to say their
ideological comfort; this made many alternatives seem contrived and unconvincing by

contrast. And certain radical critiques, such as *Partisan Review*'s attack on "the new failure of nerve" (to be discussed in chapter 4) or those proposed by members of the Frankfurt School, seemed by comparison simply beside the point.

THE MYTHMAKERS

If we examine the writings of Gottlieb, Newman, and Rothko on the primitive, we find the same emphases located in Modern Man literature. Like the Modern Man writers, the artists subscribed to the belief in a generic primitive; furthermore, they treated primitive and archaic cultures as similar in important respects, particularly in terms of their artistic forms. Rothko's drafts of a letter to Jewell, quoted at the beginning of this chapter, demonstrate just this point. Newman equated Egyptian art with barbarian totemism and contrasted both with classical Greek aestheticism.[62] Such conjunctions of the contemporary categories *primitive* and *archaic* were typically mediated by assertions of similarities in purpose, expressive content, dependence upon myth, and so on.

The artists were also convinced of the profound continuity of the primitive and the modern. There were two components to this belief. The first was that the experience of primitive man was identical in some essential ways with that of modern man. One source of evidence of this identity was the response of modern viewers to primitive art. Regarding an exhibition of Pre-Columbian stone sculptures, Newman presumed to speak for all viewers:

> The New York art public found that these arts held for them a personal message. They were no longer the historical curiosities of a forgotten people, the crude expression of a primitive, undeveloped people. Rather, they were the sublime creation of highly sophisticated artists with the same doubts, the same wonderings, and the same searching for salvation, that same indomitable courage which activates men of spirit today. Here indeed was the expression and preoccupation with the problems of our own spirit.[63]

Gottlieb and Rothko voiced a similar verdict on primitive art and myth.

> Those who think that the world of today is more gentle and graceful than the primeval and predatory passions from which these myths spring, are either not aware of reality or do not wish to see it in art. The myth holds us, therefore, not thru its romantic flavor, not thru the remembrance of the beauty of some bygone age, not thru the possibilities of fantasy, but because it expresses to us something real and existing in ourselves.[64]

At times this proposed continuity of primitive and modern experience dissolved into a larger claim for the unchanging character, the universality, of the human condition and for the involvement of all great art with this condition.

The second component of the argument for continuity is implicit in the first: the claim that primitive art was directly and immediately accessible to the modern viewer. Boas' disagreement notwithstanding, these artists believed in the unproblematic intelligibility of primitive art across culture and history. Newman repeated this claim throughout the 1940s. His picture of the encounter proposed that we could "transcend time and place to participate in the spiritual life of a forgotten people," and that this participation could best be achieved through a purely aesthetic approach to the objects, free from the confusion produced by ethnological considerations. Gottlieb and Rothko similarly defended their use of primitive forms and myth against charges of unintel-

ligibility. "The artistically literate person has no difficulty in grasping the meaning of
Chinese, Egyptian, African, Eskimo, Early Christian, Archaic Greek or even prehistoric
art, even though he has but a slight acquaintance with the religious or superstitious
beliefs of any of these peoples."[65]

Such positions have been thoroughly discredited and appear profoundly dated now.
They are wide open to attack on various fronts: the idealistic and implausible model of
artistic communication posited; the dubious assumption that archaic objects were made
for aesthetic contemplation, or that the cultures in question had a category equivalent to
the modern Western concept *art;* the blatant appropriation of the products of distant
cultures and societies for the legitimation of one's own interests and commitments, and
so on. Such assumptions have been so widely challenged that they require no further
comment here, despite their persistence into the 1980s in certain modernist strong-
holds.[66] Least of all do I want to seem to be interested in dispensing blame. What matters
is that the partial and constructed character of the beliefs of the New York School artists
be apparent, that they be seen not as impartial statements of the truth about primitive art
but as a set of beliefs intimately related to the artistic practice being developed by these
painters as well as to wider cultural concerns. Gottlieb, Newman, and Rothko envi-
sioned primitive art as messages in a spiritual discourse between natural man and his
personifications of cosmic power; they felt it expressed in a universal language essential
truths about human experience.

The emotional and aesthetic responses evoked in these artists by so-called primitive
objects revealed the experience of early life to be fraught with terror, vulnerability, and
the experience of tragedy, and they took such evidence to be at least as reliable as the
findings of anthropologists. Their emphasis on the place of terror in primitive society and
art is another important similarity to Modern Man primitivism. The words of the artists
left no doubt of their commitment to this position. "All primitive expression reveals the
constant awareness of powerful forces, the immediate presence of terror and fear, a
recognition and acceptance of the brutality of the natural world as well as the eternal
insecurity of life."[67] This belief has a history in the visual arts as well as a place in
Modern Man discourse. Artists of various stripes represented the idea. A work titled *The
Tornado,* by the regionalist painter (and antimodernist) John Steuart Curry, was de-
scribed in *Time* magazine in 1934 as expressing "man's elemental terror of nature."[68] At
the other end of the artistic spectrum, Jill Lloyd has described a position very close to
Newman's taken by certain of the German Expressionists, notably Max Pechstein,
possibly under the influence of Wilhelm Worringer's writing.[69] Modern Man discourse
was not necessarily a source for the primitivism of the Mythmakers, but it offers insight
into the ideological appeal and cultural functioning of the latter. That the primitivizing
elements in their paintings also linked those works to the modernist tradition was an
important consideration for the Mythmakers, as Rothko's drafts for the globalism letter
indicated.

The notion that it was the job of painting to express the terror and tragedy of modern
experience was widely held in New York at the time. In 1939 Nicolas Calas set this
objective at the center of the challenges he saw facing painting: "How will painting
continue and at the same time express the tragedy of our days?"[70] In his foreword to the
catalogue of the 1941 Salvador Dalí exhibition at the Museum of Modern Art, Monroe
Wheeler, then MoMA's director of exhibitions and publications, wrote that "a tragic

sense" was felt as a necessity in art at this time, especially in mounting museum exhibitions.

> One thing we all understand now is that the optimism of the fortunate civilized nations has been of great peril to civilization. Dali's dream of the present is tragic, and we should not shrink from the shock and pain of it.[71]

The tone and substance of Modern Man literature is here—in the belief that optimism had been discredited as naive and dangerous, and a new, more realistic picture of the present (of the human situation? human nature?) was needed. Many artists came to agree with Wheeler's appraisal and sought to express the tragic in their work. Examples are by no means hard to find; one such painting appears at the perimeter of the Mythmakers' first published manifesto. The third work singled out for comment in the review that prompted the Mythmakers' June 1943 letter to the *New York Times* was *Trijugated Tragedy,* by the now-forgotten Theodore Schewe. This surrealist painting (alternatively titled *E Pluribus Unum* in the catalogue) was reproduced in the *Times* immediately above the famous letter and directly between Gottlieb's *Rape of Persephone* and Rothko's *Syrian Bull.* In other words, the commitment to the tragic vision (be it "trijugated" or not) was commonplace in art by 1943. It continued to be a prominent feature of the New York artistic landscape through the later 1940s, when Stephen Greene's paintings, such as *The Burial* (1947) and *Mourning* (1947) began to attract attention. His works were based, as he put it, on a "tragic concept of man," who was inclined toward good but mired in evil, and they participated in defining a figurative, symbolist counterpart to the painting of the Mythmaker group. But through these years, the Mythmakers developed and pursued the idea of tragedy more intensely and became more closely identified with it than other contemporary artists, and they gave it a distinctive inflection by binding it to the art and experience of primitive man.

Newman's discussions of terror in primitive art are more specific than his colleagues'. They yield a virtual typology of terror, based often on subtle or obscure distinctions, but always terror nonetheless, or tragedy—the "higher reality" of terror.[72]

> If it can be said that the distinguishing character of Negro African art is that it is an art of terror, terror before nature as the idea of nature made itself manifest to them in terms of the jungle; if Mexican art can be said to contain a terror of power, then it can be said that despite its wide range, the distinguishing character of Oceanic art, the quality that gives us a clue to its difference from all other art traditions, is its sense of magic. It is magic based on terror, but unlike the African terror before nature this is a terror before nature's meaning, the terror involved in a search for answers to nature's mysterious forces.[73]

The passage provides an anthology of primitivist tropes: jungle, magic, terror of power, assigned to particular sites and peoples. And what terror was to primitive cultures, Newman maintained in another essay, tragedy was to archaic: "The Egyptian notion of tragedy was an expression of inevitability, a personal statement of being. The Greek notion of tragedy was not ontological, but a social notion, a statement concerning the chaos of individual action."[74] This monomaniacal account of history and art history was made possible by the idealistic model of artistic communication underpinning it. The painters based their argument for the prominence of terror in primitive cultures principally on their intuitive responses to historically and culturally distant artifacts; their interpretations were as conditioned by particular contemporary interests, preconcep-

tions, and expectations as the Modern Man authors' selective readings of bits of anthropology. Such limitations also affected the analysis of individual works. Newman, for example, described a rather restrained sculpted head of a jaguar (fig. 6) as follows: "In the art of Costa Rica, we find the same desire to catch the secret of nature's power. The head of a jaguar . . . so characteristic of that region, shows how the artist has caught the brutality of life, the ferocity of nature."[75] Newman overlooks the head's calm elegance and delicate linearity and assumes that the terror he perceived was obvious to any sensitive viewer. The "noble and austere formality" that Rothko posited in ambiguous relation to "outward savagery," in his drafts for a letter to the *Times*, does not figure in Newman's consideration of this piece.

Histories of the New York School sometimes suggest that the anthropological beliefs and assumptions I have been describing are derived from certain other texts—not strictly speaking anthropologies—known to have been important to the artists. Jackson Rushing, for example, has argued for the relevance of works by Nietzsche, Wilhelm Worringer, and Jung to the Mythmaker program, and in some respects his arguments are quite convincing. He traces the belief that modern and primitive experience were essentially the same, as well as some of Newman's ideas about tragedy and terror, to these authors.[76] In situating Mythmaker writings, even temporarily, within a somewhat narrowly anthropological matrix, I am less interested in tracing their precise origins than in elucidating through comparison the network of beliefs and assumptions about primitive man and his art that inform the work and theory under consideration. By no means do I imagine that anthropological assumptions must have come from anthropological texts; on the contrary, I find Modern Man discourse a far more illuminating and snug frame for the Mythmakers' theories and representations. Since I am unconcerned with the respectability of Mythmaker ideas, their lineage or pedigree is correspondingly less important.

Although the artists and the Modern Man writers may have based their assertions about the place of terror in primitive cultures on very different materials, their conclusions were similar, largely because their directing interests were the same. Both groups started from the modern experience of terror and projected it back onto the primordial human condition, a tactic that naturalized it. The shared sense of terror was the lynchpin in the continuity both groups posited between primitive and modern. The clearest and most concise statement of artists' claim is the passage from the radio broadcast quoted above. (All primitive expression reveals the constant awareness of powerful forces, the

6. Head of a jaguar. *Pre-Columbian (Costa Rica). Lava rock, 20 x 29 cm. Courtesy Department of Library Services, American Museum of Natural History, New York. Reproduced on the cover of the catalogue* Pre-Columbian Stone Sculpture, *Wakefield Gallery, New York, 16 May–5 June 1944.*

immediate presence of terror and fear, a recognition and acceptance of the brutality of the natural world as well as the eternal insecurity of life.) It needs only to be extended by one sentence:

> That these feelings are being experienced by many people thruout the world today is an unfortunate fact, and to us an art that glosses over or evades these feelings, is superficial or meaningless.[77]

Let me leave aside for the moment the implications of that final clause and focus on the penultimate one. This idea became a common refrain of Mythmaker writing in the 1940s: the world is as primitive now as ever; primitivism is the spiritual face of our time; the primitive is the expression of and the preoccupation with the same problems we face; and so on. In eternalizing the anxiety and fear provoked by twentieth-century history, the Mythmakers pursued the strategies of amelioration developing in Modern Man literature. Their artistic theory constructed the primitive in the image of the modern, casting it in a form that would help to make modern experience manageable—or perhaps I should say to contain it—within the established parameters of bourgeois ideology.

In Modern Man literature, an already developing discourse on the primitive was adapted for the containment and analysis of Nazism and Stalinism; this project went on alongside other ideological work being done by the category, including especially the critique of modernity. The same complexities attended Mythmaker primitivism, but they were inflected too by the well-known Nazi opposition to primitivizing modernist art. By categorizing this work as *Entartete Kunst* (degenerate art), the Nazis complicated for art audiences in Europe and the United States any representation of Fascism as primitivism, even when an artist sought to connect primitivizing art and Fascist ideology, as in Emil Nolde's case. For Nolde, artistic primitivism and Fascism were utterly complementary; primitive forms, in his view, displayed an artistic purity superior to subsequent mongrel forms and analogous to the racial purity Nazism cherished.[78] Nolde's proposal was probably largely unknown in the United States, drowned out by the highly publicized Nazi antagonism to primitivizing art. Nolde himself was classified by the Nazis as a degenerate artist. Nonetheless, such examples further complicated the field of relations between Fascism and visual primitivism. Visual artists were, in this regard, operating within a net of positions and propositions a bit more tangled than that faced by the Modern Man writers.

PSYCHE AND COSMOS

There was a tension within the Mythmakers' analysis of modern terror, a tension visible also in the Modern Man discourse. Two lines of explanation, fundamentally different in orientation, are intertwined in each account. On one hand, we find powerful external forces man can neither channel nor comprehend; on the other, internal forces—instincts and impulses—also beyond the control of reason. This dual momentum inward and outward, into the core of the individual psyche and out to the laws of the cosmos, is a defining component of Modern Man discourse. The recourse to the primitive functions in one case to reveal the nature of those instincts and drives, in the other to establish the inevitability, the universality, of the human condition.

This dual character could be demonstrated by returning to the Modern Man literature quoted above, but I prefer to introduce a visual counterpart to those texts—a collage by Peter Vardo (fig. 7). Vardo was a commercial artist, a member for a short time of the design staff of *Fortune* magazine.[79] The collage was produced to accompany the article by Susanne Langer from which I have quoted above.[80] It shows us Modern Man—his science, in the form of the circulatory system depicted in Vesalius' treatise on the human body, marks his very identity—encircled by violence and destruction. Some of the horror is of his own creation, as shown in the excerpt from Dürer's *Martyrdom of the Ten Thousand Christians;* here, figures carrying spears force their victims off a ledge to be impaled on the pointed tree stumps below. And another part of the chaos is entirely beyond his control, as we see in the fall of the stars from Dürer's *Apocalypse,* or the scenes from Bruegel's *Triumph of Death.* This point is reinforced by the dominant image in the collage, clipped from a black-and-white reproduction of Bruegel's painting *The Tower of Babel.* The tower serves to remind us that human attempts to control the universe are hubristic and futile. Man's cruel plight, in other words, is shown to be partly his own doing and partly his tragic fate. And once again the primitive and the archaic take their place in this chain of ideas. At the tips of the central figure's right fingers are a cave drawing and a Sumerian pictographic tablet. Primitive man's aggressive instincts are evoked in the paleolithic silhouettes of people who appear to be doing violence to one another. The pictograph demonstrates that man's effort to represent his experience, to understand and come to terms with it through symbolic representation, is also a primitive impulse. The other elements that make up the collage affirm this impulse's persistence and resilience. As in other Modern Man documents, history is obviated here; the important factors in the explanation of man's condition are the universal ones.

The inward/outward dynamic in Modern Man discourse was somewhat less neat and balanced than I have yet acknowledged. When we survey a large sample of this literature it becomes apparent that one strategy seemed to work better than the other; that is, it occupied more space and attention, generated more interest and excitement, and proved more intriguing, or held out a greater offer of relief. If, as it seems to me, both tactics were being tested in this literature, one was having more success than the other. The outward movement toward tragic fatalism was a bit threadbare, it appears; it did offer some consolation of the sort Leo Lowenthal detected in the work of the novelist Knut Hamsun. "To be a victim in the world of men is a threat to dignity. There is a certain solace, on the other hand, in being a victim of majestic natural forces for which man cannot be expected to be personally accountable."[81] But this solace was compromised by the hopelessness of the situation. Bourgeois ideology may find absolute pessimism acceptable in extremis, but it will always prefer an optimistic alternative. The inward displacement appeared to offer more room for hope. The interest in man's primitive nature and instincts was inseparable from the concern with the unconscious, and psychoanalysis seemed to hold promise that irrational forces might someday be understood and controlled. That hope was sometimes slight and by no means universally shared, but it was real. The unconscious might still be barely charted terrain, but was not all of nature once so, as studies of primitive peoples confirmed? Just as reason and science had conquered physical nature, so they would eventually map the darker reaches of the mental realm, bring them under control, and put them to constructive use as another

7. *Peter Vardo.* Untitled collage/illustration
["The Lord of Creation"]. *Published in*
Fortune, *Jan. 1944, 126 © Fortune*
magazine, 1944.

resource to be developed.[82] Bourgeois ideology thus could cope with the serious threats presented to it by the world it had structured. Its fundamental components, its principles and strategies, could be salvaged; all that seemed necessary was to extend them further into new frontiers. Notions of human nature and mental process would have to be revised, but in terms that preserved the integrity of the ideological framework containing them.

If we turn back now to Mythmaker theory, what becomes striking is the relative onesidedness of its account of the tragedy and terror of human experience. While the Mythmakers' common refrains in the mid-1940s harmonize with Modern Man discourse, they reverse the preferences of the latter and tip the scales toward the tragic fatalism side. Gottlieb, Rothko, and Newman portrayed brutality, terror, and danger principally as facts of the natural world or the cosmic order. They were simply the terms of existence, entirely beyond human control, and their primitive origins verified their inevitability. The human contributions to this tragic state of affairs were given only a fragile and uncertain place alongside the dominant idea. Consider these words of Barnett Newman, published in June 1946.

> Though all men live in terror, it is the objects of terror that contain within themselves those elements of cultural interpretation that permit the differentiation of its various subjective expressions. *Modern man is his own terror.* To the African and to the Mexican, it was the jungle. To the South Sea Islander, it could not have been a like terror before an immobile nature, but a terror before forces, the mysterious forces of nature, the unpredictable sea and the whirlwind. In Oceania, terror is indefinable flux rather than tangible image.[83]

Modern man is his own terror. It is hard to know exactly what Newman means here, given his emphasis on humanity's inevitably tragic condition. Since all men live in terror, and only the objects of terror vary across cultures, is it by will or necessity that modern man terrifies himself? The same peculiar tension is visible, with a bit more clarity, in his essay "The New Sense of Fate."

> The war the surrealists predicted has robbed us of our hidden terror, as terror can exist only if the forces of tragedy are unknown. We now know the terror to expect. Hiroshima showed it to us. We are no longer, then, in the face of a mystery. After all, wasn't it an American boy who did it? The terror has indeed become as real as life. What we now have is a tragic rather than a terrifying situation. . . .
>
> Our tragedy is again a tragedy of action in the chaos that is society (it is interesting that this Greek idea is also a Hebraic concept); and no matter how heroic, or innocent, or moral our individual lives may be, this new fate hangs over us. We are living, then, through a Greek drama; and each of us now stands like Oedipus and can by his acts or lack of action, in innocence, kill his father and desecrate his mother.[84]

This essay, never published by Newman, seems meant to be experimental and exploratory, which might explain in part why its conflicts are so clearly visible. The human agency in modern brutality is recognized, but it is wrapped securely in tragic inevitability. The idea that man is the source of modern evil seems to be penetrating Newman's theory only against staunch resistance from contradictory beliefs. Man may cause his own suffering, but he is compelled to do so. It is, as Newman puts it, "in innocence" that modern man, like Oedipus, kills and desecrates. Related to this dynamic is the Mythmakers' conception of the unconscious. For them it was less the seat of the evil

within man, or the opening into man's bestial essence, than it was the individual's interface with the species and its past—that is, the site of an uncomplicated communication between the primitive artist and the modern viewer, or between the modern painter of abstract symbols and the viewer. The Mythmaker position, in other words, contained an inward component, but it was an ineluctable, impersonal, unchanging one—an inner Fate persisting from an archaic past.

THEORY AND PRACTICE

So far I have been attending exclusively to the theory of the Mythmakers. What, if anything, has this to do with their practice? The answer will vary from artist to artist, and even within a single artist's oeuvre. Gottlieb, for example, often engineered a relatively close fit between theory and practice, as in his *Alphabet of Terror* (fig. 8), which may be taken as representative of his work of the early and middle 1940s—the formative period of Mythmaker art.[85] The forms and title of this painting conjure the activity of early humans as they indulged in symbolizations that would lead to written language. Gottlieb asserts the place of terror in their lives by designing most of the symbols around grimaces, bared teeth, and disembodied eyes. The faces are often brutally distorted, some of these resembling African masks; others are more elegantly formal, and some grimaces recall the Pre-Columbian jaguar described by Newman. The imagery is, apparently, meant to make vivid for the modern viewer the primitive experience of terror and to suggest the universality of that experience. But the painting's controlled execution and its neat compartmentalization and containment of the images of terror reduce the immediacy of the effect. The structuring of terror is underway; it is recognized and representable. Its aspect may be fearsome, but it stands outside the ordering mind, which is able to work the material over with relative calm and distance, as if formulating a visual language. In this respect Gottlieb's painting resembles the Sumerian pictographic tablet included in Vardo's collage. These features become particularly striking when we compare the painting with a roughly contemporary work by Pollock (fig. 9). Pollock's *Pasiphaë* (named for the daughter of the sun god, Helios, in Greek mythology, whose unnatural lust for a bull resulted in the birth of the Minotaur) aligns itself with the other, introjective tendency in Modern Man discourse. The glimpses of violence and struggle, forms that elude identification, disorienting and vertiginous composition, agitated brushwork, signifiers of unconsciousness—these elements add up, I think, to a representation of the proposal that the sources of modern evil and anxiety lie in unknown and uncontrollable elements in human nature and mind. They are not susceptible to direct manipulation by reason but emerge only fragmentarily through struggle.

The terms used to describe Pollock's painting style—violence, agitation, struggle—point to another contrast with Gottlieb's *Alphabet of Terror*. The latter strives to be a frightful image, representing modern fear as a transformation of the primitive experience. The viewer is placed in what is constructed as a universal human position—powerlessness before terrible mysterious forces, the only available course of action being representation of these forces. The implications of individual impotence Pollock's paintings contain are undermined, on the other hand, by the frenzy of potency in which they are realized. For Pollock, representation entails an overabundance of energetic

8. Adolph Gottlieb. Alphabet of Terror, *or,*
Eyes of Oedipus. *1945. Oil and casein on
canvas, 91 × 71 cm. © 1979 Adolph and
Esther Gottlieb Foundation, New York.
Photograph by Ken Cohen.*

activity. The source of activity still may be mysterious forces beyond reason, impervious
to human will; nonetheless, it is within and through human activity that these forces take
their effect. Since the forces are contained within the subject, activity of some sort
remains a possibility, even a necessity, for modern man and the modern artist: only

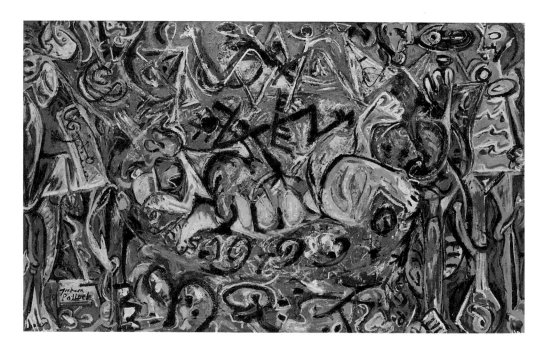

9. *Jackson Pollock.* Pasiphaë. *1943. Oil on canvas, 143 × 244 cm. Collection of the Metropolitan Museum of Art, New York; purchase, Rogers, Fletcher and Harris Brisbane Dick Funds and Joseph Pulitzer Bequest, 1982.*

through such activity can the powers that buffet individuals be observed, charted, and perhaps eventually controlled.

In contrast to Gottlieb's work, Rothko's maintains an ambiguous relation to the aspects of the Mythmaker program under discussion here. In *The Syrian Bull* of 1943 (fig. 10), for example, a cluster of interconnecting and overlapping forms is rooted in or stands upon desert sand. The area of radiating white lines at the right rear of the cluster recalls the patterned detailing of Assyrian reliefs, or perhaps a feathered headdress or fetish, or a bird.[86] Yes, the forms are somewhat reminiscent of archaic art, and yes, we may, with difficulty, be able to glimpse something of tragedy in the painting, but both these features are upstaged by the picture's surrealism. Rothko's figures are essentially surrealist personnages or biomorphs posing in a landscape. Whatever tragedy and terror they evoke issues, in a highly generalized form, from the signifiers of *myth* that fill the painting. For these artists, myth was the quintessential form through which humankind had always come to terms with the tragedy of its situation.

Although significant discrepancy between a painter's theory and practice may warrant critical comment, it is important to acknowledge that works of art routinely exceed the theory that grounds them. Here we have a case where a close interdependence of theory and practice might have been a liability, limiting the cultural significance of the work. Had the art of this group corresponded more closely to their theory, the art would

10. *Mark Rothko.* The Syrian Bull. *1943. Oil on canvas, 100 × 70 cm. Collection of Allen Memorial Art Museum, Oberlin College; gift of Annalee Newman in honor of Ellen Johnson. The two paintings* Syrian Bull *by Mark Rothko and* Rape of Persephone *by Adolph Gottlieb were given to Barnett Newman by Rothko and Gottlieb in apppreciation for Newman's help in formulating the letter that Rothko and Gottlieb sent to Edward Alden Jewell, art editor of the* New York Times, *which was published on June 13, 1943. ©1992 Kate Rothko-Prizel and Christopher Rothko/ARS, New York.*

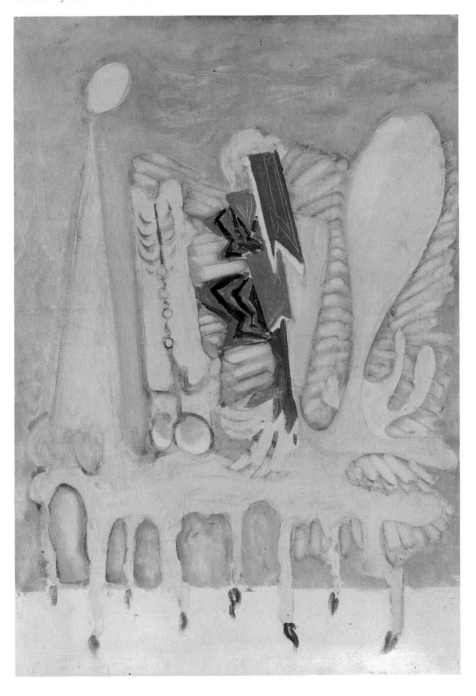

have been much less resonant for American culture then and now. Given the two current alternatives—man's tragic condition arising from his own nature, or from inexorable fate—the Mythmaker program subscribed to the latter, the strategy of displacement that was perhaps more immediately attractive but that proved less enduring. The historical stature of Mythmaker art in its biomorphic and symbolic phase may benefit from the distance that existed between that stated belief and the forms of the work. The art may escape the datedness of its premises and remain open to interpretations that redirect its emphases and motivations. Rothko's work of the mid-1940s has been handled in this way, as has Gottlieb's to some extent. Part of this process has been an emphasis upon the centrality of myth itself in the thinking of these artists—*myth* treated as a category much richer than the philosophy of terror I have presented earlier as fundamental. The importance of myth to this group is beyond question; it is attested not only in their chosen name and in the titles of their paintings but also in the prominent place it occupied in their artistic theorizing. But myth had a more particular meaning for these artists than it has had for the art historians writing about them. The latter have tended to capitalize upon the richness and breadth of the term *myth,* constructed as a vague and complex network of universal human themes and portrayed as a generative theme in itself for these artists.[87] However, myth actually was for the group of painters something a bit narrower: it was the premier expression of primitive man's tragic fatalism. What underlay their interest in myth was the terror and tragedy they found in the form, as they found these elements in primitive art.

> If our titles recall the known myths of antiquity, we have used them again because they are the eternal symbols upon which we must fall back to express basic psychological ideas. They are the symbols of man's primitive fears and motivations, no matter in which land or what time, changing only in detail but never in substance.[88]

THE TRAGIC SENSE OF LIFE

It may be useful at this point to circle back a bit and compare the Mythmakers' views with those of an anthropologist. Paul Radin's subject in 1927 was "the intellectual class" among primitive societies, a vague and problematic stratum produced by the effort to adapt James Harvey Robinson's brand of intellectual history to anthropological investigation. Radin held that for the majority of primitive peoples the characteristic attitude was calm acceptance of human limitations and burdens. Primitive man, Radin believed, had been far more successful than modern man in cultivating this lofty ideal.

> Among us the recognition of the truth of human nature drives us into pessimism, cynicism, or sensationalism: the full realization of the limitations of man and the insignificant role he plays in the world and the universe, drives many, on the other hand, to seek refuge in religion. In both cases the problem is not faced. Ridiculous as it may seem on a superficial view, it yet does remain a fact that primitive peoples do and have faced the problem far more frequently and far more consistently than the people of Western Europe.[89]

Here academic anthropology approaches the primitivism of Modern Man and Mythmaker theory, though the fit is not perfect; the claim of fundamental identity between primitive and modern is undermined. But Radin goes on to argue that some individuals among the intellectual class of primitives develop a "tragic sense of life," which may

progress into pessimism and fatalism, although these stances are exceptional.[90] Nonetheless, the tragic view he describes is at times quite similar to Newman's conception.

Radin proposes two sources for the sense of tragedy among primitives. One is the memory of past struggles of tribe against tribe, recorded and symbolized in primitive tragic myth, just as it is in the *Iliad,* the *Chanson de Roland,* and the *Niebelungenlied.* The other is the conflict of passions, desires, and ambitions within each individual— conflict especially between greed and morality. Pride and greed may come to be thought irresistible, so that, presented with temptation, the ordinary person is doomed. In some tales, consequently, "an inevitable and inexorable chain of events, all of them explicable from a human standpoint, impels these people onward and constrains them to their doom just as bitterly as in Greek tragedy. But here it is not an external crime with its inevitable punishment but an inner transgression, flowing from the very nature of human cravings followed by an inevitable retribution."[91] There are similarities to Mythmaker conceptions and language in this passage. Modern Man and Mythmaker sorts of beliefs were not absent from contemporary anthropological discourse, but the writers and artists presented them selectively and tendentiously. Even here, where popular anthropology in the James Harvey Robinson mold borders the Modern Man genre, there are important differences to be recognized. First, there is no terror involved; it was Radin, remember, who noted the "refusal to be terrified" among primitive peoples. Second, human complicity is an essential component of primitive tragedy as described by Radin; no fantasy of innocence is indulged.[92] Third, fate is not hypostatized as humanity's nemesis. And finally, the occurrence of this fatalism among primitive peoples is highly circumscribed; Radin limits it to some individuals among the intellectual class. By no means does he want it to be seen as a widespread or "natural" frame of mind.

Radin's thesis marks a point of close relation between Mythmaker theory and anthropological discourse. The artistic theory is closest to the anthropological when the latter is closest in orientation and intention to Modern Man discourse. Radin was popularizing new anthropological knowledge, and to do so he generalized and simplified the characteristics of generic primitive man, often indulging in comparisons to generic modern man.

A second example of contemporary anthropological writing that overlaps provocatively with Mythmaker theory comes from an angle very different from Radin's. Claude Lévi-Strauss wrote in 1943 a lyrical aesthetic appreciation of Northwest Coast Indian art and myth. In its expansive poetry and exuberant evocation of an exotic and alien world, it shows us the Lévi-Strauss who was part of the Surrealist circle at this time. Its description and reading of Northwest Coast Indian art indicates points of contact between Surrealist, Mythmaker, and Modern Man primitivisms. He writes of the "tragic mystery and stern anxiety" he finds characteristic of the art of the Northwest Coast.

> The primitive message was one of such violence that even today the prophylactic isolation of the vitrine does not prevent its ardent communication. . . . This unique art unites in its figures the contemplative serenity of the statues of Chartres and the Egyptian tombs with the gnashing artifices of Hallowe'en. These two traditions of equal grandeur and parallel authenticity, of which the stands of the amusement parks and the cathedrals today dispute the dismembered shreds, reign here in their primitive and undisturbed unity.[93]

Lévi-Strauss does not inflate the terror and tragedy he locates in these arts to the extent

the Mythmakers did; and furthermore, his tone is closer to delighted indulgence in the imaginative world the artifacts evoke than to the contemporary artists' anxious grasping after the perception of a kindred spirit. But his remarks do indicate that the Mythmakers' theory of primitive art may have overlapped with certain strands of Surrealist primitivism.

PRIMITIVE SPIRITUALITY AND NEWMAN'S FIRST MAN

There is one last congruity between Modern Man and Mythmaker versions of the primitive. We have seen already that for Gottlieb, Newman, and Rothko, as well as for the Modern Man authors, the primitive centered on the experience and expression of terror and brutality, and this construction of the concept served the culture's effort to address and contain the barbarism of twentieth-century history. What remains to be shown is that these artists' notion of the primitive also had a component of high spirituality, which participated in the critique of the materialism, secularism, and scientism in modern life. Gottlieb, Rothko, Newman, and Still routinely complained of the despiritualized character of modern life.[94] They often contrasted what they saw as the spiritual, transcendental, and religious aspects of primitive art with the frivolously aestheticized, materialistic, and "mock heroic" character of modern Western art.[95] Newman's description of some Pre-Columbian objects illustrates this. "In these masks is the best expression yet made by an artist of the greatest of all life's mysteries—death. It can be said that theirs was a religious art cut out of the depth of man's soul. The Aztec sacred figure has a pathos unsurpassed by the religious art of Western Europe."[96] With sharp sarcasm, Rothko made the criticism explicit in "The Romantics Were Prompted." He wrote, "Since the archaic artist was living in a more practical society than ours, the urgency for transcendent experience was understood, and given an official status."[97]

This view was, of course, a traditional component of primitivism in the history of visual modernism. Most modern cultures construct a myth of an earlier, idealized pastoral state which serves as a foil for their own expressions of unhappiness, dissatisfaction, and anxiety, and modern art has often participated in this process.[98] Jill Lloyd has pointed out that for many German Expressionist painters, the primitive represented an ideal of "close organic unity between art and society governed by spirituality."[99] While acknowledging such diachronic relations within visual modernism, I want to foreground the synchronic parallel between Modern Man literature and Mythmaker theory: both primitivisms encompassed longing for lost spirituality and community together with fascination with the terrible and violent. In each the critique of modernity blended with the containment of Fascism.

The most concentrated example of the Mythmakers' valorization of primitive spirituality, combined with an expression of contempt for modern rationality and science, is Newman's essay "The First Man Was an Artist" from 1947. The essay's point of departure was a much publicized discovery by the paleontologist G. H. R. von Koenigswald. Working in Java, von Koenigswald had uncovered a number of relics of early humans, including "a jaw that surpassed a gorilla's in size yet showed unmistakable human characteristics."[100] This find, coupled with a group of very large teeth collected from Chinese drugstores, where they had been sold with other tooth fossils as "dragon teeth,"

led to the postulation of a new type of early man—*Meganthropus palaeojavanicus*—dating from 500,000 years ago.

Newman took offense at the fact that the paleontologist's discovery of a giant human ancestor was generating so much excitement. It provided an occasion for him to vent his anger over the ability of science to excite the modern imagination and to hold a privileged place among the forms of knowledge. His charge was that "there is the implication in this paleontological find of another attempt to claim possession of the poetic gesture; that the scientist rather than the artist discovered the Giant." Newman proposes that Cyclops and the Beanstalk giant are of the same order of knowledge, the same epistemological status, as Meganthropus palaeojavanicus. How else can we understand the scorn he expressed for those who see the latter as "more real" or "the Truth." "Discovered" is the key word in the sentence, and Newman goes on to assert that he will not concede discovery of truth to science, while art settles for "fashioning" truth, which isolates art as an inferior form of knowledge. At this point in the argument Newman's choice is to defend artistic knowledge or attack scientific knowledge, and he chooses the latter. Using imagery calculated to embarass scientists ("we have seen mushroom a vast cloud of 'sciences'") Newman accuses science of trying to "invade" the nonmaterial world—the fields of culture, history, and philosophy. Science, it seems, is behaving like an imperialist nation (who could have resisted conjuring an image of the Soviet Union in the cold war climate?), trying to secure its "base of operations" by spreading into all realms of thought and attempting to conquer the metaphysical world. "Like any state or church, science found the drive to conquer necessary to protect the security of its own state of physics."[101] In this cold war drama, the part of Western Europe is played by the humanities and social sciences, that of the USSR by von Koenigswald and company.

Newman envies the power of science to capture the public imagination—especially when presented in the detective-story format used to report von Koenigswald's discoveries—and to claim the status of truth for its products. The atomic bomb may have given rise to questions about the ethical use of science, but its credibility had never been greater. As Newman saw it, science had taken over the mind of modern man, and scientific method had become a new theology; truth was being identified with "proof."

Newman ultimately asserts the primacy of aesthetic knowledge. The aesthetic act precedes the social one; dream has greater urgency than utilitarian need; understanding the unknowable is more necessary than discovering the unknown; and the poetic outcry preceded the communicative utterance.[102] These are Newman's postulates, and all are really corollaries of a single premise: man's artistic nature is primary. A reader is entitled to uncertainty about Newman's literary tactics: Is he speaking literally or meta-phorically? Does he believe he is articulating self-evident fact, or is he instead imparting immediacy to his speculation on human nature when he states baldly that "the myth came before the hunt." The literary blurring of these modes could be seen as an apt vehicle for the effort to close the gap between scientific and nonscientific knowledge. But it soon becomes clear that Newman means to be taken literally. Following a chicken-egg discussion of the axe and the axehead idol, Newman writes: "The God image, not pottery, was the first manual act. It is the materialistic corruption of present-day anthropology that has tried to make men believe that original man fashioned pottery before he made sculpture. Pottery is the product of civilization. The artistic act is man's personal birthright."[103]

Newman has cast original man in the image of the modern artist. He concludes by proposing that artists currently are striving to recover the status of original man, the creative state, and thus are closer to the truth about him than are the paleontologists. The talk of truth is outlandish given the blatant tendentiousness of Newman's picture of primitive man. "Man's first expression, like his first dream, was an aesthetic one. Speech was a poetic outcry rather than a demand for communication. Original man, shouting his consonants, did so in yells of awe and anger at his tragic state, at his own self-awareness and at his own helplessness before the void."[104]

Here, again, is primitive man as the Mythmakers conceived him—in their own image. He takes his place in an argument for the necessity of renewed aesthetic relationship with the unknowable, with divinity, an argument which also opposes the preeminence of science and materialism in the modern world. These beliefs place the Mythmakers within a widespread cultural retreat from science and reason that developed in the United States in the mid-1940s, a retreat that one of its critics, the philosopher Sidney Hook, termed "the new failure of nerve." Hook's catalogue of the components of this tendency included "the refurbishing of theological and metaphysical dogmas about the infinite as necessary presuppositions of knowledge of the finite; a concern with mystery rather than with problems, and the belief that myth and mysteries are modes of knowledge.[105] This critique will be discussed at greater length in chapter 4. For now it is enough to add that Lowenthal prescribed a rationalist cure for the experience of terror. "It is only by applying the efforts of reason—in its theory and practice—to the phenomena of terror, their roots and their consequences, that mankind can hope to wrest itself from the most sinister threat and ultimately pathetic fate in which it has ever become involved."[106] Hook and Lowenthal, like Robinson before them, were promoting enlightenment in the belief that the exercise of reason could reduce the tendency toward "primitive" behavior. In their *Dialectic of Enlightenment,* Adorno and Horkheimer questioned this belief. They maintained that enlightenment engenders domination, and domination forces mankind back to anthropologically more primitive stages of social organization and behavior. "The curse of irresistible progress is irresistible regression."[107]

AMERICAN PRIMITIVES

I have not yet indicated whether preferences for particular primitive cultures or arts appear in Modern Man and Mythmaker writing, but the question is a significant one. While both sets of texts treat the primitive generically, as if the differences between particular societies and cultures were largely superficial, the Mythmakers, and especially Newman, often singled out certain varieties of primitive art for special attention—in exhibitions as well as essays. Why did the Mythmakers show particular interest in the arts of Pre-Columbian and Native American peoples?

More important in attracting them to this work than any formal qualities in the art were nationalistic considerations. American primitive arts were doubly appealing because of the special contribution they could make to the effort to create an American artistic identity within the parameters of modernism. South Seas and African arts were fine, but new world primitivism was better. Newman's early essays on Pre-Columbian stone sculpture made much of its Americanness.

The growing aesthetic appreciation of Pre-Columbian art is one of the satisfying results of our inter-American consciousness. . . . The excitement of the aesthetic experience will achieve the very aims of statesmen and scientists who feel that our common hemispheric heritage is a vital link in inter-American understanding.[108]

It is a hopeful sign for our cultural rapprochement to watch the growing aesthetic appreciation of Pre-Columbian art. For here we have ready-made, so to speak, a large body of art which should unite all the Americas since it is the common heritage of both hemispheres. An inter-American understanding of our common cultural inheritance should act as a catalytic agent to draw together the inheritors. Here in this art is the moral base for that intercultural community that is the foundation of permanent friendship.[109]

There is even a hint of anti-Europeanism in these writings, as when Newman contrasts the grandeur and dignity of Pre-Columbian sculpture with the "mock heroic, the voluptuous, the superficial realism that inhibited the medium for so many European centuries."[110]

Whatever moved Newman to take this particular tone and approach, the fact remains that they placed his writing and curating securely in the service of the U.S. war effort. Pre-Columbian art was becoming a weapon in the cultural arena, and Newman's part in the process was not a negligible one. The journal *La Revista Belga,* for which Newman wrote an essay on Pre-Columbian art and two subsequent articles, was a diplomatic organ operated by the Belgian government through its Office for Latin America, in New York.[111] Its purpose was to promote inter-American cultural relations. According to Annalee Newman's recollection, her husband's association with the journal grew out of a meeting with its editor, Luis J. Navascues, at the exhibition of Pre-Columbian art Newman had curated for Betty Parsons at the Wakefield Gallery in May 1944. The explicit concern with consolidating inter-American cultural relations expressed by Newman in the show's catalogue, and quoted above, must have struck Navascues as potentially valuable for his own purposes, and he invited Newman to contribute an expanded essay to *La Revista Belga.* Navascues arranged to have this essay translated into Spanish. As the second excerpt above indicates, Newman preserved and extended the slant that made his original essay appealing to Navascues; his subsequent articles for this journal were also markedly concerned with fostering inter-American cultural unity.

Newman undoubtedly realized that his interest dovetailed neatly with the efforts of Nelson Rockefeller and the Museum of Modern Art in Latin America. Rockefeller, who had been involved in the oil and hotel businesses in Venezuela before the war, became in 1941 a dollar-a-year man for Roosevelt, with the title of Coordinator of Commercial and Cultural Relations between the American Republics for the Council of National Defense. He was charged with "countering the Fascist influence in Latin America."[112] In 1944–45 he was promoted to assistant secretary of state for Latin American Affairs. The position of coordinator of commercial and cultural relations was tailor-made for Rockefeller; for some time he had been combining commercial ventures in South America with attention to its cultural productions. He had involved MoMA in this enterprise well before his government appointment, as the *New York Times* pointed out.[113] Although he resigned as president of MoMA shortly after he accepted Roosevelt's appointment, he continued to enlist the aid of the museum in his work. Several of the thirty-eight wartime contracts executed by MoMA for government agencies came from Rockefeller's office; these

included exhibitions sent to Latin American countries and exhibitions of Latin American art installed at the museum. The museum also acquired during this period what it described as "the most important collection of contemporary Latin-American art in the United States, or for that matter in the world (including our sister republics to the south)." This boast appeared in the foreword by Alfred Barr to the catalogue of MoMA's collection of Latin American Art prepared in 1943 by the newly appointed consultant in Latin American art, Lincoln Kirstein. Barr's language is close to Newman's.

> Thanks to the second World War and to certain men of good will throughout our Western Hemisphere, we are dropping those blinders in cultural understanding which have kept the eyes of all the American republics fixed on Europe with scarcely a side glance at each other during the past century and a half.
>
> In the field of art we are beginning to look each other full in the face with interest and some comprehension.[114]

The exuberant tone and explicit attention to diplomacy in this text resemble Newman's later *Revista Belga* essays, but such similarities should not be too surprising. They became standard features of writing and thinking about Central American and South American art during the war years. Critics and artists followed MoMA's lead, and the attention and goodwill extended to the art and artists of the other Americas helped to produce a vogue for such art. For example, when E. A. Jewell wrote in the *New York Times* on 13 April 1941 that "Mexican art occupies a place of prominence just now in the current panorama," he was not referring solely to the work of Orozco, Rivera, and Siqueiros.[115] In the wake of the MoMA exhibition "Twenty Centuries of Mexican Art" in the summer of 1940, commercial galleries were installing shows, books and articles were being published, and painters such as Uribe, Mérida, Galván, Meza, Ruiz, and others were becoming familiar to New York art enthusiasts. And Mexican art was getting only slightly more attention than that of other Central and South American countries.

Savvy New York artists were quite aware of this particular interest and involvement by MoMA and Rockefeller and of the general politicization of cultural relations with Latin America. In early 1941 the Artists' Coordination Committee (ACC), representing fourteen artists' organizations in New York City, rallied to the cause. It organized a symposium at MoMA entitled "Inter-American Cultural Relations in the Field of Art" in May 1941.[116] The ACC also contacted John Abbott, executive vice-president of MoMA—although to the artists he was merely an agent of Rockefeller[117]—about participating in a South American cultural exchange being organized by Rockefeller's office with the assistance of a committee chaired by Abbott. The exchange, actually three shows that traveled simultaneously through the Americas, was previewed for the United States public in April 1941 at the Metropolitan Museum.[118] Although none of the Mythmaker group were included in the exchange, it is worth noting that Rothko was the representative from the FMPS to the ACC in early 1941 and that he showed particular interest in this project.[119] Less than ten years after the painting over of Rivera's mural for the RCA Building in Rockefeller Center had incited their outrage, advanced artists seemed to have no reservations about exhibiting in Latin America under Rockefeller's aegis.

The vogue for Latin American art being promoted by MoMA was obviously politically motivated. The actions of many advanced artists indicate that they, like Newman,

knew this and either approved the political program or were willing to exploit the situation to gain a forum for their art. Given these conditions, it is hardly surprising that Pre-Columbian art should have captured the attention of artists inclined toward primitivism. However, in spite of Newman's prominent attention to Pre-Columbian art, it did not significantly influence the forms of Mythmaker art. On occasion, this absence seemed to be an obstacle to the promotion of their work. Newman was a writer and critic at this time, having not yet made painting his primary occupation (until 1945 he described himself in *La Revista Belga* as an "escritor y crítico de arte neoyorquino"). Newman wasted no opportunity to promote the art of his friends, even when such remarks had no natural place in his essays.[120] But he never forged a direct link between these friends and Pre-Columbian art. In his article on Tamayo and Gottlieb published in April 1945, for instance, he highlighted both artists' "deep understanding and respect for the indigenous art of the American aborigines . . . [and their] link with the American past," but although Tamayo's link was to Pre-Columbian Mexican art, Gottlieb's was to Indian art of the Northwest Coast. Newman left no doubt in the minds of his readers, however, that this Northwest Coast art was as valuable a tool for artistic nationalism and pan-Americanism as Pre-Columbian work.

> An analysis of their working aesthetics should give us a clue to the attitude that ought to motivate our American artists and those art laymen who are concerned with the establishment of an "American" tradition. Tamayo and Gottlieb are alike in that, working in the free atmosphere of the art tradition of the school of Paris, they have their roots deep in the great art traditions of our American aborigines. . . .
>
> Tamayo [like Gottlieb] understands that to be close to one's country one must be close to its art rather than to the contemporary people who surround one. He knows that merely to paint an Indian does not create an indigenous art.[121]

Newman's article on Tamayo and Gottlieb is interesting for at least two reasons. First, it pulls Northwest Coast Indian art into the nationalistic arena Newman had already established for Pre-Columbian work. U.S. artists found this indigenous work appealing in part because they could use it in establishing a specifically American modernism. Evocation of Native American art became an effective and widely used means of binding artistic projects derived from European traditions to the American "soil" and "spirit," thereby differentiating them from European work. Richard Pousette-Dart's retrospective words make this process explicit: "I felt close to the spirit of Indian art. My work came from some spirit or force in America, not Europe."[122]

MoMA also played a part in promoting the appropriation of Native American arts for nationalistic and pan-Americanist effects: its 1941 exhibition "Indian Art of the United States" was an effort to affirm that Indian heritage "constitutes part of the artistic and spiritual wealth of this country," as Eleanor Roosevelt phrased it in her introductory note to the catalogue. She went on to assert that Indian art had sources that "reach far beyond our borders, both to the north and the south," making it emblematic of the "hemispheric interchange of ideas [that] is as old as man on this continent." The essential unity of the Americas, from Alaska and Canada to the Andes, was resoundingly declared in her remarks. In the catalogue proper, Frederic H. Douglas and René d'Harnoncourt noted that although "for centuries the white man has taken advantage of the practical [agricultural] contributions made by the Indians to civilization, . . . we have hardly ever

stopped to ask what values there may be in Indian thought and art." There is brutal irony in these attempts to appropriate the artistic traditions of Native American cultures for the imperialist nation that had persecuted and exterminated those cultures and appropriated their land. The project of refiguring Indian arts as "roots" of Euro-American cultural and visual traditions required an active effort to obliterate historical memory. The MoMA catalogue expressed remorse for the fact that for four centuries the Indians "were exposed to the onslaught of the white invader, and military conquest was followed everywhere by civilian domination. . . . Only in recent years has it been realized that such a policy was not merely a violation of intrinsic human rights but was actually destroying values which could never be replaced."[123]

But a new initiative was underway, Douglas and d'Harnoncourt assured their readers; the exhibition itself implicitly was part of an effort to recover those values and atone for past behaviors. A vogue for Native American art, which had begun early in the century, was in full swing in the 1930s. In 1931 Grand Central Galleries in New York hosted the highly publicized "Exposition of Indian Tribal Arts," and through the decade both temporary and permanent exhibitions were installed at the Brooklyn Museum, the American Museum of Natural History, and the Museum of the American Indian. The Indian Reorganization Act (IRA) passed by Congress in 1934 was cited in the MoMA catalogue as another step in the direction of cultural preservation and recovery. The IRA was drafted by John Collier, President Roosevelt's commissioner of Indian affairs and a former member of the Taos colony of artists and intellectuals who celebrated Pueblo life as a communal, utopian alternative to competitive and individualistic industrial capitalism. Collier's IRA was an ambitious effort to promote Native American self-determination and cultural revival on many fronts, but the act was eviscerated in its passage through Congress. As one historian summarized the effects of the congressional deletions and amendments, "congressmen made clear that they subscribed to a very limited ideal of cultural pluralism and self-determination. If Collier hoped to revive old-time tribal community control and culture, Congress at best preferred to stabilize Indian acculturation and assimilation as it was in 1934 without forcing change either forward or backward."[124]

Another part of the New Deal for Indians was cosmetic—the dismantling of national monuments that embodied embarrassing memories. In 1939 the House of Representatives considered a resolution to remove one of the many racist sculptural decorations, dating from the nineteenth century, from the exterior of the Capitol building in Washington. Horatio Greenough's sculpture *The Rescue,* which showed an enormous white pioneer overwhelming a savage Indian about to tomahawk the pioneer's cowering, defenseless wife and child, should be

> ground into dust, and scattered to the four winds, that no more remembrance may be perpetuated of our barbaric past, and that it may not be a constant reminder to our American Indian citizens. . . .
>
> This monument is a constant reminder of ill-will toward the American Indian, who has now become a part of this Nation and has, as far as this Government will permit, assumed the duties of citizenship and has become as law abiding, as honorable, and as patriotic as any other race in our complex civilization.[125]

This resolution did not pass, but in 1941 another proposed that the "disgraceful" sculp-

ture be replaced by a monument to "one of the great Indian leaders famous in American history."[126] With the Indian wars long concluded everywhere but in Hollywood, an official rehabilitation of both history and the Indian could begin. The government's newfound generosity toward Native Americans was tainted: it was much more a matter of images and rhetoric than of political or economic concessions, and self-interest was present in large measure. But the officially sanctioned celebration and appropriation of Native American cultures simultaneously lent momentum to other, unofficial programs. "Primitive" American arts figured prominently not only in the production of national and pan-American unity in wartime, but also in the critique of modern capitalism, industrialism, and middle-class values then in a state of crisis. The community of artists and intellectuals in Taos was an early manifestation of a turn toward Native American philosophies and social organizations in the effort to escape, as well as criticize and reform, United States society and its dominant values.[127] Many of these individuals were disillusioned reformers and radicals from New York who, in the face of the brutal government repression of progressive and radical initiatives in the years following World War I, looked toward new horizons. John Collier had been an organizer and teacher of social work and community development when the repression of 1919 brought an end to "practically all that I, we, all of us, had put all of our being into. My own disillusionment toward the 'occidental ethos and genius' as being the hope of the world was complete."[128] Some turned to psychology, especially to Jung, as the next chapter will show; others embraced Native American societies as models of utopian, organic, spiritual communities. Collier was a highly visible publicist and activist for the idea that the United States, and the Western world in general, should learn some important lessons from Native American peoples. In 1947 he published a history entitled *The Indians of the Americas*. The introduction to this book reveals the Modern Man aspects of Collier's project.

> The deep cause of our world agony is that we have lost that passion and reverence for human personality and for the web of life and the earth which the American Indians have tended as a central, sacred fire since before the Stone Age. Our *long* hope is to renew that sacred fire in us all. It is our only long hope. (P. 17)

Collier argued that the contemporary world crisis revealed the distortions of humanity and life engendered in the industrial revolution, in the free market's self-interested man and his fixation on material life, science, and technology.

> Because the free market's rationally self-interested man is only a small fragment of the human race, and because if men cannot have good societies they will have worse ones, there took form those new societies, exploitative of the psychotic trends in men, which World War II was waged to suppress. Yet can the psychopathic pursuit of a basic need be stopped through war or force, if the healthful pursuit of basic needs is made impossible by the condition or drift or fanaticism, or the myopia, of a world's age? (P. 25)

In the face of relentless assault by the capitalist, materialist, secular society of the United States, Native American cultures preserved their "spiritual possessions," precisely what, Collier maintained, "our sick world most needs" (p. 21). Modern man's need to regain lost spirituality and community could be recognized and fulfilled through close study of Native American cultures; in the words of Rothko, quoted earlier, these, like other

primitive and archaic cultures, were "more practical societ[ies] than ours," since "the urgency for transcendent experience was understood and given an official status." Comparison of Collier's and Rothko's words illustrates a linkage between the work of the Mythmakers and Modern Man discourse in terms of a broad appropriation of Native American cultures for purposes of cultural criticism. Newman and the Mythmakers, and sometimes Pollock and other New York School artists, enlisted native primitivisms in both the production of national and pan-American cultural identities and in the critique of modernity. Their incorporation of Native American arts, through theory and practice, into modernist visual traditions, served official national interests on one hand and certain oppositional, reformist platforms on the other.[129]

A second noteworthy feature of Newman's essay is the insight it offers into the popularity of Tamayo among the Mythmakers and other proponents of modernism in the 1940s.[130] Tamayo became an important ally in the pan-American cultural initiative. Interested in native American primitivism, he alone of the well-known Mexican artists embraced an ostensibly apolitical modernism. Newman placed considerable emphasis on this aspect of Tamayo's aesthetics.

> The attempts of our nationalist politics and artists, in both South and North America, have failed and must continue to do so.
>
> [They have failed because] The objection to nationalism in art is not the simple one that politics is an unnecessary marriage for the artist, . . . the case against nationalism lies deeper; that nationalism in art, whether of the status quo or for the revolution, shows a lack of understanding of what art is about—of its nature. . . .
>
> Dominated by the archnationalists Rivera and Orozco, self-proclaimed artists of the revolution, contemporary Mexican art finds only small space for its outstanding artist, Rufino Tamayo. The result has been to make Tamayo a virtual exile.[131]

In Newman's definition nationalism required explicit political content. His own deeply nationalistic impulses, which contributed to his attraction to the work of Tamayo, were invisible to him. The explicit but superficial antinationalism in the agenda of Newman and in that of other New York School painters has been accepted at face value in most accounts of the ambitions of those artists. However, the attribution of internationalist commitments to these artists exists uncomfortably alongside another cliché of New York School criticism: that the achievement of these artists was predicated upon their development of a modernism that enunciated a distinctly American culture and experience. As the story goes, their efforts to match and extend the great modern tradition used American ingredients to transcend mere imitation of the European example and to root their expressions in their own lived experience. The nationalism of Newman and others is thus acknowledged, but soft-pedaled.

Joaquín Torres-García was a South American artist frequently aligned with Tamayo. An Uruguayan painter with an impeccable modernist pedigree, whose work drew upon Pre-Columbian motifs, he was widely exhibited and respected in the early 1940s.[132] He was represented in Gallatin's and MoMA's collections and included in the 1943 exhibition of the MoMA Latin American collection. He figured little in the Mythmakers' writing at the time, surprisingly little in light of the similarities between his work and Gottlieb's. Perhaps the similarities were too close for comfort, or perhaps the opportunity to treat them never arose. One wonders whether Newman considered pairing Torres-García and Gottlieb in his *Revista Belga* article.

Newman failed to offer any nonnationalistic argument for the special significance he accorded to Pre-Columbian art. Its salient features, as Newman saw and described them—majestic form, the expression of life's tragedy and terror, and so forth—were the same as those he and his colleagues discovered in all primitive and archaic art. Nor were the particular forms in Pre-Columbian art borrowed or adapted in any discernible way for contemporary paintings. One senses that Newman would have jumped at the chance to draw attention to the presence of Pre-Columbian forms in the work of Rothko or Gottlieb; that he did not attempt it might be taken as evidence that he did not believe such formal ties were there. He might have argued for a Pre-Columbian influence mediated by Torres-García in Gottlieb's paintings, but he did not. The Pre-Columbian interest apparently was principally a matter of Mythmaker writing and theorizing.

The story is somewhat different regarding Northwest Coast Indian art. One could argue, as Newman did, that Gottlieb's paintings were related formally to Chilkat, Kwakiutl, or Tlingit images in which an animal's form is splayed and flattened into a network of geometric compartments, each of which contains or is a symbolic representation of a part of the animal. Gottlieb's pictographs are organized on a similar principle, insofar as they contain symbolic forms, with eyes and teeth predominating, within a rectilinear grid; reviews of his work routinely discerned a relation to Native American art.[133] The differences, however, are numerous and significant. The relationship among Gottlieb's symbols is presented as a problem to the viewer; the irregularity of the grid reinforces the problematic character of this relationship. Its basis, however, is adamantly thematic, psychological, metaphoric, synecdochic. Northwest Coast Indian images contain symbols whose organic interrelation is unquestioned and whose character, identity, and arrangement are established by convention. The tightly interlocking, symmetrical grid suits this form of organic, symbolic, metonymic interrelation.

More important than the pictorial structure and mechanics of Northwest Coast Indian art for Gottlieb and Newman was what they took its basic character to be: that of an essentially abstract art which conveyed symbolically an intellectual content—myths, beliefs, ideas—understood without difficulty by its audience. To produce modernist paintings with just these characteristics was the ambition and dream of these artists in the 1940s; part of the special attraction of Northwest Coast art, over other sorts of primitive and archaic art, was that it offered proof of the possibility, even the naturalness, of this ambition.

> It is of interest here to make the point that the attitude that despises modern abstract art as the esoteric expression of a decadent and disintegrating society, the purposeless play of a sophisticated, self-appointed elite removed from the people and its problems, overlooks the fact that in the healthy, primitive, well-integrated societies of the Northwest Coast, abstract painting was the standard tradition.[134]

This construction of the Indian art was a misrepresentation that depended upon the aesthetic response to the objects practiced and encouraged by Newman and his colleagues and upon the interests and commitments that governed their interpretations. It presumed that there were fundamental similarities between Haida or Chilkat objects and modern artworks in terms of status, purpose, and conditions of production, appreciation, and interpretation. Here is a description by Newman of Northwest Coast art:

> The art of the Northwest Coast Indians is an abstract symbolic art of the highest sophistica-

tion. It is not to be confused with the geometric designs of its decorative arts, which were a separate realm practiced by the women of the tribes. The serious art of these tribes, practiced by the men, took the form of a highly abstract concept. Working with abstract shapes in a flat two-dimensional space the men strove to express a symbolic idea.[135]

Newman seems to have believed that Northwest Coast Indians had a category "serious art" analogous to "our" own. Like ours, it was superior to mere decoration and it elicited aesthetic contemplation from its viewers; like ours, it was "done by men." He also considered this art abstract and conceptual in the same senses in which he applied these terms to the work of Gottlieb and Rothko and, later, himself. Just as there are discrepancies between the beliefs of these painters and those of Boas and other anthropologists regarding the primitive and primitive art, so are there discrepancies between them regarding Northwest Coast Indian art specifically.

Boas' emphasis is on not the abstract but the representational character of this art, which involves a method of projection that contrasts with Western perspective. Newman certainly understood the pictorial mechanics of Northwest Coast Indian art, as is revealed in his essay for an exhibition of this art at Betty Parsons Gallery in 1946. But for polemical purposes he chose to attend to the abstractness of the symbols without noting how deeply they are rooted in established conventions of representation. Newman's distinction between "serious" and "decorative" Northwest Coast art corresponds to Boas' distinction between "symbolic" and "formal" styles, the former "full of meaning" and done by men, the latter women's work, mostly patterns without "especially marked significance."[136] Boas, however, notes that both types of art adorn utilitarian objects; in general, he is less inclined than Newman to draw conclusions about the relative importance of the two styles. The subjects represented in the realistic, symbolic style are animals, totems, and mythical beasts, sometimes in relations that originate in mythic narratives; to imply that their content is conceptual, in the sense applicable, for example, to Gottlieb's efforts to paint the mind-body problem, is unjustified in Boas' terms. Finally, Boas made clear that there was often considerable disagreement among native viewers concerning what precisely these schematic images represented. The content of this "universal" art seems to have been clearer to Newman than, by Boas' account, it was to members of the culture in which it was produced and functioned.

These discrepancies should lead us to question, or further question, two beliefs: first, that Northwest Coast Indian art is evidence for the viability of the model of artistic communication and meaning held by Gottlieb, Newman, and Rothko in the 1940s; and second, that the primitivism of these artists was in some essential way an application of the work of Boas and other well-known anthropologists of the time.[137] The Mythmakers were ill-disposed in crucial ways toward ethnographic and scientific treatments of primitive artifacts; the extent to which their interpretations were misreadings of leading authorities on the Indian art is difficult to assess.[138] Many of their assertions were contradicted even by MoMA's catalogue for the 1941 exhibition of Native American arts. The essays in that catalogue challenged various common "misinterpretations" of Northwest Coast and other Indian arts, questioning, for example, the sufficiency of purely aesthetic approaches to the art, the assumption that the images are meant to be sinister and evoke fear, and any distinction between fine and applied arts in Native American cultures.[139]

The two varieties of indigenous American arts being appropriated by Newman and the Mythmakers shared little more than relative geographic proximity. When Newman describes them as simply new world variations on generic primitive art, profound differences in social structure and culture and in the character and function of artifacts between and among Northwest Coast and Pre-Columbian civilizations are effaced. The two are unified as a primitive "them," counterposed to the modern "us." Unification is effected on both sides of the opposition: just as diverse societies and peoples are homogenized as "primitive," so a United States society internally fractured and fragmented—frighteningly so, especially during the preceding decade—is unified as "modern." This assumption of national unity was another significant political aspect of Newman's primitivism and nationalism. Unity was produced not simply through opposition to the primitive, but also through identification with it. As the Mythmakers saw it, the plight of all humans was identically tragic; we all find ourselves in the same position that primitive men experienced and expressed in their art. It is unusual in the history of modernist primitivism that the gap between primitive and modern is so narrow. The factors that account for this close identification are historical and particular. One is the wartime desire for pan-American unification, a project in which the primitive was discovered to be a valuable tool by Western governments. The rehabilitation by the United States of the image of the Indian and the overtures by the Belgian and U.S. governments to South and Latin America via Pre-Columbian arts were undertaken in the pursuit of this objective. Another factor was the reconstitution of human nature and identity in an effort to explain evil, tragedy, and modern calamity, and to this my discussion will return. Mythmaker primitivism was both a product of and a factor in these varied enterprises.

PAALEN AND *DYN*

At the same time that the Mythmakers were structuring their primitivist theories around Pre-Columbian and Northwest Coast Indian art, Wolfgang Paalen and his associates at the magazine *Dyn* were developing a similar double focus. Paalen himself was a truly international character; of Austrian and French background, he was educated in France, Italy, and Germany, lived and worked in Paris in the late 1930s (during which time he became close to the Surrealists), and settled finally in Mexico in 1939. His initial attraction to primitive arts was probably a result of his affiliation with the Surrealists, who were interested in (and collected) African and Oceanic as well as Pre-Columbian and Northwest Coast Indian art.[140] The latter two areas, those primitive arts that had been least tapped by European modernism, were the ones Paalen pursued. He spent four or five months of 1939 among the Indians of British Columbia before establishing residence in Mexico. His amateur ethnological and archaeological activities in each region were the basis for extensive writings on the primitive and archaic arts. There is no strong evidence that Paalen's work was directly influential upon the Mythmakers. His writing is generally more balanced and anthropologically informed than theirs, although it is certainly idiosyncratic, and develops some eccentric (possibly Jungian) arguments. He differs from the Mythmakers on some crucial points, such as the alienness of the primitive, arguing, for example, that "one must be acquainted with the mythology of an ethnic group in order to understand when it intends to personify a monstrous being and

not qualify as such everything that differs from our own esthetic."[141] Furthermore, there is no overt nationalism in play in his writing. Paalen's perspective is international; nonetheless, his work acquired a nationalistic aspect in the United States. At least one of his friends, a contributor to *Dyn*—the Mexican illustrator and artist Miguel Covarrubias—was involved in some of MoMA's Latin American projects.[142]

Rather than a relation of influence, Paalen's case points to an additional consideration in the analysis of the appeal of particular primitive arts to the Mythmakers. Their relative freshness, their lack of a history in visual modernism, may have been part of the attraction that Pre-Columbian and Northwest Coast Indian art held for the Mythmakers, as it likely was for Paalen. These arts were grist for the continually expanding Western visual culture mill. The imperialist embrace of Western culture was extended into fresh domains, and the enormous breadth of that culture, its essential centrality, its encompassing sweep and scope, were affirmed.[143]

VARIETIES OF VISUAL PRIMITIVISM

Given the broad cultural interest in the primitive, and given the many sorts of ideological work this category proved capable of doing, that it figured prominently in an enormous number and variety of visual works will come as no surprise. By looking at some of these it may become possible to define more precisely Mythmaker primitivism and to account for its success in attracting attention and arousing interest among the audience for advanced art. We are used to thinking of primitivism in this period as the special preserve of the New York School painters, and it is true that many of them demonstrated interest in it. Having said this, however, I should offer three clarifications.

First, not all New York School artists were interested in the primitive. Motherwell, for example, who spent some time with Paalen in Mexico in 1941, recalls, "I didn't have the slightest interest in modern Mexican painting or in Pre-Columbian art."[144] Primitivism seems also to have had little significance for Gorky, who criticized the vogue for primitivism in a letter to his sister.

> For me great art derives from complexity, from the clash of many new and opposing ideas. Primitive art results largely from isolation and isolation cannot produce aesthetic or high art because it lacks all-encompassing experience. . . . Primitives have mastered certain fundamental techniques, but since I value the mind as the center of great art, I criticize primitive art essentially because, through lack of international contact, through isolation, the mind of primitive art lags behind that of advanced societies. By advanced societies I mean those which, in moving forward in culture and science, have streaked out in paths never before entered by humanity, thereby pushing the mind to hitherto unknown extents.[145]

Like Gorky, Motherwell and also de Kooning seem to have preferred modernist sophistication to primitivism.

Second, those of the New York School artists who were interested in the primitive produced varied readings and uses of the notion. The primitivisms of Jackson Pollock and David Smith, for example, had little of the coloring of Mythmaker primitivism, with its emphasis on tragedy and terror. All of these artists were strongly influenced by the ideas of John Graham, but they gravitated toward different aspects of his thinking.[146] Pollock was allegedly so impressed by Graham's article "Primitive Art and Picasso" that

he arranged to introduce himself to the author—not the sort of thing Pollock ordinarily did.[147] Graham's primary claim about the primitive in that article was that it involved privileged access to the unconscious and to cosmic knowledge.

> Primitive races and primitive genius have readier access to their unconscious mind than so-called civilized people. . . . This access to the Unconscious permitted primitive people to comprehend the origin of species and the evolution of forms eons of years ago. (P. 237)

Such views were not uniquely Graham's. They owe a great deal to Jung, and they were also being expressed in Modern Man literature. Wylie and Carncross, who used *primitive* and *unconscious* as synonyms, are cases in point. But unlike these writers, concerned to emphasize the irrational ingredients of the primitive-unconscious nexus—violence, brutality, terror—Graham concentrated upon the knowledge of form and of plastic qualities that the unconscious contained, and this is where his relation to the Mythmakers is most apparent. Recall the last sentence quoted above, or consider the following:

> The primitive artists, on the road to the elucidation of their plastic problems, similarly reached deep into their primordial memories. (P. 260.)

Perhaps because of this strange belief about the contents of the unconscious, it is hard to detect the influence of the primitive in Graham's own paintings; he is sufficiently vague about the distinctive character of primitive forms that the viewer has very little idea what to look for. Although he was an active collector and dealer in primitive art, mostly African, his paintings seldom indulged in overt primitivizing of any sort. Perhaps the closest he came to this was in the painting *Interior* (fig. 11), done about the same time as Pollock's *Birth* (fig. 12), which it vaguely resembles. *Birth* was the first mature painting exhibited by Pollock. It was included in a show called "American and French Painting" at McMillen, curated by Graham in January 1942. Compared to Pollock's painting, *Interior* is tasteful and well-behaved; its primitivism, if it can be called that, is restrained. The painting is, after all, an abstracted view of an interior, with a strange, primitive-looking sun or mask dominating the composition. The difference shows that Graham's influence on Pollock was a matter of ideas, not example; it also hints that Pollock's version of the primitive-unconscious nexus combined Graham's views with the beliefs of Modern Man authors, a suggestion I shall pursue in the next chapter. The more important point here is that the primitivism of Pollock's painting is some distance from Mythmaker primitivism. In Pollock's work, the signifiers of the primitive—masks, abstract patterning, violence—indicate both the presence of the unconscious and the character of its contents. Primitive and unconscious are inseparable in his work; they are the two faces of the dark side of human mind and human nature. Newman, by contrast, for all his interest in the primitive, could write that he was relatively uninterested in the unconscious per se.[148] For Pollock the primitive, as mediated by Graham's ideas, Jungian therapy, and Modern Man literature, offered access to the mysterious and dangerous contents of the unconscious; it was not necessarily the natural expression of an emotional and psychic condition virtually identical to that of modern man as it was for the Mythmakers.

Explaining the imagery in Gottlieb's *Rape of Persephone*, in a letter to the *New York*

11. John Graham. Interior. *Ca. 1939–40. Oil on canvas, 76 × 51 cm. Collection of the Rose Art Museum, Brandeis University, Waltham, Massachusetts; bequest of Louis Shapiro. Photograph by Muldoon Studio.*

Times in June 1943, the Mythmaker group revealed something of the connection they made between the primitive and the unconscious:

> [The painting] is a poetic expression of the essence of the myth; the presentation of the concept of seed and its earth with all its brutal implications.[149]

The violent abduction of Persephone by Hades, and the cycle of vegetal (and human) death and rebirth the narrative explains, are distilled into the essential, brutal, natural, violent but generative relation of seed and earth. At this fundamental, universal level, primitivism and myth seem to remain relevant for modernity. The description recalls a representation of the unconscious developed by an earlier generation of United States modernists and articulated by their impresario, Alfred Stieglitz:

> The subconscious pushing through the conscious . . . trying to live in the light, like the seed pushing up through the earth—will alone have roots, can alone be fertile.[150]

Juxtaposing the two seed-earth images allows for a picture of the unconscious as fundamentally mythic in form and content. Stieglitz provides a guiding metaphor that illuminates the Mythmakers' view of the unconscious as the repository of primitive experience, in the form of myth, which intrudes into consciousness in a mythic process. So much was suggested by Rothko in 1946, when he evoked the Persephone myth in his catalogue essay for the exhibition that introduced Clyfford Still to the New York art audience.

Still expresses the tragic-religious drama which is generic to all Myths at all times. . . . For me, Still's pictorial dramas are an extension of the Greek Persephone Myth. As he himself has expressed it his paintings are "of the Earth, the Damned, and of the Recreated."[151]

The contrast with Pollock's models of the unconscious and its primitive dimensions, to be further developed in the next chapter, is striking.

Yet I do not want to exaggerate the distance between the primitivisms to which various of the New York School artists subscribed. There were elements of Jungianism in the Mythmaker version, and aspects of the Mythmaker platform to which Pollock would have agreed. The differences are largely in emphases and priorities.

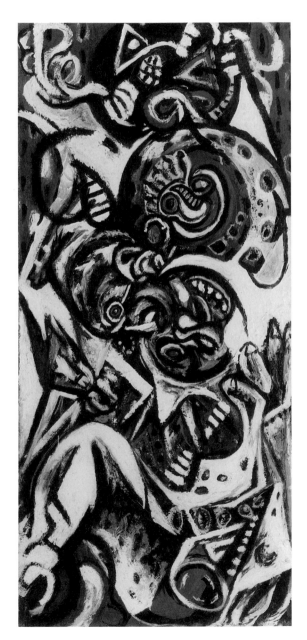

12. Jackson Pollock. Birth. *1938–41. Oil on canvas mounted on plywood, 117 × 55 cm. Collection of the Tate Gallery, London.*

The third point to be made is that a number of painters not associated with the New York School, and different from each other in style and ideology, produced work involving primitivism of one sort or another. Philip Evergood was one of a few realists who tried to portray the primitive. The foreground of his *Elephant Hunt* (fig. 13) shows a group of naked spear- and shield-wielding African hunters, depicted from behind, in pursuit of an elephant in the distance. The painting amply illustrates the difficulties such a subject presented for realism. Its exoticism and fascination were overpowering, not unlike the lure of Orientalism for an earlier generation, and Evergood's picture descends into *National Geographic* romanticism and *Life* magazine voyeurism. But painting was no match for photography in these terms; one need only compare *Elephant Hunt* with photos published in *Life* showing cannibals roasting a man (fig. 14).[152]

Traditional School of Paris primitivism had its U.S. practitioners in the 1940s. Foremost among them was Edward John Stevens, whose precociousness (he was born in 1923) and commercial success were much noted in the art press. His shows at the Weyhe Gallery—the first in 1944—annually sold out to museums and prestigious private collections, some of which (Frank Crowninshield's, for example) were known for their holdings of primitive art. Stevens' *Woman with a Mask, Number 2*, a representative work from 1945 (fig. 15), gave the mask faces of Picasso's *Les Demoiselles d'Avignon* a delicate decorative turn, placing one among patterned pictorial fields in a tightly designed composition. It was precisely the sort of refined product, openly derived from Parisian modernism, that the New York art market craved during the wartime shortage of European imports. Such work traded on its obvious affiliation with the pedigreed primitivisms of modern painting. Critical verdicts such as that offered by *Art News*—"though his graphic alphabet is derivative, it is used refreshingly"—were no liability for Stevens, in the short term, at least.[153] His popularity was considerable; he appeared on the cover of *Life* in 1950 as one of the nineteen artists under thirty-six years old whose work that magazine considered "representative of the best young painting being done in the country today."[154] While Stamos and Hedda Sterne were included in the group, few of the

13. Philip Evergood. Elephant Hunt. 1946. Oil on canvas, 61 × 50 cm. Collection of Mervin Jules.

14. (opposite, above) Osa Johnson. Photograph captioned "Cannibals Roast a Man." Life, 25 March 1940, 12–13. Courtesy Northwestern University Library.

artists made abstract paintings; most adhered rather closely to various School of Paris traditions. *Life*'s version of the Triumph of American Painting celebrated the sort of work dealers such as Kootz were unloading in an effort to consolidate the strength of Intrasubjectivism. Although Stevens continued to be successful in the postwar years, he was unable to capitalize on the strong nationalism so crucial to the success of the New York School artists.[155]

Stevens' adaptations of African art forms took their place in a growing tradition in the United States, stretching from early modernists such as Max Weber and Man Ray to John Graham.[156] Parallel to that tradition and overlapping it, although excluded and unrecognized by modernist art history, is the work of contemporary African American artists, many of whom were associated with the Harlem Renaissance. While these two visual traditions are similar in many respects, there is also tension between them. Although Aaron Douglas (see, for example, *Aspects of Negro Life*, 1934), Lois Mailou Jones (*Fetishes*, 1938), Hale Woodruff (*Native Forms*, n.d.), and other African American artists were knowledgeable and skilled in the modernist idioms with which they worked, their motivation in appropriating African forms was to contribute to the formation of a cultural identity for African Americans by affirming the existence of vital visual traditions inherited from their African ancestors and by extending or transforming those traditions (see Malvin Gray Johnson, *Negro Masks*, 1932 [fig. 16]). Laying such claim to African visual traditions would have required wresting those forms away from the dominant culture: specifically, European-influenced, U.S. modernist art. What made such a move impossible, however, was the fact that African arts were only available to the Harlem artists through modernism and its readings and uses of African forms. Douglas' exposure to African arts came via his study with Othon Friesz in Paris and through his study of the African and modernist art collection of Albert Barnes. As was the case for the other Harlem Renaissance artists, Douglas' connection to African art was mediated by modernism and its misreadings.

15. Edward John Stevens. Woman with a
Mask, Number 2. *1945. Gouache on paper,
56 × 46 cm. Collection of Bryn Mawr College.*

At the same time, however, African American appropriations of African art did not
read as true primitivism (and arguably still do not, if MoMA's 1984 survey of twentieth-
century primitivism is a fair indication). For influential white patrons, the forms that
signified "primitivism" in the work of white artists revealed merely "inherent Negro
traits" in the work of black artists. Their primitivism was not seen as a calculated artistic
maneuver but as derived from "deeply rooted capacities and instincts capable of being
translated into vital art forms."[157] Black artists, like contemporary Native American
artists, generally were denied the subjectivity necessary for primitivism. The primitive

could not be an elusive, concealed, repressed other within them, nor something perceived and represented as a subtle conflict across layers of the mind. Where African American artists were concerned, the primitive *was* them; there was no accretion of civilization impeding the expression of primitive perceptions or behaviors. Their work was not primitivizing, it was *primitive*.

The critical reception in New York of the work of the Cuban artist Wifredo Lam is illuminating in this context. Although Lam spent very little time during the 1940s in the United States—he preferred to live and work in Cuba—his work was influential in New York during the decade following his first exhibition there in 1939. He was on occasion described as belonging to the so-called new tendency developing around 1945–46 that synthesized Surrealism and abstraction and included the future New York School artists.[158] Lam's painting from that time does indeed fit that description; it mixes forms distinctly reminiscent of Picasso and Ernst, as, for example, in *The Jungle* (fig. 17),

16. *Malvin Gray Johnson. Negro Masks.*
1932. Oil on canvas, 71 × 49 cm. Collection
of the Hampton University Museum,
Hampton, Virginia.

purchased by the Museum of Modern Art in 1943. Lam had studied painting in Paris with Picasso and had become associated with Breton and the Surrealists until the war led them to depart from Paris. Not only is his work a textbook synthesis of Cubism and Surrealism, but it resembles in significant respects some contemporary work of the Mythmakers, particularly Gottlieb and Rothko. They share an interest in primitive and mythic imagery, although Lam's primitivism takes as its point of reference Cuban and African Cuban religions and traditions. Despite these thematic and formal continuities with the early New York School, Lam's work generally elicited a different sort of response from New York critics. The fact that he was from Cuba and, more important, that he was partly black—his mother was an African Cuban, his father was Chinese—often led critics to treat his work differently. Usually his exotic heritage was mentioned prominently at the start of the review; the *Art Digest,* for example, opened its review of his 1942 exhibition by noting that Lam was a Cuban painter "in whose veins runs both Chinese and Negro blood."[159]

His background gave Lam's primitivism, in the eyes of many reviewers, an authenticity to which any modernist artifice he employed was secondary. André Breton highlighted this point in the catalogue to Lam's first solo exhibition in New York in 1942, where he observed that this artist's paintings started from "the primitive myth he bore within him."[160] But in reviewing that exhibition, E. A. Jewell of the *New York Times* cited Lam's indebtedness to Picasso as the most prominent feature of the work; he quoted Breton's words only to ridicule them with the suggestion that perhaps Lam's works "were painted under a kind of spell."[161] Although Lam's debts to Picasso and the School of Paris were always prominent in his art—indeed his work was often criticized for being derivative—the notion that his painting revealed a special access to the primitive, a function of his racial identity, was a persistent feature of the criticism. His "native heritage" was routinely adduced to explain the special intensity and force of his primitivizing work. One reviewer felt "the powerful legendary undercurrent that runs deep in the personality that is Wifredo Lam."[162] Another noted that

> Lam rediscovered through Picasso the message which he bore within him. . . . He found his real self . . . [in canvases] in which the emotions of black magic were clearly expressed. I had just returned form Haiti, the land of Voodoo, and immediately recognized in Lam's figures the divinities honored in native ritual ceremonies.[163]

Thomas Hess felt constrained to write in *Art News* that "although [Lam] is half-Chinese and half-Negro, it would be a mistake to attribute the svelte sophistication of his calligraphy or the hypnotic savagery of his totems to any occult racial memories."[164] Valuable though Hess' cautionary words are, that first clause—particularly the word *although*—implies that the explanation he dismisses had some logic. Even the skeptics held deeply internalized assumptions about race and the primitive.

This aspect of Lam's critical reception is perfectly congruent with the dominant popular attitudes of whites toward black artists and performers during the interwar period. The eager white spectators who traveled up to Harlem in search of exciting entertainment understood and explained their fascination with jazz, tap dancing, and other exotic performances in terms of the authentic primitivism of those forms (fig. 18). Uptown they thought they could find savage impulses generating music and dance, primitive instincts coming to expression in artistic works that constantly teetered at the

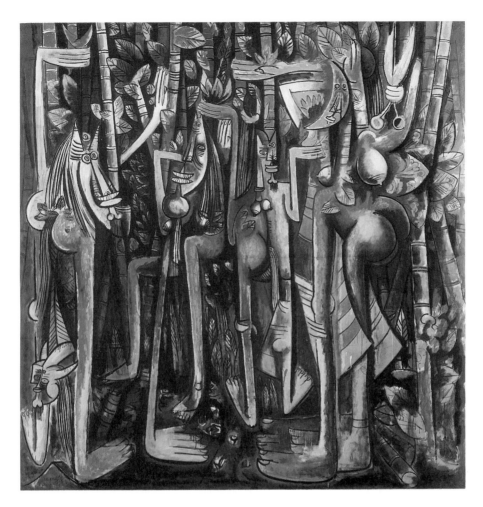

17. Wifredo Lam. The Jungle. *1943.*
Gouache on paper mounted on canvas, 239
× 230 cm. Collection of the Museum of
Modern Art, New York; Inter-American Fund.

edge of uncontrol. Nathan Huggins writes, "In the darkness and closeness, the music, infectious and unrelenting, drove on. Into its vortex white ladies and gentlemen were pulled, to dance the jungle dance." (Jazz and Harlem were only two of many vortexes appearing in U.S. culture at that moment, as I will argue in chapter 5.) Huggins relates the prevailing image of the savage, primitive Negro to the construction of white identity in the wake of both the war and the popularization of Freudian psychology. Negroes became "that essential self one somehow lost on the way to civility, ghosts of one's primal nature whose very nearness could spark electric race-memory of pure sensation untouched by self-consciousness and doubt."[165]

"The Negro fad," as Helene Magaret termed it in an article in *Forum* magazine in 1932, hinged upon the interest of white spectators in watching African Americans "play the wild man," an enthusiasm she thought "tragically similar to a child's enthusiasm for the circus clown."[166] Magaret's essay stands out as unusually perceptive within the

18. *Franz Kline*. Hot Jazz *(Bleecker Street Tavern Mural). 1940. Oil on board, 116 × 118 cm. Collection of the Chrysler Museum, Norfolk, Virginia.*

contemporary coverage of the subject by the mass-circulation press. Though she would go on to become a poet, novelist, and professor of English, Magaret was still an undergraduate at Barnard College when she published this article. Drawing upon the insights of Langston Hughes and other African American writers and commentators, Magaret recognized the ideological character of the "sensual savage myth" of the Negro (p. 41); she noted that "it is because America wants to look upon the Negro in this way that she has been remarkably receptive to the savage myth" (p. 42). Furthermore, she pointed out that the temporary advantages the Negro fad might bring to blacks would be bought at the cost of perpetuating racist stereotypes.

> Civilized America may be amused by savagery; she may find it a fascinating fad; but she will never admire and respect a people whom she considers less sophisticated than herself. . . . If the Negro race is to receive the right kind of recognition from the white race, it must force white men and women to acknowledge in the colored man those universal virtues of all civilized people. The white population of America must eventually learn to regard the Negro as he really is—an educated American citizen. (Pp. 42–43.)

The rare insight of Magaret's essay contrasts with Jung's discussion in "Your Negroid and Indian Behavior: The Primitive Elements in the American Mind," which had been published in the same magazine only two years earlier. Jung's unsurpassably noxious racism is couched here in the wholesome, avuncular, reasonable tone of a fireside chat. The article was embellished with stereotyping caricatures by the Mexican artist Miguel Covarrubias, taken from his book *Negro Drawings* (1927). Jung's purpose in the essay was "to explain how the Americans descending from European stock have arrived at their striking peculiarities" (p. 195). His answer was that Americans have a larger measure than Europeans of the primitive, which comes from their living in proximity to Negroes and Indians. Europeans, isolated from such primitive forces, "do not have to hold the moral standard against the heavy downward pull of primitive life" (p. 196), but for Americans, resistance is impossible: "Since the Negro lives within your cities and even within your houses, he also lives within your skin, subconsciously"

Jung's familiar premises and pseudologic are sketched in the following passage:

> The inferior man [the Negro] exercises a tremendous pull upon civilized beings who are forced to live with him, because he fascinates the inferior layers of our psyche, which has lived through untold ages of similar conditions. *On revient toujours à ses premiers amours.* To our subconscious mind contact with primitives recalls not only our childhood, but also our prehistory; and with the Germanic races this means a harking back of only about twelve hundred years. The barbarous man in us is still wonderfully strong and he easily yields to the lure of youthful memories. (P. 196.)

Hence, presumably, the appeal of jazz among whites: it reactivates their memories of primitive existence. Jung's remarks may be a ludicrous and extreme statement of the case, but they represent all too accurately the premises that underpinned white responses to black cultural productions during the Harlem vogue; his us vs. them opposition postulates a simple, primitive subjectivity for African Americans, different from the multilayered white self, whose lower depths could be stimulated, in a delightfully titillating experience, by the primal rhythms of jazz or the visceral power of black art. Jung, ironically, offers a basis upon which African borrowings could have been construed in nationalist terms by white U.S. artists. Stevens' work, for example, might have acquired the nationalist force that Mythmaker primitivism assumed if it had been portrayed as distinctly American in Jung's sense. This possibility never developed, possibly because the Harlem artists' claims upon African art complicated such borrowings for white New Yorkers, or because the attractiveness and availability of Native American and Pre-Columbian arts overshadowed African options.

Jung's explanation for the influence of Indians on the American (by which he means the U.S.) character had to be somewhat different, given that generally *these* primitives were isolated on reservations and consequently seldom occupied the same houses as whites. In this case, a mystical quality of the air and soil accounted for the influence.

> In the air and soil of a country there is an x and a y which slowly permeate man and mold him to the type of the aboriginal inhabitant, even to the point of slightly remodeling his physical features. (P. 197.)

Here was something Newman and the Mythmakers might have embraced as a rationale for their identification with Native American artists. To imagine that "the spirit of the Indian gets at the American within and without" (p. 197) offers some escape from the uncomfortable ironies attending the appropriation of the arts of a heretofore demonized and persecuted people.

At precisely the same time that Newman and the Mythmakers were defining and articulating their aesthetics around Native American arts, another group of artists, collected around the writer Kenneth Beaudoin, was pursuing the same interest. This group was known variously as the Gallery Neuf group, after the name of Beaudoin's gallery; the Iconograph group, after the magazine he published; or the Semeiologists—the name Beaudoin gave them. Most of the artists constituting the group—including Robert Barrell, Gertrude Barrer, Peter Busa, Oscar Collier, and Steve Wheeler—attempted to combine elements of Northwest Coast Indian art with elements of European modernism. As spokesperson for the group, Beaudoin described their interest in Northwest Coast Indian art in terms of the appeal of both a rich pictorial vocabulary and a system of expression involving the arrangement of symbols across a flat space. They were, in his

view, "painting a new magic out of old star-driven symbols."[167] Ann Gibson has pointed out the substantial similarities between the Gallery Neuf interests and those of the Mythmakers, but it is important to notice crucial differences as well in order to understand why this art failed to attract the widespread interest and support Mythmaker art did.[168] For the Gallery Neuf artists, Northwest Coast Indian art offered a usable formal language; the Mythmakers had little interest in the forms of the art. The latter group repeatedly denied the intention of borrowing primitive forms. "While modern art got its first impetus thru discovering the forms of primitive art, we feel that its true significance lies not merely in formal arrangements, but in the spiritual meaning underlying all archaic works."[169] Pollock agreed with the Mythmakers on this point, saying, "I have always been very impressed with the plastic qualities of American Indian art. . . . Some people find references to American Indian art and calligraphy in parts of my pictures. That wasn't intentional; probably was the result of early memories and enthusiasms."[170] The interest of the primitive arts for the Mythmakers lay primarily in the works' motivations and expressive content. It had relatively little to do with forms, which they believed had to be replaced with modern equivalents. Nonetheless, both the Mythmakers and the Gallery Neuf artists tried to combine characteristics of Northwest Coast Indian art with elements of European modernism. The failure of the Gallery Neuf fusion of primitivism and modernism to generate any real excitement among New York art audiences provides an instructive contrast to the Mythmakers' success.

To account for this discrepancy, Greenberg's criticism of the Gallery Neuf group offers a good starting point. "Most of the work produced under this inspiration," he wrote, "is still too literal in its dependence, too imitative of the influence itself, and too mechanical in execution."[171] Few viewers will have any trouble, I think, discerning what Greenberg means (see fig. 19). These artists developed that aspect of Northwest Coast art emphasized by Boas—the interest in patterned ordering. (Here is one piece of evidence for a theme that will emerge in this study: strict compatibility with respectable intellectual sources is not necessarily a good thing for art.) They kept the look of the forms but abandoned their original syntactic relations. The forms were assembled either according to typically Western representational conventions (by Busa, for example) or into densely packed, largely abstract, allover fields (as by Wheeler). The engagement with the primitive was focused principally on the formal character of a certain primitive art.

Greenberg singled out one member of the Gallery Neuf group for special praise. He described Gertrude Barrer in 1947 as "one of the most promising young painters in the country" (see fig. 20).

> Gertrude Barrer, who had her first show at the Gallery Neuf last month, is, however, one artist who succeeds in assimilating Klee and Haida art to her own personality. In Miss Barrer's hands Klee's influence serves admirably to expand the absolutely flat and formal patterns of Northwestern Indian art and render them permeable to contemporary feeling. A more delicate linearism breaks up and softens the stiff, stylized patterns, and floating washes of brownish-grayish color assert the picture plane without permitting that frozen, flat decorativeness which usually results when Haida or South Sea art is transposed too directly into easel painting.[172]

It is tempting to read into that obscure phrase "render them permeable to contemporary

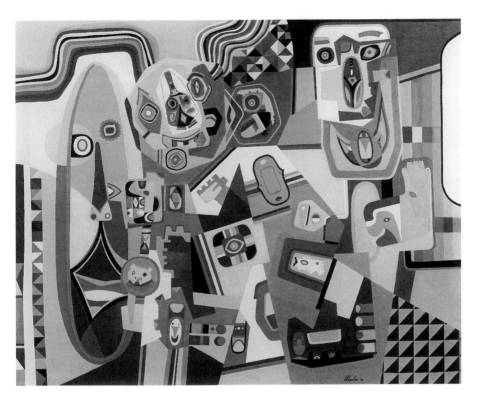

19. Steve Wheeler. Laughing Boy Rolling.
1946. Oil on canvas, 91 × 114 cm.
Collection of the Whitney Museum of
American Art, New York. Photograph by
Geoffrey Clements.

feeling" some comment on the concept of primitivism in play, as if Greenberg were implying that Barrer's adaptation of primitive forms was successful because of the way it constructed the category for its modern audience; but the sense of the statement is certainly different. The distinction he saw between Barrer and her colleagues hinged on a few important formal departures, not on the nature of the primitivism deployed. Her use of Northwest Coast Indian forms was entirely in line with that of the other Gallery Neuf artists, but her "delicate linearism," her loosening of surface tectonics, and her somewhat freer handling of paint shifted her work closer formally to Miró, Gorky, and Pollock. Her engagement with primitive prototypes remained largely formal, and what rescued her work for Greenberg was the quality of the formal synthesis with modernism, which accounted for her works' appeal to contemporary aesthetic feeling. Greenberg did not draw a comparison with the painting of the Mythmakers; if he had Barrer would probably have come out on top. Not only did her primitivism yield rigorous, progressive formal painting, but it seemed to Greenberg, moreover, free of the "symbolical" and "metaphysical" content he criticized in the work of Gottlieb, Newman, and Rothko (see Chapter 1). What Greenberg considered assets, however, might also be seen as liabilities. Like Evergood's realistic primitivism, the formal Gallery Neuf variety failed to offer a complex, psychological engagement with the notion of the primitive. Gallery Neuf paintings did not strive to represent or enact any resurgence of primitive experience

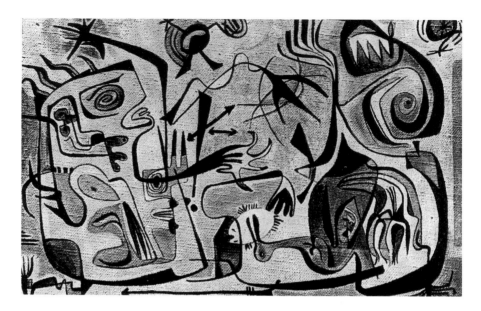

20. *Gertrude Barrer*. The Hunter. *1946*. Oil
on canvas. Dimensions and location
unknown. *Reproduced in* Iconograph *3 (Fall
1946): 20. By permission of the artist.*

within the artist-subject; they did not signify the effort to devise articulate modern forms
for resurgent primitive materials; nor did they attempt to represent conflict or difficulty
attendant to the experience of resurgence. Precisely these significations constituted the
emphatic core of Mythmaker primitivism.

Sorting through the various forms of primitivizing art developed and practiced in
New York in the 1940s helps to locate the particularity of the Mythmaker project. Its
emphasis on the contemporary subject, modern man, and its effort to give legible form
both to the primitive elements in his subjectivity and to the intricate dynamics by which
those elements become recognizable and effect expression, in confluence and in conflict
with other components of self and psyche—these interests and commitments defined
and distinguished Mythmaker art and theory. This project assumed a subjectivity in
which primitive elements had been overlain and obscured with filters produced by
civilization and, particularly, modernity. Mythmaker painting succeeded in producing
visual forms and verbal explanations that were convincing and legible as representations
of the emergent, complex, conflicted, multilayered, primitive subjectivity developing in
Modern Man discourse; this successful engagement with pressing cultural and ideologi-
cal issues accounts in substantial measure for the centrality Mythmaker and, more
broadly, New York School art acquired in the culture. It was this aspect that compelled
attention, that made the "viciousness" of Gottlieb's *Expectation of Evil* seem "convinc-
ing" and that gave his work the sense of being a "revelation of the psychiatric configura-
tions of the 'id' or inner panorama of the mind of modern man," or that made Rothko's
work seem "a sortie into unexplored territory." As such, this art acquired the power to
"most sensitively figure the doubts, insecurities and extremities of the post-war
world."[173]

There is yet another kind of contemporary cultural production, this one directed at a mass audience, that may shed some light on Mythmaker primitivism and particularly its focus on the notions of tragedy and terror. The forms in which *film noir* represents tragedy and terror relate it to the Mythmakers' reading of the primitive, underlining the character and significance of these themes in U.S. culture at the time. Myth has been isolated by film critics as an important element in *film noir*. In the words of Raymond Durgnat, "The first detective thriller is *Oedipus Rex,* and it has the profoundest twist of all; detective, murderer, and executioner are one man. The Clytemnestra plot underlies innumerable *films noirs,* from *The Postman Always Rings Twice* to [Antonioni's] *Cronaca di Un Amore.*"[174] Here once again *Oedipus Rex* seems, as it did for Newman above, a valuable point of reference for the period and its cultural products.

A phenomenon precisely contemporary with the development of Mythmaker art and theory, *film noir* (the term was coined in 1946 by French film critics struck by the dim lighting and dark mood of recent films from the United States[175]) worked with similar cultural materials and was involved in similar ideological processes. It too is about tragedy and terror—anxiety, paranoia, impotence, and fate. Like Mythmaker painting, *film noir* attributes a complex, layered, conflicted subjectivity to its protagonists, in terms that situate it securely within the contemporary discourse on modern man. It too participates in the inward and outward displacement of responsibility and effectivity from modern man's consciousness and rationality to his dark primitive interior and to his tragic situation. The typical *noir* hero is a sympathetic male character who commits crimes, acts violently or brutally, destroying others and himself for reasons he does not understand and cannot control. Sometimes mysterious inner compulsions are portrayed as the principal factors in his destructive actions: for example, obsessive attraction to a dangerous woman (*The Postman Always Rings Twice,* 1946), unresolved Oedipal conflict (*The Dark Past,* 1948; *White Heat,* 1949), or repressed wartime trauma (*The Blue Dahlia,* 1946). At least as often, inscrutable fate is the implicit or explicit cause of his antisocial behavior. In *Detour,* the low-budget 1945 film by Edgar G. Ulmer, a largely innocent and likable character is brought to ruin by a string of circumstances quite beyond his control. At the end of the film, as he gets into the police car that will take him away, his voice, which has narrated the story, sums up its moral:

> "One day fate or some mysterious force can put the finger on you or me for no good reason at all."

In a voice-over near the opening of the flashback in *Criss Cross,* a *noir* classic from 1949 by Robert Siodmak, the protagonist makes the same point.

> "From the start, it all went one way. It was in the cards, or it was fate, or a jinx, or whatever you want to call it."

Fate colludes in his destructive obsession with a deceitful woman. Protestations of helplessness and expressions of tragic fatalism are characteristic of the *noir* hero, who is perpetually out of control of his actions and the direction of his life. He may murder, as a French critic noted of Edward G. Robinson in *Woman in the Window* (1945) "not out of depravity, bestiality or madness, but in an inevitable sequence of circumstances."[176] Happy endings were categorically rejected by *noir* writers and directors; in modern life,

as they saw it, there were none, and movies might as well own up to this truth.[177] The picture of life painted in *noir* films was sometimes so bleak and pessimistic that one French film critic, Jean-Pierre Chartier, was led to wonder why the United States government allowed the films to be made: "I understand that the Hays Office prohibited for years the cinematic adaptation of two novels by James Cain, titled *Double Indemnity* and *The Postman Always Rings Twice*. What I don't understand is why, from the point of view of this virtuous censor, the prohibition was lifted, because it is hard to imagine a more extreme pessimism and disgust with humanity."[178]

Rarely, *noir* films attribute the malaise enacted by their characters to the historical moment, in terms evocative of some of the Mythmakers' public statements. In the 1947 film *Crossfire*, one character (an ex-WPA painter and soldier named Mitchell, played by George Cooper) expresses his confusion, depression, and anxiety in a question to his friend Keely (Robert Mitchum): "Has everything suddenly gone crazy, or is it just me?" Keely is a strong, impassive, and wise character, and his reply is quintessentially *noir*.

> "No, it's not you. The snakes are loose. Anybody can get them. I get them myself, but they're friends of mine."

That is, it is not you in particular, but it is some vague, ominous blight that strikes the interior of the individual; moreover, to learn to live with it stoically, perhaps even to develop a masochistic appreciation for it, is the exemplary masculine response. Just what "the snakes are loose" might mean is suggested in another scene in which a Jewish war veteran, who will be murdered by an anti-Semitic soldier, offers his thoughts on the troubled times in a conversation with Mitchell:

> "I think maybe it's suddenly not having a lot of enemies to hate anymore. Maybe it's because for four years now we've been focusing our mind on one little peanut, the win-the-war peanut. That was all. Get it over. Eat that peanut. All at once, no peanut. Now we start looking at each other again. We don't know what we're supposed to do. We don't know what's supposed to happen. We're too used to fighting. But we just don't know what to fight. You can feel the tension in the air. A whole lot of fight and hate that doesn't know where to go. A guy like you maybe starts hating himself. Well, one of these days maybe we'll all learn to shift gears. Maybe we'll stop hating and start liking things again."

In its attribution of psychological distress to the events of recent history this passage recalls Gottlieb's remark from the same year.

> Today when our aspirations have been reduced to a desperate attempt to escape from evil, and times are out of joint, our obsessive, subterranean and pictographic images are the expression of the neurosis which is our reality.[179]

The very possibility, as well as the claim to significance, of both *noir* film and Mythmaker painting was grounded in the presumption of a complicated subjectivity under stress, suffused in (primitive) terror and tragedy. Viewers who responded to such assessments of the moment—that the snakes were loose and "the time" out of joint—were invited to identify with the troubled, deep, complicated (primitive) selves represented in these arts as the pressure points, the proper sites for analysis and treatment.

Mythmaker art and *film noir*, then, shared fundamental features, although art history has assigned New York School painting an aggressively transcendental and highbrow classification, which has isolated that art from the contemporary popular cultural forms

with which it had so much in common.[180] Both Mythmaker painting and *film noir* engaged crucial materials in the culture—fear, anxiety, the sense of helplessness, disillusionment, and doom—materials that needed representing. At this level their function can be envisioned as analogous to that of the mock executions staged by prison inmates during the French Revolution. The prisoners' enactments in their cells of their own trial, condemnation, execution, and banishment to hell helped to alleviate their anxiety and terror by giving it symbolic form.[181] Beyond this symbolic function, both Mythmaker art and *film noir* posited the complex white male individual and his cosmic situation as the proper focus for analysis and explanation of contemporary experience. What consolation they offered lay in the universality of the situation and the majestic power of the forces victimizing man. Both saw the situation as outside of history and as facing the individual alone; each person had to come to terms with it for herself or himself. This radically atomized representation of the problem permitted only certain questions to be asked; others were unframable; consequently, as subsequent chapters of this book will argue, prevailing ideological categories and subject positions were reinforced. Both arts proposed a mode of behavior characterized by impassive toughness in the face of inescapable tragedy.[182] Dignity lay in acceptance of the pointlessness of resistance or ameliorative action. In the memorable words of the *noir* character played by Jan Sterling in *The Big Carnival*, "I don't pray. Kneeling bags my nylons."

The comic note sounded in that last line may seem to undermine a bit the point I wished to make. Comedy *is* ameliorative, and insofar as it figures in *film noir* as hardboiled wisecracking and weird metaphor, the oppressiveness of tragedy and terror is diminished. This is another striking parallel with Mythmaker art. There, too, comedy and tragedy are interconnected. Gottlieb's and Rothko's paintings, perhaps of necessity, change the valency of the terrible and the tragic in the process of symbolizing them. Gottlieb's mask faces (see fig. 8) have a touch of the carnival grotesque about them; sneers and grimaces are, after all, quite close to smiles. Furthermore, deliberate playfulness is in evidence in the eyes peeking out of the frame sideways from the lower left corner, or, on the next register up, in the second face from left, built from profiles facing in opposite directions. The humor in Rothko's *Syrian Bull* (fig. 10) is more Miróesque; it is visible in the spindly legs proliferating and prancing across the ground area (or burrowing into it), and in the balloon shape that teeters atop the pinnacle at left. At least one critic noticed this feature of Rothko's work: in 1945 Jon Stroup wrote of *Slow Swirl by the Edge of the Sea* that "it conjures up for us an image of heroic grandeur and, at the same time, of ridiculous lugubriousness, similar to that of the Mock Turtle and the Gryphon executing the quadrille. Paradoxically and typically, for Rothko's art permits both."[183] The comic in these paintings is a conversion of the tragic and retains traces of the original fear, much as Sterling's comic remark provokes laughter tinged by fear and arising from it. Both art forms resort to tweaking the nose of the terrible as respite from and as an integral part of the experience of terror.[184]

Though Mythmaker theory and *film noir* share particular cultural origins and implications, there are significant differences in the way each handles the shared material. Most striking are the contrasting choices of arenas for working over the troubling problems. *Film noir* gives us modern man in his modern world; revised beliefs about his nature and conditions are put into play against the background of his immediate historical circumstances. The characters are meant to seem relatively realistic; though they may

face exaggerated instances of modern problems, their experiences are open to easy and immediate appropriation by the viewer. The characters' feelings would have been familiar, in a less acute form, to many contemporary viewers, and their stoic resignation would have offered a compelling model of dignified acceptance and control of those feelings. Mythmaker art and theory, on the other hand, project the problematic materials they address into an abstract and timeless realm. They take some distance from the specific shapes of modern tragedy and terror; more distanced contemplation is invited. But at the same time the paintings' imagery is meant to strike more basic human faculties; it is meant to activate the primal terror reflexes and stimulate memories of primitive fright deep within the individual unconscious. It seeks responses both philosophical and visceral. If, as some contemporary critics felt, it fails to achieve these goals, theoretical weaknesses are largely responsible. The charge that this art was unintelligible or inscrutable implicitly questions the model of artistic communication and the conception of the structure of the mind operative in the Mythmaker program. Its premise that abstract pictorial forms could function effectively as modern counterparts to ancient myth was groundless.[185]

To some extent these differences should be seen as differences in the interests, capabilities, and inclinations of the anticipated audiences. Both art forms aimed to recreate in their viewers the experiences of terror and tragedy and to organize, contain, address, and rationalize, in part at least, those experiences. *Film noir* appealed to a mass audience by giving engrossing and immediate form to its fantasy of (masculine) innocence.[186] Narrative conventions adapted from the mystery and the thriller were combined with a familiar setting—the modern, "real" world—to maximize accessibility and viewer identification with the protagonist. Guilt was frantically displaced from the protagonist onto the most readily available scapegoats—fate, woman, or the other within; the individual's impotence was universalized and dignified. The Mythmakers pursued a similar purpose for an audience with different expectations of its cultural forms. It provided its viewers an opportunity to mobilize acquired knowledge and skills and to assume a more distanced and contemplative position with regard to current anxieties. The audience it addressed was supposedly familiar with classical tragedy and European modernism, eager to demonstrate this sophistication, and convinced by the conception of its own experience as part of an abstract universal continuum.[187]

Whether these differences between Mythmaker art and *film noir* are taken to be fundamental or superficial, there is underlying unity in the operations and effects of these arts with regard to ideological and individual psychological adjustments. This gives grounds for questioning efforts to theorize the relation between high- and low-cultural practices in terms of attitudes toward meaning. The idea that meaning is somehow refused in mass culture—whether this refusal is applauded, as by Baudrillard,[188] or bemoaned, as by mass culture's critics—is misleading, in this case at least. The *film noir* audience may prefer being fascinated to being made to think, but meaning is secured nonetheless. Just as psychological fantasies are products and instruments of ideology, so cultural fantasies participate in the "hegemony of meaning" that mass culture is often believed to evade. Here elite and mass culture are both faces of the same ideological order; their mutual wariness, even antagonism, sometimes masks a considerable similarity of purpose. Hegemony depends upon it.

These arts of terror and tragedy proposed a sort of stoicism as a way of coping with present anxieties. Suffering was naturalized and made to seem even noble; passive acceptance of the cruel blows of fate was offered as the dignified response. Hegel's critique of stoicism as a slave ideology, arising in a situation of "universal fear and bondage," is apt here.[189] It mattered little whether one befriended the snakes and adopted a remote, hard-boiled, *noir* demeanor, or issued poetic outcries of awe and anger in the form of paintings and manifestoes, like the first man confronted with his tragic helplessness before the void. Either way, hope of remedial action was abjured in favor of reevaluation of self and acceptance of the universal human situation. Fundamental to these instanciations of exemplary behavior was the constitution of subjectivity effected in these arts, and here is where their real significance and commonality lie. Mythmaker painting—and in this context I think it is possible to speak of New York School art generally—and *film noir* gave visual form to the complicated subjectivity emergent in Modern Man discourse. Although they ordinarily did this in very different ways—*noir* characters enacted it and attempted to articulate it, Mythmaker paintings represented it as a set of symbolic forms signifying remote contents and conflicted processes of mind and spirit—each sometimes ventured into the other's territory. *Noir* films sometimes attempted to give symbolic representation to subjective materials and processes—usually to dreams and the unconscious, a subject that belongs to the next chapter. And if Mythmaker paintings sometimes failed to deliver on the promises of their theory, the artists' public identities went some way toward filling the gap. The personas projected by some of the Mythmakers, as well as by many of the other New York School artists, reeked of *noir,* strong evidence of the essential congruence of the two notions of self. Tough-talking, morose, troubled, hard-drinking, and two-fisted, the public image and sometimes the self-image of the New York School artists made their careers into *noir* dramas. Sometimes even the formal strategies of their public presentation overlapped strikingly with conventions of *film noir.* Namuth's photos of Pollock at work on *Autumn Rhythm* and *One* (for example, fig. 21)—often shot from atop a stepladder, ostensibly to maximize the visibility of both artist and canvas—recall the *noir* reliance upon low- and high-angle shots to give a cornered, boxed-in effect. After Professor Wanly (Edward G. Robinson) has murdered a man in *Woman in the Window,* an overhead shot underscores his look of confusion; he appears lost, trapped, helpless (fig. 22). He recalls the Pollock of figure 21, looking isolated and small as he contemplates the results of his own actions and seems surprised and overwhelmed by them. Similarly, facial expression and shadow are used in a manner evocative of *noir* style in a *Life* portrait of Rothko accompanying an article in 1959 (see figs. 23 and 24).[190] The text accompanying the photo of Pollock that ran in the same *Life* series—in which the artist's head is juxtaposed with a nearby skull— left no room for doubt (fig. 25).

> His face deeply furrowed, his eyes shadowed and searching, Jackson Pollock wore the look of a man seldom at peace.[191]

As early as 1949 *Life* had portrayed Pollock standing "moodily" next to *Number 9, 1949* in the article that raised the question whether he was "the greatest living painter in the United States."[192] This *noir*-ish presentation was often more influential in the culture's absorption of the New York School artists than was their work.[193] Much of the

literature on these artists—even some with scholarly ambitions—has focused on the dramas and melodramas of their careers. Apparently, the cold stares into *Life* magazine's camera (the infamous "Irascibles" photograph of 1951 [fig. 65] is the classic example) and the violent deaths and suicides are not as easily separable from the cultural effects and ideological significance of New York School art as we might assume.

PESSIMISM AND SUBVERSION

As a coda to this chapter, I want to consider briefly the pessimism that has emerged in the preceding analysis as characteristic of Mythmaker art. The work of Newman and his colleagues, and indeed New York School art in general, has long been attributed significant subversive force, and one of the possible grounds for such a reading is the art's pessimism. Robert Warshow, the film critic for *Partisan Review,* articulated the basic

21. Hans Namuth. Photograph of Jackson Pollock in his studio. *1950. © Hans Namuth 1991.*

22. Still from Woman in the Window. *1944. © 1944 The Christie Corp. Renewed 1972 United Artists Corporation. All rights reserved.*

23. *Bert Stern.* Portrait of Mark Rothko.
Published in Life, *16 November 1959, 82.*
© Bert Stern.

24. *Publicity still from* The Blue Dahlia.
1946. © Universal Pictures, a Division of
Universal City Studios, Inc. Courtesy of MCA
Publishing Rights, a Division of MCA Inc.
Photograph courtesy Museum of Modern Art
Film Stills Library.

25. Arnold Newman. Jackson Pollock. *1949.
Published in* Life, *9 November 1959, 70.
© Arnold Newman.*

rationale for such a claim in 1948, noting that "America, as a social and political organization, is committed to a cheerful view of life." As he put it,

> The sense of tragedy is a luxury of aristocratic societies, where the fate of the individual is not conceived of as having a direct and legitimate political importance, being determined by a fixed and supra-political—that is, non-controversial—moral order or fate. Modern equalitarian societies, however, whether democratic or authoritarian in their political forms, always base themselves on the claim that they are making life happier. . . . If an American or a Russian is unhappy, it implies a certain reprobation of his society, and therefore, by a logic of which we can all recognize the necessity, it becomes an obligation of citizenship to be cheerful.[194]

Not only cheerful but optimistic as well, since pessimism implies lack of faith in the ability of one's society, political system, or leaders to weather current storms. The United States government's promotion of New York School painting as a weapon in the cold war would not have been conceivable prior to the construction of an affirmative reading of that art, a reading in which its anxiety and extremism were counterweighed by courage, heroism, and freedom.

It would be hasty to conclude, however, that cultural pessimism is always in some sense politically subversive. On the contrary, might it not have a productive part to play in the ordinary functioning of assertively egalitarian societies? Surely there is benefit for the political status quo in the universalizing, dehistoricizing, and individualizing of tragedy and terror implicit in Mythmaker aesthetics?

It may be useful at this point to contrast the ideological implications of Mythmaker painting and *film noir* as arts of terror with those of an earlier European example that attracted some interest in the wartime United States—the novels of Franz Kafka. Adorno's praise of Kafka indicates both the value of certain ambitions Kafka shared with the Mythmakers and a crucial difference in effect between his work and theirs. In his essay "Commitment," Adorno contrasted Kafka and Beckett with committed art and existentialism, exemplified by Brecht and Sartre.

> Kafka and Beckett arouse the fear which existentialism merely talks about. By dismantling appearance, they explode from within the art which committed proclamation subjugates from without, and hence only in appearance. The inescapability of their work compels the change of attitude which committed works merely demand. He over whom Kafka's wheels have passed has lost forever both any peace with the world and any chance of consoling himself with the judgment that the way of the world is bad; the element of ratification which lurks in resigned admission of the dominance of evil is burnt away.[195]

In Adorno's Kafka, brutality and terror are not the human condition, but the bases of power and privilege. Adorno's argument can be extrapolated from his other writings. Monsters are collective projections of the monstrous total state, and terror is entirely avoidable.[196] Tragic arts serve as consolation, not protest; and insofar as an art of tragedy or terror disguises the conditions of authoritarian domination, it is a tool of bourgeois ideology. Kafka's work, in Adorno's estimation, escapes this fate by, among other things, resisting relegation to the zones of psychology and mythology,[197] but there can be little question that Adorno's verdict on the Mythmakers and *film noir* would be different. How should we account for the differences between Kafka and the Mythmakers given that both ostensibly were committed to a critical relation to their societies?[198] Although appraising the successes and failures of the Mythmakers' critical ambitions is not my principal concern in this study, the subject warrants attention nonetheless.

Addressing these questions involves anticipating arguments and claims that will not be developed and supported until subsequent chapters. My use of the notions of "dominant ideology" and "hegemony" should not give the impression that Mythmaker art and theory were the products and vehicles of some form of class conspiracy, of which the artists themselves were witting agents or unwitting dupes. The hegemonic ideology in late capitalist societies is not so easily mobilized or manipulated: it is far too ill-defined, disintegrative, and unlocalized, as Abercrombie, Hill, and Turner have pointed out.[199] Nonetheless, the history of Abstract Expressionism reveals that it is a powerful factor in

culture and society, with substantial self-preservative momentum and effectivity in legitimating prevailing power relations. Its diffuseness is the product of its profound permeation of the subjectivities, discourses, and institutions of a society. Middle-class ideology has been so imbricated in civil and social institutions and individuals that it can no longer be identified with any one class. Hegemony has been secured. As Gramsci describes the process, the ideology of a class

> propagates itself throughout society—bringing about not only a unison of economic and political aims, but also intellectual and moral unity, posing all the questions around which the struggle rages not on a corporate but on a "universal" plane, and thus creating the hegemony of a fundamental social group over a series of subordinate groups. . . . the dominant group is coordinated concretely with the general interests of the subordinate groups, and the life of the State is conceived of as a continuous process of formation and superseding of unstable equilibria (on the juridical plane) between the interests of the fundamental group and those of the subordinate groups—equilibria in which the interests of the dominant group prevail, but only up to a certain point, i.e. stopping short of narrowly corporate economic interest.[200]

In this situation—that is, once hegemony has been achieved—an ideology becomes self-sustaining; the interests of those individuals and institutions constituted by it will entail preserving, reproducing, and adjusting the ideology and deflecting potential threats to its stability. Cultural production is a privileged arena in these processes. It is, in this sense, appropriate and essential to see the discourses of Mythmaker art, *film noir,* and Modern Man literature as operating within the hegemonic process. All were authentic efforts by imaginative and resourceful individuals to negotiate a new framework for understanding the Real as mediated by the lived experience of twentieth-century history. This project sometimes revealed and tested the structures and limits to discourse that defined the dominant ideology. As a result, the ideological terrain was changed somewhat, and the field extended, but what is far more striking in retrospect is that the ultimate effect was preservative. The pessimism and the superficial criticism offered in these discourses may have come at times to seem quite serious in the light of antagonistic and even occasionally splenetic treatment in the popular press, but the dominant ideology easily accommodated these challenges in return for the strengthening, resecuring, and restructuring of its fundamental principles.[201] The process has been described by Roland Barthes as "inoculation": "One immunizes the contents of the collective imagination by means of a small inoculation of acknowledged evil; one thus protects it against the risk of a generalized subversion."[202] The fundamental principles of the hegemonic ideology in question were deeply embedded in the developing new discourses and were universalized by them. The dominant ideology's intellectual and moral viability was affirmed; with a little tuning up, to be detailed in chapter 4, the engine purred once again.

The viewers standing before Gottlieb's *Alkahest of Paracelsus* (fig. 26) were expected to read the symbols in such a way that they were reminded of the ancient analogues and origins of their own feelings of terror and fears of doom. If they were familiar enough with history to know of Paracelsus and his Alkahest—"an imaginary universal solvent, capable of dissolving all bodies"[203]—a further dehistoricization of modern experience would be effected, as the atomic bomb was subsumed in the realm of alchemy. The painting's meaning, in other words, comprised propositions about culturally significant issues and about proper contexts and channels for understanding those

issues; the political aspects of this meaning were usually obscured. The Mythmakers compounded this obscurity by aggressively asserting the apoliticality of their art. These delusions, so cherished by the artists as well as by their most devoted chroniclers, made them utterly subject in crucial aspects to the power of the dominant ideology. Here is where the contrast with Kafka is most pointed. The Mythmakers' avant-gardist critical relation to their society disguised a far more profound relation of complicity; by steadfastly insulating themselves from the political implications of their positions—Newman's comments on nationalism in art are pertinent—the possibility of real criticism was diminished, and the dominant ideology occupied the vacuum. William Rubin's intuition that primitivism in modern art is an antibourgeois, "countercultural battering ram" proves on analysis, in this particular case at least, to be misleading and far too simple.[204] The relatively advanced, even radical, form of the art obscures its complicity with the dominant ideology, its fundamental values, its categories of racial identity, and its strategies of renewal. And form has been the focus of critical and historical attention to this art, to the almost complete neglect of its ideological content. In this way, the art's critical veneer has been highlighted and magnified. New York School painting, consequently, has been endowed with contradictory significances simultaneously: on one hand, it has been celebrated as the perfect expression or embodiment of postwar United States culture; on the other, it is represented as a profound critique of that culture.

I do not want to imply that the failures of the Mythmaker critique could have been reversed in any simple way, certainly not by some unimaginable conversion to Kafka's politics. The constraints were part of the very fabric of the Mythmakers' experience, development, ambition, and subjectivity; they were embedded in the modernist paradigm the artists engaged and in the philosophical position they adapted, as well as, at a fundamental level, in the forms and significations of their paintings. The art of Rothko, Gottlieb, and Newman took up the premises and assumptions of Modern Man discourse along with its concerns. The misrepresentations were built into the project from the start; they were the conditions of its possibility. The situation is elucidated by Bercovitch's description of hegemony: "The very terms of cultural restriction become a source of creative release; they serve to incite the imagination, to unleash the energies of reform, to encourage diversity and accommodate change—all this, while directing the rights of diversity into a rite of cultural assent."[205] And not only the very possibility but also the success of Mythmaker art was grounded in the hegemonic ideology: the work's cultural force resided largely in its participation in the ideological maneuvering under way in the culture's dominant discourses, its help in devising and representing the new subjectivity needed. Had the Mythmakers been inclined and able to effect the critical analysis and restructuring necessary to dismantle the hegemonic ideology's imbrication in their thought and work, they almost certainly would have enforced thereby the marginalization of their own work, consigning it to the *terrain vague* inhabited by Philip Evergood and Ben Shahn. With only a peripheral relation to the categories and constructions of the dominant ideology, this imaginary Mythmaker art would doubtless have seemed to its contemporaries little more than eccentric and largely beside the point. Radical opposition to the hegemonic ideology was certainly possible, but the price was high.

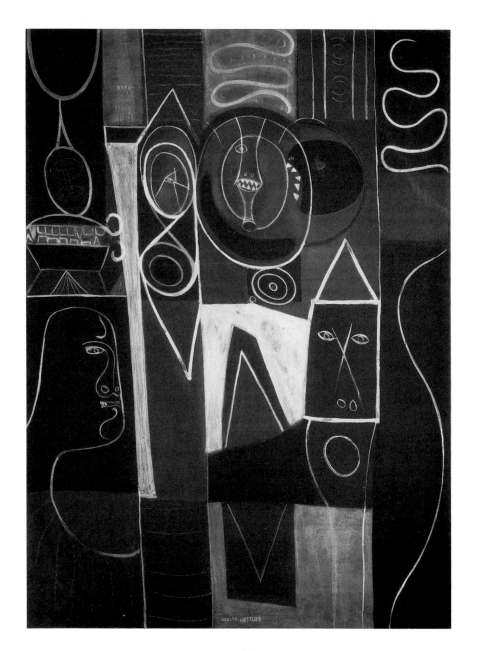

26. Adolph Gottlieb. The Alkahest of
Paracelsus. *1945. Oil on canvas, 151 × 110
cm. Collection of the Museum of Fine Arts,
Boston; Arthur Gordon Tompkins Fund.*

Insofar, then, as the particular aspects of Mythmaker theory under discussion here
are concerned, the causes of bourgeois ideology and hegemony were well served.
Although the artists were trying to strike at the heart of their society's fracturing shib-
boleths, their art and theory were, in part at least, helping to shore up the fissures.

THREE

JACKSON POLLOCK &

THE UNCONSCIOUS

*Painting has . . . other needs, and it is
not and cannot be just a photo of the
unconscious.*
Nicolas Calas, *"Painting in Paris Is
Poetry"*

Although several of the New York School
painters took pains to make it clear, at cer-
tain stages of their careers, that their art en-
gaged "the unconscious," none pursued this
engagement more insistently than Jackson
Pollock. As his friend and colleague James
Brooks put it, Pollock's "break into the irra-
tional was the most violent of any of the
artists', and his exploration of the uncon-
scious, the most daring and persistent."[1] Al-
though persistent, Pollock's engagement
with the unconscious was by no means con-
sistent, linear, or straightforward. To see
something of its complexity, one need only
look at a representative sampling of paintings
from three different phases of his career.

Guardians of the Secret from 1943 (fig.
27) is a work of his early maturity; it was
reproduced alongside his first published
statement about his work, a February 1944
interview in *Arts and Architecture*. Reflect-
ing upon the impact of the European painters
recently arrived in New York, Pollock re-
marked that he had been influenced more by
an idea they promoted than by their work:
specifically, by "their concept of the source
of art being the unconscious." *Guardians* is a

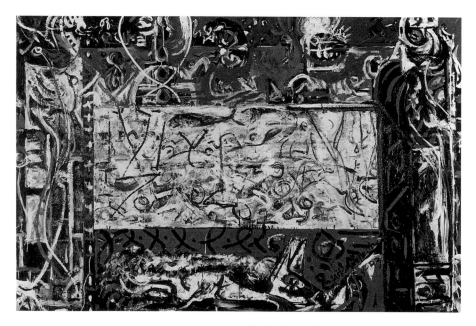

27. *Jackson Pollock.* Guardians of the Secret.
1943. Oil on canvas, 123 × 191 cm.
Collection of the San Francisco Museum of
Modern Art; Albert M. Bender Collection.
Photograph by Joe Schopplein.

relatively conventional modernist easel painting: the forms have been drawn with brushes and sticks, and the rough, vigorous handling combines with a tight pictorial structure to yield an expressionistic variant of Cubist figuration.

Four years later, Pollock painted *Full Fathom Five* (fig. 28), arguably one of the works to which he was referring when he wrote in a draft of a statement for the magazine *Possibilities* in 1947, "The source of my painting is the unconscious."[2] In his paintings from this time, fluid and elegant poured lines generate a viscous and turbulent surface, encrusting studio detritus such as nails, cigarettes, and paint-tube caps. Now no figuration is apparent.

Just two months before he died in 1956, Pollock told an interviewer:

I'm very representational some of the time, and a little all of the time. But when you're painting out of your unconscious figures are bound to emerge. We're all of us influenced by Freud, I guess. I've been a Jungian for a long time.[3]

Portrait and a Dream (1953; fig. 29) is a good contemporary point of reference for these remarks. The right (portrait) side of the painting is composed of delicate and deliberate drawing; it is juxtaposed with the semifigurative linear network stained into the left side of the canvas.

This sequence demonstrates the persistence of Pollock's interest in, and difficulties with, "painting out of the unconscious." Throughout his mature career, from first published statement to last, Pollock asserted that the source of his painting was the unconscious—this in itself is a striking and important fact. Combined with the considerable diversity among the pictorial materials he presented as unconsciously generated, it

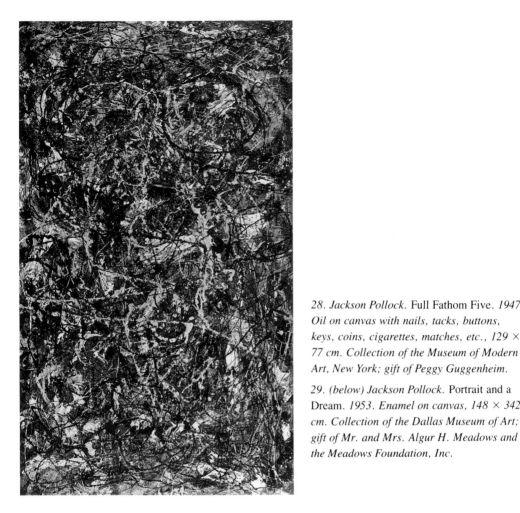

28. *Jackson Pollock*. Full Fathom Five. *1947. Oil on canvas with nails, tacks, buttons, keys, coins, cigarettes, matches, etc., 129 × 77 cm. Collection of the Museum of Modern Art, New York; gift of Peggy Guggenheim.*

29. *(below) Jackson Pollock*. Portrait and a Dream. *1953. Enamel on canvas, 148 × 342 cm. Collection of the Dallas Museum of Art; gift of Mr. and Mrs. Algur H. Meadows and the Meadows Foundation, Inc.*

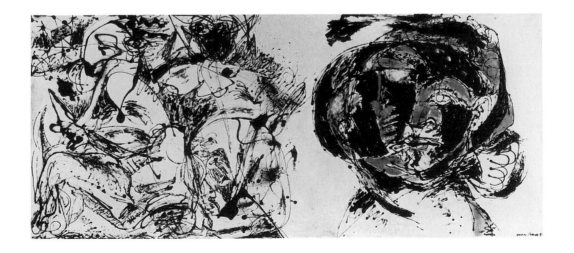

becomes even more intriguing. If, as Pollock apparently believed, the sources of *all* these paintings, with their various approaches to imagery and paint handling, were in the unconscious, then what can we say about his conception of the unconscious? What sort(s) of understanding of the unconscious should we impute to Pollock in order to be able to take his assertions seriously?

Pollock's case is the crucial one in the analysis of this concept and the attraction it held for wartime United States artists. By tracing the development of this interest of Pollock's and attending to various possible sources for his information and beliefs, my object is to develop a fuller image of the model(s) of the unconscious that he produced and embraced, and to propose some cultural determinants of his interest and conceptions. Variants of these questions have been quite prominent in Pollock scholarship lately; before proceeding, I perhaps should say something about this discussion and the intended relation of my work to it.

In the 1970s a small controversy erupted in the pages of some popular art magazines. It began with an attempt by a few young art historians to develop Jungian interpretations for some of Pollock's early, symbolic paintings. In these paintings, it was claimed, Pollock was "involved in a process of private symbol making," a process "intimately related to Pollock's mental, that is, his psychic, life." These writers believed that Pollock's encounters with Jungianism led him to incorporate Jungian notions of psychic development, archetypal symbols, and so on, quite literally into his work. His paintings must be understood, in their view, "as expressions of conscious and unconscious psychic forces and as vehicles of [Pollock's] search for psychic health."[4]

I will not speculate on the causes of this tendency in Pollock studies, but one obvious enabling condition requires mention—the sale and exhibition in 1970 of Pollock's so-called psychoanalytic drawings. Very briefly put, the details of this prior event—an overblown and tawdry affair—are as follows. In 1970 the Whitney Museum of American Art exhibited a set of eighty-three drawings originally held by Dr. Joseph L. Henderson. Henderson had been Pollock's analyst for a period of eighteen months in 1939–40, and these drawings had been used in the analysis. Thirty years later, in the wake of a major exhibition of Pollock's work at the Museum of Modern Art in New York, Henderson had decided to sell them to a San Francisco gallery. This gallery undertook a high-visibility marketing campaign involving exhibitions and the publication of a book reproducing the drawings along with some of Henderson's recollections of the case.[5]

The exhibition and book succeeded in attracting considerable attention, but they also brought opposition from various quarters, including from Pollock's widow, Lee Krasner. She filed a complaint against Henderson with the State Board of Medical Quality Assurance in California, charging breach of ethics. It is important to understand that Krasner did not object to the exhibition of the drawings, nor did she oppose Henderson's selling them as his own property, even though they had not been retained as any form of payment. She was offended, however, by the publishing and publicizing of his professional evaluation of the psychological contents of the drawings and of Pollock's mental state in 1940, especially the charge that the artist was schizophrenic, a diagnosis Henderson quickly qualified.[6] She also opposed the bracketing of the collection as "the psychoanalytic drawings," when in fact they were not specially produced for analysis and were by Henderson's own admission sketches for works in progress, completely

continuous with Pollock's contemporary public work. Nothing came of the case; six years later it was still "pending."[7] But Pollock's public image became even more enshrouded in myth than it had been. His status as a lunatic visionary, a sort of American Van Gogh, was confirmed.

The effects of the event on the thinking of art historians were striking, as I have begun to indicate. Henderson's psychological interpretations of the drawings and his recollections of Pollock's case have been perhaps more influential than the release of the drawings. His words offered some insight into the sort of therapy Pollock was receiving in those crucial, formative years. One effect of Henderson's commentary was to make vivid and immediate the sense of Pollock as psychologically distressed. Another consequence resulted from Henderson's confident assumption that Pollock's drawings were engaged in a specifically Jungian discourse. It had been known in a general way previously that some of Pollock's analysts were Jungians,[8] but actually seeing the Jungian mode of interpretation applied to the drawings, albeit very crudely in many cases, convinced some art historians that Jungianism offered real insight into the work. They began to argue that Pollock's early paintings were largely analytic documents recording his psychic condition, struggle, and progress in terms of consciously and unconsciously generated Jungian archetypal symbolism.[9]

The efforts of these Jungian interpreters challenged the established modernist account of Pollock in two obvious ways. First, they focused attention on the artist's early work, the semifigurative symbolic paintings that preceded the "classic" pourings. Second, they undermined the prevailing image of Pollock as a painter whose sources were visual and art historical, not literary or conceptual, and whose concern was with "making the best paintings of which he was capable."[10] These transgressions alone would have warranted outraged reply from the defenders of the modernist view, but the interpretative excesses and the theoretical and methodological inadequacies that plagued the Jungian interpreters' essays insured it. A comprehensive assault came from William Rubin, then director of the Department of Painting and Sculpture at the Museum of Modern Art and author of the most developed modernist assessment of Pollock published to date. Rubin's avuncular reprimand justly drew attention to the glaring faults in the Jungian interpretations, and it put an end, at least temporarily, to the reckless imposition of strictly Jungian symbol systems onto Pollock's work.[11] But his intentions were larger than this, and so have been the effects of his articles.

Rubin's rebuttal employed at least three different offensive strategies. One was to minimize the importance of Jungian considerations by granting them only a secondary place in the analysis of Pollock's secondary—"less original," or "more interesting than good"—work. Rubin argued, "Pollock was not simply—or even primarily—an 'auto-analysand' or a symbolist poet. He was before all else a painter." In every instance of interpretation, as Rubin practices it, formal and stylistic considerations will be primary. If numbers appear in Pollock's paintings, we should understand that they were chosen "as much, if not more, for their shape as for any symbolic connotations." This is in keeping with the general principle that we should expect Pollock to be influenced much more by visual material and pictorial concerns than by "literary" or conceptual material.[12]

Another of Rubin's strategies was to rule out psychological content as inevitably

inaccessible. "I want to make clear that while I think Pollock considered all his images to have psychological content, their *precise* definition or identification—given how little we know of the artist's intimate life and thought—is a chancy if not impossible (and most likely wrong-headed) task, even if we do not misread the forms."[13] Rubin has accepted the assumption of the Jungian interpreters that a Jungian (psychological) reading of Pollock's painting must be a reading of the meaning of specific symbols contained within them. Since these cannot be pinned down (Rubin offers "Freudian" alternatives to some of the readings by the Jungian critics) the whole project is pointless.

And Rubin's third strategy was to subsume elements of the Jungian paradigm within the modernist view. "The pictorial paradigm for Pollock's growth that I outlined in 1967 is based, of course, on the assumption that *pictorial problems and their resolutions are not formal exercises or disembodied professional games but significant projections of psychic and spiritual states,* whether or not the esthetic structures involved accommodate images."[14]

By appropriating for the modernist account what was compelling in the Jungian paradigm, and by reasserting the absolute priority of the modernist frame of reference, Rubin effectively choked off provocative questions about the relation between Pollock and Jungianism, or between wartime art and the discourse of psychoanalytic institutions in the United States. The debate between the Jungians and the modernists has reduced the questions to a false dichotomy: Was artmaking being subsumed into self-analysis, or was the analysis providing props and ideas for an essentially deliberate process of producing art? When we look at *Birth* (fig. 12) for example, one of Pollock's early paintings, should we see sexual fantasy and unconscious imagery revealing Pollock's psychic condition, or should we be struck by the sophistication and complexity of his engagement with Picasso and believe that his foremost concern was developing the modernist pictorial tradition? In the words of one Jungian interpreter:

> Pollock subsumes borrowed motifs into his own psychological drama. . . .
> [N]o matter how richly he clothes this theme with primitive, Picassoid, alchemical or Eastern mystical imagery, its most essential meaning is psychological.[15]

Rubin and his allies firmly disagree.

> Rubin is right to stress a rivalry with Picasso, rather than a dependence upon Jung, as Pollock's primary motivation.[16]

And one of the questions facing the Jungian paradigm is, What happens in 1947, when the symbolic works yield to the poured works? The latter almost always have been discussed in essentially formal terms, and the Jungian interpreters generally have concurred by either leaving the question open or maintaining that Pollock was more or less cured at this time and therefore was free to return to more purely pictorial problems.[17]

I do not believe this debate will take us very far. Pollock's persistent statements of interest in producing art from his unconscious should be taken seriously; they do indicate that artmaking and self-analysis were not distinct operations in his own view. Furthermore, any thorough account of Pollock's work should offer some explanation of his having seen even the poured works as issuing from the unconscious. To get beyond this impasse I think it will be necessary to redirect the questioning, enlarge the frame of reference, and develop another conception of psychological explanation.

REPRESENTING THE UNCONSCIOUS

As the terms of my discussion have implied, taking Pollock seriously does not mean taking him literally. The idea of "painting out of the unconscious" may have been a productive fiction for Pollock and his audiences, but it will not suffice as an explanation for the forms of his paintings and the meanings they have elicited. In recent decades, theorizing about the unconscious has yielded grounds for skepticism toward some of the most fundamental and obvious propositions about mental process implied in Pollock's paintings and statements. His confidence in the accessibility of the unconscious—its susceptibility to automatic and spontaneous exposure—is suspect by any standards. Likewise, there is reason to doubt not only that Pollock's version of the characteristic imagery of the unconscious is the correct one, but that the unconscious has *any* characteristic imagery. As Jacques Lacan has emphasized, the unconscious is revealed not in a particular set of symbols or themes, but in the interferences and interruptions of a subject's discourse, those traces of the division in which subjecthood is constituted. "The unconscious is always manifested as that which vacillates in a split in the subject."[18] Lacan's model of the unconscious—as the complex of symbolic orders that determines the formation of a subject in language but which the subject represses in order to imagine it constitutes itself—employs different metaphors and consequently offers a basis from which to appraise prior models. Deleuze and Guattari have offered a formulation that goes a step further: in their "schizoanalysis," the unconscious has no material and no structure—it is neither oedipal nor "like a language," as Lacan would have it. For them, the unconscious is "an order of production, not representation. . . . It does not speak, it engineers."[19] These alternative conceptions help to illuminate the metaphorical eccentricities of the Freudian and Jungian models, many of which inform and structure Pollock's work and its reception.

There is yet another basis from which a critique of prevailing assumptions about the role of unconscious material in Pollock's paintings may proceed. From an historical and anthropological point of view, *the unconscious* has come to be understood as a constructed category, its particular form always contingent upon social and historical conditions. The unconscious is not a fixed, transhistorical, preexistent entity whose structure and contents can be discovered by scientific investigation. It is rather, as the sociologist Peter Berger has emphasized, a conceptual construction socially determined, originating in social processes of identity production and confirmation.[20] The individual experiences the unconscious, and all of psychological reality, in a form defined and shaped by a culture and its models of self, subject, and identity. Therefore, even if it were true that Pollock was painting (out of) his unconscious—and indeed he was, insofar as one's psychological reality is determined by prevailing psychological models—we would still need to know *which* unconscious he was painting, that is, the unconscious as constructed in what manner, involving what historical and social determinants.

Pollock's project—painting out of the unconscious—is best described and understood as *representing* the unconscious.[21] He was engaged in a revision of modernist artistic practice consciously directed at accommodating the unconscious, giving it rein, or space, or voice—whatever "it" preferred, so long as its presence and force were signified. The uncertainty owed in large part to the difficulty of the concept, but it was compounded by the fragmentary and inconsistent character of Pollock's learning; he had

absorbed disparate bits and pieces of information concerning psychic structures, operations, and contents. If they were to add up to anything it would happen in the process and imagery of his art, where those fragments became the flint he hoped would set his unconscious firing.

Three sets of questions should be asked in a study of Pollock's representation of the unconscious. First, what was "painting out of the unconscious" for Pollock? (Some of the ambiguities are contained in this single phrase. For example, how should we understand that "out of?" On one hand the unconscious is imaged as a well or paint bucket, into which one's brushes may be dipped. But on the other, it is something to be escaped or transcended, as one gets—or paints—oneself out of a corner or out of trouble.) When we put his statements and work together, how clear a description can be formulated of the beliefs and assumptions about the unconscious and its operations implicit in them? Second, how are these beliefs figured in the work? Can his wide range of forms, imagery, and handling be related productively to some set of notions of the unconscious? And third, how were Pollock's representations of the unconscious related to the historical circumstances of the wartime and postwar United States? What was the shape of their constructedness? Or, to put the question another way, what was at stake in representing the unconscious in this way (or these ways)? For many viewers, as Brooks attests above, Pollock's paintings were exceptionally meaningful or persuasive as "unconscious outpourings"; indeed, this power is still commonly attributed to them in current scholarship. In investigating wherein this power resides, it will be necessary to ask what features made (make) Pollock's paintings convincing as unconscious productions, and why, and, moreover, to ask why such a subject mattered. In what form and under what circumstances would the project of painting from one's unconscious be interesting to Pollock and his particular audience?

My subjects, then, are Pollock's assumptions, conceptions, drawings, and paintings, without separation between beliefs and forms. He was in no sense illustrating preformed ideas, but rather forming, assimilating, and testing propositions in representation—whether mental or pictorial. Both beliefs and forms were highly synthetic— made up of bits of information collected and absorbed from all sorts of sources. Pollock's practice was such that he eschewed intensive, systematic study of Surrealism, the mind, and psychoanalytic theory in favor of learning visually—synthesizing in visual imagery what relevant data he had heard, gathered from diverse and fragmentary reading, or seen. His artistic ambitions and personal needs presupposed an imagery of the unconscious, and in the effort to fulfill them he became involved in representing the unconscious. This is not to say necessarily that Pollock's works hold little "real" unconscious content—that they offer little evidence of Pollock's personal mental condition and difficulties. It *is* to wonder, however, where such evidence may be found. That evidence may lie in the character and the handling of the sexual and violent imagery produced, as the works seem deliberately to suggest. Or it may lie rather in the disruptions of the fabric of overtly, aggressively "unconscious" imagery—in such passages, for example, as the scene, from one of the psychoanalytic drawings, of bandits ambushing an auto in a desert landscape. The elaborateness, legibility, humor, coherence, and plausibility of this vignette make it anomalous in the drawings. If it seems preposterous to suggest that this is where the unconscious showed itself, it seems so partly because of Pollock's success in

these drawings. They give convincing visual form to the beliefs about the unconscious to which he was exposed in the 1930s and 1940s and which continue to hold sway to a surprising extent today.

However fragmentary and inconsistent the beliefs informing Pollock's paintings, the fact that the unconscious is an explicit subject requires that efforts at psychological interpretation take this factor into account. The paintings establish certain specific preconditions for psychological interpretation. While Ernst Kris could attempt to read unconscious motivations out of Franz Messerschmidt's sculpture entirely on the basis of his own conception of the unconscious, without attending to any beliefs the artist may have held about the unconscious or its place in aesthetic expression,[22] this is not a viable methodological option in Pollock's case. Even the most cautious of the psychological interpretations of his work have failed to recognize this.[23] If a plausible psychological reading of Pollock's work is to be produced at all, it will have to maneuver around and through Pollock's own models, starting from the disjunctions in the Jungian and Freudian hybrids that conditioned his artistic production. And such a strategy will not be available until we have a more developed picture of Pollock's operative paradigms.

ADAPTING FORMAL AND SYMBOLIC VOCABULARIES

Both Pollock's modernist and Jungian interpreters have more or less agreed that his paintings do have unconscious content—that is, that much of Pollock's painting has been substantially determined by mental material we could properly describe as unconscious. While they may disagree about the importance or accessibility of this material, none have questioned that it is there. Implicit in their analyses is a particular model of Pollock's painting process, one in which a more or less deliberate suspension of conscious censorship results in an upwelling of images and symbols produced or affected by unconscious activities of mind. This "automatist" model is based on psychoanalytic theories of free association and dreaming.

In some ways Pollock's paintings and drawings undermine this first claim to unconsciousness. Even in those passages that seem most automatic and unconscious, as certain sections of the psychoanalytic drawings do, there is clear evidence of deliberation. An analogy with Impressionist painting may not be out of place here. Many Impressionist works in which the appearance of spontaneity and hasty manufacture is most striking are utterly deceptive. Close analysis has revealed that the work was produced laboriously and painstakingly, building up layer upon layer, allowing days of drying time in between, sometimes over a period of years. The effect of spontaneity is not necessarily produced by spontaneity.[24] Likewise, the aggressive and convincing representation of the unconscious undertaken by Pollock entails much more than automatism. Much of the evidence I will present in this chapter will document the deliberate and calculated nature of his working of the imagery.

There is, first of all, a distinct continuity between the drawings used in analysis and the larger, more formal paintings Pollock was producing concurrently for public exhibition. An apparently rather traditional relationship between sketch and finished work is often operative here. This proposal is necessarily speculative, since precise dates, and therefore sequence, cannot be established conclusively for most of these early works.

But often motifs are sketched out and tested, with variations, in the drawings, providing a basis for the more finished forms of contemporary paintings. For example, several of the drawings given to Henderson contain a "ritual figure" motif. One sheet (JP-CR 3: 520r [fig. 30]) contains three versions of this form (at lower left, middle of left edge, and just right of center), revealing it to be a product of experimentation with the deployment of symbolic shapes symmetrically across a vertical axis in order to produce the suggestion of an iconic figure. Another version of the form appears at the upper-right edge of JP-CR 3: 537r (fig. 31). Oppositions such as sun/moon and straight line/circle are subsumed within the unifying framework of a figurative presence. The suggestion of influence from Jungian theory in the choice of symbols is striking, but let it remain for now merely a suggestion. I want to focus attention on the deliberate formal experimentation with this motif in the psychoanalytic drawings.

At least two of the drawings Pollock gave a short time later to his second Jungian analyst, Dr. Violet Staub de Laszlo, isolate and develop this same general motif, although the point of departure may not have been the particular versions given to Henderson. In both JP-CR 3: 589 (fig. 32) and JP-CR 3: 590 (fig. 33) the vertical torso of a similar figure provides the structural axis for symmetrical juxtaposition of dark and light shapes, in one case, and of faces with contrasting expressions, in the other. These drawings, in turn, probably served as the basis for a subsequent painting.[25] *Bird* (fig. 34) is a major work from this early period employing the same motif as the drawings and establishing a similar symmetrical opposition. In this case the opposition is between the heads with differing expressions and, arguably, gender traits, at the base of the figure. The gender identifications (male at right, female at left) suggested by the handling of the facial features correspond to the forms of the wings directly above them. The left wing terminates in a curved shape suggesting a cylindrical opening; the right projects a phallic form.

What this progression demonstrates so neatly is the deliberate, systematic development of a formal motif, from early notations to finished version. Pollock is not repeatedly rendering an obsessive image, as might be expected in automatist works, but rather is developing symbol combinations into other, complex symbolic configurations. The process appears quite methodical, especially if we conceive it as grounded within a Jungian (and Freudian) theoretical matrix. The strangeness of the symbols fades—they become in fact quite conventional—and the conscious working of them becomes more apparent.

The progression described above is not an isolated case. Several other sheets of psychoanalytic drawings exhibit similar concerns: JP-CR 3: 518v and JP-CR 3: 519v focus on the creation of an allusive structure built from sun and moon symbols; JP-CR 3: 519v and JP-CR 3: 535r pursue the formation of animal and human faces from mandala forms. And several of the drawings apparently provided points of departure for larger paintings: JP-CR 3: 515, for example, is related in significant ways to *Composition with Donkey Head* (JP-CR 1: 61); and JP-CR 3: 620 (given to de Laszlo) appears to be a preparatory drawing for *Head* (JP-CR 1: 71). If, in his "professional" work at this time, Pollock often developed, elaborated, and consolidated forms and motifs explored in the psychoanalytic drawings, how should we understand the absence of a distinction between public and private imagery? It might be a symptom of psychosis, the artist being

30. Jackson Pollock. Untitled drawing, JP-CR
3:520r. *1939–40. Pencil on paper, 36 × 28
cm. Private collection. Photograph courtesy
Nielsen Gallery, Boston.*

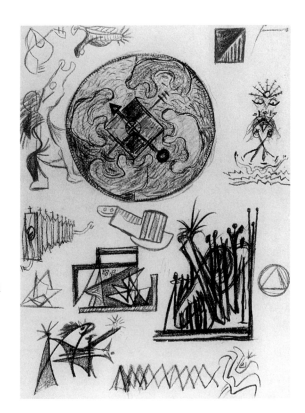

31. *Jackson Pollock.* Untitled drawing, JP-CR
3:537r. *1939–40. Pencil and deep orange
pencil on paper, 38 × 28 cm. Collection of
Andrea and Glen Urban. Photograph
courtesy Nielsen Gallery, Boston.*

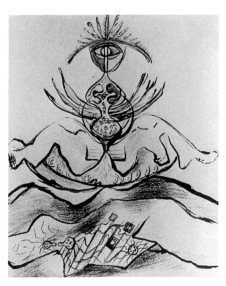

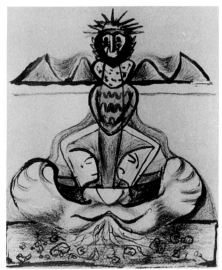

32. *Jackson Pollock.* Untitled drawing, JP-CR
3:589. *1941–42. India ink, watercolor, and
crayon on watercolor paper, 33 × 26 cm.
© 1992 The Pollock-Krasner
Foundation/ARS, New York.*

33. *Jackson Pollock.* Untitled drawing, JP-CR
3:590. *1941–42. India ink and crayon on
watercolor paper, 33 × 26 cm.
© 1992 The Pollock-Krasner
Foundation/ARS, New York.*

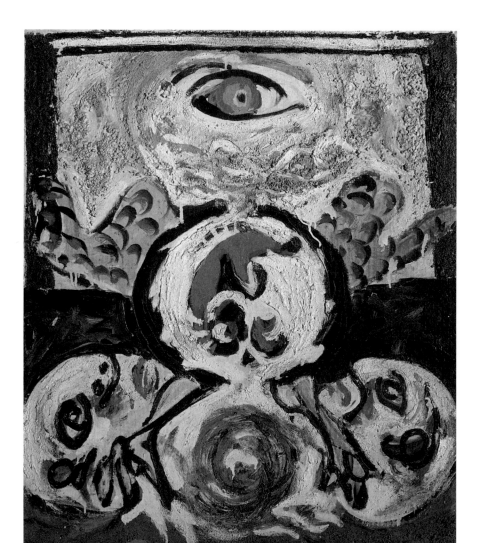

34. Jackson Pollock. Bird. Ca. 1941. Oil and sand on canvas, 71 × 62 cm. Collection of the Museum of Modern Art, New York; gift of Lee Krasner in memory of Jackson Pollock.

unable or unwilling to make the distinction. More likely it is a function both of the particular conception of the unconscious (collective, universal) being developed and of the character of Pollock's interest in the unconscious, as further evidence will clarify.

A second indication of the unspontaneous complexity of this work is the density of art historical borrowings and influences that figure in both the paintings and the drawings. Some of these are quite blatant—Picasso's presence, of course, looming largest of all. Modernist influences on Pollock's painting at this time are so pervasive that the point hardly requires demonstration. (Rubin's verdict, "less original," returns to mind.) Should we be surprised to find a similar range and depth of debts in the psychoanalytic drawings? Greenberg was inclined to see "the observance of norms and conventions" as

evidence against "unconsciousness" in Pollock's work.[26] However, the presence of borrowed forms and observed conventions in Pollock's drawings does not preclude unconscious content or automatist facture; indeed, borrowed forms—from myth, symbolic languages, what Freud calls daytime residues, visual memory, and other sources—compose, by most accounts, the lingua franca of the unconscious. Perhaps the art historical references in Pollock's drawings should be understood simply as marking his unconscious as that of a visually educated artist. I do not think this answer is quite satisfactory. While the borrowings, on first impression, may seem to exhibit the characteristics commonly associated with unconscious materials—irrational selection, seemingly inexplicable juxtaposition, transformation through Freudian primary processes, such as condensation, displacement, and so on—closer examination reveals them to occupy a rather narrow plot in the field of available imagery and forms. Furthermore, the rules by which they are combined and arranged are also rather limited and fixed. These features may be read as subtle evidence of artistic work being done more or less systematically. It could be argued that an artistic project was being pursued in these drawings, a project involving the selection and adaptation of visual sources compatible with evolving notions of the unconscious and of unconscious visual production—notions that drew heavily upon Jungian discourse, as I shall claim. At the very least, Pollock's persistent recourse to borrowed forms indicates the complexity and difficulty of the effort to figure unconscious material. It may help us to recognize the extent to which the project was consciously directed and shaped by standard artistic practices. Pollock's representation of the unconscious was forged through his adaptation of modernist visual schemata.

Pollock's effort to make his unconscious the source of his art required that he mobilize and adapt various familiar representational modes in order both to conceive and to depict the contents and distorting effects of the unconscious. Several figurative paradigms were adopted. Even lessons learned under Thomas Hart Benton's tutelage from Renaissance and Baroque masters were pressed into service. For example, two of the works given to Henderson—JP-CR 3: 536r (fig. 35) and the crucifixion gouache, JP-CR 4: 940 (fig. 40)—appear related to sketches Pollock did after black-and-white reproductions of paintings by Rubens. A sheet of studies from the mid-1930s (JP-CR 3: 442r; fig. 36) includes a drawing from Rubens' *Defeat of Maxentius;* it focuses on the tangled mass of human and animal bodies in the lower right quadrant of the picture and reproduces a motif resembling that in JP-CR 3: 536r (fig. 35). However, far more common in these drawings are Pollock's more current and enduring enthusiasms: Orozco and Picasso.[27] The former's murals of the 1930s and the latter's works of the same decade, especially *Guernica,* are the dominant stylistic and iconographic sources for these drawings. The horses, bulls, and frantic, tortured figures of *Guernica* and Picasso's other contemporary work are staples of the psychoanalytic drawings. Some details, such as the pointed tongue of the screaming woman at the left of *Guernica,* are used verbatim by Pollock, as in JP-CR 3: 582r, and JP-CR 3: 516 (fig. 37). A very Picassoid seated woman occupies the foreground of the latter. Snakes, skeletons, skulls, birds, and entangled figures rendered in a blocky, simplified, stylized manner give evidence of close study of Orozco. The Dartmouth murals, which Pollock reportedly visited soon after their completion,[28] are echoed in many of the psychoanalytic drawings. The angular head in JP-CR 3: 544

35. *Jackson Pollock.* Untitled drawing, JP-CR
3:536r. *1939–40. Pencil on paper, 38 × 28
cm. Collection of Noriko Togo, Tokyo.*

36. *Jackson Pollock.* Untitled drawing, JP-CR
3:442r. *1937–38. Colored pencil on paper,
43 × 35 cm. © 1992 The Pollock-Krasner
Foundation/ARS, New York.*

37. *Jackson Pollock.* Untitled drawing, JP-CR
3:516. *1939–40. Pencil and colored pencil on
paper, 33 × 26 cm. Collection of Allan and
Miriam Haven. Photograph courtesy Nielsen
Gallery, Boston.*

(fig. 38), seemingly so anomalous in Pollock's imagery at this time, becomes less obtrusive when seen in the context of the extensive influence of Orozco. The masked figures in the primitivizing portion of his Dartmouth fresco titled *Ancient Human Sacrifice* (fig. 39) provide a genetic pool for Pollock's image. Furthermore, one of the more striking stylistic features of Pollock's drawings and paintings at this time was probably learned from Orozco: what Rosalind Krauss has described as "a configuration in which areas of the figure get reconverted into ground for new, yet more autonomous pieces of figuration, they in turn becoming ground for further figures."[29]

Once recognized, these two features of Pollock's psychoanalytic drawings—their systematic exploration and development of motifs, and their deep engagement with certain influential artistic precursors—tend to diminish their simply "unconscious" aspect. To insist that these apparently informal, automatist drawings are highly structured, deliberate explorations of artistic modernism may seem to support the case of the modernist historians against the Jungian interpreters. However, this aspect of the drawings should not overshadow or even be seen as separable from another: the sincerity and seriousness of the effort in them to figure the unconscious. The directed, artistic operations we have noted were exactly the vehicle for Pollock's conception and representation of unconscious mind. Representations are not spontaneously generated. They are always developed from received schemata or paradigms which are revised to suit new interests.[30] Such a process is precisely what we see here. Pollock's principal starting point was the symbolic, politically committed art of Picasso and Orozco, whose vocabulary and syntax he adapted, depoliticized, and transferred to a cosmic frame. Political-struggle-become-cosmic-conflict was the path to conceiving and representing the unconscious for Pollock. In both the drawings and the paintings there is visible a sustained effort to adapt that pictorial language in ways that will make it signify unconsciousness—by using ambiguity, varying the conventional syntax, and so on. The crucifixion gouache Pollock gave to Henderson as a going-away present offers a good

38. Jackson Pollock. Untitled drawing, JP-CR 3:544. *1939–40. Blue and orange pencil on paper, 38 × 28 cm. Collection of Ueda Culture Projects, Ltd., Tokyo.*

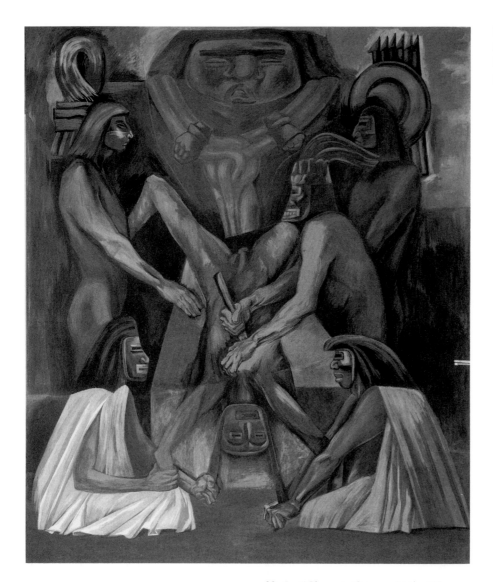

39. José Clemente Orozco. Ancient Human
Sacrifice, *from* The Epic of American
Civilization. *1932–34. Fresco. Baker
Library, Dartmouth College. Commissioned
by the Trustees of Dartmouth College,
Hanover, New Hampshire.*

illustration of this subtle recasting (fig. 40). O'Connor has proposed Orozco's 1924
fresco *The Trench,* from the National Preparatory School in Mexico City, as a possible
source for Pollock's image.[31] There are other, perhaps more persuasive sources in
Orozco's oeuvre—*The Shadowy Forces* (1936–39) from the Government Palace in
Guadalajara, for example, or the fresco of *Cortés and the Cross* (1932–34) from the
Dartmouth cycle (fig. 41), which shows Cortés standing before a heap of slaughtered
Aztec warriors. Orozco's use of symbols is relatively specific and localized: costumes,
attributes, gestures, and actions produce generally coherent narration and clear meaning.

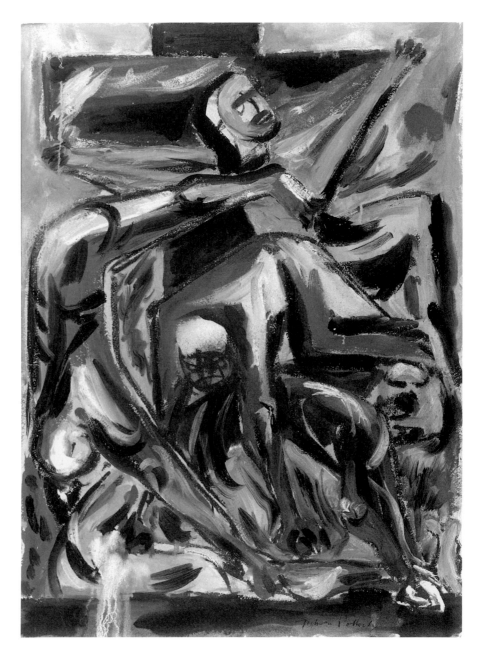

40. Jackson Pollock. Untitled [Crucifixion]
gouache, JP-CR 4:940. *1940. Gouache on
paper, 55 × 39 cm. Collection of Craig and
Mary Wood, Tampa, Florida.*

His shadowy forces are distinctly military and clerical, and they oppress the vulnerable mortals in their path. Conflict and threat have localized and historical origins and agents. Pollock's symbols operate at a much greater level of abstraction, outside of history and specific locale—at the level of human, animal, sun, god, conflict, struggle, atonement. Still, much remains the same: abbreviated, crude modeling; tangled forms making figure-ground distinction an elusive and shifting puzzle; even some of the symbols; but

the images take on rather different sorts of meaning. Orozco's indictment of specific oppressive institutions contrasts with Pollock's portrayal of humanity's timeless struggle to subdue ambiguous, cosmic shadowy forces. Pollock transports the style and imagery of Orozco and Picasso, Benton and Beckmann from modern history to a realm of myth or to the Jungian unconscious.

Pollock's analysis played an important part in effecting this transformation. The details of this process belong to a later part of this chapter, but here it should be noted that Henderson was very interested in Picasso's work at this time, as were most of the members of the Analytical Psychology Club of New York (APC-NY), the organization of Jungian analysts in which both Henderson and de Laszlo were active. Henderson himself has indicated that his discussion of Pollock's drawings directly dealt with their relation to Picasso and ways of getting beyond or adapting his influence. As Henderson told an interviewer in 1980, "I offered occasional criticisms which I thought might be helpful in order to free him from his influences (mainly Picasso) that seemed to inhibit his own native ability."[32] The inseparability of art-making and self-analysis visible in Pollock's art was also characteristic, apparently, of his therapy. Henderson was helping Pollock refine his representation of his (or "the") unconscious as part of his psychological cure. At times, it seems, the artistic project took precedence. Henderson wrote in retrospect:

> I wonder why I neglected to find out, study or analyze his personal problems in the first year of his work. . . . I wonder why I did not seem to try to cure his alcoholism. . . . I have

41. José Clemente Orozco. Cortéz and the Cross, *from* The Epic of American Civilization. *1932–34. Fresco. Baker Library, Dartmouth College. Commissioned by the Trustees of Dartmouth College, Hanover, New Hampshire.*

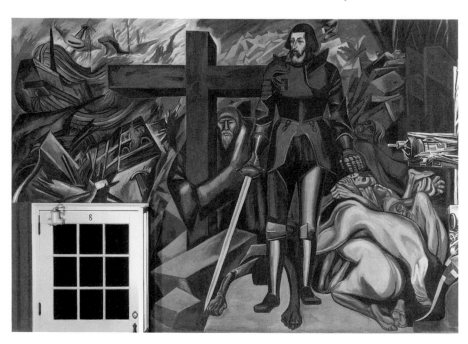

decided that it is because his unconscious drawings brought me strongly into a state of counter-transference to the symbolic material he produced. Thus I was compelled to follow the movement of his symbolism as inevitably as he was motivated to produce it.[33]

I interpret Henderson to be implying that he was neglecting Pollock's personal problems because those were not the only, or even perhaps the preeminent or most interesting, content of the drawings. Insofar as the drawings were involved in depicting the unconscious, in giving visual form to that agency as it was being conceived and described according to influential contemporary models, Henderson became captivated and involved. His interpretations of the drawings helped Pollock to refine his portrayal of the unconscious as much if not more than they engaged his immediate personal problems. This is not to say that Henderson was not giving Pollock what he needed. Given the interdependence of Pollock's artistic and therapeutic concerns at the time, a contribution to one was a contribution to the other.

The picture of Pollock's early interests and development that emerges from the preceding pages is one of deliberate construction of a formal vocabulary adequate to the representation of the unconscious and its contents, as Pollock was coming to conceive these entities. The path to that representation lay through the political, symbolic art of Picasso and Orozco, which Pollock adapted, with the help of his analysts, to conform to his developing notion of the mind. Some readers may wonder at my skepticism concerning the Surrealist idea of automatism and my neglect of Surrealism overall in his development. Pollock himself was quite open about his debts to Surrealism. In 1944 he acknowledged that his primary interest in the European artists who had recently come to America lay in "their concept of the source of art being the unconscious." He went on to say, however: "This idea interests me more than these specific painters do, for the two artists I admire most, Picasso and Miró, are still abroad."[34] John Bernard Myers recalled asking Pollock if he had ever been influenced by the Surrealists. "He said yes, in one way: their belief in 'automatism' or making a picture without 'conscious' control of what would happen on the canvas before beginning one. He felt that Masson in particular had obtained some happy results utilizing 'automatism.'"[35] On both occasions Pollock put some distance between himself and the core Surrealists; except for the notion of painting from the unconscious, they had little to offer him. No doubt the humor, flamboyance, and gimmickry of much Surrealist art conflicted with his own high-seriousness from the very beginning. But apparently the connection between the unconscious and art was one the Surrealists helped Pollock make in the late 1930s. It is a small but crucial link in a large and complex engagement. If Pollock chose to follow Orozco and Picasso to this goal instead of the Surrealists, it may have been because his already developed and developing conception of the unconscious favored such a path. The artistic significance of the unconscious for Pollock was entangled with personal and cultural meanings and needs. In order to clarify this situation, it will be necessary to trace the development of Pollock's interest in and exposure to the idea of the unconscious.

I will propose, in the end, that there were two basic models of the unconscious around which Pollock's thinking and work turned: a symbolic model, and an energic or electrodynamic model. Each had a continuous role in Pollock's artistic theory and practice from the early 1940s on, although one or the other usually predominated. The two models are diametrically opposed in some respects, but both have origins in Freu-

dian and Jungian theory, both were in wide circulation in United States culture in the 1940s and 1950s, and both were doing specific kinds of ideological work in that culture.[36]

POLLOCK'S PSYCHOLOGICAL EDUCATION

Pollock's exposure to psychology and to Jung is usually said to have begun around 1934. At that time Pollock, working as a janitor at the City and Country School in New York City, is supposed to have met Helen Marot, a teacher interested in Jungian psychology.[37] Both encounters, I believe, should be dated a few years earlier and should be seen as mediated by Thomas Hart Benton. Benton, Pollock's first teacher, seems to have introduced him casually in the early 1930s both to some of the popular literature on psychology and to literary friends with a special interest in the mind and its workings.

The earliest indication of Pollock's own interest in psychology is a notation on the back of a drawing of two partial figures (JP-CR 3: 384) dating from 1930 to 1933.

> Man starts with impressions of general situations
> Gradually handling things (getting familiar with the
> content of such general situations) he makes distinctions
> The distinctions he classifys. (names)
> From these come inferences.[38]

This notation, in Pollock's handwriting, was probably made while he read through the following passage.

> Locke thought that we first got simple ideas and then combined them into more complex conceptions and finally into generalizations or abstract ideas. But this is not the way that man's knowledge arose. He started with mere impressions of general situations, and gradually by his ability to handle things he came upon distinctions, which in time he made clearer by attaching names to them. We keep repeating this process when we *learn* about anything. The typewriter is at first a mere mass impression, and only gradually and imperfectly do most of us distinguish certain of its parts; only the men who made it are likely to realize its full complexity by noting and assigning names to all the levers, wheels, gears, bearings, controls, and adjustments. John Stuart Mill thought that the chief function of the mind was making *inferences*. But making distinctions is equally fundamental—seeing that there are really many things where only one was at first apparent. This process of analysis has been man's supreme accomplishment. This is what has made his mind grow.[39]

It is a partial and inadequate account of mental process, to be sure; its valorization of the analytic process is a product of the author's ideological commitments. Nonetheless, it apparently struck the young Pollock as compelling enough to deserve recording, indicating that a general interest in the mind and its operations may have preceded his fascination with the unconscious.

The excerpt is from a book introduced in the last chapter—James Harvey Robinson's *Mind in the Making*, published in 1921. The author was a well-known and respected intellectual historian who left Columbia University after twenty-five years of teaching to found the New School for Social Research in 1919.[40] His ambitions in founding the New School were identical to those he pursued in the writing of this book— to make accessible to the general public the new knowledge yielded by the social

sciences and to use this knowledge both to understand man's present beliefs and behavior and to guide his future progress. Even this brief description of the author's intentions should be enough to indicate that *The Mind in the Making* belongs to the genre of Modern Man literature I have been outlining. Indeed it was a crucial, even founding text in that genre.

Like so many Modern Man texts, Robinson's book devotes considerable attention to new developments in psychological theory and their implications for our understanding of the nature of the mind. Robinson was a student at Harvard of William James, whom he credited with stimulating his interest in psychology. The body of *The Mind in the Making* opens with an introduction to the unconscious and to Freudian theory; although Robinson points out that his primary concern will be the conscious mind and its operations, the similarity of his project to the genetic aspect of the Freudian one—evaluation of the determining effects of past experiences and development on subsequent mental functioning—is patent. He distinguishes four layers which compose the modern mind: animal, child, savage, and civilized, all of which interact in individual behavior. Then, in speculating upon the nature of the primitive mind, he presents the passage which Pollock found intriguing. Uncharacteristically, Robinson introduces this theory of the mind's natural operation as indisputable fact and cites neither a source nor supporting evidence for it.[41] It is, of course, not surprising that a scholar so committed to the scientific ideal should project the analytic process into the mind's very core. But whether or not this idea or others presented in the book made a lasting impression on Pollock is not of pressing concern. The importance of the evidence here is twofold: to show first that already in the early 1930s Pollock had an interest in the mind and its operation; and second, that also early in his career Pollock made contact with a source which mediated and synthesized many new and important ideas, including some from Freudian theory, and presented them in an engaging and easily digested format.

Benton very likely played a part in stimulating this interest of Pollock's and in directing him to the Robinson book. Robinson was part of the group of progressive liberal historians and social scientists, including Charles Beard, Thorstein Veblen, and Alvin Johnson, to which Benton was attracted and indebted in the 1920s and 1930s. Benton, in fact, singled out *The Mind in the Making* as a work that had had a strong influence on him.[42] And he was the most influential figure in the young Pollock's life and art. Earlier Benton had cultivated a familiarity with Freud's work and psychological theory. Indeed, around the time of World War I, he says, "I got involved in psychological theory and worked up elaborate though confused psychological defenses of my paintings."[43] He had progressed well beyond this stage by the time Pollock joined his classes in 1930, but Benton's interest in artistic processes insured that his curiosity about psychological theory would survive. Furthermore, a number of the artists, writers, and intellectuals with whom he kept company were deeply involved in such matters. If Benton himself did not contribute, through his teaching or example, to Pollock's appreciation for the new psychological theories, members of his circle certainly did.

Shortly after enrolling in Benton's classes in the fall of 1930, Pollock was posing for the *America Today* murals, and probably as early as the next year he began spending part of each summer at the Bentons' vacation cottage on Martha's Vineyard. He developed a close attachment to the Bentons—Rita as much as Tom—in the early 1930s, and through

his participation in their social occasions he gravitated to the periphery of the Bentons'

circle. Among those whom Pollock was likely to have met in this milieu were Caroline Pratt and Helen Marot. The two women were summer neighbors of the Bentons on Martha's Vineyard, and Pratt, like Pollock, posed for the New School murals in the winter of 1930–31.[44] Pratt had founded in 1915 a small, progressive school modeled on the theories of John Dewey; it quickly grew into the City and Country School, to which many of Greenwich Village's artists and literati, including the Bentons, sent their children. The school often provided work for Benton's students. Pollock's brother Charles, who had begun studying with Benton in 1926, was employed there part-time as a teacher in 1933. Jackson and a second brother, Sanford McCoy, found jobs as janitors there in 1934. Jackson became close both to Pratt and, especially, Helen Marot, Pratt's longtime companion. Although he was more than forty years her junior, Pollock developed an attachment to Marot that apparently became quite deep; her sudden death in June 1940 was a shock to him, as Pratt observed in a poignant note to Pollock shortly afterwards.[45] While Pollock's coming to work at the City and Country School in 1934 probably provided the opportunity for this relationship to develop, its origins were likely earlier and in the Benton milieu.

Helen Marot's importance to Pollock and her role in his psychological education warrant at least a cursory examination of her intellectual biography. Unfortunately, the documentary evidence is weakest for the years most important to the present study—the 1920s and 1930s. She was born in Philadelphia in 1865, and she began her career there as a teacher and librarian. By 1899 some of the interests that would dominate her life had begun to emerge. While working as a librarian at the Free Library of Economics and Political Science in Philadelphia, she compiled *A Handbook of Labor Literature.* Economics and politics, particularly with regard to labor issues, would become her specialties. Subsequently she worked as an investigator for the U.S. Industrial Commission and the New York Child Labor Commission, and as Secretary of the Pennsylvania Child Labor Commission. These experiences apparently led her to adopt an increasingly radical position on social and political issues, until, at the age of forty, she became a union organizer. From 1906 to 1914 she worked as executive secretary of the Women's Trade Union League of New York. Looking back in 1914 over the league's first decade of work, she noted that it had "aided in the organization of 150,000 women" working in every sort of trade. She also published that year a book entitled *American Labor Unions,* which the *New York Times* labeled "a friendly explanation of their point of view," although the anonymous reviewer predictably found unionism fundamentally misguided.[46]

After two years of service on the U.S. Industrial Relations Commission, Marot turned to journalism. In April 1916 she began contributing articles to the monthly socialist magazine the *Masses.* The accounts of the economic and political events she wrote at this time would no longer have been thought "friendly" by her counterparts at the *Times.* She pulled no punches in this forum. She warned that if the country heeded Elihu Root and armed for war, those arms would be used against labor. She was tireless in her promotion of unions and their rights: "The unions have now to make clear . . . that it is *the function of capital to serve labor.*" And she called attention to the lawlessness of American law in its treatment of labor. After five months as a regular contributor, Marot

became a contributing editor of the *Masses,* alongside John Reed, Max Eastman, Stuart Davis, Boardman Robinson, and other notable critics of American capitalism. She remained an editor through the final issue of the magazine in December 1917, when it was forced to cease publication after being denied second-class mailing privileges by the U.S. Post Office, thereby effectively being banned from the mails.[47]

Shortly before the demise of the *Masses,* Marot had begun to direct her efforts toward another book and then toward another magazine—the *Dial.* In 1918 new owners and publishers moved the magazine from Chicago to New York and gave it a new orientation: it went from being a book review journal to an "organ of Reconstruction," in the words of an associate editor at the time, Lewis Mumford. The hope was that the end of the war would provide the occasion for wholesale reshaping of existing institutions on an enlightened, humane, and truly democratic basis. This project was a sort of socio-political counterpart to the intellectual reconstruction being promoted by James Harvey Robinson and others at the same time. Marot herself argued, "The reconstruction period will be a time of formative thought; institutions will be attacked and on the defensive; and out of the great need of the nations there may come change." The new *Dial* would strive to promote and guide the process. Marot became one of the three senior editors in charge of the Reconstruction program, along with John Dewey and Thorstein Veblen, and she was wholly dedicated to this optimistic initiative; Mumford recalled that Marot played a large role in directing the magazine's editorial policy at this time, and that she "led a group of *Dial* employees to join a parade on Fifth Avenue in celebration of the Russian Revolution."[48]

The book Marot published in 1918, *Creative Impulse in Industry,* is a product of this moment. In it she argues for the necessity of reconstructing both industry and education in order to provide the industrial worker with a creative experience. She considers various strategies of industrial management and primary education in terms of their potential for making collective work stimulating and gratifying. Creative expression should not have to be confined to the limited, individualistic field of art, but should be characteristic of associated effort as well. Art may someday be coextensive with life, she dared to hope. The work of Dewey, Veblen, and Caroline Pratt, to whom the book is dedicated, figured prominently in Marot's thinking.

But the hopes of 1918 were dashed by the realities of 1919: massive strikes, many violently broken, the Red Scare, and Attorney General Palmer's brutal suppression of the left. The earlier fate of the *Masses* proved to be merely a preview of things to come. As if the disillusion and despair brought on by such events were not enough, Marot herself was "summoned to inquisitorial State hearings and bound under some undisclosed threat not to reveal what questions were asked."[49] All of this proved too much for her. At fifty-four, after two decades as a social reformer and radical activist, Marot gave up hopes for revolution and reconstruction. She became one of what Malcolm Cowley called the "former people" of Greenwich Village, so alien to the new "young men on the make": "'They' had been rebels: they wanted to change the world, be leaders in the fight for justice and art, help to create a society in which individuals could express themselves. . . . Now, with illusions shattered, they were cynics. . . . 'We' were convinced at the time that society could never be changed by an effort of the will."[50] It was at this moment that she turned to the study of psychology.

Marot had been interested in psychology for some time already. Indeed, her work was perceived as participating in the extension of psychological theory to economics.

> Recently there has been more attention to the psychological factors in economics and in directions that lead away from the old psychological point of view. Veblen, Marot, and Tead, in analyzing the psychological factors in industry and in the business system, have come nearer the new point of view and have begun an application of the new psychology to social problems that promises a revolution in economics.[51]

The similarity to Robinson's program is striking here: established beliefs and practices are being examined and revised in the light of new social-scientific knowledge. Marot's last publication, in September 1920, urged the application of psychology to industrial organization in order to find alternatives to financial incentives—alternatives that maximized the workers' creative interest, dignity, and psychological fulfillment.[52] But the profound mental changes she underwent in 1919–20 apparently led to changes in the level and nature of her interest in psychology. As her confidence in social activism declined, her interest in psychological processes and motivations rose. Mumford probably exaggerates the decisiveness of the change, but his account of its nature is persuasive.

> Seeking a more fundamental insight into the human condition, Helen turned to the study of psychology, in search of a firmer basis than that provided by the dominant behaviorists or the stimulus-response school. . . . [s]he fumbled over the means, for she sought this knowledge mainly through Sherrington, whose classic work on the integrative action of the sympathetic nervous system for a time became her bible. . . . Overnight the Helen Marot I had known on *The Dial* dropped the preoccupations of a whole lifetime, as if they were so many soiled garments.[53]

The embers of her activist impulses continued to glow, however, in her work as a teacher at Pratt's school in the 1920s and 1930s.

The progress of Marot's psychological enthusiasms is difficult to trace, since she published nothing on the subject. Somehow she moved from Sherrington to depth psychology, and by the 1930s she was conversant with Jungian theory and in contact with followers of Jung. It was through her friend Cary Baynes that Pollock was put in touch with Henderson in 1939. While Baynes was not an analyst herself, she was a translator of Jung and a Bollingen Press editor in close contact with the Analytical Psychology Club in New York. Her husband, Helton Godwin Baynes, a prominent British Jungian analyst, has a part in this story as well. First, he helped bring Jungian analysis to popular attention in the United States in 1926; Anne Stillman, the wife of the National City Bank director James Stillman, credited him with helping her to "find herself" and win from her husband the celebrated divorce suit that had fueled the tabloids for six years. Also, it was Baynes' example and encouragement that led Henderson to Zurich to be analyzed by Jung in 1929. And later Helton Baynes' books aroused considerable interest among the members of the APC-NY. So when Marot turned to Mrs. Baynes for a referral for Pollock, she was going to the top—consulting a member of a very powerful and prominent couple in international Jungian circles.[54] Why did Marot guide Pollock in a Jungian direction, and what led her to become attracted to Jungianism herself? These questions cannot be answered with any degree of certainty, but they do indicate some suggestive lines of investigation.

If we turn to other reconstructionists and reformers for evidence of incipient interest in Jung, the future founders of the APC-NY loom large on the horizon. These people were reformers, not radicals; they fared much better generally in the wake of World War I than Marot and the others in the Fifth Avenue parade. But the same milieu that promoted Marot's turn to psychology also generated the foundations of the APC-NY, *the* institution central to Pollock's psychological education. Like Marot and Pratt, the founders of the APC-NY were originally professional women; activists; educators; promoters of women's rights, child labor laws, and the well-being of workers. Kristine Mann and Eleanor Bertine were doctors at the time World War I began. Mann was conducting an investigation of the health of female department-store employees; she later became the director of the Health Foundation Center for Women and Children. Bertine served as director of the Bureau of Social Education of the YWCA. Both were committed to improving the lot of working women by promoting exercise, proper diet, good posture, mental hygiene, and sensible shoes.[55] While on a camping trip together in the White Mountains in 1916 or 1917, they discovered Jung's *Psychology of the Unconscious*.[56] Before long both were off to Europe to be analyzed—Bertine in 1920, Mann in 1925. Marot evidently was by no means alone in turning from activism to psychology, and eventually Jungian psychology, in the aftermath of the war.

It would be oversimplifying to presume that each of these individuals was attracted by exactly the same elements in Jungianism; nonetheless, the similarities in attitudes and interests noted above should lead us to expect that Jung's appeal for them was lodged within a particular matrix of readings. Central to that matrix would be reformist and feminist interpretations of Jung's significance. Jung's appeal to the left at the time was neatly articulated by Floyd Dell, the managing editor of the *Masses,* in an article entitled "The Science of the Soul." For Dell, Jung's work represented an advance over Freud's in two important respects. First, it opened up the notion of "libido," desexualized it, expanded it to encompass life energy in all its forms. Second, it

> finished the destruction of Freud's early notion that neuroses were due to incidents occurring in childhood; [Jung] showed that the emergence of infantile memories is due to the fact that the life energy, having turned away from the real or present world, goes into the past, where it revives infantile memories and fantasies. The effect of this revision is to take attention away from the past and place it in the present; for it is Jung's conviction that the cause of neurosis is a refusal to meet the difficulties and dangers of life in the actual world. (P. 31.)

Dell was led to conclude that Jung's *Psychology of the Unconscious* was the best work on the subject of psychoanalysis to have appeared so far. "With the revisions of Jung we have in sharper outlines cleared of the labyrinthine detail of dream-interpretation and the monotonous insistence on sexual matters a revolutionizing science of man's psychical life: a science which explains the obscure causes and effects of his acceptance or refusal of the difficult realities of life" (p. 31). These aspects of Jungianism enabled Dell and his colleagues to appropriate psychoanalysis in an immediate way for their own program. Socialism and Jungianism seemed to agree on the importance of facing and engaging the difficult realities of the present. To be sure, there were differences and tensions yet to be resolved: Were those present difficulties historical or transhistorical? Was the required work essentially individual or collective? But at least there seemed now to be some common ground and some hope for further rapprochement.[57] When the tensions were

resolved in psychology's favor, as in Marot's case, socially disruptive energies were redirected into channels less dangerous and more acceptable to the ruling institutions.

The particular appeal of Jungianism to women in the interwar United States has been noted by Henderson, who recalls that it was a topic of discussion within the almost exclusively female APC-NY. In retrospect he believed that this phenomenon was a product of Jungian psychology's "new valuation of woman's position in the culture."[58] I read this as suggesting that the attention given to "the female" by Jung—his emphasis on the role of the mother in the Oedipus complex, the prominence given female archetypes, his notion of an "anima" (the female component in the male unconscious)—coincided with ongoing social and ideological changes in the U.S. regarding women. The third founding member of the APC-NY, M. Esther Harding, who came to the United States from England in the mid-1920s, focused her attention on the implications of Jung's work for understanding the female psyche and the emotional life of modern woman. She described Jung as an exceptionally farsighted man who had recognized the problem of developing an analysis of the psychology of women outside the male point of view. Also, his concept of the anima she found suggestive for analyzing prevailing categories and behaviors imposed upon women by men. She brought Jungian theory to bear upon the full range of female experience and devoted a chapter of her book *The Way of All Women* to the dynamics of friendships and love relationships between women. The increased frequency of self-supporting women living together, and the greater incidence of lesbianism among women were treated by Harding as effects of an ongoing social revolution in the process of women's psychological liberation. "A new and more individual capacity might be developed in woman in her own realm."[59] Harding herself opted for this strategy; she and Bertine were close companions, sharing residences, until the latter's death in 1968. As Harding looked back, on her eightieth birthday, over the work of the APC-NY, she felt that one of its essential achievements had been the pioneering of a "new attitude toward the feminine."[60]

POLLOCK, JUNG, AND THE ANALYTICAL PSYCHOLOGY CLUB OF NEW YORK CITY

These considerations help to set the stage for Pollock's often highly mediated early encounters with psychology and the APC-NY. His contact with the analytic group was mediated by de Laszlo and Henderson, a relationship in turn mediated originally by Marot. Likewise, I shall argue, little of his knowledge of Jungian theory was acquired "directly"—that is, by reading Jung's texts—although I would not assume, as Rubin does, that Pollock "almost certainly did not read Jung."[61] Jungian and Freudian theories were conveyed by his analysts, Marot, and others; by Modern Man publications; and by other cultural usages and transformations of the ideas.

Pollock's first encounters with psychological theory and notions of the unconscious, in books such as *The Mind in the Making* and in conversation with Marot, Benton, and others, reflected the ordinary intellectual curiosity of a young artist seeking to comprehend the influential ideas in his culture and their implications for his own work. But sometime around 1936–37 the unconscious began to acquire a new and personal urgency for him. It began to seem a possible cause for certain problematic aspects of his behavior.

Pollock's behavior was troubled and troublesome from the time of his adolescence.

By the age of sixteen he had developed a drinking problem, and his high school years were marked by rebelliousness and expulsions. The problems did not go away when he moved to New York, and by 1936–37 they had become acute. In the fall of 1936 he wrecked his car in a collision for which he was responsible, and in the summer of 1937 he was arrested on Martha's Vineyard for drunkenness and disturbing the peace. At this time the letters to family members written by Pollock's brother Sanford, with whom Jackson shared an apartment, began to give evidence of growing difficulty. On 27 July 1937 Sanford wrote to Charles:

> Jack has been having a very difficult time with himself. This past year has been a succession of periods of emotional instability for him which is usually expressed by a complete loss of responsibility both to himself and to us. Accompanied, of course, with drinking. It came to the point where it was obvious that the man needed help. He was mentally sick. So I took him to a well recommended Doctor, a Psychiatrist, who has been trying to help the man find himself. As you know troubles such as his are very deep-rooted, in childhood usually, and it takes a long while to get them ironed out. He has been going some six months now and I feel there is a slight improvement in his point of view.[62]

The clichés of Freudianism were already so well known to these brothers that statement of them was felt to require a prefatory "as you know." Nowadays the premises of psychoanalytic theory are so familiar that it is hard for us to recover the impact of the changes in Pollock's thinking. It was at this time that he began to believe that his own personal distress had psychological and unconscious origins, something he would become utterly convinced of in subsequent years. He was just beginning to develop a sense of an other within his mind, an other whose motivations he could not begin to fathom. The development of this belief coincided with a gradual turning away from social and political explanations for collective and personal distress. In this respect Pollock's intellectual evolution reenacted Marot's.

That Pollock held radical political views in the 1930s is well known, so I will not belabor the point here. It is enough to quote a 1933 letter to his father:

> This system is on the rocks so no need try to pay rent and all the rest of the hokum that goes with the price system. Curious enough the artists are having it better now than before. They are getting more aid—the pot bellied financiers are turning to art as an escape from the some what blunt and forceful reality of today.[63]

In 1936 Pollock worked in Siqueiros' experimental workshop, helping to construct floats and banners for Communist demonstrations. But during the later 1930s his political interests declined as his psychological interests rose. This development was overdetermined. It was part of the general movement of the American literary and artistic left well documented by Daniel Aaron, James Burkhart Gilbert, and Serge Guilbaut.[64] In the face of disillusion and despair, psychology presented itself to many, once again, as a promising alternative pursuit. Surrealism both contributed to and benefited from this situation. Pollock's art had never been overtly political; nor did it become, strictly speaking, Surrealist. But he did adapt, as I have argued, a visual schema derived from the political art of Picasso and Orozco to a more ambiguous, cosmic, psychologically weighted form of expression drawing directly upon Surrealist practices and forms. I do not want to make this process appear overly linear. Pollock's priorities in the 1930s may be said to have shifted from mystico-religious explanations for collective and personal misery to social

ones and then to psychological ones.[65] All three broad frameworks, however, remained more or less active in his thinking throughout his life. If it was inevitable that Pollock "discover" a psychological basis for his own distress, it was only because cultural and historical factors made it so. Specific cultural forces helped him to conceive his problems as psychological, and his own troubled experience led him to accept psychological explanations for social and political problems. The two forms of evil merged, and Pollock's stake in the concept of the unconscious was multiplied. This is something that sets him apart from the other artists of the New York School. Although several of his colleagues also tried to adapt their artistic practice to the new notions of mind and mental process, few had as much personal investment in the project or pursued it with equal urgency.

Pollock's initial experience with psychiatric treatment did not bring the desired results, despite Sanford's expression of optimism in the letter to Charles. Yet as his situation became more desperate, Pollock became increasingly serious about and committed to the pursuit of a psychological solution. In the summer of 1938, at his own request and with the assistance of his psychiatrist, he was hospitalized for medical and psychiatric treatment of acute alcoholism. Another letter from Sanford to Charles picks up the story.

> For a few months after his release he showed improvement. But it didn't last and we had to get help again. He has been seeing a Doctor more or less steadily ever since. He needs help and is getting it. He is afflicted with a definate neurosis. Whether he comes through to normalcy and self-dependentcy depends on many subtle factors and some obvious ones. Since part of his trouble (perhaps a large part) lies in his childhood relationships with his Mother in particular and family in general, it would be extremely trying and might be disastrous for him to see her at this time. No one could predict accurately his reaction but there is reason to feel it might be unfavorable. I wont go into details or attempt an analysis of his case for the reason that it is infinately too complex and though I comprehend it in part I am not equiped to write clearly on the subject. To mention some of the symptoms will give you an idea of the nature of the problem, irresponsibility, depressive mania (Dad), over intensity and alcohol are some of the more obvious ones. Self destruction, too.[66]

The new doctor Sanford referred to was Henderson, then in his first year of practice. This was Pollock's first stable and extended (eighteen months) experience with analysis, and it played a crucial role in developing and consolidating his beliefs about his mind and unconscious. At this time his interest in and study of psychology moved to a higher level of seriousness; he also brought his art into direct and sustained involvement with psychological theory in general and with his therapy in particular.[67] And under the influence of Henderson and de Laszlo, Pollock's thinking about the mind and the unconscious acquired a distinctly Jungian cast.

Part of the dispute between the modernist and the Jungian interpreters of Pollock's work has centered on how much Jungian theory Pollock was likely to have acquired from his analysts. Gordon questioned both Henderson and de Laszlo about this in 1980, and they claimed to have avoided psychological talk and intellectualization in sessions with Pollock. Gordon accepted this routine and problematic assertion at face value and used it to shed doubt upon the assumption of the Jungian interpreters that "mere psychologists could have fostered in a fiercely independent painter some kind of Jungian dogma."[68] This image of Pollock is a long way from the vulnerable, groping, confused young man

he was at this time. Furthermore, as recorded in Gordon's article, "Pollock's *Bird*" (p. 44), both analysts acknowledged significant exceptions to this general principle. Gordon first quotes Henderson:

> "My treatment was supportive and I did not consciously discuss Jung or Jungian theories with him."

But Gordon then has immediately to qualify the claim, on the basis of Henderson's statements quoted in Wysuph's text:

> It is known that Henderson offered Pollock the Jungian faith in "a psychic birth-death-rebirth cycle" as well as the "symbol-ordering" device of the circular mandala.

Likewise, Gordon quotes de Laszlo:

> "We rarely discussed abstract concepts; nor do I recollect discussing archetypes since I wished to avoid intellectualization."

But this analyst also mentions significant exceptions.

> And similarly, de Laszlo recalls that she explained to Pollock the concept of rebirth in order "to help give him hope and confidence," and also the meaning of the mandala as "interrelating formerly fragmented parts of the psyche."

More significant even than these acknowledged exceptions are the beliefs conveyed to Pollock without awareness, or long forgotten: deeply held assumptions about fundamental questions of life, behavior, and mind—some specifically Jungian, but many deriving from depth psychology broadly. The drawings Pollock brought to his analytic sessions offer considerable evidence that many of these beliefs took root. As records of Pollock's early active engagement with the idea of the unconscious, these drawings indicate that in this early stage of his career, Pollock's representation of the unconscious was deeply grounded in Jungian theory. Something of Jungianism's particular functions and appeal can be ascertained by looking at the specific character of the debts.

There are documents related to the psychoanalytic drawings and dating from the same years that indicate Pollock's engagement with Jungian concepts was quite direct and explicit. Among the papers Pollock saved is a list in his own handwriting dating from about 1940–41. It contains ten titles, each designating a paper presented at a meeting of the APC-NY between 2 October 1936 and 1 March 1940 and subsequently published in the *Papers of the Analytical Psychology Club of New York,* an informal publication intended principally for circulation among club members and associates. Pollock's bibliography was probably made from the first four volumes of the *Papers,* since the sequence of titles corresponds precisely to that of their publication. The list is transcribed below.

> *The Analytical Psychology Club of N.Y.C.—*
>
> The Concept of the Collective Unconscious, C. G. Jung
> Redemption Ideas in Alchemy, M. Esther Harding
> The Individual and the Group, Eleanor Bertine
> The Eranos Conference, Hildegard Nagel
> The Mother Archetype and its Functioning in Life, M. Esther Harding
> Early Concepts of Jahweh, Jane Abbott Pratt
> Initiation Rites, Joseph L. Henderson
> The Psychological Aspects of War, Eleanor Bertine

Two Papers—The Shadow of Death, and The Self-Analysis of Emanuel Swedenborg, Kristine Mann

Picasso, C. G. Jung Alda F. Oertly[69]

If this list is what it seems—that is, a collection of titles Pollock intended to peruse either at someone's recommendation or by his own discovery—its significance is clear. It documents an initiative to pursue psychological knowledge well beyond the exigencies of his own treatment, and it records his exposure and access to the discourse of the APC-NY. The existence of the list indicates that Pollock's analysis provided opportunities for acquiring "abstract" psychological knowledge, that Pollock intended to pursue some of these, and that the knowledge he acquired was likely to be strongly colored by the particular interests and beliefs of the APC-NY. In and around his therapy Pollock would have learned about depth psychology through the Jungian lens ground in the discourse of the APC-NY. He may well have encountered this discourse in club publications as well as in the thinking and practice of his early analysts.

The effects of this exposure are evident at various levels of Pollock's art and thought, from specific notions to broad thematic interests to overarching conceptual framework. I will present some examples from each level, moving from the simpler to the more abstract and complex. There are too many overlaps between Pollock's work and the discourse of the APC-NY to permit any assertion that the institution's influence on his psychological knowledge was minor. Disposing of this misconception eliminates the grounds for believing that Pollock was innocently generating Jungian symbolism and thereby confirming Jungian theory.

There is evidence among Pollock's drawings from this time that he was wrestling with Jungian notions and pondering their implications for his art. In JP-CR 3: 469r (fig. 42) a notation appears beneath a slender phallic form and beside a biomorphic cluster:

Passive fantasy
Active "

It refers to the Jungian distinction between fantasies that erupt into consciousness and

42. Jackson Pollock. Untitled drawing, JP-CR 3:469r. *1938–39. Pencil and colored crayon on paper, 36 × 25 cm. © 1992 The Pollock-Krasner Foundation/ARS, New York.*

those that require action from the ego to bring them into consciousness. Jung described passive fantasy as the product of a dissociated psyche and a completely passive consciousness in the subject. Such fantasies, he says, belong "to the category of psychic *automatismes* (Janet)." Active fantasies, in contrast, are produced by healthy psyches and are among the highest forms of psychic activity, since they involve the positive participation of consciousness with unconscious materials. They are, furthermore, "the principal attribute of the artistic mentality."[70] One can imagine Pollock pondering this distinction as he conjured the forms on the page, and although this imagining is no more than a hypothetical narrative, it offers, I think, a plausible model of the dynamic between ideas and visual imagery in Pollock's "work" on the unconscious. In what ways might Pollock have learned of these Jungian categories? The most likely source would have to be Henderson, since these notions were not prominent in Jungian literature and theory. However, the text in which they were most fully explained had been translated by H. G. Baynes and published in New York in 1923. Pollock himself could have consulted the "Definitions" section of *Psychological Types,* or Marot might have known it and mediated it for him.

There is somewhat less uncertainty about the notations on another drawing, JP-CR 3: 556 (fig. 43). Pollock's Jungian interpreters have often cited this sketch, since it shows the artist clearly using Jungian concepts in the construction of an image.[71] The notations on it refer to Jung's distinction of four properties or functions of consciousness: thinking, feeling, sensation, and intuition. To these functions Pollock assigned colors: red for emotion or feeling, green for sensation, blue for thinking, yellow for intuition. Black had been considered for sensation but was crossed out and relocated to the lower left, beneath a cluster of interlocked arcs. At the center of the notations is a sketch for the crucifixion gouache Pollock gave Henderson as a going-away present in the summer of 1940.

Is it fair to assume that Pollock expected Henderson to appreciate the color coding and conceptual organization contained in this image? If so, we probably should presume that they had at least discussed these ideas on some prior occasion, and it is quite plausible that Pollock's gift of thanks was planned to acknowledge the influence Henderson had had on the artist. But again, Henderson cannot be pinned down as the source of the ideas behind the sketch. The four functions were very commonly discussed in contemporary Jungian literature; in fact, there is a striking correspondence between the sketch and Jung's discussion of drawings by one of his patients—the woman whose case is the focus of chapter two of *The Integration of the Personality.*

> For my patient, red signified Eros, the emotional principle, and blue the intellectual, or Logos, principle. . . . The center is green, signifying growth, and is surrounded with gold, which indicates value. Round about are some black contours. . . . The picture expresses a consciousness of the structure of man's being. The latter is represented by the number 4 . . . the number of the basic psychological functions: sensation, thinking, feeling, intuition.[72]

The color coding presented here was developed further in Jung's work on alchemical symbolism, and it was adopted and re-presented by some of his followers.[73] It became a basic tool of the Jungian interpretation of visual imagery. Jung's text proceeded to consider the relation of trinity to quaternity. Totality includes the trinity of the good world

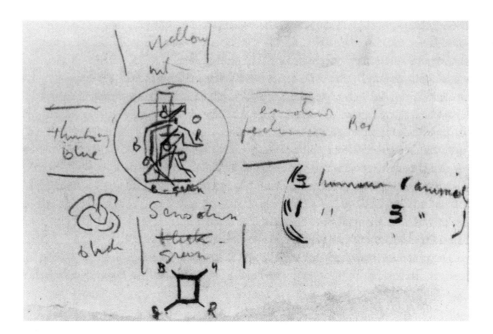

43. Jackson Pollock. Untitled drawing, JP-CR
3:556. *1939–40. Pencil and charcoal pencil
on paper, 13 × 20 cm.* © *1992 The Pollock-
Krasner Foundation/ARS, New York.*

along with the black substance of evil. Conflict is built into the totality of human life in a
three-to-one ratio between good and evil.

> The cross of the quaternity is unavoidable and indispensable if we are to continue our
> pilgrimage through life.[74]

Pollock's sketch contains a figure on a cross with three figures before it locked in
struggle. At right another notation reads:

3 humans 1 animal
1　　″　　3　　″

If Pollock was meditating upon Jung's ratio, he chose to have the humans symbolize "the
good" and the animal "evil." In the finished gouache (fig. 40) red and blue human figures
try to subdue a brownish black animal form; behind them a yellow human looks heaven-
ward from a green cross. I noted earlier that in this work formal devices learned from
Orozco were adapted and transferred to a cosmic symbolic frame of reference. Jungian
theory, mediated by Henderson and the APC-NY, was a crucial factor in this process.
There is no reason to try to assign any single or precise source or identity to Pollock's
symbols; even if we are persuaded by the similarities to Jung's text, we cannot tell
whether Pollock read it or whether Henderson mediated. The newly published *Integra-
tion of the Personality* was an enthusiasm of the APC-NY in early 1940; the February issue
of the club *Bulletin* contained responses by a number of club members to the publication.
Henderson almost certainly read the book at this time, and he may have either provoked
Pollock to read it or communicated parts of it, perhaps unknowingly. Pollock had access

to texts on psychology that were not in his library, and he was interested enough in several such texts to have perused them. The evidence is strong that Pollock's analysis profoundly affected his understanding of depth psychology and, necessarily, his art.

This evidence of Pollock's direct and explicit engagement with particular Jungian concepts prepares us to recognize less exact and circumscribed Jungian debts in the drawings. The drawings were a crucible in which Pollock mixed and tested the elements that constituted his first, symbolic model of the unconscious, viewed as a dark, primordial, subterranean realm populated by mythic and religious symbols. Two features of the Jungian component in this model are of particular interest—the exotic symbolic vocabulary and thematics, and the drive toward synthesis or unification of opposites. These features will be central to my explanation of the particular appeal of Jungianism to Pollock and many of his contemporaries; I will try to document them briefly without becoming mired in Jungian theory and symbolism.

A symbolic vocabulary for the unconscious was securely established in the discourse of the APC-NY around 1940; it featured a small cluster of fundamental symbols—snake, bird, cross, circle/mandala/quadripartite structure, yin-yang, disk-crescent. These typically were discovered in patients' drawings and in ancient narratives and inscriptions and were taken to represent key components of Jungian theory. The same symbolic vocabulary also dominates the visual language of Pollock's psychoanalytic drawings, where it merges with overlapping sets of symbols adopted from Picasso, Orozco, Native American art, and other sources.

The snake, for example, was commonly interpreted by Jung and his followers as a symbol of man's instinctual, animal nature as well as of processes of transformation and renewal. The same essay that presented the color coding for the four functions and the three-to-one ratio of good to evil also interpreted snake symbolism in the patient's drawings. There the serpent was, for Jung, the "lower man" as well as the devil and evil. It represented the baser part of human nature—the passions, the "dark part."[75]

> She had come to a standstill because she was pulled upon by "above" and "below." From now on she was no longer torn by opposites, for she could accept the "lower" man as he is. She recognized that evil, the serpent, is a necessary part of the process of growth. The dark part must be brought completely above the horizon, so that life can go on; and the serpent raised to the sky illustrates this truth.[76]

Jung's followers also found numerous occasions for discussing snake symbolism. In his *Mythology of the Soul,* Baynes treated it as symbolizing "that primordial instinctual force which the wise man fears because it can also fascinate." Significantly, his discussion of the symbol centered upon the Hopi snake-dance ritual, about which he had been tutored by Henderson. Henderson himself considered snake symbolism in his "A Question of Space," a short contribution to the APC-NY *Bulletin* in early 1939. Harding's *Woman's Mysteries* discussed the snake and its relation to moon symbolism, both of which, she argued, may evoke either secret, mysterious, subterranean regions or the idea of rebirth and renewal. And Jacobi in 1942 described the "snake of passion" (see fig. 44) as the "symbol of the undifferentiated world of drives in men."[77]

The snake, in Jungian interpretation, is less a sexual, phallic symbol than a symbol of the lower, baser part of human nature. Lowness is usually one of its literal attributes in symbolic configurations. The same applies to most of the snake imagery in Pollock's

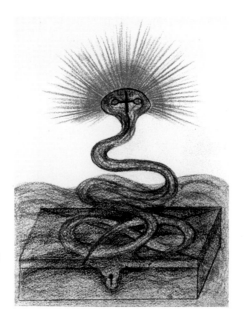

44. The Snake of the Passions. *Plate 2 in Jolande Jacobi,* The Psychology of C. G. Jung, *1942. London: Routledge and Kegan Paul.* © *Routledge, London.*

psychoanalytic drawings. A common motif in these drawings is the so-called ritual figure described above, composed of various symbols arranged symmetrically or asymmetrically across a vertical axis. In many of these figures (including two of the three in figure 30: those at the lower left and at the right of center), the bottom levels are composed of coiled snakes, while the higher levels contain sun and moon or eye forms—symbols, generally, of higher psychic states. Other drawings, in which human and animal figures are stacked or entangled, also assign the snake a subordinate position suggestive of psychic or moral inferiority.[78]

There are, of course, various other possible sources for such snake symbolism and syntactic practices; Langhorne has detected, for example, the influence of Yoga here.[79] The case for the relevance of Jungianism rests in large part on the larger symbolic matrix. Another of its elements is the circle/mandala/quadripartite form. A prominent and distinguishing component of Jungian theory, this motif is discussed at length by Jung and virtually all of the writers who have developed his work. Both Henderson and de Laszlo acknowledged that the mandala was one of the few elements of Jungian theory they deliberately taught Pollock. Jung chose the term *mandala* because "this word denotes the ritualistic or magical circle employed in Lamaism and also in the Tantric yoga as a yantra, or aid to contemplation." He believed that such symbols were universal, occurring throughout the world from the earliest moments of human history. They were for him representations of the "psychic centre of the personality."[80]

> We can hardly avoid the impression that the unconscious process moves in a spiral path around a "centre" that it slowly approaches, the "properties" of the "centre," meanwhile, showing themselves always more clearly. We could also put it the other way around and say that the central point, unknowable in itself, acts like a magnet upon the disparate materials and processes of the unconscious and, like a crystal grating, catches them one by one.[81]

Jung believed, furthermore, that one of the properties peculiar to this circular psychic center was "the phenomenon of fourfoldness."[82] The frequent appearance of quadripar-

tite division within the mandala led him to conclude that something fundamental in the structure of the psyche was responsible for it. He developed a model of psychic structure as a circle quadrisected by the four mental functions.

That Pollock knew this mandala model of the psyche is clear from the drawings given to Henderson. I have already introduced several works that use this form; one, a virtual diagram of it, is the sketch for the crucifixion gouache (fig. 43). More commonly the motif appears as a frame for formal experimentation. In JP-CR 3: 521v (fig. 45), for

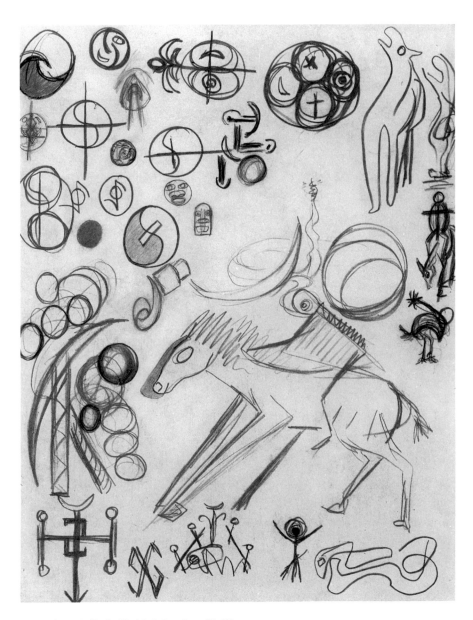

45. Jackson Pollock. Untitled drawing, JP-CR *3:521v. 1939–40. Red and orange pencil and pencil on paper, 36 × 28 cm. Collection of the Museum of Art, Rhode Island School of Design; gift of Polly and Erwin Strasmich in memory of Ida Malloy. Photograph by Michael Jorge.*

example, in the top right corner, encircled disk, crescent, and cross symbols are juxtaposed within a larger containing circle. In JP-CR 3: 537r (fig. 31) four amoeboid forms encircle a square quadrisected by lines terminating in symbolic shapes. The color scheme is the same as that devised for the four mental functions (fig. 43). Pollock also experimented with spirals within circles, as in JP-CR 3: 534r. There are at least five or six other drawings in which similar imagery is engaged,[83] as well, arguably, as various paintings ranging from *Circle* (1938–41), to *Night Sounds* (1944) and *Shimmering Substance* (1946), to *Four Opposites* (1953). These examples indicate that Pollock, like the Jungians, used the mandala both as an image of the structure of the psyche and as a form for the unification and synthesis of symbolic oppositions.

This synthetic function of the mandala is an initial indication of how Jungian discourse offered Pollock not only a rich visual symbolics but also a larger conceptual framework. Other symbolic elements Pollock explored also carried with them strong Jungian significations. An important example is a symbolic opposition thematized in Jungian discourse and pervasive in Pollock's drawings: the disk-crescent or sun-moon pairing, which has been noted and discussed by Langhorne.[84] This symbolic opposition has already appeared at the top of some of Pollock's ritual figures; it was also the focus of some of the systematic, formal experimentation in Pollock's work that I pointed out above. JP-CR 3: 518v (fig. 46) shows Pollock using disk and crescent symbols to construct faces, figures, and symmetrical structures reminiscent of ritual figures. Several of these symmetrical structures, not only here but also in, for example, JP-CR 3: 520r (fig. 30), use the disk-crescent symbolic opposition quite prominently. Even the bull's head at lower left of the latter drawing is constructed from this pairing. In several other drawings the motif is less focal, but it plays a nonetheless crucial part in the imagery. Most often it serves multiple functions: illuminating the synthetic, additive character of a complex symbol; establishing a powerful tension within an enclosing form; bracketing an intermediate form with opposing force fields; or structuring the higher levels of the ritual figures. Read as symbols of sun and moon, disk and crescent are extraordinarily efficient and economical vehicles for the visual representation of natural opposition.

Jung and his followers in the APC-NY paid extensive attention to sun-moon imagery in their analyses of symbols, whether in patients' drawings or ancient inscriptions. They typically associated the sun with consciousness or with psychic wholeness, and the moon with unconsciousness or the anima. As that last term indicates, this opposition was strongly gendered in Jungian discourse. Baynes is a representative voice in this respect; in the analysis of a drawing produced by one of his patients, he wrote, "The masculine logos-principle, symbolized by the sun, rules the left half of the field; while the right half is governed by the feminine principle, under the symbol of the crescent moon."[85] I will return to the question of gender presently, but first I want to pursue the link between the sun-moon and conscious-unconscious pairings. In interpreting other drawings, Baynes explained the imagery of solar eclipse as representing the consciousness being engulfed by the unconscious; the reemergence of the sun symbolized rebirth and the reorientation of consciousness. When sun and moon symbols were joined, conscious and unconscious were said to be acting in concert. Of the moon, he wrote, "The moon is therefore the cosmic counterpart to the ambiguity of the anima, or, more correctly, the anima is the ambiguous moon-goddess ruling the nocturnal world of the unconscious and uniting

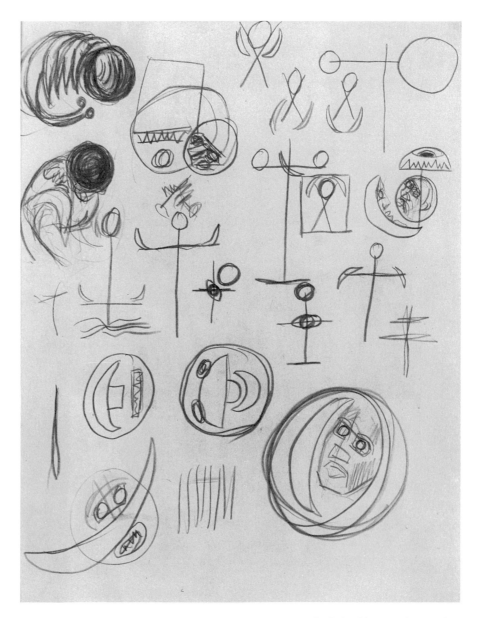

46. *Jackson Pollock.* Untitled drawing, JP-CR
3:518v. *1939–40. Orange pencil on paper,
36 × 28 cm. Collection of Eric Saltzman and
Victoria Munroe.*

goddess and daemon in her own nature."[86] The identification was secure in Jungian
discourse: representations of sun and moon evoked the psyche and the essential conflict
that structured it.

Pollock's use of sun-moon imagery fits securely into this framework. There are
here, as elsewhere, other plausible sources for the motif—American Indian art, Surreal-
ism, mysticism, and so on; nonetheless, in his hands its Jungian dimensions are striking.
Pollock followed the conventional Jungian gendering, as I will argue, and he often

positioned the motif in the topmost, "psychic" regions of his ritual figures. Furthermore, he devoted considerable energy and attention to finding a visual symbol for the integration of the two. His determination to integrate them, to merge them into a new totality, is one of the striking features of Pollock's handling of the sun and moon symbols. The drawings reveal him as striving to make the disk and crescent integral parts of a greater form—face, figure, bull's head, flower, ritual figure, symbol cluster, and so forth. In drawing after drawing, disk and crescent are yoked together in all manner of combination, including copulation, as occurs in the upper-left corner of JP-CR 3: 521r (fig. 47).

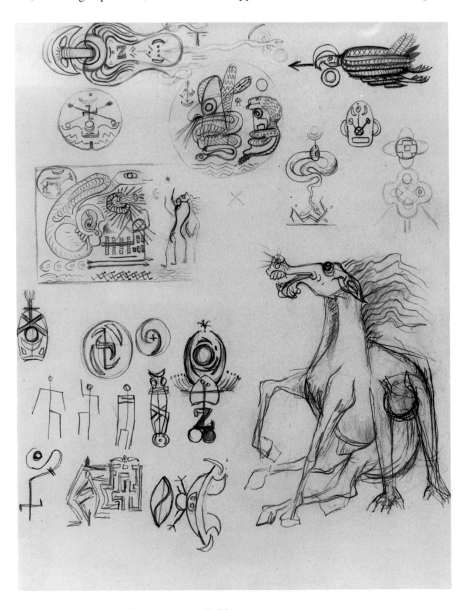

47. Jackson Pollock. Untitled drawing, JP-CR *3:521r. 1939–40. Pencil on paper, 36 × 28 cm. Collection of the Museum of Art, Rhode Island School of Design; gift of Polly and Erwin Strasmich in memory of Ida Malloy. Photograph by Michael Jorge.*

This urge to integrate the elements of a symbolic opposition is not limited to the disk-crescent motif. It is apparent also in the handling of other symbolic pairings—for example, human-animal and male-female. Many of the drawings depict some sort of human-animal conflict or struggle. Sometimes fragmentary forms—hands, hooves, faces, horns—signify that the chaotic, throbbing mass in which they are embedded is polarized along this axis (see, e.g., JP-CR 3: 515, fig. 48). At other times the human-animal opposition is given hierarchical form, human (or humanoid) above and animal below (for instance, JP-CR 3: 550, fig. 49). Several of the drawings contain passages in which two heads merge into one. Sometimes one head is animal and one human (JP-CR 3: 510); sometimes both are human-animal hybrids (JP-CR 3: 526); and sometimes two bodies come together to share one head, as at the top center and near the middle of the right side of JP-CR 3: 522r (fig. 50) and in JP-CR 3: 539. In the painting *Pasiphaë* from 1943 (fig. 9), a related merging of human and animal is evoked by both title and imagery.[87] Male-female integration is usually achieved by giving paired figures features of both sexes (see the left side of JP-CR 3: 549 [fig. 51], also JP-CR 3: 523, and JP-CR 3: 491). This strategy comes to full realization in the 1943 painting *Male and Female*. Various commentators have noted this work's refusal to effect the distinction offered in the title.[88] The association of rectilinearity with maleness and curvilinearity with female-ness is likely derived from Synthetic Cubist convention. Picasso might even have pioneered the combination or compression of both into a single figure.[89] But the presence, in the Henderson drawings, of non-Cubist explorations of the same theme suggests that Pollock's interest in this union has another source, one that underlies his impulse toward integration and reconciliation generally. Jungian discourse is a likely candidate.

All the visual devices catalogued in the preceding paragraph may be characterized as efforts to depict or symbolize the unification of opposition. To some extent this impulse in Pollock's work could be related to his study of "primitive" and modernist art. One need only look again at JP-CR 3: 522r (fig. 50) to see evidence supporting just this connection. The middle-right portion of the sheet contains an example of the motif in which two bodies are united under one head. In this case, however, the form has a specifically Northwest Coast Indian character. So do the heads of the two symmetrical

48. *Jackson Pollock.* Untitled drawing, JP-CR 3:515. *1939–40. Colored pencil on paper, 27 × 21 cm. Private collection. Photograph by Jon Chomitz.*

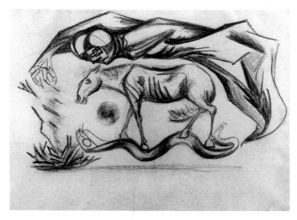

49. *Jackson Pollock.* Untitled drawing, JP-CR 3:550. *1939–40. Colored pencil on paper, 30 × 46 cm. Collection of the Eastbrook Foundation, Boston. Photograph courtesy Nielsen Gallery, Boston.*

50. *(below) Jackson Pollock. Untitled drawing, JP-CR 3:522r. 1939–40. Graphite and purple colored pencil on paper, 36 × 28 cm. Collection of the Museum of Fine Arts, Boston; Jessie H. Wilkinson Fund.*

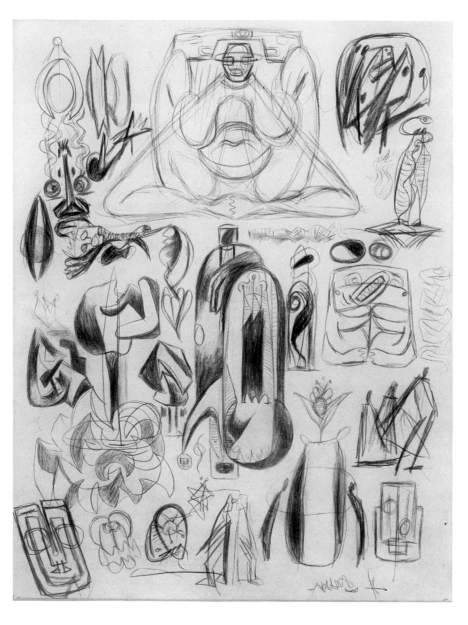

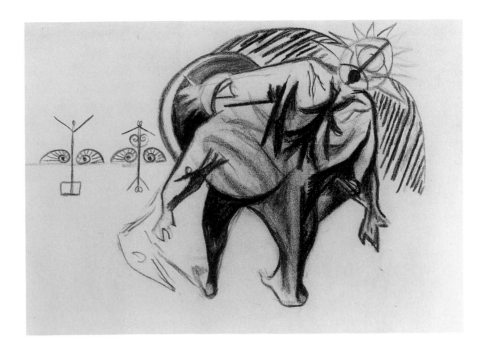

51. Jackson Pollock. Untitled drawing, JP-CR
3:549. *1939–40. Colored pencil on paper, 30
× 45 cm. Collection of Clara Diament Sujo.
Photograph courtesy Nielsen Gallery, Boston.*

figures at the top of the page, which become transformed into the legs of a large
triangulated woman. Pollock would have encountered variations on this theme in North-
west Coast Indian art, as well as in the work of Picasso and other European modernists;
these visual sources may well have contributed to his interest in this particular formal
device. But the extent to which the unification of oppositions is thematized in his work of
this period, and the range of forms it is given, argue for the influence of Jungian theory.
Jungian discourse would have given such formal practices philosophical significance,
and it would have extended the set of available symbolic oppositions. In works of such an
experimental and inclusive nature, we should not be surprised to find "formal" and
"psychoanalytic" influences interpenetrating. Pollock's early work indicates that these
were not at all contradictory or even separable elements in his artistic practice at this
time; that they have come to seem so is one of the ill effects of the dispute between the
psychoanalytic interpreters and the modernists.

Jung's psychological theory is structured around opposition and unification of oppo-
sites. The fundamental opposition is that of consciousness and unconsciousness, and the
ultimate goal of Jungian analysis is a harmonious and balanced synthesis of these two at a
higher psychic level. Jung and his followers posited the same dynamic for a number of
other dualities—sun/moon, male/female, hot/cold, dry/wet, light/dark, gold/silver,
round/square, fire/water, physical/spiritual, and so on.[90] Such were the terms by which
psychic conflict was believed to be figured symbolically in dreams and drawings; recon-
ciliation was often accomplished through the mandala. Opposition came to seem to Jung
a structural principle of the psyche, "a principle inherent in human nature." He contin-

ued, "A scientific theory which shall go further than a mere technical method of treat-ment must be based upon the principle of the opposites, for without this, it could only lead to the re-establishment of a neurotically unbalanced psyche. There is no equilib-rium, and no system of self-regulation apart from opposition. And the psyche is a system depending upon self-regulation."[91] Jung believed opposites were undifferentiated in the unconscious in its natural state. "The identity of the opposites is the characteristic of every psychic event that is unconscious."[92] This undifferentiated state was fragile and unstable and could not survive the awakening of consciousness. Reconciliation had to be achieved on a higher level, involving both conscious and unconscious. Jung and his followers believed that symbols were often the medium through which reconciliation of oppositions (psychic conflict) was effected. *Reconciling symbols* was the term used for those symbols that "not only unite the opposites, but also endow them with an individual distinctiveness and value."[93] Opposites, furthermore, played an essential part in the Jungian conception of mental dynamics; like the terminals of a battery, these antitheses generated psychic energy.[94] They were also believed to be inherent in the archetypes. And finally, published accounts of particular cases routinely divided the analysis into antithetical phases that gradually progressed toward unity.[95] Jung used the notions of opposition, intrinsic duality, and redemption through reconciliation of opposites in analyzing Picasso's work.

> With my patients, there follows after the time of the *Katabasis* and *Katalysis*, a recognition of the oppositional character of human nature, and the necessity of the conflict-fraught pairs of opposites. Therefore, after the symbol of the experience of craziness during the dissolution, follow pictures which show the coming together of the pairs of opposites: light-dark, above-below, white-black, male-female, etc. In the latest of Picasso's pictures, there is to be found very clearly the motif of the uniting of the opposites in their direct juxtaposition.[96]

Jungianism's commitment to the synthesis of opposites into transcendent unity provides a noteworthy point of contact between Jungian psychology and certain mysticisms, such as Theosophy—one of Pollock's early enthusiasms.

The disk-crescent motif embodied another, particular, structural influence of Jungianism on Pollock's symbology—the gendering of the psyche. Disk and crescent were not always interpreted as sun and moon by Jungian authors. Sometimes another reading was offered: disk and crescent as two opposing phases in the lunar cycle, full moon and new moon. This alternative reading was also strongly gendered, not as an opposition, but as a thoroughly feminine motif. It figured prominently in Harding's *Woman's Mysteries,* which was an exhaustive treatment of moon symbolism in myth, religion, and modern life. Several of the images that Harding discussed contained disk-crescent forms representing the waxing and waning moon, as in, for example, her figures 1 and 3 (see fig. 52). This observation did not problematize or displace the sun-moon interpretation, which Harding applied to other manifestations of the disk-crescent motif.[97] The two forms were permitted, consequently, two quite different significations: as sun and moon, they evoked consciousness and unconsciousness, the masculine and feminine aspects of the psyche; as full moon and crescent moon, they symbolized rebirth and regeneration as well as the two faces, good and evil, of the moon goddess–unconscious.

Some exclusively lunar imagery in Harding's text is markedly reminiscent of some

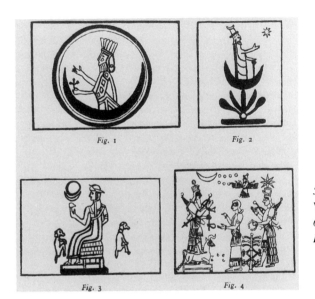

Fig. 1 Fig. 2

Fig. 3 Fig. 4

52. *Figures 1 to 4 from M. Esther Harding,*
Woman's Mysteries, Ancient and Modern,
*61. Courtesy Northwestern University
Library.*

of Pollock's symbolic configurations in the Henderson drawings. The combination of cross, disk, and crescent in her figure 29 (fig. 53), for example, described as a Phoenician moon emblem, resembles the experimental arrangements of these same elements in JP-CR 3: 518v and JP-CR 3: 519r (figs. 46 and 54). A skeptic might say that play with these basic formal elements was bound to produce configurations not unlike the Phoenician one, but more striking similarities connect Harding's figure 37 (fig. 55) with JP-CR 3: 525 (fig. 56). The mandala-like forms at the top of Pollock's sheet seem to be variations on the lunar swastikas from Crete, Tibet, and, especially, Sicily that Harding reproduced.[98]

Harding's book was a pivotal text within the APC-NY. If Pollock looked at the articles whose titles he jotted down in the list reproduced above, he would have seen *Woman's Mysteries* cited in several contexts—even Henderson's essay "Initiation Rites" footnoted it. But once again I want to stop short of asserting that Pollock actually used this particular text as a source of images and ideas for his drawings and paintings. There are too many other possible avenues—some, no doubt, still undiscovered—by which he

53. Figures 28 to 31 from Harding, Woman's
Mysteries, *196. Courtesy Northwestern
University Library. See especially figure 29.*

*54. (opposite, above) Jackson Pollock.
Untitled drawing, JP-CR 3:519r. 1939–40.
Orange pencil on paper, 36 × 28 cm.
Collection of Gina and Nemo Librizzi.
Photograph courtesy Nielsen Gallery, Boston.*

Fig. 28

Fig. 29

Fig. 30

Fig. 31

might have encountered similar material. De Laszlo, after all, acknowledged that she explained the Jungian notion of rebirth to Pollock. Her explanation might well have utilized imagery of the lunar cycle, a common vehicle for the rebirth idea in APC-NY discourse. She recalled that Pollock

> had an affinity for the moon, which I associated with the feminine element in his nature, and in these disparate drawings—little improvisations, or whatever you wish to call them—quite often a half moon would appear.[99]

If de Laszlo did articulate her associations with Pollock's moon imagery, the discussion might have had impact on Pollock's *Moon-Woman* paintings. But the Henderson drawings indicate that Pollock's introduction to the Jungian moon-female-unconscious idea-chain had occurred much earlier.

Woman's Mysteries is perhaps the most explicit treatment of this idea-complex. As a

Fig. 35

Fig. 37

Fig. 36

Fig. 38

Fig. 39

55. *Figures 35 to 39 from Harding,* Woman's
Mysteries, 205. *Courtesy Northwestern
University Library. See especially figure 37.*

result of the book's influence, moon symbolism became an abiding interest of the APC-NY. Harding intended in studying this symbolism to uncover the features of the "feminine principle." In ancient times this principle, an essential ingredient of mental life, had been given expression naturally. The modern era, however, had come to favor the "masculine principle," the logos, to the neglect of the feminine eros, and contemporary crises were the result. This argument bears a strong structural resemblance to Modern Man discourse, where the neglect of spirituality or other deep-rooted impulses or needs in human nature, or some imbalance in human endeavor, was held responsible for modern calamities. Harding was optimistic, however.

> We have given our allegiance too exclusively to masculine forces. Today, however, the ancient feminine principle is reasserting its power. Forced on by the suffering and unhappiness incurred through disregard of the Eros values, men and women are turning once again towards the Moon Mother, not, however, through a religious cult, not even with a conscious knowledge of what they are doing, but through a change in psychological attitude. For that power, which in ancient and more naïve days was projected into the form of a goddess, is no longer seen in the guise of a religious tenet but is now sensed as a psychological force arising from the unconscious, having, as had the Magna Dea of old, power to mould the destinies of mankind. (P. 324.)

The importance of moon imagery was, in Harding's view, that it embodied the purest expression of the feminine principle—it was the primary form onto which men and

56. Jackson Pollock. Untitled drawing, JP-CR
*3:525. 1939–40. Pencil and red pencil on
paper, 36 × 28 cm. Collection of Mr. and
Mrs. Leonard Granoff. Photograph courtesy
Nielsen Gallery, Boston.*

women of ages past had projected unconscious materials. By analyzing the numerous forms given it, Harding could both demonstrate its universal presence in human mind and nature and distill a set of essential features. Her point of departure was Jungian—specifically Jung's symbol theory and notion of the anima. The book began as a study undertaken at Jung's suggestion. "It originated in a study of the symbolism of the Crescent and the rites of the Magna Dea of the East, which was undertaken at his [Jung's] suggestion for presentation to his Seminar Group, when he was discussing the masculine and feminine principles, as they appeared in dreams" (p. ix). Harding stated the relation moon-female-unconscious as follows:

> The myths of the Moon Goddess and the characteristics she possesses shadow forth a truth which could not be perceived directly by human beings, namely: the inner subjective reality of feminine psychology. In the past the moon represented, and in man's unconscious imagery still represents today, the picture or image of the feminine principle which functions in men as well as in women. But while in women's psychology it is the dominant principle, it is for men the ruler of the night only, the *principle* under whose aegis the *unconscious* functions. (P. 71. The italics are Harding's.)

Harding embraced the stereotypical terms in which the male-female opposition is constructed in Jungian theory. The male principle was the logos, rational and objective; the female was eros—instinctive, emotional, subjective. She accepted the associations male-sun-consciousness and female-moon-unconsciousness, which, as I indicated above, were fundamental structural poles of Jungian theory.

> In the symbolism we have been considering and which seems to be practically universal, the feminine principle or Eros is represented by the moon and the masculine principle or Logos by the sun, as the Creation myth in Genesis states: God created two lights, the greater light to rule the day and the lesser light to rule the night. The sun as masculine principle is ruler of the day, of consciousness, of work and achievement and of conscious understanding and discrimination, the Logos. The moon, the feminine principle, is ruler of the night, of the unconscious. She is goddess of love, controller of those mysterious forces beyond human understanding, which attract certain human beings irresistibly to each other, or as unaccountably force them apart. She is the Eros, powerful and fateful, and incomprehensible. (P. 228.)

Harding's goal was not to challenge this construction but to valorize the feminine side of it, to restore to the female principle the significance and recognition it deserved and demanded.

Much more could be said in summary and clarification of Harding's arguments, but I think the lines essential for present purposes are reasonably clear. Jungian theory contained as a structural principle a notion of the psyche as gendered, and the predominantly female APC-NY took special interest in developing the analysis of the feminine components of the mind. Harding led this initiative, if published work is an adequate indicator. Her research on moon imagery as well as on the mother archetype strongly influenced the collective work and thought of the APC-NY.[100] Within that group a distinct picture of the feminized unconscious emerged, constructed as lunar, mysterious, changeable, and polarized between good and bad aspects. Since Pollock's contact with Jungianism was mediated largely by this club, we might expect to find that he shared their conception of the mind. And, indeed, there are significant indications in the early drawings and paintings that Pollock conceived of the unconscious as feminine and lunar in character.

The connection between moon and woman is secured rather firmly in some of the Henderson drawings. Several of them contain female figures with crescent or disk-crescent forms composing the genital area. In JP-CR 3: 522r (fig. 50), for example, the triangulated female form at the top of the page has a horizontal crescent where her genitalia should be; it is offset by the disk breasts above and by the disk-crescent amalgamations at the upper and lower left of the figure. JP-CR 3: 525 (fig. 56), the drawing that contains the lunar swastikas, also shows a female figure at the lower left with disk-crescent head and another crescent beneath her pubic region. And JP-CR 3: 547 (fig. 57) has been singled out by Langhorne for precisely this reason; it presents a female figure with genital area composed of a small disk nestled within a larger crescent.[101]

The moon-woman link is also forged in the titles of some of Pollock's early paintings. The obvious point of reference here is the set of three *Moon Woman* paintings Pollock produced between 1941 and 1943 and included in his first solo exhibition (see, e.g., fig. 73). If, as there is good reason to believe, these titles were motivated, in part at least, by Pollock's exposure to the Jungianism of the APC-NY, then they would have been meant to suggest that the subject of the paintings was Pollock's, or the, unconscious. This impression is reinforced by the continuation of imagery from the Henderson drawings, which has led some of Pollock's Jungian interpreters to read these paintings as documenting his psychic condition. But the Moon Woman was not a fabrication of Pollock's unconscious or his imagination. She was a noteworthy presence in U.S.

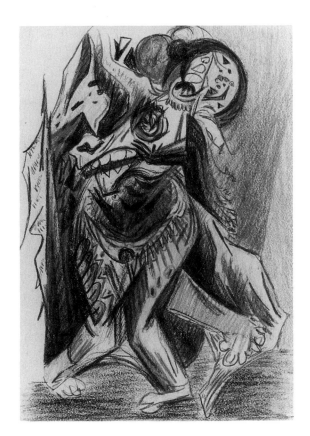

57. *Jackson Pollock.* Untitled drawing, JP-CR 3:547. *1939–40. Colored pencil on paper, 38 × 28 cm. Collection of Marisa del Re Gallery, New York.*

culture of the 1940s, most prominent and most accessible to Pollock in the discourse of the APC-NY.[102] As Jungian metaphor for the anima or unconscious, the moon woman seems to have served Pollock, for a while at least, as an armature upon which to construct a representation of the unconscious.

Furthermore, in Jungian discourse, the moon woman was also the goddess of creative inner activity and, especially, of art. Jung presented both Picasso's paintings and Joyce's *Ulysses* as issuing from the domain of the moon goddess. In *Woman's Mysteries* Harding summarized his point as follows.

> In his recent book *Wirklichkeit der Seele* C. G. Jung has discussed two such art products, namely, the art of Piccasso [sic] and the *Ulysses* of Joyce, and has shown how these works also follow a law, but not the law of reason, the masculine Logos. Instead they turn aside from the rational and the consciously controlled and go by the path of the left, which leads down to darkness, into the primordial slime from which life first emerged. In these depths are the dark, sinister, feminine beginnings. It is the dark *Yin*. A region ruled over, not by the bright Logos of intellect, but by the dark Eros of the feelings. (P. 222)

The moon woman, as embodiment or ruler of the unconscious, was associated with various recurrent themes and symbols in Pollock's early titles and imagery—night, magic, birth and rebirth, snakes, bulls, and so on. Harding argued,

> The Moon Goddess, however, is not only Goddess of Storms and of Fertility, that is, of disturbances and creations in the outer world, she is also goddess of disturbances and of creative activity which take place in the inner world. She is responsible for lunacy and, on the positive side, is Giver of Vision. . . . Thus the Underworld Queen is mistress of all that lives in the hidden parts of the psyche, in the unconscious as we should say. She is the Goddess of Magic and of magicians. Contact with the dark side of the Moon Goddess was considered to be the sole reliable instrument for the working of magic. (Pp. 95–96.)

> Thus the Moon Goddesses in their underworld phase, are often represented as snakes or as carrying snakes in their hands. (P. 192.)

> . . . horned animals, especially the bull and the cow, are among the animals associated with the moon. (P. 55.)

Troubled Queen, Birth, Night Magic, Moon Vessel, Night Dancer, Night Ceremony, High Priestess—collectively Pollock's titles evoke a Jungian conception of the unconscious over which the moon woman–anima presides. Of her two aspects the terrible one prevails in these images, as it does in the male psyche generally. The calm figure of *The Moon Woman* (1942; fig. 73) is rendered "mad" in one work (*Mad Moon-Woman* 1941), violent in another (*Moon-Woman Cuts the Circle* 1943). "Cutting the circle" is an ambiguous action not much clarified by Jungian writing on the moon woman. Perhaps she cuts the circle of the full moon to produce the crescent, or she may so appear in her character as Opener of the Womb, or as the deity to whom circumcisions were dedicated (*Woman's Mysteries*, pp. 102, 98, 170). Other paintings from this same time, such as *She-Wolf* and *Pasiphaë* (fig. 9), also evoke a bestial, violent, dangerous anima; it may have been, in fact, the matter of gender that made *Pasiphaë* a more appealing title for Pollock than his prior choice, *Moby Dick*. Many fewer works from the early 1940s have masculine titles than have feminine ones.[103]

The construction of the unconscious as feminine was a distinctive feature of Jungian psychology and a pronounced element of Pollock's efforts, especially early on, to

represent the unconscious. This link might be taken to reveal something of Jungianism's attractiveness to Pollock as well as something of its influence upon him—to reveal, that is, a possible source of Jung's hold on Pollock and evidence of that hold. There is considerable evidence Pollock believed that the moon was an important factor in his psychic life, although it is impossible to know whether this was an influence of his Jungian analysis or a preexistent belief that would have made him especially receptive to Jungian theory. In recounting an illuminating incident he recalled from around 1940, one of Pollock's friends, Reggie Wilson, connected Pollock's interest in the moon with his attraction to the paintings of Albert Pinkham Ryder.

> As a lot of us were, he was very moved by the work of Ryder, and he had a thing about the moon. One night we'd had a couple of beers at that Frenchtown hotel and there was a bright moon. After we'd gone to our rooms we heard a great noise on the roof, so Bernie Schardt and I went out and saw Jackson up there. He was running back and forth along the ridge pole, waving his fists at the moon and shouting, "You goddam moon, you goddam moon!" We talked him down after a while, but we were really scared![104]

Lee Krasner recalled of Pollock that

> the moon had a tremendous effect on him. . . . He painted a series of moon pictures, and spoke about it often. This is one of the things we had in common, because the moon had quite an effect on me, too. It made me feel more emotional, more intense—it would build a momentum of some sort for me. He spoke of the moon quite often. He referred to *Portrait in a Dream* [sic] as "the dark side of the moon." There was a whole series of moon paintings—*Moon Woman, Mad Moon Woman, Moon Woman Cuts the Circle.*[105]

In an earlier interview Krasner had been more precise about *Portrait and a Dream* (fig. 29).

> I only heard him [talk about the imagery of his paintings] once. Lillian Kiesler and Alice Hodges were visiting and we were looking at *Portrait and a Dream*. In response to their questions, Jackson talked for a long time about the left section. He spoke freely and brilliantly. I wish I had had a tape-recorder. The only thing I remember was that he described the upper right-hand corner of the left panel as "the dark side of the moon."[106]

Another title from that same year—*Moon Vibrations*—attests that the moon's presence in Pollock's paintings spanned his mature career, as did his interest in the unconscious.

The vehemence with which Pollock embraced the anima–moon woman as personification of the unconscious suggests that this image struck a responsive chord. Although the source of its power need not be in his own psychological condition or experience, that possibility merits consideration. The notion of the anima seems to have provided Pollock with the basis for a recognition, or acting out, or "admission," of "feminine" components in his psyche and sexuality. If the recognition of these components troubled him, or if he experienced any sexual ambivalence during these early years, the concept of the anima would have helped him to understand and address the difficulties. The case for this hypothetical explanation of Pollock's fascination with the feminized unconscious rests upon various types of evidence. Some can be found in the early drawings—JP-CR 3: 555, in which a lower torso of indeterminate sex is penetrated by a huge shaft emanating from the earth, would be an obvious starting point. Some can be found in biographical data—for example, his brother Sanford's recollection, noted earlier, that in 1938

Dr. Wall of Bloomingdale attributed psychological significance to Pollock's interest in drawing the male nude.[107] Such evidence is fragmentary and cannot be pushed too far; but considered alongside the intensity with which Pollock explored this imagery, it prompts speculation that certain psychological motivations played some part in his attraction to Jungianism in general and, in particular, to this specific theme within it.

One further structural component of Jungian psychology should be mentioned at this point, although it raises a question too large to be examined thoroughly here. Jungianism shared with other forms of depth psychology and with certain tendencies in philosophy (exemplified by Cassirer and Langer) a confidence in the privileged status of symbolism within mental processes. Jungian analysts seem to have been especially inclined to view the language of the unconscious as one of essentially visual symbolism. The rich imagery of many of the passages quoted above will have struck many readers already. The Jungian belief in the universality of symbols, as products of the collective unconscious, made interpretation of them generally a simpler, relatively codifiable process—mired less in the contingencies of a particular case—than it became in other interpretative systems. This simplification, in combination with the positive aesthetic delight Jung and his followers took in working with symbols, made Jungianism well suited to artistic representation of the unconscious. It offered a rich store of visual images and an unrestrained celebration of symbolization without imposing strict equivalencies between particular symbols and specific meanings.

> As opposed to an objective, conscious representation, all pictorially represented processes and influences in the psychic hinterland are symbolic: that is, they stand for and point out, as well and as closely as possible, a meaning not at the time known.[108]

The importance of ambiguity was acknowledged by Jungian writers.

> Of a symbol we can never say "this is this," or "that is that," translating each factor into equivalent terms of the known. For the symbolic creations of the unconscious contain layer after layer of meaning which cannot be exhausted in a word.[109]

This observation is valuable not only in terms of assessing the appeal of Jungian symbol theory to Pollock; it is also effectively cautionary, warning against mechanical interpretation of Pollock's symbols in an effort to read the psychological meaning of his works. The Jungian interpreters have tended to take precisely this latter tack, using Jungian symbolic paradigms. My intention, on the other hand, is to locate the paradigms in the art and determine the nature of their utility and appeal to Pollock and his audience. Jungianism seems to have offered just what many artists interested in the unconscious and mental process, including Pollock, would have wanted: it offered symbolization as the language of the unconscious, a core set of unconscious symbols, a field of peripheral and variable symbols, and an imaginative and challenging example for assembling and interpreting those symbols. Pollock knew the strength of symbolization as well as the necessity of ambiguity. His paintings of the early 1940s move away from the Henderson drawings in the direction of less clarity and readability of the symbols. The painting *Guardians of the Secret* (fig. 27), the title of which may have been inspired by Theosophical doctrine or by Jung's analysis of that doctrine,[110] contains a central rectangular slab on which legible symbols and images were originally drawn.[111] Pollock obscured these in the finished painting, giving an early demonstration of his characteristic inclina-

tion to "veil" his images. His painting elicits reading as a metaphorical representation of the problem posed by the unconscious and its guarded, inaccessible, secret meanings. A somewhat literal reading might see the mind's censorship mechanisms as personified by the figures flanking and behind the central tablet, which is filled with illegible marks. Pollock has resisted inscribing the secret tablet—metaphor for the unconscious, as well as for the canvas—with Jungian archetypal symbols, opting instead for suggestive but indecipherable markings. Marks ordinarily function in painting to yield or elicit meanings, but here they refuse legibility at precisely that site in the picture where legibility seems most important. By thwarting meaning-production at this level, the marks come to stand for the meaning-effect; they signify illegibility. Here as elsewhere in his drawings and paintings from the late 1930s and early 1940s, Pollock showed evidence of learning from Jungian discourse a method of working with symbols, integrating them, and balancing legibility with obscurity. He knew the lesson Meyer Schapiro articulated in the 1948 *Life* magazine "Round Table on Modern Art": that the privacy of symbolism was the guarantee of its validity; if the usage was too programmatic or too predictable, it was unconvincing as personal expression.[112] Pollock's high regard for symbolization as well as his way of handling it are subtle indications of further Jungian influence upon Pollock's thought and art.

THERAPY AND INTERPRETATION

There are various ways Pollock might have picked up the various bits of Jungian doctrine and practices and the Jungian model of the unconscious embedded in his early work; Henderson and de Laszlo are only the most likely avenues. We can only speculate about the precise character of their discussions with Pollock, but we can find in contemporary Jungian literature influential paradigms for the productive engagement of visual imagery by Jungian theory. It is significant, for example, that Henderson admired H. G. Baynes' treatment of visual material in *Mythology of the Soul,* a painstaking interpretation of nearly fifty drawings produced by two patients undergoing analysis with Baynes. In a preface written for a reprinting of the volume, Henderson recalled having participated with great interest in discussions with Baynes concerning issues addressed in the book, discussions that must have occurred immediately prior to the time of Pollock's analysis with Henderson.

> When Dr. Baynes was writing *The Mythology of the Soul* I was a frequent week-end guest at his house in Surrey. . . . From our conversations of that time I recall two main themes of special interest to which Baynes seemed always to return, how the methods of depth psychology could be applied to the treatment of schizophrenia and to the interpretation of schizophrenic-like products of modern art. . . . He reacted directly to the artist or the art product and only secondarily to a possible psychiatric diagnosis, so that in a large number of cases he found there was no diagnosis to be made. It all depended on whether the artist was truly expressing a primordial image appropriate to the spirit of his time, or merely a personal complex.[113]

Precisely this sort of dual interest characterizes and problematizes Jungian analysis of visual art. Henderson makes it seem a clear-cut matter, but how, in practice, is one to make the distinction? Given the ambiguity of much of the imagery and its openness to

various readings, very much would seem to rest upon the inclinations of the analyst. If a body of imagery is available to reading as archetypal and as corresponding to a healthy configuration in terms of Jungian theory, and if an analyst is inclined to look for these features, a drawing might qualify as a "primordial image appropriate to the spirit of the time." Obstacles to such a reading or an analyst's inclination to look for signs of mental dysfunctioning are likely to produce evidence of "a personal complex." Approval is most likely to characterize the reception of a patient's visual imagery when that imagery is structured upon archetypal symbols and is arranged in conformity with established lines of analytic interpretation. This is something that can and will be learned by the patient, a fact implicitly acknowledged by the practice of placing greatest emphasis upon the first dreams and drawings of a person entering analysis.[114]

Baynes' interest in applying Jungian theory to the interpretation of visual materials was shared not only by Henderson but by many of the other members of the APC-NY. Several of them published books that gave this project serious attention—Harding's *Woman's Mysteries* and Frances Wickes' *The Inner World of Man* would have ranked with Baynes' book as the most influential. The club's profound interest in the Picasso exhibition that opened in November 1939 at the Museum of Modern Art is further evidence of this collective concern. In this milieu, Pollock would have been an extremely interesting and challenging case for Henderson, one allowing him to test himself against the examples of his own teacher, his colleagues, and even the master himself. Jung's "Study in the Process of Individuation," a case study focusing on a patient's drawings, had recently been published as chapter 2 of *The Integration of the Personality.* As Picasso was to Pollock, so Jung and Baynes were to Henderson. Such considerations allow further insight into Henderson's admission of initial lack of interest in trying to cure Pollock and of "compulsion to follow the movement of his symbolism." Henderson's fascination with Pollock's symbolism and his desire to ascertain his own competence in reading it could very likely have resulted in his teaching Pollock about Jungian symbol theory—or, to put it another way, in his helping Pollock shape himself as a Jungian subject—to a much greater extent than he realized.

For his part, the young Pollock stood to learn a great deal from his contact with the APC-NY. Confused and troubled, becoming convinced by friends and by the influence of the contemporary cultural fascination with psychology that his behavioral problems were psychological, Pollock could have gained—and no doubt did—many things from his analytic experience. His effort to comprehend the workings of his mind and the character of his unconscious led him to absorb many principles and procedures from Jungian theory, with or without the complicity of his analysts. Jungianism affected his thinking not only about his personal situation but about broader issues of human nature and world history. Its rich symbolics, its feminized unconscious, and its orientation toward transcendent unification provided him with more than artistic materials; they also participated in recasting his notions of self and mind faltering under personal stresses and cultural pressures. His bouts with depression, alcoholism, and violent behavior—experiences of a self beyond conscious control—found explanation here. And although Pollock's case may have been exceptionally acute and somewhat idiosyncratic, he was far from alone in finding relief of more or less this sort in Jungian theory at this time.[115]

Jungianism, then, served Pollock in many of the ways reform movements and

associations in the nineteenth-century United States served the displaced youth, the "oddfellows," who had migrated to the cities. It eased his discomfort, and at the same time it socialized him, exerting a measure of social control. Here the relevance of the reformist backgrounds of Marot and the founders of the APC-NY becomes clearest; the participation of these former promoters of the YMCAs, health movements, and social programs underscores Jungianism's appeal as an updated and modernized "order of oddfellows"—a stabilizing institution for the socially and psychologically dislocated.[116]

Pollock, in a sense, was channeled by an influential cultural belief-system into a certain way of conceiving and representing his experience. Conversely, as elements and features of depth psychology came to direct his painting, his work exerted cultural influence of its own. His successful engagement with the fraught subjects of human mind and nature, in terms then current in cultural debate, helps to account for the cultural resonance and impact his work has enjoyed in the United States since his first solo exhibition in 1943.

JOHN GRAHAM

The Jungianism of the APC-NY was not the only factor conditioning Pollock's conception and representation of the unconscious in the late 1930s and early 1940s. Other influences have been more generally acknowledged in prevailing accounts of his intellectual and artistic development. For example, in chapter 2 above, I gave brief mention to the impact John Graham had on Pollock's beliefs about the primitive. Those beliefs were corollary to more comprehensive ideas about the unconscious proposed by Graham, ideas that were essentially Jungian but were given a rather eccentric inflection. The influence of Graham and the knowledge Pollock absorbed from the APC-NY reinforced one another to a considerable extent. Here is Graham:

> It should be understood that the unconscious mind is the creative factor and the source and the storehouse of power and of all knowledge, past and future. The conscious mind is but a critical factor and clearing house. Most people lose access to their unconscious at about the age of seven. By this age, all repressions, ancestral and individual, have been established and free access to the source of all power has been closed.
>
> . . . the art of primitive races has a highly evocative quality which allows it to bring to our consciousness the clarities of the unconscious mind, stored with all the individual and collective wisdom of past generations and forms. In other words, an evocative art is the means and the result of getting in touch with the powers of our unconscious.[117]

Such ideas interacted to mutual advantage with those Pollock developed in his experience with Jungian analysis. Their hold upon him was deep and enduring. One of Pollock's friends, Nicholas Carone, recalled that Pollock often acknowledged his respect for Graham's understanding of such matters. "He said that John Graham understood that infinite well of the unconscious, but tapping that source is very dangerous." Even in the later 1940s, when he was producing the abstract poured paintings, Carone said that Pollock continued to affirm the relevance of Graham to his work.

> I asked Jackson, "Who the hell do you know who understands your picture? People understand the painting—talk about the technique, the dripping, the splattering, the automatism and all that, but who really knows the picture, the content? . . . does Greenberg know what

your picture is about?" Finally he says, "No. He doesn't know what it is about. There's only one man who really knows what it's about, John Graham."[118]

The implication here is that in Pollock's view, the abstract works, too, had significant relation to the "infinite well of the unconscious" as Graham constructed it. The "uncon- sciousness" of these paintings is something Pollock made explicit in other contexts, although this commitment has not been taken seriously in the dominant art historical analyses of the poured works. I will try to show later on in this chapter that, by continuing to trace Pollock's conception of the unconscious, the abstract paintings too can be seen as a form of representation of it.

The relation of Pollock's conception of the unconscious to the ideas of Graham and of other influential voices in contemporary artistic discourse, especially the Surrealists, has been noted at length in the literature on Pollock; little if any attention has been paid, however, to the relation of his thought to extra-artistic cultural developments. Yet this, I believe, is where crucial insight is to be gained into the particular character and the cultural significance of Pollock's representation of the unconscious. I want to begin to move, at this point, from the first question I asked at the beginning of this chapter, Of what did "painting out of the unconscious" consist for Pollock? to a second: Under what conditions would such a project be interesting to a particular middle-class audience? Modern Man discourse will be, once again, a critical element in the analysis; it has, I think, important bearing upon both questions.

MODERN MAN'S UNCONSCIOUS

I pointed out previously in this chapter that very early in his career Pollock was exposed to Modern Man literature, in the form of James Harvey Robinson's *Mind in the Making*, and that he was particularly interested, at the time, in a passage concerning the natural operation of the mind. This contact was not an isolated case. Pollock's library contained at least two other Modern Man texts, both of which have significance for the present discussion. It should be understood from the start that I am not insisting that Pollock read these books and was affected by them. I have not been able to determine when Pollock acquired these books, nor have I found any noncircumstantial evidence that he read them. In any case, the question of direct influence is of minor significance. Although I will want to argue for the *appropriateness* of these texts as sources of ideas for Pollock's work, my primary concern is to draw attention to the mutual interest in the unconscious and to similarities in the representations of this elusive entity.

The first book, *The Importance of Living,* was written by Lin Yutang, a Chinese author residing in New York and well versed in modern Western culture. Lin's contribu- tion to the Modern Man genre was to bring Chinese thought to bear on its central questions. His angle was somewhat unusual, insofar as his emphasis was ostensibly on old knowledge rather than new; but what was old in Chinese culture could and did look quite new in the U.S., and, in fact, many Modern Man authors before and after Lin turned to Eastern philosophy, mysticism, and literature. Moreover, many features of Lin's text indicated that it had been conceived within the parameters of the Modern Man genre. For instance, such writers as Robinson and Alexis Carrel, author of *Man, the Unknown,* were cited in the text; new scientific and social scientific knowledge played an

important, albeit quiet, part in the argument; and the fundamental question of the book was quintessential Modern Man material: What is human nature and how might one devise a mode of living in harmony with it?

Psychological theory received relatively little explicit mention in the text, but its presence can be felt throughout. Lin was an intelligent, alert, and well-read man who seems to have been familiar with Freudian psychology, at the least; both Freud and Jung are cited in *The Importance of Living* (pp. 168, 182). Their work was, presumably, among the specialized researches Lin wanted to see subjected to "the urgently needed process of integration, the effort to integrate all these aspects of knowledge and make them serve the supreme end, which is the wisdom of life" (p. 415). Like most Modern Man authors he was concerned to draw pragmatic and philosophical conclusions from psychological theory in combination with other new knowledge, and in this process a measure of distortion inevitably came into play. Lin's psychological premises were not strictly Freudian or Jungian; what emerges, rather, is a generic depth psychology that mixes elements of both with still other ingredients. The evil in life is portrayed by Lin as having three different psychological or mental causes or sources. It may result from the repression of instincts or drives, which then demand release in violent and distorted form (for example, the sex instinct; pp. 48–49). Or it may, inversely, be an expression of the dark impulses resident within human mind and being (p. 36). Finally, it may come from overdependence on mechanical logic at the expense of reasonableness and intuition (pp. 424–26). All are effects of a failure to appreciate the complexity of human nature and mind. Lin's prescription for minimizing these occurrences is integration of instinct and reason in a harmonious, balanced life.

> Any adequate philosophy of life must be based on the harmony of our given instincts. (P. 143)
>
> When man comes to understand himself better and realizes the futility of warring against his own instincts, with which nature has endowed him, man will appreciate more such simple wisdom. (P. 168)
>
> For such is the duty of the human mind, that it is not called upon to make a stupidly logical argument, but should try to maintain a sane balance in an ever-changing sea of conflicting impulses, feelings, and desires. (P. 424)

Modern Man has to steer a mediate course between the forces to which he is subject—symbolized by yin and yang, positive and negative. Despite Lin's favorable mention of Jung, it may very well be that the latter was not a significant presence in Lin's thought; these and other similarities to Jungian theory may be related rather to Eastern philosophy and mysticism, to which Jungianism itself was heavily indebted. The effect, nonetheless, is of a typical hybrid depth psychology. The problem addressed is how to give release to unconscious material and yet keep it under some control, keep it from emerging as Fascism or Communism—the worry that persists throughout the text, surfacing periodically, and confronted explicitly in the concluding paragraphs. In Lin's view, Fascism and Communism were aberrant and lethal combinations of logic and irrational fanaticism.

> I am less terrified by the theories of Fascism and Communism than by the fanatical spirit which infuses them and the method by which men push their theories doggedly to logical absurdities. . . . In a sense we may say that today Europe is not ruled by the reasonable spirit, nor even by the spirit of reason, but rather by the spirit of fanaticism. (Pp. 425–26.)

The overlap with Modern Man primitivism should come as no surprise. As I have emphasized, the two categories were deeply intertwined and involved in the same ideological processes. Political and social demons lent urgency to the process of reckoning with the unconscious in Modern Man literature.

The Importance of Living is one illustration of the ways in which the psychological ideas that attracted Pollock were being adapted and applied, in hybrid and extended form, by Modern Man literature. These Modern Man variations may have affected Pollock's thinking; they may have reinforced his conviction of the importance of the concepts; they may have suggested new relevance for the ideas in personal, social, or political spheres; or they may simply demonstrate for us how the ideas were functioning within one set of cultural concerns as expressed and addressed in one set of cultural productions. Before endorsing any or all of these options, I want to introduce some further evidence.

Another Modern Man text in Pollock's library—Harvey Fergusson's *Modern Man: His Belief and Behavior*—merits more extensive consideration. The connections between Fergusson's book and Robinson's, and the place of both in the genre that I am calling Modern Man literature, were perceived by some contemporary critics. Horace M. Kallen, a philosopher whose own work participated in the development of Modern Man discourse,[119] made the point in the *Saturday Review of Literature*.

> Shortly after the war, James Harvey Robinson wrote a little book on human nature and human destiny which he called "The Mind in the Making." Since then there has been a series of such books by amateurs of philosophy expressing much the same mood and the same faith. The last in this series which has come my way is "Modern Man, His Belief and Behavior." Mr. Harvey Fergusson, the author, is described as a novelist. Concerning his merits in that calling I have no judgment, not having had the luck to read any of his stories. But I am highly intrigued by his quality of psychologist and philosopher manifest in the tangencies and incidentals of his argument.[120]

Fergusson was primarily a novelist, although he was also a journalist and screenwriter as well. His background and professional training were rather different from Robinson's, but his wide range of interests and enterprises was typical of Modern Man authors.

Harvey Fergusson (1890–1971) came from a Southern aristocratic family that had relocated in Albuquerque, New Mexico, after the Civil War. By the age of eleven he had his own horse and gun. He attended college in Virginia, then moved to Washington, D.C., where he became a newspaper reporter and aspiring novelist. After publishing his first two novels in 1921 and 1923, he moved to New York City and wrote five more before 1930. At this point in his career Hollywood beckoned, and Fergusson responded, spending the next ten years there as a screenwriter. Most of these enterprises were collaborative and apparently forgettable, but films were made of two of his novels— *Wolf Song* (1929), starring Gary Cooper, and *Hot Saturday* (1932), starring Cary Grant. He continued to write books during these years and produced a novel, a work of history called *Rio Grande* (1933), and *Modern Man* (1936). In 1942 he moved to Berkeley, California, where he remained until his death in 1971. He continued to publish until 1954, producing three more novels, and one more work of nonfiction, titled *People and Power* (1947), which dealt with political behavior in the United States.

With few exceptions, Fergusson's novels are set in the American Southwest. These latter books have been described as opening "a new vein in American fiction—the

realistic interpretation of New Mexican history and contemporary life." Throughout his life, Fergusson returned to Taos and Santa Fe "for material and renewal of literary inspiration." He has been the subject of at least three monographs, none of which makes immodest claims regarding his achievement or importance. Fergusson's tendency to allow philosophizing to become too blatant a component of his work is frequently lamented.[121]

Modern Man is a book of practical or amateur philosophy, psychology, sociology, anthropology, and art theory. Very much in the mold of *Mind in the Making,* although more attentive to the nature of art and the creative process, it is an attempt to outline a theory of human behavior and history based on personal observation and then-current knowledge. It tries to purge modern thinking of outworn beliefs and assumptions that had once served a social function but were no longer tenable, such as the existence of choice, or free will. The book is divided into three sections. The first, "The Illusion of Choice," argues that belief in free will or human choice

> is not in harmony with modern knowledge, which constantly contradicts it. . . . [i]t is a cultural survival from primitive and medieval conditions. (Pp. 14–15)

Fergusson proposes an alternative view that all action is a product of inner necessity (impulsion) or outer necessity (group or social compulsion). Freedom, or autonomy, consists in maximizing the role of the former and minimizing that of the latter. Part 2, "The Ethic of Balance," describes the states of equilibrium an individual must achieve internally, between conflicting impulses, and externally, between himself and his social group, if he is to partake fully of the growth and action that constitute life. Perfect internal balance is a goal rarely achieved (but a requirement of the great artist); most people have to lean on extrinsic supports (tradition, habit, group values, and so forth) to achieve balance. The amount of support offered by a group varies inversely with its size, and Fergusson contends that individuals gravitate toward the size and structure—on the scale from village to metropolis—that offers the measure of support each needs. Finally, part 3, "The Growth of Consciousness," describes the deliberate process of integrating belief and behavior, the rational complement to the trial-and-error achievement of balance.

Although heavily indebted to Robinson—perhaps indirectly, since his influence is not acknowledged—Fergusson's presentation is unlike others in the Modern Man genre in some respects, most of which are peripheral to its central theses. Most significant, its abstract passages mingle with discussions of a rich variety of practical subjects presented in a homey, engaging tone, no hint of which is given in the above synopsis. A listing of some of these subjects bears a marked resemblance to Pollock's interests and problems at this time. Fergusson displays a deep love of the American West, and much of his discussion centers on the contrasts between metropolitan and small-town life. He reflects at length upon the difficulty of adjustment for anyone moving from a small town to the big city. Fergusson is also interested in comparing the art and psychology of the American Indians, as representatives of primitive man, with those of modern man. Another cluster of themes concerns the causes of alcoholism, violence, neurosis, and insanity and the role in these played by the biochemistry of the body. All of these subjects would have had immediate relevance for Pollock in the late 1930s and 1940s.

Politically, Fergusson reveals himself to be a nonrevolutionary, anti-Stalinist Social-

ist, and he discusses capitalism, John D. Rockefeller, and Socialist goals in a tone with which Pollock surely would have sympathized. Thinkers and authors in whom Pollock was interested, such as Einstein, Freud, Joyce, Eliot, Proust, and Frazer, are given varying measures of attention and sympathy. By no means do I want to imply that Pollock would have agreed with Fergusson's treatment of all these subjects, especially his criticisms of Freud and Joyce; nonetheless, he likely would have been interested in the discussion.

Modern Man is written in simple language, makes frequent use of analogy, and is best read impressionistically, since close analysis reveals contradiction and confusion in the text. But this should not imply that the book is simple-minded. Fergusson had read widely, albeit not as widely and discriminatingly as Robinson or some other Modern Man authors, and he saw his thought as deriving from C. S. Peirce, Henri Bergson, and Havelock Ellis, among others. I have already given some indication of the critical response to this work in the positive review by H. M. Kallen, a professor of philosophy at the New School for Social Research. The *New York Times Book Review* gave *Modern Man* its unqualified stamp of approval.

> The result is a singularly satisfying performance. In a few respects, indeed, it is unique. . . . [Fergusson] has taken the liberty to think for himself, without bothering to ascertain in advance whether or not his thoughts would prove to be in harmony with those of Marx or Pareto. Like a true philosopher, he began by observing his own consciousness and behavior. Much of his comment on modern man arises from his discovery that he himself "seldom, and strictly speaking never, did what he intended." This seems a simple observation, yet there hangs onto it an argument which is almost a new presentation of the problem of civilized man—and which makes this, indeed, one of the most civilized books of our rather uncivil period. One may speak of it in the same breath with "The Dance of Life" without doing an injustice to Havelock Ellis.[122]

Scholarly journals condescendingly noted the author's lack of familiarity with much previous discussion of his themes, but even these usually found something of value in the book. R. H. Waters wrote in the *American Journal of Psychology*, "The chief importance of the book rests upon the fact that the author is a keen observer, and that he puts old problems in a new and suggestive setting. The reviewer feels, also, that there is a definite place for a book that attempts to picture in simple, direct language the basic assumptions and principles underlying the behavior of modern man."[123] Most academic reviewers commended the author's ambition and seemed to be taken with the refreshing eccentricity of the result.

My synopsis is intended to serve a number of purposes: clarifying the notion of a "Modern Man text" by sketching a typical example, indicating the widespread interest in the issues addressed in such texts, establishing the potential appeal of such a literary source for Pollock, and providing a framework for more detailed consideration of the psychological premises of the text and of the relation of these to Pollock's developing notions.

POLLOCK AND FERGUSSON

In the catalogue for Pollock's first solo exhibition, James Johnson Sweeney wrote:

> Pollock's talent is volcanic. It has fire. It is unpredictable. It is undisciplined. It spills itself

out in a mineral prodigality not yet crystallized. It is lavish, explosive, untidy. . . . It is true that Pollock needs self-discipline. But to profit from pruning, a plant must have vitality.[124]

Pollock was thus challenged to discipline himself and his talent, and what such a process might entail was suggested by Sweeney's metaphors: tidying, pruning. What Sweeney had in mind was some sort of active ordering or controlling, and in view of this, Pollock's response may seem a bit strange.

> The self-discipline you speak of—will come, I think, as a natural growth of a deeper, more integrated experience.[125]

For Pollock the process is not active at all, or at most, indirectly so. The acquisition of discipline is apparently not immediately within his power; his sights are on a deeper, more integrated experience, though it is not clear whether even this is something he can actively pursue. Further ambiguity results from his retention of Sweeney's term *self-discipline* when it appears that Pollock would more properly have used *discipline*.

The peculiarities of this reply deserve closer scrutiny despite the risk of overwhelming a casual, personal message with ponderous exegesis. The preceding discussion has paved the way for interpretation of Pollock's statements as heavily influenced by his experience with Jungian analysis and theory. *Integration* was indeed a key concept for Jung, and if Pollock applies it to experience rather than, as a more scrupulous Jungian would, to the structures of the psyche, he cannot be faulted much for that. A bit more troublesome is the fact that according to Jung's writings it takes discipline to achieve integration, nor integration to achieve self-discipline, as Pollock would have it. Either Pollock's understanding of Jung was imprecise, or some other ideas may be in play alongside them. Perhaps Lin Yutang's sense of the word *integration* has some relevance here, or Harvey Fergusson's.

Indeed, Fergusson's *Modern Man* may be used to shed some light upon Pollock's thinking, but the help it provides is on the order of guidance rather than definition. That is to say that if Fergusson's notions were known to Pollock and did influence him, they were no doubt absorbed and applied with an admixture of contributions from numerous other sources. But there is a distinct note of confidence in Pollock's use and arrangement of his key terms—discipline, natural growth, integrated experience—the terms also of *Modern Man,* and this confidence suggests that an argued account of mind and behavior linking these terms may have been encountered by Pollock, found persuasive, and assimilated to some degree.

Three component ideas can be extracted from Pollock's response: that discipline is not an active process; that it is, rather, a product of nature; and that it results from a condition of integration. Concerning the first, Fergusson wrote:

> I ask the reader to free his mind, for the time being, of the usual conception of discipline as a human invention to which he must submit or which he must impose upon himself.

This request is a corollary to his argument involving the second idea.

> The discipline of growth and action is not a human achievement, but a natural condition; not a thing which man must devise for himself, but a thing of which he may make more use by becoming more conscious of it.[126]

Before proceeding to the third idea, some enlargement upon these first two is necessary.

The context within which they operate is a refutation of what Fergusson calls "super-naturalism," that is, any view that assumes man differs in a qualitative way from other living organisms. Just as there is only one source of energy responsible for trees as well as artworks, there is only one order of being. Consciousness does not distinguish and elevate man, because animals display a capacity for a lower order of consciousness in their ability to develop inhibitions, to sustain group life, to be educated, and to go insane. Consequently, the conception of man and nature as diverse or opposed is rejected outright by Fergusson. Another of Pollock's remarks becomes relevant here: only a year before writing the letter quoted above, Pollock had been introduced by Lee Krasner to Hans Hofmann. When Hofmann observed that Pollock worked "from the heart" and suggested that he try working from nature, Pollock replied, "I am nature." Difficult as it is to pry this remark loose from the myth of Pollock as primitive genius, the statement may be viewed as assenting to arguments close to Fergusson's.[127]

Fergusson proceeds from his demonstration of the man-nature fusion to a discrediting of the assumption that order is a quality imposed by man upon nature and himself. Man is not the creator of order but rather is subject to the inherent order of nature and life. All growth and action, human and natural, issue from pulses of spontaneous energy that contain within themselves their own form, order, and discipline. A tree, for example, "grows spontaneously out of the earth."

> As the tree grows, it throws out branches in all directions, and it also tapers as it rises. In a word, it takes form in order to keep its balance. If the tree is fortunately situated, like a blue spruce growing in the open and in favorable soil, it may achieve an almost classic symmetry, piercing the sky like an arrow-head. And this symmetry is the very condition of its growth. The tree must have form in order to have balance, and without balance it could not rise. (P. 181)

More generally stated, the point is that

> There can be no growth without form, no action without balance. Form and balance, which are but two aspects of the same thing, are the conditions of all spontaneity and therefore of all life. (P. 184)

Therefore, ordered form and symmetry in balance are inherent in any smooth flow of spontaneous energy. There is no need nor real possibility for human disciplining of growth or action—discipline is taken by Fergusson to be an effort toward ordering—and this brings us back to his statements on discipline quoted originally. As far as I have been able to determine, this is a rather unusual view of the nature of discipline, and Pollock's use of the term *self-discipline* in this peculiar sense hints at contact with Fergusson's ideas.

The third component idea in Pollock's statement also has an analogue in *Modern Man*. Fergusson recognizes, of course, situations in which disorder and asymmetry prevail and discipline is lacking. This occurs when the flow of spontaneous energy has been obstructed, usually by a condition of imbalance. Unless the whole range of conflicting impulses present in every human consciousness is kept in a state of equilibrium, with or without the help of extrinsic supports, a spontaneous impulse is not permitted full realization in action. There is no growth or action without balance; what remains is mere movement. Disorder exists to the degree that growth and action are inhibited.

An integral component of balance is belief. If belief and action, or behavior, become

discoordinated, the affected person may be said to lack integration of consciousness. Fergusson tells us that his purpose in writing *Modern Man* is to effect such integration. "An attempt at intellectual integration, such as I am now making . . . is essentially an effort to integrate all I believe with all I do" (p. 56). Without this condition of integration, the achievement of individual balance is inhibited, and action is impaired. The art produced by someone with this problem would manifest a disintegrative style, lacking order and discipline. It is noteworthy that a primary cause of disintegration of consciousness, in Fergusson's theory, is a period of rapid change in which the individual is unable continually to revise his beliefs and bring them into alignment "both with the conditions of life, on the one hand, and with the state of knowledge on the other" (p. 11). That the troubled young Pollock may have identified with this predicament is a plausible speculation.

Although it is never articulated by Fergusson, a strong implication of the discussion of the disintegrative condition is that the individual is not fully integrated with the fluid, natural unity that is all creation. Consider the following description of the state of "passionate detachment and loss of the subject in the object that is the first essential of genius in art."

> Any man who is wholly absorbed in what he is doing—in the object of his work or love—is then exercising his genius, whether he is writing a poem, building a boat, wooing a girl, or knocking a home run. He is then wholly unfrightened, perfectly balanced, and in perfect equilibrium with the object of his energy. He has no more illusion of choice than a river on its way to the sea. His energy flows powerfully into its inevitable objective . . . He and his environment are one, and for the moment he experiences the essential unity of being. (P. 258.)

This vision of total integration is one that Pollock—the youthful mystic, the painter in "pure harmony" with his painting, the painter of *One*—apparently shared.

It will perhaps be objected that a more plausible source for Pollock's notions of the natural discipline of form and growth is D'Arcy Thompson's well-known and widely read *On Growth and Form*. This book, too, was in Pollock's library, although the edition was rather late—1948.[128] Pollock could, of course, have encountered or read the book long before he owned it, or never have read it at all in spite of having owned a copy. Juxtaposing Fergusson and Thompson raises interesting questions about plausible intellectual frames for Pollock's ideas. It has become a commonplace of accounts of Pollock's intellectual biography that Thompson's book was an important influence, although it has never been made clear when it became so nor how the influence is manifest.[129] Presumably, the assumption is that Matta or others in Surrealist circles infected Pollock with an interest in morphology. An excerpt from *On Growth and Form* is revealing in comparison with the Pollock letter to Sweeney, in regard to both the nature of the terms employed and the texture of the language. I found no passage of Thompson's paralleling Pollock's, so I offer his definition of growth.

> The form of organisms is a phenomenon to be referred in part to the direct action of molecular forces, in larger part to a more complex and slower process, indirectly resulting from chemical, osmotic, and other forces, by which material is introduced into the organism and transferred from one part of it to another. It is this latter complex phenomenon which we usually speak of as growth. (Vol. 1, p. 82)

This excerpt reveals that form is treated by Thompson, as he says, in "a very concrete

way . . . [as] a quasi-mechanical effect on Matter of the operation of chemico-physical forces" (vol. 1, p. 81). His intention in writing *On Growth and Form* was to offer "an easy introduction to the study of organic Form, by methods which are the commonplaces of physical science," and, in doing so, to make this realm of natural science more scientific by giving it a mathematical basis (Preface).

This description should not imply that Thompson's book is inaccessible to the layman; it is not. But its language is highly specific, its propositions narrowly drawn and concretely grounded, and its concepts tightly interlocked, that is, not easily separated and adapted. These things cannot be said of *Modern Man,* and a question presents itself: in the absence of any direct evidence of influence, which type of source is the more likely to have been of use to an artist like Pollock? The tendency, of course, is to favor the more intellectually dignified ideas and, consequently, Thompson. But surely Fergusson's text is more congruent with Pollock's statements and interests. Immediately relevant to Pollock in many ways, on the one hand; broad and suggestive but imprecise, on the other; and furthermore, highly accessible yet intellectually respectable, *Modern Man* is precisely the kind of book that we should expect to have mattered to Pollock.

Certainly, I am not advancing the propositions that either Thompson or Fergusson had to be the primary source of Pollock's notions of growth, form, and discipline, and that, for various reasons, the latter is the more likely and, therefore, *the* source. The parallels in vocabulary and content between Fergusson and Pollock were pushed, perhaps too hard, in the analysis above to insist on the possibility of the match. But the fit is far from perfect; there are gaps, and there are other potential sources that were not taken into account. Dewey's concept of the aesthetic effect as a product of integrated experience,[130] Benton's teaching at the Art Students League, and the psychoanalytic focus on "deeper" levels of analysis will have to be added to the mix, no doubt along with numerous other possible sources for both central and peripheral component ideas. Some of these still unrecognized sources might have been more directly involved in this cluster of ideas than either Thompson or Fergusson. Nonetheless, I am arguing that any attempt to fill in the gaps in Pollock's statements and thought, or to situate that thought in cultural and social history, would be well advised to attend to sources on the order of *Modern Man* for at least three reasons. First, they would often have phrased the challenging and powerful ideas of the culture in a language suitable for adaptation and manipulation, or, to put it another way, they would have mediated the influential concepts which, for one reason or another, an artist did not assimilate in direct or theoretically pure form. The original or classic formulation of an important idea is not necessarily the most culturally fecund, the most useful to an artist such as Pollock. Even when revolutionary concepts are presented by the originator in language accessible to the layman or artist, they are often less adaptable than their mediated versions, the very shortcomings of which— ambiguity, eccentricity, metaphorical extension, or oversimplification—can be benefits to the maker of art.[131] Second, sources such as *Modern Man* can serve as examples of the confused process of assimilating modern discoveries, a process in which Pollock and other New York School painters must also have been involved. Fergusson is an articulate spokesman here.

> In the contemporary world philosophers and savants of a hundred kinds compete for the public ear and agree with each other about nothing except that we have fallen into confusion.

Modern thought is a wilderness of contention and contradiction. It offers to the inquiring mind no belief to which all men can subscribe, no discipline to which they can all submit, such as some of the older cultures possessed.

In such a situation every reflective man must be, in a measure, his own philosopher. (P. vii.)

And third, they can help us to recover a sense of the social, cultural, and ideological matrices in which the ideas were taking shape and significance.

THE ENERGIC UNCONSCIOUS

Fergusson's *Modern Man* has still more, I believe, to tell us concerning Pollock's ideas about mental processes and the unconscious. Several of Pollock's statements over a decade about art, his own work, and his procedure correspond in many respects to the notions advanced by Fergusson in his book. Consider the following pairs of views.

Their [the American Indians'] vision has the basic universality of all real art.[132]

—Pollock, 1944

[The great artist embodies in his work] those qualities of the experience expressed which are universally human. (p. 155) —Fergusson

She-Wolf came into existence because I had to paint it. Any attempt on my part to say something about it, to attempt explanation of the inexplicable, could only destroy it.[133]

—Pollock, 1944

A living whole, which is a product of spontaneous integration, cannot be thus analyzed. When you analyze it, you destroy it. You destroy the unity or identity which makes it a living whole. It is for this reason that a work of art can be neither defined nor analyzed. (p. 299)

—Fergusson

The source of my painting is the unconscious.[134] —Pollock, 1947

The novel, if it is a genuine work of art, grows spontaneously out of the unconscious part of the human being. (p. 183) —Fergusson

It is only when I lose contact with the painting that the result is a mess. Otherwise there is pure harmony, an easy give and take, and the painting comes out well.[135] —Pollock, 1947

Any man who is wholly absorbed in what he is doing . . . is then exercising his genius. . . . He is then in perfect equilibrium with the object of his energy. (p. 258) —Fergusson

I have no fears about making changes, destroying the image, etc., because the painting has a life of its own. I try to let it come through.[136] —Pollock, 1947

Every man who has ever done spontaneous work in any of the arts . . . knows that the work creates its own form as it grows. (p. 90) —Fergusson

When I am painting I am not much aware of what is taking place—it is only after that I see what I have done.[137] —Pollock, 1947

A spontaneous impulse, working through the artist, gives form to amorphous elements in human being, and he typically feels as though he were but a passive medium for that particular manifestation of creative energy. (p. 183) —Fergusson

I approach painting the same way I approach drawing, that is direct—with no preliminary studies.[138] —Pollock, 1947

It seems to me of the first significance that men of high creative power, when they reflect upon their own work, recognize that the idea of volition is wholly alien and hostile to that work— that they succeed precisely in so far as they can renounce volition. (p. 89) —Fergusson

The modern artist, it seems to me, is working and expressing an inner world—in other words—expressing the energy, the motion, and other inner forces.[139] —Pollock, 1950

It is evident that a work of art in which the energy of the artist is completely projected into a symbol has this essential quality of action. A great work of art is a great action and has the objectivity which all action requires. (p. 154) —Fergusson

 energy and motion
made visible——[140] —Pollock, 1950

Men should come to think of order as a form of movement rather than as a form of static arrangement. (p. 208) —Fergusson

Painting is self-discovery. Every good artist paints what he is.[141] —Pollock, 1956

Writing a truly spontaneous work, as I have observed, has always the character of a discovery. As the work takes form the writer becomes increasingly conscious of the emotion which gave rise to it and of all the implications of that emotion. He embodies feeling in objective form and contemplates it. When he has finished his work, he is a more conscious being than he was before. . . . Whatever he may say he is doing, one thing he does is to create his own consciousness, which is the form of his spiritual or mental being. (p. 183) —Fergusson

Granting that not all of these paired statements are perfectly matched, taken together they still suggest a fairly wide ground of agreement. Again, I do not mean to imply that Fergusson was the source of Pollock's formulations in each or any case, although I do not see any reason to rule out the possibility of influence, either. The question of influence is relatively insignificant; Pollock's artistic philosophy was, in many of its aspects, fairly banal. What interests me more is the fact that the beliefs expressed in these excerpts attracted adherents as diverse as Pollock and Fergusson and including many other producers and consumers of Modern Man literature and New York School painting. I suggest we account for the similarities by viewing the two sets of statements as parallel and related attempts to formulate a model of artistic process that accommodated new and powerful ideas, especially psychological concepts, in the culture. Although it is quite possible that Pollock had learned something from Fergusson's efforts, this need not be the case for Fergusson's work to have significance for the analysis of Pollock's theories and paintings. That is, *Modern Man* may have mediated some ideas for Pollock, may have offered him a working model of the process of synthesizing the new knowledge, or it may have forged links between particular ideas which he found useful; but even if he never opened the book, its resemblances to his own views of the mind and the artistic process can call our attention to certain fundamental beliefs and attitudes the two shared—beliefs and attitudes frequently being expressed in Modern Man literature and generally gaining currency in the dominant culture of the interwar and wartime United States. Such ideas may have come to Pollock through Surrealism, analytic psychology, or any number of other sources; but the appeal of these ideas to him and to his audience should be seen in terms of the cultural preoccupations dominating Modern Man discourse.

As Pollock's work and thinking progressed through the 1940s, he seemed to be moving away from the Jungian conception of the unconscious that captivated him in the early part of the decade—in particular its emphasis on symbolism. He continued to believe that he was painting from the unconscious, but his works and statements indicate that his model of the unconscious was evolving. Fergusson's book can help us to see that emerging model and understand something of its attraction for Pollock and his contemporaries. Some of the more striking parallels in the statements paired above can best be explained in terms of fundamental similarities between Fergusson's and Pollock's non-symbolic conceptions of the unconscious and of mental and artistic processes. I will focus on two essential aspects of Fergusson's model of the mind: his notion of mind as impulse-action mechanism, and his view of the nature and function of the unconscious.

Fergusson was apparently quite unfamiliar with Jung's work. His knowledge of Freud's theories was imprecise, as his occasional misuse of psychoanalytic terminology testifies,[142] and presumably largely indirect. He cited approvingly the book by Joseph Jastrow called *The House That Freud Built* and followed Jastrow in adopting a critical position toward some fundamental tenets of psychoanalytic theory. For example, he doubted the value of bringing unconscious impulses into consciousness, believing that psychopathic conditions are caused by conflicts within consciousness. But despite serious reservations about the theory, Fergusson's own model of mental process was similar to Freud's. Like Freud he envisioned the mind as a drive-discharge structure, that is, as a structure within which excitations or enervations produced by perceptions, whether endogenous (for example, hunger) or exogenous (heat), accumulate as unpleasure, until their release is effected through remedial action. Freud used this reflex-arc construction as a hypothetical model of the primitive mind and as the basis for his first (topographic) model of the developed mind. In the latter case, this fundamental mechanism was made to accommodate several intermediate agencies that allowed Freud to account for an enormous range of psychic phenomena, especially the phenomenon that preoccupied him during that early period—the accessibility or inaccessibility of various mental contents to consciousness. Fergusson, however, dispensed with the complex intrapsychic processing of innervations described by Freud and focused instead on the reflex-arc structure in simple form, adapting it to accommodate other borrowed ideas, especially Bergson's *élan vital,* as well as his own theses.[143]

According to Fergusson's model, an impulse arises in the unconscious and proceeds to the conscious part of the mind, where it is experienced as emotion. From there the impulse ideally is transformed into action, that is, the spontaneous expenditure of energy upon the environment. It may become diverted into fantasy or reflection, but unless these mental activities serve as expedients for resolving conflict and achieving the balance required for uninterrupted flow of energy into action, they are dangerous obstacles to mental and physical health. For Freud, growth emerges from the effort to control these innervations; for Fergusson, control is counterproductive. When Fergusson applied this model of mental functioning to the making of artworks, his words came astonishingly close to Pollock's own. A work of art was portrayed as pure and simple action, spontaneous and intuitive, free of conscious control, requiring precise mental and physical balance, and prompted by unconscious energy impulses. Pollock's mature practice could be viewed as a quite literal embodiment of this conception of mental and artistic process—the making visible of inner forces, energy, and motion. Fergusson could have

helped Pollock devise such a practice, but, alternatively, Pollock could have constructed it quite independently on the basis of his exposure to Surrealist theory or Jungian analysis. The latter, no less than Freudian theory, was based upon energic metaphors, and members of the APC-NY used these routinely in their analysis of patients' drawings. Consider Baynes' descriptions of a drawing (fig. 58).

> It had been suddenly revealed to him that the essential activity of the mind was a dancing, flowing circuit of emotional energy, leaping from one node to the next in a living stream. . . .
>
> In the whirling convolutions of her rope the anima seems to be exulting in the fact that the purposive unity of the psychic process has been restored, and that the brittle, soulless artificiality of a world governed by mechanism and rigid law has given place to the free dance of life.[144]

And if Henderson's retrospective analyses of Pollock's drawings bear any similarity to his initial responses, we can expect that psychic energy had a significant role in the discussion of some of them, for example JP-CR 3: 531 (fig. 59).

> All energy seems to have been drawn from the upper "conscious" region, which appears lifeless, wooden and anguished. The life force or psychic energy is represented by the huge snake (lower center) which denotes the unconscious and upon which the human figure is completely and dependently attached.[145]

58. *Drawing 12, by anonymous patient, from H. G. Baynes,* Mythology of the Soul, *pt. 2, p. 602. Courtesy Northwestern University Library.*

DRAWING 12.

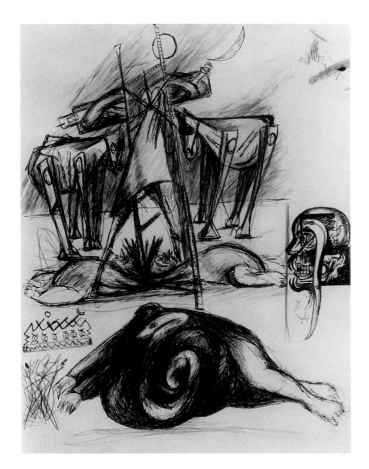

59. Jackson Pollock. Untitled drawing, JP-CR
3:531. *1939–40. Colored pencil, crayon, pen
and ink wash on paper, 36 × 28 cm.
Collection of Janina R. Galler and Burton D.
Rabinowitz, Boston. Photograph courtesy
Nielsen Gallery, Boston.*

Clearly, Pollock didn't need Fergusson to suggest artistic equivalents for depth psychology's energic model of mental processes. But Fergusson does help us to see that if Pollock proceeded in this direction, he was not alone.

Fergusson's devaluation of the conscious faculties is a standard component of books in the Modern Man genre; usually, however, it is accompanied by the allotment of an enlarged sphere of influence to the unconscious. His reservations about the Freudian unconscious distance Fergusson somewhat from the norm. For him, the unconscious is a shapeless, unstructured entity mysterious enough to serve as the source in the individual of the pulses of vitality that account for all activity. But its importance is limited in Fergusson's scheme by the fact that it is essentially a mere vehicle; the ultimate source of these impulses is mystical and unitary, strongly reminiscent of Bergson's cosmic vital impulse. In Fergusson's deterministic, energy-driven universe, the unconscious is the individual's power box, connected directly to the Central Power Plant that initiates all

action. These two dimensions of the unconscious—as a source of energy impulses and as a point of contact with the cosmic center—are not of Fergusson's creation. Although such component ideas were common enough at the time in psychological discourse, and although both Freud and Jung portrayed the unconscious as a source of impulses that may become cathected (charged with energy) as a result of intrapsychic dynamics,[146] Fergusson's formulation of the ideas strongly evokes another influential tradition in United States psychology, one in which the unconscious was represented as a "storehouse of dynamic power" linked directly to the Divine.

This other tradition is an older energist or vitalist one that unites religious and psychological interests and has very deep roots in U.S. cultural and intellectual history. It has been traced by Robert C. Fuller back to the early and mid nineteenth century, but it continued to figure prominently in both psychological commentary and Modern Man literature through the middle of the twentieth century. Fuller has pointed to early manifestations of this tradition in Transcendentalist philosophy (citing Emerson's, "I become a transparent eyeball; I am nothing; I see all; the currents of the Universal Being circulate through me") and in Franz Anton Mesmer's conception of a universal medium of magnetic fluids, as promoted by his American followers, such as Phineas Parkhurst Quimby. Later variations of the idea were developed in various quarters: by William James, who urged receptivity to mental energies that filter into the mind through the unconscious; by turn-of-the-century natural theologists, in their image of God as "the Power which is disclosed in every throb of the mighty rhythmic life of the universe," and "the Infinite and Eternal Energy from which all things proceed"; by the psychologist Richard Cabot of the Emmanuel Movement, who portrayed the nervous system as an electric trolley powered by "currents of energy supplied from without by our fellow men, by nature, and by God"; by James Jackson Putnam, who promoted Freud's theories in the United States in a form that distinguished between lower and higher (that is, spiritual) mental energies; and even by Norman Vincent Peale, who maintained that "in the unconscious lie hidden energies," and who encouraged readers to live in "harmony with nature and in contact with the Divine energy."[147] In Fuller's analysis, psychology in the United States has traditionally been closely linked to religion, and the vitalist model of the unconscious reveals that link in its most direct and apparent form. His study is valuable in demonstrating the importance of this strain among the dominant conceptions of the unconscious and in pointing out the strong mystical, religious dimension it contained. "American psychology has characteristically maintained that the mind's unconscious depths defy reduction to the categories of positivistic science" (p. 164).

One influential popularizer of this spiritual, vitalist tradition who might well have conveyed it to Fergusson or other Modern Man authors was H. Addington Bruce.[148] A journalist, Bruce reported on mental healing, psychological theory, and occult phenomena (these topics were seen as continuous) for readers of *Forum, North American Review, American Magazine,* and *Good Housekeeping* in the first quarter of the twentieth century. In his "Religion and the Larger Self," published in *Good Housekeeping* in January 1916, Bruce adduced the psychological "principle of surplus energy," which he attributed to William James and Boris Sidis—an influential authority on abnormal psychology, who was working with hypnosis—as evidence for his belief that reserves of energy stored in the subconscious could be activated and turned to profit through religious faith.

Bruce quoted James Jackson Putnam at some length in support of this claim. In an earlier article he had argued that science confirmed "the existence of an amazing 'underground' mental life—a strange 'subconscious' realm with powers transcending those of the ordinary consciousness."[149] I will have more to say about Bruce in the following chapter; for the moment I want principally to emphasize his significance as one influential popularizer of the vitalist model of the unconscious and as someone intent on preserving the link between psychological vitalism and religion.

As far as Pollock specifically is concerned, another possible agent for a version of this model—a version somewhat less spiritual and more physiological than Bruce's— was Helen Marot. In spite of the depth of her interest in Jung, which led her to direct Pollock to the Jungian Analytical Psychology Club, Marot's psychological commitments also encompassed the neuropsychological researchers of Charles Scott Sherrington and Charles Judson Herrick. Sherrington's analysis of reflexes and the transmission of stimuli through the nervous system, and Herrick's description of brain cells as batteries generating electrical energy of their own accord, were popular and influential in the 1930s.[150] Herrick's research was featured in a front-page article in the Sunday *New York Times* in 1933, headlined "Brain Cells Create Electric Currents."[151] Influenced by these theories, which were easily reconciled with the vitalist components of Jungianism, Marot endorsed an impulse- and energy-based model of unconscious operations and psychic growth—a model quite congruent, especially in terms of language, both with Fergusson's construction and with Pollock's.[152]

There were, of course, other viable sources for vitalist theories in circulation at the time, and they often interacted with the models discussed above. One important ingredient issued from Eastern mysticisms popular in the United States, which propagated an image of the cosmos as a vast network of energies.[153] Pollock had contact with these ideas directly, as well as through Jungian mediation, and possibly through Modern Man texts such as Lin's *Importance of Living*. ("In order to understand the essence of art at all, we have to go back to the physical basis of art as an overflow of energy." [p. 368]) Some Modern Man texts gave mental energy an explicitly sexual aspect. Horace Carncross put it this way in *Escape from the Primitive:*

> There is this instinctive, primitive, terrific, immeasurable force in human nature that can not
> be destroyed, but like every other form of energy may be largely transmuted. . . . [T]he sex
> instinct is a terrible, incalculable energy that may work for good or ill. (Pp. 195–96)

Such texts promoted the idea that sexual repression was in fact a damming up of vital energies and natural impulses in need of release; without it they would grow disproportionately and take over the psyche.

No doubt vitalist ideas had numerous other contemporary forms and sources, but enough has been said to give a representative picture of their shapes and possible significances.

THE *NOIR* UNCONSCIOUS

Before proceeding to further characterize and analyze Pollock's preferred models of the unconscious, I wish to reintroduce *film noir* as an important vehicle for the popularization of ideas about the unconscious and its functioning. Two recurrent concerns of these

movies were the contents and operations of the unconscious and the complex dynamics of mental processes; segments of the films sometimes became documentary primers in simplified psychoanalytic fundamentals. *The Dark Past* (1948, as a remake of the 1939 film *Blind Alley*) provides a good case study in this regard.

The Dark Past is a *noir* "message" film: it is cast as a treatise on the relation between crime and unconscious mental disturbances, and it is explicit about its intent to promote psychiatric rehabilitation of criminals in order to "salvage some of this waste." As the film opens, a police psychiatrist named Andrew Collins (Lee J. Cobb), formerly a professor of psychology at a state university, is attempting to convince an officer that a young man the latter had arrested should be recommended for psychiatric evaluation. "People behave badly sometimes. It doesn't mean they're bad," Collins says. The officer's response is skeptical: "Yeah, yeah. You're gonna tell me that there's a little bit of good in the worst of us." "Well," says Collins, "maybe there's just a little bit of bad deep down in the hearts of the best of us." To illustrate his point he recounts a story, which constitutes the core of the film, presented as a flashback.

Collins' narrative concerns a notorious murderer named Al Walker (William Holden), who, as the flashback begins, has just escaped from jail. In his effort to elude the police he and his henchmen commandeer the weekend home occupied by then-Professor Collins, his family, and guests. All are held captive while the criminals await a boat that will be their means of escape. While waiting, Collins becomes intrigued by Walker and begins to psychoanalyze him. In an effort to get him to open up, and reveal the sources of his psychic torment, Collins gives him a basic course on the workings of the mind. On a sheet of paper he draws a head in profile, showing the mind as bifurcated into top and bottom parts (fig. 60):

> "You don't know a thing about what takes place down here, the unconscious; like the bottom part of an iceberg, submerged beneath the sea, it's there, but you don't see it. What's more the conscious mind, this upper part, absolutely refuses to have anything to do with the lower part. So to keep anything from pushing through, the conscious builds a wall across here. We call this the censor band. The top part is afraid of what's in the bottom part. The bottom part is full of things that the top half wants to forget. Things that you pushed into the lower part when you were a child, because they frightened you. That's what makes my job necessary. Sometimes

60. *Still from* The Dark Past. *1948. Courtesy of Columbia Pictures.* © *1949, renewed 1976 Columbia Pictures Industries, Inc. All rights reserved.*

the censor band doesn't do its work properly. Thoughts and ideas creep into the top part and make trouble" [such as the paralyzed hand from which Walker suffers].

When Walker tries to sleep, his tormented tossing and turning cause the psychiatrist to question the convict's girlfriend, Betty (Nina Foch). She relates Walker's obsessive dream, which is rendered in the film as projected negative images: Walker is caught in the rain, an umbrella appears over him, he hides under it, but raindrops come through a hole in the umbrella. He tries to stop the rain with his hand, but he cannot, and he cannot get out from under the umbrella because there are bars all around him. Collins continues his instruction, telling Betty:

> "His dream has a very definite meaning. It's tied up with something in his early life. There's a meaning to nightmares. They're symbols of something in your subconscious mind, the lower half of this sketch I drew for you."

When Walker puts the drawing on a dartboard as a show of contempt, Collins throws a dart through the censor band, prefiguring a successful analysis.

> "Your nightmare is caused by something that happened when you were a child. Something you're ashamed of. But the thought doesn't come to you in any ordinary way. It comes disguised as a dream. Everything in your nightmare is a substitute for something else: the rain, the umbrella, the bars around the umbrella. Now if we could only find out what those symbols stand for, we'll know what your dream means, and you'll never dream it again as long as you live.
>
> "Perhaps the memory that causes your dream has to do with your family. Your mom was the only woman you ever really loved."

Walker confirms the truth of this in a violent outburst directed at Betty.

Eventually, Walker and Collins undertake a word-association game, which produces a revelatory breakthrough. Each element of the dream is revealed to be a fixed, legible, mimetic sign for part of a critical past event. The umbrella stands in for a table in a barroom, under which the young Walker crouches. The table is surrounded by the policemen's legs (the imprisoning bars). Walker had deliberately led the police to this barroom, his criminal father's hiding place, in exchange for money; the betrayal results in the shooting of his father by the police. His father's corpse has fallen on the table, and the rain that drips through the holes in the umbrella (the cracks in the table) is his father's blood. Walker's efforts to stop the blood with his hand causes the hand to become paralyzed.

Walker had hated his father, who beat him. Much worse, when he sporadically returned to the family after long disappearances, his wife neglected her young son. After the father's death, Walker took his place in the house, appropriating his father's gun (phallus) and claiming full possession of the mother: "From then on we were alone in the house."

In the end, Walker's case is portrayed as a crude oedipal fixation. Collins spells out its connections to Walker's present behavior and is exceedingly optimistic about the effects of the breakthrough.

> "Anyone who opposes you becomes your father, trying to take back his gun, trying to regain his power over you. Every time you kill a man you're killing your father all over again.
>
> "You'll never have that dream again. You're cured. You know now every time you kill you're murdering your father. You'll never kill another man; you can't."

So ends the flashback, and we return to present time with the words "Walker would never kill again. With proper attention earlier in life, perhaps he would never have killed at all. Only it was too late." In the end the arresting officer in the framing story is persuaded to remand his young criminal to psychiatric care. "There, with very little difference in the basic human equation, goes any one of us or our kids."

Walker is a typical *noir* hero, out of control of his actions, haunted by his past and his complicated psyche, and led by them into evil. The source of evil lies within the self— there's just a little bit of bad deep down in the hearts of the best of us—and there is where remedial action should be directed. Murder is the type of generic violence and evil here, and the unconscious is the source of it. The film is uncharacteristic of the *noir* genre in giving cause for optimism concerning the prospects for alleviating evil in the world. As a case study it indicates how explicit could be the ideological operations of *noir* film. The genre was typically more allusive and ambiguous than *The Dark Past,* but the premises were remarkably consistent: tragic fate and conflicted subjectivity accounted for the evil done by modern man. Unconscious motivations were a central ingredient in its account of human nature and the human condition.

The confused mix I have presented of varied ideas about the unconscious and of cultural forms engaging them is evidence that the unconscious was a powerful and mercurial concept in United States culture during the interwar and World War II periods. It was to be encountered in many diverse cultural products, and not only in the relatively pure Jungian and Freudian variants circulated by the APC-NY and the American Psychoanalytic Association, but also in a strong vitalist form and in a wide variety of hybrid and synthetic forms as well. Modern Man literature and *film noir* were important crucibles both for forging these hybrids and for putting them to ideological work, and they were joined in this by New York School painting. Interpreting Pollock's representations of the unconscious will require recognizing their involvement in the same complex of difficulties and concerns that characterized the conceptions developed by Modern Man authors and *film noir* directors. Pollock's efforts were in many ways strikingly similar to theirs; in chapter 5, I will argue that this mutuality extended not only to ideological operations and preferred versions of the unconscious but also to visual forms signifying unconsciousness.

THE OSCILLATING UNCONSCIOUS

The model of the unconscious presented in *The Dark Past* is essentially a simplified, debased, Freudian one. Although it overlaps considerably with Pollock's highly synthetic beliefs about the unconscious, his works and statements generally foreground different aspects of the unconscious and its functioning. I think it is possible to discern two fairly distinct models of the unconscious in his oeuvre—two poles between which his painting oscillated throughout his career. I will conclude this chapter by contrasting those two models and proposing some explanations for the attraction they held for Pollock and his viewers.

The first of these models was seen, in perhaps its most Jungian form, in the earlier discussion of the psychoanalytic drawings and the early paintings. To broaden it a bit: it engages the hydraulic, topographic, and temporal metaphors deeply embedded in U.S.

psychoanalytic discourse at the time. The unconscious is conceived as a murky domain, the site of primitive memories, drives, and symbols, "a realm of dark and dreadful jungle lore."[154] From this realm, pregnant images and ideas, usually violent and/or sexual, float up to consciousness when censorship is suspended. Pollock gave visual form to these metaphors by populating a dark, ominous, Gothic terrain with dimly recognizable images and symbols, vague suggestions of sexuality and violence, elusive references to myth and so-called primitive arts, always refusing absolute recognition and understanding. Pollock's work in this mode was distinguished by its archetypal symbolics and by its effort to effect formal integration or synthesis of symbolic oppositions.

As I have been arguing in this chapter, depth psychology was doing important ideological work in wartime United States culture: shoring up middle-class ideology with new, plausible accounts of human violence and evil; rationalizing and introjecting the sensation of powerlessness and victimization experienced by those so immediately affected by world historical events. Anomie, disorientation, and destructive or violent behavior were, in a variety of cultural materials, being attributed to the workings of the unconscious, as was the appearance of Fascism, war, and mass brutality on the international stage. But was all depth psychology—Freudian, Jungian, vitalist, and so on— equally suited to serve these and other desirable functions effectively in all cultural forms? How should we account for the particular strength of the symbolic, Jungian model of the unconscious to the young Pollock, his audience, and a large segment of U.S. culture—artists, writers, and so on—at this historical moment? Why was this construction of the unconscious favored by many in this particular social and cultural context? Earlier I offered some explanations for its appeal to Pollock: particularly the graphic orientation and the rich, visual vocabulary constituted in Jungian discourse. It was, in a sense, the version of the unconscious best suited to visual representation—to the project of "visualizing" the unconscious—and it seemed, in particular, a marked improvement over Freudian dream illustration. But more important generally, I think, were its elements of mysticism and transcendentalism, precisely those qualities highlighted in the formal problem that attracted Pollock—the production of synthesis. The Jungian unconscious was the most magical, esoteric, religious, and mysterious on offer. It turned the unconscious into a vehicle for the reenchantment of the individual and of the world, returning to them mystery, transcendent reality, even divinity. As such, it played upon certain widespread and deep misgivings about rationalism, science, and technology. Overdependence on these areas was being proposed widely as a primary cause of the modern chaos. An antirationalist critique of U.S. society and culture was flourishing within that culture, and, as the previous analysis of the Mythmakers' views revealed, some New York School artists sympathized with the critique. The particular symbolic model of the unconscious I have been describing was one well suited to satisfy the "urgency for transcendent experience" Rothko and others felt.[155] Pollock had embraced mysticism and Theosophy as a very young man before turning to social and political explanations for collective and personal problems in the mid-1930s. After the collapse of the left in the late 1930s, this early predilection returned and colored his psychological preferences; he was attracted to that version of depth psychology deeply concerned with mysticism, astrology, occultism, alchemy, religion, and the lore of the East—interests which have led Freudians to view Jungianism more as a religious philosophy than as a

psychology.[156] Pollock was drawn to a construction of the unconscious directly involved in the critique of modern rationalism as that critique was being articulated by some Modern Man authors. Philip Wylie's *Generation of Vipers* illustrates the tendency: in this best-selling book, Wylie presented Jungian theory as a vital corrective to his culture's faith in the progress of science and in the unequivocal goodness of human nature. The thesis of the book, which draws heavily upon Jungian theory, is that

> Americans have lost their moral sensibilities by living too objectively and with too little subjective awareness. Or, as the Bible puts it, "What is a man profited, if he shall gain the whole world, and lose his own soul?" (P. xxii.)

Jungian theory was appreciated by Wylie and others for its difference from Freudianism and ego psychology. Unlike these two, Jungianism was not principally concerned with extending and applying rational analysis to the workings of the unconscious; rather, it imbued the unconscious with a spiritual mystery essentially alien to the Freudian approach. The dominant ideology's reductive model of the individual subject could be enriched and mystified through Jungian theory as a means of restoring explanatory power and viability to that model. Wylie's text is representative of a tendency apparent among various cultural productions of this moment to embrace Jungian theory and apply it, with specific emphases, to contemporary preoccupations. The Jungian unconscious had a distinct and specifiable role in the ideological readjustments underway, and popular texts such as Wylie's joined the art of some New York School painters to serve as medium and vehicle for the work.[157]

This mystical, symbolic model of the unconscious was dominant in Pollock's artistic efforts and thinking in the late 1930s and early 1940s. It remained a strong component of his work throughout his mature career, although it underwent considerable evolution, beginning in his paintings of the early 1940s. There—embodied, as I have discussed, in a symbolic visual vocabulary and syntax derived, and transformed, from the work of Orozco and Picasso—it merged with modernist pictorial concerns in the development of a style that conveyed struggle, opacity, violence, and inaccessibility. If we return once more to *Guardians of the Secret* (fig. 27), its differences from the earlier psychoanalytic drawings will become evident. The title and imagery of the painting may have been inspired by Jung directly, as I suggested earlier, but what becomes clear now is that the markings themselves have come to bear the signs of unconscious production; that they have entailed difficulty, conflict, and struggle is "attested" in the thick, labored, overwrought surface. The technique and handling, for all their formal sophistication, maximize the impression of urgency, of violent, labored execution. Legibility in the painting is restricted by the dark-gray areas surrounding the central tablet. Although these appear at first to be only the ground of the picture, closer examination reveals them to be covering figurative passages that had been clearly visible at earlier stages in the work.[158] Access to this obscured content is now blocked. *Guardians* may be read as evidence that Pollock was exploring ways of enlisting modernist pictorial strategies (equivocation between figuration and abstraction, inversion of figure and ground) in his effort to forge a visual language that could signify the struggle and conflict involved in "painting out of the unconscious." By conveying many of the characteristic features of the unconscious— illegibility, inaccessibility, struggle—through modernist pictorial dynamics, Pollock

was able to reduce the burden carried by explicitly unconscious (particularly Jungian) symbols.

The model of the unconscious as a sea of turbulent, garbled imagery with a Jungian cast is perpetuated also in the titles of the 1940s paintings: *Conflict, Night Ceremony, The First Dream, The Blue Unconscious, Something of the Past,* to name only a few. But stabilizing this model proved a difficult and delicate enterprise for Pollock. How much figuration is proper? To what degree should the fevered execution be permitted to obscure recognizable imagery? These were open questions, and the frequent shifting of the balance between figuration and abstraction in Pollock's early work is partly an effort to find a solution. Internal instabilities were aggravated by conflict with other models of the unconscious and other theses about it that demanded attention. One competing model was particularly compelling, apparently: a model related to the energic, vitalist paradigm codified by Fergusson. In Pollock's hands, its metaphors were principally electro-dynamic, hydraulic, and energic, envisioning mental processes as involving the circulation and distribution of energy flows. While it is vaguely discernible in Pollock's 1943 letter to Sweeney, and in several early paintings—for example, in the energetic gesture conveyed through both agitated brushing and spattering in *Water Birds* and *Troubled Queen*—it is perhaps clearest around 1948–50, when Pollock began to describe the "inner world" expressed in his paintings as a realm of energy and motion.

> The modern artist, it seems to me, is working and expressing an inner world—in other words—expressing the energy, the motion, and other inner forces.

> energy and motion
> made visible——
> memories arrested in space,
> human needs and motives——[159]
> acceptance——

The flowing syntax of the latter notation—virtually devoid of punctuation, with long dashes preserving the onrush of words—well suits the interests articulated. Pollock's conjoining of energy and motion with an inner world and memories suggests that his idea of the unconscious was at this time closer to some sort of dynamic model than to an eerie realm of mysterious figures and elusive symbols.

It is not difficult to see how the pouring and flinging process would have seemed a solution to accommodating the vitalist model, as it recorded energy impulses precisely and without impediment from the drag of brush over canvas. Michael Fried notes in his famous description of the abstract poured paintings, particularly *Number 1, 1948,* line is detached from its traditional functions of defining contour, shape, and figure; as a result of this liberation, it becomes "responsive to the slightest impulse of the painter":

> Line, in these paintings, is entirely transparent both to the non-illusionistic space it inhabits but does not structure, and to the pulses of something like pure, disembodied energy that seem to move without resistance through them.[160]

For Fried the lines embody energy—spiraling, doubling back, and interweaving, their paths seem undetermined except by the pulses of energy that produce them. But in many of the poured paintings, the lines can be read as signifying the energic unconscious in another way as well. In addition to evoking physical traces of the unconscious, records or

indexical signs of its involvement in the work, they signify the unconscious meta-phorically. They continue to *depict* by showing us an image of the dynamic unconscious as vortex (see, e.g., fig. 87): a whirling rush of energy both refusing to yield its own contents—pulling them back ever further from the reach of consciousness—and threaten-ing to swallow the viewer who dares to peer in too closely. In some works, in other words, Pollock's poured line is both an indexical and iconic signifier of the energic unconscious.

Some of the reviewers of Pollock's first exhibition of the poured paintings saw them in similar terms. Robert Coates, for example, wrote in the *New Yorker:*

> The main thing one gets from his work is an impression of tremendous energy. . . . I can say of such pieces as *Lucifer, Reflection of the Big Dipper,* and *Cathedral* only that they seem mere unorganized explosions of random energy, and therefore meaningless.[161]

Coates' judgment that the pictures are meaningless is surprising, following, as it does, such revealing description. One wonders whether his readers were more alert than he to the meanings that "explosions of random energy" evoked in 1948. In the years after the war, the energic model of the unconscious acquired colorations and distortions from intersection with a new discourse on energy in the wake of the atrocities at Hiroshima and Nagasaki. In the catalogue for Pollock's 1951 exhibition at Parsons Gallery, Pollock's friend Alfonso Ossorio wrote that "energy sustains and is the common denominator of the phenomena among which we live." A few years later, Parker Tyler reiterated the point in terms that paved the way for Fried's description above: "Pollock's fluent callig-raphy of paint whorls and thrusts . . . possesses the darting and continuous energy of the forces circulating around, through and in all substances."[162] These remarks are indica-tive of a developing pan-energism which sustained and functioned as common denomi-nator of influential contemporary representations of both nuclear destruction and the unconscious. These two inscrutable, fearsome powers became blurred, mapped onto common terrain, consolidating somewhat the anxiety they aroused. To my knowledge, the blending was seldom explicitly acknowledged or consciously recognized. Coates' remarks are representative in this respect. Occasionally the link was cast as a matter of resemblance: Henry McBride wrote of one of Pollock's pourings, "The effect it makes is that of a flat, war-shattered city, possibly Hiroshima, as seen from a great height in moonlight."[163] That Pollock's paintings were "explosive" became a cliché of the critical commentary.

One result of the merging of these discourses was that the force of the unconscious was naturalized, but at the same time it was cast in a form apparently susceptible to scientific study and control: Just as scientists were learning to liberate and harness the immense energy contained within the atom, so were psychoanalysts discovering ways to release and channel unconscious energy. The rationalism of this view played upon an embattled but persistent confidence in science, reason, and technology. In this respect, we are at the opposite end of the spectrum from the mystical, mysterious, symbolic model of the unconscious, which participated in the antirationalist critique of the domi-nant national culture. Yet, the energic model contained a strong antirationalist, spiritual dimension as well, as was attested by the frequent coupling of religious and psychologi-cal interests in the development of the vitalist unconscious. Ossorio's pan-energism reveals more than a hint of this. The energic model of the unconscious, therefore, could simultaneously gratify cultural desires similar to and diametrically opposed to those that

sustained the symbolic model. Its elasticity was exceptional: it encompassed representations that reenchanted the individual alongside others that portrayed the individual as a battery-driven mechanism. Both the prominence and utility of the idea of the unconscious in 1940s U.S. culture were fostered by this breadth.

I do not want to give the impression of a neat division between two models of the unconscious and two styles of painting, as if each notion of mental process generated an appropriate corresponding style. It is highly unlikely that one discrete and integral model of the unconscious succeeded another in Pollock's mind. He was, like most of us, always coping in a rough and ready way with various conflicting bits of information and belief picked up from an enormous range of cultural materials. It is important to envision, I think, his notion of the unconscious as an unstable and growing collection of component ideas that he tested in various arrangements of dominance and recession over the course of his career. There is mixing and overlap of styles throughout his career. This perhaps becomes clearest in 1951, when Pollock may have begun to feel that his poured work had become too elegant and decorative, without energy or symbolism. The difficult, resistant, unruly quality of the unconscious was lost. His solution was to return aggressively to the imagery of his earlier work and merge it with his linear networks. In the resulting works a deliberate superimposition is attempted; potent symbols and network of energies reconciled. Should they intertwine or coexist? Or is the hope of directing energy to the description of elusive symbols a futile one, bound to end by compromising both concerns? Within two years Pollock had abandoned this format and begun to experiment again. *The Deep* (1953, fig. 66) is one of a number of works suggesting that the unconscious continued to fascinate him and that his conception of it remained hybrid and complex to the end.

UNCONSCIOUS AND IDEOLOGY

What I hope has emerged from this chapter is a different way of seeing "unconsciousness" in Pollock's work. I have been seeking the unconscious not as a collection of effects of real psychic conditions and activities uncomprehended by Pollock, but rather as a category Pollock was engaged in representing to himself and his culture. In that culture, the unconscious was, like the primitive, an essential ideological construction, mobilized in the effort to cope with the trauma and perplexity induced by recent historical events. In a broad array of cultural productions, Fascism and modern evil were portrayed as products of the mysterious depths of the unconscious or of the unnatural functioning of the mind—the absence of reason, or the overdependence upon it. In either case, the unconscious was demanding the attention it had too long been denied. The terms of the literature and art are clear: if modern man's faith in reason, science, and technology had failed him, it was probably because their opposites—emotion, instinct, unreason, that part of his nature that had been strictly repressed—had begun to intrude into his affairs. This other side of human nature had to be attended to, had to be recognized, imaged, and released; but these processes would have to be carefully controlled, so the renewal and fertility they offered could be tapped without releasing a modern deluge. One of the most revealing statements of the case comes from Harding's *Woman's Mysteries:*

If once let loose in the world these forces of nature may grow and spread leading one knows

not where. They may sweep aside all established rule and order and flood the known civilized world with a deluge which could break all bounds. The rise of instinct released from ancient taboos, the flood of emotion or of ecstasy rising from the unconscious depths of the psyche, the unleashed powers latent in the masses, where these things will stop if once let loose, we cannot tell. (P. 300)

Even a professional analyst, presumably more comfortable with the unconscious than most, was susceptible to fantasies of dystopia inspired by unconscious outpouring. The unleashed powers latent in the masses were evident and terrifying enough in Fascism and Communism to give anyone pause, and *the unconscious* became an effective category for representing them. Theorization about the unconscious may at times justly claim intellectual radicality, but in this period its historical effects were paradoxically conservative. By helping to psychologize and individualize the violence and brutality of modern experience, it dehistoricized that experience. Pressure upon the socioeconomic and political orders and the nationalism, imperialism, and authoritarianism they fostered was dissipated as efforts to refurbish the culture's prevailing model of subjectivity came to dominate the nation's intellectual agenda. This reconstructed subject—modern man as locus of the interaction of complex forces and drives, the site of the conflicts at the center of modern life's crises—took form in art, literature, Hollywood films, essays, and journalistic reports, all of which drew heavily upon one form of depth psychology or another. Psychological theory has a capacity to become a totalizing form of explanation, a capacity from which U.S. middle-class ideology has benefited more than once. When it exceeds its proper frame it displaces attention from other otherwise plausible forms of explanation. As Rita Felski has put it, "The focus on self-development can become an exclusive preoccupation which replaces rather than complements further forms of critical and political activity."[164]

Robert C. Fuller, in his analysis of this culture's engagement with the unconscious, finds it "hard to escape the conclusion that Americans' continuing interest in their unconscious mind is motivated by the compelling need to find evidence in support of religious faith."[165] In his view, psychology in the United States reinforced religion in guiding the individual's quest for wholeness and fulfillment; because of the importance of these cultural functions, Freudian theory was resisted. In *Americans and the Unconscious,* Fuller endorses a popular judgment, articulated by Joseph Adelson and others, that American optimism precluded acceptance of fundamental elements of Freud's essentially tragic view of life; optimism made it "well nigh impossible for Americans to view the psyche as composed of dark and archaic components" (p. 124). In Fuller's view,

American psychology is the creation of a cultural tradition which esteems vigor and flexibility; it consequently resists trammeling the self with a complex inner structure. (P. 124)

This view of the social and cultural purposes served by the unconscious in the United States—preserving Puritan ideology, spirituality, and a sense of order in a new, confusing, secular, industrial age—conflicts with the picture that has emerged from the present analysis of Pollock's engagement with the unconscious. Where Fuller emphasized an American tendency to figure the unconscious so as to symbolize "harmony, restoration, and revitalization" rather than "rift, alienation, and inner division" (pp. 5–6), I would argue that both sets of qualities were crucial, the latter increasingly so as the century progressed toward World War II. Fuller intended "to demonstrate the various ways in

which the unconscious has functioned as a religious symbol" (p. 9); his selection of evidence was guided by this purpose. As the present study has indicated, to that observation must be added the recognition that a means for trammeling the self with a complex inner structure was precisely what made psychology attractive, even necessary, to U.S. culture in the interwar, wartime, and post–World War II period.[166]

UNCONSCIOUS AND SUBJECTIVITY

Like many of his contemporaries, Pollock internalized constructions of the unconscious as the form and substance of conflict in his life. The unruly experience of a confused young man was given shape and order in the encounter with powerful institutions and discourses of the unconscious. Pollock interpreted and ordered his experience in terms of psychoanalysis. He deeply absorbed its accounts of mind and behavior, which became the explanatory frame to which he turned naturally for understanding even mundane events. Finding himself locked out of his studio one day in 1956, with an interviewer waiting to see his latest work, Pollock automatically saw the event in psychological terms.

> "Lee hasn't got one either. There just isn't any key," he smiled wryly. "There's something for the analyst!" he said. "The painter locks himself out of his studio. And then has to break in like a thief."[167]

Cultural forces helped Pollock recognize and conceive of more serious personal problems, too, as psychological, and his own troubled experience led him to accept psychological explanations for social and political problems. Pollock thus became both subject and agent of ideological mechanisms. His sense of self and identity was shaped by the powerful models of the unconscious circulating in his culture, and his development of a modernist art accommodating those models contributed to their articulation and consolidation. He was, in other words, a constructed subject, whose work participated in the evolution and development of the construction. His paintings served the function that Clifford Geertz has attributed to works of art in general: "They materialize a way of experiencing, bring a particular cast of mind out into the world of objects, where men can look at it." And "they generate and regenerate the very subjectivity they pretend only to display."[168]

Psychoanalytic theory provided Pollock throughout his mature life with models and metaphors crucial to the ordering of his experience and the development of his work. These models and metaphors were so fundamental and elastic that they often merged with metaphors adapted from other cultural concerns. Pollock was able to keep two influential but in some respects contradictory models of the unconscious in productive tension in his work: his early symbolic imagery persists alongside and within the abstract, poured works. Pollock deliberately exploited this tension, as is suggested in the brief survey of his work at the opening of this chapter; the subject will be pursued more carefully in chapter 5. At times he made this commitment more or less explicit: he wrote to Ossorio that his black pourings of 1951–52 featured "my early images coming through" the poured veils.[169] Pollock's determination to represent the (unrepresentable) unconscious, an ambition which led to sustained engagement with some of the most powerful models available—despite the fact that those models were in some respects

contradictory—helps explain both the striking variety in his representations of the unconscious and their cultural influence.

Depth psychology also has provided metaphors through which Pollock's work has been absorbed by U.S. culture. His canvases are popularly seen as arenas in which mental demons were exorcised and expressed, the unconscious faced, grappled with, stared down. His status as culture-hero rests largely upon a general perception that his tortured life was somehow noble: he was both in closer touch with the dark side of the psyche than most of us and courageous enough to face it, risking the "loss of orientation, moral or mental dissolution or even insanity" that is thought to attend such an enterprise.[170] Pollock's life and career offer rich and convincing substantiation to some of the myths of the artist most deeply cherished the U.S. culture. His celebrated alcoholism, his string of analysts, his actually stepping into the canvas, willingly giving up his orientation and making vivid the impression of physical struggle, his artistic superstardom purchased at great personal cost—these traits are essential in the cultural appreciation of Pollock. They contribute to the representation of him as an artist who took up the urgent challenge to himself and his culture presented by the growing irrepressibility of the dark, mysterious depths of the psyche.

My purpose in this chapter, as in the book overall, has been to reconstruct the discursive fields that shaped and were shaped by New York School art. Reading that art as participating in dialogues with contemporary intellectual and cultural productions— all engaged in ideological processes—should help us see and account better for its specific forms, its trajectory, and its reception. But by concentrating my efforts in this direction, I have underemphasized idiosyncrasies in Pollock's representations—the ways in which they do not conform with evolving dominant notions of the unconscious. I do not want to give the impression of believing Pollock's works are transparent to psychological theory, Modern Man discourse, or a dominant national ideology. Nor do I argue that these latter *precede* his representations. In the process of representing—the process in which ideology comes into being—gaps, breaks, and inconsistencies with other representations develop. I have given priority to reconstituting the discursive structure and setting Pollock's art within it; to complete the story, it will be necessary eventually to isolate and analyze the disjunctions and oppositions between these two objects of study.

FOUR

NARCISSUS IN CHAOS: SUBJECTIVITY, IDEOLOGY, MODERN MAN & WOMAN

The period through which we are living presents itself as one of unmitigated confusion and disintegration. . . . Now, as once before in the disintegrating classic and medieval worlds, the achievement of a new personality, a new attitude toward man and nature and the cosmos, are matters of life and death. We must recapture once more our sense of what it is to be a man.

Lewis Mumford, *The Condition of Man*

It is time for man to make a new appraisal of himself. His failure is abject. His plans for the future are infantile. The varied forms of his civilization in this century are smashing each other. . . . If we do not turn upon ourselves the terrible honesty our science has turned upon goods, we are done for. This war, this uprooting—the second—will be only a stumble on the path back to a new start in a new savagery far deeper than that of a thousand years ago.

Philip Wylie, *Generation of Vipers*

Mumford and Wylie, as quoted in the epigraphs above, were anything but voices in the wilderness. The imperative they articulated could be found in one form or another

in the pages of a remarkable number of books and articles published in wartime (as well as prewar and postwar) New York. By the time of World War II, the quest for a new view of "human nature," for a new form of human self-description, had become a high priority of middle-class culture in the United States.

Several of the texts engaged in this quest were cited and discussed in the preceding chapters, which focused on two principal concerns of Modern Man discourse: the incorporation of new knowledge concerning primitive and unconscious determinants of human behavior into an expanded conception of human nature. I also proposed that verbal and visual representations of "human nature" were deeply implicated in contemporary ideological dynamics. In this chapter I will develop a fuller description of this discourse on Modern Man and his nature and examine in greater detail its historical and ideological character.

A proviso or two is necessary. The modern man introduced in the preceding chapters is a discursive construction, a structure in language and ideology that cuts across disciplines and disputes, across professional, philosophical, and political alignments. It is a subject so broad and manifold that treating it in one chapter will inevitably require dangerously large measures of selection and generalization. My effort to outline its shape and development will necessarily be limited, but even so it must draw upon primary sources in psychology, philosophy, religion, anthropology, cultural commentary, self-help literature, journalism, and advertising, and upon secondary historical treatments of several of these fields, and others.[1] The principal subject of the present study being the complex relations between New York School painting and Modern Man discourse, I cannot claim to do justice to all or any of the other fields that figure prominently in the constitution of the discourse, nor can I attempt to chart precisely the fluctuations, discrepancies, or disjunctions inherent in it both across fields and over time. My purposes in this chapter are to sketch the shape and vicissitudes of the discourse, indicate its sweep, and situate it in the cultural and social history of the United States in the twentieth century.

As I have noted already, Modern Man discourse should be understood as a structure of belief and assumption informing a highly diverse range of literary and visual texts. This diffuseness is a mark of the significance of the discourse, but it renders definition difficult. Part of the difficulty stems from the fact that attraction to the Modern Man model of the human individual traverses the spectra of political and aesthetic commitment. As the preceding chapters have indicated, paradigms of man attributing primitive and unconscious motivations to behavior appealed simultaneously to radical and conservative, highbrow and lowbrow authors and artists. Aspects of the Jungian model of man, for example, were endorsed and promoted by a conservative, virulently anticommunist, patriotic, misanthropic writer of popular fiction and essays for mass circulation magazines (Wylie), a radical reformer and former editor of a highbrow literary journal (Marot), and a left-sympathizing painter of pictures in the high-modernist tradition (Pollock). Likewise, as we shall see, among the opposition to Modern Man discourse and its fascination with the primitive and irrational in man were an archconservative, highbrow literary critic (Babbitt), a left-liberal pragmatic philosopher (Dewey), and a leftist, social-realist painter (Evergood). This disrespect for conventional boundaries may make the phenomenon I am describing seem hopelessly formless, elusive, and

mercurial. I hope rather to demonstrate that despite extensive variation in character, origin, and intent, the developments I categorize as Modern Man discourse are coherent. Any attempt to describe a dominant model of self in a culture as diverse as the United States during the World War II era also must necessarily elide distinctions that, in other historical studies, hold considerable importance. As compensation for such imprecision, this broad study may serve to reveal and explain how left and right, highbrow and lowbrow, avant-garde and academy sometimes collaborate inadvertently in cultural and ideological change.[2]

The discourse I am delineating includes texts by respected scholars alongside those of much less talented and accomplished thinkers and writers. Differences in intellectual rigor between Langer and Overstreet, for example, or Cassirer and Fergusson are evident, certainly, but they are largely peripheral to my argument. Attraction to the fundamental premises of Modern Man discourse could be as little a matter of intelligence or education as of political or philosophical orientation. In this chapter, the discovery of substantial agreement among producers of academic and popular knowledge at this historical moment—agreement over which issues and problems are the pressing ones and which lines of inquiry are most promising—takes precedence over the recognition that the paradigms vary widely in terms of cogency, consistency, sophistication, and breadth.

In describing the character and development of Modern Man discourse, I have tried to make a selection of texts representative of the diversity of the discourse instead of trying to map its further reaches or to manufacture an essential core for it. The question of limits is a difficult one for this study. Even in its diffuse, expanded form—as discursive structure permeating a wide variety of texts—the Modern Man field may seem too narrowly drawn. To limit the study, for example, to materials produced in the United States between the end of World War I and circa 1950 may appear rather arbitrary. Are such parameters defensible for a discourse centered on questions so fundamental as these:

> What is man? What meaning has his life? What is his origin, his condition, his destiny? To what extent is he a creature of forces beyond his knowledge and control, the plaything of nature and the sport of the gods? To what extent is he a creator . . . who refashions the world to which nature has bound him?[3]

Is there justification for bracketing and attaching significance to any particular historical posing of such questions, or for observing national boundaries in the study of interest in them? The latter challenge seems especially pointed when the questions coincide with the international upheavals of the world wars and the period between them. Even if the concerns I am describing can be shown to have some particularized form and valency for the interwar period, can they also be in some sense specific to the United States? In short, can temporal and geographical boundaries be drawn around such apparently timeless questions?

While the questions may seem undistinguished, even historically universal, Michel Foucault's archaeology of the human sciences in *The Order of Things* has demonstrated persuasively that they are not. The questions posed in Modern Man literature are firmly situated in the "arrangements of knowledge" by which man was "invented" some two

hundred years ago. The "man" whose nature is restructured in Modern Man discourse occupies a surprisingly brief period in the history of Western culture.

> When natural history becomes biology, when the analysis of wealth becomes economics, when, above all, reflection upon language becomes philology, and Classical discourse, in which being and representation found their common locus, is eclipsed, then, in the profound upheaval of such an archaeological mutation, man appears in his ambiguous position as an object of knowledge and as a subject that knows: enslaved sovereign, observed spectator. (P. 312)

Just as the turn of the nineteenth century marks one divide in the history of the concept "man," so does the later twentieth century mark another; it is no longer possible, in Foucault's view, to ask the questions of Modern Man discourse.

> To all those who still wish to talk about man, about his reign or his liberation, to all those who still ask themselves questions about what man is in his essence, to all those who wish to take him as their starting-point in their attempts to reach the truth, to all those who, on the other hand, refer all knowledge back to the truths of man himself, to all those who refuse to formalize without anthropologizing, who refuse to mythologize without demystifying, who refuse to think without immediately thinking that it is man who is thinking, to all these warped and twisted forms of reflection we can answer only with a philosophical laugh—which means, to a certain extent, a silent one. (Pp. 342–43)

But even when we recognize the embeddedness of such questions in historical developments specific to the West over the past two centuries—developments that brought the human sciences into being—one may still be justified in wondering whether there is any reason to give special attention to their appearance in the United States in the era of the world wars. This chapter attempts to demonstrate that there is—that the U.S. wartime resurgence, like any other, is marked by historical particularity. If the construction "man" has retained its essential identity over the past two centuries, it has also developed and changed in response to local pressures. As Merle Curti has pointed out, "interest in the nature of human nature has often increased in times of marked social malaise and tension."[4] An image of (white, middle-class) man and a corresponding notion of human nature are such sensitive and fundamental components of the belief systems of Western culture that they will be highlighted and reaffirmed or reworked whenever major or minor adjustments in ideological formations occur. Profound social and cultural changes in Western countries over the past two centuries have kept questions of human nature persistently in the foreground; the frequency of change and the high pitch of disputes over apparently small matters should alert us to the significance of slight variations in details. Throughout this book I have opted for historical particularity whenever a choice between broad and narrow focus has presented itself; that orientation persists here as well.

The noteworthy changes in representations of man will be found not only in the answers proposed to fundamental questions about his nature and condition but also to some extent in the questions posed. Answers are, after all, already written into the questions that generate them. The emphases in Mumford's construction of man, as embedded in the questions above, differ from those informing the queries of Ricardo, Cuvier, or Bopp, as examined by Foucault. Certain features and nuances of Mumford's way of wondering about man—the prominence he gives to the conflict between fate and

human agency, the measure of his confidence that while individual lives can be gener-
alized as "human," the individual is the proper object of inquiry (implied in his prefer-
ence for third person singular nouns and pronouns), the worry evident in his assertions
that "human life" has meaning and destiny and that humans are distinct from and subject
to forces of nature and divinity, and so on—begin to configure his "man" as the Modern
Man of interwar and wartime U.S. culture.

In addition to this somewhat idiosyncratic form, Mumford's questions are marked
by a distinctive urgency, which is also evident in the epigraphs to this chapter, drawn
from Mumford and Wylie: "matters of life and death," "we are done for," and so on. The
handwringing and desperation are a far cry from the dark humor and irreverence that
permeate so many Dada and Surrealist responses to war and calamity. The sense of
radical break from the recent past and of a dire need for a new paradigm are characteristic
of Modern Man literature. Ernst Cassirer termed the situation "The Crisis in Man's
Knowledge of Himself" in his *Essay on Man* (1944). Given the pitch at which these
matters were being discussed, the word *crisis* was no exaggeration. The word and the
situation bring to mind Thomas Kuhn's description of the tension and anxiety surround-
ing paradigm shifts in the history of science.[5] Though it would be misleading to extend
Kuhn's model without careful adjustment, it may be useful to envision the cultural
phenomenon I am describing as a state of ideological crisis brought on by the breakup of
the dominant ideology's paradigm of human nature.

Another measure of the urgency of these questions is the fact that professional
philosophers, psychologists, sociologists, theologians, and anthropologists as well as
nonprofessionals from all sorts of literary disciplines felt compelled to take up the
subject. Mumford, a cultural historian and critic, made an excursion into somewhat
unfamiliar territory in his assessment of the condition of man. Wylie was even further
from familiar turf; he, like Harvey Fergusson, was one of many writers of popular fiction
and journalism who took up amateur practical philosophy.[6] The sizable market for such
books encouraged the influx of writers of all manner of training and interest into the
domains of philosophy and cultural analysis. Wylie's *Generation of Vipers* was arguably
"the best known book of its time," according to Wylie's biographer. It was praised on
Walter Winchell's radio show, sold 180,000 copies, generated 60,000 letters to the
author, and spent six weeks on the *New York Times* nonfiction bestseller list.[7] Mumford's
book didn't make the list, but it was reviewed prominently, including on the first page of
the *New York Times Book Review* section.[8] *Time, Newsweek,* the *New Yorker,* and
newspapers across the country regularly summarized and reviewed the publications of
any author, regardless of credentials, who professed to have some contribution to make
to the collective identity crisis.

Of course this urgency was by no means peculiar to the United States in those
troubled times. As previous chapters have indicated, cataclysmic international events
played catalytic and causal parts in the development of Modern Man discourse. The
experience of the First World War seems to have been one decisive factor in prompting
the initial, tentative forays into the genre, some of which, like Robinson's, were very
popular and influential. Interest in the questions they raised grew steadily and diver-
sified, so that by the mid-1930s, in the aftermath of the Depression, one could easily
discern both a genre of literature and a discourse taking shape. The appearance of Nazism

and Stalinism and the outbreak of World War II brought these developments to a climax.

That these contributing causes were international in effect suggests that other Western countries might well have undergone cultural and intellectual changes analogous to those I am documenting for the United States. Indeed, there is much in the work by historians of the period that suggests this.[9] David Harvey's observation that "during the interwar years there was something desperate about the search for a mythology that could somehow straighten society out in such troubled times" is meant to apply to the West taken broadly. His account of modernism discerns a middle stage—" 'heroic' but fraught with disaster"—spanning the years 1918 to 1945 and marked by a shift in tone, stemming from "the need to confront head-on the sense of anarchy, disorder, and despair that Nietzsche had sown at a time of astonishing agitation, restlessness, and instability in political-economic life. . . . The articulation of erotic, psychological, and irrational needs (of the sort that Freud identified and Klimt represented in his free-flowing art) added another dimension to the confusion."[10] Clearly, the experiences and pressures of the interwar period were similar in Europe and the United States and engendered similar cultural developments. Indeed the exchange of artists and intellectuals between countries—particularly before and during World War II, as refugees from Europe settled in America and participated in the production of Modern Man artifacts—is another cause for seeing the developments as to some extent international.

Nonetheless, significant differences are to be noted between Europe and the United States in this period, in terms of historical experiences (proximity of the terrain of war; extent of military participation; economic and political status in the aftermath of war; sense of vindication or failure, strength or weakness, independence or dependence), ideological formations (dominant constructions of national identity, self, morality, value), and cultural developments (strength of modernist traditions, interpretations and applications of new social-scientific theories). Some combination of these factors should help to explain, for example, such a stark contrast as the lack of a full-blooded Dada or Surrealist movement in the United States, or the differences between the interpretations of Freud that became characteristic in the U.S. as opposed to France.[11] Modern Man discourse itself is a relatively conservative response to the historical developments to which the Dada and Surrealist artists in Europe responded radically. This disjunction in the range of cultural responses to shared historical circumstances offers justification for my tight focus on the particular history and culture of the United States.

There is a different danger to be mentioned here: the danger that my tight focus may not be tight enough. For those convinced of the cultural significance of subtle changes in dominant models of self, my analysis may seem too broad in scope and sweep. In a brief sketch of the changing conceptions of self in the twentieth-century United States, Warren Susman discerned three specific stages between 1910 and the late 1940s. His conviction that "changes in culture do mean changes in modal types of character and that social structures do generate their own symbols" led him to account for cultural changes in terms of visions of self, and to demarcate periods dominated by guilt (1910 to late 1920s), shame (1929 to 1938), and anxiety (1939 to late 1940s).[12] Susman's study, which focuses on self-help and advice manuals, separates threads that often get woven together in Modern Man literature. This is not to imply that the period under discussion is in any sense unitary in terms of preferred conceptions of human nature. Its variety is best

represented, however, not as neat sequential subperiods dominated by a single feature but rather as a persistent conflict among competing conceptions of self and human nature. The first gropings that would become Modern Man discourse emerged in this period; they assembled into conglomerates that challenged other models of self and eventually attained a measure of popularity among significant and influential segments of the population. Disagreement over the viability of various models was substantial, but the battle lines were seldom clear, and a new consensus evolved with an unmistakable inevitability. The eventual dominance of Modern Man discourse was indebted to its shifting, evolving, and disparate nature.

BOURGEOIS IDEOLOGY AND MODERN MAN

Modern Man discourse developed in response to a crisis in the ideology and subjectivity cuturally dominant in the United States through the nineteenth and much of the twentieth centuries; I have been calling that dominant ideology *bourgeois,* but the terms *Protestant* and *capitalist* also merit some place in its description. These associations signify more than the principal constituencies for the belief system; while bourgeois ideology does comprise the basic propositions about people and the world generally endorsed by members of the middle classes and the Protestant faiths, more important, it represents the interests of those economic, social, and religious classes—not as interests or beliefs per se, but as universal, uncontroversial, fundamental truths. The essentially individual basis of human responsibility and behavior; the morality of industriousness, ingenuity, efficiency, and other traits whose effects include the maximization of profit; the ethics of private ownership: in its classic forms bourgeois ideology held these to represent the natural order of things. Most germane to the present study is the fact that the truth of the self was understood to be a rational core, unitary and central: reason might occasionally succumb to emotion or feeling, but its essential eminence could not and should not be questioned. As Donna Haraway has put it, "personality and strategic rationality together make a [bourgeois individual's] 'self.' "[13] This centered, rational self was deeply embedded in the values and principles middle-class, Protestant, capitalist culture held dearest: self-control, restraint, autonomy, efficiency, progress, and science.[14]

Historians of the nineteenth-century United States have charted the components of this ideology throughout the century and have studied the processes by which its hegemony was secured and sustained. The importance of the construction of the rational, centered, autonomous subject to these developments has been made clear.[15] Paul Johnson has noted that "Christian self-control" was "the moral imperative around which the northern middle class became a class" in the early decades of the century.[16] Mary Ryan's social history of the family, titled *Cradle of the Middle Class,* documented the part played by the family in the social reproduction of ideology, through the imparting of bourgeois values to children.

> The values that this elaborate system was designed to implant in the child's personality are almost too mundane and obvious to recount: the usual array of petit bourgeois traits— honesty, industry, frugality, temperance, and, pre-eminently, self-control. Already in the 1830s, during the infancy of the young adults of the Civil War era, the literate native-born Protestants of Utica had worked out a set of strategies for the reproduction of the middle-class

personality. In the process they defined the upper as well as the lower boundaries of the middle class, for the model child was infused not with the spirit of a daring, aggressive entrepreneur but with, rather, that of a cautious, prudent small-business man.[17]

Donna Haraway has noted that virtually the same qualities are promulgated post-humously by Teddy Roosevelt, speaking through the inscriptions that surround the visitor to the Theodore Roosevelt Memorial at the Museum of Natural History in New York: "Courage, hard work, self-mastery, and intelligent effort are essential to a success-ful life."[18]

Neoclassical sculpture made during the mid-nineteenth century was appreciated for its affirmation of moral self-control and self-possession, especially in the face of dire threat. Joy Kasson finds that "control of others and self-control are two important themes in the writings of critics and collectors about the significance of art in nineteenth-century American life."[19] Finally, for the late nineteenth century, Alan Trachtenberg's analysis of the middle-class ideology embodied in the literary realism of William Dean Howells draws attention to another component of the ideology that would soon come under threat: optimism. Howells, the editor of *Harper's Monthly*, believed that life, particularly in the United States, was "governed by a moral universe"; there was a natural law supporting a naturally reasonable society. "For Howells, realism and America were always inter-changeable terms, the one informing and assuring the other of that ultimate coming-out-all-right which held together the middle-class Protestant view."[20] Man, like nature and the universal order, was naturally good. Trachtenberg points out that this notion became embedded in the image of the U.S. as a nation. American exceptionalism—the idea that the United States was a special case, where life was truly governed by moral order, uncompromised by what might happen in corrupt and decadent European countries—fostered deep-rooted optimism, which gave way only slowly and painfully.

This middle-class ideology, with its rational, unconflicted, directed subject, contin-ued to flourish in the U.S. well into the twentieth century, perhaps most visibly in the 1920s, the decade of Sinclair Lewis's *Babbitt*. It developed particular emphases and priorities then, although still at its core were a bullish confidence in the power of the individual to control his or her own well-being and fate, and a faith in scientific and technological progress. These were amalgamated with a strong sense of the United States as a nation and of its superiority over other nations, and an excessive valuation of material possessions and comforts—amounting, indeed, to a belief in self-fulfillment through acquisition. The particular conception of and desire for the good life embedded in this ideology was assumed to be innate and universal; every individual—of whatever culture, race, or gender—would strive toward it rationally and systematically if given the opportunity.

This ideology was by no means monolithic and seamless; nor was its hegemony in the U.S. in the 1920s uncontested, as Lewis's novel indicates; indeed, it was at this time that Modern Man discourse began seriously to challenge and revise some of the prevail-ing ideology's premises regarding the self. Nonetheless, the traditional form remained securely dominant and effectively self-sustaining.[21] Its fundamental propositions con-tinued to be taken as natural and obvious facts, generally assumed by political liberals as well as conservatives. Through the new and expanded vehicles of mass culture—mass-circulation magazines, radio, movies, advertising—as well as through violent state

offensives, such as the Palmer raids, it infiltrated and homogenized the local and ethnic cultures of working-class, immigrant, and marginalized groups.

It was ostensibly as a threat to this ideology, but in fact to salvage it, that so-called modern man came to replace the rational, centered subject. By challenging the secure hold of reason and goodness, Modern Man discourse was better able to explain the new dimensions of violence, human cruelty, and malevolence witnessed in recent historical events. The great advantage of this form of explanation was that it would preserve safe from question both the individualist orientation and the ideal of self-control; through the application of science to the complex, divided subject, the domination of reason and law ultimately might be restored. The quid pro quo was in no sense a planned strategy; what enforced it was the self-preservative momentum of the dominant ideology as embodied in individual subjects. Those subjects apparently favored forms of explanation that necessitated less than radical revision of the cherished belief system. It was not as difficult to acknowledge an opposite to reason residing within the interior of the self as to doubt one's experience of individuality or question one's aspirations to autonomy, especially since an anti- or non-rational component in subjectivity had been acknowledged sporadically throughout modern Western history and particularly since the era of romanticism. In the wake of World War II, liberal political theorists eagerly appropriated the new idea of man and shaped him to mesh smoothly with existing institutions, social practices, political traditions, and ideological verities. In order to show how that fit was possible, it will be necessary to sketch briefly the birth and maturation of modern man: a specific form of the bourgeois self at a particular moment in history.

ORIGINS AND DEVELOPMENT OF MODERN MAN DISCOURSE

While some of the beliefs and assumptions that I have presented as constitutive of Modern Man discourse were relatively new ingredients in the dominant culture of the U.S., many built upon longstanding traditions. The tragic fatalism evident to varying degrees in the work of the Mythmakers, Wylie, and such others as Joseph Wood Krutch stands as an example of a newer component. It extended a variety of romanticism, mediated by Nietzsche, that ran against the grain of the optimism widely celebrated as characteristically American. "America has always taken tragedy lightly," lamented an American who did not—Henry Adams.[22] Indeed, pessimism was uncommon enough in U.S. cultural production by the later 1940s—or, to be precise, such was the official wisdom amidst an outburst of cultural pessimism—that it arguably constituted grounds for an appearance before the House Committee on Un-American Activities.[23] On the other hand, the belief in a "human nature" structured upon internal conflict has had a long tradition in the United States. The Constitution was designed deliberately to balance opposing forces—reason and passion—believed to be inherent in humans. The Federalists used this dualism to justify their distrust of the masses and democracy; likewise, for the Anti-Federalists it underpinned a distrust of powerful government. In this case, a single image of human nature served to justify conflicting political agendas.[24]

A century later, Darwin's theories helped spread the idea that vestiges of animal and tribal states still reside in civilized man. Henry Ward Beecher wrote in 1870 that the Franco-Prussian War demonstrated "the remnant in man of that old fighting animal from

which Mr. Darwin says we sprang."[25] As World War I approached, some observers saw the policies of the European nations as evidence that base instincts were inherent to human nature and remained largely untempered by centuries of civilization. William Graham Sumner wrote in 1903, "Since evil passions are a part of human nature and are in all societies all the time, a . . . war in the future will be the clash of policies of national vanity and selfishness when they cross each other's path."[26] In *Atlantic Monthly* a military engineer, Hiram Martin Chittenden, wrote in 1912 that "The commonest defense of the militarist against the attacks of the peace party is the assumed immutability of human nature. 'Civilization,' he asserts, 'has not changed human nature. The nature of man makes war inevitable.'"[27] Chittenden went on to admit that passions such as "envy, jealousy, anger, hatred, pugnacity, falsehood" were innate in human nature, but civilization contained restraining potentials to keep these motivations in check. The framework for his speculations was the nature/nurture debate—whether human nature was immutably given, or rather was susceptible to change in response to environmental factors. The base instincts that most of these earlier writers described were essentially petty emotions and exaggerated forms of approved motivations (self-interest), all easily accessible to consciousness; the idea that these passions might be a threat to the dominance of reason or might be in some sense unrecognizable to the subject was not yet widely held. As Chittenden concluded, "Immutability in human nature does not mean a limitation upon progress, but it shows where the responsibility for progress lies. Humanity is seen to be the architect of its own fortune, the conserver of its own destiny. It cannot shirk this responsibility, nor lay upon Providence its own shortcomings." Tragic fate, primitive terror, and irrationality were not yet credible forces in this cosmos.

The difference between such typical pre–World War I views of conflict within the human interior and the positions taken by the Modern Man artists and authors later can be made vivid by looking at a late nineteenth-century sculpture that takes the split as its subject. George Grey Barnard's *Struggle of Two Natures in Man* (1889–94; fig. 61) was originally titled after a quotation from Victor Hugo: "Je sens deux hommes en moi." It presents twin male figures in conflict, their struggle momentarily halted as both attend to something seen or heard in the distance. The unity of their attention conjoins them; they respond as a single person to an external stimulus. But one figure lies pinned beneath the foot of the other; the match has apparently been settled. The sculpture was probably begun as a "Liberty" group, evolved into a "Victory," and ended as *Two Natures,* the divine self victorious over the base one.[28] It was a great success at the Paris Salon of 1894, admired even by Rodin, and it launched the artist's career. What is striking in it is that internal conflict is given a premodernist realization—the artist's own subjectivity is represented not stylistically but symbolically. Barnard was convinced enough of the hegemony of reason and control within himself that internal human conflict could be represented through a process and style dominated by rational and systematic design and execution. Conflict is contained within consciousness, and the threat is rather to morality and ethics than to rational self-control. De Kooning's *Woman with a Bicycle,* to be discussed below, will signify a more acute and threatening form of internal conflict, one so deep-rooted, intensely felt, and inescapable that it intrudes into the making of the picture; the painting becomes, as a result, an enactment as well as a symbolization of conflict.

61. *George Grey Barnard.* Struggle of Two
Natures in Man. *1889–94. Marble, 258 cm.
high. Collection of the Metropolitan Museum
of Art, New York; gift of Alfred Corning
Clark, 1896.*

The historical distinction to be drawn here is somewhat less tidy than I have yet
acknowledged. Jackson Lears' thorough and original study of antimodernism in U.S.
culture between 1880 and 1920 reveals that some of the developments I am charting
through the interwar period were rooted in the late nineteenth and early twentieth
centuries. Lears has convincingly demonstrated that for a segment of the ruling class—
principally the old, northeastern, WASP elite—identity became problematic during the
Gilded Age, and by the turn of the century, a sense of self as divided or fragmented was
being expressed with some frequency. Members of this elite, intrigued by mesmerism,

experiments with hypnosis and trances, accounts of multiple personalities, and the New Psychology, began to use psychological evidence to understand and order their own experience of disintegration. To make this point Lears quotes H. Addington Bruce, a figure I introduced in the last chapter as a promoter of religious and psychological vitalism. Bruce was a journalist and popularizer of the theories of mental healing advanced by Morton Prince, Boris Sidis, Pierre Janet, and Freud; in 1908 he wrote in the *North American Review:*

> The human self is a much more complex and unstable affair than is generally supposed. . . . indeed, the self of which a man is normally conscious is but a self within a larger self, of which he becomes aware only in moments of inspiration, exaltation, or crisis. . . . [These facts] promise ultimately to revolutionize our conception not only of the mind of man but even of the nature of man.[29]

For Bruce, and possibly for some of his readers as well, the fascination with unconscious mental activity was part of a larger interest in "paranormal" and religious phenomena: his book *Historic Ghosts and Ghost Hunters* was also published in 1908, and in 1916 his article "Religion and the Larger Self" argued that subconscious energy and faith in God were virtually identical. The religious and vitalist conception of the unconscious articulated in the latter article links Bruce closely to Fergusson and Pollock, as I noted earlier. Bruce publicized new developments in dynamic psychology in several other articles published in *American Magazine* and *Forum*.[30] He wrote that science had confirmed "the existence of an amazing 'underground' mental life—a strange 'subconscious' realm with powers transcending those of the ordinary consciousness." A sense of the "complexity and instability of the self" was growing.[31] Henry Adams, although professing to be "unable to fathom the depths of the new psychology," found that such suggestions matched his own experience. He imagined the mind in the form of a bicycle rider

> mechanically balancing himself by inhibiting all his inferior personalities, and sure to fall into the sub-conscious chaos below, if one of his inferior personalities got on top. The only absolute truth was the sub-conscious chaos below, which every one could feel when he sought it.[32]

An effect of the new social and psychological theories, in Lears' view, was that by the end of the nineteenth century, for many educated, affluent Americans "the self seemed neither independent, nor unified, nor fully conscious, but rather interdependent, discontinuous, divided, and subject to the play of unconscious or inherited impulses." The new, insubstantial self undermined the older solid, centered one that had been the basis of the bourgeois world view.[33]

The value of Lears' study to my own goes well beyond illustrating the high-cultural origins of beliefs that became revised, extended, and popularized in the interwar period. The early appearance of aspects of the Modern Man reconstruction of self reveals that the historical conditions motivating it must be earlier and broader than the twentieth-century catastrophes proffered as causes in Modern Man texts. Lears offers a far-reaching and plausible assessment of causes, largely socioeconomic, intellectual, and moral, which I will summarize briefly. The texts he examines describe a feeling of loss of individual autonomy, in part attributable to the growth of a national market economy. As individuals became detached from intimate social communities and participated in larger, more

anonymous networks of production and consumption, individual causal potency and autonomy were eroded. Economic and social interdependence contributed to a sense of self as a conglomeration of social roles; "selfhood consisted only in a series of manipulatable social masks." The increased mobility of the cosmopolitan elite exacerbated this sense, as the novels of Henry James reveal in Lears' analysis. Another important effect of the maturing capitalist society was the commodification of the self: the self came to be seen as something defined and expressed through the objects it owned, used, and wore. The core of self was transposed from a secure interior to a highly malleable, unfixed surface. Urbanization and the expanded capitalist market had other sorts of effects as well, which Lears categorizes as "moral." The increased rationalization of the inner world, promoted by moralists, reformers, and advocates of self-control, generated reaction, which encouraged recognition of unruly and unfocused impulses within the self. Furthermore, acute tensions in bourgeois morality were evolving. "The contradictory expectations provided by the domestic ideal—the sharp distinction between work and home, the rivalrous claims of autonomy and dependence—these strengthened an emerging distinction between public and private 'selves'." The process of secularization also played an important part in destabilizing the bases of selfhood.[34]

Lears' reconstruction of the early origins of Modern Man discourse reveals that the modern self has a cultural logic and a perceptible basis apart from the twentieth-century contingencies that nourished it. In no sense should the world wars and the Depression be construed as the simple *causes* of the reconstruction of self I have been documenting; Lears' work demonstrates that the causes are much more sweeping and deep-rooted and originate in an earlier historical period. To assign their origins to an earlier moment is not at all to imply that these causes cease to be relevant later; most of them certainly remain important factors through the twentieth century. For example, Harvey Fergusson's attention in *Modern Man: His Belief and Behavior* to the psychosocial effects for an individual of a move from country to city is one indication of the persistent relevance of effects of urbanization to the reimagining of self. Throughout the 1920s and 1930s a therapeutic intent ran through Modern Man texts. Many authors claimed to be prompted by a sense of dislocation in modern life—between belief and behavior, or culture and technology, or spiritual life and material life, sometimes presented as a lack of balance or integration. Perhaps the most common form given to this feeling was the claim that outdated beliefs, vestiges of past stages in human history, were continuing to exert influence over modern man's thought and action, creating confusion and disorientation. Evolution had left vestigial layers of belief in the mind, and it would be necessary to weed out the past in order to improve the present. Robinson's *Mind in the Making* was perhaps the first call to "bring the mind up to date" that reached a broad popular audience, although his effort was justified not in terms of therapeutic improvement but rather of liberal commitment to social and political amelioration.[35] Various authors professed to offer guidance for alleviating social dislocation and personal distress and for enhancing one's quotient of joy, energy, control, balance, or fulfillment. Harry Allen Overstreet's various publications are representative of this tendency. Overstreet was a professor in the department of philosophy at the College of the City of New York, well known for his widely distributed popularizations of philosophical and psychological theories—books with titles such as *Influencing Human Behavior* (1925), *About Ourselves* (1927), *The Enduring Quest: A*

Search for a Philosophy of Life (1931), and *The Mature Mind* (1949). In *About Ourselves,* Overstreet's intention was "to reveal ourselves to ourselves through some of the knowledge that has come to us out of the past fifty years or so of psychological research." His motivation for doing so was that:

> We are worrying ourselves about this, or having an inner conflict about that; we are fussy, or irritated, or gloomy, or disappointed, or frustrated, or prejudiced, or ridiculously conceited. Are we not, perhaps,—most of us—in need of a good deal of mental and emotional reshaping?[36]

Compensating for the disintegrative effects of modern life—urbanization, industrialization, expansion and contraction of the competitive capitalist market—upon the psychic and social condition of modern man remained a prominent motivation and attraction of Modern Man literature. The wars and other distressing events between 1914 and 1950 should be understood as context, catalysts, and contributing causes for the evolution of a Gilded Age self into modern man, and for the spread of this model to the middle classes at large. It is these processes that began in the 1920s and flowered in the 1940s.

As Lears points out, the new divided self of the Gilded Age was the first serious threat to the rational, self-interested, economic man of liberal capitalist ideology. That construction of human nature, dear to the bourgeois ruling elite, was characterized by "balance, decorum, blind faith in human goodness, and progress," in Lears' paraphrase of Henry Adams. Lears notes that "the plausibility of the liberal Economic Man, rationally directing his life in accordance with his own self-interest" was undermined by the historical processes and the psychological theories of the late 19th century.[37] But the cultural history of succeeding years is not that of a steady erosion and replacement of that dominant model by a Modern Man version. The liberal economic man did not succumb quietly: he survived easily and underwent numerous revivals and reaffirmations during periods of threat or challenge. He remained arguably the dominant ideology's preferred model of self in the 1920s, and he persists even into the Reagan-Bush era, when the preeminence of strategic self-interest (of dubious rationality or enlightenment) in political and economic behavior is unchallenged. As I have already suggested, the story of these alternative models of human mind and nature in the twentieth century is a complex one of accommodation, resistance, and appropriation. Modern Man discourse was the medium in which the dominant bourgeois ideology became reconciled with an apparently resistant, threatening model of self—divided and tragic—whose eventual appropriation made possible the preservation of the ideology's fundamental character and cultural authority. Thus refurbished, bourgeois ideology managed an uneasy coexistence between the older, rational, economic man and divided modern man; the therapeutic culture of the post–World War II era, described critically by Rieff, Lasch, and others, proposed happiness and fulfillment as rewards for turning the unruly, conflicted, irrational self into a rationalized, controlled, narcissistic, balanced, economic self.[38]

During the first half of the twentieth century, war, calamity, and socioeconomic strife became preeminent justifications for ruminations about the self and its primitive and unconscious aspects. The longstanding social, economic, moral, and psychological factors motivating the development of new models of self, while still evident, were overshadowed by the frightening historical events that loomed so large. In the wake of World War I and its horrors, the talk of instincts, motivations, and interior conflict

escalated and modulated. Not only was it necessary now to comprehend the massive and senseless death, brutality, and destruction of the war itself, but there was also the ominous aftermath of the war to be addressed. The Russian Revolution provided as great a challenge as the war itself, directly inspiring voluminous reflections and speculations on human mind and character. The idea, widely cherished in the U.S., that Socialism was inherently incompatible with human nature could collapse in the face of the Bolshevik Revolution. Some sought to hasten its demise, while others tried to shore it up. On the domestic front, the postwar labor strife—strikes and suppressions—generated bitterness and violence that suggested to many the operations of "deep-rooted irrational drives in human beings."[39] The outburst of racial conflict and the increased activity of the Ku Klux Klan generated further anxiety; "scientific research" into mind and character was often oriented around racial difference, a racist project that appropriated Darwin's theory of evolution as justification. Many commentators perceived a steady worsening of the situation between the world wars; in 1935, the time of the first war seemed to artist Kerr Eby almost halcyon.

> The world today is a more savage place than the world of 1914. Those of us who remember anything before that year know this. By no stretch of the imagination was it a perfect place then but by comparison it was far more gentle. There is immeasurably more hate and distrust everywhere now and far less hope. We as youngsters before 1914 had at least a fighting chance to do what we wanted to do. Given enough stuff on the ball and hard work we felt that we could go somewhere. We did not have that blighting sense of being just one too many that so many of the young ones of today must feel. I should hate to be starting now. All this an inheritance of war and what men died for. Hell! I'd like to hear what they would say.[40]

As Curti sums up the situation, "Much that happened in the postwar years darkened hopes for the reconstruction of human nature through the environment."[41] More "radical" approaches and solutions would be needed. Popular analysts found themselves and their audiences becoming more and more receptive to outlandish psychological and social-scientific theories as the questions they asked became more desperate; for a while in the 1940s, in the full face of what seemed an "unleashing of maniacal forces,"[42] the question "Can man survive?" thoroughly displaced worries about winning friends and influencing people. Terror inspired by seemingly uncontrollable external events challenged anomie as the focus and motivation for the effort to reconceive human nature. The public discussion of disturbing world events became the crucible in which the self of Modern Man discourse was forged.

ROBINSON AND DEWEY

It was in the context of the post–World War I political repression and pessimism that Helen Marot turned from radical reform to psychology. In popular books and magazines, Freudian and Darwinian theories were more widely discussed and a little less easily dismissed. Skepticism certainly continued to enshroud Freudian ideas especially, but they began to be recognized as having utility for understanding barbaric and irrational behavior. "The agonies of these last years have forced us all to give thought to their causes," wrote Arthur Bullard in an effort to explain and temper the new pessimism for *Harper's Monthly* readers in 1922. After noting that the fantasy of Arcadia, a past

originary golden age, had been "definitely discredited" by Darwin's account of mankind's humble and hideous beginnings, Bullard went on to present the Freudian case.

> The research of the last few decades in psychology has thrown further disrepute on our ancestors and has stridently emphasized the importance to us of our heritage. Instincts are habits which became fixed in remote generations. Our mental machine is compared to an iceberg, of which only a small part, the conscious mind, is visible; the greater bulk is hidden from view below the waves. This unseen, subconscious mind, which—we are told—rules us, is in turn ruled by the instincts, inherited from distant ages of the *lex talionis.* It is a realm of dark and dreadful jungle lore. Our conscious thoughts may wear civilized evening clothes, but our instincts, which have the final word, are hairy and brutish. We feel—a much more important matter than how we think—as did our uncouth and savage ancestors. Compared with the overmastering control on our behavior exercised by the subconscious mind, the influence of reason is so small—according to the more excited disciples of Freud—that we wonder why Nature wasted her time inventing intellect. . . . While a considerable skepticism is prudent in regard to the travelers' tales which these psycho-analysts bring back from their explorations into the *terra incognita* of our subconsciousness, there is accumulating proof from many sources that we have every reason to be ashamed of our ancestors.[43]

The passage gives eloquent documentation of the primitivization of the unconscious. Bullard's attitude toward it, skeptical but fascinated, is representative. In the end, he adopts a position he seems to think anti-Freudian, although he derives it from Freud's concept of sublimation: unconscious energy can be channeled into constructive outlets, and in this way, instincts and the unconscious can be controlled by the exercise of reason and community effort.

Combining as it does elements of Freud and Darwin; mediated by Robinson, anticipating Fergusson, and beating back pessimism; Bullard's essay is a good example of another form of early or proto–Modern Man text, a type different from—in some ways opposite to—that described by Lears. The questions it raises, its points of reference and sources, its tone—all of these link it to later, fuller Modern Man texts. What marks it as early is its ultimate confidence in the efficacy of reason and collective effort and its downplaying of irrationality; although Freud and irrationality are introduced, they are brought on stage largely to be defused. Another distinctive feature of Bullard's essay is the depth of indebtedness to Robinson. Robinson's *Mind in the Making* was one of a few highly influential books on human nature published in 1921–22—particularly important years, as Merle Curti has noted, for the conceptualization of human nature in the U.S.[44] Along with Robinson's book, John Dewey's *Human Nature and Conduct* defined a progressivist or reconstructionist model of human nature, one that backed away somewhat from the divided self, played down the significance of the irrational, tried to formulate a rational, directed self capable of undertaking social amelioration, and, nonetheless, still pointed the way to Modern Man discourse. Different though these texts may be from quintessential Modern Man examples, they provided a project (bringing belief up to date) and a model (peeling apart layers of primitive and unconscious accumulation in the mind) that would provide a point of departure for later authors. One important source for Modern man discourse, therefore, may be located in the intellectual "reconstruction" undertaken in the wake of World War I by progressive liberal social scientists at Columbia and the New School, and at the *Dial* under the editorship of Marot, Veblen, and Dewey.

Robinson's *Mind in the Making,* the book from which Pollock copied a passage by

hand, was described in the preceding chapter, so it may be treated briefly here. Robinson
believed that "the shocking derangement of human affairs which now prevails in most
civilized countries, including our own," demanded an "intellectual regeneration" based
upon a thorough critical reconsideration of "the opinions about man and his relations to
his fellow-men which have been handed down to us by previous generations who lived in
far other conditions and possessed far less information about the world and themselves"
(4–5). This formulation would be taken up and adapted by Fergusson, Mumford, Wylie,
and others. A liberal reformer, Robinson held that intellectual regeneration and mass
education were the ways to a better international and social order. In *Mind in the Making*
he attempted to reconstruct the intellectual history of man from his savage beginnings to
the present and to appraise the enduring legacy of each stage in his development. He
outlined the components of modern culture that had survived from primitive society,
Greece, Rome, the Middle Ages, and the seventeenth century. With the historical basis
of each modern conviction exposed, it was left to the reader to decide whether continued
adherence was merited. But Robinson did not conceal his regret that so much of our
medieval inheritance survived at the expense of the scientific knowledge of the seven-
teenth century. As he saw it, not until our conduct of life and social relations was brought
into harmony with modern knowledge and enlightened opinion could we hope to con-
quer such existing evils as the threat of another war, the labor and capital problem,
national arrogance, race animosity, and political corruption and inefficiency. Robinson
seems to have assumed that changes in prevailing beliefs would be the precondition and
the motor for correction of political and social problems. This idealist assumption
became a common premise of Modern Man literature: to update popular beliefs was felt
to be the crucial and primary project; political and social reconstruction—to whatever
degree these were felt necessary by the particular author—would inevitably follow as a
secondary, contingent process. Many later texts did not even bother to articulate the final
link in the chain; for them, indeed, intellectual change itself was apparently enough. The
effect of this orientation was that the dislocations of modern life were represented as an
intellectual matter: a problem with ideas and, specifically, with prevailing ideas about
human nature and mind.

Robinson's project was fundamentally congruent with Dewey's in *Human Nature
and Conduct,* intended as a contribution to the "development of a science of human
nature," which Dewey believed was an historically more significant enterprise of the
moment than "the nationalistic and economic wars which are the chief outward mark of
the present" (295). Departing from the nature/nurture controversy, he contended that "all
conduct is interaction between elements of human nature and the environment, natural
and social" (11). Human nature may be composed of fixed and ineradicable impulses and
tendencies, but these are drafted into various channels by habit, culture, and social
practices. War, for example, he saw as "a function of social institutions, not of what is
natively fixed in human constitution" (108). In a sense, Dewey turned the tables on the
heredity/environment debate by asserting that human nature is highly malleable; the
difficult things to change are habit and custom. Progress lies in the direction of education
and social guidance, through which an environment may be maintained "in which human
desire and choice count for something" (11). This aspect of Dewey's project went against
the grain of the resolutely individualist orientation of Modern Man discourse.

Many of Dewey's themes were picked up repeatedly by the Modern Man authors, and they often respectfully acknowledged his influence. Fundamental differences between them were obscured by the fact that in several respects he and they seemed to be saying the same thing. Wylie's urgent call in the epigraph above—"If we do not turn upon ourselves the terrible honesty our science has turned upon goods, we are done for"—is an intensified echo of Dewey and the reconstructionists:

> Physical science and its technological applications were highly developed while the science of man, moral science, is backward. I believe that it is not possible to estimate how much of the difficulties of the present world situation are due to the disproportion and unbalance thus introduced into affairs. (P. 294)

Both agreed that science's unblinking rational analysis had to be turned inward upon man himself. But there was considerable distance between them when it came to imagining how that should be done and what would be found. Dewey's vision of human nature remained one in which rational control could simply overpower and redirect destructive impulses. While he acknowledged that psychology promised significant revision to our conception of self, that promise was as yet unrealized, in his view.

> We have so nearly nothing in the way of psychological science. Yet . . . we now have the basis for the development of such a science of man. Signs of its coming into existence are present in the movements in clinical, behavioristic and social (in its narrower sense) psychology. (P. 295)

Psychoanalysis and depth psychology were conspicuously absent from Dewey's list. When the *New Republic* admonished Robinson for succumbing, in *Mind in the Making*, to "the fashionable distrust of reason," Dewey rushed to his defense. The magazine had charged that Robinson's book did little to ease the "plight in which American liberalism finds itself as a result of the cataclysmic events of the last decade." In detecting "motives" underlying the exercise of reason, Robinson "belittled the process of rationalization or the finding of 'good' logical reasons." The *New Republic* editors granted that the old liberalism of the eighteenth century had come to grief because its enthusiasm for reason led it to ignore the "roots of humanity in brute animal nature"; in consequence, it was undone by the "voluminous emotions of nationalism and greed." But that was no reason to reject traditional liberalism, in the opinion of the editors; rather

> the discovery that the flowers of human life have their roots in the dark soil does not in any way deny the value and importance of sunlight. We seem to be living in a time when the worship of the Olympian gods of the air, the sky and the sunlight is being replaced by the worship of the underground deities. But, it is well to remember that it has always been of the very essence of liberal civilization that the organic or basic motives of man should be regulated and controlled by the light of reason.[45]

The peculiarity of this attack upon Robinson is that it misrepresents his project and then calls for precisely the work he had done. Dewey's response to the editorial was to call attention to this fact, as well as to the editors' "intellectual unsophistication which one would not believe possible in these times of currency of psycho-analytic jargon." Dewey's ringing defense of Robinson against charges of irrationalism is at the same time an endorsement of his commitment to Enlightenment rationalism. Dewey maintained his resistance to psychoanalytic theory through the 1920s, against the tide of its increasing

popularity. Even ten years later, in "What I Believe," his notion of the nonrational dimensions of man remained limited to emotions and habits. "We have lost confidence in reason because we have learned that man is chiefly a creature of habit and emotion. The notion that habit and impulse can themselves be rendered intelligent on any large and social scale is felt to be only another illusion" (182). Even so, Dewey had little patience for the pessimism Modern Man artists and authors would voice; his confidence in the potential of "a thoroughgoing philosophy of experience, framed in the light of science and technique" remained secure (182). "Faith in the power of intelligence to imagine a future which is the projection of the desirable in the present, and to invent the instrumentalities of its realization is our salvation. And it is a faith which must be nurtured and made articulate; surely a sufficiently large task for our philosophy."[46] The liberal pragmatism promoted by Dewey and Robinson was a resilient and influential tendency in intellectual circles between the wars; endorsed by New Deal liberals and radical reformers, its rather traditional model of mind held its own against more adventurous versions. But as the 1930s and 1940s unfolded and a more complex and conflicted picture of the human psyche found new justifications, simple confidence in the good intentions of men—including scientists and reformers—became difficult to sustain; the position of Dewey and Robinson came to seem somewhat quaint and dated as liberalism secured new intellectual foundations.

Their commitment to turning philosophy and rational analysis to social amelioration stemmed from attributing to reason a power to intervene in and shape the world. Dewey wrote, "Reason, or thought, in its more general sense, has a real, though limited, function, a creative constructive function. . . . the world will be different from what it would have been if thought had not intervened. This consideration confirms the human and moral importance of thought and of its reflective operation in experience."[47] As a result, the human individual, through the exercise of reason, was endowed with power and effectivity in Dewey's philosophy. This portrait of human agency not only flourished in liberal reform and reconstruction but also correlated with the rapidly growing power and international prestige of the United States. As Cornel West has pointed out, "the coming-of-age of American pragmatism occurs just as the United States emerges as a world power." Dewey was, West observes, "thinking through the implications of the notions of power, provocation, and personality, the themes of voluntarism, optimism, individualism, and meliorism in relation to the plethora of intervening intellectual breakthroughs and in light of the prevailing conditions."[48]

Dewey's and Robinson's philosophy had immense ideological resonance through the 1920s and 1930s, both for those seeking to solve America's social problems and for those who sought to make the United States the leader in a new, rational, international order. But the growth of pessimism and a sense of individual powerlessness and victimization undid such confidence in the effectivity of the individual and reason, and the notion of applying science to man took on new colorations. Wylie's call for the turning of science to the study of man may sound very much like Robinson and Dewey, but his sense of the project encompassed Jungian analysis, a far more mystical form of psychological science than theirs and one willing to tolerate a great deal more mystery and conflict. And eventually Nazi science and the Manhattan Project compelled a more complex and thoroughgoing critique of rationalism, its applications, and effects.

The unwavering devotion of Dewey and Robinson to the ultimate triumph of reason over habit, emotion, and unreason may make their position seem more reactionary than it was. Other features of their philosophy—particularly its dedication to scientific rigor and objective analysis in the study of man, and its acknowledgement of the interest and potential significance of psychological theories—opened it to progressive development and made it a point of departure for subsequent Modern Man authors. The liberal bourgeois image of human nature endorsed by Dewey and Robinson can be sharply distinguished from its more conservative competition through comparison with perhaps the most extreme example: the aristocratic model advanced in the New Humanism. The New Humanism was a movement of academic intellectuals that promoted the old, puritan virtues of individual self-control, moderation, common sense, and common decency, in explicit opposition to the excesses and primitivism of modernism and romanticism. Its principal figure was Irving Babbitt, a literary critic and professor at Harvard whose work was widely published and discussed in the interwar period. Babbitt promoted the "higher will" or "immortal essence" which he saw as responsible for the "imposition of limits on the expansive 'lusts' of the natural man."[49] Edward Aswell admiringly summarized Babbitt's intellectual identity for the readers of *Forum* magazine:

> His relation to the present time is in many points an exact parallel to that of Socrates to his. He represents pure reason seeking, questioning, and at length reestablishing upon the indisputable facts of human nature those standards of decorum, of order, of inner control—the essence of sound individualism—which the decline of religious faith and a new breed of Sophists have all but overthrown.[50]

But to many contemporaries Babbitt and his ilk were effete anachronisms; their preaching for aristocratic values in a bourgeois culture was an indication of their detachment and alienation. Malcolm Cowley wrote:

> Babbitt and his disciples like to talk about poise, proportionateness, the imitation of great models, decorum, and the Inner Check. Those too were leisure-class ideals and I decided that they were simply the student virtues [which Cowley had identified as good taste, good manner, cleanliness, chastity, gentlemanliness, reticence, and the spirit of competition in sports] rephrased in loftier language. The truth was that the new humanism grew out of Eastern university life, where it flourished as in a penthouse garden.[51]

In aesthetics, Babbitt championed a neoclassicism, insisting upon cultivation of the classical virtues (decorum, restraint, discipline, balance) and the classical ideals (universality, nobility). In art as in life, impulse and instinct must be subjected to an "inner check," tempering passion and inspiration and insuring balanced, measured expression. Babbitt was less interested in understanding the sources and character of impulses than he was in insuring that they were controlled. His models of mind and human nature were, paradoxically, quite close to those of the most enthusiastic followers of contemporary psychology, but his attitude toward their irrational components was principally defensive: passions, instincts, emotions are real, but they can and ought to be firmly repressed by the superior rational faculties.

Babbitt's importance to the present study is not solely that of advocate of absolute

repression of "primitive" and irrational impulse, the most influential representative of defensive reaction against the elaboration of the modern man model. Almost as important, his influence upon Clement Greenberg helps to illuminate critical aspects of the latter's work, particularly his antipathy for the "Gothic" elements in New York School painting.

In his perceptive article on Greenberg's early writings, T. J. Clark discerned a tension in that work that evoked the label *Eliotic Trotskyism:* "a serious and grim picture of culture under capitalism . . . the cadencies shifting line by line from 'Socialism or Barbarism' to 'Shakespeare and the Stoicism of Seneca.'"[52] Babbitt had been Eliot's teacher at Harvard, and the two maintained lifelong contact. Perhaps some of the "Eliotic" component of Greenberg's early criticism is also a mark of the direct influence of Babbitt. Babbitt's *The New Laokoon: An Essay on the Confusion of the Arts* was the obvious point of reference for Greenberg's "Towards a Newer Laocoon," published in *Partisan Review* in July/August 1940. The similarities do not end with the title. Both refer to Lessing's *Laokoön* (1766), which first used the figure of the Trojan priest of Apollo as a focus for theorizing about the distinctness of artistic realms. Laocoön had argued vehemently that the wooden horse should not be brought inside the walls of Troy. As he spoke, denouncing the horse as a trick, the god Poseidon, who wished to see Troy fall, sent two sea serpents to crush Laocoön and his two sons. Two very different depictions of their death—in a Greek marble sculpture and in Virgil's *Aeneid*—account for the prolonged association between this mythological motif and the theme of the confusion of the arts.

Lessing took issue with Winckelmann's analysis of the sculpture, which argued that the reason it portrays Laocoön enduring pain and terror with dignified restraint was the Greek culture's respect for noble simplicity and quiet grandeur. Laocoön's bodily pain is tempered by nobility of soul, arousing admiration and imitation in the viewer. Winckelmann compared this treatment with its less dignified, and consequently inferior, Roman counterpart—Virgil's depiction of Laocoön bellowing and issuing appalling cries throughout the attack. For Lessing, both portrayals were equally powerful and affecting; their differences stemmed from the different strengths and inherent limitations of the media involved. He attributed specific powers and weaknesses to the visual arts, treated collectively, and contrasted them with the powers he found inherent in the nature of poetry. In the end, he envisioned art and poetry as equitable and friendly neighbors sharing common boundaries, across which minor incursions were permissible.

Babbitt agreed with Lessing that the arts had particular domains, and he went on to argue that the recognition and observance of distinctions between them would be an important corrective to the debilitating confusion of the arts characteristic of the current "romantic" moment. He distinguished between the neoclassical and romantic versions of relations among the arts: the former characterized by analytical translation, the latter by emotional running together. His call for separation of the arts and the genres was part of his larger polemic advocating the reassertion of intellect and restraint over emotion and expansiveness, the means for recovering the balance between formal, neoclassical values and vital, romantic ones necessary to great art. To allow romantic primitivism and naturalism to continue to reign unchecked by humanistic constraint was, in Babbitt's view, to pave the way for an inevitable result: the imperialism and militarism peculiar to

epochs of decadence. When all other laws are disposed of, force will prevail. Clearly Babbitt's text is, in its own way, a response to some of the same problems and pressures that exercised the Modern Man authors. He, however, came down firmly on the side of law in politics and measure in art. Like Lessing, he believed in the flexible application of specialization in the arts: "Each art and genre may be as suggestive as it can of other arts and genres, while remaining true to its own form and proportion."[53]

When we come to Greenberg's contribution to the discussion, we find that the "friendly neighbors" have retreated to their jealously guarded inner sancta. The relevance of Laocoön to his essay is indirect, via references to and borrowings from Lessing and Babbitt. But with the new intransigence of the argument, Laocoön begins to take on a different and metaphorical significance: he becomes a symbol for the separation of the arts. Just as he counseled protection of the perimeter of Troy and the refusal of intrusion by alien elements, no matter how harmless they might seem, for the sake of the well-being and preservation of the entity, so Greenberg reads and approves that strategy for the arts in the twentieth century. Greenberg's treatment of Lessing is crude and dismissive, but his debt to Babbitt for ideas and language is considerable, despite the fact that the only mention of Babbitt is in a footnote in which Greenberg seems to put some distance between their positions.[54] Of course, Greenberg did not share Babbitt's hostility to modernism; nonetheless, there are striking points of agreement: for example, the analysis of romanticism, the account of the history of poetry and music in the nineteenth century, certain difficult examples (Gautier, Mallarmé), and the connecting of developments in the arts to social and historical conditions.

Most important for the present context, however, is the fact that Greenberg's aesthetics matched Babbitt's in designating control, balance, measure, and discipline as the marks of greatness in art. "It's Athene whom we want: formal culture with its infinity of aspects, its luxuriance, its large comprehension," Greenberg had written a few months before publishing his "Laocoon." Through the 1940s he repeatedly lamented the failure of American artists to cultivate this aesthetic, even though it might go against the grain of the distressing experience of contemporary life.

> Modern man has *in theory* solved the great public and private questions, and the fact that he has not solved them in practice and that actuality has become more problematical than ever in our day ought not to prevent, in this country, the development of a bland, large, balanced, Apollonian art in which passion does not fill in the gaps left by the faulty or omitted application of theory but takes off from where the most advanced theory stops, and in which an intense detachment informs all. Only such an art, resting on rationality but without permitting itself to be rationalized, can adequately answer contemporary life, found our sensibilities, and, by containing and vicariously relieving them, remunerate us for those particular and necessary frustrations that ensue from living at the present moment in the history of western civilization.[55]

This passage reveals the logic underlying a Marxist critic's endorsement not only of the aristocratic aesthetics of Babbitt and the New Humanism but also the latter's picture of preferred mental operations. Greenberg's confidence in modern man as a predominantly rational creature was apparently completely unshaken by recent historical developments. The current crises were merely effects of the failure to implement the rational theory (Marxism) that could solve the existing problems. Aesthetic and intellectual

detachment from such local contingencies was warranted, and whatever passions and mental impulses might underlie modern tragedies or be evoked by them should be suppressed. Ambitious art should take as its starting point the pinnacle of rational theory, not lamentable practice, and in so doing it would promote the sharpening of our rational faculties and provide for viewers relief and fulfillment.

His sympathy for New Humanist aesthetics and behavioral ideals helps to explain Greenberg's difficulty with the New York School artists and their work—his refusal to recognize certain of their interests, and the vehement philosophical and aesthetic disagreements that alienated him from them. (Some of the evidence of this mismatch was discussed in chapter 1; the subject will be taken up again in chapter 5.) Greenberg accorded no significance to the Modern Man subjectivity these artists struggled to represent. To explore irrational and primitive elements of human mind and nature and to balance these with conscious faculties might yield a "truer" picture of modern man, but that was no progressive accomplishment in Greenberg's view. Progress and greatness were to come not from acknowledging and working with unconscious and primitive instincts but from burying them. The true challenge was to learn from the best, rational accomplishments of the past and move from them to ever more controlled, balanced achievements. For Greenberg, the irrational need not be a significant factor in the future of civilization: art and social theory should collaborate to erase it from experience.[56]

Greenberg's aesthetic debts to the New Humanism were substantial, but his commitments to modernism and Marxism aligned him more closely with Dewey's and Robinson's brand of positivist rationalism than with Babbitt's rational self-control. In fact, Greenberg's association with *Partisan Review* in the 1940s coincided with the campaign waged in that magazine by Dewey, Sidney Hook, and others against what they saw as a "failure of nerve"—a loss of commitment, in the face of current events, to science, reason, and progressive social reconstruction and a turn instead to spirituality, mysticism, mystery, and tragic philosophies. Greenberg and the New York School artists were on opposite sides of this dispute, as will be demonstrated below. One question raised by the controversy should be introduced here: Was psychoanalytic theory to be classed as a form of rational investigation—a science—of the human mind, or rather as just another form of misguided and spineless mysticism? Greenberg apparently thought the latter and did not see the necessity of distinguishing among varieties of psychoanalytic theory. "At the present moment only a positive attitude, abandoning Freudian interpretation as well as religion and mysticism, can bring life into art without betraying one or the other."[57]

THE DEPRESSION AND THE 1930S

The progressive social philosophy of Robinson and Dewey paved the way for the growth of social and economic reform movements, particularly in the wake of the Depression. Cultural historians have noted that the decade of the 1930s in the U.S. was a particularly complicated one. In his article "American Culture and the Great Depression" Lawrence Levine described it as "a world in which a crisis in values accompanied the crisis in the economy; . . . the normal process of cumulative and barely perceptible [cultural] change was expedited and made more visible by the presence of prolonged crisis" (p. 223). Yet at the same time, the viability of old values and verities was insistently

affirmed. Government and business attempted to restore optimism and confidence to the anxious, miserable population by asserting that the economic crisis resulted not from any failure of the economic system, but from the failure of individuals to adhere to the principles of bourgeois ideology, represented as respectable, moral, "common-sense" behavior. Popular culture in the period also resonated with affirmations of the importance of hard work, determination, discipline, thrift, and resilience. Levine has shown how popular entertainments, from *Amos 'n' Andy* to *Gone With the Wind* "remained a central vehicle for the dissemination and perpetuation of those traditional values that emphasized personal responsibility for one's position in the world" (ibid., 208). And such messages found a receptive audience in a population long steeped in the lessons of individual responsibility; one evidence of the secure hold such beliefs maintained is the ubiquitous shame and self-blame expressed by the impoverished, as if it were indeed their own moral weakness that had brought on their decline.

Nonetheless, significant shifts in prevailing beliefs were occurring, particularly as the decade wore on.

> Americans had been living in what they had assured themselves was a supremely rational and progressive society. Suddenly they found themselves inhabiting a land whose cruel incongruities and ironies could no longer be ignored. . . . Not only were they suddenly transformed from recipients of the ever-increasing fruits of a golden land into victims of malevolent forces, but these forces appeared to be almost anonymous and unidentifiable. (Ibid., 198–99)

Ambivalence began to compromise the success ethic, and the sense grew that "the world no longer worked as it was supposed to, that the old verities and certainties no longer held sway" (ibid., 221). Levine sees this ambivalence expressed in frustration with the institutional and bureaucratic constraints that characterized American society. Developments in Modern Man discourse draw attention to different issues, particularly to the ways in which the disparity between the belief in individual responsibility and the sense of individual impotence was negotiated. The "unidentifiable malevolent forces" began to take forms other than the failure of individual will, and these forms—both within Modern Man discourse and in opposition to it—began to attract adherents and exert influence.

One opinion that became widespread held that the economic crisis was the work of greedy businessmen, bankers, and politicians, and that the assets of the rich were procured with the lives and well-being of the workers. Diego Rivera's highly controversial fresco *Frozen Assets,* made for his 1931 Museum of Modern Art exhibition, depicted a bank as a morgue, containing the frozen bodies of workers; they could be thawed when needed after the crisis was passed. Efforts to address contemporary problems by focusing on economic, social, and political structures rather than on the individual psyche attracted greater public attention and large numbers of sympathizers in the 1930s. Much of this radical energy collected in eccentric channels, namely the "dissident" movements led by Father Coughlin, Francis Townsend, Senator Huey Long, and others.[58] Dispersion and misdirection kept the considerable public sympathy for radical change from provoking many significant or lasting gains. Among intellectuals and artists, leftist political commitments were the norm by the mid-1930s, and broad coalitions, such as the Writers' and Artists' Unions and Congress, collected wide memberships under the

umbrella of the Popular Front.[59] The aesthetic allegiances of the politically committed artists and writers varied considerably, but there was general agreement that their activities should be directed toward rationalization of the political and economic spheres. With few exceptions, attention to the individual's internal psychic processes and conflicts was minimized in aesthetic programs that argued for the social efficacy of a particular type of art.

The lack of a vital and influential Surrealist movement in the United States at this time that would have attempted to forge a synthesis between Marxist and Freudian interests permitted the opposition between the individual psychic and the politico-economic spheres of attention and explanation to become more polarized than it might have been. The idea that capitalist society might condition the structuring and representation of the psyche,[60] or the alternative idea that the unconscious might be a weapon to be wielded against the established capitalist order did not take root. Various artists and writers did try to work in this gap—the fascinating paintings of social Surrealists, such as Walter Quirt, come to mind, and the early writings of Nicolas Calas and Harold Rosenberg and some of the writers associated with *View*—but such efforts failed to gather sufficient momentum to blur the boundary and undermine the polarization. At most, capitalism was blamed for modern man's neuroses and mental distress, the extreme dysfunctioning of his psyche considered characteristic of the modern period. Meyer Schapiro forcefully articulated the skepticism of many American intellectuals concerning what he saw as the radical pretensions of Surrealism:

> The prison camp of the practical world is exchanged for an underground dungeon. In this way they restore in a Freudian disguise the mechanistic views they wished to escape, for their subconscious operates irresponsibly and spontaneously by a mechanism subject to the "strictest laws," like the laws they attribute, incidentally, to the movement of society. They maintain and even widen the older moralistic separation of reason and impulse. . . . In this anti-rational theory nothing is more isolated, more mysterious, more bizarre—hence more surrealist—than reason and purpose.[61]

As a result of the polarization of psyche and society, social utopianism defined in the radicalized U.S. culture of the 1930s a counter-tendency to Modern Man discourse and its constructions. Those who targeted the individual as the site for reconstructive work of course envisioned collective social improvement as a desirable effect, and likewise, leftists foresaw the improvement of the mental and physical condition of the individual as a result of economic and political reorganization. While the projects were in no sense mutually exclusive, their opposing priorities amounted to more than simply different means to the same end. Modern Man solutions meshed much more smoothly with the dominant middle-class ideology and its individualist orientation: they lent themselves to processes of correction and adjustment of prevailing structures of belief and subjectivity in ways that radical oppositional solutions did not.

The "collective man" discourse that flourished in the 1930s produced its own versions of Modern Man texts: books describing human nature in more accommodating, that is, collectivist terms. Such books as Hyman Levy's *Philosophy for a Modern Man* and, later, Vernon Venable's *Human Nature: The Marxian View* looked to class struggle and the inequities of the capitalist system for explanation of current crises, not to the psyche of the individual. Indeed Venable argued against any notion of a human essence;

rather, "human nature" was portrayed as constituted within physical and historical environments, subject to change. For Venable, generalizations about "man" were inevitably ideological, as attested by their class- and ethno-centrism (p. 21). "The ultimate determinant of human behavior, and hence the primary conditioning factor in the transformation of human nature, is the mode of production" (p. 80). By changing the productive system, changes in human nature could be effected. In this view, fixation upon the models of human nature generated under the current economic system—here, modern man—was deeply misguided. While many artists in the mid-1930s may have subscribed to some version of this position, or at least accepted its priorities in practice, few maintained it after the Hitler-Stalin pact of 1939, which made the defense of Communist and Marxist positions difficult for many U.S. leftists. Some, including several of the New York School painters, gravitated toward Modern Man discourse at this point, shifting attention from socioeconomic explanatory frames to the individual psyche and the tragic fate of the individual. Other artists construed such a turn as a failure of nerve and instead retained faith in and commitment to rational social reordering as fundamental to individual improvement. Philip Evergood spoke as one of the latter in his essay "Sure, I'm a Social Painter," published in November 1943, in which he vented his disrespect for the inward turn taken by many of his contemporaries. "[Some painters today] concentrate on their own inner selves, and, by putting their inflamed entrails on public view, divulge irrevocably the fact that these convulsive viscera have stimulated a desire for fame far beyond their owner's artistic capacity."[62]

Paradoxically, while one effect of the Depression was the galvanizing of oppositional political energies, another was the heightening of the individual's sense of powerlessness. One effect of modernization was the centralization of political and economic power in abstract bureaucratic organizations located in a relatively few very large cities. The events transpiring on Wall Street or in big business and national government seemed remote, the stuff of newspaper stories and radio reports; yet their effects on the everyday, lived experience of citizens were immediate and obvious enough. Against such centralized, impenetrable powers, the efforts of an individual seemed puny and hopeless. The Lynds' 1935 sociological study *Middletown in Transition* noted among the middle-class residents of Muncie, Indiana, the growth of a sense of being an outsider, of losing contact with and access to centers of power.[63] Such feelings became widespread in the 1930s and 1940s; they were graphically represented in the *noir* film *I Walk Alone* (1948), in which a gangster tries to take by force his share of a former accomplice's nightclub operation, only to find that the business is so thoroughly removed into overlapping corporate structures and holding companies that even with his guns and mob he is powerless to affect it. Even gangsters, icons of individual autonomy during the Prohibition years, later found themselves relatively disempowered in the modernized economy.

This other side of the 1930s, marked by widespread feelings of alienation and loss of autonomy, constituted a resurgence of the conditions that coincided with the appearance of Modern Man discourse at the turn of the century. Unsurprisingly, this discourse continued to develop energetically through the decade, despite the growth of competing discourses. Like much of the nation, the residents of Muncie remained resolute in their faith that American government and institutions were sound; current problems were due principally to "poor, weak human nature."[64] Harvey Fergusson's *Modern Man: His Belief and Behavior* was itself a product of this moment. For those readers willing to

entertain more revolutionary proposals, Samuel D. Schmalhausen was influential in adapting the Modern Man paradigm to the new political context. Schmalhausen was a psychologist, essayist, editor, and anthologist, and for a while co-editor with V. F. Calverton of the socialist journal the *Modern Quarterly.* Just before the Depression, Schmalhausen published two Modern Man texts: *Why We Misbehave* (1928) and *Our Changing Human Nature* (1929). Both were attempts to popularize new psychological knowledge, especially Freudian theory, and to argue for its potential to revolutionize modern life. Schmalhausen attributed misbehavior and the ills of the modern experience to the constitution of human nature: "a strange compound, very badly mixed, consisting of these ingredients, to wit: (1) 60% animal. (2) 20% savage. (3) 15% childish. (4) 5% civilized." (*Our Changing Human Nature,* 467). This brutish nature bred narcissism and egotism, and the failure of most individuals to progress beyond these infantile stages to psychological maturity and unselfish humanism was the greatest obstacle to the implementation of the "new society which socialists and communists and anarchists are thinking, dreaming, writing, and working for" (ibid., 475).

> The greatest question in the contemporary world for those of us who have not been spiritually and psychologically shell-shocked by the Great War, and its crazy aftermath, is this: Can we re-fashion the living universe nearer to our hearts' desire?
>
> The new psychology answers: Yes, if we use our heads. . . . Can we, however radical or revolutionary our economic philosophy may be, create a civilized and civilizing society without the aid of psychoanalytic psychology? I think not. . . . We need, as radicals, to be wise to all the queer, obstructive, and self-defeating attributes of human nature that stand in the way of building a more cooperative and a more harmonious society, one founded at last upon freedom and fellowship. (Pp. 491–92)

Psychological education and improvement of the individual was presented by Schmalhausen as prerequisite to social improvement. His goals may have been radical, but the means and logic remained those of Modern Man discourse.

By 1932 Schmalhausen's thinking was shedding its earlier orientation. In "Psychoanalysis *and* Communism," he argued that concentration upon human nature and instincts had led to an undervaluation of the role of social and environmental considerations in the analysis of behavior. How, he wondered, had so many analysts ransacked whole libraries "in quest of instances and anecdotes, myths and poetrys, all manner of illustrative material for their pet dogmas, . . . [and yet] managed to keep off the track of economics and kindred social sciences?"

> Though they know it not, when the instinct psychologists speak of human nature what they mean can be more accurately described as human institutions, customs, habits, values. . . . Nothing is so telltale in this whole field of endless controversy as the apologetic and rationalizing nature of the arguments built around the congenital deficiencies in the human nature of the very class that challenges the dominance of the class in control. If one made a list of the significant names of the psychologists, biologists, sociologists, and philosophers at large who have argued most intensely in favor of instinct-and-native-endowment psychology, the surprise in store for him would consist of the realization of the thoroughly bourgeois and anti-proletarian status and outlook of this whole group of "human nature" theorists. (P. 65)

Schmalhausen saw the two faces of psychoanalysis, the revolutionary and the reactionary; he vacillated between celebration and criticism of Freud. He was one of very few contemporary commentators whose appreciation of psychoanalysis was sufficiently dia-

lectical that it permitted him to see the ideological dynamic in which it—and with it, Modern Man discourse—was involved.

In the same year Schmalhausen wrote the passage just quoted, he edited a volume that clarified his shift in emphasis and indicated a new direction. *Our Neurotic Age* shared much with Schmalhausen's previous books, but this influential anthology departed from them in stressing that the neuroses and psychic discomfort suffered by modern man were the product of his society. While the text never recorded a doubt that man's capacity for evil, his primitive and unconscious drives, were part of his nature, the authors did hold that the competition, repression, and inequity characteristic of capitalism seriously exacerbated and even generated psychic conflict. Despite the fact that modern man's psychic distress was to be understood now as having a historical basis, much of the book's discussion remained within the Modern Man frame of reference. The introductory essay pulled Robinson's liberal paradigm into full-blown Modern Man discourse. Titled "The Mind in the Breaking," it was written by John J. B. Morgan, an associate professor of psychology at Northwestern University and a psychological examiner for the army during World War I. Schmalhausen's introduction to Morgan's essay told the story:

> Only a decade ago Prof. James Harvey Robinson wrote brilliantly of *The Mind in the Making.* Though the triumph of Freudianism had already marked a new epoch in the history of Psychology, the assumptions of our liberal thinkers were all still primarily based upon an underlying normality and sanity in the civilized mind. The graphic line of division is represented of course by the Great War. Psychologically the distance between 1912 and 1932 cannot be measured by the arithmetical span of 20 years! Changes of the most revolutionary nature in economics and in morals, in physics and in psychology, in life and in thought have altered the very texture of existence. From a psychoanalytic point of view, we are much nearer the facts if we speak of *The Mind in the Breaking.* . . . Though it runs counter to our most cherished prejudices, the truth is that irrationality and psychoneurosis are more fundamentally characteristic of the human mind than rationality and normality.

Robinson has been radically revised here, irrationality being thrust into the spotlight in the examination of mind and the present situation. But the light Schmalhausen and some of his contributors wanted to turn on the human mind was colored by political radicalism. New questions were articulated:

> Is modern man neurotic *or rather* modern civilization? Is human nature inherently predisposed to psychoneuroses or is our bourgeois social order loaded with contradictions and social conflicts, with tensions and pressures that are unbalancing man's nervous system and breaking his psychological apparatus? The evidence at hand is overwhelmingly in favor of the thesis that our competitive civilization is the fertile begetter of psychoneurotic malaise and misery. . . . Can it be of no importance, psychiatrically as well as socially, that in a period of collectivization the philosophy of individualism shall still be rampant? (Pp. xii–xiii; the italics are Schmalhausen's.)

Schmalhausen went on to assert that "the culture of communism promises to minimize and even eliminate these psychoneurotic sources of human misery, creating ultimately a social world of marvelously sane character." Once the ego humiliation, sex denial, social frustration, and creative inhibition characteristic of capitalist society had given way to economic security, self-confidence, and emotional outlets, neurosis would once more become an aberration rather than the norm.

By no means did all of Schmalhausen's contributing writers successfully sustain the balance he sought between intrapsychic operations and social determinations in the explanation of modern mental trauma. Many oriented their analyses around the element in Freudian theory that held cultural suppression of unconscious instincts responsible for psychic distress; in Ernest Jones' words, quoted by George Pratt: "Any chronic maladjustment to one's environment or to other personalities is an outcome of an imperfect cultural modification of primary instinctual impulses which are directed to culturally archaic goals."[65] Yet the essays in *Our Neurotic Age* reveal how difficult it was to reconcile, for example, the unconscious death instinct with social causes for suicide ("personal disorganization develops more readily when there is a disintegration of society"), or the developmental "maladjustments" thought responsible for homosexuality with the effects of cultural disapproval.[66] Sometimes the prescription for reducing neurosis offered in these essays was individualist, for example, "the fabrication of methods that will toughen personalities in the making [during childhood] to a point that will enable the individual to meet the vicissitudes of everyday living without cracking under the strain."[67] Even within radical critiques, the tendencies of Modern Man discourse persisted.

FROM *FORUM* TO "THE NEW FAILURE OF NERVE"

Popular magazines were as important as books in formulating and reformulating modern man's nature. Most general-interest magazines published during the interwar period gave substantial attention to the discoveries and arguments swirling around the image of "man"; several made Modern Man columns a regular feature. A useful case study is *Forum,* the self-described "Magazine of Controversy," whose circulation rose dramatically during the period under discussion. Henry Goddard Leach, a specialist in Scandinavian history and culture and former editor of a Scandinavian-American publication, took over as editor in July 1923, when the *Forum's* circulation was between 2,000 and 3,000. He quickly enlarged the format, focused the magazine's attention on intellectual controversies, and within five years increased circulation to 100,000.[68] In March 1936, when the magazine celebrated its fiftieth anniversary, it received congratulatory and appreciative telegrams from a devoted readership that included Franklin and Eleanor Roosevelt, Henry Wallace, Walter Lippman, Charles Beard, Felix Frankfurter, Fiorello La Guardia, Walter White (secretary of the NAACP), college presidents, clergymen, heads of corporations, and a grateful "army of Americans," one of whom called attention to the regularity with which *Reader's Digest* featured condensed *Forum* articles. Most of the telegrams and letters praised *Forum* for doing just what it claimed: providing an impartial hearing on any and every question facing the United States as a society. Its masthead defined its purpose:

> The Magazine of Controversy. Its method is to give a fair and friendly hearing to both sides, all sides, of important questions of the day. Its practice is, in an age of shifting authority, of relativity and specialization, to apply common sense both to threadbare tradition and to glittering novelty. Its object is, by stimulating independent thinking, to promote sound individualism in a democracy.

Each issue of the magazine highlighted at least one debate: Do we need a new God?

"Old conceptions of God no longer fit the framework and perspective of modern knowledge" (Harry Elmer Barnes, April 1929). Have we free will? (December 1937). Is psychoanalysis a science? (George Sylvester Viereck took the affirmative side, Aldous Huxley the negative in March 1925). The question for January 1930, addressed to Howard Mumford Jones and Will Durant, was whether "the cultural ABC's" (the popularization of modern knowledge) were "softening our brains." Presumably the editors sided with Durant in rejecting this suggestion: books popularizing new knowledge in the sciences, social sciences, and humanities—including Modern Man texts of every stripe—were reviewed regularly in *Forum*. Several debates centered on art: Does America discourage art? (April 1929). Is cubism pure art? (June 1925). Is politics ruining art? (August 1933).

"The primitive" and "the unconscious" received extensive attention in the *Forum*. The magazine published both Jung's article "Your Negroid and Indian Behavior" and Helene Magaret's article "The Negro Fad," discussed in chapter 2. G V. Hamilton described the unconscious for *Forum* readers as "our wanting machine" in terms reminiscent of both Marcel Duchamp and Deleuze and Guattari:

> The driving force of all human conduct is located in a "wanting" apparatus which is largely hidden from man's mind in the deepest layers of his personality. This "wanting" part of every man is without moral scruples of any kind, and it ignores all the strictures of reality. It manufactures wants without regard for rhyme, reason, or right. (April 1930, pp. 231–32)

Five years earlier, George Sylvester Viereck had painstakingly drawn the Freudian map of the unconscious in "Freud: Columbus of the Unconscious" (March 1925).

Beginning in September 1929 *Forum* featured a series of articles entitled "What I Believe," for which leading intellectuals were invited to relate their "convictions and beliefs concerning the nature of the world and of man." Contributors to the series included Bertrand Russell, Theodore Dreiser, Irving Babbitt, John Dewey, Irwin Edman, Joseph Wood Krutch, Howard Mumford Jones, and other leading thinkers now less recognized. The series was introduced by an editorial foreword which revealed Leach's allegiance to the New Humanism of Babbitt and his commitment to the construction of a *juste milieu* position for every issue.

> The individualism of these thinkers is a matter of supreme importance. It is not likely that any two of their philosophies will agree in fundamentals. For this reason, the problem which these articles will present to the thinking reader is a peculiarly modern one. It is the problem of exercising one's native intelligence upon all the cross currents of modern thought in order to isolate the principles upon which to build a sound individualism. This is the very central core of humanism, which is not so much a doctrine or an ordered philosophy in itself as a point of view, an attitude of critical and detached judgment which reasserts the supreme right of common sense to hold the middle of the road between the jostlings of specialists and technicians of every hue and color to right and left.[69]

No wonder *Forum* became such a popular and cherished arena for working through cultural anxieties. It guaranteed that disturbing insights and radical suggestions would be tempered by opposing arguments, and the whole business of intellectual inquiry bathed in sanity and common sense—that is to say, securely framed within the dominant ideology. Individualism and humanism would be clutched tight while troubling new ideas were mulled over and assimilated. The *Forum* was one of the venues in which the

paradigms of Babbitt, Dewey, and Robinson were revised and challenged and developed into Modern Man discourse.

In June 1939, just a year before it ceased publication, the *Forum* published a lampoon of Modern Man literature by James Thurber. Thurber ridiculed the genre's solemn, pompous rationality and intense self-absorption, as he described himself "[getting] Man down on his back" to "look at the tongue of his intellect and feel the pulse of his soul." He speculated that in turning to reasoning in the effort to plumb the mysteries of his nature and destiny, man had moved "further way from the Answer than any other animal this side of the ladybug." The discourse's distinctive urgency and threats of impending doom also came in for ridicule: "What is all this fear of and opposition to Oblivion? What is the matter with the soft Darkness, the Dreamless Sleep?"[70]

Although in character and political orientation a very different publication, the *Nation* revived in 1939 the *Forum*'s popular "What I Believe" series. From the vantage of the late 1930s, the early part of the decade, when the series was new, looked remarkably "paradisiacal," to quote Clifton Fadiman's introduction to the volume collecting these later "living philosophies."

> Despite the economic crisis in which, during the early thirties, the whole world was caught, there seemed no special reason to doubt that mankind was adequate to cope with its difficulties. But with the rise of totalitarian powers, unquestionably the most important historical event of the century so far, a change has come over the minds of men. [All the contributors] feel the chill of the black shadow of our times—the shadow of unreason, the shadow of organized cruelty to mankind.[71]

Lin Yutang, Franz Boas, Havelock Ellis, and others offered their meditations on the worsened situation; several writers who had contributed to the earlier *Forum* series, including Dewey, Mumford, and Krutch, were invited to amend their essays in the light of the latest catastrophes. The increased urgency of the moment perhaps explains the fact that the contributors were generally disinclined to reflect upon possible psychological or socio-political explanations for the rise of Fascism and Communism, but rather felt compelled to affirm the importance of liberal, humanist, democratic values and resistance to totalitarianism.

Throughout the 1930s many other mass circulation magazines participated in the development of Modern Man discourse, although few were as thoroughly attentive to its myriad aspects as *Forum*. *Scribner's*, for example, published in 1935 a series of articles titled "Is Man Improving?" Abbé Ernest Dimnet pointed out that science may be progressing, but spiritual improvement does not necessarily follow in its train. We are not, in terms of spirit, mind, and culture, as far removed from primitive man as we think (June 1935, pp. 321–27). Robert Briffault was more optimistic, believing that few nations would follow Germany in sinking back into barbarism (July 1935, pp. 8–13). C. E. M. Joad concluded the series with a forceful statement of Modern Man dogma:

> The last war showed that modern man, when terror and pugnacity have stripped away the surface of his civilization, has "improved" so little that he can still on occasion behave like a paleolithic savage. . . . man, "improved" in his mastery of the means to the good life, is still comparatively "unimproved" in respect of the art of living. . . . *The enemy, in fact, is not now without, but within; it is no longer Nature, but human nature.* And the "improvement" in this sphere is, I suggest, still to seek. It is, indeed, so urgently required that, unless we can bring

our political and ethical wisdom, our knowledge of how to live in communities and as individuals, up to the level of our scientific technique and material achievement, unless we can distribute our goods, live at peace with our neighbors, learn to use our leisure without becoming a nuisance either to ourselves or to others, our civilization will go the way of its predecessors. (August 1935, pp. 112, 114. Italics added.)

The passage anticipates Wylie and Mumford in argument, language, and tenor.

In the later 1930s, the periodical literature makes especially apparent the conflict and contestation over the representation of modern man; much was seen to hinge on the matter of which portrayal of human nature achieved cultural dominance. Various interest groups perceived specific immediate threats to be implicit in Modern Man discourse, and they took steps to undermine, challenge, or redirect those threats. *Commonweal,* for example, protected the interests of its largely Catholic readership by arguing against secularized versions of human nature and for a spiritual one. The magazine devoted considerable space to Modern Man issues because, it believed, "the root cause of the world's trouble lies in a false concept of the nature of man as a being whose sole concern is with this life." In concert with the National Catholic Alumni Federation, *Commonweal* asserted that human nature "is unchanging and unchangable," and that "man at the core of his being is of a spiritual nature."[72] These claims are not in essence different from those Rothko, Gottlieb, and Newman would articulate in the 1940s. Affirmation of modern man's spirituality was not at all incompatible with Modern Man discourse, although other aspects of the Catholic position were—for example, the focus on the afterlife, or the faith that a rational, just, and beneficent divinity was ordering and overseeing human history. Ironically, for the editors of *Commonweal,* these beliefs seem to have accommodated the views of Dr. Alexis Carrel, a surgeon, scientist, and author of the influential book *Man: The Unknown. Commonweal* published the text of an address Carrel delivered on the occasion of receiving the Cardinal Newman Award in 1937. Titled "For a New Knowledge of Man," it called for a remaking of society on the basis of the laws of human nature, as those laws were deduced from complete knowledge of human body and soul. The statement contained a thinly veiled defense of eugenics as a viable way out of the doom that faces modern civilization, a position Carrel had developed in his earlier, controversial book. What endeared him to Catholic organizations were no doubt his criticisms of science—its analytic orientation, its susceptibility to misuse, its neglect of man's spirit and psyche. That the darker side of his philosophy was far from innocuous became obvious when Carrel was arrested in France as a collaborationist in 1944.

Certain conservative authors and publications targeted other specific components of Modern Man discourse. The *Saturday Evening Post,* for example, published in 1938 an article by "Henry C. Link, Ph.D." entitled "Man in Chains." The essay was a tirade against an implication of certain "widely accepted beliefs about human nature": that "the individual is a victim of forces beyond his control" (p. 71). The text was accompanied by an illustration showing modern man and two male children in the poses of Laocoön and his sons, struggling against entangling chains (configured to spell the word *fear*) in place of Poseidon's serpents (fig. 62). Link challenged the emerging representations of modern man, which in his view "substituted for the real man an economic fiction, a biological fiction, a pseudo-psychological fiction, a social fiction, and many other fallacies or half-

62. *Cesare,* Untitled ["Man in Chains"].
Reprinted from the Saturday Evening Post, *7
May 1938, 25.* © *Saturday Evening Post
1938.*

truths." His worries about these competing representations were not complicated or obscure; it seemed that "the more man learns about the world, the more numerous the forces of which he finds himself a victim, and the more numerous his excuses for dependence or despair" (p. 71). What could be more contrary to traditional (bourgeois) American values (ideology) than dependence or despair? Indeed, such beliefs were the "foundation for Fascism both as it exists abroad and as it is being prepared by the organized social trends in America." As Link saw it, the notion of modern man enchained by forces beyond his control would stifle self-respect, confidence, willpower, and individual initiative—the backbones of national greatness. The 1939 World's Fair would try to drive this point home: in the terms of Westinghouse's widely circulated

promotional film advertising the fair, the nation needed doers, not talkers or quitters, because "prosperity and pessimism don't travel together." To emphasize that self-respecting Americans should resist dependence, Link related the case of an eighteen-year-old youth who wondered whether he should go on relief in order to be able to attend engineering school or whether he should continue doing menial labor to support himself and his mother while trying to finish high school at night. Link's reply was decisive:

> You have the most priceless ingredient of success in the world, namely, self-dependence. . . . As soon as you accept help from an outside source you sacrifice your intellectual and moral independence, unless you can do it through a business-like loan or a scholarship based on merit. An engineering education obtained in this way will not do nearly so much for your success as will the attempt to obtain such an education independently. (P. 75)

In case readers were drawing the wrong conclusions from Modern Man discourse, in case they were applying its mistaken argument to their daily lives and imagining that it licensed social welfare, Link and the *Post* intended to set them straight. The affirmation of individual power, control, self-reliance, and enterprise was an effort to revive the dominant ideology's failing model of subjectivity; Link claimed support from a new "scientific school" of psychology whose "discoveries" (for example, that personality is an achievement, not an endowment) disputed those of psychoanalytic and behavioral "pseudo-psychologies."

Reader's Digest took another approach to combatting despair and pessimism. It published a condensation of an article entitled "Human Nature *Has* Changed" (December 1941), adapted from *Liberty* magazine. The author, Roger William Riis, affirmed that "human nature is changing for the better." If you think our recent behavior has been atrocious, the article proposed, just look at the behavior of our ancestors. Riis culled from the pages of Western history some of the more cruel and barbaric practices on record and presented them as grounds for belief in progress and hope for the future.

Another publication, the *American Mercury*, expressed a different worry about Modern Man discourse: that it was eroding class distictions. In "Why We Do Not Behave Like Human Beings," architect Ralph Adams Cram proposed a simple explanation: most of us are not human beings. Cram had been a very successful practitioner of Gothic Revival architecture, specializing in churches and college buildings, and had left his mark on the campuses of Princeton, West Point, and Sweet Briar as well as on numerous northeastern cities (the church of St. John the Divine in New York was one of his best-known projects). Cram wrote that most of us were unreconstructed Neolithic brutes, part of the ignominious substratum, the savage and ignorant mob, that has always constituted the bulk of humanity. Human nature has long been overestimated because we have tended to "gauge humanity by the best it has to show": by those fine, noble personalities eminent in the historic record, from Pharaoh Akhnaton to Confucius, Charlemagne, Leonardo, and George Washington. Cram offered a compelling image of humanity as a turbulent lava sea from which periodically fountains rose, "slim jets of golden lava, that caught the sun and opened into delicate fireworks of falling jewels, beautiful beyond imagination." Those virile fountains symbolized the natural aristocracy of the human spirit, whose inherent superiority had been obscured by democratic doctrines of equality and by the development of universal education and suffrage. The mob has been merely disguised, not changed or improved, by these institutions; its true nature is revealed in its

tastes in "art": "movies, jazz, modernist architecture, the comic strip and the subway magazine." His inclusion of modernist architecture in this company is a mark of Cram's aesthetic allegiances. Democracy has resulted in the assumption of universal control by the Neolithic men, and this, for Cram, was "the cause of comprehensive failure and the bar to recovery."

Cram's article was originally published in the *American Mercury* in September 1932, when the magazine was under H. L. Mencken's editorship. It was republished in August 1938 because of the subsequent editors' belief that it was "one of the most important contributions ever made to an American magazine" and had profound relevance to "the social and political disintegration now so markedly in progress in America" ("Editor's Note," p. 418). Cram, then seventy-five years old, was invited to contribute a sequel to the republication; no doubt the editors hoped he would dispel some of its ambiguities and offer a concrete program for recovery. Emboldened by the apparent confirmation of his analysis during the intervening years, Cram carried his argument to its obvious conclusion in "Mass-Man Takes Over" (October 1938). Government "by the barbarian factor in human affairs" was responsible for the current "descent towards Avernus," Cram continued. Developments in the aesthetic sphere ("from post-office murals to sadistic surrealism and lunatic abstractionism") and in the intellectual ("flatulent philosophies that spring up like mushrooms") mirrored the declines on the political, social, and international fronts. "We are where we are because we lack a true aristocracy." Himself descended from German nobility and part of a socially prominent New England Puritan family, Cram called for an end to democracy and for the subordination of the masses to aristocratic parliamentary rule. A new standard of personal and social values would thus be established and act as a "powerful censor" upon popular behavior; the phrase recalled Babbitt's "inner check" and indicated a link to the New Humanism: perhaps it was more than coincidence that the eastern university milieu in which Babbitt's philosophy thrived was done up in Cram's Collegiate Gothic decor. Cram contended that the "Jeffersonian principles" of "birth, worth, and talent" in government might save humanity from catastrophe.

Cram's essays meant to correct some impressions generated by the "flatulent philosophies" composing Modern Man discourse, with its concentration upon the complex dynamics of "human nature": the leveling it implied, its even apportionment of blame, its suggestion that distinctions among men were relatively insignificant. There was, indeed, an erasure of difference effected in Modern Man discourse, but that erasure was a two-edged sword: its obscuring of class distinctions could be construed by Cram as a slight or injustice to the socially elect, but it also offered protection against those who believed that the elite had never really ceded power to the masses. For those members of the nation's upper classes who preferred to forgo close examination of the extent of their power, their fitness to hold it, or the measure of their responsibility for current difficulties, the erasure of difference in Modern Man discourse was a considerable convenience. Cram would have squandered this advantage. If he meant to distinguish between an empowered bourgeois elite and a disempowered true aristocracy, the distinction was not clarified in his essay. His mistake was to take the dominant ideology at face value and imagine that the masses had really come to power. Had his program been successful and the power of the "natural aristocrats" been formalized and legitimated, their politics of self-interest would have been dangerously exposed.

Ironically, the same issue of *American Mercury* that featured the republication of "Why We Do Not Behave Like Human Beings" opened with an editorial titled "Wanted: An American Upper Class." The editors noted that the American elite had not been observing the upper-class code of manners and conduct of late. Far too many of its members had been turning up in highly publicized scandals; they were failing to exemplify the virtues, integrities, and decencies that any society expects and requires of its upper class. The editorial placed the responsibility for this at the feet of American society, which loads its upper class lavishly with privileges but then, in its distaste for snobbery, forbids the indulgence of anything but a middle-class system of manners. As a result, the lower classes had little to emulate but "a crew of high-grade thieves and unadmirable racketeers" (August 1938, p. 389).

A different kind of critique of Modern Man discourse was launched from the left side of the political spectrum, a critique that focused on its irrational, mystical, and "obscurantist" dimensions. Throughout the 1930s leftist journals such as *Modern Monthly, Common Sense,* and *Partisan Review* attacked authors who advanced Modern Man arguments, typically reserving the most scathing criticism for those writers occupying vaguely leftist positions. To cite one representative example: C. Hartley Grattan published in *Modern Monthly* in 1933 open letters to Ludwig Lewisohn, Joseph Wood Krutch, and Lewis Mumford, all of whom had recently published influential books that Grattan found objectionable. Of Lewisohn's *Expression in America,* only marginally a Modern Man text, Grattan wrote that its "religio-freudianism," "pervasive irrationalism," and attempt to effect an alliance between literature and religion were "a direct encouragement to a sort of irrationality of which we have a great plenty already." Krutch's *The Modern Temper* was criticized as defeatist and sentimental: it "set up two major enemies of man: nature and science," and juxtaposed them with "two nostalgias: for a universe under perfect control of man and for the past." The result was an absurd "hypochondria of the mind . . . an inevitable expression of a disorderly period in human history." Mumford was faulted for "a pervasive weakness for the vague, the mystical and the pseudo-mystical," manifested, for example, in his "persistent use of the word 'spiritual.' "[73]

For many of those on the left, Lewis Mumford's work came to epitomize the degeneration of leftist cultural analysis under the influence of Modern Man tendencies. Over his long career as a writer, beginning with *The Story of Utopias* in 1922, he developed a romantic, organicist, utopian socialism that balanced concern with the individual self against concern with culture and society. As he wrote in his contribution to *Forum*'s "What I Believe" series, "I believe in a rounded, symmetrical development of both the human personality and the community itself" (November 1930, p. 267). His writing, comprising criticism of art, architecture, and literature; the histories of thought and urbanism; and social and cultural commentary; occupied and intersected the various genres central to the present study. His activity spanned the full period under consideration: he had been an associate editor, with Helen Marot, at the *Dial* following World War I; he delivered the opening address at the First American Artists' Congress against War and Fascism in 1936; and in the decade between 1934 and 1944 he published a three-volume study intended to:

> give a rounded interpretation of the development of Western man, and to show what changes

in his plan of life are necessary. . . . Not once, but repeatedly in man's history has an all-enveloping crisis provided the conditions essential to a renewal of the personality and the community. In the darkness of the present day that memory is also a promise.[74]

His attention to the human individual and to the need to reconceive that individual's nature as a means of addressing current crises, his disdain for hard rationality and science, his admiration for Jung,[75] and his affirmation of modern man's "spiritual" and "tragic" aspects—all of these set him within Modern Man discourse and account for the appearance of his words at the head of more than one chapter in this book.

Yet Mumford's work does not reside comfortably within the parameters of Modern Man discourse. This is a matter, on one hand, of the constant balancing of his focus on the individual with attention to the nature and effects of community. Mumford acknowledged Freud's insight in discovering the unconscious, but he criticized him for "desocializing" the self, as well as for overdependence upon science.[76] Furthermore, it is an effect of the tensions in the model of the individual that Mumford promoted. As Meyer Schapiro pointed out in a highly critical review, Mumford ultimately placed his faith in "men of good will" for the restoration of society to organic, communitarian, humanist principles. His confidence in rational, purposive effort based on human goodwill as a vehicle for social improvement ran fundamentally against the grain of Modern Man discourse, which challenged traditional humanist beliefs in basic human goodness, unconflicted motivation, and autonomous rationality. Mumford's project entailed a revival of bourgeois humanism: Malcolm Cowley described Mumford as "the last of the great humanists," though James T. Farrell saw his humanitarianism as "vague and Utopian."[77] So while Mumford's work often had the veneer and tone of Modern Man literature, the model of human nature it endorsed was very close to the traditional paradigm whose inadequacies that body of work was designed to address. Despite this mismatch, the criticisms elicited from the left by Mumford's work were those they directed at Modern Man discourse generally. For example, Meyer Schapiro's critique of *The Culture of Cities,* the second volume of Mumford's trilogy, blasted the book for its "mysticism of the organic" and for its "psychologizing of capitalism," which "veil[ed] its historical and social character in moral categories."[78] Schapiro charged that Mumford did with his historical narratives "what he often does with our own society; its evils and virtues are made to flow from the special psychologies of the predatory and the 'organic' man. On the whole, he tends to psychologize causes and moralize effects." A more apt description of Modern Man discourse would be hard to locate.

Mumford's work attracted extensive criticism from various factions on the left throughout the 1930s and 1940s, especially from the period 1938 to 1944, when he became a self-appointed conscience of the left intelligentsia and a visible and vocal proponent of the United States' entry into war against Fascism as well as a controversial analyst of current problems. Mumford was repeatedly criticized in the left periodical press for obscurantism, spiritualism, irrationalism, and psychologism.[79] James Farrell quoted the following passages from *The Condition of Man* as capsule illustrations of Mumford's irrationalism, overemphasis upon individual personality, and misunderstanding of Marxism and socialism:[80]

> "Today our best plans miscarry because they are in the hands of people who have undergone no inner growth."

"In the great successful personalities of the communist movement, Marx's aggressive and domineering impulses played a disproportionate part and rippled on through their followers."

"Only the acceptance of a mystery beyond the compass of reason keeps man's life from becoming devaluated and his spirit from becoming discouraged over the reports of reason."

Sidney Hook voiced similar criticisms in a response to Mumford's *Faith for Living*, singling out for special attention Mumford's obscure metaphysics, which entailed "belief in the primacy of metaphysical faith" at the expense of the "rationale of the scientific method." He also ridiculed Mumford's notion of the tragic sense of life, as expressed in the following passage, quoted by Hook: "Unless life is conceived as a tragedy, in which the ultimate certainty of death counts at every moment in one's actions and plans for living, it becomes little better than a farce." Hook grouped Mumford with Waldo Frank and Archibald MacLeish as representatives of a tendency among leftist intellectuals to turn away from science and reason and to try to struggle against Hitlerism with "metaphysics, mysticism, and hysteria." All three writers presented, in Hook's view, a picture of current crises as the product of misguided philosophy and a "condition of men's minds"; the solution they offered was a "new doctrine of the world and man, an organic metaphysics and theology."[81]

With the escalation of the war in the early 1940s, a number of anti-Stalinist, anti-Fascist, Socialist and liberal intellectuals joined Hook in this attack against antirationalism. The specific target of the attack, however, shifted slightly, away from Mumford, Frank, and MacLeish, and toward others who had come to seem more influential and dangerous as missionaries of Modern Man religion during the crisis of faith brought on by the war. Although Hook specified that his own charges continued to apply to Mumford, Frank, and MacLeish, he considered them mere literary critics, not philosophers or political figures, the complicitous "lay brothers of the forward-looking obscurantists" who seek to induce social reconstruction through individual spiritual regeneration.[82] The new assault erupted in the pages of the *Partisan Review* in early 1943; the magazine published a series of articles attacking what it called "the new failure of nerve." Sidney Hook wrote the lead article, articulating a platform that was further elaborated in essays by John Dewey, Ernest Nagel, Norbert Guterman, Richard V. Chase, and Ruth Benedict. Hook quoted Gilbert Murray's description, in *Four Stages of Greek Religion*, of the period from 300 B.C. to 100 A.D. as marked by a "failure of nerve":

> a rise of asceticism, of mysticism, in a sense, of pessimism; a loss of self-confidence, of hope in this life and of faith in normal human efforts; a despair of patient inquiry, a cry for infallible revelation: an indifference to the welfare of the state, a conversion of the soul to God. ("The New Failure of Nerve," 2–3)

Hook's principal target was a turn to religion that had gathered considerable momentum among intellectuals in the early years of World War II. Reinhold Neibuhr's *The Nature and Destiny of Man*, published in 1941, was one of the most visible and influential components of this development; consequently, Niebuhr, along with Jacques Maritain, was singled out for criticism by the *Partisan Review* authors. Niebuhr's book was in some respects a quintessential Modern Man text, following the core model established by Robinson: the author set out to untangle the difficulties and confusions that surrounded

the conception of "human nature" as a result of its amalgamating classical, Christian, and modern beliefs (vol. 1, p. 18). Neibuhr argued that man's essential nature contained two elements: his natural endowments, that is, a set of characteristics that imbedded him in the natural order; and a free, transcendental spirit, which removed him from nature (vol. 1, p. 270). While science could address the first part of this nature, the second was the proper domain of Christian theology. Psychology, for Niebuhr, had demonstrated the limitations of science in the analysis of human nature; it was capable of dealing with the "depth in the human spirit" only insofar as it left the confines of natural science and admitted philosophical and semireligious speculations (vol. 1, p. 73–74).

Hook and his colleagues viewed Niebuhr's arguments as part of a large-scale attack on science, philosophical naturalism, and rationality itself. Not only was science being portrayed by antinaturalists and supernaturalists as inadequate to the analysis of current crises, it was also being held responsible for those crises: exclusive dependence upon science and reason and neglect of spirituality, it was claimed, had promoted, if not actually caused, the disintegration of modern life. Hook led the counterattack against antinaturalism, which he characterized as obscurantist and mystical. While his own principal objectives—the defense of science and naturalism and the unmasking of spiritual revival as a misapplication of reconstructive energies—were fairly narrow, many of his criticisms and those of several of his collaborators applied to Modern Man discourse broadly.

> There is hardly a field of theoretical life from which these signs of intellectual panic, heralded as portents of spiritual revival, are lacking. No catalogue can do justice to the variety of doctrines in which this mood appears. For purposes of illustration we mention the recrudescence of beliefs in the original depravity of human nature; prophecies of doom for western culture, no matter who wins the war or peace, dressed up as laws of social-dynamics; the frenzied search for a center of value that transcends human interests; the mystical apotheosis of "the leader" and elites; contempt for all political organizations and social programs because of the obvious failure of some of them, together with the belief that good will is sufficient to settle thorny problems of social and economic reconstruction; posturing about the cultivation of spiritual purity; the refurbishing of theological and metaphysical dogmas about the infinite as necessary presuppositions of knowledge of the finite; a concern with mystery rather than with problems, and the belief that myth and mysteries are modes of knowledge; a veritable campaign to "prove" that without a belief in God and immortality, democracy—or even plain moral decency—cannot be reasonably justified.[83]

While Hook's criticisms focused on Niebuhr and Maritain, Richard Chase took Aldous Huxley to task for his belief that "the crisis and its cure are purely psychological," and he blasted Gerald Heard for seeking to escape the troubles of the time through a psychoanalytic spiritualism. Ruth Benedict challenged the prevailing tendency to scapegoat Neanderthal man: to assign the social disorders of the modern world to inherent aspects of human nature, such as belligerence. "Human nature does not prescribe any one selected kind of human world," Benedict wrote. What marked human nature above all was an orientation toward problem solving: using reason, foresight, and judgment for the solution of human problems. That was precisely what was needed at the moment, she argued: acknowledgment that modern crises were "consequences of inadequate social solutions of human problems." Sidney Hook's concluding segment attacked the left for

itself succumbing to the "atmosphere of mysticism, of passionate, sometimes sacrificial, unrealism, and of hysterical busywork which today fills the zones of the radical spirit."[84]

The battle was a version of the feud Arthur Koestler described in "The Yogi and the Commissar": the commissars—die-hard revolutionaries of the 1930s, rationalists, believers that the solutions to current problems could come only from social and political reorganization—against the yogis—the new seekers of spiritual regeneration from within the individual, antirationalists, mystics.[85] Koestler wondered that psychologists had not undertaken to study what was emerging as a widespread pattern of conversion— "the revolutionary's transformation into a cynic or mystic." Part of the problem, as Koestler saw it, was that the left was failing to come to terms with the "revolution in psychology" and its implications for politics: the commissars had "completely severed relations with the subconscious." Where the left was failing, the center would show more ingenuity, as I will argue. Incidentally, artists, in Koestler's view, (arty commissars as opposed to political commissars) constituted the group least resistant to conversion.

The positions articulated by Hook and his associates constituted a powerful critique of what I have been calling Modern Man discourse. Yet some of the premises of the critique—particularly Hook's and Dewey's untempered, "spiritual" faith in science and reason—were themselves open to criticism, and a number of respondents posed serious questions and raised difficult challenges. Within *Partisan Review* itself and from the left, David Merian charged that Hook's scientism was an "empty veneration of method," that is, that science was in no sense innocent of political and social dimensions but could be applied for fascist and counter-revolutionary ends as well as for progressive ones.

> The choice today is not between supernaturalism and naturalism, irrationality and science. It is between the socialist program and the half dozen schemes which are more or less naturalistic and scientific in their economic and political calculations, but are designed to maintain the present system with all its cruelties and chaos. The greatest enemy is not the metaphysician or the priest, dangerous as he may be, but the armed class opponent who uses the resources of science for his own ends. ("The Nerve of Sidney Hook," p. 257)

The literary magazine *Chimera* published a series of articles critical of the *Partisan Review* authors.[86] In one of them, Kenneth Burke pointed out the facility of the dualism between scientific and nonscientific knowledge in the *Partisan Review* essays; he objected that science itself necessarily requires liberal quantities of "intuition," "imagination," "vision," and "revelation" for its ordinary operation.[87] W. H. Auden contributed an intense exploration of his identity as an "anxious subject" and the religious problem inherent in it.

> Whenever a scientist attacks religion in general, he betrays his anxiety lest it should turn out that when he is not engaged in actual experiments on objects which are weaker than he, but is placed in any of those situations called personal, i.e., when he is forced to be an existing subject and the object of attention from other subjects, far from remaining impersonal and scientific, he becomes a passive object, the blind tragic hero with a shocking temper, the bewildered rat of his own maze.[88]

Faith in science, Auden suggested, required confidence in the subject's position of centrality, authority, and control, precisely the confidence that modern man was increasingly unable to sustain.

The debate would have benefited from the critique of Enlightenment values then

being developed in Los Angeles by the German refugees Max Horkheimer and Theodor Adorno. Their representation of Enlightenment science and rationality as a dialectical mode of domination—as "the vehicle of progress and regression at one and the same time" (p. 35), and as harboring and preserving the religious mythology it meant to overthrow—might have helped undermine the oversimplifying, stark oppositions that structured the "New Failure of Nerve" exchanges. Horkheimer's argument that "attacks on reason were designed to reconcile men to the irrationality of the prevailing order" might have offered a provocative new perspective on the situation.[89]

COMMENTARY

My narrative may seem to have drifted toward highbrow manifestations and criticisms of Modern Man literature, but that impression is a bit misleading. The mass-circulation news magazines and the daily papers devoted considerable attention to the activities and writings of Mumford, MacLeish, and others.[90] MacLeish, after all, served as Librarian of Congress and as director of information and cultural affairs in the State Department. His public pronouncements were newsworthy events. And there was no shortage of other Modern Man representations directed to a mass audience. Philip Wylie's best-selling *Generation of Vipers* was a product of this same moment. (Clement Greenberg titled a 1947 review of Wylie's work "Pessimism for Mass Consumption.") Walter Lippman was then popularizing his own views on the subject, views remarkably similar to Babbitt's and Greenberg's.[91] When Norman Cousins declared the end of modern man in the aftermath of Hiroshima and Nagasaki, his essay, "Modern Man is Obsolete," sold out the August 1945 issue of *Saturday Review* and was quickly republished in book form by Viking Press. Cousins affirmed that man must now remake himself for the atomic age; he must change both himself, by putting an end to competitive individualism, and his government, by eliminating nationalism and establishing a world government. With the appearance of the atom at center stage, Modern Man discourse began to undergo some of the changes, notably the resurgence of vitalist traditions, discussed in chapter 3.

Still, the postwar urge to begin anew the analysis of man did not result in the disposal of the version that had evolved in the interwar years. Some of the most interesting discussions concerning modern man in the wake of the war took place in the pages of a new journal that began publication in November 1945. *Commentary,* styled "a Jewish Review" and published by the American Jewish Committee, gathered together a group of intellectuals whose ethnic and religious identities made the horrors of recent history especially immediate. Despite vast differences in political and philosophical orientation and intended audience, *Commentary* picked up where *Forum* left off, making the study of modern man a principal focus and trying to represent the full range of opinion on important issues.

Commentary included a regular column called "The Study of Man," which surveyed "the significant research, thought and speculation in the sciences dealing with man and society."[92] Nathan Glazer, the editor responsible for coverage of sociology, psychology, and anthropology (Sidney Hook covered philosophy, ethics, and education), called one column "The 'Alienation' of Modern Man, Some Diagnoses of the Malady" (April

1947), and another "The Dark Ground of Prejudice, Discussing Some Psychological Factors" (June 1947). A number of writers were invited to contribute to a series titled "The Crisis of the Individual," addressing such questions as:

> Where did our Western civilization go wrong? . . . Is the contemporary crisis due to technology and large-scale planning, or their present day misuse; or to a distortion of basic ideals which would require a renascence of religious belief or some other inner revaluation of values? (January 1946, p. 1)

Reinhold Niebuhr ("Will Civilization Survive Technics?"), Leo Lowenthal ("Terror's Atomization of Man"), John Dewey ("The Crisis in Human History: The Danger of the Retreat to Individualism"), William Orton ("Everyman amid the Stereotypes; Needed: 'A Revolution of the Spirit of Man'"), Waldo Frank ("The Central Problem of Modern Man; The Choice: Wholeness or Doom"), Abram Kardiner ("Western Personality and Social Crisis: A Psychiatrist Looks at Human Aggression"), Louis Finkelstein ("Modern Man's Anxiety: Its Remedy"), Sidney Hook ("Intelligence and Evil in Human History"), and others—including a few women, notably Hannah Arendt and Pearl Buck—contributed to the series between 1945 and 1947. The philosopher Irwin Edman's contribution ("Religion without Tears: Do Moderns Need an Other-Worldly Faith?") reconsidered the issues behind the "failure of nerve" controversy.

Modern Man literature was reviewed regularly in the pages of *Commentary.* Clement Greenberg, one of the magazine's founding editors, took up Philip Wylie's *Essay on Morals* in 1947. Greenberg thought Wylie's claim "that man can solve his present difficulties only by freeing his instincts from the domination of the ego," was "nonsense," but he was disturbed more by the author's purveying a vulgarized "profundity for the masses." What made Wylie's book important, for Greenberg, was its status as a banal "symptom of a dissatisfaction with the quality of contemporary American life that is spreading even to the smuggest and most worldly-successful sectors of our society."[93]

In an important article published in *Commentary* in August 1946, Siegfried Kracauer pulled Hollywood's recent surge of *noir* and terror films into the orbit of Modern Man discourse. Kracauer was a film critic and refugee from Germany particularly interested in the "social implications of the cinema." His study *From Caligari to Hitler: A Psychological History of the German Film* had recently gone to press. He wrote:

> The tide in Hollywood has turned toward sick souls and fancy psychiatrists. And many a current melodrama suggests that normal and abnormal states of mind merge into each other imperceptibly and are hard to keep separate. . . . unlike the gangster movies of the depression era, the new films deal less with social abuses than with psychological aberrations. And this time the failure of the movies to offer or suggest solutions has become particularly striking; the all-pervasive fear that threatens the psychic integrity of the average person seems accepted as inevitable and almost inscrutable. ("Hollywood's Terror Films," p. 133)

Kracauer did not distinguish between *noir* (the term had not yet been imported from France) and thriller or terror films; he spoke of *Dark Corner* alongside *Shadow of a Doubt, Suspicion, Spellbound, Shock,* and *The Stranger,* all sharing a taste for morbidity and sadism. He read these developments as "reflecting a contemporary American state of mind" directly responsive to the conditions of current life:

> The political and social struggles of our time are not concerned merely with external changes and new borders—they involve the very core of our existence. A civil war is being fought

inside every soul; and the movies reflect the uncertainties of that war in the form of general
inner disintegration and mental disturbance. (Ibid., p. 136)

Kracauer regretted that these new Hollywood movies offered little cause for hope, no suggestions for solutions; unlike some foreign films, such as *Open City,* they represented no positive forces or "principles of human integrity" that might battle the deranged world and its forces of cruelty, violence, and fear. Instead Hollywood offered two kinds of therapeutic relief:

> One type dramatizes psychoanalytic healing to show how mental balance can be restored from within . . . [the other] shows us Catholic life, and intimates that reintegration may be obtained from without, under the ministrations of the Church. (Ibid., p. 135)

Kracauer's insights and worries—for example, that the acclimation of horror and fear to the American scene might produce an "emotional preparedness for fascism"— sometimes betray a too direct and mechanistic model of the relation between representation and society. Nonetheless, his characterization of the new tendency in Hollywood film production was pathbreaking.

THE VITAL CENTER

To conclude this schematic historical survey of the development of Modern Man discourse, I want to turn briefly to Arthur Schlesinger, Jr.'s *The Vital Center,* an influential book which, as Serge Guilbaut has ably demonstrated, codified a new centrist platform for political liberalism in the cold war era. Schlesinger, the son of a professor of history at Harvard, had grown up in Cambridge, Massachusetts, and attended Phillips Exeter Academy and Harvard College; subsequently he spent a year at Cambridge University as a Henry Fellow and three years in Harvard's Society of Fellows. By the time *The Vital Center* was published, Schlesinger had secured a place in the Harvard history department for himself. But he was no ivory-tower intellectual; throughout his career Schlesinger was actively involved in government and politics. During the war he served in the government's Office of War Information and Office of Strategic Services; in 1947 he became a founder and vice-president of Americans for Democratic Action (an organization of anticommunist liberals). Schlesinger became an influential designer, defender, and promoter of a centrist political platform that combined elements of New Deal liberalism and anticommunist conservatism (he and others in the ADA tried to draft Eisenhower as the Democratic candidate for president in 1948; and in the early 1950s he was accused by *Nation* contributor Carey McWilliams of speaking "the language of McCarthy with a Harvard accent").[94] During the Truman presidency, the time during which he wrote *The Vital Center,* Arthur Schlesinger was "an Administration man"—a vocal defender of government policies promoting containment of Communism and reconstruction of Europe, including the Truman Doctrine, the Atlantic Pact, and the Marshall Plan.[95] His articles appeared in magazines spanning the political and cultural spectra, including *Collier's, Saturday Evening Post, New Leader, Partisan Review, Nation, New Republic, Saturday Review of Literature, New York Times Magazine, Fortune,* and *Life.*[96]

In Guilbaut's study Schlesinger's *Vital Center* stands as the quintessential articula-

tion of that political ideology which Abstract Expressionist painting came to serve by virtue of its participation in U.S. cultural diplomacy during the 1950s. The work of Pollock and his colleagues was presented as representing the anxiety, alienation, and frustration that distinguished the free individual in the modern world; psychological discomfort was, for Schlesinger, the mark and price of freedom, and in the context of government sponsorship the paintings affirmed that the United States remained the land of the free. Totalitarian governments, both right and left, permitted the individual no choice, and therefore engendered no anxiety, Schlesinger argued. "Against totalitarian certitude, free society can only offer modern man devoured by alienation and fallibility."[97]

Although bedecked here in Existentialist accoutrements, the "modern man" of Schlesinger's free society is very much the character who has become all too familiar to the reader by now. One of the principal purposes of *The Vital Center* was to ground liberal political theory upon a new conception of man. "Mid-twentieth-century liberalism, I believe, has thus been fundamentally reshaped by the hope of the New Deal, by the exposure of the Soviet Union, and *by the deepening of our knowledge of man*" (p. ix; italics added). Schlesinger used modern man as a weapon against the two political extremes he wished to marginalize: conservatism and progressivism. The former did not adequately restrain man's base impulses, the latter did not even recognize them. He distinguished a "death-wish" in unregulated capitalism, whose advocates were "driven by dark impulses beyond their own control to conspire in their own destruction" (p. 28). Progressivism, on the other hand, had succumbed to an unwarranted optimism about man: its utopian faith in science and the goodness of man had blinded it to "the dark and subterranean forces in human nature" (p. 39). The possibilities for human depravity, Schlesinger noted, had been amply charted by Dostoevsky, Kierkegaard, Nietzsche, Sorel, and Freud; and they were realized by Hitler, Mussolini, and Stalin. A viable political organization would be one that both preserved the potent weapons industrialism has given man from "the pride and the greed of man, the sadism and the masochism, the ecstasy in power and the ecstasy in submission" (pp. 5–6) and preserved at the same time the liberty of the individual. Schlesinger cited Niebuhr and Freud in support of his claim that private ownership was not the cause of injustice and evil in modern society. The root of aggression was not social organization: "the root remains man" (p. 46). The strength of the new liberalism, Schlesinger claimed, issued in part from the lessons it had learned about modern man:

> Today, finally and tardily, the skeptical insights are in process of restoration to the liberal mind. The psychology of Freud has renewed the intellectual's belief in the dark, slumbering forces of the will. The theology of Barth and Niebuhr has given new power to the old and chastening truths of Christianity. More than anything else, the rise of Hitler and Stalin has revealed in terms no one can deny the awful reality of the human impulses toward aggrandizement and destruction—impulses for which the liberal intellectual had left no room in his philosophy. (P. 165)

Liberals had once known this about man; Andrew Jackson and Nathaniel Hawthorne are cited as representatives of the liberal tradition of "a moderate pessimism about man" (p. 165). But the subsequent influence of sentimentalists and utopians had caused it to be forgotten. Now, with the formation of the Americans for Democratic Action, "American

liberalism began to base itself once again on a solid conception of man and of history," abandoning "the old faith in the full rationality of man" (p. 166). The advantage of pessimism over progressivism, Schlesinger affirmed, was that the former "truly fortifies society against authoritarianism," because "far from promoting authoritarianism, [it] alone can inoculate the democratic faith against it" (pp. 169–70).

Schlesinger also drew upon Existentialism in his reformulation of liberal doctrine. Kierkegaard, Sartre, Dostoevsky, and Fromm all attest in his text to the torment and anxiety caused by freedom and choice. The desire to escape from freedom is proffered as an explanation for the appeal of totalitarianism.

> The "anxious man," we have seen, is the characteristic inhabitant of free society in the twentieth century. . . . Totalitarianism sets out to liquidate the tragic insights which gave man a sense of his limitations. . . . the totalitarians have eliminated the conflict between man and the universe, healed the estrangement. (*The Vital Center*, pp. 56–57)

The individual who would remain free must become reconciled to the psychic discomfort freedom necessarily entails. Yet the part played by Existentialist rhetoric in the book is rather small compared to the essential, structural role of Modern Man discourse. This may owe to a discrepancy between Existentialism's reempowered individual, endowed with the capacity to engage in self-determination through directed action, and the psychoanalytic attributes (automatism, determination by past events or psychic forces, internal division) essential to the Modern Man model. In Existentialism, division is between the individual and the cosmic order; while this account might be able to accommodate much of the Mythmaker view of modern man and his condition, other crucial aspects, such as modern man's internal fragmentation and division, are necessarily minimized or excluded. Furthermore, the dogged, albeit besieged optimism and the untroubled essentialism of Modern Man discourse distinguish it from Existentialism. *The Vital Center* reveals the extent to which the discourse on modern man specifically enabled the reconstruction and revitalization of moderate liberalism during the wartime and postwar period. The discourse, whose development had always been guided by the dominant ideology, was now fully recognized by that ideology and articulated in political terms. The process was as much reclamation as appropriation. The strength of the new centrist liberalism codified by Schlesinger, which became the dominant political ideology of the cold war era, rested in large part upon its incorporation of the new model of human nature. The problems voiced by the editors of the *New Republic* in 1922—their worry about the "plight in which American liberalism finds itself as a result of the cataclysmic events of the last decade"—were finally and effectively addressed in Schlesinger's formulation. The hegemonic ideology was now equipped to turn back the challenges that had been mounted in the 1930s; the path to retrenchment was cleared.

In 1956, marking the centenary of Freud's birth, the Harvard psychologist Jerome S. Bruner meditated in *Partisan Review* upon Freud's contribution to the revolutionary new image of man that had become part of the "common understanding."[98] (1956 was also the year of Pollock's remark that "we're all of us influenced by Freud, I guess" and, later, of his death.) He wondered why the Freudian model, so vehemently resisted at first, had ultimately "found a ready home in the rising, liberal intellectual middle class" ("Freud and the Image of Man," p. 347). Beyond affirming the importance of this new image of man to the new liberal world view, the essay offers interesting contemporary speculations

regarding possible causes for the shift. Ultimately, Bruner attributes the power of Freud's new conception of man to its truth: the fact that it resolved polarities that had plagued the human sciences for centuries—that is, it established continuities between categories formerly thought discontinuous ("between man and the animal kingdom, between dreams and unreason on one side and waking rationality on the other, between madness and sanity, between consciousness and unconsciousness, between the mind of the child and the adult mind, between primitive and civilized man" [p. 340]). But the popular acceptance of its truth was due, in Bruner's view, as much to the style as to the substance of Freudian theory. He proposed that Freud's imagery was an important component of the ideological power of his model. Its engaging and familiar dramatic character was one factor: relations among "the blind, energic, pleasure-seeking id; the priggish and puni-tive super-ego; the ego, battling for its being by diverting the energy of the others to its own use" found no shortage of prototypes and counterparts in traditional and mass culture (p. 346). Moreover, the "tragic quality" of the imagery "fits the human plight, its conflictedness, its private torment, its impulsiveness, its secret and frightening urges" (p. 347); that is, it holds existential as well as philosophical truth: it matches the lived experience of modern man. And finally, the "hydraulic" and electrical character of Freud's imagery, its casting of mental processes in terms of liquid and electrical flows, "fitted well the common-sense physics of its age" (p. 347). This aspect of Bruner's analysis overlaps with my argument in chapter 3, regarding the character of Pollock's metaphorical models of the unconscious and the sources of their power to compel attention. Bruner's essay is itself still too much a product and vehicle of Modern Man discourse to contribute much to the more distanced analysis of attractions and functions that I have been attempting in this study. Still, some of the article's insights go right to the heart of my arguments—none more so than Bruner's statement of the political signifi-cance of changes in the dominant conception of man: "Those who govern must perforce be jealous guardians of man's ideas about man, for the structure of government rests upon an uneasy consensus about human nature and human wants" (p. 341).

Optimism and hope of social improvement may be harder to sustain now than they were in 1930s and 1940s. Writing in 1989, Richard Rorty saw the course of recent tragic events dwarfing those of the earlier era.

> The cynical and impregnable Soviet Empire, the continuing shortsightedness and greed of the surviving democracies, and the exploding, starving populations of the Southern Hemisphere make the problems our parents faced in the 1930s—Fascism and unemployment—look almost manageable. People who try to update and rewrite the standard social democratic scenario about human equality, the scenario which their grandparents wrote around the turn of the century, are not having much success. The problems which metaphysically inclined social thinkers [Rorty has Habermas in mind] believe to be caused by our failure to find the right sort of theoretical glue—a philosophy which can command wide assent in an individualistic and pluralistic society—are, I think, caused by a set of historical contingencies.[99]

Rorty and other "liberal ironists" are inclined to devise rather different philosophical responses to the current situation, but, for better or worse, it was the achievement of that metaphysics of human nature evolved within Modern Man discourse to command wide assent in the individualistic and pluralistic society of the 1930s and 1940s. It provided the "common vocabularies and common hopes"—the vocabularies of the social sciences and the hope that the new knowledge of man would lead to better behavior in the future—

that bound the society together. Modern Man discourse managed to "divinize the self as a replacement for a divinized world."[100] Just as every credible theology, especially those projecting a beneficent deity, must account for evil, injustice, and cruelty in the world, so must the divinized self have the same capacity. It was the achievement of Modern Man to rationalize hitherto unprecedented levels of violence and evil while sustaining the bulk of the society's traditional institutions, beliefs, values—in short, the hegemonic ideology. In New York School theorizing, *film noir* and other Modern Man cultural productions, cruelty, violence, injustice, and evil seemed to have few, if any, social, economic, or political dimensions.

MODERN MAN DISCOURSE AND THE NEW YORK SCHOOL

Barnett Newman's observation that he and the other New York School painters had "made cathedrals of ourselves" attests to their participation in the divinization of the self. Schematic though it may be, the preceding outline of some of the varied strands within Modern Man discourse provides an illuminating cultural matrix for the interests and works of the New York School painters. Like the Modern Man authors, these artists saw their work as responsive to the war and other contemporary stresses. One might assume that this was true to some extent of all art made during the war, but this was not the case. Reviewing the "Artists for Victory" show at the Metropolitan Museum in 1942, Manny Farber remarked on the paucity of images addressing the war and its implications.

> It is interesting how few of these painters were influenced by the war. (Though perhaps the hand of the selection jury may be felt here.) Out of 468 I think there are only three war pictures, yet nothing else is so constantly on our minds and in our feelings. It is as though American painters are so tied to copying scenes on tables, out the window, or on the model stand that they will have to see the war to paint it. But it is just such profound and close to terrifying emotions that Americans seem to be afraid to respond to. These people are artists: they are supposed to have gone beyond the strictures of our culture. Yet there seems to be a definite fear behind the pictures in this exhibit of saying something the spectator will have to look at silently and without even mental phrases, of exposing the emotions we do not talk of politely, of, in other words, being at all profound and personal.[101]

To be profound and personal was the challenge that Rothko, Gottlieb, Pollock, and others were then taking up with a vengeance, as the numerous manifestoes of the following year make clear. Gottlieb's remark in *Tiger's Eye* in 1947 makes vivid the relation between the painters and the discourse on modern man: "Today when our aspirations have been reduced to a desperate attempt to escape from evil, and times are out of joint, our obsessive, subterranean and pictographic images are the expression of the neurosis which is our reality."[102] To cope with the perception of pervasive evil by looking to the subterranean interior, thereby expressing the neurosis of the time, was a preferred strategy of Modern Man authors as well as New York School artists. While histories of this art commonly have traced its notions of self and the human situation to new "existentialist" philosophies filtering into the U.S. from Europe in the wake of the war, there is reason to argue that the subjective identities shaped by the artists and imbricated in their paintings were already highly developed and thoroughly implemented by then. Nor is an existentialist influence necessary (or even able) to explain the

formal changes witnessed in New York School art during these postwar years, specifi-
cally the gravitation toward system, simplification, and abstraction; the next chapter is
meant to illustrate this point, taking the work of Pollock as a crucial case study and
building upon the discussion in chapter 3.

The paintings and statements analyzed in the preceding chapters and seen now in the
broader context delineated just above, indicate that the work and thought of the New
York School artists were deeply rooted in the discourse about modern man. Questions
about primitive instincts and unconscious impulses and the role of these in mental
processes are the principal links between the artists and this broad discourse. These links
were not lost on contemporary observers. "The subject of the paintings of Adolph
Gottlieb is without question an attempt at revelation of the psychiatric configurations of
the 'id' or inner panorama of the mind of modern man," wrote one reviewer.[103] The
locution *modern man* was ubiquitous in 1949; in itself it signifies little and is not
sufficient to fix a text as part of Modern Man discourse unless it conjures, as here, the
particular terms of the discourse. Even in this narrower sense, the locution permeated the
criticism and commentary on New York School painting with fluid ease—a mark of
congruence between the art and the discourse that engendered the term and gave it
meaning.

The differences in priorities and attitudes among the artists, some of which I pointed
out as obstacles to group identity, become less obtrusive when situated within the
enveloping discourse. Whether an artist focuses on primitivism or unconsciousness,
whether science and reason are seen as causes or solutions to modern problems—such
discrepancies matter less once an overarching discursive frame situates them as different
positions within a circumscribed network of beliefs, assumptions, attitudes, and inter-
ests. Furthermore, other interests, which formerly seemed idiosyncratic or irrelevant,
may acquire new significance as a result of reintegration into the discourse. One example
is the penchant for intellectuality and philosophy in the work of many of the artists—
sometimes explicit, sometimes implicit, in an insistence on the importance of the "sub-
ject" in their work. Philosophical ambitions motivated much New York School work,
and the philosophy engaged tended to be that of Modern Man discourse. Like the
Modern Man authors, many of the artists exhibited a tendency toward idealism—if the
realm of ideas was the terrain on which the major work of reconstruction would take
place, then some painters with "reconstructive" interests and ambitions might want to
stake a claim to intellectual territory. This ambition could mean more than merely
becoming involved with powerful ideas, as the Mythmakers made explicit in the mid to
late 1940s: it might also justify devising a deliberately idea-based art. This is, I believe,
the proper frame for understanding Newman's insistence on the intellectual character of
art—an insistence I began to document in chapter 1. In essay after essay, he made the
claim in no uncertain terms.

> In short, modernism brought the artist back to first principles. It taught that art is an expres-
> sion of thought, of important truths, not of a sentimental and artificial "beauty."[104]

> Art is a realm of pure thought.[105]

> I therefore wish to call the new painting "plasmic," because the plastic elements of the art
> have been converted into mental plasma. The effect of these new pictures is that the shapes
> and colors act as symbols to [elicit] sympathetic participation on the part of the beholder in the

artist's vision. . . . The new painter owes the abstract artist a debt for giving him his language, but the new painting is concerned with a new type of abstract thought. . . . If it were possible to define the essence of this new [American] movement, one might say that it was an attempt to achieve feeling through intellectual content. The new pictures are therefore philosophic.[106]

Motherwell wrote of Pollock that "painting is his thought's medium," and Harold Rosenberg described the action painter's canvas as "the 'mind' through which the painter thinks."[107]

Gottlieb's "ideographic" painting turned toward philosophy quite literally, for a while at least. His 1944 show of drawings at the Wakefield Gallery was meant to be taken as a foray into philosophy, as the catalogue essay by Newman made explicit:

> The artist never dared to contemplate the human figure in terms of body and soul. That he left to the poets and philosophers.
>
> It is a pleasure, then, to see Adolph Gottlieb repudiate, in these studies of bodies and heads, this narcissus attitude, to face the age-old philosophic problem of mind and matter, the flesh and the spirit, on equal ground with the philosophers.[108]

Gottlieb's show received passing mention from Howard Devree in the *New York Times,* a flippant paragraph that did not satisfy the artist.[109] He wrote to Jewell to invite comment from the senior critic. Jewell did not manage to get to the gallery until the exhibition had closed, but he did ask to see the pictures anyway, and he commented upon them in the *Times.* Jewell seems to have developed a rapport with the feisty Mythmakers—he enjoyed sparring as much as they, and the promise of controversy, to their mutual benefit, was always palpable.

> Odder than the frequent juggling of malapropos titles by abstractionists is Adolph Gottlieb's metaphysical effort to paint "body" and "soul" as separate entities. I saw his pictures after the show had closed last week at the Wakefield. There were seven "Heads," imaginative and moving; there were seven gloomily amorphous "Figures," or "headless bodies," if bodies they must be called. I don't think the idea clicks at all. And speaking of metaphysics, has Mr. Gottlieb ever pondered the theory that matter and spirit are one, differing only in degree?[110]

Gottlieb immediately dashed off a response to Jewell.

> The answer to your query "have I ever pondered the metaphysical theory that matter and spirit are one, differing only in degree," is that I have pondered it, indeed!
>
> My answer was very plain in two of the pictures shown, one called Embrace, the other called Fusion, both of which you seem to have overlooked completely. Each drawing depicted a two-headed female form.[111]

The last sentence above was deleted by Gottlieb from the final draft; apparently he thought it revealed too much. Instead he went on to put his intentions in perspective.

> I did not intend to resolve with arrogant finality the answer to a philosophic problem that has agitated the mind of man, or as you seem to prefer, the mind and body of man, since he began to think. I was interested only in presenting the problem—in plastic terms, of course. And I tried to explore it in all of its implications.

None of the drawings from this exhibition can be located, nor are there any known photographs of them. It is quite possible that sometime after the show, Gottlieb judged the works failed or misconceived, and destroyed them. If they were as literal as they

sound—"mind/soul" signified by a head, "body" by a headless torso—we can perhaps understand why. But whatever we think of Gottlieb's attempt to address artistically the mind-body problem, the fact of the effort offers valuable insight into the beliefs, ambitions, and methods generative of early New York School painting. This episode in Gottlieb's career has not fit very well into the existing accounts of his artistic interests and commitments, but Modern Man discourse helps to clarify the matter. Not only was Gottlieb laying claim to philosophic significance for his art, but he was engaging a question frequently taken up in Modern Man literature. As Richard Chase pointed out in his contribution to *Partisan Review*'s attack on the "new failure of nerve," the mind-body problem was a distinctive preoccupation of "all the latter-day mystics." His complaint was that the mystical antinaturalists often endorsed a simplistic privileging of good mind/spirit over evil matter/body; this was part of the case against science and Marxism. But even when a less one-sided resolution was sought, the problem remained central to Modern Man discourse. Finding a way to reconcile spirit and matter was an integral part of any suggestion that the solution to modern crises lay in renewed appreciation of the spiritual dimension of man. The interdependence or unity of mind and body was asserted in numerous texts addressing Modern Man issues, for example, works by Robinson, Carncross, Carrel, Overstreet, Krutch, Langdon-Davies, and Calverton and Schmalhausen, to name just a few.[112] It was a standard theme in the genre.

> The sharp distinction between the mind and the body is, as we shall find, a very ancient and spontaneous uncritical savage prepossession. What we think of as "mind" is so intimately associated with what we call "body" that we are coming to realize that the one cannot be understood without the other. (Robinson, *Mind in the Making*, p. 34)

Mind/body unity was part of the new knowledge that seemed to have value in the reconstruction of modern man's belief and behavior—sometimes as a way of addressing the pervasive sense of dislocation, sometimes as part of the explanation of instincts and drives. Rothko, too, asserted his support for a version of the idea in his statement for the David Porter exhibition in early 1945: "I insist upon the equal existence of the world engendered in the mind and the world engendered by God outside of it."[113] And Robert Motherwell saw the mind-body connection as the answer to the anti-intellectualism of American artists.

> The anti-intellectualism of English and American artists has led them to the error of not perceiving the connection between the feeling of modern forms and modern ideas. By feeling is meant the response of the "body-and-mind" *as a whole* to the events of reality.[114]

In short, idealism in general, and the mind/body problem in particular, mark a philosophical interest and ambition that link Modern Man discourse and the theory and practice of some of the young artists of the New York School.

The various ties that bound New York School painting to Modern Man discourse would also make it susceptible to criticisms lodged against the latter. Sidney Hook's charge that it represented a failure of nerve was extended to the arts; he asserted that literature and the arts had been deeply affected by the shifts that constituted what I have been calling Modern Man discourse.

> In the literary arts, the tom-tom of theology and the bagpipes of transcendental metaphysics are growing more insistent and shrill. We are told that . . . none of the arts and no form of

literature can achieve imaginative distinction without "postulating a transcendental reality." *Obscurantism is no longer apologetic; it has now become precious and wilful.*[115]

Hook's article preceded by only a few months the letter to the art editor of the *New York Times* written by Gottlieb, Rothko, and Newman which defended their work as "an adventure into an unknown world," a world of the imagination, which is "fancy-free and violently opposed to common sense." Their "obscurantist" (so Jewell found it) art, with its allusions to "myth," and their profession of "spiritual kinship with primitive and archaic art" would have made these artists appropriate targets for Hook's criticisms. Likewise Robert Motherwell's defense of the modern artist as "the last active spiritual being in the great world. . . . it is the artists who guard the spiritual in the modern world."[116]

But among the critical responses to Hook's article were defenders of the artistic tendencies the New York School artists represented. David Merian wrote in "The Nerve of Sidney Hook":

> It is necessary to speak of this positive side of the so-called "failure of nerve," because the same question may be posed today; to what extent the irrationalist content of contemporary arts, their motifs of anxiety and exasperation, the sympathy with the tormented, suffering, psychotic, primitive, infantile and magical, and the violent hostility to social life, and even to science, include a valid criticism of existing institutions and make us more deeply aware of the inner world of the self. The literature and painting which remain today on the standpoint of a cheerful, sane naturalism appear to us unspeakably shallow. (P. 249)

Whether inclined toward enactment or interpellation of the new self—toward representation of inner conflict or toward the production of provocative screens eliciting from the viewer identification with the Modern Man self—the New York School artists could not have asked for a better defense of their present and subsequent work. A leftist challenge to the radicality of their project was contested by another faction of the left. In light of the present study, Merian's claim that critical force inhered in enhanced awareness of the inner world of the self oversimplifies the case.

GENDER AND SUBJECTIVITY

Each of the terms that names the discourse I have described has definitive significance. The word *modern* functioned to distinguish the new subjectivity from that of earlier humans, principally "primitives," although, conversely, authors often emphasized similarity and continuity between them and modern man. *Modern* designated a status implicitly denied to all African-Americans and Native Americans merely by virtue of their racial identity, which was assumed to entail a fixed core of unreconstructed—and unreconstructable—"primitive" human nature. The term *man* was equally loaded, as it served to distinguish humanity from animal, nature, and god, even as some of those boundaries were being erased.[117] It also opposed the human individual to culture, society, and community, aggressively asserting the priority of individuality over collectivity. *Man* was generally used in a seemingly nondiscriminatory way, apparently designating all humanity. In fact, it was not nearly so comprehensive. While the exclusion of certain classes of humans (for example, men of African-American, Native American, Asian-American, or Latin American ancestry, to speak only of the U.S. population) was

not revealed in the term *modern man*, the subtextual exclusion of women did find expression there. The cultural project I have been documenting in this book was exclusionary in all the predictable ways. My heavy reliance upon contemporary terminology (*modern man, human nature, primitive,* etc.) is in no sense meant to leave opaque the ideological character of the project. African-Americans, Native Americans, women, and other excluded groups served principally as foils in opposition to which a subjectivity for white, heterosexual, middle-class males was reconstituted. The gendering of this subjectivity is to be explored in this section. Beginning with an analysis of gender identity within the New York School, the discussion will open out to address Modern Man discourse broadly and reveal gendering as another mark of congruence and connection.

Two mid-1950s portraits of Willem and Elaine Fried de Kooning offer a useful point of departure (figs. 63 and 64). They suggest that while both male and female artists occupied the Abstract Expressionist studio, their hold on that space was not equally secure. Male and female artists are portrayed here in bohemian variants of highly clichéd postures: man standing, woman seated; male attention outer-directed, female absorbed within; man commanding space, woman contained. In both cases there is reason to believe that we are in the man's studio: Willem is more proprietary in each, closer to action, while Elaine stares absently, cigarette elegantly poised. (I will turn to using first names here, not intending disrespect or familiarity but to distinguish efficiently between artists who share a last name.) In the painting by René Bouché, Willem seems to be contemplating a picture off to the left; in the Hans Namuth photograph, taken at Leo Castelli's East Hampton house, one of Willem's unfinished paintings is tacked to the wall behind.[118]

There are photographs of Elaine in her own studio from this time, but Willem is not included in them. This same asymmetry holds for contemporary studio photographs of

63. *Hans Namuth*. Elaine and Willem de Kooning. *1953. Photograph. © Hans Namuth 1991.*

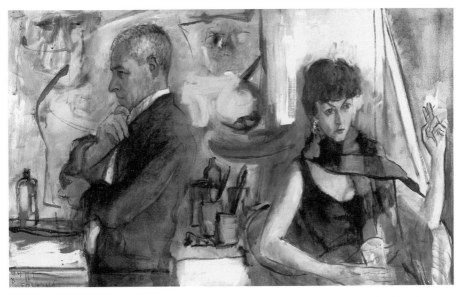

64. René Bouché. Bill and Elaine de
Kooning. *1955. Oil on canvas, 102 × 168
cm. Collection of the Estate of Elaine de
Kooning. Photograph by Edvard Lieber.*

Pollock and Krasner. We might wonder, in passing, how the men would have presented themselves had they appeared in the women's work areas. Merely asking the question sharpens our awareness of the intransitivity of the positions occupied. For the men to appear upstaged, idle, or doting was unthinkable; while for the women to appear so could serve valuable signifying purposes, some of which are evident here. First, the women stand as essential accessories of bohemia, their casual dress and posture helping to fill out a cultural image (or fantasy) of the male artist. They also keep that image within certain limits by confirming the heterosexuality or "masculinity" of their partners. Thomas Hart Benton's contemporary ravings about the ill effects of the high proportion of homosexuals in the art world seemed to verify widespread popular suspicions. Such photos as these situated Jackson Pollock and Willem de Kooning in a normalized, domesticated bohemia. In a different vein: sometimes the women enact a form of attention—toward the work of art or the male artist—that the photograph posits as paradigmatic. Their relaxed and distracted but deep contemplation, and even occasionally loving admiration, provided models for viewers to emulate. And there is also the marketing convention that attaches a pretty girl to the commodity, whether car or refrigerator or painting. For the male viewer especially, she lends, in the variations illustrated here, sex appeal to the paintings and simultaneously displaces attention from the sexiness of the male artist, which might otherwise be susceptible to appreciation or questioning.

What makes the Namuth photo of the de Koonings an especially dense and revealing image is the fact that center stage has been given over to that larger than life-size image of woman looming over Elaine. Even without her legs, which are obscured by a plywood board resting against the bottom of the picture, the painted woman is an imposing, intrusive figure. The photograph juxtaposes the two kinds of female presence that

occupied the space of Abstract Expressionism; it begins to establish parameters for a treatment of gender in the New York School (and, by extension, Modern Man discourse).

Abstract Expressionism has been recognized, from its first accounts, as a male domain, ruled by a familiar social construction of "masculine" as tough, aggressive, sweeping, bold. The features of this art most appreciated in the critical and historical literature—scale, action, energy, space, and so on—are, as T. J. Clark has noted, "operators of sexual difference," part of an "informing metaphorics of masculinity."[119] As we have gained distance from the Abstract Expressionist milieu, the diverse ethnic and class backgrounds of the principal male New York School artists have come to seem less significant, and the art's complicity in processes of cold war cultural imperialism has become more important for scholarship. As a result, Abstract Expressionism has come to appear more and more a homogenous white male art, an apt artistic counterpart to the cold war politics of the contemporary white male U.S. political establishment.

The functions served by Abstract Expressionism's aura of masculinity have also come into clearer focus: it was a crucial component of cold war U.S. national identity, differentiating the nation politically and culturally from a Europe portrayed as weakened and effeminate. In some contemporary aesthetic theory it served to distinguish avant-garde painting from kitsch, also strongly gendered as feminine.

Lately the difficulties of women artists affiliated with Abstract Expressionism have begun to be acknowledged and studied. Lee Krasner's struggle to forge an artistic identity within this aesthetic (one distinct from that of her husband, Jackson Pollock) has attracted much attention, and the bepedestaled Hedda Sterne in the famous Irascibles photo published in *Life* in 1951 (fig. 65) has become perhaps the best symbol of the marginal presence women have been accorded in Abstract Expressionism.[120] Until recently most of the sparse critical and art historical attention directed to these women was condescending, and recent efforts to enlarge the canon to include their work have been very slow to gather momentum.

Perhaps most revealing of the "masculinity" apparently inherent in Abstract Expressionist art is the fact that so few women attempted to align themselves with it during the crucial formative years, the 1940s and early 1950s. Other dominant contemporary visual modes—realisms, Surrealism, and geometric abstraction, for example—drew somewhat higher proportions of women to the ranks, and in those other ranks, women were occasionally able to command positions of considerable prestige. Around 1940, Lee Krasner herself was acknowledged by Greenberg and others in-the-know to be one of the most talented and promising younger painters in New York. But once School of Paris aesthetics was overshadowed by an aggressively "American" and virile abstract idiom, that sort of promise was not so easily accorded to women. Those who did attempt to work within the evolving parameters of Abstract Expressionism often devised strategies to mask their gender: Lenore Krasner Pollock's preference for the name Lee, for example, or her use of her initials as a professional signature; or Grace Hartigan's adoption of the name George (after George Sand) for a while in the early 1950s.[121] There is also the preference for subject matter calculated to signify masculinity in one way or another: Elaine de Kooning's sports subjects led at least one critic to note that the artist had been a "tomboy" in her youth.[122] A few works take the concealment of identity as thematic, for example, Hartigan's *Masquerade* and *The Masker,* both from 1954.

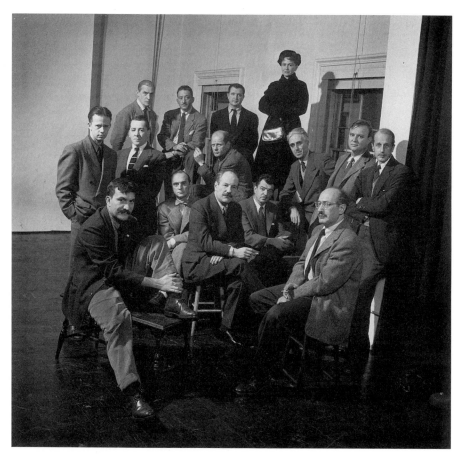

65. *Nina Leen. Photograph captioned* "Irascible
Group of Advanced Artists." *1951. Published
in* Life, *15 January 1951, 34.* © *Time Warner
Inc. Top row, l. to r.:* de Kooning, Gottlieb,
Reinhardt, and Sterne. *Middle:* Pousette-Dart,
Baziotes, Pollock, Still, Motherwell, and
Tomlin. *Bottom:* Stamos, Jimmy Ernst,
Newman, Brooks, and Rothko.

My intention here is not to document the exclusion of women from Abstract Expressionism, but rather to examine the processes and mechanisms by which that exclusion was effected then and now. What made Abstract Expressionism so inhospitable to artists who were women, and why has it been so difficult for critics and historians of both sexes to attribute much of the characteristic content and meaning of Abstract Expressionism to work by female artists? The answer centers, I believe, on the subjectivity inscribed in Abstract Expressionist art: the particular beliefs about and experiences of self, individuality, identity, human nature, and mental process that both inform and take form in this art. This was, I have been arguing, an art that thematized subjectivity—it claimed to issue from and represent mind and experience, as these were revealed in mythic and unconscious materials and structures held to constitute the submerged foundations of

human nature and being. I wish to propose now that the specific model of the human subject it inscribed was profoundly gendered.

In New York School painting as in Modern Man discourse, the emerging model of the subject was articulated through the male individual. That the focus of the discourse was the new, complicated "modern *man*" was not simply a matter of linguistic convenience. The specifically male individual became the locus of the interaction of complex forces and drives, the site of the conflicts at the source of modern tragedies. Although the work of various female scholars figured prominently in the construction of this new subject—Ruth Benedict, Margaret Mead, and Susanne Langer, to name just a few—the model they helped to shape seems not to have been easily extended to women.

The exclusion of women from this new subjectivity was effected largely through its structural constitution. The internal divisions that distinguish the subject—between conscious and unconscious, modern and primitive, control and uncontrol—were commonly represented as gendered. In a broad range of cultural productions from this time—in popular psychology, *film noir*, cultural criticism, and popular philosophy, as well as in Abstract Expressionism—an "other within" modern man was given female personification and objectification, whether that other was primarily the unconscious, primitive instincts and residues, vague irresistible forces, or all of these. Women often symbolized the powerful force fields that had to be negotiated by the conscious, rational part of the subject—gendered as masculine—in his quest for balance, harmony, and resolution of conflict. Before drawing out the implications of this gendered internal division, I will illustrate it with a few examples.

One of the most obvious examples of such gendering is the Jungian treatment of the anima—the feminine unconscious in the male subject—developed in detail by authors and analysts associated with the Analytical Psychology Club of New York. M. Esther Harding's *Woman's Mysteries* was one of the most comprehensive analyses of the topic. Since I treated this material in some detail in chapter 3 above, I will focus here on another, by now rather familiar, set of representations that was especially heavy-handed in its employment of gendering to structure the conflict within the modern man–subject: *film noir*. *Noir* protagonists are typically sympathetic male characters who commit crimes or act violently, brutally, and irrationally for reasons they do not understand and cannot control. They are extreme cases of modern men: their personas are "deep, dark, mysterious, and agitated," as one character snappily phrased it in the film *D.O.A.* (1950); their minds and beings are overheated circuits of primitive impulses and unconscious drives.

Only very rarely are female characters in these films accorded this sort of subjectivity: ordinarily it is understood to be a distinctly male phenomenon. *Noir* dialogue is punctuated with remarks such as "you're just like every other man, only more so: you feel restless, trapped, confused." Or "a man can be like that, Paula"—meaning confused, dissatisfied, driven by unknown desires, haunted by memories and past actions. Women are generally less complex creatures in these films; though the devious webs they often weave may be stunningly intricate, their motivations are generally less conflicted. They seem congenitally good or evil: if they represent evil, that evil is largely uncompromised by contradictory inclinations. One common narrative theme posits a male protagonist who is incapable of returning a good woman's love until he has played out his powerful, irresistible attraction to a dangerous, destructive woman. His attraction to the

latter is patently symbolic of his susceptibility to internal drives toward danger, evil, and
self-destruction. The *noir* hero often laments his utter inability to resist the tragic forces
personified by the dangerous woman. For example, in the film *Criss Cross* (1949), Burt
Lancaster, lying alone on his cot, staring up at the ceiling, speaks in a voiceover about the
irresistibility of his desire for his ex-wife, who will bring about his destruction, as he
knows only too well.

> A man eats an apple. He gets a piece of the core stuck between his teeth, you know. He tries to
> work it out with some cellophane off a cigarette pack. What happens? The cellophane gets
> stuck in there too. Anna. What was the use. I knew one way or the other somehow I'd wind up
> seeing her that night.

In this quintessentially *noir* recasting of Garden of Eden imagery, the inevitability of
Lancaster's demise is foretold. Happy endings are uncommon in *noir* films; more often
than not, the protagonist's playing out of his attraction to evil proves fatal.

It is important to distinguish between these films and traditional femme fatale
imagery. Here the focus is on the psychological dynamics of the male protagonist and the
causes for his behavior. The films' particular emphases imply that simple assignment of
blame to the woman will not carry much weight anymore, it will not suffice as explana-
tion for evil. The *noir* male must recognize that the source of the problem is within him,
and it is the character and framework of that internal dynamic—the impulses and desires
that the *noir* woman merely activates and personifies—that is at issue in these films. One
noir film, *Gilda* (1946), features Rita Hayworth singing the song "Put the blame on
Mame," a parody of the femme fatale cliché. The song is a clear statement of the
inadequacy of simply blaming the woman in the *noir* world.

Yet, projecting onto the women in *noir* films the same heroic, conflicted struggles
enacted by men is virtually impossible. Though the cool, tough female types ubiquitous
in these movies had strong appeal for women as well as men, they displayed less
complexity and centrality in the narratives.[123] The women were denied the same
capacity for internal conflict, nor could they have control of the narrative of self-
exploration; they were required to play rather closely circumscribed roles. The barrier
between men and women was sharp: in *Out of the Past*, one male character, using the
lingo that refers to guns as "rods," observed that "a dame with a rod is like a guy with a
knitting needle." Such remarks amount to more than assertions of separate male and
female spheres; they conjure the authentic phallus (one that shoots) as passkey to full-
bodied subjectivity. The female characters in these films are usually ancillary and contin-
gent; they serve primarily as objectifications of the obstacles and force fields, both good
and evil, that modern men have to negotiate in their struggle to resolve the conflicts at the
center of their subjectivity. As Janey Place puts it: "*Film noir* is a male fantasy. . . .
women are defined *in relation* to men."[124] This gendered structuring of modern man
subjectivity represents an extension of a familiar prior convention portraying a less
radically sundered human nature comprising masculine intellect and feminine heart or
emotion.

A similar structural use of gender operates in much New York School painting. The
self-conception and presentation of many of the male artists as masculine *noir* characters
is one indication of a linkage of this sort, as I have already argued. Such linkages played a
part in generating public interest in these artists by channeling their characters, artistic
commitments, and careers into territory made familiar by *noir* dramas. The identifica-

tion was reinforced by the language some of them used. Pollock is the most striking case: his public pronouncements enacted masculinity through clipped, direct sentences; firm statements of positions; spare use of adjectives; tough-guy idiom ("I've knocked around some in California"); and reticence. His preference for the interview format over straightforward statement of purpose may also be relevant: it provided him an opportunity to enact both his reticence and his tough directness. Such devices brought his speech strikingly close to that of *noir* characters.

More important, however, in Abstract Expressionism, too, women serve as symbols of the powerful force fields constitutive and definitive of modern man's subjectivity. One need only return to Pollock's imagery of the unconscious for a demonstration of this. In his early work, informed by the structural principle "moon-female-unconscious" derived from Jungian theory, he often gave the unconscious a feminine gendering and even used an explicit feminine symbol for the "anima"—the moon woman. Vestiges of this earlier gendering survived in the abstract work, insofar as the notion of the anima as source of the mind's "dancing, flowing circuit of emotional energy" was counterposed in the paintings to the "ravaging, aggressive virility" of Pollock's line.[125] Pollock's linear webs, in other words, were susceptible to interpretation as both (either) masculine and (or) feminine. And in some of his works, obvious metaphors for the unconscious are explicitly assimilated to imagery of female sexuality, for example in *Vortex* (fig. 87) and

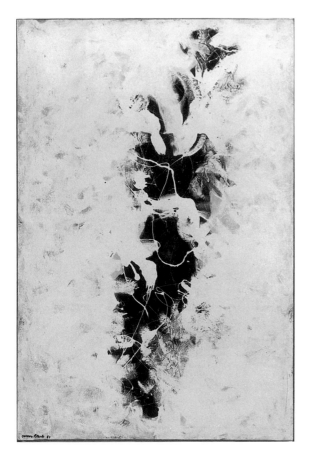

66. *Jackson Pollock.* The Deep. *1953. Oil and enamel on canvas, 220 × 150 cm. Collection of the Musée National d'Art Moderne, Centre Georges Pompidou, Paris.*

The Deep (fig. 66). The mysteries of the unconscious are metaphorically equated with the mysteries presumed to reside in the interior spaces of the female body.

Gendering enabled so-called unconscious and primitive materials to assume the place in artistic practice formerly occupied by that difficult, resistant, sexually charged other: the female nude. This substitution positioned the male artist/subject in a familiar relation to his artistic object; and simultaneously, women were presented with a new situation in which to be uncomfortable. The gendering of the Abstract Expressionist intrasubjective drama rendered difficult and necessarily incomplete both a woman's occupation of the place of conscious (masculine) protagonist and her disidentification with the (feminized) "other within." The woman who tried to constitute herself as split subject found gender identification an obstacle rather than a vehicle for focusing and structuring the opposition. She found herself precast as the other within the self, deprived of a basis for imagining and experiencing the division between that other and the self crucial to Abstract Expressionist subjectivity. The poles of self and other were blurred, if not fully inverted. Consequently, for female artists, the radicality of the split within the subject was necessarily compromised. This difficulty conditioned both the production and reception of Abstract Expressionist paintings by women artists.

The great irony is that women might seem—as symbols of the unconscious and the primitive, and their nexus in uncontrollable sexuality—to have privileged relations to these spheres and be, therefore, in a better position to represent or express them. And indeed, this had been the case just a generation earlier, as the critical reception of Georgia O'Keeffe's painting reveals. O'Keeffe's rise to prominence in the 1920s rested on a reading of her work as shaped and infused by a woman's special access to the natural, the primitive, the subconscious. Her exceptionally unmediated relation to the realm of feeling, emotion, intuition, elementary being was "discovered" as the source of meaning and significance in her work by friends and colleagues as well as critics; it was the basis of Stieglitz's promotion of her work, as Barbara Buhler Lynes has shown. "He understood O'Keeffe's art as the pure expression of her unconscious,"[126] and partly through his influence this view came to dominate critical reaction to her work. The male modernist artists of Stieglitz's circle, themselves trying to tap an inner subconscious, emotional core of self, could envy O'Keeffe's gender advantage. As Arthur Dove put it to Stieglitz: "This girl is doing naturally what many of us fellows are trying to do, and failing."[127] For the male artist, the conscious mind and reason operated as a barrier blocking access to the subconscious. O'Keeffe's seeming advantage entailed profound disadvantages, among which was a blindness to the conscious, rational, skillful, controlled process that produced her work. Stieglitz's early description of O'Keeffe—"The Great Child pouring out some more of her Woman self on paper"—reveals just how little room there was for a deliberate, professional artist in her artistic persona.[128] In this respect, despite the seeming advantages early modernist aesthetics in the U.S. offered to the woman artist, she remained excluded from full-fledged (male) subjectivity.

For women artists of the 1940s, the situation had changed as an effect of changes in the dominant cultural forms and functions of the unconscious. As the unconscious became more articulated and came to acquire a more ominous—barbaric and explosive—cast, came to serve fully in the explanation of evil and to be a source of intrapsychic conflict, woman's close association with it became a thoroughgoing lia-

bility. The increasing emphasis on division within the self exacerbated woman's disqualification from subjectivity. Being made into anima, earth mother, and locus of sexual desire made woman an object, not a subject, of Abstract Expressionist painting, even when the Abstract Expressionist painter was a woman. The pictures interpellate male viewers within the dominant ideology's evolving model of self, and what holds for viewers holds as well for producers. A dame with an Abstract Expressionist brush is no less a misfit than a *noir* heroine with a rod.

Joy Kasson has argued, in her study of neoclassical sculpture in the U.S., that in the mid-nineteenth century it was often the (white, middle-class) female subject who was represented as the locus of internal conflict.[129] She quotes the influential art critic Henry Tuckerman who, in writing about Erastus Dow Palmer's *White Captive* (1859), appreciated the enactment of internal conflict, of struggle for self-mastery, for Christian resignation in the face of profound fear and anguish, which he saw embodied in the face and gesture of this female youth held captive by Indians. Kasson relates this theme, which recurs frequently in the critical reception of the various sculpted female captives and victims she studies, to anxiety over the nature of woman specifically; she sees it principally as an expression of a cultural desire to reaffirm the ideal of submissiveness in women. What is not clear is the extent to which the white, middle-class, female subject was, in this case, understood to represent humanity generally, and the affirmation of self-control she articulated interpreted as applying to every subject. The story of the transition from female to male subject as preferred site for staging of the drama of self-control, the morality play so crucial to bourgeois ideology and its social order, would be a fascinating and revealing tale. The gender shift would be accompanied by the relocation of evil from the alien cultural other (the Indian kidnapper) to the interior of the white self, formerly believed to be naturally good. It would also involve a profound loss of confidence in the ability of reason to overcome its antagonists without assistance from specialized and esoteric bodies of knowledge.

Examining a pair of paintings by the de Koonings in the context of the paradigm I have sketched may help to clarify the implications of my argument for our readings of Abstract Expressionist art. Elaine's *High Man* (fig. 67) from 1954 and Willem's *Woman with a Bicycle* (fig. 68) from 1953 are contemporaneous and in some ways analogous: each artist has presented in a loosely brushed field a figure or figures of the opposite sex in an athletic situation.

Elaine's basketball players are threads in the web of dynamic pictorial forces that constitutes the picture; there is considerable harmony and continuity between figurative and nonfigurative passages in the painting. Often in Abstract Expressionist work, the divided subject is evoked in the dialectic of abstraction and figuration, signifying control and uncontrol, structure and disruption; but here as elsewhere Elaine favors a comparatively symbiotic relation. The figures are not psychological presences at all, but rather dematerialized bodies rematerialized as paint. They do not register as others and are not made the source or site of uncontrol, rupture, or division in the picture.

Willem's woman, by contrast, is a resistant, intrusive, disruptive presence, refusing to dissolve into the paint surface. She assumes only enough detail to signify two crucial things: her gender (her preposterous breasts leave no question of that), and her deranged, mocking expression, underscored by the presence of two loony grins; these latter features make her materialization in the picture a taunt to painter and viewer, a taunt made

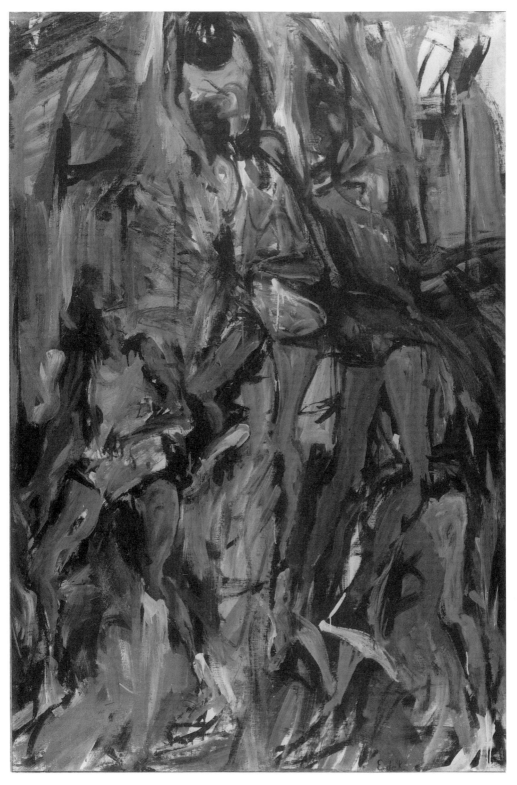

67. Elaine de Kooning. High Man. *1954. Oil
on canvas, 201 × 135 cm. Courtesy
Washburn Gallery, New York. Photograph by
Edvard Lieber.*

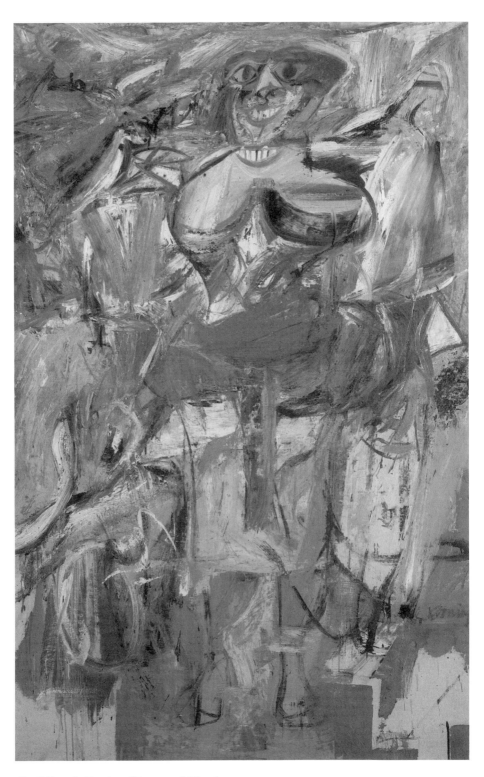

68. Willem de Kooning. Woman and Bicycle.
1952–53. Oil on canvas, 194 × 124 cm.
Collection of the Whitney Museum of
American Art, New York. Photograph by
Geoffrey Clements.

worse by her evanescent bicycle, which frames her like an enormous article of jewelry—

its wheels rhyming with her breasts—but which gracefully blends into the paint surface
to a degree she herself resists.[130] She seems to will her own emergence from the abstract
painted field, her presence and expression challenging de Kooning's authority. I may be
going too far in attributing to her a ferocious determination to insinuate herself at the
center of de Kooning's canvas, in apparent defiance of his effort to compose a modernist,
abstract painting; but one could back down this road quite some way and still retain the
point that the female figure personifies the forces against which the act of painting—the
securing of pictorial unity—is performed. William Seitz wrote of de Kooning's women
that they "struggle against recession, flatness, and structure." And in a contemporary
review, Leo Steinberg made a related observation: he noted that the woman "remains an
impediment to the free flow of energy through the pictorial space."[131] For some critics,
conflict in these paintings was principally a matter of de Kooning's "wrestling match
with the materials of art" (as Michel Seuphor put it); but for many others the materials of
art were only the vehicle for signifying "struggle" of a different, more primal order,
sometimes articulated as occuring within the author as subject.[132] To James Fitzsim-
mons, de Kooning was engaged in "a terrible struggle with a female force. . . . this is a
bloody hand to hand combat." Rudi Blesh and Harriet Janis similarly portrayed the
woman paintings as a war between artist and image.

> Van Gogh and Soutine painted violently but their paintings were momentary releases from the
> battle they waged with themselves. De Kooning, attacking the canvas, attacked himself.
> Though the ikon seemed to be *Woman*, it was her creator smothering in the nascent paint.
> Finished, it is the tragic litter of a battlefield. No other artist ever left such paintings. The
> *Woman* would not be destroyed. Battered and wounded, hideous yet inexpressibly sad, she
> still sits implacable within a storm that will never cease.[133]

At times the woman was described in terms even closer to those I have outlined above;
she was seen as the embodiment of primitive and unconscious elements that had intruded
into the present, into consciousness and representation.

> Rising from the darkness of the past or the atavistic depths of consciousness, she stands, like
> the ancient Cybele who drove her lover Attis to madness and castration, a cult image of the
> eternal female.[134]

> It is to the unconscious (and to the American unconscious in particular, I fear) that The
> Woman appeals.
> . . . this female personification of all that is unacceptable, perverse and infantile in
> ourselves, also personifies all that is still undeveloped. I can't explain her horrid fascination
> otherwise.
> . . . though she belongs to the dawn of our history, she is still very much with us, and we
> must not be misled if she chooses to ride a bicycle and wear a boater instead of a crown.[135]

> She is a first emergence, unsteeped from a tangle of desire and fear, with some millenia of
> civilizing evolution still ahead of her. . . . de Kooning has descried a familiar shape, a form
> that even Adam would have recognized as from an ancient knowledge.[136]

For some viewers, apparently, the physical attributes of de Kooning's woman were
evocative and legible. Her depravity and mockery worked to situate her within the
domain of the irrational; her exaggerated breasts and hips and her frontal, hieratic pose
identified her as "primitive," a relative of archaic fertility goddesses; her physical threat
operated as a metaphor for the threat to the psyche and to personal and social well-being

posed by unconscious and primitive components in human nature.[137] Fitzsimmons'
words bear repeating: she was a "female personification of all that is unacceptable,
perverse and infantile in ourselves." De Kooning himself made a related suggestion in
1956: he told an interviewer that "maybe . . . I was painting the woman in me."[138] (He
felt compelled to follow up this revelation with a stern defense of his heterosexuality;
acknowledging some feminine component of the male self was not to be taken as
any surrender of virility.) One critic, writing in *Time* magazine, explicitly related de
Kooning's women to a character notorious in Modern Man literature: "Mom," the
protective, possessive matriarch, the rapacious loving mother made famous by Philip
Wylie's *Generation of Vipers.*[139] Wylie had based his caricature loosely on Freudian
theory and modeled her to bear principal responsibility for oedipal distress; she became a
popular cultural symbol encompassing every sort of feminized threat.[140] To see de
Kooning's *Woman* as Mom was to construe her both as embodiment and cause of (male)
psychic torment.

Could a female artist give such valencies to the figure, and if so, the figure gendered
how? We have the example of one woman who worked on the female figure, for a while
in a manner quite clearly indebted to de Kooning's example. When Grace Hartigan
endeavored to introduce recognizable forms into her own largely abstract work—
specifically, figures reminiscent of de Kooning's women—she found herself alienated
from the imagery. She articulated the difficulty in a retrospective comment made in
1974, seeing the problem not simply as a product of her new imagery but of her various
borrowings from the more established male artists. "I began to get guilty for walking in
and freely taking their [Pollock's and de Kooning's] form . . . [without] having gone
through their struggle for content, or having any context except an understanding of
formal qualities."[141] Hartigan assumed that what she needed to do was to confront for
herself the old masters—Velásquez, Rubens, Goya, et al., to engage in a personal
struggle with their example, and to "paint my way through art history"; in this way, she
believed, she could devise a form of painting with which she could more closely identify.
I suspect that the real problem was somewhat different: that her difficulty with identifica-
tion stemmed rather from her inability to occupy the subject position inscribed in her
sources unless she somehow disidentified herself with "woman." Arguably, the same
difficulty provoked a later generation of woman artists, including Cindy Sherman,
Barbara Kruger, and Laurie Anderson, to deconstruct the subjectivity that excluded and
marginalized them.

If we return now to the point of departure for this section—the Namuth studio
portrait of the de Koonings—the painted woman's upstaging of Elaine in the photo may
have acquired some added poignancy. In part because of her and what she represents,
Elaine and other female Abstract Expressionists were structurally excluded from the
construction of subjectivity embedded in the full experience and production of Abstract
Expressionist art. Anne Wagner has written that Lee Krasner's art is characterized by its
refusal to produce a self in painting. She contends that Krasner declined to let her self
emerge in her art for fear that it would betray her femaleness and undermine her neces-
sary masquerade as male. In Wagner's view, Krasner effected this refusal by resisting
certain components of Pollock's art—in particular, his evocations of mythic and primi-
tivizing imagery and his involvement in psychologically loaded symbolics and figura-

tion. This refusal, she proposes, became a means of establishing an otherness to Pollock that was not—or could not be easily dismissed as—the otherness of woman.[142] The reasons why this argument interests me are no doubt obvious by now, as are the sorts of amendments to it that I feel necessary. In my view, the frame Wagner posits for Krasner's resistance—principally, the dynamics of her relationship with Pollock (and to some extent general gender dynamics in the New York art world of the 1940s)—is a bit too localized; while it sensitizes us to the special difficulty of Krasner's situation, it overpersonalizes her problem. Other women working in an Abstract Expressionist mode shared that problem, regardless of their proximity to Pollock. Furthermore, I think it crucially important to insist on the historically constituted character of the subjectivity that Krasner was both disinclined and disempowered to produce. In other words, I am proposing to recast Wagner's insights in this way: Krasner's work thematizes a situation that faced all aspiring Abstract Expressionists who were women—exclusion from the experience of and the power to represent the self of Modern Man discourse, as that self was embodied in Abstract Expressionist painting and aesthetics.

To conclude this consideration of the place of woman in Modern Man discourse, I wish to juxtapose briefly the Namuth photo with a *film noir* image—a publicity still from *Woman in the Window,* a 1945 film directed by Fritz Lang (fig. 69). In this shot, Edward G.

69. *Publicity still from* Woman in the Window. *1945. © 1944 The Christie Corp. Renewed 1972 United Artists Corporation. All rights reserved. Photograph courtesy of the Academy of Motion Picture Arts and Sciences.*

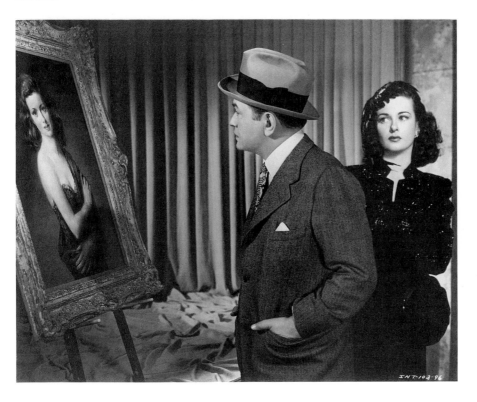

Robinson is gazing at a portrait of Joan Bennett on display in a gallery window, a portrait whose dark allure leads him to sexual fantasy. Pausing in front of this painting and indulging his fantasy cause him to meet the real woman; this is the moment shown in the photo, when she is about to ask him for a light. It is a quintessential *noir* trope that contact between man and woman—especially their initial contact—is mediated by a flame. Bennett will escort Robinson into a nightmare of murder, deceit, paranoia, destruction of family and professional life, and finally suicide. It turns out to be literally a nightmare—a dream—in the end, but the moral of the story is unchanged. In this image, Bennett watches Robinson gaze at her own painted likeness; she is able for a moment to be simultaneously object and unseen observer of the male gaze. But positing too close an identification between Bennett and her portrait would be ill-advised. The portrait here may bear a closer resemblance to Bennett than Willem de Kooning's painting does to any conceivable woman, but neither painting has anything much to do with the character, psychology, or subjectivity of the woman portrayed. They are meant rather to reveal something important about the *male* figures in these photographs. It is their psychology and subjectivity that is being represented. The narrative frame of the movie makes Bennett's portrait stand as a material symbol of the repressed, dangerous desires lurking in Robinson's character. It is everything against which he must struggle if he is to retain the comfortable, orderly bourgeois life as a university professor that he cherishes. Likewise de Kooning's painted woman is a symbol that enables the staging of his subjectivity as a combat between opposing drives. He does not have a filmic narrative to situate and encode the painted image, as the painter of Bennett's portrait did; as a consequence de Kooning must work the full conflict into the forms and handling of the imagery.

Both forms—New York School painting and *film noir*—thematize the sensations of loss of control and autonomy for the male subject. Both reveal this preoccupation in a shrill insistence on the continuing, pivotal importance and transcendence of the subject and in an emphasis on figuring its vulnerability and division. The reliance upon gender in the conception and representation of this historical subjectivity consigned women artists to the sizable ranks of Abstract Expressionism's others, and it predetermined their marginality in practice and in critical and art historical discourse.

SUBJECTIVITY AND IDEOLOGY

In chapter 1, I quoted Rothko's letter to the art editor of the *New York Times,* written in response to the *Problem for Critics* review. The passage was a broad statement of Rothko's artistic interests, in terms general enough to apply to most of the New York School painters.

> If previous abstractions paralleled the scientific and objective preoccupations of our time, ours are finding a pictorial equivalent for man's new knowledge and consciousness of his more complex inner self. [143]

I hope that now these terms seem more resonant and meaningful than they did at first. Such notions as "man's new knowledge" and "consciousness of his more complex inner self" meant in 1945 something rather more precise than they do for us. "New knowl-

edge" likely signified many things, but as the evidence adduced above indicates, foremost among them were the recent proposals of anthropology and psychology concerning nonconscious determinants of human behavior. This was by no means the first time that artists and thinkers in the United States had turned their attention in these directions. The remark by Lewis Mumford that serves as the epigraph for the introduction to the present study traces more or less the same interests back to Emerson.

> "Dreams and beasts," Emerson noted in an early *Journal*, "are the two keys by which we are to find out the secrets of our own nature." That has proved an even more penetrating intuition than he could have guessed.[144]

But as Mumford's own comment indicates, the recourse to such evidence in wartime U.S. culture had a unique urgency. He was writing in 1956, looking back over more than twenty years of personal and public preoccupation with such questions, and his understatement works to emphasize the centrality of that matrix of themes and forms I have called Modern Man discourse.

The statements I quoted in chapter 1, from Rothko, Pollock, Newman, and others seem, and are, rather banal as statements of artistic interest in the twentieth century. But in the context of the present study their reference to an interior world or inner self as the subject matter of an artistic enterprise reminds us of something essential about New York School painting, something that unifies much of it and distinguishes it from many other contemporary artistic projects. The differences in specific emphases and styles notwithstanding, New York School artists took their subjectivity as thematic in their work, a subjectivity they imagined as "interior"—a metaphysically loaded topographical structuring, as Derrida has pointed out. The "subjects of the artist" were the artists as subjects.[145] They believed that the representation or mobilization of newly discovered structures and contents of human nature, mind, and individuality was of central importance in their art. This interest was prominent in their slowly evolving group identity: it was the premise of the important ground exhibition that collected and defined them in the fall of 1949—Sam Kootz's *The Intrasubjectives*. In the pamphlet of the same name printed to accompany the exhibition, Kootz introduced the exhibiting artists—including Baziotes, de Kooning, Gottlieb, Motherwell, Pollock, Rothko, and others—as "among the first to paint within this new realm of ideas" concerning the interior of the individual. Kootz described their paintings as part of a "concerted effort to abandon the tyranny of the object and the sickness of naturalism and to enter within consciousness." Intrasubjectivism was, he wrote, a "point of view in painting, rather than an identical painting style." What united the artists was the fact that they created "from an internal world rather than an external one. . . . each painting contains part of the artist's self." There were various sorts of images, apparently, that could be convincing, even compelling as representations of the modern self. In the same catalogue Harold Rosenberg described the internal space or "nothingness" that these artists strove to represent. He reassured viewers that they had within themselves the same void, recognition of which would make the paintings intelligible.

> Such recognition is not very difficult. The spectator has the nothing in himself, too. Sometimes it gets out of hand. That busy man does not go to the psychiatrist for pleasure or to learn to cook. He wants his cavity filled and the herr doctor does it by stepping up his "functioning" and giving him a past all his own. At any rate, it was knowing the nothing that made him ring

that fatal doorbell. Naturally, under the circumstances, there is no use looking for silos or madonnas. They have all melted into the void. But as I said, the void itself, you have that, just as surely as your grandfather had a sun-speckled lawn.

The show was taken up and discussed in the pages of the popular press. In the *New York Times*, Stuart Preston wrote of being disturbed by the stylistic diversity of the work, which the notion of "intrasubjectivism" failed to contain. *Time* was concerned primarily to ridicule the occasion, quoting Rosenberg's most provocative and least illuminating phrases and describing Pollock's work as resembling either an aerial view of a battlefield or a microscopic view of bacteria.[146] These images are revealing in unintended ways, some of which undercut their ridicule: the caricature is betrayed by its evocations of radical shifts in scale, of unusual or ordinarily inaccessible perspectives on nature and humanity, and of conflict or battle inscribed in the work. The larger significance of such suggestions will be taken up in the next chapter.

The subjectivity conceived, explored, experienced, and represented by these artists was not a natural phenomenon but a specific social and cultural construction. That construction—"modern man"—has been a primary object, one might say the protagonist, of my study. The preceding chapters have aimed to illuminate this figure's internal architecture. Its basic structural element, I have argued, was a matrix of primitive instincts, habits, and unconscious impulses. These components, as I have also tried to show, were responses to specific historical and cultural conditions. The restabilization of bourgeois ideology in the face of the shock of modern historical events depended upon the construction of psychologizing explanations for those events; crucial to this project were the insights offered by the study of "primitive" human life and the unconscious mind. This construction of the problem and its solution achieved wide currency in 1940s America. I have tried to suggest how profound were the effects of its positing the human (white, middle-class, male) individual as the subject—in the sense of a real, identifiable, coherent entity—of reflection upon modernity. This male individual was portrayed as the locus of the conflicts at the source of modern life's tragedies. He was understood to be both agent and victim of the mysterious impulses or forces producing those conflicts.

Much as modern man was believed to be both agent and victim of powerful internal and external forces, the New York School painters—as well, for that matter, as the authors of Modern Man literature and the makers of *film noir*—were, inevitably, both subjects and agents of ideology. In chapter 2, I used the Gramscian notion of "hegemony" to describe the process: the dominant middle-class ideology had so permeated the institutions and discourses that shaped the New York School painters that its constraints were part of the very fabric of their experience, development, ambition, and subjectivity. In the absence of deliberate, direct, sustained, radical deconstructive work on that ideology by the artists themselves, its limits were bound to contain their authentic efforts to produce art that would convey something of the difficulty of their lived experience. In the end, those efforts contributed to the renovation and elaboration of the dominant ideology and its models of human nature, mind, and subjectivity.

Another way of envisioning the relation between the dominant ideology and the New York School artists is suggested in the work of Michel Foucault. Near the opening of this study I quoted Foucault's injunction to question received syntheses, a challenge that dates from the late 1960s—the period of his structural analysis of the discourses of

the human sciences. It is fitting that he return here, as the preeminent analyst of "discourses"—that critical concept enabling the analysis of thought and language as a social and political practice—this time with insights dating from the mid-1970s, the period of his preoccupation with the nature of power.[147]

> Power must be analyzed as something which circulates, or rather as something which only functions in the form of a chain. It is never localised here or there, never in anybody's hands, never appropriated as a commodity or piece of wealth. Power is employed and exercised through a net-like organisation. And not only do individuals circulate between its threads; they are always in the position of simultaneously undergoing and exercising this power. They are not only its inert or consenting target; they are always also the elements of its articulation. In other words, individuals are the vehicles of power, not its points of application.
>
> The individual is not to be conceived as a sort of elementary nucleus, a primitive atom, a multiple and inert material on which power comes to fasten or against which it happens to strike, and in so doing subdues or crushes individuals. In fact, it is already one of the prime effects of power that certain bodies, certain gestures, certain discourses, certain desires, come to be identified and constituted as individuals. The individual, that is, is not the *vis-à-vis* of power; it is, I believe, one of its prime effects. The individual is an effect of power, and at the same time, or precisely to the extent to which it is that effect, it is the element of its articulation. The individual which power has constituted is at the same time its vehicle.[148]

I introduce this passage because I find it an indispensable description of certain fundamental aspects of the historical phenomena under analysis. Foucault's picture of power as thoroughly diffused throughout the social body—as constituting entities (discourses, subjects) within the threads of power's web, articulating it, acting as its vehicles as well as its effects—fits the processes of ideological reconstruction I have been tracing. A subject's preference for one form of explanation over another, a preference conditioned by the subject's ideological constitution, is one form in which the constitutive power is articulated and exercised. What I have called the "momentum" of discourses and ideologies—although "inertia" may be more precise—is preserved through such quotidian and apparently insignificant activities.

Foucault's statement encapsulates the relation observed in the present study between the constitution of the subject and the subject's participation in the circulation of power. The New York School painters were, speaking generally, Modern Man subjects, constituted by the dominant ideology and its model of subjectivity, both of which their art reproduced, elaborated, and promoted. Their representations of their conflicted interior worlds or inner selves as dominated by particular primitive and unconscious components helped to consolidate evolving notions of the human individual's nature and mind.

Through this complex interlocking of subjectivity and ideology, New York School painting illuminates fundamental mechanisms of culture in a modern bourgeois capitalist society—or at least in a society whose dominant ideology is as secure in its hegemony as is bourgeois ideology in the United States. Consent was not so much manufactured or engineered in the wartime U.S. as it was self-sustaining, so deeply was the dominant ideology embedded in the very subjectivity, mentality, and experience of the subjects it constructed. Those subjects "instinctively" acted as its agents, identifying its interests closely with theirs. Certain subjects employed in characterizing and representing collective experience for large segments of the population—the cultural critics, journalists, popular authors, fiction writers, artists, filmmakers—engaged in "democratic" pro-

cesses of exchange (including debate and dispute as well as friendly give and take) which functioned ultimately to promote the efficient and continual calibration of integral elements in the hegemonic ideology. Radical critique was not impossible, certainly, as some of the voices heard in this chapter reveal. It could issue from the conflicts and gaps among the various subject positions that individuals were called upon to inhabit, negotiate, and reconcile as members of collectivities and as isolated monads. Most commonly, however, radical critique was overshadowed and undermined by reformist proposals. Resisting the key elements of Modern Man discourse was evidently far more difficult and unusual than succumbing to their seductions.

Popularization was an important vehicle for the (further) ideological adaptation of "scientific" knowledge. In determining the implications and applications of the hypotheses and discoveries of workers doing esoteric research on the symbolic and intellectual frontiers of the sciences, social sciences, and the humanities, popularizers molded those discoveries to fit the shapes of prevailing beliefs and needs. The processes of selecting, editing, and adapting new knowledge transformed that knowledge, often dulling whatever critical edges it might have. This popularization or mediation of ideas was generally synonymous with accommodation to the dominant ideology; what else could popularization mean but recasting esoteric and recalcitrant material into forms assimilable by normative subjectivities.

Foucault's discussion above of the power in subjection is not the whole story of power, as Foucault himself has acknowledged.

> It is certain that the mechanisms of subjection cannot be studied outside their relation to the mechanisms of exploitation and domination. But they do not merely constitute the "terminal" of more fundamental mechanisms. They entertain complex and circular relations with other forms.[149]

In this expanded field it is incorrect to say that power "is never localized here or there, never in anybody's hands"; exploitation and domination entail localized concentrations of power. Schmalhausen endorsed this second model of power distribution when he observed that the ranks of the Modern Man authors were swelled with thoroughly bourgeois, antiproletarian characters hot in pursuit of class interests. Perhaps the "complex and circular relations" between subjection and exploitation-domination can be clarified by distinguishing between Harvey Fergusson's articulation of the hegemonic ideology and Arthur Schlesinger's. More important than the fact that Schlesinger occupied a position that entailed political, social, and economic power and cultural influence (so, after all, did Fergusson) was his explicit concern with the direct management of political and economic power. His efforts were directly addressed to resecuring the ailing ideology: his brilliant insight was that the patient could be revived through a massive dose of particular antibodies generated within the patient's own body. His strategic application of the cure (strategic because Schlesinger certainly did not enact conflicted and unfathomed modern man subjectivity in his text; as author he seems not to have experienced this subjectivity but only to have mobilized it as argument) was intended to put the patient back to work. Schlesinger's case contrasts sharply with the activities of Fergusson, who was confused and flailing, suffering from the psychic pain caused by the realization that his sense of subjectivity was failing. His remedial actions, like Schlesinger's, also served the hegemonic ideology, but Fergusson's articulation of power is

qualitatively, not just quantitatively different. It seems to me worthwhile to distinguish
between phases in which the discourse was *evolving* in a confused, groping, contradic-
tory fashion within the parameters of the dominant ideology, and phases in which the
discourse was *being used*—by empowered individuals and groups explicitly for the
management of power.[150] In the interwar and wartime period in the United States, the
hegemonic ideology needed tending and revitalization through the sorting and appro-
priation of the innovative productions of its own subjects, a service its especially em-
powered subjects were only too eager to provide. Foucault's earlier description of the
dispersal of power as a neat and regular net must not render us oblivious to the existence
of such bumps and pockets, to say nothing of the gaps created by the denial of full
modern man subjectivity to women, African-Americans, Native Americans, and other
groups.

By balancing Foucault's analysis of the economy of power in subjection with
recognition of different configurations entailed in domination and exploitation, it be-
comes possible to address the pervasive sensation of powerlessness experienced and
expressed by many and varied individuals in the period under consideration. The feel-
ings noted by the Lynds among the residents of Muncie in 1935 grew steadily over the
next decade; the sense of remoteness from centers and figures of power was transmuted
into suspicion that events had moved beyond any and all human control. Such experi-
ences underpinned the popularity of the tragic view of life and conflicted subjectivity—
the answers Modern Man discourse offered to the problem. Another contemporary
answer, which vied against Modern Man discourse and which provides historical ballast
for the analysis of exploitation and domination here, is the position articulated by C.
Wright Mills in such books as *The New Men of Power* (1948), *White Collar* (1951), and
The Power Elite (1956). Mills was one of the most astute analysts of the changes in the
configuration and exercise of power taking shape in the U.S. at mid-century. He rejected
the Mythmaker position that life was inherently tragic, arguing that this view was
debilitating and enervating; it deprived individuals of motivation for social activism.[151]
Instead he portrayed the pervasive sense of powerlessness and victimization as a function
of the mismatch between the reality and rhetoric of power distribution in the United
States. American democracy, as he saw it, was a political system in which most individ-
uals were virtually powerless; power was concentrated in the hands of the propertied and
managerial elites. Mills paid close attention to subtle contemporary changes in the
organization of power: he concluded that the effects of such changes as the bureaucrati-
zation of the powers of property and the "managerial revolution" were the increased
centralization and concentration of power.

> So far as men may do as they will with the property that they own or that they manage for
> owners, they have power over other men. Changes in the size and the distribution of property
> have brought with them an increased power for some and a corresponding powerlessness for
> many. The shift is from widespread entrepreneurial property to narrowed class property. The
> ownership of property now means much more than power over the things that are owned; it
> means power over men who do not own these things; it selects those who may command and
> those who must obey. (*White Collar*, pp. 105–06)

This highly irregular topography of power, in which a few ranges of peaks tower above

extensive valleys must be disguised in some way, must be made to resemble Foucault's homogenous, flat, even web, in order to preserve its general contours.

> The whole growth of ideological work is based on the need for the vested interests lodged in the new power centers to be softened, whitened, blurred, misinterpreted to those who serve the interests of the bureaucracies inside, and to those in its sphere outside. (Ibid., p. 154)

Somehow, then, the two ill-fitting topographies of power, the two opposed fluid economies, must be seamlessly joined. Both tell an essential part of the story: power was indeed diffused, articulated as a function of subjectivity by the mass of subjects constituted by the dominant ideology, but at the same time some subjects held exceptional power, exerted it upon others, and worked to preserve it. Preservation entailed protection of the hegemonic ideology, tuning and resecuring it, promoting the new model. Only by keeping in play these two mismatched topographies can we account adequately for the parts played by Fergusson and Schlesinger, or by the New York School artists and their promoters in the State Department, the U.S. Information Agency, and the Museum of Modern Art, in the reconstruction of the hegemonic, middle-class ideology in the United States in the years surrounding World War II. If a physical embodiment of this double, laminated topography of power would be useful as a conceptual model, nothing would serve better than a painting like Jackson Pollock's *Full Fathom Five* (fig. 28). Simultaneously even, all-over, linear web and variegated, high-relief surface, the painting diagrams the economies of power in which it was itself embedded. Close analysis of Pollock's forms as signifiers in Modern Man discourse is the enterprise of the next chapter.

F I V E

POLLOCK & METAPHOR

. . . the spatial distinctions achieved by lines and spots of color within Pollock's rectangles go as much beyond mere optical vision as seems possible to painting.
Parker Tyler, *"Jackson Pollock: The Infinite Labyrinth"*

Jackson Pollock's paintings have endured intense critical scrutiny since their first exhibition, and over the years, through repetition, elaboration, and consolidation of selected propositions, an orthodox assessment of their evolution and significance has become established. There are, to be sure, tensions and instabilities within this prevailing account of Pollock's oeuvre, and there is considerable disagreement among scholars over some of its details and emphases; but its principal aspects, its fundamental premises and categories, have achieved such currency that their logic now appears self-evident. At the heart of this account is a narrative that conforms to a familiar structure in modernist art history: it features a protagonist who, although (or perhaps because) beset with emotional, psychological, and practical difficulties, engages with a disparate and fascinating range of visual and intellectual influences and produces a corpus of paintings that is perhaps uneven but overall among the most original, accomplished, expressive, and influential of its

era. Information and analysis concerning Pollock and his work have been generated and contained by this conceptual framework, whose models of subjectivity and artistic production convert questions of interpretation and explanation into issues of individual psychology and aesthetics. This canonical account depends upon and perpetuates a structural opposition between subject and object that is central to Western humanist ideology. Pollock is represented as an unstable but self-contained subject whose paintings document a progression of encounters with various objects: works of art, literary texts, nature, New York City, psychoanalysis, and so forth. His personal, largely intuitive responses and reactions to these objects, his readings and misreadings, are the principal factors in prevailing explanations of the trajectory and significance of his work.

This story has been told so often and so thoroughly that there is no useful purpose in reprising it here.[1] Because Pollock's is the best studied and documented body of New York School art as well as that school's benchmark oeuvre, I want to use it here to indicate some of the ways in which the present study opens up possibilities for a reformulated approach to this art. Inevitably, elements of the standard account will be perpetuated in my own analysis—more, no doubt, than I recognize; but my effort will be directed specifically toward making Pollock less a discrete, experiencing, centered subject and more a porous, constituted, decentered one by portraying his work less as the product of a highly individual monad's temperament, creativity, and personal and professional experience and more as an integral component of a network of contemporary representations. This amounts to showing how the paintings are imbricated in Modern Man discourse and subjectivity—how they both signify that they have been produced by a Modern Man subject and simultaneously reproduce that subject-position for the viewer and artist. Historicizing Pollock's work in this way entails a theory and practice of art history disengaged from dependence upon and promotion of the modernist variant of the Modern Man notion of subject. The congruence of the preferred traditional subject of modern art history—the tormented genius constituted in the gap between skilled participant in a sophisticated, formal, visual tradition and intuitive or unconscious seer of inner visions—and the self of Modern Man discourse is a subject for another essay. The enduring stature of Pollock and his colleagues in art history has benefited from the match, but the grip of the shared paradigm consequently has been slow to loosen around them.

CONTROL AND UNCONTROL

In the discussion of Pollock's paintings in chapter 3, one of their aspects was emphasized: their signification of unconsciousness, of origination in a site or faculty beyond conscious experience and control. Whether through imagery culturally recognizable as "unconscious" or through seemingly unconstrained—"automatic"—production of line and form, Pollock's art consistently impressed its viewers as largely out of control. Sweeney's brief notes in the Art of This Century pamphlet (1943) emphasized this point ("unpredictable . . . undisciplined . . . lavish . . . explosive . . . untidy") and in his review of that first solo show in the *New York Times,* Jewell opined that Sweeney's commentary "strikes exactly the right note."[2] There is no shortage of subsequent critical variations on this theme ("sprawling coloramas . . . surcharged with violent emotional

reaction which never is clarified enough in the expression to establish true communication"; "like a weather vane in a high wind whirling in mad circles"; "painted . . . in the throes of a nearly ungovernable passion"; "mere unorganized explosions of random energy"), culminating perhaps in *Time's* story highlighting the comments of Italian critic Bruno Alfieri on the paintings shown at the 1950 Venice Biennale: "Chaos. Absolute lack of harmony. Complete lack of structural organization."[3] Pollock's own comments about his work often fed this response; his *Possibilities* statement was quoted, for example, in the infamous *Life* profile in 1949:

> "When I am *in* my painting," says Pollock, "I'm not aware of what I'm doing." To find out what he has been doing he stops and contemplates the picture during what he calls his "get acquainted" period.[4]

The point that Pollock's paintings issued from some sub- or non-conscious faculty was made here with a maximum of irony.

But at the same time the structure and formal order of his works has been recognized as an essential part of his achievement. Manny Farber, for example, opposed the Sweeney-Jewell response to the early work, writing of *Mural* that it was "so well ordered that it composes the wall in a quiet, contained, buoyant way."[5] Clement Greenberg was the critic principally responsible for emphasizing and encouraging the deliberate aspect of Pollock's work:

> Pollock's superiority to his contemporaries in this country lies in his ability to create a genuinely violent and extravagant art without losing stylistic control. His emotion starts out pictorially; it does not have to be castrated and translated in order to be put into a picture.[6]

Pollock's virile emotion had, it seemed to Greenberg, a naturally pictorial structure; it adapted easily, without emasculation, to the exigencies of formal painting. Here the locus of unruly emotion within the individual is traced to a masculine core of aggressive violence—a gendering that, strangely, was able to coexist harmoniously with the feminization of the unconscious. Greenberg tirelessly called attention to the sophisticated formal order in Pollock's work, distinguishing precisely between Cubist and post-Cubist structural elements. And Pollock also vigorously defended himself against charges that he was not in control of his work. The assertion of his control over his materials became a principal theme of his statements around 1950. "With experience—it seems to be possible to control the flow of the paint, to a great extent . . . I deny the accident"; "I CAN control the flow of the paint. There IS no accident"; and in response to the *Time* article quoted above, "No chaos, damn it."[7] On an undated, schematic notation of his aesthetic commitments, he listed prominently "states of order."[8]

Pollock was committed both to painting from the unconscious and to outdoing Picasso and others in the making of sophisticated, structured, modernist paintings. These largely contradictory goals demanded that he devise ways of signifying disorder, irrationality, and unconcern with structure in opposition to and yet compatible with modernist forms of pictorial ordering. This was the promise held out by the synthesis of formalism and Surrealism for the New York School artists in the mid-1940s. In the dialectic between precise control and chaotic uncontrol characteristic of his mature paintings, Pollock remained true to the abstract-Surrealist origins that were taken as the early distinguishing features of New York School art. The critical reception of his work indicates that he did this with remarkable and consistent success.

The tension between control and uncontrol in Pollock's work was arguably the feature most prominent in contemporary critical discussion and in the coverage of the artist in both the art press and the mass circulation media. This involvement effectively set Pollock's work near the heart of Modern Man interests. Modernist structure and uncontrolled automatism become in Pollock's work emblematic of conflict between order and disorder, control and uncontrol, self and "other within." The reception of his paintings as battlefields where mysterious "inner forces" clash with rational and conscious forces of order striving to maintain control pulls the work securely into Modern Man discourse,[9] where formulations of intrapsychic conflict, employing wide-ranging terminology—emotional vs. intellectual, subjective vs. objective, instinctual vs. rational, primitive vs. modern, unconscious vs. conscious—were a distinguishing feature.

> Man, possessed of an ego into which he forever tries to stuff his whole awareness, denies that he has instincts because to admit it would deflate his ego by restoring some of its contents to his history.[10]

> For life success, the emotional core of personality is coming to be recognized as of equal if not greater importance than intelligence, since the most intelligent person is of little value to himself or to society if his emotional life is confused and dislocated.[11]

One might also recall Niebuhr's "rational man" vs. "natural man," or cite a book-jacket advertisement for Erich Fromm's *Man for Himself* that describes modern man as "the helpless prey of forces both within and without himself," who nonetheless struggles to exert control over his individual life and that of society.[12]

Pollock's paintings constituted an unusually balanced and legible visual representation of these conflicts. They read as compelling and authentic products of an artist/subject divided; a proper response to them required, it seemed, conscious and unconscious identification in the viewer. Given the currency such ideas had, and the larger implications attached to the problem of control-uncontrol, one can understand why paintings that seemed to center on this issue might capture public interest, both positive and negative.[13] The contemporary criticism indicates that Pollock effected this signification more vividly than most of his contemporaries. We might wonder how this was accomplished: What signifiers of control and uncontrol did Pollock exploit, signifiers which were independently legible and yet were capable of working in concert (or opposition) within a single pictorial field?

One painting that can serve as a valuable point of reference for discussion of such questions is Pollock's *Out of the Web: Number 7, 1949* (fig. 70). This painting is an eloquent example of many of the specific features upon which I wish to concentrate in this chapter, so I will describe it briefly here. The painting is quite large, four by eight feet, the size of the standard sheet of masonite which serves as its ground. Masonite was a material with overtones of the modern about it in 1949; the 1933 Century of Progress exhibition in Chicago had featured a masonite house as part of its display of modern domestic architecture. Pollock's use of it here should be seen as part of the interest in new and unconventional materials and techniques that led him to work with duco enamel, aluminum paint, and basting syringes. *Out of the Web* was done on the textured side of the panel, which had been primed with a white ground; the web of the masonite surface provided a rigid equivalent for canvas weave. The paint was poured on in layers, apparently starting with a dark blue-black layer, which supplied a provisional architec-

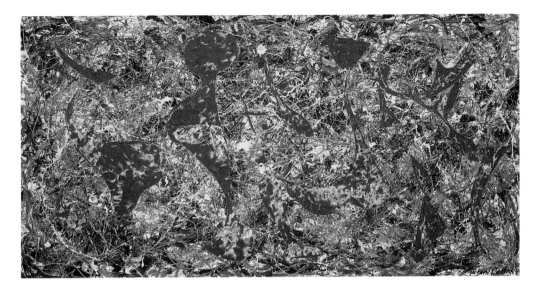

70. *Jackson Pollock.* Out of the Web: Number 7, 1949. *Oil and enamel on masonite, 122 × 244 cm. Collection of the Staatsgalerie, Stuttgart.*

ture for the picture. This was followed by a layer of blue-gray middle tone, and then a very light gray; but this layering has been obscured by intermixing—bringing back the bottom colors in subsequent layers, and dragging a brush through multiple wet layers. Into this chromatically neutral framework, substantial pourings and brushings of bright colors were injected throughout the field; there are large areas of the primary colors and smaller accents of turquoise, green, and orange.

The application of paint is remarkably varied. Considerable variation is evident in the viscosity of the paint; thinned paint has left splashy marks that reveal fully the underlying textures; thick paint is visible in pasty impasto and in raised, smooth-edged lines and pools. The width of the line varies greatly as an index of viscosity and speed of the gesture. There are areas of high-volume pouring and of hair-thin pouring. And finally, there is considerable variety in brushwork; in some areas a dry brush has been dragged over textured surfaces, in others, the brush was pulled through a wet web, interrupting the flow and delicacy. Clark has suggested that such variety in the handling of paint in Pollock's work suggests the absence of a unitary producing subject.

> The marks in these paintings, it seems to me, are not meant to be read as consistent trace of a subject, a controlling presence, but rather as a texture of interruptions, gaps, zigzags, arhythms and incorrectnesses, which all signify a making, no doubt, but one that enacts precisely the absence of a singular maker, an "artist"—a central continuous psyche persisting from start to finish. Of course this enactment of absence may also be a fiction, but it seems the fiction Pollock wanted. [14]

Paint handling in *Out of the Web* bears out Clark's judgment, and his interpretation of the effects of its disunity reinforces the links to Modern Man discourse that I wish to draw. The challenge to which much New York School painting responded was precisely the dismantling of the appearance of fabrication by a central, continuous, controlling sub-

ject. How could a painter tap primitive and unconscious others within the psyche and get them to play a significant part in the process of making a painting? Such objectives translated into immediate, practical problems: how to make paintings that *looked like* the product of a fragmented, divided, complex self; how to get those othernesses registered in the picture's forms. It was far more important that pictorial means be found for signifying disunity, uncontrol, and rupture than that any real experience of division and uncontrol figure in the painting process, although presumably some such experience or fiction was usually a precondition for effecting the signification. Discontinuous handling is one of the strategies by which Pollock both figures disorder and uncontrol and simultaneously signifies division and conflict within the subject. This form of "dissonance," to use Clark's term, is a mark, on one hand, of irrationality, automatism, and disorder in the painting, and on the other, of intrasubjective division, of production by a complex, split, or fragmented author, one capable of handling materials with both wild abandon and authoritative precision.

Pollock's paintings routinely situate passages of wild, chaotic linear energy alongside areas of precise, delicate, virtuoso control. In *Out of the Web,* the former feature is perhaps most striking in areas where pouring and energetic, random brushing coincide—where a web of frenzied brushmarks intrudes into a web of wet poured lines. To illustrate precise control, one can point to the small spots of gray paint, no more than an inch in diameter, upon which have been inscribed delicate, intricate, black patternings—lines of a hair's width that zigzag evenly across the spots in a pattern extending from top to bottom (fig. 71). It is hard to imagine how these were done; no doubt such lines required both a steady, regular, and delicate gesture and a precise manipulation of the elasticity of the maximally attenuated paint stream in order for the line to fall with such precision and regularity. However it was done, it stands as an extreme manifestation of the control and order exercised throughout.

A similar dynamic can be observed on other levels in the painting—at the level of composition, for example. The balance and consistent density of the composition has been remarked by Fried. Yet the field is far from homogenous. Large sections of the painted surface have been carved away, exposing the masonite beneath. I will have more to say about these carved-out areas presently; for the moment, I wish to concentrate on the way in which rupture and unity in surface and composition are made to coincide. The exposed masonite is close in tonal value to that of the overall painted field, and the patches of white ground that are left serve to mottle the cut-out areas and keep them from having a disruptive uniformity. Largely because the carved-out areas lose themselves against the painted field, Fried prefers this picture to a contemporary work such as *Cut Out* (fig. 80), in which there is a radical disjunction between painted surface and cut-out section. His taste is indicative of a modernist preference for controlled unity in the Abstract Expressionist pictorial field, a valorization that has served to ground judgments of quality among New York School paintings and, in so doing, to lead to underappreciation of disjunctive works and of the functioning and structural importance of disunity in Pollock's paintings.[15]

In certain of Pollock's poured works, the balance between control and uncontrol is tipped toward the display of control over materials and forms, or perhaps it is more precise to say that control is signified in ways particularly susceptible to demonstration

71. *Detail of* Out of the Web (figure 70).

and description. One such painting is *Number 7, 1951* (fig. 72), one of the group of black
pourings Pollock made in 1951–52. Like most of the others in this category, it is
monochromatic—made from black enamel poured on cream-colored canvas—and is
marked by overt figuration. This particular painting is bisected: the left side largely
abstract and the right structured by a well-defined female figure. One of Pollock's
motives in undertaking the black pourings was a desire to make his control of medium
more evident. A letter to friends Alfonso Ossorio and Ted Dragon indicated that the new
paintings were addressed in part to those who doubted the difficulty of Pollock's tech-
nique. His principal strategy for reasserting mastery rested upon figuration:

> I've had a period of drawing on canvas in black—with some of my early images coming
> thru—think the non-objectivists will find them disturbing—and the kids who think it simple
> to splash a Pollock out.[16]

The implication of the statement is that figuration was an effective way of signifying
control, mastery, and skill, in opposition to the uncontrolled, automatic, abstract line. I
will take up this suggestion in the next section of this chapter; for the moment, however, I
wish to focus on evidence of control in *Number 7, 1951* that has little if anything to do
with its handling of figuration.

What makes *Number 7, 1951* a tour de force of controlled pouring is its use of
precise, deliberate repetitions of distinctive formal motifs. Much of the painting is
loosely compartmentalized, and within each section a specific type of mark is repeated to
fill the allotted space. Several of these marks individually required considerable skill,

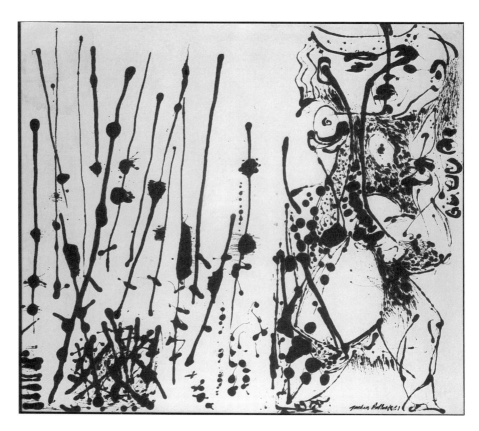

72. Jackson Pollock. Number 7, 1951. Oil on canvas, 142 × 168 cm. Collection of the National Gallery of Art, Washington, D.C.; gift of the Collectors Committee.

care, and control in the making, but what is most striking is that Pollock was able to duplicate them at will, with precision and/or deliberate variation. For example, very small, unconnected, dripped black dots must have been rather difficult to regularize, yet this has been done in the area of the figure's forehead and along the left side of the torso. In some sections of the torso, collections of dots are connected by thin lines; that is, they are part of a single continuous pouring process involving regimented movement and stasis. These markings are juxtaposed with areas in which lines and dots are layered upon one another, having been produced as separate operations.

On the right side of the picture, just above the figure's pelvis, is an area in which each of a series of small dots is connected by a thin line to a corresponding large pool. These clusters are arranged in a more or less straight line. Between the figure's knees is another line of dots with identical descending linear tails. These tails are so thin that they are better described as drizzled than poured; upon close inspection, the line degenerates into a delicate chain of miniscule points. In other compartments of the figure, large spots are placed so close together that they form a fat, segmented, caterpillar line—a magnified, compressed, denser counterpart to the dematerialized, drizzled line. The drizzling technique is visible also in the figure's hair at the right side of the painting; here it seems

to be juxtaposed principally with the hair on the other side of the figure's head, conjured through a sequence of precisely nested, wavy, poured lines.

The left side of the picture comprises vertical lines regularly punctuated by pools. A moment's indecision in the production of these lines would have resulted in disruption of their regularity. They spill into the figurative side of the picture, blending with the lines that compose and obscure the figure's distorted skeleton. Along the upper-right edge of the painting, below the drizzled hair, is a vertical sequence of variations on arcs that produces a symbolic weight, like obscure lettering. This is a familiar device in Pollock's work—a sequence of drawn lines verging on lettering or hieroglyphics.

The painting seems an explicit demonstration both of the range of markings that constitutes Pollock's visual vocabulary and of his ability to execute particular, complex marks at will. By segregating and patterning these different markings the picture produces planes of different tonal values, planes that refer back to tonally compartmentalized earlier works such as *The Key* (1946; fig. 75), whose colored segments are further distinguished by surface articulations—spots, dashes, lines—reminiscent of *Number 7*. The latter, in short, serves as an especially striking and vivid illustration of Pollock's control of line, a control Frank O'Hara detected throughout Pollock's work.

> There has never been enough said about Pollock's draftsmanship, that amazing ability to quicken a line by thinning it, to slow it by flooding, to elaborate that simplest of elements, the line—to change, to reinvigorate, to extend, to build up an embarrassment of riches in the mass by drawing alone.[17]

The control-uncontrol tension is, of course, the foundation of Modern Man subjectivity. The image of man struggling to exert control over the powerful forces within and without him found compelling visual form in Pollock's work. Like other contemporary culture heroes—the jazz musician teetering at the edge of chaos, or the private detective or *film noir* protagonist struggling to make order of chaos and to master the forces of evil within and without himself—the Abstract Expressionist painter metaphorically enacted just such a dynamic using and adapting the language of visual modernism. As the viewer moved back and forth, near and far, in front of Pollock's paintings, a dramatic narrative unfolded, composed from the multiple and various significations of order and disorder, control and uncontrol. The formal order secured in the painting, against the tide of irrationality, chaos, and wildness, took on a heroic quality. The other, in being given voice, was contained. In the 1940s and early 1950s, these dynamics carried such significant and specific weight within U.S. culture and were so integral to Modern Man discourse that to divorce the paintings from that discourse is to diminish them. The readings of Pollock's painting developed in the criticism of the 1940s and early 1950s— that the works are exercises in ordering the uncontrollable (they were frequently compared with jazz),[18] that they result from allowing the artist's unconscious and primitive drives to intervene in the process of constructing paintings (and therefore are icons or traces of struggle between self and other within the artist), and so on—drew their significance and force from the participation of both the criticism and the painting in Modern Man discourse. This argument can be reinforced, I believe, by attending to other forms of metaphor operative within the work and drawing their relation to Modern Man discourse.

FIGURATION AND ABSTRACTION

Another way in which the control-uncontrol dynamic is realized in Pollock's work is through the opposition of figuration and abstraction. That the poured line is subject to control can be signified through its being directed to form crudely figurative shapes—so Pollock acknowledged in his commentary on the black pourings—as well as through its yielding delicate regular patterns and overall compositional complexity. This is not, however, a clear and simple signification. The figures also evoke—through their spontaneous formation, fragmentariness, elusiveness, and dislocation—imagery attributed to the source of uncontrol: the unconscious. Figuration is, for these reasons, a valuable component of Pollock's visual language; not surprisingly, it is a consistent presence, even through the predominantly abstract period of 1947–50. And when it is not unequivocally present in a particular painting, its *possibility* is often an important factor in the semiotic operations of the work.

Despite the fact that figuration was an important component of Pollock's work throughout his career, its ultimate importance relative to abstraction has been a subject of some dispute among critics and historians. The paintings that traditionally have been valued most highly are those that are most abstract, and the three- or four-year period in which the abstract work was concentrated—1947–50—was early established as the pinnacle of Pollock's career. Some historians have suggested that representational imagery continued to figure in the production of the abstract works. Their claims rest on various foundations: one is provided by the persistence of figuration in a significant number of poured works from this period; another is Pollock's own testimony, as when he spoke of himself as "very representational some of the time, and a little all of the time" and noted that on at least one occasion he had chosen to "veil the imagery" under a tangle of abstract forms.[19] For a number of other reasons—among them, that figuration was such an established and integral component of Pollock's method and interests, that its value to the aesthetic position and commitments he had defined for himself was so great, and that his painting process was so ill-equipped to defend against the emergence of figuration in his work—it would be remarkable indeed if Pollock's abstract works were devoid of figurative components, veiled and otherwise. More apt is Frank O'Hara's early observation that "the crisis of figurative as opposed to non-figurative art pursued him throughout his life."[20]

The dispute is indicative of two things, in my view: it gives corroborating evidence that the possibility of figuration in the abstract works is an issue germane to the paintings (and the possibility is arguably as important as the fact in this case), and it indicates that something important is at stake in the matter of whether the paintings are categorized as pure abstraction or allusive, impure abstraction, namely, what sort of modernist teleology and what account of postwar United States art will they be taken to validate. Pollock's stature as leading figure of the New York School and, consequently, the stature of the school generally, rest in significant part on the type and magnitude of achievement attributed to these pictures. According to Greenberg's influential account, as modified and developed by Fried, Rubin, and others, Pollock's "advance" over previous modernist painting consisted in part of his having devised a purely optical form of spatial illusion produced by lines freed from figurative status. In Fried's classic description,

In these works Pollock has managed to free line not only from its function of representing

objects in the world, but also from its task of describing or bounding shapes or figures, whether abstract or representational, on the surface of the canvas. In a painting such as *Number One* there is only a pictorial field so homogeneous, overall and devoid both of recognizable objects and of abstract shapes that I want to call it *optical*, to distinguish it from the structured, essentially tactile pictorial field of previous modernist painting.[21]

This account of Pollock's achievement requires that his line be abstract. Despite the fact that Greenberg himself was for a while attentive to Pollock's equivocation between abstraction and figuration, and that Fried appreciated Pollock's efforts to introduce figuration through nonlinear means (specifically, excision), any drawing with line tends to be construed by these critics as a mark of retreat, decline, or of "chafing at the high price he had to pay for this achievement [optical space]."[22] Rubin goes further, sacrificing descriptive nuance for unambiguous statement of the principle: "[Pollock's] linear webs were, in the radical nature of their all-over drawing, incompatible with literal representation."[23] The ferocity with which Rubin later defended this position against erosion, as we will see, is a mark of its importance to the modernist reading of Pollock. Rosenberg's alternative reading of New York School art as "action painting" agrees with the Greenbergian position in this respect. Pure abstraction is required if the paintings are to be understood as generated by pure gesture, unimpeded by reference, allusion, or other constraints.

For many of those seeking to challenge the hegemony of these accounts, the figuration issue marks an especially weak point in the enemy's defenses. Fried and Rubin could not help but recognize some figurative passages in the poured paintings—for example, Fried mentioned *Summertime, Wooden Horse,* and *White Cockatoo* (all from 1948) in this vein, while Rubin pointed out a head and shoulders at the right of *Wooden Horse*— but such passages and works were construed generally as experimental efforts marking lapses in rigor.[24] The number of such works is too great, however, and the issue too persistent in Pollock's oeuvre to permit such a convenient evasion of the problem. My reading of the pictorial evidence endorses the position taken by Krasner, O'Hara, Hess, Clark, and others (including the early Greenberg), which sees a dialectic between figuration and abstraction as a motor of Pollock's work throughout the 1940s and early 1950s.

My ambition in this section is to study the handling of figuration principally during the period of Pollock's classic abstractions—1947 to 1950—without making representational interests into the "subject" of the paintings and the site of their meaning. To try to escape the limitations of narrowly formal analysis of largely abstract art by isolating its representational components and subjecting them to iconographic analysis is merely to avoid addressing the difficult problem of subject matter. The persistence of interest in figuration in Pollock's painting must be counterposed to the simultaneous commitment to abstraction—that is, to the fabrication of an opposite to figuration. Pollock's 1956 remark that he was "very representational some of the time and a little all of the time" must be balanced with his comment to an interviewer from the *New Yorker* in 1950: "Abstract painting is abstract. It confronts you."[25] Though somewhat unyielding in itself, this comment was intended, apparently, as an endorsement of Lee Krasner's observation that her husband preferred numbers to titles for his pictures because they were less allusive and encouraged viewers "to look at a picture for what it is—pure painting."

Pollock's work simultaneously engages both of these seemingly incompatible projects, and this contradiction should not be obscured in the interest of constituting a coherent, noncontradictory artistic identity for him. Yet there is an aspect of his work that undermines any attempt to treat figuration and abstraction as contradictory. The contrivance, simplification, and conceptual inadequacy of the opposition are crystallized in Pollock's painting. The identification of a work as "abstract" hinges upon evidence that figuration deliberately has been suppressed, controlled, veiled, erased, expunged, etc., from the work. A painting's status as an abstraction is contingent upon figuration's hovering at the margins, as difference or absence; its eschewal must be verified continually on every level and in every corner of the picture. In Pollock's abstract paintings, figuration's possibility is so close, so palpable, its functioning as absence so inconclusive, that it becomes ironically a ghostly presence, an irrepressible suspicion strong enough to jeopardize the picture's classification as abstraction. The paintings invite consideration of the abstraction/figuration issue, and then frustrate efforts to resolve it; this dynamic simultaneously animates the pictures and asserts the impossibility of simple resolutions.

For these reasons, I am not interested in delineating boundaries or in attempting to enlarge the domain of the figurative works at the expense of the abstract, or vice versa. My purpose is to demonstrate and investigate the interest in figuration and to explore its interaction with abstraction. I will limit my discussion to works in which the presence of figurative interests is patent; many of these are works that have tended to be underappreciated in the prevailing accounts of Pollock's art, partly on the basis of the overtness of their figuration, sometimes because of smallish size or unusual medium, sometimes because their overall numbers are relatively small during the "abstract phase." They are often dismissed as "sporadic attempts at figuration" and the importance of the abiding interest they represent ignored.[26] Argument for the importance of a dialectic between figuration and abstraction in Pollock's work does not require as precondition a certain consistent volume of emphatically figurative works. If the relatively short period in which the balance tips toward abstraction is viewed within the context of Pollock's mature oeuvre—that is, if we resist the prevailing tendency to isolate and exalt the "classic" period, 1947–50—the principally abstract works constitute the numerical minority. I have selected works that demonstrate the range of approaches tested by Pollock for producing figuration and for relating it to a pictorial field.

In the discussion in chapter 3 of Pollock's development of a Jungian symbolics of the unconscious circa 1940, the degree to which his early mature works, such as *Guardians of the Secret* (fig. 27), utilized recognizable imagery was apparent. It is worth, however, returning briefly to that period to see how figuration was produced and integrated into the pictorial field. One painting in particular is a valuable point of reference in these respects because of its relation to later poured works: *The Moon Woman* (1942; fig. 73). As in many of Pollock's paintings, the mimetic reference registered here is greater than is at first apparent. The figure, a composite of devices borrowed from Picasso and Miró and of elements developed in his psychoanalytic drawings (note especially the figure's eye and ear), faces a pair of hovering flowers, their stems and leaves rendered in thick yellow paint. A tulip shape floats above a sunflower shape, the sunflower doing double duty as a second left hand attached to the figure's spine by a partially obscured green line suggest-

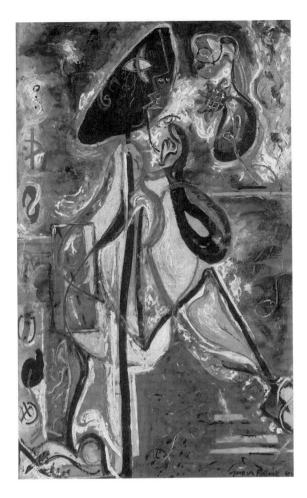

73. Jackson Pollock. The Moon Woman.
*1942. Oil on canvas, 175 × 109 cm. Peggy
Guggenheim Collection, Venice, 1976, The
Solomon R. Guggenheim Foundation, New
York. Photograph by Robert E. Mates.*

ing an arm. Such playfulness permeates the painting: the moon woman's head is repre-
sented by a black crescent shape facing the opposite direction from a small crescent
contained within it, which is punctured by the oval eye. There is explicit play also with
the referentiality of forms: some are mimetic (figure, flowers), some are ostensibly
symbolic (the sequence of marks along left edge of the canvas), and some ambiguous
(red and green lines).

The figure is built upon a black armature. A straight black line descends from the
figure's head to the bottom of the canvas, where it makes a ninety-degree left turn to
structure a strange large foot/hoof similar to those that appear in other paintings from this
time, such as *Male and Female* (1942) and *Pasiphaë* (1943; fig. 9). Another emphatic
black line runs parallel to the middle third of this spine before jutting out to the right to
form an upraised knee and foot. Upon this knee rests the pronounced form of a forearm
and hand; they are outlined, and the forearm partially filled in, with the same black used
for the head and spine. This forearm/hand shape, with less black weight, is repeated just
to the right and above the first, interlaced with the flowers and sharing some of their
components. The figure's double left arm (triple, if we count the green arm with
flower/hand) is balanced in part by a short black line extruding from the other side of the
spine at the same level as the principal left arm.

To this point, the moon woman is essentially a black stick-figure with multiple and hypertrophied left arms. But other, more fluid forms participate in the construction of the figure as well, fleshing out the skeleton provided by the black lines. For example, lines in other colors join or cross the spine, suggesting alternate or supplementary appendages. The figure's abbreviated right arm is filled out by a red line that delineates a tubular upper arm. Here, as in the figure's head, line functions to bound form rather than to stand as equivalent for it. One of the ends of this line is left to dangle below the elbow, affirming its status as line; the other goes on to suggest the contour of a torso; a breast form is also indicated in red. Part of the red upper arm is echoed by a green line that issues in a green rectangle, which seems a kind of counterpart to the black forearm/hand opposite it. Another green line reinforces the breast contour and connects the spine with the figure's left foot, and still another line bisects the red field on the right side of the picture; the latter is apparently unrelated to the figure proper, like the black line rising from the figure's right foot. Both these lines are positioned quite close to nearly identical lines that serve explicitly figurative functions—the black spine and the green line forming the figure's third left arm.

The Moon Woman is one of Pollock's most provocative early experiments in constructing a figure from line. Although here done in smooth strokes with a wide brush, the pictorial operations visible in this picture will be developed in poured works in the later 1940s. What makes this painting especially interesting and what points the way to the later works are two features in particular: the interaction between structuring lines and automatic lines, and the relation between figure and pictorial field. The lines forming the figural architecture are freely cut short or overextended; they are converted into non-figurative lines and allowed to wander or to merge with other elements of the scene. This gives the production of the figure a casual, automatic, spontaneous character, a character contradicted by the fact that the figure is built into the pictorial field and structures it. The moon woman divides the painting into distinct sections, each of which has a different dominant color and character. Her spine divides the pink lower-left side of the painting, which resembles *Male and Female* (1942), from the right; the right in turn is subdivided by the figure's raised left leg into a red upper part, recalling *Magic Mirror* (1941), and a green lower part. The figure, consequently, while it structures the pictorial field, is the spontaneous, casual product of an automatic, wandering line.

By mid-decade Pollock's handling of the figure was moving in different directions. Some are revealed in *There Were Seven in Eight* (1945; fig. 74), the painting to which Pollock was referring when he told Lee Krasner that he had chosen to "veil the images." In a 1969 interview, Krasner noted that Pollock often began his abstract pictures with recognizable imagery. "Many of them, many of the most abstract, began with more or less recognizable imagery—heads, parts of the body, fantastic creatures."[27] Under pressure from William Rubin, Krasner restricted her observation to this one picture,[28] but the sense of her original remarks is unmistakable. All of Pollock's work, she said, including many of the most abstract pictures, originated in the distinctive, recognizable visual imagery he developed in the 1930s; there are no sharp breaks in his career, whether between figuration and abstraction or on any other grounds. One might also cite in this context Pollock's previously quoted letter to Ossorio and Dragon, in which he wrote that he had had "a period of drawing on canvas in black—with some of my early images

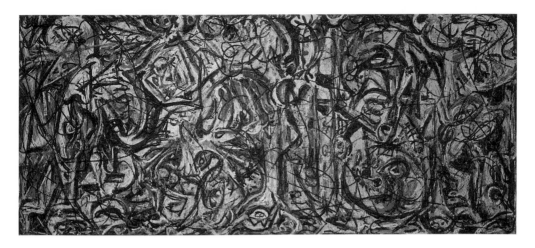

74. Jackson Pollock. There Were Seven in
Eight. *Ca. 1945. Oil on canvas, 109 × 257
cm. Collection of the Museum of Modern Art,
New York; Mr. and Mrs. Walter Bareiss Fund
and purchase.*

coming thru." The locution "coming thru" is suggestive but ambiguous: coming through
what? The paint skein? Should we take it to imply that the veil was parting or thinning to
reveal material previously concealed? How long previously? Is there not also in his
remark an evocation of depth psychology and its models of mental operations: a sugges-
tion that early, symbolic, psychologically charged imagery was surfacing once more,
bubbling up from the unconscious depths, marking a return of the repressed—that which
had been there all along, in the mind as in the painting, but merely undercover? That
Pollock's phrasing merges so completely aspects of a model of mental process with a
reading of his painting's structure is indicative of the extent to which the two remained
intertwined throughout his career. It reveals also some justification for keeping a reading
of his paintings as metaphors for the mind and its operations, involving both symbolic
and energetic—figurative and abstract—materials, always in play in the larger analysis.

The two ways of handling line that were made compatible in *The Moon Woman* have
become separated and opposed in *There Were Seven in Eight.* On one hand, line produces
many of the various recognizable figures and abstract forms that constitute the pictorial
field, but on the other hand it also operates to conceal, obscure, and imprison those
forms. Over most of the painting, the topmost (foremost) layer comprises brushed, black
lines, a tangle that passes in front of the various bits of recognizable and semirecogniz-
able imagery—a hand, a snake, a head—obscuring, containing, and uniting them. The
line is clumsy and slow compared to the poured lines that will soon replace it; it seems to
strive for but cannot match the spontaneity and fluidity of the lines that will dominate
Pollock's subsequent work. Nonetheless, this painting indicates that heightened sponta-
neity is becoming detached from figurative suggestion; when the line in *There Were
Seven in Eight* is at its most automatic, it works against the directed, figurative, slightly
less spontaneous line underneath. The directed and undirected aspects of line are distin-
guished and distanced. It is important to resist establishing an oversimplified equiva-

lence between directedness and figuration and between undirectedness and abstraction; the forms defined by the figurative lines are designed to signify spontaneity themselves, and the abstract line is carefully controlled as it meanders more or less evenly over the surface. The opposition must be qualified but not lost or understated.

This painting is one of the earliest in which a decisive painting-out of the figurative takes place. The top layer constitutes an action against what has come before, just as the predominantly abstract poured works to come ought to be read in part as a reaction against prior figuration. Yet the weapon wielded against figuration arose out of figuration and always maintains that original tie, alongside a promise, threat, and enactment of reversion to its origins. That weapon is the automatic line whose distance from the figurative cannot be insured if it is to carry full weight as automatic. It is an equivocal instrument against figuration, and what is more, its referentiality is not eliminated when line is directed to veiling imagery, but only changed. The new metaphors it comes to evoke will be considered later in this chapter, but apropos of this painting, it should be noted that in describing *There Were Seven in Eight,* commentators have remarked upon the "weblike formation of its image" and have noted that here as in several paintings from this period "Pollock's formerly recognizable imagery has somehow become ensnared."[29] Web, entrapment, ensnaring—these are metaphors that will be courted increasingly as Pollock's handling of the figure-field dynamic proceeds. That which formerly made the figures now imprisons them. Pollock may have freed line from one manner of bounding form, but it does not necessarily become nonmimetic, "pure" line (if such a thing is imaginable) as a result.

There Were Seven in Eight exemplifies an early stage of Pollock's "all-over" composition: visual incident and interest are spread more or less evenly over the full surface of the canvas. This is partly an effect of its surface layer of line and partly a function of its fragmentation of "unconscious" material, which is pulverized and scattered across the surface. Field structure now can be generated by emotional-psychological material; an even more complete integration of Surrealist and abstract traditions and interests is realized.

The Key (1946; fig. 75) illustrates another kind of mid-decade figurative experimentation. The figuration in this picture is subtle enough that on first viewing one is likely to think the painting abstract. Figures are broken down into bounded, colored areas that blend into the overall patterned field. Distinctions between figure and ground are effectively undermined by this patchwork organization. The composition is very similar to that of earlier paintings, such as *Pasiphaë* (fig. 9), *Stenographic Figure,* and *Guardians of the Secret* (fig. 27). *The Key* even contains specific forms that recall those works: for example, the arm reaching across the top from the upper left corner, as in *Stenographic Figure,* or the oval forms at the center, from *Pasiphaë.* As in the earlier pictures, figures flank a central area, here rendered as landscape, with blue sky, green hill, blue water. The paint surface is thin and unlabored, with much bare canvas showing. Paint has been knifed on in most areas, but various sorts of surface articulations—dots, flecks, scribbles, dabs, lines—decorate and further differentiate the juxtaposed color regions.

The painting began with architectonic compositional lines, some of which define figures and forms while others divide the canvas. This linear pictorial architecture is

punctuated by calligraphic eruptions. The figure on the left is drawn loosely but deliber-

ately, the constituent lines precisely arranged. In contrast, the lines forming the figure on
the right are more hectic; they seem more autonomous, less under control or directed. For
example, there is the scribble that makes up the figure's left hand: three parabola fingers,
a couple of arcs, and a loopy figure-eight on a raised arm. The form evokes the linear
overlay of *There Were Seven in Eight*. From this scribble emerges what looks like an old-
fashioned skeleton key. The figure's head is sketched in raw sienna and black lines; it is
made of a horizontal "8" form and an enclosing circle, both of which have been drawn
repeatedly, as if the gesture were obsessive. These lines go under, over, and through
white paint that has been caked on with green and blue accents. The left foot of this figure
also consists of a horizontal "8" form. It is connected to the left hand by a continuous
tubular form, which turns at the lower-right corner of the picture and continues along the
bottom. There are two illegible circular forms in the picture, at the lower-left center and
lower-right center. Their placement, forming a pyramid with a green triangle at the
center, recalls the gender-coded heads in *Bird* (fig. 34), although here no features are
rendered. The circle on the right contains scribbles like those that compose the hand
holding the key.

In this painting, then, another form of spontaneous line—line apparently produced
by obsessive, repetitive gesture—has entered into the production of the figure. This
device enables the figure to stand as a site of spontaneity, uncontrol, and automatism, as
well as being a mark of the containment and directedness of the line. In this way, both

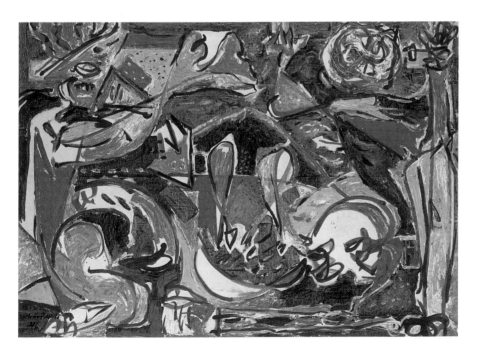

75. *Jackson Pollock.* The Key. *1946. Oil on
canvas, 150 × 216 cm. Collection of the Art
Institute of Chicago; through prior gift of Mr.
and Mrs. Edward Morris.*

control and uncontrol can be signified in the delineation of the figures alone, and the two figures bracketing *The Key* stand as emblems of the alternatives. Nonfigurative lines are also shown in this picture to be capable of considerable range over the spectrum of control/uncontrol; at times they appear relatively unconstrained by pictorial logic, whether mimetic or structural, while at other times their placement and character are quite obviously structurally determined.

The following year (1947), Pollock painted *Untitled [Composition with Black Pouring]* (fig. 76), a work that reveals his interest in figuration persisting into the period of his earliest systematic experimentation with pouring processes. Here the poured line is put to the service of delineating a figure who occupies and structures the pictorial field much the way the moon woman did hers. As in the earlier painting, the focal point of the picture is the interaction between the figure's head and an equally dense form hovering opposite it in the upper-right corner of the picture, a form that appears to be both the figure's left hand and something more. The "something more" is far less legible here than in *Moon Woman,* as are the personage's facial features. The comparison directs attention to the crudeness of the drawing in the poured work and to the ragged quality of its lines. Whereas several of the dominant lines composing the moon woman have a clean, hard edge, despite having been made by brushing, the poured figure is constructed from lines whose edges are so irregular that they resist being read as poured. The pouring must have been done painstakingly slowly, each vibration of hand and arm, each splash and interruption of the flow registering in a compressed area, like a vibrating marker on a slowly turning drum. The edges are further frayed by the coarse topography of the brushed ground; its valleys accept the flowing paint while its elevations repel it. There are no marks of absorption at all, no halo left by oil separating from pigment; the slick ground provided little resistance to flow over it. As a result of these various features, the poured lines have an additive, built, even a brushed character that assimilates them to the brushed ground beneath. The disparity in process, in facture, between figure and ground, is softened.

Yet despite this deceptive similarity between line and ground, the tight integration of figure and ground achieved in *The Key* has been refused decisively in this picture. The background is made from light gray colors brushed over white with blue, red, and yellow accents. The emphatic, wide, poured lines, principally figurative, were applied last, on top of the light ground. The value contrast between figure and ground is quite marked, more so than the contrast of facture; yet here too the opposition is softened somewhat. An array of substantially narrower and smoother black pourings keeps the contrast from being absolute; nonetheless, the black, poured figure stands out sharply against the brushed, light background, its dominating presence mitigated by neither a containing linear network nor a tonally variegated color field. The few thin, nonfigurative black lines, like the occasional white lines that come up from the underpainting into the top layers, serve less to obscure or conceal the figure than to affix it to the ground and secure, by antithesis, its mimesis.

In another contrast with *The Moon Woman,* more of the lines in *Composition with Black Pouring* stand as the contours of the figure; its perimeter is loosely defined by several of the lines, while hands and feet are marked by abstract linear incidents. Yet the figure's coherence and integrity in the field are by no means unequivocal: its delineation

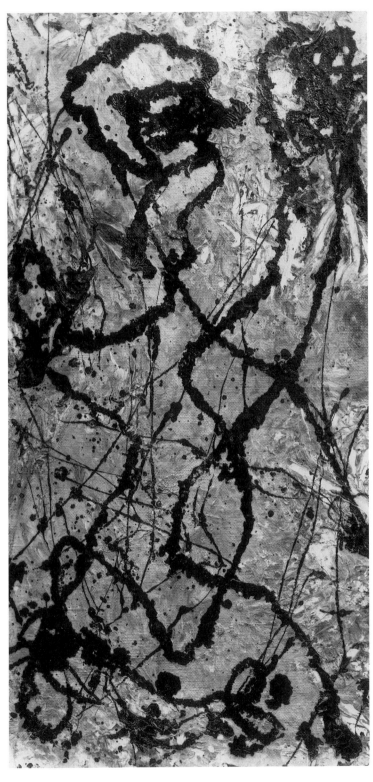

76. *Jackson Pollock.* Untitled [Composition
with Black Pouring]. *1947. Oil on board, 44*
× 24 cm. Collection of Mrs. Richard
Rodgers, New York.

has been subordinated enough to the exigencies of the pouring process and of the overall composition, and its forms have been sufficiently distorted (a left hand that becomes in effect a second head, for example) that it resists somewhat isolation and focalization. The figure is just enough a collection of seemingly automatic pictorial incidents and events that its identity and integrity are mitigated. To suspend recognition of the figure and attend to the line as abstract, material form is difficult but by no means impossible.[30]

A subsequent figurative pouring, *Number 22A, 1948* (fig. 77), extends further the opposition between figure and ground by setting its dark, linear, glossy, poured figures on an unmodulated, light, matte ground. Relatively little effort has been made here to impede the projection of deep space into the pictorial field or to embed the figures in the material of that field. And just as the noise has been eliminated from the ground, so the irregularities in the line have been radically reduced here. The line in this work evokes speed, fluency, and elegance, owing both to its smoothed arcs and to its wide, silver-gray halo. Pollock here hit upon a combination of ground (gessoed paper) and paint (enamel) that yielded lines striking for their delicacy and illusionistic volume. All the lines in the picture consist of a dark filament with a light gray halo, the halo keeping a more or less consistent width despite considerable variation in the width of the filament. The result is a line that suggests drawing in space with silvery wire. Calder is evoked not only in this respect but in the way some of the figures are constructed; the line acts as a sort of armature approximating and supporting essential features and sustaining a continuous flow from part to part, a challenge to the wit and ingenuity of the artist. The speed of

77. Jackson Pollock. Number 22A, 1948.
Enamel on gessoed paper, 57 × 78 cm.
Courtesy Jason McCoy, Inc.
Zindman/Fremont photograph.

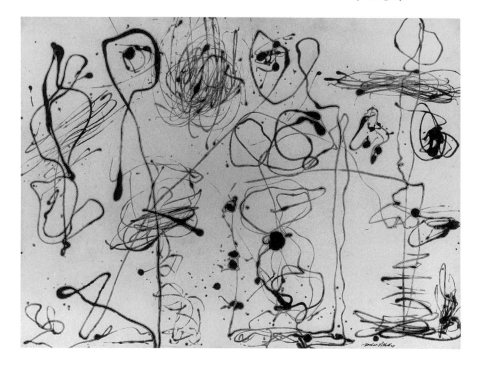

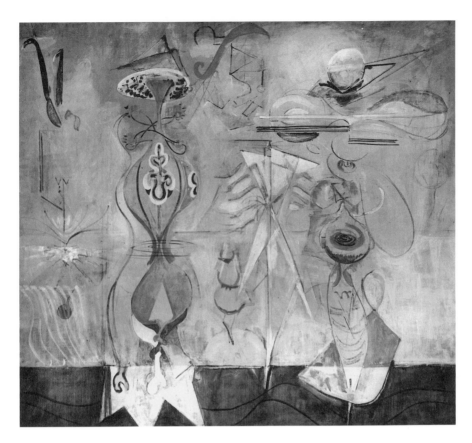

78. Mark Rothko. Slow Swirl by the Edge of
the Sea. *1944. Oil on canvas, 192 × 215 cm.*
Collection of the Museum of Modern Art,
New York; bequest of Mrs. Mark Rothko
through the Mark Rothko Foundation, Inc..

Pollock's line is enhanced by the impression that the dark thread travels along a prepared
track.

Again in this work Pollock resorts to what is emerging as a set of characteristic
formal techniques for decentering his figures and keeping them from too simple or stark a
legibility. The figure just to the right of center is a good illustration. Her head, breasts,
abdomen, and one foot are rendered with considerable specificity, but the assembly of
these parts into a figure is made difficult by the second head, as in *Composition with
Black Pouring,* and by the tubular appendage running the length of her left side and
underneath her, reminiscent of the figure at right in *The Key.* A strange half-figure
occupies the extreme left of the field, disrupting the spatial rhythm established by the
other three figures. (These decentering devices vaguely evoke the decentered subject of
Modern Man discourse.) Finally, all the figures have been obscured partially by patches
of nonfigurative lines—principally "scribbled" pourings, sometimes zigzagged, as in
the neck and legs of the figure at right and across the middle of the half-figure at left;
sometimes unsystematic, as in the clot separating the heads of the central figures, and the
markings extending from the mid-section to the bottom of the figure left of center. This

nonfigurative pouring seems to have been applied after the figurative drawing; uncharacteristically, it is confined largely to clearly demarcated areas which have been situated with respect to the figures—between them, over them, and so forth. That the work against figuration should be so largely contained, that it should read in so many instances as explicit crossing out, and that automatic, repetitive gesture should be so fully distinguished from directed, controlled rendering of figures—all these features mark *Number 22A* as an idiosyncratic work, one in which opposition overshadows integration.

In order that the degree of this opposition not be exaggerated, it may be useful to introduce a comparison with a much larger painting from four years earlier by Rothko, entitled *Slow Swirl by the Edge of the Sea* (fig. 78). *Number 22A* resembles *Slow Swirl* in terms of its disposition of figures, but in the Rothko, the extrafigural markings are as delicate and precise as those that compose the figures themselves. By comparison, the extent to which all of the drawing in the Pollock—figurative and nonfigurative— signifies uncontrol, as if some kind of autonomous linear momentum were barely being restrained, is apparent. Contestation remains visible even in the most directed of the drawing. The figures are both part of a linear continuum—an automatic line—and its justification. A balance between figurative presence and allover linear design is effected. Though the veerings away from delineation may be less apparent here and the explosions of erratic gesture more contained, nonetheless, the figures retain a significant measure of automatism, as comparison with *Slow Swirl* indicates.

Triad (1948; fig. 79) tests yet another course for composing and relating figure and field. It is structured by three interlocked, overlapping figurative forms, although two seem joined into a two-headed figure reminiscent of the *Composition with Black Pouring*. A slight figure-ground inversion results from the use of white paint on a black ground; more striking, however, is the fact that all the poured lines, both structural and abstract-patterned, are confined within the strict perimeters of figurative bodies. A few specks and dots of white appear outside these boundaries, remotely suggesting the deep space of a starry sky, but the majority of marks give the impression of having been poured through a stencil, so regular is the figurative boundary they observe. Even gestural, zigzagging lines remain within the implied perimeters. Regular and irregular, erratic gestures are controlled enough to serve the production of distinct, legible figures. The constitution of figures from drawn and patterned marks is, consequently, the principal subject of this work, although the problem of relating figure to ground has not been abandoned. The absence of an outline bounding the figures keeps the separation between figure and ground from completeness; the black ground permeates the interior of the bodies, anchoring them and subverting their autonomy. Still, the fact that line in this picture works exclusively to constitute figures and not to produce simultaneously an encompassing field marks another variation in Pollock's handling of figure-field relations.

Triad's separation of figure and ground and the suggestion of cut-out layering evoked by the implied stenciling relate this work to Pollock's 1948 series of collage experiments. These latter fall into pairings whose members relate to one another as positive and negative variants of a figure-field combination. They were made by excising a figurative form from the surface of a poured painting on paper, and using the removed section, collaged intact to a new ground, as the core of another work. In this way, two reciprocal but distinct sorts of figure-field interactions could be worked on simultaneously.

Cut Out (fig. 80) and *Cut-Out Figure* (fig. 81), both from 1948 (although the former was not completed until 1950 or after), constitute one pair. In *Cut Out*, a flat-headed figure with crudely articulated limbs and torso has been cut from the center of a multi-colored poured field dominated by a network of crisscrossing bright red-orange lines. The figure, once an indistinguishable part of this thicket, has materialized in the very process of being extracted from it. In the delineation and removal of the figure, process becomes metaphor and introduces a narrative element into the work; it becomes the story of a figure engendered in and freed from material bonds—a story, roughly, of birth and some form of deliverance. As part of this narrative the linear network comes to signify containment undermined, as though the figure were literally extricated from bondage. But the figure is not simply an absence in this work, although it has been interpreted this way. Michael Fried's influential reading treats the figure as if it marked an absolute void or "blind spot"; in his words, the figure

> is not seen as an object in the world, or shape on a flat surface—in fact it is not seen as the presence of anything—but rather as the absence, over a particular area, of the visual field.[31]

Read as the negation of material, tactile presence, this figure enables Pollock, in Fried's view, to achieve figuration within a purely optical spatial field.

79. *Jackson Pollock.* Triad. *1948. Oil and enamel on paper, mounted on board, 52 × 65 cm. Collection of Art Enterprises Ltd., a private collection. Photograph courtesy B. C. Holland, Inc., Chicago.*

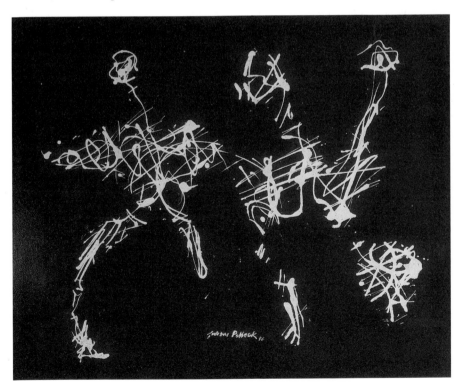

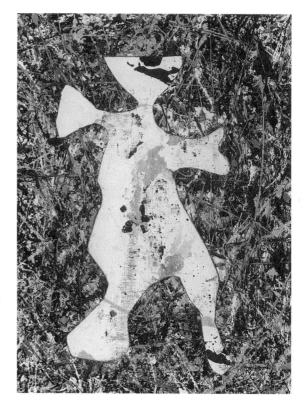

80. Jackson Pollock. Cut Out. *1948–50. Oil on cut-out paper mounted on canvas, 77 × 57 cm. Collection of the Ohara Museum of Art, Kurashiki.*

In the end, the relation between the field and the figure is simply not spatial at all: it is purely and wholly optical: so that the figure created by removing part of the painted field and backing it with canvas-board seems to lie somewhere within our own eyes, as strange as this may sound.

Such a reading might seem to fit the earliest form of this work, before the canvas-board backing had been applied, when the figure was simply a hole in the surface of the picture. Pollock apparently kept the picture in this state for a while; there are studio photographs from 1950 that show *Cut Out* tacked to the wall next to *Number 32, 1950,* witnessing the production of the large-scale, abstract, poured works of that year, such as *Autumn Rhythm* and *One*.[32] Even then the planks of the barn wall showing through lent material presence to the figure; but their persistent legibility as "wall," continuous with the field surrounding the painting, enforced awareness of the absence at the center of the picture. It is possible that Pollock used *Cut Out* in this unbacked form in the production of other works. He made two paintings on paper sometime in late 1948 or early 1949 that echo its figure so closely that some of the pouring could have been done *through Cut Out,* using it as a stencil to guide the paint stream without touching it. JP-CR 3: 783 and JP-CR 3: 785 are virtually identical to *Cut Out* in size and feature its figure at their centers. JP-CR 3: 783 was done in black enamel on white ground; a continuous meandering line, punctuated with spots and blobs, marks off the space occupied by the figure. Two spots fix the eyes. In JP-CR 3: 785, a lost work known only in photographs, the pouring is done in light paint on a dark ground. The figure is filled to a higher density with poured lines, and its eyes are delineated with even greater emphasis and detail. Other forms have been

added to this composition, including a triangular shape to the right of the head which inverts the head's form and functions compositionally like the flower/hand in *Moon Woman* or the second head in *Composition with Black Pouring*. *Cut Out* may have been quite literally instrumental in imparting order and structure to Pollock's pouring in these works. It enabled his line to form figures largely without recourse to conventional techniques of delineating boundaries, contours, or structural elements. In these paintings line merely inhabits or colonizes the field in such a way that a figure is passively described. A strong sense of automatism is preserved within a composed image.

In the end, Pollock decided to cover the hole in *Cut Out*, and he did so with a backing much lighter in tone than the dark barn wood that had served as de facto ground for some time. He mounted the painting on a marked, white canvas-board, so that the silhouette opens onto a white field smeared with patches of orange, green, brown, and dark-blue paint. This mottling gives the figure material "presence" and brings it back into the space of the poured field. Some of the markings, such as the green bands across the figure's ankles, reinscribe the figure in the linear network of the overlaid field and sustain the image of bondage. Restored to the field, the figure's gesture—its left shoulder and arm dropped and left leg outstretched, as if twisting, turning forward or backward within the thicket (the similarity to Vardo's *Lord of Creation* [fig. 7] is striking)—reinforces the suggestion of containment. In other words, the figure in *Cut Out* introduces a dialectic of presence and absence; its extraction from and replacement in the containing field takes the figuration-abstraction dynamic beyond considerations of control and uncontrol, although this aspect certainly persists. More important, the work produces relations of

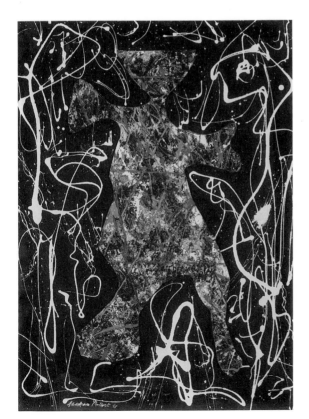

81. Jackson Pollock. Cut-Out Figure. *1948. Oil on cut paper mounted on masonite, 79 × 57 cm. Private collection, Montreal. Photograph courtesy National Gallery of Canada, Ottawa.*

figure and field—the figure detached, alienated from the field, yet ensnared by it—that generate other resonances with Modern Man discourse.

The pendant to this work, *Cut-Out Figure,* is structured upon a related figure-field dynamic. The figure from *Cut Out* has been affixed to the center of a dark ground virtually identical in size to the sheet of which the figure was originally part. The pourings and markings the form acquired as part of the field of *Cut Out* apparently have not been changed; conspicuous still are the bright red-orange lines crossing the body at all angles. The field surrounding the figure has been marked with white linear pourings which blanket the field overall in a uniform density. The pours fill every area of the ground, venturing into all the varied peninsulas formed by the appendages of the figure; but the lines always stop right at the pronounced edge of the figure. With one or two minor possible exceptions, the pours do not violate the perimeter of the collaged figure. In this way, and in the parallel oppositions between multicolor-monochrome and collaged-painted, disjunction between figure and ground is reinforced while integration and containment of the former by the latter is effected.

Another wrinkle is added to the figure-field dynamic in *Cut-Out Figure* by the fact that the heaviest pours on both sides of the painting delineate figures—standing figures turned inward to face the collaged humanoid. Once recognized, these poured figures structure the composition in such a way that it recalls the now familiar pattern of sentinels flanking a centered motif, as in *Guardians of the Secret* and *The Key.* Here the figures are formed entirely from poured lines, whose automatic momentum has been controlled only enough to describe legible body fragments and an overall figurative configuration as well as to accentuate key components of the anatomy by thickening the line. The figures, consequently, emerge subtly from the seemingly abstract scribble, establishing the presence of some measure of control, if not intentionality, in the seemingly uncontrolled markings. By comparison, the linear network within the collaged figure becomes striking for the absence of an organizing principle structuring it; the dialectic of control and uncontrol becomes superimposed on a dialectic of interior and exterior—another mark of congruence with Modern Man discourse.

The collaged figure, then, is doubly engaged with the lines that surround it: in one sense it is immersed or entangled in them, in another it participates in an interaction with them as figures. An exchange of attention or gesture seems to take place between the figures, pulling the collaged figure more fully into the space of the painting. Even in this form of engagement, however, the integration remains partial at best; the differences and separations between collaged and painted elements are too striking to be overlooked. Space as a result becomes highly dislocated, marked by intense figure-ground vacillation: the collaged figure alternately lurches forward and is drawn back depending on whether recognition of the poured figures is grasped or suspended.

From this juxtaposition of Pollock's two preferred methods for producing figuration within fields of automatist gestural abstraction emerges a powerful symbolization for dialectics of alienation and entrapment, interiority and exteriority, control and uncontrol. Oddly, this complex and fascinating work has been overlooked in the Pollock literature and excluded from the canon; that so revealing a picture can be easily dismissed as idiosyncratic and experimental and its significant allusions backwards and forwards in Pollock's oeuvre unnoticed is a sign that the parameters of the dominant accounts have

been too narrowly drawn. If, for example, line has been freed from its traditional function of bounding forms in this work, it also has not been so liberated. Linear contour, cut and drawn, carries considerable weight in this picture; the emphasis and attention drawn to it indicate that it was neither peripheral nor extraneous to Pollock's pictorial interests at this time.

Another pair of works from 1948 was generated by the same excision-collage process—*Untitled* (*Rhythmical Dance*, JP-CR 4: 1032; fig. 82) and *Untitled* (JP-CR 4: 1033; fig. 83)—but with some noteworthy variations. In this pair, the figures are smaller and decentered; furthermore, their limbs and torsos have been so attenuated that they merge harmoniously with the poured linear fields, almost as if they were simply aggregates of especially heavy pours. Their forms are evocative of Picasso's Surrealist bathers of about twenty years earlier; as with those prototypes, and partly as a result of invoking them, their gestures can be read as expressing both exasperation and play. The disruption of the physical surface of *Rhythmical Dance* by the excision of the two figures is mitigated by the striking material irregularity of the poured field. The paints Pollock used here ranged widely in viscosity, so that some lines stand in high relief while others are flat splashes; in the midst of so much tactile variation, the cut edges of the figures are less conspicuous. While the field has greater materiality and power of containment, the suggestion of the figures' containment is reduced. The smooth, subtly variegated dark backing that fills the space of the figures gives them a distinct but immaterial presence; whatever alienation or bondage within the material field might be suggested by this difference or by the overweighed gestures of the figures is counterbalanced by the decorative and harmonious disposition of the figures in the field.

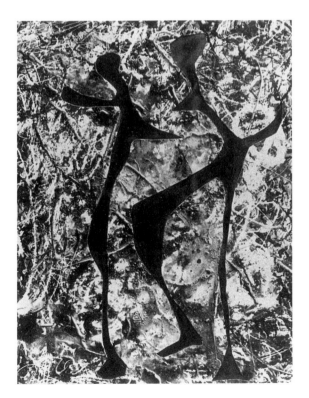

82. Jackson Pollock. Untitled ([Rhythmical Dance], JP-CR 4:1032). *1948. Oil on cut-out paper, 81 × 61 cm. Location unknown.* © *1992 The Pollock-Krasner Foundation/ARS, New York.*

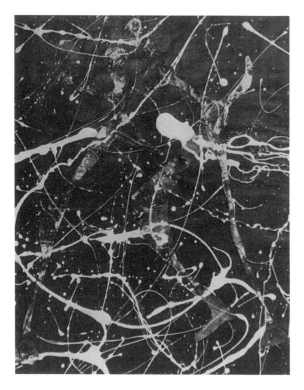

83. Jackson Pollock. Untitled (JP-CR 4:1033). *1948. Paint and cut-out paper on masonite, 79 × 58 cm. Private collection. © 1992 The Pollock-Krasner Foundation/ARS, New York.*

In the untitled pendant, however, the effect is quite different. One reason for the difference is that the collaged figures have been positioned differently on the ground. The figure at left here leans inward toward the center of the composition; the figure at right has been rotated slightly counterclockwise. As a result the figures appear much more unstable, and their gestures now indicate urgency or struggle (regardless of which of the upper appendages of the figure at right the viewer takes to be the head—a now-familiar Pollock ambiguity). Another difference from *Rhythmical Dance* is the fact that the figures literally have been enmeshed by the poured field. In contrast with *Cut-Out Figure*, the pourings that constitute the painted field here pass over the collaged figures. The trajectories of the pours are largely undetermined and uninterrupted by the figures they contain, although in some areas the figures apparently are ensnared by the paint swirls; for example, one loop centers on a leg of the figure at right, as if to encircle it. With elements embedded in the poured web and positioned as if suspended or restrained, metaphors of entrapment and entanglement proliferate. Moreover, in this painting the dialectic of interior-exterior is tuned to high pitch; the network of pourings that is the collaged figures is played against the network that is the encompassing field. Within and without, the figure is constituted and immersed in fields in which control and uncontrol, order and disorder do battle. Modern man is figured with remarkable fullness.

Another painting from this time, known as *Shadows: Number 2, 1948* (JP-CR 4: 1034; fig. 84), combines features of both *Rhythmical Dance* and its untitled pendant. Greenberg singled out this picture in his review of Pollock's 1949 exhibition at Parsons', noting that it ("the one with the black cut-out shapes . . . that hung next to [Number One]") was one of a group of pictures in the show that justified "the claim that Pollock is one of the major painters of our time."[33] Subsequent inaccessibility has kept this painting

from taking its proper place in Pollock studies. When the Pollock *Catalogue Raisonné* was compiled in 1978, the authors were unable to ascertain the exact medium of this picture (see O'Connor and Thaw); photographs do not permit us to distinguish whether the three black silhouetted figures have been excised from the poured field or collaged onto it. The painting is now, more than twenty years later, locked in a Swiss bank vault, still unavailable for examination. What photography reveals is that the field is underpainted in light colors—mint green, lemon yellow, violets, and earth tones—applied by brush in irregular patches. Upon this light, decorative, variegated ground is a web of poured, glossy, black paint, probably enamel. The black pouring varies widely in thickness and regularity of the line, but it covers the field, including the figures, more or less evenly. The figures, again strongly reminiscent of Picasso or Miró, are solid black, either on or behind the painted field. Two of them are posed as if walking from left to right across the field; the central figure is clearly marked as male, the right figure as female. Because the figures are black, the contrast with the black pouring is slight, principally a matter of difference in gloss and tone. Partly for this reason, the picture appears at first to resemble *Rhythmical Dance* very closely. Continuity between silhouetted forms and pourings is established even more explicitly in *Shadows;* a large pool of black paint in the lower left corner is hard to distinguish from the feet of the figure at left; heavy lines and puddles throughout the painting blend indistinguishably with the extremely attenuated elements of the figures. Other features, however, align *Shadows* with the untitled work JP-CR 4: 1033: the lack of surface materiality, for example, and especially the ensnaring of the figures within the painted web.

By far the largest and most complex work in this category is *Out of the Web: Number 7, 1949* (fig. 70), a work whose title makes explicit the motif I have begun to trace. After

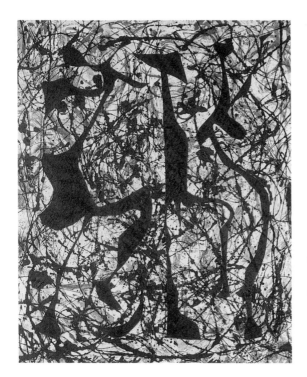

84. Jackson Pollock. Shadows: Number 2, 1948. *Medium uncertain, 137 × 112 cm. Private collection, Lausanne.*

the application of paint was completed, as described in some detail above, Pollock used a knife or razor blade to incise shapes into the masonite surface; then, with a chisel, he removed the surface within the incised boundaries. The process of removal was violent and labor-intensive; it is often misdescribed as a matter of "peeling off" the paint layer. The evidence of the surface is rather that extraction involved gouging and hacking; the exposed masonite is deeply scarred from the violent labor of removing the figures. The process was obviously slow and laborious, or at least it was made to look so. Much of the scraping was done with the side of the chisel, leaving deep ridges and occasionally revealing at the edges of the forms a neat cross section of the paint layers. In some forms, bits of the original surface have been left, as if too resistant to be overcome. Elsewhere the masonite is white or brown: where the scraping is shallow, traces of the white ground and even some surface color remain visible; where the gouging is deep, only the brown matter of the masonite panel is exposed. Some of the cut-out figures are completely discrete, while others have an open side that allows the painted field to bleed in. Liberation from the surface web apparently has entailed some costs to the integrity of the figures. The difficulty of extraction has been made part of the message of the surface.

One figure, at the middle right, evokes Picasso's squatting demoiselle d'Avignon; her back is turned toward the viewer and, in Pollock's version, her foot points improbably inward. The two large figures at the left are strongly Miróesque—one humanoid, the other biomorphic. The figure at the right of the picture seems to be running or falling toward the left. The contours of these forms are generally elegant and fluid; they produce a rhythmic, even balletic formal movement proceeding from right to left. This formal elegance in the drawing of the figures, dominant when the painting is viewed from a distance, contrasts sharply with the tortured facture visible at close range. Proximity and separation provide partial and contradictory readings, and through the disparity, the picture unites the harmonious grace of *Rhythmical Dance* with the disjunctive figure-field relations of *Cut Out*. As I noted above with regard to surface and composition, rupture and unity are made to coincide in this painting. Fried's preference for *Out of the Web* over *Cut Out* on the grounds that the tonal harmony of figure and field yields a more unified and allover composition assumes a distant viewing position. Here, as so often in modernist formal analysis of Pollock's work, a disembodied, idealized "optical" image takes absolute priority over the dense and often resistant material object.

Web imagery is present at many levels in the picture—in the texture of the masonite, highlighted in some areas by the drag of a dry brush across it; in the gray crosshatchings brushed into the wet surface; in the overall tangle of poured lines that dominates the field. At each level, metaphors of containment and release are effected by the carved-out figures. What makes this work different from all the examples I have described until now is the prominent staging given to labor and violence in the process of extraction; the destructive and deconstructive aspects of the effort to combine figure and field in the cut and collaged works are insistently demonstrated here. As a result, the artist's presence and role in the production of the image are highlighted and take on new significances. Pollock is revealed as producer of both delicate and violent gestures: in the first stage, a process of controlling the uncontrolled, he generates the dense, entangling web that is the painted field; then he constitutes figures within that web through a traditional process of (automatic) drawing with a nontraditional tool—a knife; and finally, he liberates those

figures through vigorous cutting and hacking. The process allows plenty of room to indulge and signify Pollock's control and uncontrol as both artist and subject. In consequence, the painting operates as both index and icon of modern man: as *trace of his activity*, enactment of internal division and conflict in the oppositions between control and uncontrol, figuration and abstraction, addition and subtraction, unity and rupture, delicacy and violence, entanglement and liberation; and simultaneously as *self-image*, self-portrait as inhabitant of a labyrinthine web, a self whose violent and laborious constitution and liberation can be no more than imperfect given the self's permeation by the web. Extraction has left a battered and scarred shadow, half in and half out, with residue of the internal web visible throughout.

The discussion of this series of cut or pasted figurative works has precipitated a progression from analysis of dynamics of control and uncontrol to readings of metaphor. These paintings render explicit certain metaphorical implications of the poured, abstract fields, implications that often have been recognized and articulated in contemporary and subsequent critical writings on even the nonfigurative poured paintings. Sometimes the most resolutely formalist of that criticism is the most thoroughly laced with metaphorical language of web, tangle, labyrinth, and so on. The presence and operation of this metaphor in the criticism of the abstract poured works will be taken up in the next section of this chapter. It will have implications for any attempt to draw boundaries between figuration and abstraction in Pollock's painting. But before proceeding to that discussion, I want to bring to a provisional conclusion this extended consideration of the relation of figuration/abstraction dynamics in Pollock's oeuvre to Modern Man discourse.

I will close this section by looking back to *Number 7, 1951* (fig. 72), the picture described above as revealing with unusual clarity Pollock's precise control of his pouring technique. With this painting, we move chronologically into the period of the black pourings, during and after which figuration remained a continual and overt presence in Pollock's work. As I pointed out above, Pollock explicitly stated his intention that the black pourings would make his control and mastery more evident: in terms both of the careful drawing with line and the design of complex figurative compositions, Pollock hoped "the kids who think it simple to splash a Pollock out" would learn a thing or two from this work. To assert his mastery, facing squarely *Time* magazine's charges of "chaos" and "absolute lack of harmony and structure," Pollock turned to figuration. Even within this context, *Number 7* stands out for the degree of precision and control evident in its line; yet, the figure it yields is no academic life study.

In delineating the figure, the poured line in *Number 7* is precise and economical in some areas but generally refuses to stick to contours. Typically, the lines give part of a contour and then break away to do something abstract and willful. For example, the line that makes the hairline and eyebrows doubles back across the middle of the cheek and descends through the middle of the torso. Its descent mirrors that of a line extruding from the figure's right ear and forming part of the contour of the face before it too descends through the torso, between the two overly separated breasts. One of these breasts is formed by a line that begins by bisecting the face, passes through the pools that form the nose, mouth, and chin, then darts at a right angle to the left to form a schematic jaw and shoulder, and ends (across a slight gap) by circling back upon itself to form breast and

nipple. Line shows itself to be capable of elegant and economical figuration, but these interests are tempered by simultaneous pursuit of fluidity, spontaneity, and automatism. The lines forming the figure's legs are somewhat less unruly. They render legs as a set of interlocking arcs and geometric shapes, evoking the limbs of Boccioni's sculpted *Unique Forms of Continuity in Space* (1913). Other strong lines structuring the figure have a referential function so ambiguous or obscure that they blend into the sequence of verticals spilling in from the left side of the painting. Line moves freely between reference and nonreference, or hovers at the edge of referentiality. Yet overall, control dominates, to the detriment of the balance that activates Pollock's most interesting work. The minimization of effects of automatism for purposes of figurative drawing and patterning tips the scale toward control. In place of the acute tension between order and disorder that often distinguishes Pollock's work, we are given elegance and virtuosity, and the mastery they imply. The tension is resolved in the bisection of the canvas, with a separate sphere of dominance available to each component. *Portrait and a Dream* of 1953 (fig. 29) takes this option a step further, replacing interdependence with juxtaposition.

Figuration—be it overt or covert, isolated or integrated, veiled, buried, upright, sideways, or upside down—is present throughout Pollock's work. The possibilities and varieties of linear referentiality are thoroughly explored in his paintings. Palpable or elusive, this figurative tendency is neither simply playful nor gratuitous; it has a prominent part both in dynamics of control and uncontrol and in producing metaphors in the work. These effects can be achieved even when figuration is seemingly absent or concealed; suspicion or putative discovery of depictive elements in the image can lead interpretation in this direction. For example, *Number 26A, 1948* (fig. 85) is apparently fully abstract, although inevitably, given the generally irregular and unsystematic character of the markings, it provokes in the viewer recognition of depictive fragments throughout its surface. This irrepressible emergence of recognizable forms—as much a function of suggestive configurations of lines as of the Rorschach effect—leads one to discover in the painting or impute to it ordering movements, direction, and conscious or unconscious intentionality. One locates areas where the gesture is marked by repetition or patterning, where, for example, gestural tendencies toward centrifugality produce spiraling forms evocative of eyes, breasts, vortexes. The viewer wonders whether these fragments are distinct pictorial incidents or projections. In either case, order is emerging within apparent disorder, and the linear network is becoming a web in which all manner of fragments are ensnared. Such tendencies could be limited, of course; one possibility was to liquefy the pours, producing splashes and spills to flatten the lines, as in *Number 27, 1950* and *Lavender Mist*. Figuration and metaphor could be contained, but on the whole, Pollock seems to have preferred to indulge them.

One of the paintings that both Fried and Rubin acknowledge as containing figuration is *The Wooden Horse: Number 10A, 1948*. While the wooden horse-head collage is one site of figuration, another is the head and shoulders Rubin notes at the right of the picture.[34] But when the painting is turned on its side, in the orientation recorded in several portraits of Pollock taken by Hans Namuth around 1949–50 (see, e.g., fig. 86), where the painting leans against the barn door or wall, the composition resolves into a fully figurative work, marked by the characteristic, decentering, doubled head (here, raised arm/smaller head to the right of the principal head), and by the posture of the

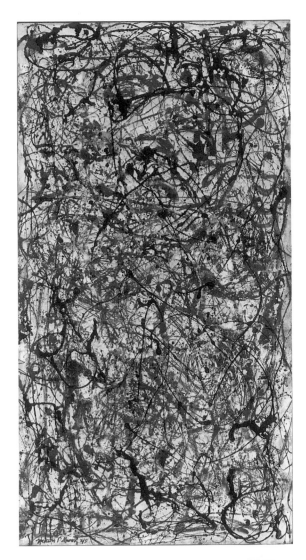

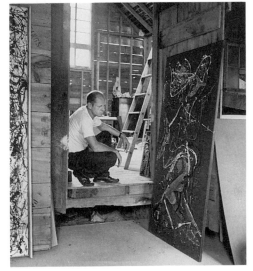

85. Jackson Pollock. Number 26A, 1948. *Enamel on canvas, 208 × 122 cm. Collection of the Musée National d'Art Moderne, Centre Georges Pompidou, Paris.*

86. Hans Namuth. Jackson Pollock with Wooden Horse. *1950. Photograph. © Hans Namuth 1991.*

figure, so evocative of an earlier psychoanalytic drawing of a woman (fig. 57). The figure, in other words, could be "veiled" in many ways, and still something of the control or direction imparted to the genetically figurative line might come through, tempering the apparent automatism.

SPACE

The spatial illusion engendered in Pollock's poured paintings has been the subject of much description and commentary since the works were first exhibited. It has always been seen as unusual and complex and frequently has been hailed as a principal feature of his achievement. Even largely unsympathetic reviewers sometimes found the spatial effects of the paintings redeeming.[35] In the attempt to describe the spatial sensation of standing before a Pollock painting, critics and commentators have gone to great lengths and conjured a wide range of analogies and metaphors; a few, however, recur with remarkable consistency.

Web, labyrinth, maze, vortex: these are among the metaphors most commonly invoked by the critics, curators, and historians writing about Pollock's poured paintings. What is meant by the terms is in no sense obvious: in some contexts they are meant to suggest that the space of the pictures is shallow; at other times, deep. Over time the ubiquitousness of these tropes in the Pollock literature has rendered them transparent; they now seem neutral, obvious choices, convenient when efforts at fresh description flounder or grow tedious. My argument in this section will be that these metaphors are not transparent, neutral, or innocent at all. They carry considerable weight in the story of Pollock's reception and interpretation, and they are indispensable to an understanding of the cultural force that his painting acquired. Moreover, by virtue of both their conjunction and the specific colorings they acquired in 1940s U.S. culture, these metaphors document the linkage between Pollock's art and Modern Man discourse.

Pollock's first exhibition of poured paintings, in January 1948 at Betty Parsons Gallery, featured works whose subtle and complex spatial effects were reinforced by titles strongly evocative of distinct spatial experiences. The titles *Comet, Shooting Star,* and *Reflection of the Big Dipper* (as well as *Galaxy,* designating a painting that was not in the show) conjured the infinite space of the night sky; *Phosphorescence, Full Fathom Five, Watery Paths,* and *Sea Change* invoked the mysterious depths of the ocean. Both these sets of titles position the viewer in a disorienting relation to the picture plane. In looking into the painting one imagines looking up or down; in the ordinary perception of sky and sea, the viewer's own body would usually be aligned with the axis of recession, rather than perpendicular to it. However, in these paintings the spatial axis normally experienced as vertical has been turned to the horizontal.[36] Other titles in the exhibition offered a more familiar spatial orientation. *Enchanted Forest,* for example, presents its lines as branches, stalks, and tangles of vines defining the space of the deep forest; the title suggests that the space of this picture is a soothing counterpoint to the vertiginous depths and heights of the others. There is ominousness, too, evoked in some of the titles and imagery: *Unfounded,* for example, with its suggestion that no fixity, spatial or otherwise, is to be found in this work; or *Vortex,* which is part of a group of three pictures (the others are *Prism* and *Nest*), all of which contain dominant central spiral forms. In

Vortex (fig. 87) space becomes explicitly threatening and dangerous to the viewer; small though the picture is, to approach it is to risk loss of orientation and stability. In chapter 3 I proposed reading the space of *Vortex* as metaphor for the unconscious—a whirling rush of energy threatening to swallow the viewer who peers in too closely. While I want to keep that suggestion in play, it will be important to overlay that reading with others— acknowledging that the painting's metaphors and dangers are not simple or fixed.

The spatial cues Pollock provided in these early titles were taken up by his reviewers. An anonymous *Art News* reviewer of the 1948 exhibition cited the "beautiful astronomical effects" created by the pictures. Even after the evocative titles had been dropped in favor of numbers, the associations suggested in the first exhibition continued to appear in reviews and essays. Thomas Hess was reminded of "winter fields crisscrossed by wire fences; of tufts of grass blowing along wide Long Island beaches; of submarine life barely moving on the floor of a frozen, translucent pond. Landscape is

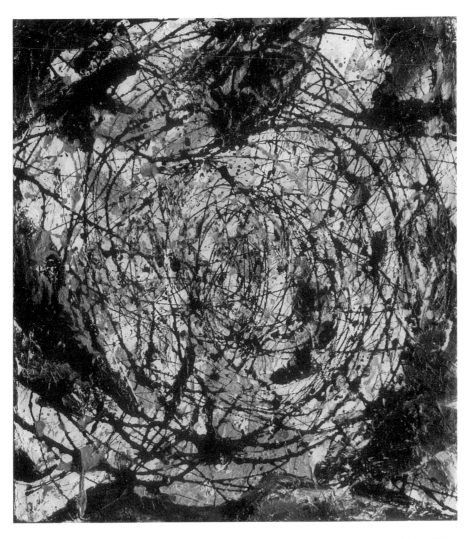

87. Jackson Pollock. Vortex. *1947. Oil on canvas, 52 × 46 cm. Private collection.*

interior, not in the sense of within mind or body, but as inside a dark forest on an August day, or inside a lake, or pastures seen while lying flat on one's stomach."[37] James Fitzsimmons noted that in one picture he found "heavy black lines rolling with the slow surge of the sea, or thrashing about like the tails of giant fish in an expanse of white foam."[38] Parker Tyler, writing in 1950, found that "Pollock's paint flies through space like the elongating bodies of comets"; we look at the pictures "in exactly the way that we look at the heavens with their invisible labyrinths of movement provided in cosmic time by the revolutions of the stars and the infinity of universes."[39] Five years later, Tyler still found the heavens an apt metaphor; the forms, he wrote, recalled "telescopic images of nebular universes."[40] *Life* magazine advised its readers that Pollock's painting "suggests to some the mazy sweep of the Milky Way."[41] A published description of Kandinsky's space was applied by Dore Ashton to Pollock's work: "Like interstellar space, reference is only to extremely distant points, conceived in terms of movement."[42] Sam Hunter too was reminded by Pollock's drip paintings of the sublime effects of space in nature. "For me they arouse rather primitive, lyrical feelings associated with such majestic and sonorous phrases as 'the deep' or 'the starry firmament.' "[43] He went on in another essay to suggest a link between these natural spatial associations and the condition of modern man. As he saw it, Pollock's art marked a break from the

> closed and intelligible universe of post-Renaissance art where man cut space to his own measure. It belonged rather to the vast free spaces of modern science and, in pictorial metaphor, showed the limits of the modern individual's rational powers by opening up glimpses of a nature essentially irrational and chaotic.[44]

For Hunter, modern man's perception of nature was characterized by its attention to nature's infinite and incomprehensible aspects, and Pollock's art spoke to that perception.

Even more common in the writing on Pollock's work than invocations of cosmic depth is allusion to a particular natural form with strong metaphorical overtones: the web. The figure *web* had a distinct formal advantage over sky and sea in its ability to combine the articulation of a plane with a view through to space beyond. The earliest critical uses of this image predate Pollock's own in the title of *Out of the Web,* first exhibited in late 1949.[45] The *New York Times* was a prominent early source of web metaphors in writing about Pollock. An anonymous reviewer's reference to "webs of very white ash with tar" in January 1948 was among the earliest.[46] The next year, Sam Hunter wrote of Pollock's "curiously webbed linear variations . . . (which visually are like agitated coils of barbed wire)."[47] Stuart Preston continued the campaign, writing of Pollock's "dense web of paint that weaves back and forth" and the "spider web of black" in *Number 23.*[48] After the 1949 exhibition, *Art News* and *Art Digest* took up the web metaphor: Amy Robinson perceived "tightly woven webs of paint . . . woven layers of different colored lines," while for Belle Krasne, they were "immensely complicated webs."[49] In a review of the 1951 exhibition of black pourings, James Fitzsimmons discerned that "now, from the webs and snares of black, faces and figures in ever changing combinations emerge, sometimes distinctly, sometimes only by suggestion."[50] And Dore Ashton suggested that the spectator can assume the position of the spider deep within the web:

> One can, like a spider, sit at the heart of the structure, and, behind the foreground, remain sheltered in the interior of the great web.[51]

In the latter two descriptions, another advantage of the web metaphor has begun to become explicit: the web's function—its capacity to ensnare and hold a victim—also resonates with Pollock's work. A web's ability to contain living creatures, who may flail about in it without effect, chimes with the relation between figurative forms and encompassing abstract linear field that viewers observed in the work of Pollock. Whether the ensnaring capacity of the web was explicitly invoked in a particular critical use of the metaphor or not, it was ineradicable subliminally and subtextually. Finally, what made the web an especially apt and common metaphor in the Pollock literature was its definitive fusion of delicate beauty and danger.

The viability of the web motif for Pollock depended upon its remaining an elusive suggestion, avoiding the fixed legibility of illustration. Only by maintaining the evanescence and indeterminacy that permitted painter, viewer, and depicted figure simultaneously to occupy the space of web and situated the web/field in the terrain of unconscious or cosmic space could the paintings sustain the thematic syntheses that underpinned their cultural force. Some of the sculpture associated with Abstract Expressionism indicates the dangers of invoking metaphor too literally. That this art, with the possible exception of David Smith's work, has proven resistant to integration into the history of the New York School no doubt has much to do with the inhospitability of cast-metal sculpture to spontaneous facture and other characteristic aspects of Abstract Expressionist aesthetics. But the critical and cultural devaluation of the sculpture may be also a function of its failure to read as expressive enactment or equivalent—rather than illustration—of psychic or cosmic conflict. Seymour Lipton's *Imprisoned Figure* of 1948 (fig. 88), for example, presents a figure contained within a surrounding network of lines suggestive of web and cage. Its formal closure is too complete and its handling of the motif too obviously rational to engage and represent the more complex subjectivity inscribed in Pollock's web imagery.

The utility for Pollock's critics of the ominous, threatening aspect of the web metaphor was exemplified in the preceding section of this chapter: it figured prominently in my own description of the figuration/abstraction dynamic in Pollock's work, culminating in *Out of the Web*, where the violent, laborious extraction of the figures from the painted surface was read as marking the difficulty of disentanglement. Also, in the discussion of *There Were Seven in Eight*, I quoted some recent critical language that remarked upon the "weblike formation of its image" and noted that "Pollock's formerly recognizable imagery has somehow become ensnared."[52] There were other levels as well at which ensnarement occurred in Pollock's work. In some of the abstract paintings, the linear network's capacity to ensnare was realized on a material level: it held captive an array of three-dimensional objects embedded in the paint surface: cigarettes, nails, stones, paint-tube caps, insects. In other abstract works, handprints and footprints mark the presence of the artist in the web, a condition Pollock repeatedly underscored in his public statements about being "in" his paintings. There are overtones of his own ensnarement in such language.

Even when applied to the nonfigurative paintings, and even when a purely formal resemblance seems to have been the conscious motivation for the choice, the web metaphor is too complex and unruly to submit to such limitations. I will go on to argue that for critics writing in the 1940s and early 1950s, the image of the web was a highly

88. Seymour Lipton. Imprisoned Figure. *1948. Wood and sheet-lead construction, 215 × 78 × 60 cm. Collection of the Museum of Modern Art, New York: gift of the artist.*

charged one, one that could not be contained by formal analysis but necessarily spilled over into Modern Man discourse, carrying Pollock's paintings along. For later critics, writing after the web had begun to lose its privileged status in U.S. cultural discourses, the web image remained unmanageable and resisted purely formal circumscription. In the writing of the modernist critics, for example, the unruliness of the web metaphor often destabilizes the text, undermining the claims being developed. To quote Greenberg, for example:

> The interstitial spots and areas left by Pollock's webs of paint answer Picasso's and Braque's original facet-planes, and create an analogously ambiguous illusion of shallow depth. This is played off, however, against a far more emphatic surface, and Pollock can open and close his webs with much greater freedom because they do not have to follow a model in nature.[53]

Greenberg's language insistently invokes a natural model for Pollock's composition, only to revoke it at the end. There is also William Rubin's assertion that "[Pollock's] linear webs were, in the radical nature of their all-over drawing, incompatible with literal representation."[54] At certain points these essays rely so heavily upon the figure of the web that its supraformal aspects refuse to be suppressed.[55]

Another image common in the Pollock literature is that of labyrinth or maze. It was encountered above, blended with the starry firmament motif, in Tyler's "invisible labyrinths" of the heaves and *Life*'s "mazy sweep of the Milky Way." *Life*'s corporate partner, *Time,* also invoked the image: "Laymen wonder what to look for in the labyrinths which

Pollock achieves by dripping paint onto canvases laid flat on the floor." The accompanying photo of Pollock in action was captioned "At one extremity, labyrinths."[56] Alfred Barr had used the labyrinth image a few months earlier, when he portrayed Pollock as "weaving the thin stream of color into a rhythmic, variegated labyrinth."[57] For Dore Ashton, maze and labyrinth blended with web in Pollock's work; in her description the spectator was led into Pollock's paintings as if into a maze. "The labyrinth of lines, crossing and recrossing, occupies a narrow space, defined laterally. The spectator enters it and, led through the magical maze of the web, follows the chance succession of lines."[58] Sam Hunter too read the structure of the pictures as a maze. His retrospective explanation of Pollock's transition from the symbolic figurative compositions of the early and middle 1940s to the poured works utilized an extraordinarily literal rendition of the maze motif:

> Like Daedalus he had built a maze for the terrible minotaur and then found himself imprisoned in it himself. Then like Daedalus he levitated out of the maze. To complete the metaphor, Pollock carried the maze with him on his lofty flight, the pure structure of the maze minus its minotaur.[59]

The passage may lack coherence, and as a picture of Pollock's development it is certainly peculiar; nonetheless, its imagery is provocative. For Hunter, the capacity to imprison seemingly falls away as the maze is transported; metamorphosed, it becomes a pure form that has absorbed and dissipated the anxiety it was devised to contain. Purged of its demons, the maze becomes an essentially formal vehicle for "calm and measured lyricism." In this respect Hunter disagreed with his former colleague at the *Times*, Howard Devree. Devree saw the 1951 exhibition of the black pourings as revealing the capacity of Pollock's poured mazes or webs to imprison or enmesh all manner of horrific personages. In Devree's view the mazes retained their powers. His language is apocalyptic: Pollock was now "turning the automatic emotional mazes into nightmarish expressionist visions as of half-glimpsed and enmeshed witches sabbath, black mass and unholy groups of doomsday aspect."[60] The demons were back, ensnared and imprisoned.

One of the earliest and most sustained treatments of the labyrinth metaphor is an article by Parker Tyler titled "Jackson Pollock: The Infinite Labyrinth," published in the *Magazine of Art* in March 1950. Tyler was a poet and writer associated with the Surrealists in New York; he was a founding editor of *View* magazine, one of the two principal organs of Surrealism—and by far the longer-lived one—in the United States.[61] His interest in the labyrinth motif should be recognized as originating in Surrealist aesthetics, which embraced the myth of Theseus and the minotaur as a metaphor of mind. The minotaur was the strange, bestial core of the mental labyrinth; Theseus's journey to that center and ultimate reemergence symbolized the process by which the consciousness achieved self-knowledge. The story was invoked frequently in visual and literary works by Surrealist artists and authors in the 1930s and 40s, and as a further mark of its centrality to Surrealist aesthetics, it supplied the titles for the leading European Surrealist journals. Masson and Bataille suggested the title for *Minotaur,* the Surrealist artistic and literary journal published in Paris between 1933 and 1939; after the occupation, it was succeeded by the Geneva-based *Labyrinthe.* Masson, Picasso, and other Surrealist artists made numerous paintings on the subjects of the Labyrinth and the Minotaur. (In 1940 Pollock's analyst Henderson wrote a brief appreciation of Picasso's art for the *APC-*

NY Bulletin and titled it "The Minotaur.") In 1946 Willem de Kooning painted a large curtain backdrop titled *Labyrinth* for a Surrealist dance performance with the same title by Marie Marchowsky; the dance featured a dreamer pitched between characters representing the Wish, the Repressor, and the Mediator.[62] No doubt Tyler was intimately familiar with the various Surrealist glosses and significances attached to the myth of the minotaur, although his own use of the labyrinth metaphor in writing about Pollock is far removed from the myth and appears eccentric by Surrealist standards.

Tyler's article characterizes Pollock's paintings in terms of a number of paradoxes, one of which is that "any system of meaning successfully applied to [the paintings] would at the same time not apply, for it would fail to exhaust their inherent meaning." In spite of this insight, Tyler proposes to try the labyrinth metaphor. Another paradox is immediately revealed: these paintings are labyrinths without exits. Tyler opens this argument by defining the word *labyrinth* as signifying "an arbitrary sequence of directions designed, through the presentation of many alternatives of movement, to mislead and imprison." If Pollock's paintings were described as labyrinths, he suggests,

> the most unprepared spectator would immediately grasp the sense of the identification. But a labyrinth, from that of Dedalus in the myth of the Minotaur to some childish affair in a comic supplement, is a logically devised system of deception to which the creator alone has the immediate key, and which others can solve only through experiment. But even if the creator of these paintings could be assumed to have plotted his fantastic graphs, the most casual look at the more complex works would make it evident that solution is impossible because of so much superimposition. Thus we have a deliberate disorder of hypothetical hidden orders, or "multiple labyrinths." (P. 92)

The opposition of order and disorder in this art—a disorder of orders, an effort to compose "the seemingly uncomposable," and so on—is another of Tyler's thematic paradoxes. But to stay with the labyrinth image, in the world of Pollock's complex, multilayered, liquid threads, "the color of Ariadne's affords no adequate clue." This does not mean, however, that the spectator is doomed to wander eternally in Pollock's maze, because just as there is no exit, there is no entrance. Tyler, surprisingly, does not make anything of Pollock's painting process, or of the more literally labyrinthine aspect the paintings might have had while laid out flat on the studio floor, or of the artist's statements about being "in" the painting, or of the presence of fragments of figures in the pourings. In Tyler's reading, Pollock's labyrinths are

> to be observed from the outside, all at once, as a mere spectacle of intertwined paths. . . . The intelligence must halt with a start on the threshold of Pollock's rectangularly bounded visions, as though brought up before a window outside which there is an absolute space, one inhabited only by the curving multicolored skeins of Pollock's paint. A Pollock labyrinth is one which has no main exit any more than it has a main entrance, for every movement is automatically a liberation—simultaneously entrance and exit. So the painter's labyrinthine imagery does not challenge to a "solution," the triumph of a physical passage guided by the eye into and out of spatial forms. The spectator does not project himself, however theoretically, into these works; he recoils from them, but somehow does not leave their presence: he clings to them as though to life, as though to a wall on which he hangs with his eyes. (P. 93)

That last image—the spectator suspended by his eyes from the picture, hanging on for life—is arguably more precarious and tragic than being lost in a maze with no exit.

The urgency of the attachment of viewer to picture was clarified a little in a long

passage edited from the published essay.[63] Tyler was unhappy about this deletion— justly so, since the deleted paragraphs, obscure though they may be, contained the climax of his argument. In them, Tyler argued that Pollock's paintings, largely by virtue of their handling of space, go beyond optical effect to cosmic metaphor. "The spatial distinctions achieved by lines and spots of color within Pollock's rectangles go as much beyond mere optical vision as seems possible to painting." Pollock's paintings become "a conception of ultimate time and space, the labyrinth of infinity . . . an absolute being which must contain death as well as life. . . . Jackson Pollock has put the concept of the labyrinth at an infinite and unreachable distance, a distance beyond the stars—a non-human distance." That paintings—manmade objects—can represent this suprahuman realm is another paradox.

> For how can what is man-made be "non-human"? The spectator does not experience vertigo before these works, where he is as surely anchored as though he were in front of St. Peter's in Rome or gazing at Radio City from the top of the Chrysler Building. If one felt vertigo before Pollock's differentiations of space, then truly one would be lost in the abyss of an endless definition of being. One would be enclosed, trapped by the labyrinth of the picture-space. But we are safely looking at it, seeing it steadily and seeing it whole, from a point outside. Only *man*, in his paradoxical role of the *superman*, can achieve such a feat of absolute contemplation: the sight of an image of space *in which he does not exist.* [All emphasis is Tyler's.]

One can sympathize with Robert Goldwater, the editor of *Magazine of Art,* struggling to make sense of the labyrinthine turns of Tyler's paragraphs and deciding, ultimately, to drop them. For Tyler, the vertigo one might feel before a Pollock painting is no more than that of looking at Radio City from the top of the Chrysler Building (which could be considerable). For his works to become involved in such sensational effects would limit his achievement. His paintings do not engulf the spectator; they resist reversion to traditional devices, such as linear perspective, for leading the viewer into the picture and thus confining the painting within the realm of "optical vision." In Tyler's account, Pollock's paintings do something more radical: they offer the viewer a stable transcen-dent vantage from which to contemplate the dizzying space and complexity of the universe, the labyrinth of infinity, space-time so vastly cosmic that it does not register the presence of human participants or spectators. The final sentences of the essay underscore this point.

> What are his dense and spangled works but the viscera of an endless non-being of the universe? Something which cannot be recognized as part of the universe is made to represent the universe in totality of being. So we reach the truly final paradox of these paintings: being in non-being.

For Tyler, these pictures of the labyrinthine universe allow us a rare view of it from the outside, freed for a moment from its engulfment. No wonder we clutch them with our eyes, hanging on for life. As long as we stand before them, we have momentary respite: we can see as if from above the complicated mazes within which we are eternally confined. As Barbara Deming pointed out in a fascinating review in 1945 of Walt Disney's Donald Duck feature *The Three Caballeros,* when the world is falling apart and the center cannot hold, "the periphery is a strategic point from which to work."[64]

Ultimately, in Tyler's view, Pollock's painted labyrinths do not imprison spectators but liberate them from the labyrinths represented. If his painted mazes entrap spectators at all, it is not at the level of perceptual experience but of conceptual paradox.

For all its obscurity, this is an unusual and rich piece of early Pollock criticism, and it may have been one that Pollock appreciated. Two months after the article was published, the *Magazine of Art* ran a letter to the editor from S. Lane Faison of Williams College, who wrote saying that the essay was confused. "I imagine Pollock himself would be as bewildered as I am. Why not ask him?" Goldwater had a copy of the letter sent to Pollock, inviting him to respond. Pollock evidently declined, or at least no known record of a response survives. Tyler, however, wrote to Goldwater to complain about the harsh editing of his essay. He noted also that Pollock had written him in response to the article (presumably to the unedited text contained in the Pollock papers). "As to Mr. Pollock's reaction, he writes me that he is 'delighted' and adds that he usually 'points' rather than explains in words."[65] Of course, one shouldn't make too much of this expression of delight; Pollock was shrewd enough to flatter a publicist when the opportunity arose.

Some critics reported an experience opposite to Tyler's: they felt "enclosed, trapped by the labyrinth of the picture-space," or engulfed and consumed in the rush of space. The image suggested in the title of *Vortex*—a dangerous whirlpool of water or wind— was used by these reviewers to describe the spatial effects of his poured paintings. In 1950 Alfred Barr picked up the term, writing of *Number 1, 1948* that "the whirling vortex of lines develops a mysterious depth and glow of light, without however destroying the sense of picture surface." Other critics vividly described the effect of being pulled into the paintings. Hess, for example, wrote that "seeing a Pollock is entering it; one feels like the statuettes inside glass globes that, when shaken, are filled with snow flurries. The picture surrounds one, tumbling skeins of hue everywhere. After short observation, however, violence is consummated." At this point, for Hess, associations with nature, described in the excerpt quoted earlier, would take over. But that process was not as idyllic as it might seem, he continued. "There is no finality or repose in either the association or the liberty to associate. The impulse to movement returns; the vertiginous ride always starts again." Dore Ashton also described the dynamic as one in which the spectator was pulled into the picture. "[Pollock] placed himself squarely and literally in the center of his picture, and the spectator was obliged to follow him. . . . By placing the spectator in the center of the picture instead of in front of it, Pollock—and the artists who were interested in the same problem—violently rejected established pictorial conventions for delimiting recessive space."[66]

To Frank O'Hara, writing in 1959, the early critical reactions describing the sensation of being swallowed by the pictures seemed melodramatic. "When these paintings were first shown in the Betty Parsons Gallery the impression was one of inexplicable violence and savagery. They seemed about to engulf one. This violence, however, was not an intrinsic quality of the paintings, but a response to Pollock's violation of our ingrained assumptions regarding scale." By this time Pollock's paintings were beginning to acquire a classic quality for some viewers, which precluded experience of the threatening power described by earlier commentators. Yet O'Hara's metaphors sometimes betray lingering vestiges of more visceral responses to the space of the pictures. "*White Light* . . . has a blazing, acrid and dangerous glamor of a legendary kind, not unlike

those volcanoes which are said to lure the native to the lip of the crater and, by the beauty of their writhings and the strength of their fumes, cause him to fall in." And environment artists soon would rekindle the melodrama of Pollock's space as part of their own aesthetic enterprise. One artist wrote, "When his all-over canvases were shown at Betty Parsons' gallery around 1950, with four windowless walls nearly covered, the effect was that of an overwhelming *environment,* the paintings' skin rising toward the middle of the room, drenching and assaulting the visitor in waves of attacking and retreating pulsations."[67]

Whatever disagreements there may have been about how the metaphors were to be applied, there was a high level of agreement about which metaphors were relevant. The axis web/labyrinth/maze/vortex is not exhaustive—metaphors of explosion and energy are also markedly abundant, as I have shown—but it is ubiquitous. One striking feature of this conjunction of images is how different are the forms involved. A spider's web, Daedalus's labyrinth, a vortex of air or water—these forms in most respects do not resemble one another, yet they are often combined in a single sentence or paragraph descriptive of Pollock's work and its effects.[68] It would be difficult to imagine another type of visual image that could evoke or sustain all of these forms simultaneously. By merging them, Pollocks painting drew attention to an aspect that all shared: all are arrangements of elements or forces whose principal effect is engulfment, entrapment, or ensnarement.

Perhaps that seems to be putting things backwards: it might be argued that because Pollock's art evoked such effects, these particular metaphors came to seem apt. This distinction may seem insignificant, but at stake is whether priority should be given to metaphor or meaning. The latter view—that meaning precedes metaphor—invokes formalist aesthetics in implying that forms can elicit responses or establish meanings purely and autonomously, apart from whatever metaphors they evoke or sustain. This is a view to which many of the New York School painters subscribed, although most held it alongside a deep-rooted interest in and respect for metaphorical allusion, as their statements and writings reveal. Pure formalists would argue that the metaphors posited in the critical excerpts above are crude efforts to recognize and articulate the powerful effects of the purely abstract forms of Pollock's paintings.

Formalist aesthetics, with its notorious assumption of transpersonal, transcultural, and transhistorical consistency in communication and expression through visual forms, has been effectively discredited since Pollock's day.[69] The meanings produced by visual forms are now widely recognized as historically and culturally contingent; the signification of any form is understood to be conditioned by culture-bound assumptions and associations regarding color, style, and, not least, prevailing vocabularies of metaphor. The critical reception of Pollock's art lends support indirectly to the antiformalist position by indicating the ubiquitous mediation of metaphor, with all its cultural historical contingency and specificity, in the interpretation of the work. Whatever its place in the sequence of mental events that constituted interpretation, and whatever its ultimate limitations, metaphor was apparently indispensable to critics attempting to come to terms with the paintings. It was in the metaphors evoked by the paintings, and what those metaphors signified in the semiotic fields of post–World War II U.S. culture, that the force of the paintings was found to reside.

Two things made the metaphors evoked by Pollock's paintings especially potent. One was the force of the conjunction itself. That a single pictorial format could sustain that range of images and reveal previously unrecognized similarities among some of them might in itself have been dazzling. The congruence produced among web, labyrinth, and vortex magnified the engulfing, entrapping aspect of each of them and of the paintings that evoked them. The second factor, however, was inseparable from the first: the power lay not just in the fact of conjunction but in the particular images conjoined. The figures of web, vortex, and labyrinth carried a special charge at this moment in U.S. culture. They were essential ingredients in the visual manifestations of Modern Man discourse, valuable principally for their ability to produce a vivid image of modern man entangled in forces beyond his ability to understand or control—webs woven of fate, past actions, and unconscious and primitive impulses. Modern Man literature sometimes used such figures in painting its verbal picture of the human situation: "the labyrinth of subrational human motives," "the tangle underneath society," or "the deep abyss of our instinctual nature."[70] Freud was described as having "led us to the top of the volcano and made us look into the boiling crater,"[71] the same image Frank O'Hara mobilized to convey the effects of Pollock's *White Light*. Dizzying depths, entangling webs, and imprisoning structures loomed large both within modern man and about him. That he was failing to keep his intellectual or psychic balance was routinely portrayed in spatial metaphors of disorientation or fall; his subjection to forces beyond his understanding and control was commonly figured as entanglement. Often critics employed these figures for New York School paintings without linking them to the forms of the work, as when Otis Gage invoked maze or labyrinth in describing the work of Pollock, de Kooning, and other modernists: they plunged us, he said, "into the dimly lit corridors of man's own psyche."[72] In short, web, vortex, and labyrinth were not themselves the *subjects* of Pollock's paintings but rather the subtle yet insistent tropes that evoked the subject *modern man*.

As interested modern men and women, critics often found themselves compelled by the metaphors implicit in Pollock's painting even if they did not consciously attach philosophical significance to the forms, as was ordinarily the case. Their attraction to the work may have seemed to them to have an aesthetic basis, insofar as it was explicable at all; but their aesthetic preferences were imbricated in interests, discourses, and ideologies, mediated by associations glimpsed in metaphors. The imagery seems to have been experienced widely as charged and relevant; understanding and articulating that charge and relevance were not at all easy and often resulted in confused, groping, garbled writing. But all attempts to verbalize the interest compelled by Pollock's paintings, no matter how inarticulate, have significance at least on the order of word association tests in psychology. And when critics were faced with Pollock's paintings, the words web, labyrinth, maze, and vortex came to mind; through them Modern Man discourse was invoked.

The forms of Modern Man discourse that participated in the production of Pollock's paintings need not necessarily match precisely the forms in which it was identified, consciously or unconsciously, by viewers. While ideas about unconscious energy may have had a part in generating some works, for instance, web imagery may be prominent in the critical writing about those same works. That is not to say that it is mere coinci-

dence that the same discursive frame was operative in both processes. Pollock's paintings were so strongly embedded in Modern Man discourse, and their visual realization of that discourse featured so obviously the right mix of fixity and ambiguity, that critics could have persuasively invoked (and did) virtually any of the metaphors and forms that constituted the discourse. That those invocations were usually subtextual and unconscious tells us something significant about the operations of discourses and ideologies.

SPATIAL METAPHORS IN *FILM NOIR*

Once more, *film noir* will prove useful for comparison with New York School painting, since, unsurprisingly, web, vortex, and maze are familiar forms and images in these films. Figurative titles such as *The Web* (1947) and *Whirlpool* (1949) assume that viewers will easily decipher the metaphors; there is, for example, no literal web in *The Web*, nor is the word ever spoken by any of the characters. It is absolutely clear, nonetheless, that the protagonist—a lawyer who is tricked into committing a murder—is caught in a web. If he proves what he suspects—namely, that the man he killed seemingly in self-defense had no intention of doing harm to anyone but had himself been "set up"—he convicts himself of murder. As a police lieutenant spells out, "if you prove it's murder, you prove that you're a murderer." The only person who could establish the protagonist's innocence is the truly guilty character—an evil, scheming industrialist disinclined to save anyone but himself. The industrialist was the spider who wove the web that ensnared the innocent, unsuspecting lawyer, and the lawyer's struggling results only in increasingly greater entanglement. His release comes only when the spider becomes entangled in another web woven by the police lieutenant.[73]

The web motif in *film noir* is also evoked in dialogue and setting. In *Murder My Sweet* (1944) the protagonist awakes from a drug-induced nightmare feeling caught, he says, in "a gray web woven by a thousand spiders." One of the visually most striking and imaginative invocations of the web metaphor appears in the *noir* classic *Out of the Past* (1947). The entanglement of private detective Jeff Markham (Robert Mitchum) in the meshes of doom begins when he finds himself falling in love with Kathie Moffett (Jane Greer), a woman he has been hired to bring back from Mexico to the racketeer she shot and robbed. They first kiss in a scene set on a beach among a maze of suspended fishing nets, arranged, presumably, to dry in the sun (fig. 89). The couple is surrounded by nets in the moonlight as they play out their intense attraction. By becoming entangled with this character, who will turn out to be a quintessential *noir* woman—irresistible, ruthless, treacherous, fatal—the protagonist has entered into the sequence of events that will lead to his own violent death. As the nets blow against their entwined bodies, and as this particular spot on the beach becomes their private meeting place, the lovers' ensnarement is signified. A seasoned *noir* viewer would read the symbolism easily, if subliminally: nets as webs of fate, marking the protagonist's victimization.

Later in the film the web motif reappears in a different setting. The object of a manhunt as a result of being framed for murder, Markham returns to the quiet small town where he had tried to establish a new identity and escape his own sordid past. He arranges a rendezvous in the woods at night with the faithful, loving, trusting woman, Ann (Virginia Huston), with whom he had hoped to start a new life. As they walk through the

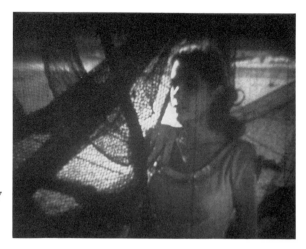

89. Still from Out of the Past. *1947. © 1947
RKO Pictures, Inc. All rights reserved.*

thick woods, surrounded by branches from which all the leaves have fallen, the moon-light casts a strong, clear shadow across the faces and clothing of both characters (fig. 90). We are meant to identify the webbed shadow that encompasses them first, literally, as the effect of branches overhead and then, subliminally, as a tangle of ropes around them. Markham's apology to the woman for getting her involved in his dirty life becomes poignant as we see her symbolically ensnared in the web that holds him.

The beach scenes in *Out of the Past* are part of a flashback sequence (the convoluted narrative is quintessentially *noir*) in which Markham (who has assumed another name) tries to explain to Ann the complex entanglements of his past, which he had tried but failed to escape. As the title of this film indicates, the past—a network of fateful encounters, bad judgments, moments of weakness, missed opportunities—is the princi-pal web that entraps the characters here, and in this respect too the film is quintessentially *noir*. The events in the past might be known or unknown—in *Lady in the Lake* (1947) the detective observes that "there's something from the past in this case that neither of us know anything about"—but their effects remain inescapable. My discussion of *The Dark Past* (1948) in chapter 3 drew attention to that film's insistence that the power of the past to entrap us may be centered in our unconscious, in repressed childhood memories and experiences. In this context, the title of Pollock's *Something of the Past* acquires a *noir* tenor.

The protagonists in *noir* films often found themselves in the position of the sor-cerer's apprentice in Walt Disney's *Fantasia* (1940). Just like Mickey Mouse in that role, when his inability to control the powers he had appropriated resulted in the flooding of the sorcerer's chambers, the *noir* hero characteristically felt as if he were caught in a whirlpool that threatened to pull him under. As Disney demonstrated, the image of vortex was an effective one for signifying visually both a situation gotten grotesquely out of control and an individual's pathetic impotence. *Noir* directors commonly sought to elicit from their audiences empathic identification with both these essential aspects of the *noir* protagonist's situation, but they generally stopped short of placing their characters literally in whirlpools or tornadoes. Ordinarily, dialogue would carry the weight, as the characters voiced feelings of inability to resist the forces that buffeted them and of increasing desperation as they found themselves "in deep" and sinking fast. Nonethe-less, visual vortexes do appear in *noir* films, most commonly as a "dissolve" device to

effect temporal transition between filmic present and flashback. One brackets the extended flashback sequence in *D.O.A.* (1950), during which the protagonist relates to the police the story of how he came to be fatally poisoned. At the close of his narrative, in which he descends a stairway, in the act of shooting the person who had poisoned him (for notarizing a seemingly inconsequential but, in fact, illegal business transaction), his grimacing face and advancing, firing body are overtaken by a swirling funnel which transports the narrative back to the police station (fig. 91). At that moment, the character, having just disappeared into the eye of the vortex of bizarre events that unjustly overwhelmed him, dies.

In *Conflict* (1945) a close-up shot of a whirlpool of water (fig. 92) serves to mark the passage into unconsciousness of the protagonist Richard Mason (Humphrey Bogart). Mason becomes upset, while driving home from his anniversary party with his wife and her sister, when he learns that the sister, to whom he is fatally attracted, will be leaving their household to return to her mother's home. His distress causes a collision, and the exploding glass of the windshield dissolves into an image of a dark whirlpool, over which are superimposed the faces of wife, sister, and the friend—a Freudian psychiatrist—who hosted the anniversary party. Each repeats statements he or she made at the party, all to do with the power of love and its frustrations to generate evil thoughts which, the psychiatrist says, "can be like a malignant disease that starts to eat away the willpower." This psychiatrist is described as a Freudian on the basis of his belief that "love is the root of all evil." Mason will go on in the film to murder his wife in order to be free to take up with her sister. In the end he will be rejected by the sister and found out by the police, largely through the initiative and ingenuity of the psychiatrist. The faces superimposed over the whirlpool speak the terms of the protagonist's unconscious conflict, reinforcing the psychological framework of the plot. This conflict, between his

90. Still from Out of the Past. *1947. © 1947 RKO Pictures, Inc. All rights reserved.*

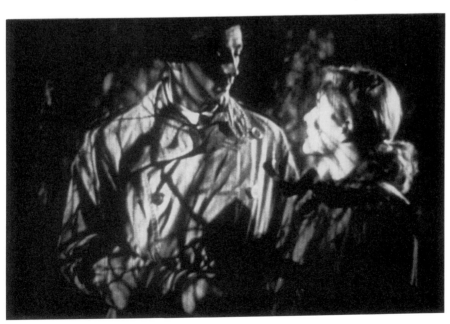

91. Still from D. O. A. *1950. United Artists.*

92. Still from Conflict. *1945.* © *1945 Turner Entertainment Co. All rights reserved.*

desire and his self-control, will pull him steadily into the downward spiral so graphically represented on the screen. The dark whirlpool itself eventually dissolves into a subjective shot of the hospital room where Mason awakens; the camera keeps us inside Mason's head for a moment longer, looking down at his slightly out-of-focus broken leg. In this case the whirlpool serves simultaneously as an evocative screen for a sort of flashback—a screen that illustrates the suction exerted by the forces of fate and mind—and as an image of the unconscious as site where elusive but dangerous thoughts swirl and submerge.

The vortex could also function to draw the viewer into subjective identification with the protagonist by conveying a sense of how the character felt. It could evoke vividly the dizzying, vertiginous sensation of being in that character's position. This function of the device is illustrated by its part in Alfred Hitchcock's film *Vertigo* (1957), where the vortex both represents the protagonist's vertigo and evokes an empathic sensation of dizziness in the viewer. In *D.O.A.* and *Conflict*, the vortex has a dizzying, disorienting effect which makes the protagonist's experience more immediate.

The dizzying effect of the vortex links it to a larger interest in disorienting and disturbing spatial effects in *film noir*, often achieved through devices such as high or low camera placement, use of mirrors, and camera movement. Some of these devices construct the spaces of the modern city as maze or eddy. Examples include the corridors of skyscrapers in *Double Indemnity* or *D.O.A.*; the ubiquitous staircases and stairwells shot precipitously from above or below, so as to turn them into literal spiraling vortexes; the

city streets seen from inside a moving car or from the vantage of someone tailing a suspect along avenues, around corners, into hallways. As a result of having been "uprooted from those values, beliefs and endeavors that offer him meaning and stability," the *noir* protagonist is left "struggling for a foothold in a maze of right and wrong. . . . Values, like identities, are constantly shifting and must be redefined at every turn."[74] Some of the most literal evocations of the maze image occur when the city and, particularly, its industrial spaces become the scene of a cat-and-mouse style of gunfight. In *D.O.A.*, for example, an abandoned mill becomes a labyrinth within which each of two figures, one always unseen by the spectator, attempts to maneuver himself into a position from which he can sight and shoot his opponent while remaining himself unseen. In such cases, the labyrinth that eternally imprisons the *noir* character finds explicit symbolic expression. The ideal literal expression of this condition—the prison, the modern labyrinth—is seldom out of mind in these films; it is a threat with which the protagonist is constantly faced. Likewise, the labyrinth within—the mind and its maze of conscious and unconscious pathways—is omnipresent in the *noir* world. In Hitchcock's *Spellbound* (1945), the psychotic male protagonist (Gregory Peck) has assumed the identity of a psychiatrist renowned for writing a classic text called *The Labyrinth of the Guilt Complex.*

Formal and thematic comparisons between painting and film will necessarily be imprecise, if only because of differences in the media and in the audiences addressed. Nonetheless, the shared vocabulary of metaphor between Pollock's paintings and *noir* film is indicative of their mutual engagement with the issues and themes of Modern Man discourse. When its metaphorical dimensions are restored, Pollock's work represents the space of that discourse—the space of entrapment and ensnarement; the space of disorientation; the space of the interior, mental landscape; the space of the infinite cosmic labyrinth. Despite his interest in the modernist notion of abstract "pure form," Pollock retained impure metaphor as a prominent and expressive feature of his art throughout his career, and it played a substantial part in the growth of interest in his work. In a significant sense, Pollock achieved his thoroughly metaphorist ambition to render "the experience of our age in terms of painting—not an illustration of—(but the equivalent)." As his statements reveal, he remained a metaphorical thinker throughout his career; if his conscious attitude to metaphor was ultimately equivocal, there was nevertheless always a strong undercurrent of attraction to it.

CONCLUSION

What are we to make, then, of this circulation of metaphor in and around Pollock's art? Does it diminish his achievement to discover that his work and its popularity belonged to a dated and somewhat banal, albeit culturally central discourse? The first answer to this question must be no. As the level of contradiction, ambiguity, struggle, and uncertainty in the criticism I have cited reveals, Pollock's art was in no sense exhausted or contained by the metaphorical world of Modern Man discourse. The match I have argued for was never more than partial and unstable, never more than one possible frame for the complex field that was Pollock's painting. But early on, that frame was an important one, and if the art does seem diminished by it, it does so only because Pollock's art has been

idealized, universalized, and dehistoricized in the intervening decades. Its temporality has been suppressed in the process of canonization; the work has been held to have reached utterly impossible achievements—impossible because grounded in idealist and formalist aesthetics. Only from this point of view would reinsertion into history seem to tarnish the art. I prefer to recognize the ingenuity, versatility, and elegance of Pollock's imagery. The production of paintings capable of effecting the conjunction of timely metaphors described above, all the while preventing any one of those or other metaphors from becoming fixed or dominant, was no mean feat. The point made by Parker Tyler is worth recalling here: "any system of meaning successfully applied to [Pollock's abstract images] would at the same time not apply, for it would fail to exhaust their inherent meaning."[75] T. J. Clark has advanced a related argument more recently:

> [Pollock's painting] is a work *against* metaphor, against any one of his pictures settling down inside a single metaphorical frame of reference. He wishes to cross metaphors, to block connotation by multiplying it. He intends so to accelerate the business of signifying that any one frame of reference will not fit. Figures of dissonance cancel out figures of totality; no metaphor will get hold of this picture's standing for a world, though we think the picture does somehow stand for one: it has the requisite density.[76]

Clark sees Pollock's work moving between two metaphoric poles—figures of totality (unity, harmony) and figures of dissonance (discontinuity, aimlessness)—which, as he says, cancel one another out. Neither can hold, as each is perpetually qualified by its antithesis. Even though the metaphors I have considered are more numerous, particularistic, and banal, and less elegantly broad and antithetical, the point stands: the paintings deliberately eschew any single frame of reference. I am inclined, however, to see the relation among competing metaphors as less one of mutual annihilation than of reinforcement, revision, and coexistence. They do, in the end, stand for a world, or at least they did for a time early in their history. Another qualification I would offer concerns the attitude of the paintings toward metaphor. Clark writes,

> In order to represent at all, I suppose, a series of marks in a picture have to be seen as standing for something besides themselves; they have to be construed metaphorically. . . . Metaphor is inescapable, and what in any case would an exit from it be like?[77]

This observation could be taken to suggest that Pollock's art gives evidence of a desire to escape from metaphor, that its deliberate refusal of a single metaphorical frame indicates resistance or aversion to metaphor. In my view, the paintings revel in the invocation and control of metaphor—unconscious, explosion, energy, web, labyrinth, vortex, etc.— and in this rests much of their achievement. The art manages to keep its engagement with metaphor broad and lively, yet not so promiscuous or unfixed that the metaphors' effects are negated. By restoring to the paintings the discourses in which they were generated and received, we can begin to appreciate the subtlety and sophistication of their work with metaphor.

Finally, let me recall that there are several levels on which metaphor operates in the pictures; those discussed in the immediately preceding section are not presented as exhausting the content of Pollock's work. The subjects of previous discussion— especially, the enactment of divided self, the split between control and uncontrol, and the movement between figuration and abstraction—are in no way incompatible with or less important than the metaphorical readings of space I have proposed last.

One final question before concluding: Where does this reading of Pollock's paintings leave the interpretations that have dominated Pollock scholarship for the last forty years? It may have come to seem in this chapter that the elegant, insightful, and renowned criticism by Greenberg, Fried, Rubin, Rosenberg, and others was peripheral to many of those aspects of Pollock's work that linked it to Modern Man discourse and underpinned its cultural relevance. I do not think it was. The work of Fried, Rubin, and other later modernist critics did indeed effect suppression of the temporality of New York School art; but even so, their writing preserves in sublimated form much of that temporality, as Fried's description of Pollock's energetic line indicates. Where Greenberg and Rosenberg are concerned, the case is more complicated. On one hand the work of these two critics in many ways overlaps and intersects with Modern Man discourse at crucial points: one need only recall Greenberg's deep interest in the control/uncontrol dynamic which is at the heart of the Modern Man reading of Pollock's work, or Rosenberg's image of the canvas as arena for "an adventure over depths in which [the artist] might find reflected the true image of his identity."[78] By no means was such criticism extraneous to Modern Man discourse or insensitive to Abstract Expressionism's engagement with it.

But there are dimensions of Greenberg's work that appear idiosyncratic when viewed against the overall reception of Pollock's paintings. Greenberg's serious and challenging appraisal of Pollock's artistic achievement in formal terms, eschewing "metaphysics," looks a bit eccentric alongside the bulk of Pollock criticism. The discussion in chapter 4 above of his sympathy for Irving Babbitt's New Humanist aesthetics and behavioral ideals, which led him to devalue the modern subjectivity the New York School artists struggled to represent, indicated one important factor in the lack of fit between his criticism and much of the rest, to say nothing of the writings and statements of the artists themselves. This was not a matter of Greenberg and Pollock endorsing different models of subjectivity: Greenberg never denied that primitive instincts and unconscious impulses were essential ingredients of human mind and nature. Like the New Humanists and the progressive liberals, he was not immune to the force of Modern Man discourse. But whereas Pollock and his colleagues sought to represent this new subjectivity, Greenberg championed an art of uncompromised rationality, an art insulated from the subrational forces within modern man.

Greenberg had sometimes attributed to painting a philosophical core, evident in his definition of "what makes painting great anywhere and at any time—that it is necessary to register what the artist makes of himself and his experience in the world." At the time he wrote this sentence, Greenberg thought Pollock accomplished this objective better than anyone. But his skepticism a year later about the importance attributed by some New York School artists to "'metaphysical' content," which he saw as "half-baked and revivalist in a familiar American way," indicated the path along which his aesthetics would develop. While his ultimately formal reading of New York School art was embraced and developed within the academy and the museums, where it provided the germ for those interpretations that would canonize the art (and suppress its temporality), it did not play as well in the mass-market magazines and newspapers, even when Greenberg himself was the author.

The significance and relevance of Pollock's art was not monolithic; its cultural

centrality depended upon the articulation of a variety of rationales and readings for different audiences and different purposes. As I described in chapter 1, Greenberg's and Rosenberg's conflicting accounts of the work of Pollock and his colleagues in the New York School attributed to that art different and in some ways complementary distinguishing features, which together facilitated its legitimation for the highbrow audience and for the liberal elite directing the exportation of U.S. culture during the cold war. Those aspects of their criticism most implicated in Modern Man discourse soon gave way to others concerned with establishing the international significance of the art in terms of the progress of the great Western artistic tradition and U.S. liberal capitalist ideology. Their combined efforts made New York School painting seem a universal aesthetic achievement. In this respect, Greenberg and Rosenberg put Pollock's work to the service of a different set of interests—those defined by Kozloff, Guilbaut, and others—which served the culture's dominant ideology in a different way, grounding its claims for moral superiority and potency on the international stage. Pollock's art was capable of sustaining a range of different readings; its many different "truths" contributed to its many cultural utilities: for *Vogue* magazine, the State Department, the Museum of Modern Art, and Modern Man discourse.

At least since 1965, when Max Kozloff published his early influential assessment of the critical reception of the New York School,[80] the story of that reception has tended to be told in terms of the debate between Greenberg and Rosenberg, largely ignoring a sizable body of important if sometimes less rigorous criticism which was just as influential in representing the art to the broad public. As a result, Greenberg's and Rosenberg's writings were taken to be more or less the conflicting "truths" of this painting; the majority of the other contemporary critical responses were seen largely as confused or unenlightened hackwork. I hope the present study has indicated that this hackwork tells us something important about some of the overlooked dimensions of Pollock's work. Orienting the study of the reception of New York School art around the dispute between Greenberg and Rosenberg has made explanation of the cultural relevance of Abstract Expressionism a bit more difficult in some ways.

Restoring the Modern Man discursive frame to New York School painting does not mean that stable and simple readings of pictures will become possible; the disagreements between Greenberg, Rosenberg, and other critics, all of whom relate Abstract Expressionism to Modern Man discourse in one way or another, make plain the fact that myriad interpretative judgments and choices remain open. But to the extent that it becomes possible to stand outside the circuit of identity construction in which artists, paintings, and critics were implicated, the possibilities for historical analysis are improved. The original situation was dynamic, circular, fluid: critics, whose own senses of self were being constructed in the process, were assessing paintings which in turn had been generated in response to contemporary discursive constructions of self by artists struggling to paint (as) modern man. The subjectivity of artist, critic, and viewer was being forged in dialectic with various representations of that subjectivity, including New York School paintings. Inevitably, the pictures remain still elusive and polyvalent, sustaining different and contradictory interpretations. Some of their codes and relevances become clearer with their restoration to their Modern Man discourse, as I hope this chapter has demonstrated. The "philosophical" content of Pollock's painting, defined broadly,

emerges as a principal source of its attraction to many. Contrary to Greenberg, Fried, and others who have wanted to concentrate on the "sheer opticality" of Pollock's pictures, stands Parker Tyler's assertion that "the spatial distinctions achieved by lines and spots of color within Pollock's rectangles go as much beyond mere optical vision as seems possible to painting."[81] And James Fitzsimmons put it this way in 1954: "For this reviewer, the exciting thing about Pollock's new paintings—the successful and unsuccessful alike—is the glimpse they afford into the metaphysical and psychological structure of things."[82] Robert Goodnough had voiced a similar opinion in *Art News* a few years earlier. He portrayed Pollock's work as "resulting from contemplation of a complex universe at work, as though [Pollock aimed] to make his own world of reality and order."[83] Goodnough's original manuscript, before it was edited by *Art News*, was even more explicit and effusive.

> Jackson Pollock is a painter who has freed himself from those hindering restrictions which keep one from coming to grips with the world which is called unknowable. . . . A painting is a manifestation of an awareness of the self living within the tremendous, indifferent, unceasing force of creation—a force unexplainable but achieving renewed tangibility in that manifestation. Pollock is involved in this.[84]

This involvement links Pollock's work to Peter Vardo's "Lord of Creation," to the drawings of psychoanalytic analysands, to the characters of *film noir* dramas, to the writings of Modern Man authors, and to the paintings by his colleagues in the New York School; and it lent his work immediate relevance for an influential segment of U.S. society in the post–World War II era.

EPILOGUE

*When [Liriope] asked
Tiresias how long her child [Narcissus]
would live—
To great old age? the prophet
answered, "Only
If never he comes to know himself."*
Ovid, *Metamorphoses*

*The sick man withdraws his libidinal
cathexes back upon his own ego, and
sends them out again when he recovers.
"Concentrated is his soul," says
Wilhelm Busch of the poet suffering from
toothache, "in his molar's narrow hole."*
Sigmund Freud, *"On Narcissism"*

*But what, concretely, is . . . ideology if
not simply the "familiar," "well-known,"
transparent myths in which a society or an
age can recognize itself (but not know
itself), the mirror it looks into for self-
recognition, precisely the mirror it must
break if it is to know itself?*
Louis Althusser, *For Marx*

*And if the artist's guardian angel should
ask him, "Why such desperation, my
friend? why such a heaving of the
breast?" the artist could very truthfully
answer, "I am a strange creature, and
strange most of all to myself." . . . And
when the demagogues of art call on you to
make the social art, the intelligible art,
the good art—spit down on them, and go
back to your dreams: the world—and your
mirror.*
William Baziotes, *"The Artist and his
Mirror"*

The process by which a mind-body constitutes itself as a subject is complicated and continual, psychological and social. In one influential account, Jacques Lacan has portrayed it as beginning with the child's recognition of the image in the mirror as the reflection of itself, perceived as an imaginary unity. This hypothetically presocial initial phase is soon succeeded by a social one: the subject becomes shaped and reshaped in the entry into the Symbolic, the domain of language and law, where otherness and difference effect a disunified identity. As a social process, subject formation is historically and culturally variable, and it is permeated by ideology.

Making its way in the Symbolic, a subject will continue to use mirror-effects and self-reflections in its efforts to "know" or fashion itself. It may envision itself a discrete totality if not a unity, and may become obsessed with its beauty or complexity, with its varied aspects, composition, or internal dynamics. In some circumstances, simple reflection may be inadequate for more complex identification processes, and other visual media may take the place of the mirror. Painting, for instance, may become a preferred field in which viewers identify their core of selfhood and see enacted its complex states and psychological operations. Both the matter of painting—the ways its materials are handled—and certain discursively resonant webs of metaphor, evoked through the handling of matter and through the production of illusory or suggestive resemblances, may be the means by which such processes of self-representation are effected. Viewers may find themselves captivated by the selves they discover in and project onto such images, or be compelled by the interpellations and mutual identifications developed in the encounter. They may resemble Narcissus, rendered enraptured and helpless by the sight of his own image, even though the disunified, terrible, vulnerable selves they recognize bear little resemblance to the enchanting beauty of Narcissus's reflection.

This book has argued for just such an interpretation of New York School painting in the wartime and postwar era, when the dominant national vision of the horrifying world was refracted through the looking glass, so to speak. What riveted the modern Narcissuses to the self-representations that hovered between them and their world was not love but fear, anxiety, and desperation. The selves they generally discovered were not ravishing unities but rather, on one hand, conflicted Neanderthals harboring frightening, unfathomable, and primitive impulses, and on the other, puny and impotent victims of nature and fate. These self-images were situated in those paintings we call Abstract Expressionist by virtue of a distinctive network of visual metaphors—of conflicted production, gendered opposition, the persistence of the primitive, the circulation of energy, unconsciousness, control and uncontrol, and spatial entrapment, among others—which engaged squarely the dominant cultural discourse on self and identity. No one of these varied metaphorical frames was sufficient to contain and stabilize the paintings; rather, the most effective and resonant works were those that exceeded each frame and generated ceaseless flow and oscillation from one trope to another. This is what gave the art its special purchase on the complicated matter of modern subjectivity.

But just as Narcissus pined away in a love that could not be satisfied, because it was solitary—or to put it another way, because it was insufficiently social—so was modern man prevented by the narrowness of his focus from finding the complex satisfactions he sought. Abstract Expressionist painting was, like Narcissus's pool, a distorting mirror (or "magic mirror," to invoke the title of a 1941 painting by Pollock). What the water showed Narcissus was a beautiful face; it was unable to reveal to him either his own

overvaluation of physical beauty or the presence of the nymph Echo, who had faded into a disembodied voice as a consequence of her unrequited love for Narcissus. (*Echo*, incidentally, was the title Pollock gave to a 1951 painting.) Similarly, Abstract Expressionist paintings rendered modern man as a narrowly psychological subject; identity apparently resided now less in the look of the body or in social positionings than in the dynamic and violent interaction among layers of the psyche. This gloss on identity was an adaptation of an older model; it was forged under the pressure exerted upon a hegemonic ideology by traumatic historical events. The new self was "friendly" to the dominant ideology insofar as it preserved a maximum of the latter's fundamental categories, tenets, and assumptions, which, indeed, had played a crucial part in the development and elaboration of the new self. In New York School paintings, as in other Modern Man texts, viewers located, shaped, and recognized themselves *as ideological subjects.* The works were vehicles by which ideology permeated the very core and structure of the individual's sense of self. This colonization of subjectivity is the source of an hegemonic ideology's force, and the condition that gives it stability and momentum. As Louis Althusser has put it in a well-known passage:

> The category of the subject is constitutive of all ideology, but at the same time and immediately I add that the category of the subject is only constitutive of all ideology insofar as all ideology has the function (which defines it) of constituting concrete individuals as subjects.[1]

In devising compelling visual forms for Modern Man subjectivity, New York School artists constituted themselves as ideological subjects and made paintings that interpellated viewers in those terms.

Just as Modern Man subjectivity had edged out an older, weakened model, so it too found itself under siege after a time. The story of that later transition, still very much in progress as I write, is beyond the scope of this volume. But from the present vantage it appears that within a decade of its appearance, the subjectivity inscribed in Abstract Expressionism had begun to seem to a significant number of artists and viewers melodramatic, even hysterical. A new attitude toward self, which we have begun to call postmodern, made early appearances in the art of Jasper Johns, Robert Rauschenberg, Andy Warhol, Roy Lichtenstein, and others. The self they rendered—without center, depth, or internal turbulence—dissolved into a fabric of repetitions and appropriations; it resembled Echo much more than it did Narcissus or Modern Man. That Echo was female is by no means insignificant here: artists whose identification with Abstract Expressionist subjectivity was impeded by their sex, race, or sexual preference have played a leading part in developing the critique and effecting transition. The influential work of Laurie Anderson, Barbara Kruger, Sherrie Levine, Adrian Piper, and Cindy Sherman, for example, has often explicitly criticized and undermined the white, heterosexual, male orientation of modernist subjectivity.

The question remains open, however, whether the so-called postmodern self amounts to the decisive break suggested in its name, or to something less radical and conclusive. Perhaps the notable difference is only that modern man has recovered enough from his illnesses that he is able, once more, to send his libidinal cathexes back out into the social world? The Modern Man premise that the psychological is antecedent to and determinative of the social and political was insufficiently dialectical; that much seems clear in retrospect. But the version of the modernist self that has been under

examination in the present study bears significant similarities to the postmodern self. The modernist subject may have been a totality, but it was not always or necessarily unified, centered, or autonomous. Because New York School painting enacted and represented the dethronement of the Lord of Creation and the reformulation of self as a composite of dispersed, warring nuclei, a case could be made that an inchoate form of the postmodern or poststructuralist self is to be found here. Just as the "progressive" aspects, as well as the conservative ones, of Freud's destabilization of the modern self have been recognized by Lacan, Derrida, and others, so Abstract Expressionism, while standing as the epitome of high modernism, should be recognized as pointing the way in some important respects toward the artistic development of postmodern subjectivity. Intrasubjective fragmentation, disintegration, and loss of autonomy had already begun in this art. Whether we view the relation between it and postmodernism as continuous or not, our separation from it is not quite so complete as we might imagine or hope. The subjectivity these artists forged continues to compel recognition; one still routinely encounters celebrations of Abstract Expressionism for just such reasons. So Frank Stella writes, "Newman was able to depict the modern artist's internal world with the same clarity that Velásquez brought to the external world of Old Master painting."[2]

It has been the object of this study to show just how contingent, how historically and culturally localized, was the picture of "the modern artist's internal world" that shaped these artists and was represented in their work. If we continue to value Abstract Expressionism highly now, its historical character—its mix of engagement with and disengagement from the various discursive frames that shaped it and were shaped by it, its combination of ideological legitimation and subversion, and so on—must play a principal part in that valuation. And if we are to learn from it, we must not overlook the fact that its progressive dimensions were deeply implicated in (one might say overwhelmed by) conservative processes. Further, just as the dominant ideology structured and used the new senses of self in New York School painting, so the postmodern self has shown itself capable of profound complicity with hegemonic powers and with the pervasive commodification of cultural life. The history of Abstract Expressionism illustrates the difficulty of ideological and political contestation in the cultural sphere; may its lessons not discourage but enhance the effectiveness of subsequent critical cultural practices.

NOTES

Certain heavily cited texts and sources have been abbreviated as follows:

AAA-SI Archives of American Art, Smithsonian Institution, Washington, D.C. (numbers following this abbreviation refer to rolls and frame numbers for microfilms)

AG Papers Adolph Gottlieb Papers

APC-NY Analytical Psychology Club of New York City

BN-SWI Barnett Newman, *Barnett Newman: Selected Writings and Interviews*, ed. John P. O'Neill

BN Papers Barnett Newman Papers

CG-CEC Clement Greenberg, *Clement Greenberg: The Collected Essays and Criticism*, Volume 1, *Perceptions and Judgments, 1939–1944*, and Volume 2, *Arrogant Purpose, 1945–1949*, ed. John O'Brian

JP-CR Francis V. O'Connor and Eugene V. Thaw, *Jackson Pollock: A Catalogue Raisonné of Paintings, Drawings, and Other Works*

JP Papers Jackson Pollock Papers

MR Papers Mark Rothko Papers

Other titles are cited in short forms. Full publication data appear in the Bibliography.

INTRODUCTION: FRAMING ABSTRACT EXPRESSIONISM

1. See Goodman, *Problems and Projects*, 115.
2. On the cultural contingency of linear perspective, see Panofsky, "Die Perspektive als 'symbolische Form'" (1927), in id., *Aufsätze zu Grundfragen der Kunstwissenschaft*, 99–167; Baxandall, *Painting and Experience in Fifteenth-Century Italy;* Jay, "Scopic Regimes of Modernity," in Foster, *Vision and Visuality*, 3–23; and Damisch, *L'Origine de la perspective.*
3. Smith, *Contingencies of Value*, 47.
4. See Lynes, "Highbrow, Lowbrow, Middlebrow." That these categories are class-based is implicitly acknowledged by Lynes: "Highbrow, lowbrow, upper middlebrow, and lower middlebrow—the lines between them are sometimes indistinct, as the lines between upper class, lower class, and middle class have always been in our traditionally fluid society." My adoption of the terms here has more to do with class than with any judgments of taste. It should be noted that Lynes' use of this terminology is not as unapologetically hierarchical as it may seem; his analysis is largely relativist, and his tone is marked by a deflationary humor and irony familiar in mass-cultural discussions of high-cultural phenomena.

 Such sweeping, gender- and race-blind categories as "highbrow," et cetera, have very limited descriptive value; in terms even of class they obscure important oppositions and heterogeneity. See Bourdieu, *Distinction*, e.g., p. 39.
5. Gage, "Reflective Eye," 4.

6. *Life*, 11 Oct. 1948, 78–79.

7. *Time*, 20 Nov. 1950, 71, referring to Hunter's column "Among the New Shows," 30 Jan. 1949.

8. "By Contemporaries," 2 Dec. 1951, sec. 2, p. 11.

9. "Among Current Shows," 14.

10. Brenson, "Divining the Legacy of Jackson Pollock," 47, 53.

11. For example, see Cockroft, "Abstract Expressionism, Weapon of the Cold War"; Guilbaut, *How New York Stole the Idea of Modern Art;* Kozloff, "American Painting during the Cold War"; and Tagg, "American Power and American Painting." For a more complete listing, see Hills' review of Guilbaut's book in *Archives of American Art Journal.*

12. "Ideology and Ideological State Apparatuses," in *Lenin and Philosophy,* 156.

13. See, for example, from *How New York Stole the Idea of Modern Art,* "Avant-garde art succeeded because the work and the ideology that supported it, articulated in the painters' writings as well as conveyed in images, coincided fairly closely with the ideology that came to dominate American political life after the 1948 presidential elections. This was the "new liberalism" set forth by Schlesinger in *The Vital Center,* an ideology that, unlike the ideologies of the conservative right and the Communist left, not only made room for avant-garde dissidence but accorded to such dissidence a position of paramount importance" (p. 3).

 See also Benjamin Buchloh's review of Guilbaut's book, which criticizes its consideration of "how the esthetic construct passes into the service of ideological interests" (Buchloh, "Concrete History of Abstract Expressionism").

14. Kavanagh, "Ideology," 310.

15. Guilbaut, *How New York Stole the Idea of Modern Art,* 77.

16. Clark, *Painting of Modern Life,* 8.

17. See, for example, Alloway, "Adolph Gottlieb and Abstract Painting," in *Adolph Gottlieb;* Cavaliere and Hobbs, "Against a Newer Laocoon"; Carmean, "Les peintures noires de Jackson Pollock et le projet d'eglise de Tony Smith"; Chave, *Mark Rothko;* and Hess, *Barnett Newman* (1971).

18. See, for example, Krauss, "Reading Jackson Pollock, Abstractly."

19. Some of the attacks upon efforts to develop an enriched conception of the New York School's sense of subject serve as a cover for reactionary demands for a return to traditional formal or expressive readings. See, for example, Hilton Kramer (a review of Anna Chave's book on Rothko), "Was Rothko An Abstract Painter?"

20. Rothko, "Romantics Were Prompted," 84.

21. Krauss, "Reading Jackson Pollock, Abstractly"; and Wood, "Howl of Minerva," 124.

22. "The Subjects of the Artist" was the name of a school opened in 1948 by several of the New York School artists: William Baziotes, David Hare, Robert Motherwell, Mark Rothko, and Clyfford Still. Barnett Newman joined them later.

23. *Contingencies of Value,* 51. The italics are Smith's. Several "New Historicist" studies in literary history concur with this judgment; see Veeser, *New Historicism.*

24. Clark, "Jackson Pollock's Abstraction," 180. The italics are Clark's.

25. Giddens' quote from *Central Problems in Social Theory,* 70. Statements of Smith appear in Paul Smith, *Discerning the Subject,* 157, 156.

26. *Painting of Modern Life,* 6.

27. Donald Preziosi and certain other critics of "historicism" tend to reduce all efforts at historical interpretation to one or another of these straw targets. See his *Rethinking Art History.*

28. For a fuller development of these issues, see Bal and Bryson, "Semiotics and Art History." The structure of my discussion of historical context is heavily indebted to theirs.

29. Both quotes are from Culler, *Framing the Sign,* xiv. They are reprinted in Bal and Bryson, "Semiotics and Art History."

30. Clark, "Jackson Pollock's Abstraction," 177. The italics are Clark's.

31. Derrida, "Living On," 81. Quoted in Bal and Bryson, "Semiotics and Art History," 178.
32. Putnam, "Craving for Objectivity," 230.
33. *Contingencies of Value*, 49–50.
34. Jameson, "Reification and Utopia in Mass Culture," 141.

1. THE FORMATION OF AN AVANT-GARDE IN NEW YORK

1. A special issue of the *Art Journal* (Fall 1988), edited by Ann Gibson and Stephen Polcari, was titled "New Myths for Old: Redefining Abstract Expressionism."
2. On the dealer-critic institutional system, see White and White, *Canvases and Careers*.
3. "'American-Type' Painting," 212. I have chosen the revised wording, which Greenberg dates to 1958, over the original phrasing that appeared in *Partisan Review* (Spring 1955): 182. The artists referred to, and the dates of their first solo exhibitions are Pollock, November 1943; Hofmann (first New York solo), March 1944; Baziotes, October 1944; Motherwell, October–November 1944; Rothko, January 1945; Still, February 1946. Gorky, de Kooning, Gottlieb, and Newman did not have solo exhibitions at Art of This Century.
4. In an earlier stage of his career, Greenberg had advanced a more complex and historical account of the origins of avant-gardism in nineteenth-century France. He never applied this earlier analysis or anything like it to the American case. See Greenberg, "Avant-Garde and Kitsch"; and Clark, "Clement Greenberg's Theory of Art."
5. See, for example, Guilbaut, *How New York Stole the Idea of Modern Art*, 154–55. Guilbaut claims that in late 1947 and 1948 "the avant-garde really emerged from obscurity and organized in a sufficiently cohesive and aggressive manner to seriously trouble the public, the critics, and some museums."
6. Guilbaut, *How New York Stole the Idea of Modern Art*, 77, 121.
7. Criticism of Greenberg's positions is relatively uncontroversial nowadays. The same is not true of criticism of Guilbaut. Lest my taking issue here with him be misconstrued as a mark of agreement with reactionary art historians who dismiss his arguments in the interest of preserving an illusionary apoliticality and transcendence in New York School art, I hasten to balance my remarks. In my view, Guilbaut's book marks an important step in the right direction, and I have taken his arguments as my point of departure more than once in the following pages. If my attention is centered on what I see as weaknesses or gaps in his account, it is so because I consider much of his work worth developing.
8. "Artists Denounce Modern Museum," *New York Times*, 17 April 1940, 25.
9. Bürger, *Theory of the Avant-Garde*.
10. The collective dimension of avant-gardism has often been ignored by writers emphasizing the allegedly prophetic, anticipatory character of avant-garde art. Such an emphasis may be coupled with an image of the artist as completely isolated. As Nicos Hadjinicolaou observes in his critique of the ideology of avant-gardism, "the key image (predominant at least until the end of World War II) is essentially romantic: the solitary artist who is misunderstood by his contemporaries but who will be discovered and appreciated by posterity, when future generations have reached the stage he now occupies" (Hadjinicolaou, "On the Ideology of Avant-Gardism," 55). The difficulties presented by this emphasis, notably its linear conception of history and its historical determinism, are noted by Hadjinicolaou, but the basic point was made earlier by Renato Poggioli (*Theory of the Avant-Garde*, 70–71).
11. See Zola's early description of this avant-garde dynamic in *Masterpiece*, 85, 196, 200, 334–35. The dynamic is by no means restricted to artistic collectives; see, for example, Stocking, "Ideas and Institutions in American Anthropology," 7, for discussion of an anthropological variation provided by the Boasian school.
12. For evidence of the influence of the Museum of Modern Art paradigm, see Newman, "Sobre el arte moderno."

13. Smith's description of this process is revealing: "We once formed a group, Graham, Edgar Levy, Resnikoff, de Kooning, Gorky and myself with Davis being asked to join. This was short-lived. We never exhibited and we lasted in union about thirty days. Our only action was to notify the Whitney Museum that we were a group and would only exhibit in the 1935 abstract show if all were asked. Some of us were, some exhibited, some didn't, and that ended our group" (from notes from a sketchbook of circa 1952, titled "Atmosphere of the Early Thirties," in McCoy, *David Smith*, 86).

14. These benefits were made explicit in Jewell, "'Organized' Artist."

15. A letter from Louis Harris to Gottlieb written in early June 1949 calls upon him to write to the *Times* in the name of the federation "condemning the stand of the Congressman Dondero" (AG Papers, AAA-SI N/69-49: 445).

16. FMPS protests addressed the following exhibitions: (a) Carnegie Institute, Pittsburgh, "Directions of American Painting," and Whitney Museum, New York, "Artists under Forty," letter published in the *New York Herald Tribune*, 25 Nov. 1941, and *Art News*, 15–31 Jan. 1942, 4; (b) Museum of Modern Art, New York, "Americans 1942," letter published in the *New York Times*, 3 Feb. 1942, 21; (c) Metropolitan Museum of Art, New York, "Artists for Victory," letter published in *Art Digest*, 15 Feb. 1943, 8; (d) Museum of Modern Art, New York, "Realists and Magic Realists," letter not published; described in MoMA memo by J. T. Soby, quoted in Lynes, *Good Old Modern* (1973), 230; (e) Museum of Modern Art, New York, "Romantic Painting in America," letter published in *Art Digest*, 1 Jan. 1944, 6; also quoted by Greenberg, in *Nation*, 12 Feb. 1944, 195–96.

17. *New York Times* critic Edward Alden Jewell's "befuddlement" before paintings by Rothko and Gottlieb, among others, prompted a now-famous letter of response from these two artists, aided anonymously by Newman. This letter and Jewell's comments provoked a number of responses from readers, some objecting to the obscurity of the art. Jewell dubbed the work of Gottlieb and Rothko "globalism," in response to the anti-isolationist manifesto that appeared in the pamphlet for the exhibition, which was the third annual group show of the FMPS, held at the Wildenstein Gallery. See the *New York Times*, 2 June 1943, p. 28; 6 June 1943, sec. 2, p. 9; 13 June 1943, sec. 2, p. 9; and 27 June 1943, sec. 2, p. 6.

18. Some of Clyfford Still's correspondence, together with his periodic withdrawal of his work from the market in the later 1940s, mark him as one possible exception to this rule.

19. See Jewell, "'Progress' under Fire."

20. A version of the list in the Pollock Papers indicates that Krasner and Pousette-Dart were late additions and that Norman Daly, Gordon Onslow-Ford, and Attilio Salemme were considered but not included (JP Papers, AAA-SI 3048: 939). The most striking absences, both in retrospect and in light of the early assessments of the new movement, are Baziotes, Lee Hersch, and Motherwell. The now-forgotten Hersch was a notable presence in the early attempt to define a New York school. He moved to Paris shortly after this time and dropped out of the artistic scene.

21. The exhibition entitled "A Painting Prophecy—1950," held in February 1945 at the David Porter Gallery in Washington, D.C., was the first exhibition organized around the new tendency.

22. A copy of the pamphlet is in AG Papers, AAA-SI N/69-49: 285.

23. Jewell, "Toward Abstract, or Away?"

24. BN Papers, AAA-SI 3481: 313; letter from Rothko to Newman dated 31 July 1945.

25. Rothko, letter to editor, *New York Times*, 8 July 1945, sec. 2, p. 2.

26. Gottlieb's objections were published two weeks later; see letter to editor, *New York Times*, 22 July 1945, sec. 2, p. 2.

27. Pollock, *Arts and Architecture*.

28. JP Papers, AAA-SI 3046: 291–93, 295, 298. See also Lader, "Howard Putzel." On connection with Hofmann, see JP Papers, AAA-SI 3046: 292–93.

29. Hofmann's response to Jewell's article was ambiguous and mystical, written in the language of Kandinsky, but basically supportive of Putzel's position (see Hofmann, letter to editor, *New York Times*, 15 July 1945, sec. 2, p. 2). Pollock apparently did not write to Jewell on this occasion.

30. Jewell, "'Organized' Artist." As evidence that this ideology flourishes in recent work on the New York School, compare the following: "To be sure, the most significant qualities in an artist's work—those that embody its artistic identity—issue from an individual's solitary efforts." (Sandler, *Triumph of American Painting*, 3.)

31. The photograph was apparently commissioned by *Life* magazine from the photographer George Karger, perhaps for coverage of Peggy Guggenheim's Art of This Century and the young U.S. artists she represented.

32. From [Georges Braque], "Testimony against Gertrude Stein," 13. A word of qualification is necessary here. This particular quest for anonymous originality was strictly circumscribed: Picasso and Braque refused to associate with the "Salle 41" Cubists, the better to preserve their prestige as founders of the movement. While profound aesthetic collaborations in modern art history usually occur only among very small groups, the Picasso-Braque dyad is a limiting case. Nonetheless, it can serve as a convenient armature upon which to hang discussion of the possibility and advantages of collaboration.

33. Hunter, "Among the New Shows," 9 Nov. 1947.

34. Tomlin to Newman, BN Papers, AAA-SI 3481: 294–95; letter dated 5 Dec. 1949.

35. William Baziotes to Christos Baziotes, 29 Nov. 1946, William Baziotes Papers, AAA-SI N/70-24: 70–71; and Mark Rothko to Barnett Newman, 8 Aug. 1950, BN Papers, AAA-SI 3481: 345–46.

36. Rothko to Newman, BN Papers, AAA-SI 3481: 323.

37. Tomlin to Newman, 3 Nov. 1949, BN Papers, AAA-SI 3481: 290.

38. Riley, "Whither Goes Abstract and Surrealist Art?", 31. Coates, "Assorted Moderns," 51; Porter, *Personal Statement,* the catalogue for the exhibition "A Painting Prophecy—1950," Feb. 1945 (see also the publicity release for the packaged version of the exhibition, which was offered for rental to exhibiting institutions nationally, in JP Papers, AAA-SI 3048: 920); Sweeney, "Art Chronicle"; and id., "Five American Painters" (the fifth painter was Milton Avery).

39. Rothko quote in Porter, *Personal Statement;* Newman in "Sobre el arte moderno"; English original text published in BN-SWI, p. 69.

40. Greenberg, "Art," *Nation*, 25 Dec. 1948, 733; reprinted in CG-CEC 2:269.

41. My translation, from Greenberg, "L'art américain au XXe siècle," 349–50. The original English text has been lost. The French reads:

> La peinture française de la lignée Cézanne-Picasso-Miro avait été pour eux une discipline technique et formelle, mais elle n'avait pas fourni de matière émotionelle. L'exemple du Surréalisme les incita à introduire dans leurs tableaux des symboles et des métaphores tirés des théories freudiennes, archéologiques et anthropologiques. Cet appareil littéraire a très peu de substance en lui-même et le contenu que les artistes lui attribuent me paraît illusoire. Mais cela contribua à les aiguiller vers une peinture d'un genre gothique, néo-expressionniste et abstrait qui est plus vraie et plus originale que leurs imitations de Picasso et de Miro. Cette oeuvre produit une impression baroque, élaborée, qui fait penser à Poe et elle est remplie d'une sensibilité sadique et scatologique. Cependant elle est disciplinée par des ambitions formelles et respecte la plupart des contraintes auxquelles Matisse, Picasso et Miro ont soumis l'usage de l'illusion de la profondeur.

42. See, for example, Sandler, *Triumph of American Painting.* Sandler's reconciliation of Rosenberg and Greenberg is effected via temporal distinctions (prior to 1947 Greenberg and structure dominate, after 1947 action painting comes into play) or intragroup discrepancies (gestural painting is Rosenbergian, color-field abstraction is Greenbergian).

43. This argument should be extended to the broader history of modernism, spanning roughly the past century and a half. David Harvey has described modernism generally as a "complex and often contradictory affair." He cites a passage from Bradbury and McFarlane in which they describe it as "an extraordinary compound of the futuristic and the nihilistic, the revolutionary and the conservative, the naturalistic and the symbolistic, the romantic and the classical. It was a celebration of a technological age and a condemnation of it; an excited acceptance of the belief that the old régimes of culture were over, and a deep despairing in the face of that fear; a mixture of convictions that the new forms were escapes from historicism and the pressures of the time with convictions that they were precisely the living expression of these things" (Bradbury and McFarlane, *Modernism,* 46; quoted in Harvey, *Condition of Postmodernity,* 24).

44. My translation, from Greenberg, "L'art américain au XXe siècle," 345:

Leur art est encore ésotérique, émotionnel à l'excès et l'oeuvre de Cézanne, Picasso et Braque est encore si peu comprise—si ce n'est peut-être par Marin—que la troisième dimension continue d'être indiquée par le clair obscur ou la couleur atmosphérique.

Many artists in the Stieglitz group aimed to convey through their work an emotion that some phenomenon had engendered in them. In the words of Abraham Walkowitz: "I am seeking to attune my art to what I feel to be the keynote of an experience. . . . When the line and color are sensitized, they seem to me alive with the rhythm which I felt in the thing that stimulated my imagination and expression. If my art is true to its purpose, then it should convey to me in graphic terms the feelings which I received in imaginative terms" (quoted in Davidson, *Early American Modernist Painting,* 37).

45. Greenberg, *Nation,* 15 June 1946, p. 727; reprinted in CG-CEC 2: 85–86.

46. My translation, from Greenberg, "L'art américain au XXe siècle," 344:

Il coincidait avec un moment de l'histoire de l'Occident où la stabilité de la société et les succès ininterrompus du capitalisme avaient fait naître le désir d'explorer tous les domaines de l'art. Le matérialisme et le radicalisme, tous deux pénétrés de confiance en l'homme, fournissaient un tremplin aux élans de l'intelligence et de l'imagination.

L'Amérique avait connu depuis les environs de 1900 cette disposition d'esprit qui se traduisit par la montée du socialisme en politique, le pragmatisme en philosophie, et, dans le domaine des lettres et des arts, par l'apparition de poètes tel que T. S. Eliot, Ezra Pound, Marianne Moore et Wallace Stevens; de peintres comme Joan [sic] Sloan, William Glackens et Maurice Prendergast.

47. My translation, from Greenberg, "L'art américain au XXe siècle," 343:

une vapeur informe d'émotion messianique, d'ésotérisme, de rhétorique emportée et irre-sponsable n'ayant guère de rapport avec l'art en question.

48. See *View,* May 1942, June 1943, Feb./March 1942.

49. Pollock, Interview, *Arts and Architecture,* 14. An even earlier statement on this point was from Richard Pousette-Dart, a peripheral figure in the group. He wrote, circa 1940, that "art is only significant as it takes us to the whole man and gives us new insights and opens secrets toward the unknown heart of our total mystic awareness" (quoted in Hobbs, "Confronting the Unknown Within," 98).

50. Motherwell, "Modern Painter's World," 13.

51. Rothko, letter to the editor, *New York Times,* 8 July 1945, sec. 2, p. 2.

52. Newman, "The Sublime Is Now," 53. The italics are Newman's.

53. From the transcript of a taped interview conducted by William Wright in 1950, broadcast in 1951 on station WERI, Westerly, R.I. (hereafter, Wright interview of Pollock). Published in JP-CR 4: 248, 250.

54. Tworkov, "Wandering Soutine," 31; and interview conducted by Dorothy Seckler, 17 Aug. 1962, 8, in AAA-SI.

55. Newman, "Plasmic Image," 140.

56. Kootz, letter to the editor, *New York Times*, 25 Jan. 1931, sec. 8, p. 12; and Kootz, letter to the editor, *New York Times*, 10 Aug. 1941, sec. 9, p. 7. See Guilbaut, *How New York Stole the Idea of Modern Art*, 64–67, for a further discussion of Kootz and the letter of August 1941.

57. Kootz and Rosenberg, *The Intrasubjectives*, unpaginated.

58. Newman, from catalogue statement for the São Paulo Bienal in 1965; reprinted in BN-SWI: 187; and Gottlieb, from "Jackson Pollock: An Artists' Symposium, Part 1," 31.

59. Schapiro and Janson in Davenport, "*Life* Round Table on Modern Art"; Schapiro ("later") in "Recent Abstract Painting," 223. Schapiro's approval stands in stark contrast to the position he took twenty years earlier: "An individual art in a society where human beings do not feel themselves to be most individual when they are inert, dreaming, passive, tormented or uncontrolled, would be very different from modern art. And in a society where all men can be free individuals, individuality must lose its exclusiveness and its ruthless and perverse character" ("The Social Bases of Art," proceedings of the *First American Artists' Congress* (1936): 37).

60. Gray, "Narcissus in Chaos," 439–40. Gray's position is quite similar to the one voiced by Meyer Schapiro in 1936, cited in the preceding footnote.

61. Quoted in Rodman, *Conversations with Artists*, 82.

62. Preston, "Early Exhibitions."

63. Annalee Newman has objected to this sort of characterization; see her letter to the editor of *Arts Magazine*, Sept. 1977, 41. Nonetheless, contemporary letters indicate that Rothko, who was very close to Newman in the mid-1940s, considered the latter primarily a writer. A letter from Rothko dated 31 July 1945 reveals that he and Newman thought of trying to get Newman a job as art critic for the *New York Times*. The same letter also matches Rothko's production of paintings to Newman's of chapters (probably of "The Plasmic Image"). (See BN Papers, AAA-SI 3481: 313–14.)

64. Newman, "Plasmic Image," 153. The last sentence was apparently deleted by the editor of BN-SWI, but it appears in Hess, *Barnett Newman* (1971), 39.

65. See Newman, "Sobre el arte moderno," 27–29. (English original published in BN-SWI: 69.)

66. Newman, "Plasmic Image," 155.

67. See, for example, Newman's catalogue essay, *Drawings by Adolph Gottlieb*, an exhibition in 1944; or his letter to Greenberg published in the *Nation*, December 1947.

68. Rothko quote from *Clyfford Still*, his essay for the catalogue of the Still exhibition at Art of This Century, February–March 1946. There were, of course, differences even within this subgroup, as the contrasting verdicts of Rothko and Newman on the "Problem for Critics" exhibition indicate. A provocative passage in a letter from Rothko, who was teaching in San Francisco, to Newman offers further evidence of this: "As to the lectures, the whole matter you wrote about never came up and I have never had to deal with it at all. . . . Our discussions, that is between you and me were strictly a personal matter, and since our terminology differs, our conflicts were never duplicated here." (BN Papers, AAA-SI 3481: 331–32; letter dated 19 July 1947.)

69. Newman, *Ideographic Picture* (exhibition catalogue), reprinted in BN-SWI: 108.

70. Ibid.

71. Personal communication, dating from 1986, between Richard and Evelyn Pousette-Dart and W. Jackson Rushing, cited in Rushing, "Impact . . . on Newman's Idea of Redemption," 194, n. 5.

72. Newman, "Plasmic Image," 141; and id., *Ideographic Picture*, reprinted in BN-SWI: 108.

73. D. Smith, "Abstract Art," 6, 15.

74. Still to Betty Parsons, 10 March 1948; Betty Parsons Papers, AAA-SI N/68-72: 663. For

explicit critiques of science and positivism as the dominant ideas of modernity, see also
Rothko, "Romantics Were Prompted," 84; and Newman, "First Man Was an Artist," 57–58.

339

NOTES TO PAGES

43–53

75. Wright interview of Pollock, JP-CR 4: 249.

76. Handwritten note, circa 1950, published in JP-CR 4: 253.

77. On Mythmakers, see Greenberg, "Art" (Dec. 1947), 630; on Pollock, see "Present Prospects of American Painting and Sculpture," 26.

78. Greenberg, "Art" (Dec. 1947), 630.

79. Rosenberg, "Introduction to 'Six American Artists.'"

80. Reinhardt, *How to Look at Modern Art in America* (figure), *PM*, 2 June 1946, m13. Hess claims that there is "often no particular order in the placement of the artists' leaves." This is not at all the case. The problem is that Hess' retrospective categories do not correspond to Reinhardt's. See Hess, "Art Comics of Ad Reinhardt."

81. See, for example, Montgomery Museum of Fine Arts, *Advancing American Art;* and Guilbaut, "Frightening Freedom of the Brush."

82. Letter dated 9 March 1948; Herbert Ferber Papers, AAA-SI N/69-133: 50.

83. See "Artists' Sessions at Studio 35 (1950)," edited by Robert Goodnough, in Motherwell and Reinhardt, *Modern Artists in America,* 10, 21.

84. De Kooning, "What Abstract Art Means to Me," 7.

85. By the end of the decade Greenberg, and to a lesser degree Rosenberg, had joined the ranks of those heralding the arrival of the New York School. See Guilbaut, *How New York Stole the Idea of Modern Art,* chap. 4.

86. Guilbaut, *How New York Stole the Idea of Modern Art,* 143, 202.

87. Tomlin to Herbert Ferber, 27 Sept. 1949; Herbert Ferber Papers, AAA-SI N/69-133: 73.

2. THE MYTHMAKERS & THE PRIMITIVE

1. The lyrics were published in "World Fair March Is Gershwin Tune," *New York Times,* 24 April 1938, sec. 2, p. 1.

2. Rodman, "What's Wrong with the 'World of Tomorrow'?", 7.

3. The quote is from the editor's introduction to Cram, "Why We Do Not Behave Like Human Beings," 418.

4. The letter, written with Barnett Newman's help, was published in Jewell, "'Globalism' Pops into View."

5. Gottlieb and Rothko, "Portrait and the Modern Artist." Typescript reprinted in Alloway and MacNaughton, *Adolph Gottlieb,* 170.

6. The notes date from 2 to 7 June 1943. MR Papers, AAA-SI 3135: 1, 3, 7.

7. Rothko was still in the early stages of establishing a new artistic identity for himself. Five months earlier he had been exhibiting work in the style of figurative expressionism he had practiced since the mid-1930s and for which he had become known. In February he made the break publicly to a new mode, and at the Federation of Modern Painters and Sculptors Annual Exhibition that June, from which Jewell had singled out his painting (see chap. 1, n. 17), presented it for only the second or third time.

8. The place of primitivism in the modern tradition had been described by Alfred Barr in various exhibitions at the Museum of Modern Art (see Barr's letter to the *College Art Journal* [Fall 1950]), and by Goldwater in *Primitivism in Modern Painting.*

9. MR Papers, AAA-SI 3135: 2, 3.

10. This "primordialism"—or imagery evoking a "fusion of geology, microbiology, and astronomy to atavistic myth"—has been described by Jeffrey Weiss in "Science and Primitivism," 86.

11. Some of the diversity contained within the category *primitivism* is suggested by the essays in the Museum of Modern Art catalogue *"Primitivism" in 20th Century Art,* ed. William Rubin.

12. Kuper, *Invention of Primitive Society,* 1, 231.

13. Ibid., 7.

14. See Meyer Schapiro's classic discussion of this question in section 2 of "Nature of Abstract Art." For more recent considerations of this and other problems of primitivism, see Hiller, *Myth of Primitivism.*

15. Torgovnick, *Gone Primitive,* 17.

16. Di Leonardo, "Otherness Is in the Details," 534.

17. See Clifford, "On Ethnographic Surrealism."

18. "Anthropology Held Essential to Victory," *New York Times,* 3 Jan. 1943, sec. 1, p. 35. The article is based on a report by Elsie V. Steedman of the anthropology department at Hunter College.

19. Walker, "Anthropology as a War Weapon," 85.

20. Keesing, "Applied Anthropology in Colonial Administration," 373.

21. See Kuper, *Invention of Primitive Society;* Godelier, *Perspectives in Marxist Anthropology,* 25–26; and Said, "Representing the Colonized."

22. See Boas' letter to the *Nation,* 20 Dec. 1919. The full story is told in Stocking, *Race, Culture, and Evolution,* chap. 11.

23. Radin, *Racial Myth;* Seligmann, *Race against Man;* Benedict, *Race: Science and Politics;* Montagu, *Man's Most Dangerous Myth.*

24. Linton, "Present World Conditions in Cultural Perspective," in *Science of Man in the World Crisis,* 201. The book was the product of a conference held the previous year.

25. Kittredge, "An Anthropologist Looks at the War," 7.

26. Ibid., 20.

27. Howells, "Can We Catch Up with Our World?" 10.

28. Mead, "Not Head-hunters, nor Appeasers, but *Men,*" 3.

29. For reasons of manageability I have had to select a representative sampling of professional anthropologists as a focus for the following discussion. In general I have chosen those anthropologists whose work was both relevant to the issues under discussion and influential within and beyond the discipline of anthropology at the time. I have leaned heavily upon precisely those professionals whose work was cited most frequently in the Modern Man literature and who have populated the intellectual histories of the New York School. As examples of the latter, see especially Polcari, "Intellectual Roots of Abstract Expressionism: Mark Rothko"; and id., "Intellectual Roots of Abstract Expressionism: Clyfford Still." The work of Dore Ashton is also relevant here; see her *New York School* and *About Rothko.* This focus explains the presence of Frazer and Lévy-Bruhl in my discussion, although strictly speaking their work belonged to a prior generation and had come under considerable criticism before World War II. (See, for example, Wittgenstein, "Bemerkungen über Frazers *The Golden Bough*"; Douglas, "Judgments on James Frazer"; Radin, *Primitive Man as Philosopher,* 28–29, 387; and Evans-Pritchard, "Lévy-Bruhl's Theory of Primitive Mentality.") Nonetheless, despite its questionable status in the 1930s and 1940s, the work of Frazer and Lévy-Bruhl has much to tell us concerning the ideological character of the anthropology of the Modern Man authors, the New York School artists, and the chroniclers of the latter.

30. See Marcus and Fischer, *Anthropology as Cultural Critique,* 22.

31. *Golden Bough,* 823.

32. Boas, *Primitive Art,* 103.

33. *Generation of Vipers,* 102.

34. Robinson, *Mind in the Making,* 82. By "far less critical," I believe, Robinson meant that ideas about human nature had been less subjected to critical, rational examination than had beliefs about phenomena in the natural world.

35. *Escape from the Primitive,* 161.

36. P. 36. See also Dollard, *Victory Over Fear,* 188.

37. Jill Lloyd suggests two possible sources for the belief in analyzing its acceptance by certain

German Expressionist artists. One is in the work of Sigmund Freud, for example, "Psycho-Analytic Notes on an Autobiographical Account of a Case of Paranoia (The Case of Schre-ber)," 82. The other is in the writings of Georg Simmel, for example, "Metropolis and Mental Life," 332. See Lloyd, "Primitivism and Modernity," 108, n. 26.

38. Some of Evans-Pritchard's work is of interest here, although it dates from slightly later than the period under discussion. Near the end of *Nuer Religion* (1956), he registers his disagree-ment with certain "laymen" (in this case two missionaries) about the extent to which fear determined (religious) ideology in tribal societies.

> Miss Ray Huffman says that their (Nuer) religion is one of fear, and I feel I ought to say, and I do so with her permission, that this is the one point with which Dr. Mary Smith finds serious fault in my account of it. She, like Miss Huffman, holds that it is a religion of fear, even of terror. For me this is an over-simplification and a misunderstanding. It is true that Nuer, like everyone else, fear death, bereavement, sickness, and other troubles, and that it is precisely in such situations that they so often pray and sacrifice. It can be admitted also that, in that these troubles are manifestations of Spirit, they fear Spirit and wish to be rid of it. But we cannot say that on that account their religion is simply one of fear, which is, moreover, a very complex state of mind, and one not easy to define or assess. On the contrary, it is because Nuer are afraid of these misfortunes that one might speak of their religion as one of hope and comfort. But I think what fits the facts best is to say that it is a religion of both fear and trust, which may be opposites but are not contraries, or that the Nuer attitude towards Spirit might be described as ambiguous, and perhaps as ambivalent. (P. 312.)

I am grateful to T. J. Clark for directing me to this passage.

39. Quote from *Golden Bough*, 105. For characteristics of primitive religion described in this paragraph, see ibid., pp. 67, 89, 377, 85, 95.

40. Benedict, *Patterns of Culture*, 119; and Radin, *Primitive Man as Philosopher*, 98–99, 113. Radin's fieldwork focused on the Winnebago Indians, but he was not among those anthro-pologists reluctant to extend their findings to the generic category *primitive man*.

41. Fergusson, *Modern Man*, 176.

42. Boas, *Primitive Art*, 325.

43. Frazer, *Golden Bough*, 127.

44. Mumford, *Condition of Man*, 413.

45. *Modern Man*, 176.

46. Langer, "Lord of Creation," 128, 150.

47. Fergusson writes, for example, in *Modern Man*, "It is further evident that a rural village controls the individual behavior in a way and in a degree that the city does not, and in very much the same way that the primitive tribe does" (p. 94); and "Rousseau put forth the notion that primitive man has a high degree of what is sometimes called "natural freedom" and that civilization has robbed him of it. This myth of primitive freedom has been completely eroded by modern anthropology and not much is heard about it any more" (p. 96).

48. Malinowski, *Crime and Custom in Savage Society*, 3. A similar case was made by Radin in *Primitive Man as Philosopher*, 36–38, and chaps. 4 and 5.

49. Benedict, *Patterns of Culture*, chap. 4, which discusses the Zuñi, a Pueblo tribe of New Mexico.

50. Beyond this general observation, Modern Man literature does not offer much of a foothold from which to observe and appraise the ideological character of the anthropological work with which I have contrasted it. The mutual critique is lopsided. More productive bases for critical analysis of the professional anthropology in question have been Marxism and recent para-digms of literary theory and interpretation. For the former, see Godelier, *Perspectives in Marxist Anthropology;* and Vidich, "Ideological Themes in American Anthropology." For the latter, see, for example, Marcus and Fischer, *Anthropology as Cultural Critique;* and Clifford

and Marcus, *Writing Culture*. For a valuable critique of postmodern analyses, see Said, "Representing the Colonized." On the United States specifically, see Wolf, "American Anthropologists and American Society."

51. Said, *Orientalism*, 203.

52. See Clifford, "On Ethnographic Surrealism."

53. *Invention of Primitive Society*, 240.

54. *Gone Primitive*, 9.

55. See Brinkley, *Voices of Protest*, 261.

56. Linton, "Present World Conditions in Cultural Perspective," in id., *Science of Man in the World Crisis*, 201–02.

57. From "Lesson of Dachau." Quoted in Peter Kurth, *American Cassandra: The Life of Dorothy Thompson* (Boston: Little, Brown, 1990), 375–76.

58. "Lesson of Dachau," 375–76.

59. Niebuhr, *Nature and Destiny of Man*, vol. 1, pp. 23–24.

60. Quoted in Kurth, *American Cassandra*, 368.

61. It is important to note that not all contemporary texts analyzing "modern man" belong to the discourse I have described. The locution was ubiquitous at the time. What I am calling Modern Man discourse defines a particular set of tendencies within the larger discussion. See Chapter 4.

62. See his "New Sense of Fate," 164–69.

63. "Escultura pre-Columbina en piedra," 57. Text quotation is from English original, published in BN-SWI, 65. The English texts of Newman's articles which were translated into Spanish and published in that language were not available until publication in BN-SWI in 1990.

64. Gottlieb and Rothko, "Portrait and the Modern Artist," 171.

65. For Newman, see, for example, "Escultura pre-Columbina en piedra," 54, 59. Gottlieb and Rothko quote is from "Portrait and the Modern Artist," 171.

66. See Rubin, *"Primitivism" in 20th Century Art;* and the exchange in *Artforum* between Rubin and Thomas McEvilley over this catalogue and the accompanying exhibition at the Museum of Modern Art: "Doctor Lawyer Indian Chief," Nov. 1984, 54–61; "Letters," Feb. 1985, 42–51; "Letters," May 1985, 63–71. Also see Clifford, "Histories of the Tribal and the Modern."

67. Gottlieb and Rothko, "Portrait and the Modern Artist," 171.

68. "U.S. Scene," *Time*, 24 Dec. 1934, 24–25. The quotation is from a photo caption which does not make clear whether the author of the caption is paraphrasing Curry or giving an interpretation of the picture.

69. She quotes Pechstein as seeing in South Seas sculpture the natives' "trembling piety and awe before the incomprehensible powers of nature; their hopes and thrills, their fears and their subservience to unavoidable fate." (Lloyd, "Primitivism and Modernity," 108.)

70. Calas, "Painting in Paris Is Poetry," 43–44.

71. In Soby, *Salvador Dalí*, 8.

72. Newman, "New Sense of Fate," 166.

73. "Las formas artísticas del Pacífico," *Ambos Mundos* (June 1946). The text here quotes from the English original, "Art of the South Seas" (1946), published in *Studio International* (Feb. 1970): 70, and in BN-SWI: 100.

74. Newman, "New Sense of Fate," 168.

75. "Escultura pre-Columbina en piedra," *La Revista Belga* 1 (August 1944): 56–57. Text quote from the English original, published in BN-SWI: 64.

76. Rushing, "Impact of Nietzsche and Northwest Coast Indian Art on Barnett Newman's Idea of Redemption in the Abstract Sublime."

77. Gottlieb and Rothko, "Portrait and the Modern Artist," 171.

78. See Ettlinger, "German Expressionism and Primitive Art," 200.

79. Vardo was listed among *Fortune*'s contributing designers between November 1943 and February 1944.

80. "Lord of Creation."

81. Lowenthal, *Literature and the Image of Man,* 192. Lowenthal continues, "Paradoxically, this new type of submission to nature is closely related to political submission."

82. An optimistic and pragmatic gloss on Freudianism was characteristic of its reception in the United States. See the discussion in Seeley, "Americanization of the Unconscious"; and in Turkle, *Psychoanalytic Politics,* 48.

83. "Las formas artisticas del Pacifico," *Ambos Mundos* (June 1946). My text quotes from the English original, "Art of the South Seas" (1946), published in *Studio International* (February 1970): 70, and in BN-SWI: 100. The italics have been added.

84. Newman, "The New Sense of Fate," 169.

85. There is some confusion about the title of this picture. The painting is reproduced and described as *Alphabet of Terror* in a review of Gottlieb's March 1945 exhibition at 67 Gallery (see *Art Digest* [1 April 1945]: 49). However, the title inscribed on the back of the painting is *Eyes of Oedipus.* It is possible that the photograph was miscaptioned in the review, and, alternatively, it is possible that Gottlieb decided to change the title of the picture sometime after the exhibition. Both titles are typical for Gottlieb at this time—continuous, for example, with *Ancient Motif* (1942), *Archaic Theme* (1942), *Oedipus* (1942), *Narcissus* (1945), *Expectation [or, Premonition] of Evil* (1946), *Oracle* (1947). I am grateful to Sanford Hirsch for his help in investigating this discrepancy.

86. Rothko's drafts for his letter to the *New York Times* reveal that his inclination was to call this painting *Assyrian Bull* (see MR Papers, AAA-SI 3135: 6). We might wonder why, if Rothko wanted to help onlookers, as he claimed, he ultimately directed them to the art of the wrong culture, a culture in which the bull was not a significant symbol. Gottlieb later punned on the title of this painting in his own *Cerulean Bull* (1945). Rothko's other primitivizing titles from this period include *Omen of the Eagle* (1942), *Archaic Idol* (1945), *Archaic Phantasy* (1945), *Primeval Landscape* (1945), and *Totemic Sign* (1946).

87. See, for example, Ashton, *About Rothko.*

88. Gottlieb and Rothko, "Portrait and the Modern Artist," 171.

89. Radin, *Primitive Man as Philosopher,* 99.

90. Ibid., xiv. Radin acknowledged Robinson and Boas as his most influential teachers.

91. *Primitive Man as Philosopher,* 176.

92. Radin focuses on myths in which transgression of an ethical code always precedes downfall (see *Primitive Man as Philosopher,* 178–207).

93. Lévi-Strauss, "Art of the Northwest Coast at the American Museum of Natural History," 180.

94. For example, see Still's letter to Betty Parsons, quoted in Chapter 1, when he removed his paintings from the market in March 1948. He made the same gesture many times.

95. On the "mock-heroic," see Newman, *Pre-Columbian Stone Sculpture* (BN-SWI: 61–62); and id., *Herbert Ferber* (BN-SWI: 110–11).

96. My text is from the English original, published in BN-SWI: 64. There are significant discrepancies between this passage and the Spanish version, published in "Escultura pre-Columbina en piedra," *La Revista Belga* 1 (Aug. 1944): 57.

En estas máscaras el artista ha conseguido representar no el simple retrato de un hombre sino el concepto abstracto hombre. Puede decirse que su arte era un arte religioso sacado de lo más profundo del alma humana. La figura sagrada azteca tiene un patetismo no sobrepasado en el arte religioso de la Europa occidental.

Whereas the Spanish locates the achievement of the masks in their representation of a generalized, abstract conception of man, the English points to them as expressions of life's greatest mystery—death.

97. Rothko, "Romantics Were Prompted," 84.

98. Other artists in New York in the 1940s were discovering the same antirational, transcendental significance in the primitive. See, for example, Kochnitzky, "Magic Portico," 19.

99. "Primitivism and Modernity," 106.

100. Von Koenigswald, "Search for Early Man," 48. Von Koenigswald's discoveries were made known to the general public through this essay and through reports in the popular press of his discoveries, e.g., *Newsweek,* 29 July 1946, 50; and *New York Times,* 15 July 1946, 27.

101. Quotes are from Newman, "First Man Was an Artist," 57, 57–58.

102. These assertions of Newman's recall a very early popularization of Freudian theory, in which an anonymous staff writer in *Scribner's* magazine speculated about primitive man's "stammerings . . . in the face of cosmic events" ("Point of View," Sept. 1909, 380). The subject of the essay was "the sub-conscious self" and the place of dreams in studying it.

103. "First Man Was an Artist," 60.

104. Ibid., 59.

105. Hook, "New Failure of Nerve," 3. See also Gilbert, *Writers and Partisans,* 253–82.

106. Lowenthal, "Terror's Atomization of Man," 8.

107. Adorno and Horkheimer, *Dialectic of Enlightenment,* 36.

108. *Pre-Columbian Stone Sculpture,* 61–62.

109. "Escultura pre-Columbina en piedra," 51. My text quotes the English original, published in BN-SWI: 63.

110. *Pre-Columbian Stone Sculpture,* 62.

111. The other two articles were "Sobre el arte moderno" and "La pintura de Tamayo y Gottlieb."

112. Associated Press story of 17 Aug. 1940, quoted in Lynes, *Good Old Modern,* 222. See also "Defense Post Goes to N. Rockefeller," *New York Times,* 17 Aug. 1940, 6; Rockefeller's essay "The Cooperative Spirit of the Americas," *Arts and Architecture* (Oct. 1942): 23, 50; and Eva Cockcroft, "Abstract Expressionism." It should be noted that several anthropologists participated in this larger project by teaching and working in Latin American countries under the auspices of the Institute of Social Anthropology at the Smithsonian Institution. See Stocking, "Ideas and Institutions in American Anthropology," in idem., *Selected Papers from the American Anthropologist,* 35.

113. "Defense Post Goes to N. Rockefeller."

114. Quotes from Alfred H. Barr, Jr., foreword to Kirstein, *Latin-American Collection of the Museum of Modern Art.* For MoMA wartime contracts, see the chronology in Barr, *Painting and Sculpture in the Museum of Modern Art,* 625–35.

115. Jewell, "Where Contemporary Banners Fly."

116. See *Bulletin of the Museum of Modern Art,* April/May 1941, p. 9.

117. Papers of the Federation of Modern Painters and Sculptors (hereafter, FMPS), AAA-SI N/69-75: 12, 15.

118. See "Latin America to See Exhibits of U.S. Art," *New York Times,* 12 April 1941, 18; and E. A. Jewell, "Art of 5 Museums to Be Seen Today," *New York Times,* 19 April 1941, 13.

119. See papers of FMPS, AAA-SI N/69-75: 13, 20.

120. See, e.g., "Sobre el arte moderno," 32.

121. "Deep understanding . . ." is from Newman, "La pintura de Tamayo y Gottlieb," 19; "An analysis . . ." from ibid., 17; and "Tamayo . . . understands . . ." from ibid., 20. My text quotes the English original, BN-SWI, pp. 73, 71–72, 74.

122. Quoted in Rushing, "Ritual and Myth," 277.

123. Quotes from Douglas and d'Harnoncourt, *Indian Art of the United States,* 9.

124. Berkhofer, *White Man's Indian,* 184.

125. House Joint Resolution 276, submitted by Clark Burdick, Representative from Rhode Island, 76th Cong., 1st sess., 26 April 1939. Quoted in Fryd, "Two Sculptures for the Capitol," 17, 37.

126. House Resolution 176, submitted by James Francis O'Connor, Representative from Montana, 77th Cong., 1st sess., 14 April 1941. Quotation from Fryd, "Two Sculptures for the Capitol," 17.

127. See Luhan, *Edge of Taos Desert;* Gibson, *Santa Fe and Taos Colonies;* and Green, *New York, 1913.*

128. Collier, *From Every Zenith,* 115.

129. Pollock's attention was centered on Native American cultures of the Southwest, and particularly on Navaho sand painting, which he related to his dripped paintings on more than one occasion. Demonstrations of sand painting were featured at the MoMA "Indian Arts of the United States" exhibition in 1941, and one of Pollock's psychoanalysts, Violet Staub de Laszlo, recalled that the works were discussed in their sessions (see Gordon, "Pollock's *Bird,*" 53, n. 50). The Mythmakers' focus on the arts of the Northwest Coast Indians might seem especially convenient under the circumstances; not only were their visual arts especially lively and rich, but the Haida, Kwakiutl, and Tlingit peoples also resided almost entirely in Canadian and Alaskan territories, and so were removed from the barbaric history of specifically U.S. treatment of Native Americans. But too much attention to such national divisions would have undermined the pan-American emphasis of the celebration of Indian arts; Canadian and Arctic Native American arts (including Northwest Coast examples) were included in the 1941 MoMA exhibition, despite the show's title. In the United States, pan-Americanism was always understood to entail U.S. leadership as well as political and economic centrality.

130. Tamayo was included in Putzel's "Problem for Critics" show in 1945. He held solo exhibitions almost annually through the 1940s at the Valentine Gallery. He was the subject of a book by Robert Goldwater (*Rufino Tamayo* [1947]) and he was featured in the first issue of *Tiger's Eye* in October 1947.

131. Newman, "La pintura de Tamayo y Gottlieb," 17, 20. My text quotes the English original, published in BN-SWI: 72, 73–74.

132. See Robbins, *Joaquín Torres-García.* Although Robbins is concerned to correct what he sees as an overemphasis on Torres-García's primitivism at the expense of his relation to Parisian modernism, he acknowledges that in the mid-1930s, Torres-García's "lectures and books demonstrate an increasing familiarity with Pre-Columbian images" (p. 27). Furthermore, "the association with primitive and Indo-American art, with little regard for his classical formation has dominated thinking about him, and it is easy to see why this has been the case. First of all, he encouraged it. Out of Montevideo those last fifteen years came an extraordinary outpouring of theory and publications calling for the creation of a new American art, primitive and strong" (p. 31).

133. See, for example, Goldwater, "Art Chronicle." Goldwater was unimpressed by the "Indian patterns" of Gottlieb; he speculated that "the day of primitive inspiration, like the day of pure abstraction, is rapidly drawing to a close. The many artists who recently have tried to draw upon the designs of the Northwest Coast have been able to do little to infuse their source material (handsome as it is) with any contemporary meaning."

134. Newman, "La pintura de Tamayo y Gottlieb," 22–23, n. 2. My text quotes the English original, BN-SWI: 75. See also Newman, *Northwest Coast Indian Painting,* BN-SWI: 105–07.

135. Newman, "La pintura de Tamayo y Gottlieb," 22–23. My text quotes the English original, published in BN-SWI: 75.

136. See Boas, *Primitive Art,* 223 (on projection); and 183 (on symbolic vs. formal).

137. Several art historians have argued for the strong influence of Native American arts on both the forms and the theories of New York School artists. In general these studies assume a fundamental spiritual, philosophical, and aesthetic harmony between them. Many make detailed cases, usually with limited success, for reading certain Abstract Expressionist paintings as incorporating particular forms from specific Native American works. The frame they provide is strictly limited to intellectual history of high culture. Among the best examples of these studies are Rushing, "Ritual and Myth"; id., "Impact of Nietzsche and Northwest Coast Indian Art . . ."; and Varnedoe," Abstract Expressionism."

138. On antipathy toward ethnographic treatments see, for example, Newman, "It is by looking at them as works of art rather than as the artifacts of history or ethnology that we can grasp their inner significance" (*Pre-Columbian Stone Sculpture*, BN-SWI: 61–62): Newman's library included three books by Boas among fourteen on North American Indian art. See Rushing, "Impact of Nietzsche and Northwest Coast Indian Art . . . ," 189.

139. Douglas and d'Harnoncourt, *Indian Art of the United States*, 11–13.

140. The Surrealists were the first modern artists to attend to Northwest Coast Indian art. See Cowling, "Eskimos, American Indians and Surrealists."

141. Paalen, "Totem Art," 26.

142. See Lynes, *Good Old Modern*, 223. Covarrubias wrote a chapter on modern Mexican art for MoMA's exhibition catalogue *Twenty Centuries of Mexican Art*. He was perhaps best known in the United States for a collection of illustrations and caricatures of African Americans entitled *Negro Drawings* (1927). Covarrubias was also the author of a very popular map of the United States, the "Covarrubias America," sold in the mass market during the war by the Associated American Artists; it was illustrated with small ideographs intended to "bring home, as never before, the real meaning of our country and the things we are fighting for" (see advertisement, *New York Times Magazine*, 22 Nov. 1942, 40).

143. On this aspect of primitivism, see Kenneth Coutts-Smith, "Some General Observations on the Problem of Cultural Colonialism," in Hiller, *Myth of Primitivism*.

144. Unpublished interview by Bryan Robertson of Robert Motherwell (1965), quoted in Mattison, *Robert Motherwell*, 41.

145. Arshile Gorky to Vartoosh Mooradian, 24 Nov. 1940, printed in Mooradian, *Many Worlds of Arshile Gorky*, 267.

146. Graham's work was, of course, well known to the Mythmakers. He had been a member of The Ten with Rothko and Gottlieb in 1938, and it was probably with Graham's assistance that Gottlieb began to collect African sculpture. (See review of his work in *Limited Edition* [December 1945]: 4: "Gottlieb has collected primitive African sculpture and it is the 'Beginnings of Seeing' of uncivilized races he means to find.") Nonetheless, the primitivism of the Mythmakers was different in emphasis from Graham's idiosyncratic Jungian variation.

147. The source of the story about Pollock is Irving Sandler. See, for example, his letter to *Art in America* in October 1980.

148. See Newman, "Plasmic Image," BN-SWI: 140:

The present painter is concerned not with his own feelings or with the mystery of his own personality but with the penetration into the world-mystery. . . . He is working with forms that are unknown even to him. He is therefore engaged in a true act of discovery in the creation of new forms and symbols that will have the living quality of creation. No matter what the psychologists say these forms arise from, that they are the inevitable expression of the unconscious, the present painter is not concerned with the process. Herein lies the difference between him and the surrealists.

149. Gottlieb and Rothko (with Newman), letter to the editor, *New York Times*, 7 June 1943.

150. Quoted in Norman, "From the Writings and Conversations of Alfred Stieglitz," 77.

151. Rothko, *Clyfford Still*, pamphlet for Art of This Century, 1946.

152. "Speaking of Pictures . . . Cannibals Roast a Man," *Life*, 25 March 1940, 12–14.

153. Haas, "Print Collector," 16. See also Hale, "Stevens: A Precocious Talent Comes of Age."

154. *Life*, 20 March 1950, 84.

155. See Guilbaut's analysis of Kootz' disposal of the work of the School of Paris modernist Byron Browne in *How New York Stole the Idea of Modern Art*, 71, 178–79.

156. See Gail Levin, "American Art," in Rubin, *"Primitivism" in 20th Century Art*. The Harlem Renaissance artists are excluded from this essay.

157. Harmon Foundation exhibition catalogues, quoted in Campbell, *Harlem Renaissance*, 49.

See also Reynolds and Wright, *Against the Odds: African-American Artists and the Harmon Foundation*. These studies indicate how white patronage of Harlem Renaissance artists (in particular, the awards and financial support offered by the Harmon Foundation) encouraged perpetuation of racial stereotypes in African American art.

158. See, for example, "A Way to Kill Space," *Newsweek,* 12 Aug. 1946, 106. My discussion of Lam is indebted to Lowery Sims, whose paper "Wifredo Lam and the New York School: Filling in the Gaps," presented at the College Art Association Annual Meeting in New York in 1990, first drew my attention to the peculiar aspects of the critical reception of Lam's primitivism.

159. "Picassolamming," 7.

160. Breton, quoted in Jewell, "Cuban Picasso," 9.

161. Jewell, "Cuban Picasso."

162. Wolf, "Wizards and Warriors," 10.

163. Mabille, "Ritual Painting of Wifredo Lam," 187.

164. Hess, "Lam," 37.

165. Huggins, *Harlem Renaissance,* 89, 91–92. Huggins extends the image of Harlem and its music as a vortex on pages 92–93.

166. Magaret, "Negro Fad," 39, 43.

167. Beaudoin, "This Is the Spring of 1946," 3.

168. See Gibson, *Theory Undeclared,* 38, 257–59; and id., "Painting outside the Paradigm."

169. Gottlieb and Rothko, "Portrait and the Modern Artist," 171.

170. Interview, *Arts and Architecture,* 14.

171. Greenberg, "Art," *Nation,* 8 March 1947, 284.

172. Ibid.

173. Quotes from anonymous review in *Art News* of Gottlieb exhibition, "Adolph Gottlieb," 21; Valente, Review of Gottlieb exhibition at Seligmann Galleries, 40; Riley, "Mythical Rothko and His Myths," 15; and Hunter, "Among the New Shows," 30 Jan. 1949, sec. 2, p. 9. Hunter was addressing principally the work of Pollock and Gottlieb.

174. "Paint It Black," 49.

175. See Frank, "Un nouveau genre 'policier'"; and Chartier, "Les Américains aussi font des films 'noirs'."

176. "Edward Robinson vient de tuer un homme non par abjection, bestialité ou folie mais dans un inévitable enchainement de circonstances" (Bourgeois, "La tragédie policière," 71).

177. These words were spoken, almost literally, by the protagonist of a later (1954) *noir* film— *The Other Woman,* directed by Hugo Haas. At the film's conclusion the protagonist, a movie director played by Haas himself, makes the point to the audience from his prison cell.

178. "Les Américains aussi font des films 'noirs'," 67. My translation.

179. "Ides of Art," 43.

180. Some of the artists, notably Baziotes, were fond of *films noirs* and *noir*-ish murder mysteries. Among the films Baziotes praised in letters to his brother are *The Killers* (1946), *Body and Soul* (1947), and *The Damned Don't Cry* (1950). See the letters dated 29 Nov. 1946, 13 April 1948, and 9 April 1951; William Baziotes Papers, AAA-SI N/70-24: 69, 110, 203.

181. See Olivier Blanc, *La dernièr lettre: Prisons et condamnés de la Révolution 1793–1794* (Paris: Robert Laffont, 1984).

182. For both *film noir* heroes and New York School painters, general impassivity did not preclude outbursts of paranoia, violence, aggression, and other intense emotions. Indeed, such outbursts were important evidence of the pressures seething beneath the surface.

183. Stroup, " . . . In Lyricism," 48. De Kooning's *Woman* paintings also exhibit this comic/ tragic combination, a fact frequently noted in the contemporary criticism.

184. Both Nietzsche and Freud might have been points of reference here. The former's analysis of the common origins of the tragic and the comic, and the latter's case for the link between humor and fear, or anxiety, were widely known at the time.

My discussion of the place of comedy in these arts and of the tragic-comic link is greatly indebted to suggestions offered by T. J. Clark and Margaret Werth.

185. See typescript of Gottlieb and Rothko, "Portrait and the Modern Artist," reprinted in Alloway and MacNaughton, *Adolph Gottlieb,* 171: "Our presentation of these myths, however, must be in our own terms, which are at once more primitive and more modern than the myths themselves—more primitive because we seek the primeval and atavistic roots of the idea rather than their graceful classical version; more modern than the myths themselves because we must redescribe their implications through our own experience."

186. Here a problem arises from the fact that statistics indicate women composed an exceptionally high proportion of the film-going audience in the 1940s and 1950s. Yet *film noir* assumed and represented a male subjectivity. This feature of both *film noir* and Abstract Expressionism will be analyzed in Chapter 4.

187. Of course, part of the problem of Mythmaker art lies in its mistaken presupposition of the availability of myth and classical tragedy to any audience in 1945. See, for example, Jameson, *Political Unconscious,* 68–69, 130.

188. Elles [les masses] flairent la terreur simplificatrice qui est derrière l'hégémonie idéale du sens, et elles réagissent à leur façon, en rabattant tous les discours articulés vers une seule dimension irrationnelle et sans fondement, là où les signes perdent leur sens et s'épuisent dans la fascination: le spectaculaire (Baudrillard, *A l'ombre des majorités silencieuses ou la fin du social,* 16). See also Modleski, "Femininity as mas(s)querade"; and Burgin, Donald, and Kaplan, *Formations of Fantasy.*

189. Hegel, *Phenomenology of Spirit,* 121 (para. 199). My thanks to T. J. Clark for this reference.

190. The photograph accompanied an article by Dorothy Seiberling, "The Varied Art of Four Pioneers."

191. Seiberling, "Baffling U.S. Art," 70.

192. "Jackson Pollock: Is He the Greatest Living Painter in the United States?" *Life,* 8 Aug. 1949, 43.

193. I have taken the liberty of introducing other New York School figures into the discussion of Mythmaker art at this point because the cultural assimilation of the Mythmakers has not taken place in isolation from that of the other New York School artists. Distinctions such as those I am proposing have not been observed to now; consequently, the image of the generic "Abstract Expressionist" has been applied to all the artists (sometimes inappropriately: photographs of Newman, for example, rarely construe him as a *noir* character). Pollock's influence has been greatest in this regard, and it has complemented very neatly the aesthetic ambitions of the Mythmakers as I have described them. As a mass-cultural organ of Modern Man discourse, *film noir* is, in my view, quite close to the ideological and cultural terrain on which the synthesis "the New York School" must be located.

194. "Gangster as Tragic Hero," 240.

195. Adorno, "Commitment," 314–15. See also id., "Notes on Kafka."

196. Adorno, *Minima Moralia,* 115, 121.

197. Adorno, "Notes on Kafka," 261, 268.

198. An alternative point of contrast—and a visual one—might be Orozco's mural cycle at Dartmouth College, *The Epic of American Civilization.* Here terrifying primitive art and religion are depicted as vehicles of oppression. Freedom and an ideal modern culture will be achieved only through active rejection of a tragic fate: Christ has chopped down his cross and vanquished the forces of subjugation represented by weapons, religious icons, and artifacts of classical culture. See Baas, "Interpreting Orozco's *Epic.*"

199. Abercrombie, Hill, and Turner, *Dominant Ideology Thesis,* 128. It is also worth citing Sacvan Bercovitch's paraphrasing of Raymond Williams: "Even when a certain ideology achieves dominance it still finds itself contending to one degree or another with the ideologies of residual and emergent cultures within the society—contending, that is, with

alternative and oppositional forms that reflect the course of historical development" ("Problem of Ideology in American Literary History," 635).

200. Gramsci, *Selections from the Prison Notebooks*, 181–82. See also Mouffe, "Hegemony and Ideology in Gramsci."

201. The process by which this particular case of "avant-garde" opposition was accommodated by bourgeois culture is quite reminiscent of models advanced in some recent studies of popular cultural opposition. See, for example, Bennett, Mercer, and Woollacott, *Popular Culture and Social Relations*. Mythmaker art, of course, cannot claim to represent a disempowered constituency or the interests of another class; nonetheless, it seems to me useful to see the processes in play as negotiations between bourgeois factions. A space for disagreement and criticism is opened and accorded significance as long as the discursive structures remain those of the dominant ideology, insuring the latter's control and benefit.

202. "Myth Today," in Barthes, *Mythologies*, 150.

203. Gottlieb, quoted in "New York Exhibitions," a review in *Limited Edition*, 6.

204. See "Modernist Primitivism, An Introduction," in Rubin, *"Primitivism" in 20th Century Art* 1: 6–7.

205. "Problem of Ideology in American Literary History," 635.

3. JACKSON POLLOCK & THE UNCONSCIOUS

1. Brooks, "Jackson Pollock: An Artists' Symposium, Part 1," 31.

2. Reprinted in JP-CR 4: 241. Pollock edited this sentence from his published statement, perhaps because its point was made in his description of his process.

3. Quoted in Rodman, *Conversations with Artists*, 82.

4. Quotes from Langhorne, "Jackson Pollock's *The Moon Woman Cuts the Circle*," 129, 128. Some have suggested that attributing conscious knowledge of Jungian principles to Pollock was not necessary to justify Jungian interpretation of his work. They propose that Pollock's unconscious was naturally or organically generating symbols that could be interpreted within a Jungian framework. The implication is that the Jungian theory of archetypal symbols is correct and that Pollock's work is a verification of it (see Langhorne, "Jackson Pollock's *The Moon Woman Cuts the Circle*," 137, n. 65; and Gordon, "Pollock's *Bird*, or How Jung Did Not Offer Much Help in Myth-Making," 43).

5. The book was Wysuph, *Jackson Pollock: Psychoanalytic Drawings*.

6. Henderson's qualification appears in "How a Disturbed Genius Talked to His Analyst with Art," 18.

7. See Carter, "Jackson Pollock's Drawings Under Analysis," 58.

8. It wasn't until 1967, however, with the publication of Francis V. O'Connor's chronology of Pollock's life, that this fact was authoritatively established and widely circulated (see O'Connor, *Jackson Pollock*, 23, 25).

9. In addition to Langhorne, see especially Wolfe, "Jungian Aspects of Jackson Pollock's Imagery"; and Freke, "Jackson Pollock: A Symbolic Self-Portrait."

10. Fried, *Three American Painters*, 13.

11. The article was Rubin, "Pollock as Jungian Illustrator." Rubin's own, modernist, interpretation appeared as "Jackson Pollock and the Modern Tradition."

12. Quotes from Rubin, "Pollock as Jungian Illustrator," pt. 2, pp. 78, 82. Rubin says in part 1 of that article, p. 110, "One might still wonder whether words (Jung's) would influence a painter—especially of Pollock's makeup—as intensely as images (Picasso's)".

13. Rubin, "Pollock as Jungian Illustrator," pt. 1, p. 117.

14. Ibid., p. 112. The italics are Rubin's.

15. Langhorne, "Jackson Pollock's *The Moon Woman Cuts the Circle*," 133, 135.

16. Gordon, "Pollock's *Bird*," 48. Gordon ostensibly agrees with Rubin generally, although the essay is so eccentric that the depth of the agreement is open to question. The essay does

contain valuable testimony from Pollock's Jungian analysts, but it closes with an unconvincing reading of Pollock's *Bird* as a pastiche of fragmentary and inverted quotations from Picasso's *Girl with Cock* (1938).

17. See, for example, Wysuph, *Jackson Pollock: Psychoanalytic Drawings,* 29.

18. "The Freudian Unconscious and Ours," in Lacan, *Four Fundamental Concepts of Psycho-Analysis,* 28.

19. Deleuze and Guattari, *Anti-Oedipus,* 53, 180, 296.

20. "Towards a Sociological Understanding of Psychoanalysis."

21. I hope it will be clear that by "representing the unconscious" I do not mean to suggest that Pollock was attempting to depict some preexisting conception or contents of the unconscious. Quite the contrary: representation is understood here as a complex process which in this case yields not only paintings and drawings believed somehow to derive from the unconscious but yields as well conceptions and contents of the unconscious.

22. See "A Psychotic Sculptor of the Eighteenth Century," in Kris, *Psychoanalytic Explorations in Art.*

23. For example, Francis O'Connor's analysis of Pollock's black pourings treats the imagery as unconditioned unconscious material open to direct interpretation (see *Black Pourings*).

24. See Herbert, "Method and Meaning in Monet."

25. Both O'Connor and Gordon have already drawn attention to this part of the sequence. In *Black Pourings,* O'Connor proposes that the painting "derives from" these drawings (p. 10). Gordon, in "Pollock's *Bird*" (p. 48), similarly considers them "preparatory" to the painting.

26. See Greenberg, "Jackson Pollock Market Soars," 42.

27. In July 1941, Pollock's brother Sanford McCoy wrote to another brother, Charles Pollock, of Jackson: "His thinking is, I think, related to that of men like Beckman, Orozco and Picasso" (letter reprinted in JP-CR 4:226). (There were five Pollock brothers. As an adult, Sanford alone changed his name to McCoy, the original paternal surname; LeRoy Pollock, his father, had taken the name of his adoptive family.) Pollock knew Orozco's work by 1930, when Orozco and Benton were simultaneously painting murals at the New School for Social Research in New York. Pollock did some action posing for Benton for this project. And Louis Bunce recalled that he and Pollock went to watch Orozco painting his *Dive Bomber* fresco at the Museum of Modern Art in 1940. It was commissioned as part of the "Twenty Centuries of Mexican Art" exhibition; afternoon visitors were allowed to observe Orozco at work in the museum galleries. See Karlstrom, "Jackson Pollock and Louis Bunce," 27, n. 24. Concerning Picasso, Sanford McCoy recalled that Pollock was a great admirer of *Guernica* from the time of its first New York showing (in May 1939 at the Valentine Gallery; in November of the same year it was included in the Museum of Modern Art's Picasso exhibition). See the notes taken by James T. Valliere at an August 1963 interview with McCoy contained in the JP Papers, AAA-SI 3048 (hereafter, Valliere–McCoy interview): 660. And finally, Lee Krasner's recollection of Pollock's frustration in his competition with Picasso is vivid and telling. See Friedman, "Interview with Lee Krasner Pollock," 7:

> There's no question that he admired Picasso and at the same time competed with him, wanted to go past him. Even before we lived in East Hampton, I remember one time I heard something fall and then Jackson yelling, 'God damn it, that guy missed nothing!' I went to see what had happened. Jackson was sitting, staring; and on the floor, where he had thrown it, was a book of Picasso's work.

> For discussion of the influence of Picasso and Orozco on the early Pollock, see O'Connor, *Genesis of Jackson Pollock.* And for a broad treatment of Pollock's complex relation to Picasso, see Weinberg, "Pollock and Picasso."

28. See Valliere–McCoy interview; frame 660. Mrs. McCoy recalled that this trip was made in the summer of 1936 or 1937; see letter from James Valliere to Charles Pollock, 26 Feb. 1967, JP Papers, AAA-SI 3048: 738.

29. "Jackson Pollock's Drawings," 61. In this essay, however, Krauss does not acknowledge any influence of Orozco on the drawings.

30. Gombrich's *Art and Illusion* is the obvious reference here, with the understanding that its narrow perceptual frame for the process of "correction" should be expanded to include ideological material. See especially Bryson, *Vision and Painting.*

31. *The Black Pourings,* 13. I assume this is the work to which O'Connor is referring, although he dates the mural 1932 and does not specify its location.

32. Quoted in Gordon, "Pollock's *Bird,*" 46.

33. Quoted in Wysuph, *Jackson Pollock: Psychoanalytic Drawings,* 14. Henderson elsewhere has drawn attention to the aesthetically seductive aspects of symbolic analysis. See his "Reflections on the History and Practice of Jungian Analysis," 18.

34. Quotes from Pollock, interview, *Arts and Architecture,* 14.

35. Myers, "Surrealism and New York Painting," 56.

36. Note that the models are not opposed along Freudian vs. Jungian lines. Such a distinction is one Pollock appears to have been unable or disinclined to make, as his statement to Rodman, quoted above, indicates.

37. The source of this belief is O'Connor's 1967 chronology in *Jackson Pollock:* 19. It is repeated by Wolfe: 65; Freke: 218; Langhorne: 136, n. 1.

38. The notation is reproduced in JP-CR 4: 217. O'Connor and Thaw have proposed two probable sources for these ideas: "Thomas Hart Benton's writings and his instruction at the Art Students League, and the introductory papers of J.W. Powell in volume 1 of the *Publications of the Bureau of Ethnology,* in one of which Powell states that 'discernment, discrimination, and classification are the processes by which a philosophy is developed'" (JP-CR 3: 2).

39. Robinson, *Mind in the Making,* 77–78. The italics are Robinson's.

40. Biographical data on Robinson is taken from Hendricks, *James Harvey Robinson;* Barnes, "James Harvey Robinson"; and J. Salwyn Schapiro, "James Harvey Robinson."

41. Richard Shiff traces a related notion of impression as primitive knowledge to Emile Littré, a positivist and disciple of Comte. See Shiff, *Cézanne and the End of Impressionism,* 18–20.

42. See Braun, "Thomas Hart Benton and Progressive Liberalism," in Braun and Branchick, *Thomas Hart Benton,* 11–37, and 36, n. 116.

43. *An Artist in America,* 42.

44. For Pollock at Martha's Vineyard, see JP-CR 1: 11; and Mumford, *Sketches from Life,* 453. Lewis Mumford was another friend and sometime–Vineyard resident. For New School murals, see Braun, "Thomas Hart Benton and Progressive Liberalism," 21. As Braun points out, Pratt has been portrayed as herself in the lower right of *City Activities with Dance Hall;* she is facing Benton's son T. P., who sits on his mother's lap, with blackboard and blocks in the background. Emphasis on building with blocks was a distinctive feature of the City and Country School curriculum, and the blocks designed by Pratt were "famous and used in thousands of schools throughout the world." Quote is from Pratt's obituary in the *New York Times,* 7 June 1954, 23.

45. For Marot's description of the new school, originally called The Play School, see Marot, "The Play School." For Charles Pollock, see JP-CR 4: 205, 217. For Pratt note to Pollock, see JP Papers, AAA-SI 3046: 288; letter dated 1 July 1940 from Chilmark, Martha's Vineyard. "I didn't mean to leave New York without seeing you. I hoped you would come over to see me. I know that Helen's sudden death was a shock to you and that you are sharing my deep sorrow."

46. Marot is quoted in "Organized 150,000 Women," *New York Times,* 10 May 1914, sec. 3, p. 8. The book was described in "Labor Unions," *New York Times,* 4 Oct. 1914, sec. 5, p. 415. For Marot's radical positions, see, e.g., Marot and Pratt, *Makers of Men's Clothing,* the report of an investigation conducted in Philadelphia by the two women.

47. Arming for war in "Immigration and Militarism"; "the function of capital" in "Syndicalist Professor," 14. The italics are Marot's. Legal treatment of labor in "American Law."

48. "Organ of Reconstruction" from Mumford, *Sketches from Life*, 217. Robinson was a contributor to both the *Masses* and the *Dial* at the time of Marot's association with the magazines. See, for example, his "Intellectual Radicalism" and "What Is the Good of History?" Marot quote is from Marot, *Creative Impulse in Industry*, xxi. Mumford on Fifth Avenue parade is in Mumford, *Sketches from Life*, 222.

49. Mumford, *Sketches from Life*, 244.

50. *Exile's Return*, 72.

51. Jordan, "New Psychology and the Social Order," 367. See also Curti, *Human Nature in American Thought*, 259.

52. See "Production and the Preservation of Initiative."

53. *Sketches from Life*, 247.

54. Among the works Cary Baynes translated were *Two Essays on Analytical Psychology* (1928, with her husband), and *Modern Man in Search of a Soul* (1933, with W. S. Dell). In the preface to the latter she thanked de Laszlo for assistance. For the Stillman divorce, see "Aided Mrs. Stillman to Win," *New York Times*, 7 Feb. 1926, sec. 1, p. 19. At the time the story broke, Baynes was spending several months in Uganda with Jung studying "the native mind." For Baynes' example to Henderson, see Henderson, "Reflections on the History and Practice of Jungian Analysis," 14. Both of Pollock's Jungian analysts knew Baynes and reviewed his books. See de Laszlo, Review of H. G. Baynes' *Mythology of the Soul;* Henderson, Review of H. G. Baynes' *Germany Possessed;* and "In Memoriam: H. G. Baynes," de Laszlo's obituary for her "old friend." At some point in the mid to late 1930s the Bayneses apparently were divorced.

55. See "Putting American Women 'On Another Footing,'" *New York Times*, 12 Oct. 1919, sec. 7, p. 10; "Says Girls' Homes Cause Ill Health," *New York Times*, 23 Oct. 1921, sec. 2, p. 12; and Mann, "Thousands of 'Well' Women Pay for Training Health Center."

56. See Bertine, "In Memoriam: Kristine Mann," *Papers of the APC-NY 5. The Psychology of the Unconscious* was the title given to Beatrice Hinkle's translation of *Wandlungen und Symbole der Libido*, published in New York in 1916.

57. See Oppenheim, "What Jung Has Done," in which the relation of Jungianism to Freudianism is portrayed as analogous to that of Walter Lippmann's work to Marxism. "Marx reduced the world to economic determinism: Mr. Lippmann in his books recognizes the economic but sees it merely as a part of the complexity."

58. "Reflections on the History and Practice of Jungian Analysis," 13.

59. *Way of All Women*, 134. See also id., *Woman's Mysteries, Ancient and Modern*.

60. Reported in Henderson, "Reflections on the History and Practice of Jungian Analysis," 13.

61. Rubin, "Pollock as Jungian Illustrator," pt. 2, p. 88.

62. JP-CR 4: 222.

63. JP-CR 4: 215.

64. Aaron, *Writers on the Left;* Gilbert, *Writers and Partisans;* and Guilbaut, *How New York Stole the Idea of Modern Art*.

65. Pollock's adolescent attraction to occult mysticism and theosophy is documented in letters dating from 1929 and 1930 (see JP-CR 4: 207–8, and 208–9). He strongly encouraged his brothers to read Mabel Collins Cook's theosophical pamphlet *Light on the Path*. The element of mysticism in Jungian theory was probably a source of its particular appeal to Pollock.

66. JP-CR 4: 226 (spelling preserved). Sanford's certainty that Jackson's relationship with their mother was part of the problem is echoed in much biographical and psychological scholarship on Pollock. This belief has not yet been set against the cultural preoccupation with the "mother complex" in the period. Contemporary popular psychology frequently treated this issue, which was most notoriously shaped by Philip Wylie's discussion of "Momism" in *Generation of Vipers*. This caricature of the overbearing matriarch was widely discussed and cited in the literature of the period; it was invoked by critics reacting to de Kooning's *Woman* paintings

(see, e.g., Eliot, "Under the Four Winds") and by Simone de Beauvoir in her analysis of American women (*American Day by Day* [1952], 250–51). Wylie's description of "Mom" was translated into French and reprinted in a special double "U.S.A." issue of *Les Temps Modernes* (August/September 1946), immediately alongside Greenberg's "L'art américain au XXe siècle."

67. Henderson's recollection that it was Pollock's suggestion that he bring his drawings to the analytic sessions has led some to speculate that Pollock had used his work in therapy earlier. This is apparently the case, although the earlier uses were much more casual and unsystematic. Dr. James Wall, who treated Pollock while he was in the Westchester Division of the New York Hospital (known as Bloomingdale) during the summer of 1938, remembered discussing the meaning of some of the imagery Pollock was producing while he was in the hospital (see Wall to James T. Valliere, 12 Sept. 1963, in JP Papers, AAA-SI 3048: 667, and JP-CR 4: 124). Sanford McCoy recalled that Dr. Wall attached importance to Pollock's interest in drawing the male nude (see Valliere–McCoy interview, JP Papers, AAA-SI 3048: 660).

68. Gordon, "Pollock's *Bird*," 44.

69. Complete or corrected titles, along with the date of presentation and the volume of publication for each, are included in the bibliography. The list is taken from JP Papers, AAA-SI 3046: 254–55. It should be noted that Pollock excluded from his list only two titles in the four volumes: Alan Watts, "The Psychology of Acceptance: The Reconciliation of the Opposites in Eastern Thought and in Analytical Psychology," and Beatrice Hinkle, "The Evolution of Woman and Her Responsibility to the World Today."

70. Quotes from Jung, *Psychological Types*, 574, 580.

71. See, for example, Langhorne's reply to Rubin in Langhorne, "More on Rubin on Pollock," 59.

72. Jung, *Integration of the Personality*, 40.

73. See, for example, Jacobi, *Psychology of C. G. Jung*, 114–15, n. 3.

74. Jung, *Integration of the Personality*, 49.

75. Jung, *Integration of the Personality*, 39–40, 93–94.

76. Ibid., 132.

77. See Baynes, *Mythology of the Soul*, 104 ("primordial . . . force"), 762n. (Hopi snake dance); Henderson, "Question of Space," 2; Harding, *Woman's Mysteries*, 191–94; and Jacobi, *Psychology of C. G. Jung*, 115.

78. See, for example, JP-CR 3: 533r, 550, 555.

79. Langhorne, "Pollock, Picasso and the Primitive," 72.

80. Jung, *Integration of the Personality*, 127.

81. Ibid., 197.

82. Ibid., 198.

83. See JP-CR 3: 516, 520r, 521r, 533v, 534v, 535r.

84. Langhorne, "Jackson Pollock's *The Moon Woman Cuts the Circle*," 129ff. Langhorne seems to believe that Pollock's production of archetypal symbolism was not dependent upon his exposure to Jungian discourse. In other words, Jungian theory is correct, the unconscious mind is accurately represented in it, and Pollock's work corroborates it. She writes in footnote 65, p. 137, "It should be noted that Pollock was actually experiencing the archetypal psychological processes described in the book [*Psychology of the Unconscious*]. Freke's thesis, p. 217, that Pollock's themes derive from a reading of the book, especially chapter 7, does not acknowledge the organic and truly psychological nature of Pollock's treatment of the themes." In "Pollock, Picasso and the Primitive," Langhorne argues that Pollock's paintings, prior to his poured works, are essentially "intuitive elaborations" of "his basic archetypal awareness." See p. 78, for example.

85. Baynes, *Mythology of the Soul*, 192. See also Harding, *Woman's Mysteries*, 228.

86. Baynes, *Mythology of the Soul*, 556–57 (solar eclipse), 421 (sun and moon joined), 745 (anima as moon-goddess).

87. The theme is suggested as well in the painting's original title, *Moby Dick.*

88. See, for example, Freke, "Jackson Pollock: A Symbolic Self-Portrait," 218–19.

89. See Rubin, "Modernist Primitivism, An Introduction," in id., *"Primitivism" in 20th Century Art* 1: 51–52.

90. Jung, *Integration of the Personality,* 242. See also de Laszlo, "Some Dreams Connected with the Present War," 64.

91. Jung, *Two Essays on Analytical Psychology,* 59, 62. See also Watts, "Psychology of Acceptance."

92. Jung, *Integration of the Personality,* 225.

93. Baynes, *Mythology of the Soul,* 501.

94. See Jacobi, *Psychology of C. G. Jung,* 70.

95. See, for example, Baynes' use of yin and yang phases in *Mythology of the Soul.*

96. Jung, "Picasso," 7–8.

97. See, for example, *Woman's Mysteries,* 157.

98. Philip Leider has noted some of the correspondences between Harding's text and Pollock's psychoanalytic drawings. See his "Surrealist and Not Surrealist In the Art of Jackson Pollock and His Contemporaries," 43–44. Leider believes some of Pollock's motifs were drawn directly from *Woman's Mysteries,* indicative of his taking up "the central intellectual adventure of the times."

99. Quoted in Potter, *To a Violent Grave,* 69.

100. The Great Mother Archetype was a distinct enthusiasm of the APC-NY in late 1938, precisely the time of Henderson's joining. During the previous summer, the Eranos conference (held annually in Ascona, Switzerland, for the purpose of discussing Jungian topics), had been concerned with this subject. Jung's own paper—"The Psychological Aspects of the Mother Archetype"—was translated by Cary Baynes and Ximena de Angulo and later published in *Spring* (1943). On 18 November the club received a report on the conference from Hildegard Nagel. The next day the club opened an exhibition at the Fuller Building entitled "The Great Mother as Represented in Art." The photographs displayed had been collected for the Eranos archive and lent to the APC-NY. The show was not open to the public, but club members were allowed to bring guests, and approximately seventy came. The catalogue of the show, as well as Nagel's report on the Eranos conference, are included in *Papers of the APC-NY* 2 (1938). At the close of the show on 2 December, Harding delivered her paper "The Mother Archetype and Its Functioning in Life" to a meeting of the club.

101. Langhorne, "Jackson Pollock's *The Moon Woman Cuts the Circle,*" 129.

102. Another source of information on moon women was Langer's *Philosophy in a New Key* (see 163ff.). Pollock's library contained a copy of this book, although it is unclear when he acquired it.

103. Of the paintings in Pollock's first solo exhibition, four or six were untitled, five had titles with no gender specified or implied (*Guardians of the Secret, Stenographic Figure, Conflict, Magic Mirror, Wounded Animal*), two combined the genders (*Male and Female, Male and Female in Search of a Symbol*), and the remaining four had female titles (*She-Wolf, The Moon Woman, Mad Moon Woman, The Moon Woman Cuts the Circle*).

104. Quoted in Potter, *To a Violent Grave,* 56. The reminiscence brings to mind a passage from Baynes' *Mythology of the Soul,* 416. Speaking of the powerful influence of the moon, Baynes wrote, "Many people with a low threshold of consciousness are fearful of lonely, moonlit promenades, because of the daemonic forms which gesticulate at them from trees and hedgerows."

105. Rose, "Jackson Pollock at Work: An Interview with Lee Krasner," 86.

106. B. H. Friedman, "An Interview with Lee Krasner Pollock," 8.

107. JP Papers, AAA-SI 3048: 660.

108. Jung, "Picasso," 3.

109. Harding, *Woman's Mysteries*, 230–31.

110. In *Two Essays on Analytical Psychology,* Jung speaks of the animus and anima as the "guardians of the threshold": "These two twilight figures of the dark hinterland of the psyche (they are the true, half-grotesque "Guardians of the Threshold," to use the pompous theosophical jargon) can assume an almost inexhaustible number of aspects, and whole volumes could be written about them" (p. 231).

111. See the photo of Pollock, with the unfinished *Guardians* behind him, reproduced in JP-CR 4: 229.

112. "*Life* Round Table on Modern Art," 76.

113. Henderson, Preface to *Mythology of the Soul,* xi, xii, xiv.

114. See Baynes, *Mythology of the Soul,* 78.

115. Martha Graham, Irene Rice Pereira, and Jack Tworkov are only a few of the artists, in the larger sense, who gravitated toward psychoanalysis at this time. Graham's analyst was Frances Wickes of the APC-NY. (See Shelton, "Jungian Roots of Martha Graham's Dance Imagery." My thanks to Susan Manning for this reference. See also Polcari, "Martha Graham and Abstract Expressionism.") Pereira tried to conceal her involvement with Jungian analysis, but her multiplanar works on glass, begun in 1945, were conceived as metaphors for the Jungian layered unconscious. (Here I am indebted to Karen Bearor's paper, "Gender Bias in Jungian Theory and Its Impact upon Irene Rice Pereira.") Tworkov discussed his analysis briefly, without specifying its variety, in an interview with Dorothy Seckler, conducted 17 August 1962, p. 8, in the collection of AAA-SI.

116. On Oddfellows, see Ryan, *Cradle of the Middle Class.*

117. Graham, "Primitive Art and Picasso," 237.

118. Carone, quoted in Potter, *To a Violent Grave,* 197 (see also p. 208), and 183.

119. See Kallen, *Individualism: An American Way of Life,* for example.

120. Kallen, "You Can't Win," 12.

121. For "new vein," see Stanley J. Kunitz and Howard Haycraft, eds., *Twentieth Century Authors* (New York: Wilson, 1942): 445–46. For return to Taos and Santa Fe, see Arrell Morgan Gibson, *The Santa Fe and Taos Colonies* (1983), 194. See also Fergusson, "Taos Remembered." The three monographs are Folsom, *Harvey Fergusson;* Pilkington, *Harvey Fergusson;* and Gish, *Fronter's End.* Biographical information on Fergusson was drawn from these sources as well as from Kunitz and Haycraft, *Twentieth Century Authors.*

122. Duffus, "Modern Man and His Dilemmas," 2.

123. Waters, review of *Modern Man,* by Harvey Fergusson, 702.

124. Sweeney, *Jackson Pollock;* reproduced in JP-CR 4: 230.

125. Pollock to Sweeney, 3 Nov. 1943; reproduced in JP-CR 4: 230.

126. Extracts are from *Modern Man,* 184–85, and 184.

127. Pollock's remark was not especially unique among avant-garde artists at this time. See Richard Pousette-Dart's comment in a notebook from around 1940:

 Let me flow, affect things, and dissolve, to be, and be no more, and be forever. For such is to be one, in accord, with nature. For nature, is that which I am, I shall be. (Quoted in Hobbs, "Confronting the Unknown Within," 82.)

 Pousette-Dart's flowery, mystical poetry is far in tone from Pollock's matter-of-fact retort to Hofmann—a mark that the idea could take very different forms and likely have very different sources and significances.

128. The first edition was published in 1917 by Cambridge University Press. B. H. Friedman has asserted that Pollock's copy was a gift from Tony Smith. See Friedman, *Jackson Pollock: Energy Made Visible,* 92.

129. Bryan Robertson, for example, claims Pollock read *On Growth and Form* "many times with special feeling" (*Jackson Pollock,* 148). B. H. Friedman notes that it was "always listed as

one of Pollock's favorite books" (*Jackson Pollock: Energy Made Visible*, 92–93). Friedman also observes that parts of the book may have "put Pollock off" or "gone over Pollock's head," but he still imagines that the artist read and studied certain passages and plates with excitement. Berenice Rose similarly claims it "was one of Pollock's favourite books" (*Jackson Pollock: Drawing into Painting*, 18). Rose quotes the introduction to the 1942 edition to demonstrate the book's relevance to Pollock:

> The form of an object is defined when we know its magnitude, actual or relative, in various directions; and Growth involves the same concepts of magnitude and direction, related to the fourth concept, or "dimension" of Time. (*On Growth and Form*)

Martica Sawin has reported Gerome Kamrowski's recollection that he encountered the book in 1937 at the Chicago Bauhaus, and that it "prompted him to look more intently at nature and the geometric basis of natural form" (Sawin, "'The Third Man,' or Automatism American Style," 183).

130. Some of the ideas outlined by Dewey in *Art as Experience* are quite close to Fergusson's. For example:

> Form may then be defined as the operation of forces that carry the experience of an event, object, scene, and situation to its own integral fulfillment. (P. 137.)

Fergusson did not acknowledge Dewey, any more than Robinson, as an influence; we cannot be certain whether this is an oversight, a reflection of the indirectness of the influence, or evidence of the indebtedness of both Dewey and Fergusson to another source.

131. Similarly, Jungian psychology may have been more appealing to Pollock than Freudian theory in part because of the former's poetic ambiguity, broad scope, and the minimization of clinical specificity. The malleability and openness of Jungian theory also constitutes part of its appeal for Pollock's interpreters.

132. Pollock, interview, *Arts and Architecture*, 14.

133. Quoted in Janis, *Abstract and Surrealist Art in America*, 112.

134. Draft of statement for *Possibilities;* reproduced in JP-CR 4: 241.

135. "My Painting," 79.

136. Ibid.

137. Draft of statement for *Possibilities;* reproduced in JP-CR 4: 241.

138. Ibid.

139. Wright interview of Pollock; published in JP-CR 4: 250.

140. Portion of a handwritten note on the back of a photograph in the artist's file, Museum of Modern Art, New York; published in JP-CR 4: 253. (For a longer excerpt, see p. 197.)

141. Quoted in Rodman, *Conversations with Artists*, 82.

142. See, for example, his references to *sublimation, Modern Man*, 57ff.

143. Fergusson's psychology is probably more closely related to that of the American Functionalists, particularly James Rowland Angell and Robert S. Woodworth. See Fuller, *Americans and the Unconscious*, 55–61.

144. *Mythology of the Soul*, 613–15. See also p. 18, where Jung's achievement is portrayed as the combination of an energic conception of the psychic process drawn from German philosophy with the empirical methods of modern scientific analysis.

145. Quoted in Wysuph, *Jackson Pollock: Psychoanalytic Drawings*, 15.

146. Freud's and Jung's energy impulses, however, do not well up into consciousness spontaneously; and the idea that the unconscious is the link to some cosmic center bears only faint resemblance to the Jungian image of the collective unconscious.

147. Quotes are taken from Fuller, *Americans and the Unconscious*, 15, 24–25, 48, 90, 105, 118, 184.

148. Bruce is extremely close at some points to Fergusson. For example, compare the following paragraph from Bruce with Fergusson's statements quoted above (p. 185).

Repeated experiments by some of the world's leading physiologists have made it certain that when a man is pleasurably occupied all the processes of his physical organism function more smoothly and energetically than when he is occupied with something that is indifferent or distasteful to him. (Pp. 59–60.)

149. Bruce, "New Mind Cure Based on Science," 774. Fuller quotes this in *Americans and the Unconscious*, 107.
150. See Sherrington, *The Integrative Action of the Nervous System* (1906) and Herrick, *The Thinking Machine* (1929). Herrick was also co-author of a volume titled *Mind and Behavior* for the series *Man and His World: Northwestern University Essays in Contemporary Thought*, edited by Baker Brownell and published in 1929. Herrick, who was on the faculty of the University of Chicago, has sometimes been confused in Pollock scholarship with James Bryan Herrick, a cardiologist at the same university.
151. 25 June 1933, sec. 1, p. 1.
152. See Mumford above, p. 145; also Naifeh and Smith, *Jackson Pollock*, 325. The authors base their description of Marot's beliefs on an unpublished manuscript by Marot titled "Oneself: A Story of Arrested Growth and Development." The present location of this manuscript is unknown.
153. For a hint of the relevance of Yoga in this regard, see Langhorne, "Pollock, Picasso and the Primitive," 71–72.
154. Bullard, "Arms and the Instincts," 167. Bullard makes very clear the bond between the primitive and the unconscious when he describes unconscious instincts as "hairy and brutish" and asserts that modern man feels still "as did our uncouth and savage ancestors."
155. Rothko, "Romantics Were Prompted," 84.
156. See Fine, *History of Psychoanalysis*, 86.
157. Wylie's work reached a broad popular audience, as the sales records indicate. More significant here, the Analytical Psychology Club of New York gave the book a complimentary, although somewhat reserved review (*Bulletin* 6 [Jan. 1944]).
158. Some of the underlying figurative passages are visible in photographs of the unfinished painting; see, for example, JP-CR 4: 229.
159. See n. 140. From a handwritten note on the back of a photograph in the artist's file, Museum of Modern Art, New York, published in JP-CR 4: 253.
160. *Three American Painters* (1965): 14.
161. "Art Galleries," *New Yorker*, 17 Jan. 1948, 44.
162. Tyler, "Hopper/Pollock," 93.
163. *New York Sun*, 23 Dec. 1949; as cited in O'Connor, *Jackson Pollock*, 49.
164. Felski, *Beyond Feminist Aesthetics*, 77.
165. Fuller, *Americans and the Unconscious*, 195. Fuller argues that "close analysis of the cultural context in which psychology attained such prominence shows that Americans appropriated psychological ideas in order to reinforce broader cultural and religious commitments" (p. 165). Fuller believes that the idea of the unconscious has been assimilated into U.S. culture principally in those forms best suited to providing a "scientific" basis for religious beliefs. Here he opposes Phillip Rieff, Christopher Lasch, Martin Gross, and Peter Berger, all of whom have portrayed psychology as occupying an adversarial position with respect to religion—functioning as a substitute for it, rather than as a buttress (p. 164).
166. Although Fuller acknowledges the importance of studying both professional and popular representations of psychological theory, and recognizes the interrelations between them, his focus on academic psychology (to the virtual exclusion of popular psychology in the period of the 1930s through the 1950s) and his neglect of Jung's importance in the U.S. (which he situates in the late 1950s and early 1960s) lead him to place the "rediscovery" of the unconscious much too late, in the 1960s. See Fuller, *Americans and the Unconscious*, 9, 99, 152.

167. Quoted in Rodman, *Conversations with Artists*, 85.

168. Geertz, "Art as a Cultural System," in *Local Knowledge*, 99; and "Notes on the Balinese Cockfight," in id., *Interpretation of Cultures*, 451.

169. Pollock to Ossorio, 7 June 1951; reprinted in JP-CR 4: 261.

170. Harding, *Woman's Mysteries*, 301.

4. NARCISSUS IN CHAOS

1. Among the historical treatments of cultural materials from the period under discussion, those most valuable to my study have been Curti, *Human Nature in American Thought;* Fuller, *Americans and the Unconscious;* Haraway, *Primate Visions;* Kuper, *Invention of Primitive Society;* Lears, *No Place of Grace;* Marcus and Fischer, *Anthropology as Cultural Critique;* Stocking, *Race, Culture, and Evolution;* Susman, *Culture as History;* and West, *American Evasion of Philosophy.*

2. Jackson Lears has drawn a similar conclusion regarding a slightly earlier period in U.S. culture: 1880–1920: "Superficially at odds, antimodernist, avant-gardist, and advertiser have often been brothers under the skin" (*No Place of Grace*, xix).

3. Mumford, *Condition of Man*, 3.

4. Curti, *Human Nature in American Thought*, 300–301.

5. See *The Structure of Scientific Revolutions*, 83–84.

6. See, for instance, Wylie's novel *Opus 21*, a popular and controversial example of what might be called Modern Man fiction. Although I concentrate in this study on the nonfiction component of Modern Man discourse, by no means do I intend to suggest that fiction had a small or insignificant part. For some indication of the rich field of fiction engaged in Modern Man issues, see Eisinger, *Fiction of the Forties*, especially chapter 7, "In Search of Man in America." Eisinger notes that "the theme of self-discovery that runs through the fiction of this period reveals the intense preoccupation of writers with the problems of the self; it reveals the struggle to define and shape a relationship between the self and American culture" (p. 308). The authors Eisinger chooses to treat in this context are Walter Van Tilburg Clark, Wallace Stegner, Wright Morris, and Saul Bellow.

7. The weeks of February 14, 21, 28; March 7, 14; and April 4, 1942. The other figures are from Keefer, *Philip Wylie*, 102–03.

8. May 21, 1944.

9. Eberhard Kolb's study of the Weimar Republic, for example, contains passages that might be taken to describe the situation in New York slightly later. See, for example, "The typical feature of the period [the 1920s] is seen to be the split between modernism and the fear of modernity, between radicalism and resignation, between sober, factual rationality and the attraction of a profound irrationalism of a mystical, contemplative, or chiliastic kind" (*Weimar Republic*, 95).

10. Harvey, *Condition of Postmodernity*, 34, 30.

11. On the contrast between U.S. and French interpretations and applications of Freud's theories, see Turkle, *Psychoanalytic Politics;* Hale, *Freud and the Americans;* and Fuller, *Americans and the Unconscious.* There are few historical studies I am aware of that explicitly take up differences between the U.S. and European war experiences; some, however, reveal aspects in passing. See Mosse, "Two World Wars and the Myth of the War Experience," 502. Mosse is concerned to delineate the differences between the two wars as experienced and mythologized by Europeans, but in passing many conditions specific to the European countries are described.

12. See chapter 14, "'Personality' and Twentieth-Century Culture," in *Culture as History*, 284–85. In another chapter of this study, entitled "Culture and Civilization: The Nineteen-Twenties," Susman discusses several of the topics considered below, including the new,

specialized social-scientific knowledge, the mania for popularization of it, and the orientation toward self (p. 111). While there is much overlap with my study, Susman's principal interest is in what he describes as a crisis in the mass view of community and civilization, rather than in the notion of the subject.

13. Haraway, *Primate Visions*, 148.

14. Andreas Huyssen has argued that while this subject originates in the development of bourgeois society, it is not necessarily inherently bourgeois. It can be "cut loose from its moorings in bourgeois individualism." See Huyssen, *After the Great Divide*, 213.

15. The status of this construction is a topic of some dispute. Fredric Jameson has distinguished between two positions on the disappearance of the centered subject: one is historicist—that a centered subject once existed, in the period of classical capitalism and the nuclear family, but is now dissolved; the other is poststructuralist—that it was never anything more than an ideological mirage. Jameson himself inclines toward the historicist position. See "Postmodernism, or the Cultural Logic of Late Capitalism," *New Left Review* (July–Aug. 1984): 63.

16. Johnson, *Shopkeeper's Millennium*, 8.

17. Ryan, *Cradle of the Middle Class*, 161.

18. Haraway, *Primate Visions*, 28.

19. Kasson, *Marble Queens and Captives*, 17.

20. Trachtenberg, *Incorporation of America*, 193.

21. The notion "dominant middle-class ideology" has generally been used without recognition of the significant differences in the ways such an ideology is experienced from different positions within the social formation—positions determined by race, sex, or class, for example. This critique—developed in recent feminist work—is one with which I am sympathetic. (See, e.g., Newton, "History as Usual?") What is striking about the ideology under discussion here—imbricated in what I call Modern Man discourse—is the overtness of its gendering and the difference in the subject positions it constructs for men and women.

22. *Education of Henry Adams*, 416. Quoted in Lears, *No Place of Grace*, 295.

23. In testimony before the House Committee on Un-American Activities, Clifford Odets' film *None but the Lonely Heart* was described by Lela Rogers as un-American on the grounds that it was moody, somber, pessimistic. See Leja, "'Tragedy' and 'Terror' in Wartime U.S. Culture," in Guilbaut, *Triumph of Pessimism*.

24. Curti, *Human Nature in American Thought*, 107–13.

25. "War," 17 July 1870, in Beecher, *Plymouth Pulpit* (9 vols., New York: Fords, Howard, and Hulbert, 1868–84)4: 341. Quoted in Curti, *Human Nature in American Thought*, 281.

26. *War and Other Essays* (New Haven, Conn.: Yale University Press, 1911): 35–36. Quoted in Curti, *Human Nature in American Thought*, 291.

27. "Does Human Nature Change?" *Atlantic Monthly*, June 1912, pp. 777, 779. Cited in Curti, *Human Nature in American Thought*, 292. The militarist quoted by Chittenden was General J. R. Storey.

28. Wayne Craven, *Sculpture in America*, 444. The theme of the two natures of man was a common one in turn-of-the-century Western art. In fact, Pollock may have encountered it early in his career in the work of Orozco. Landau suggests that Pollock's *Naked Man with a Knife* (1938–41) may be a response to Orozco's *The Two Natures of Man*, painted for the Escuela Preparatoria in Mexico City in 1922, which Pollock might have seen in reproduction. See Landau, *Jackson Pollock*, 51.

29. "Insanity and the Nation," *North American Review*, Jan. 1908, pp. 75–76. Quoted in Lears, *No Place of Grace*, 38.

30. See "Some Books on Mental Healing," "New Mind Cure Based on Science," and "Masters of the Mind" (cited in Fuller, *Americans and the Unconscious*, 107).

31. "Amazing 'underground' mental life" in Bruce, "New Mind Cure Based on Science," 774 (quoted in Fuller, *Americans and the Unconscious*, 107). "Complexity and instability" in "Insanity and the Nation," 76.

32. *Education of Henry Adams*, 433. Quoted in Lears, *No Place of Grace*, 290–91.

33. Lears, *No Place of Grace*, 38. See also Fuller, *Americans and the Unconscious*, 51.

34. See *No Place of Grace*, especially pages 32–47. Quote from p. 37.

35. Robinson, *Mind in the Making*, 14. There were earlier and contemporary texts that were highly influential in this respect—for example, Thorstein Veblen's "Modern Point of View and the New Order" (1918–19), and John Dewey's *Human Nature and Conduct*, published in 1922 but begun as lectures delivered in 1918. As early as 1891 Dewey voiced the opinion that the rapid developments of modern life had "outrun the slower step of reflective thought." (See "Poetry and Philosophy," *Andover Review*, August 1891. Quoted in West, *American Evasion of Philosophy*, 81.)

36. *About Ourselves*, 7–8.

37. Adams is cited in Lears, *No Place of Grace*, 288. "Economic Man" quote is from *No Place of Grace*, 38.

38. Lasch, *Culture of Narcissism*, Rieff, *Triumph of the Therapeutic*.

39. Curti, *Human Nature in American Thought*, 293.

40. Kerr Eby, "War," *Prints* (December 1935): 82. Cited in Ellen Landau, "'A Certain Rightness': Artists for Victory's 'America in the War' Exhibition of 1943," *Arts* (Feb. 1986): 44.

41. *Human Nature in American Thought*, 294.

42. The phrase is from Joseph Remenyi, "Aesthetic Values in Defense of Democracy," *University Review* (Spring 1943): 198.

43. "Arms and the Instincts," *Harper's Monthly*, January 1922, p. 167.

44. See *Human Nature in American Thought*, 294. Curti mentions also Charles Cooley, *Human Nature and the Social Order* (1922); William Ogburn, *Social Change: With Respect to Culture and Original Nature* (1922); and Vernon Kellogg, *Human Life as the Biologist Sees It* (1922).

45. "Liberalism and Irrationalism," *New Republic*, 17 May 1922, pp. 233–34.

46. Dewey, "Need for a Recovery of Philosophy," from Dewey, et al., *Creative Intelligence* (New York: Holt, 1917), as quoted in West, *American Evasion of Philosophy*, 101.

47. "Development of American Pragmatism," quoted in West, *American Evasion of Philosophy*, 91.

48. West, *American Evasion of Philosophy*, 85.

49. Babbitt, *On Being Creative*, xix. On Babbitt and the New Humanism, see J. David Hoeveler, *The New Humanism* (Charlottesville: University Press of Virginia, 1977); and *Dictionary of Literary Biography* 63, s.v. "Irving Babbitt."

50. "American Humanism," xviii.

51. Cowley, *Exile's Return*, 34.

52. Clark, "Clement Greenberg's Theory of Art," 148. Clark's description had been anticipated by Nicolas Calas in a letter to the editor of *View* in October 1940. The letter, which centers on Greenberg and his "Towards a Newer Laocoon," charges *Partisan Review* with following a policy that "zigzags from Trotsky to T. S. Eliot."

53. Babbitt, *New Laokoon*, 248–49.

54. Greenberg's note suggests that he thinks Babbitt misguided in blaming the confusion of the arts on romanticism: "This is the confusion of the arts for which Babbitt made Romanticism responsible" ("Towards a New Laocoon," 303).

55. "Present Prospects of American Painting and Sculpture," 27. "It's Athene" from "Avant-Garde and Kitsch," 49.

56. In this respect Greenberg belonged to a strong U.S. tradition of reformist belief in the morally and intellectually uplifting purpose of art: compare, for example, the view expressed in *Literary World* in 1847 that art should "raise the mind of man out of the depths of his lower nature" (quoted in Neil Harris, *The Artist in American Society* [Chicago: University of Chicago Press, 1966], 186).

57. My translation, from "L'art américain au XXe siècle," 352.

A l'heure actuelle seule une attitude positive, abandonnant les interprétations freudiennes aussi bien que la religion et le mysticisme, peut faire entrer la vie dans l'art sans trahir l'un ou l'autre.

58. See, e.g., Brinkley, *Voices of Protest.*

59. For accounts of these developments see Aaron, *Writers on the Left;* Monroe, *Artists Union of New York;* and Guilbaut, *How New York Stole the Idea of Modern Art.*

60. Deleuze and Guattari argue in *Anti-Oedipus,* for example, that the Freudian unconscious, structured on Oedipal repression, naturalizes capitalist society's preferred model of power relations.

61. "Blue Like an Orange," 323.

62. *Magazine of Art,* 255.

63. Lynd and Lynd, *Middletown in Transition.* See, for example, pages 456–57.

64. Ibid., 321.

65. In George K. Pratt, "Insane Complexes in Sane Minds," in Schmalhausen, *Our Neurotic Age,* 112.

66. "Personal disintegration" in Ruth Burr, "Suicide—Its Motives and Mechanisms," in ibid., 131. Developmental "maladjustments" in Phyllis Blanchard, "Homosexuality: Ancient and Modern," in ibid., 161–81.

67. Pratt, "Insane Complexes in Sane Minds," 112.

68. *Forum,* January 1929. In 1926 the magazine's subtitle was changed from "a magazine of discussion" to "the magazine of controversy," in the wake of a very popular issue featuring a controversy over Catholicism. Another spurt of growth occurred in 1930, when the magazine absorbed *Century.* Leach remained editor through June 1940 when the magazine stopped publishing. It was revived in 1945 in a smaller format, but by then its cultural significance was minimal.

69. *Forum,* September 1929, iii. In addition to his "What I Believe" article, published in February 1930, Babbitt had contributed an essay "The Critic and American Life" to the *Forum* in February 1928; it was subsequently cited by Leach as one of the most celebrated pieces published in the magazine.

70. Thurber, "Thinking Ourselves into Trouble," 310–11.

71. Fadiman, *I Believe* (New York: Simon and Schuster, 1939).

72. "In Defense of Man," *Commonweal* (31 Jan. 1936): 365–66.

73. Grattan, "Open Letters to Lewisohn, Krutch and Mumford," *Modern Monthly* (April 1933): 175–76.

74. Mumford, *The Condition of Man,* v. The other two texts composing the trilogy are *Technics and Civilization* and *The Culture of Cities.* On Mumford's life and works, see Blake, *Beloved Community,* and Miller, *Lewis Mumford: A Life.*

75. See Mumford, "What I Believe," 268.

76. Mumford, *Condition of Man,* 364–65.

77. Cowley is quoted in Miller, *Lewis Mumford: A Life,* xvii. Farrell quote is from "The Faith of Lewis Mumford," in Farrell, *League of Frightened Philistines, and Other Essays,* 107.

78. Schapiro, "Looking Forward to Looking Backward," 17, 24.

79. See, for example, MacLeish, "Assault on Liberalism," 10–13; and Chase, "Armed Obscurantist," 346–48. For further treatment of this subject, see Blake, *Beloved Community,* especially chapters 7 and 8.

80. Farrell, "Faith of Lewis Mumford," a paper originally published in the *Southern Review* in 1940 and expanded to address *The Condition of Man* in *The League of Frightened Philistines, and Other Papers,* 106–07.

81. Hook, "Metaphysics, War, and the Intellectuals," 328.

82. Hook pointed out that Jacques Maritain had hailed these three figures as allies; see Hook, "Failure of the Left," 166.

83. Hook, "New Failure of Nerve," 2–3.

84. Chase, "Huxley-Heard Paradise," 143; Benedict, "Human Nature Is Not a Trap," 163; Hook, "Failure of the Left," 165.

85. Originally published in *Horizon*, June 1942; reprinted in Koestler, *Yogi and the Commissar, and Other Essays*. A response by Nicolas Calas, defending Jung, was included in his article "The New Prometheus," *View*, October 1942.

86. One of the targets of the *Partisan Review* assault was Philip Wheelwright, an editorial advisor to *Chimera* and the author of the initial article responding to the charges. While Wheelwright's response was rather defensive and in crucial respects lent reinforcement to some of Ernest Nagel's criticisms of him, other articles in the *Chimera* series were more effective rebuttals.

87. Burke, "Tactics of Motivation," 24–25.

88. Auden, "Purely Subjective," 21.

89. Quotes are from Horkheimer and Adorno, *Dialectic of Enlightenment*, 35; and Jay, *Dialectical Imagination*, 48.

90. See, for example, the review of Mumford's *Condition of Man* in *Time*, 5 June 1948, 100–104.

91. See, for example, his "Man's Image of Man."

92. Editorial introduction, "The Study of Man," *Commentary* (December 1945): 84.

93. Greenberg, "Pessimism for Mass Consumption," 393–94.

94. This information is drawn from *Dictionary of Literary Biography* 17, s.v. "Arthur M. Schlesinger, Jr."

95. "Administration man" comes from Robert Bendiner, "Schlesinger's *Vital Center*," *Nation*, 17 Sept. 1949, 267. On Schlesinger's position in U.S. politics at this time see Guilbaut, *How New York Stole the Idea of Modern Art*; James A. Neuchterlein, "Arthur M. Schlesinger, Jr. and the Discontents of Postwar American Liberalism," *Review of Politics* (January 1977); and Ronald Radosh, "Historian in the Service of Power," *Nation*, 6 Aug. 1977.

96. The left called attention to Schlesinger's energetic proselytizing for centrist liberal politics; see Herbert Aptheker, "The Schlesinger Fraud," *Masses and Mainstream* (October 1949), from which this list of periodicals is drawn.

97. *The Vital Center*, 57; quoted in Guilbaut, *How New York Stole the Idea of Modern Art*, 202.

98. "Freud and the Image of Man." The essay was the text of a lecture delivered at a conference on "Science and the Modern World View," organized by the American Academy of Arts and Sciences. It was reprinted in *American Psychologist* (September 1956).

99. Rorty, *Contingency, Irony, and Solidarity*, 86.

100. Quotes are from ibid., 35.

101. Farber, "Artists for Victory," 280.

102. Gottlieb, "Ides of Art," 43.

103. Alfredo Valente, Review of Gottlieb exhibition at Seligmann Galleries, in *Promenade*, 40. Because this review is telling, in my view, and difficult to locate, I will quote it at length.

[Gottlieb's] method is similar to the reclining couch technique of the psychiatrist who recalls the most fuguitive, obscure, personal, sexual, atavistic memories. Drawing from the past with a certain naivete that is lost almost by its directness, Gottlieb contains complete fragments of experience in squares, one against the other, which derive from the arrangements of medieval books of hours; or again, he will insinuate details in episodic totem pole story-telling arrangements with cubistic overtones. The very use of some of these alien art forms is supposed to imply certain psychiatric throwback meanings. See *Pictograph*, reproduced. Gottlieb's work is primarily individualistic in its preoccupation with itself and, more egotistically, with the painter himself. The humanities are overlooked; love, hate, religion, man's hopes, morals and fate are secondary matters in the play of aesthetic form and experiment. Nevertheless, for those clinically interested, this show is outstanding for what is happening in the neon-lighted ateliers.

104. Newman, "Sobre el arte moderno: Examen y ratificación," *La Revista Belga* (November 1944): 20. English original published in BN-SWI: 67.

105. Newman, "La pintura de Tamayo y Gottlieb," *La Revista Belga* (April 1945): 17 ("El Arte es dominio del pensamiento puro"). English original published in BN-SWI: 72.

106. Newman, "Plasmic Image," BN-SWI: 141–42, 155.

107. Motherwell, "Painters' Objects," 97; Rosenberg, "American Action Painters," 22.

108. *Adolph Gottlieb: Drawings* 7–19 Feb. 1944; BN-SWI: 61.

109. "From a Reviewer's Notebook," 13 Feb. 1944, sec. 2, p. 7.

110. "By Our Modernists," 27 Feb. 1944, sec. 2, p. 6.

111. The letter, dated 27 Feb. 1944, is contained in the Adolph Gottlieb Papers, AAA-SI N/69-49: 234.

112. See Robinson, *Mind in the Making,* 34; Carncross, *Escape from the Primitive,* 63; Carrel, *Man: The Unknown,* 118; H. A. Overstreet, *About Ourselves,* 160; Joseph Wood Krutch, *Modern Temper,* 73; John Langdon-Davies, *Man Comes of Age,* 148ff.; Calverton and Schmalhausen, *Sex and Civilization,* 10.

113. *Personal Statement,* unpaginated.

114. Motherwell, "Modern Painter's World," 9. The italics are Motherwell's.

115. Hook, "New Failure of Nerve," 3. The italics are Hook's.

116. Motherwell, "Modern Painter's World," 10.

117. Donna Haraway has shown how the calamities of advanced industrialism, particularly the bomb, had led to an effort to "renaturalize 'man'" in the post–World War II era. See *Primate Visions,* 156.

118. I wish to thank Mary Maggini for calling my attention to the Bouché painting.

119. "Jackson Pollock's Abstraction," 229.

120. See Wagner, "Lee Krasner as L. K."

121. See Wagner, "Lee Krasner as L. K."; and Ann Schoenfeld, "Grace Hartigan in the Early 1950s: Some Sources, Influences, and the Avant-Garde," *Arts* (September 1985): 85–86.

122. Hubert Crehan, "Elaine de Kooning," *Art Digest,* 15 April 1954, p. 23.

123. In the late 1940s, Simone de Beauvoir was struck by the extent to which American women modeled themselves after the heroines of detective novels and Hollywood movies. See her *America Day By Day,* 254. (Quoted in Cooke, "Willem de Kooning: 'A Slipping Glimpser,'" 254.)

124. Janey Place, "Women in Film Noir," in Kaplan, *Women in Film Noir,* 35.

125. See H. G. Baynes, *Mythology of the Soul,* 613; and Hunter, "Among the New Shows," 30 Jan. 1949, sec. 2, p. 9.

126. Lynes, *O'Keeffe, Stieglitz and the Critics,* 16. My discussion of O'Keeffe draws principally upon Lynes and upon Anna Chave, "O'Keeffe and the Masculine Gaze," *Art in America* (Jan. 1990).

127. Quoted in Lynes, *O'Keeffe, Stieglitz and the Critics,* 16.

128. Quoted in ibid., 7.

129. Kasson, *Marble Queens and Captives,* 81.

130. The subject—woman with bicycle—may have been inspired by Léger's *Big Julie,* purchased by the Museum of Modern Art in 1945.

131. Seitz, *Abstract Expressionist Painting in America,* p. 126; Steinberg, "Month in Review," *Arts,* (Nov. 1955): 46.

132. Seuphor, *Abstract Painting* (New York: Abrams, 1961), 244. A related and characteristic reading of conflict in Willem de Kooning's paintings is articulated by Irving Sandler in *Triumph of American Painting,* 131.

Painting that manifested the signs of his creative struggle—and they are everywhere in De Kooning's pictures—was of far greater value to him than painting that exhibited qualities identified with the French regard for *métier*. . . . Indeed, De Kooning's pictures more than

anything else are metaphors for his own and modern man's existential condition, capturing the anxious, rootless, and violent reality of a swiftly paced urban life.

A more recent response to "Woman and Bicycle" is Michael Brenson, "Iconoclastic Figures by De Kooning and Dubuffet," *New York Times*, 7 Dec. 1990, B10 ("the great daubs, swabs and slashes of paint seem to relate to the figure like demons in a painting of the Temptation of St. Anthony").

133. Fitzsimmons, "Art," p. 8; Janis and Blesh, *De Kooning*, 61.

134. Seitz, *Abstract Expressionist Painting in America*, 126.

135. Fitzsimmons, "Art," 4, 6.

136. Steinberg, "Month in Review," *Arts* (Nov. 1955): 46.

137. A historian looking for a foothold for a feminist critique of Willem de Kooning's women or Jackson Pollock's moon women will look in vain to contemporary criticism by such women as Dore Ashton, Maude Riley, Emily Genauer, Margaret Breuning, and Mary Cole. Ashton, for example, minimizes the significance of the woman imagery in de Kooning's pictures in favor of appraisal of his formal and expressive achievement. One senses in fact some denial of the problems raised by the pictures in passages such as

> To me the expressive value of this painting goes beyond the fact of the two fleshy women. It is an expression of turbulent worldly emotion fixed in the carcasses of these two.
>
> I think their real importance went beyond problems of theme. . . . The ladies, however prepossessing they were, were instrumental works leading to this apogee of abstract power ("Art," *Arts and Architecture* [Dec. 1955]: 34).

The only subject positions available to aspiring critics who were women, like their counterparts among the painters, were those of the male artist/critic or the female object ("Other") of the picture. Neither alternative being attractive, women were forced to make an unpleasant choice or try to forge a double or other identity.

138. De Kooning to Rodman, *Conversations with Artists*, 102.

139. See Eliot, "Under the Four Winds," *Time*, 28 June 1954, 77.

140. Wylie, *Generation of Vipers*, 203:

> I give you mom. I give you the destroying mother. I give you her justice—from which we have never removed the eye bandage. I give you the angel—and point to the sword in her hand. I give you death—the hundred million deaths that are muttered under Yggdrasill's ash. I give you Medusa and Stheno and Euryale. I give you the harpies and the witches, and the Fates. I give you the woman in pants, and the new religion: she-popery. I give you Pandora. I give you Proserpine, the Queen of Hell. The five-and-ten-cent-store Lilith, the mother of Cain, the black widow who is poisonous and eats her mate, and I designate at the bottom of your program the grand finale of all the soap operas: the mother of America's Cinderella.

Cinderella is another of Wylie's vicious caricatural stereotypes; male variants include "the scientist," "the businessman," and "the statesman." See also chapter 3 above, note 66.

141. Quoted in Sandler, *New York School*, 113.

142. Wagner, "Lee Krasner as L. K."

143. Letter to the editor, *New York Times*, 8 July 1945, sec. 2, p. 2.

144. *Transformations of Man*, 21–22.

145. Recall that "The Subjects of the Artist" was the name of a school started by Baziotes, David Hare, Motherwell, and Rothko in 1948.

146. Preston, "Early Exhibitions"; and "Into the Void," *Time*, 3 October 1949.

147. For a valuable discussion of the arguments in Foucault's work relevant to the issues under consideration here, see Dews, "Power and Subjectivity in Foucault"; and the same author's "Adorno, Post-Structuralism and the Critique of Identity." Also influential in my thinking

about the relation of subjectivity and ideology in New York School painting was Burniston and Weedon, "Ideology, Subjectivity and the Artistic Text." A useful reference with a wide scope is Heller, Sosna, and Wellbery, *Reconstructing Individualism*.

148. *Power/Knowledge*, 98.

149. Foucault, "The Subject and Power," in Hubert L. Dreyfus and Paul Rabinow, *Michel Foucault: Beyond Structuralism and Hermeneutics* (Chicago: University of Chicago Press, 1983), 213.

150. An economic case, similar and related to Schlesinger's political one, in which power management was attempted through the adaptation of new discursive formations would be the appropriation during this period by business and advertising of new theories of human nature and the unconscious. See, for example, Elton Mayo, "The Irrational Factor in Human Behavior—The 'Night Mind' in Industry," *Psychology in Business*, November 1923. For an overview, see Merle Curti, "The Changing Concept of 'Human Nature' in the Literature of American Advertising," *Business History Review* (Winter 1967); also Stuart Ewen, *Captains of Consciousness* (New York: McGraw-Hill, 1977); and id., *All Consuming Images* (New York: Basic, 1988): esp. 47ff.

151. See Cornel West's discussion of this aspect of Mills' work in *American Evasion of Philosophy*, 129.

5. POLLOCK & METAPHOR

1. See Landau, *Jackson Pollock*, for a recent and comprehensive codification of this account.

2. *New York Times*, 14 Nov. 1943, sec. 2, p. 6; reprinted in JP-CR 4: 230.

3. Quotes from Howard Devree, *New York Times*, 25 March 1945, sec. 2, p. 8; Eleanor Jewett, *Chicago Daily Tribune*, 6 March 1945, 13, quoted in O'Connor, *Jackson Pollock*, 36; Jon Stroup, *Town and Country*, March 1945, 86; and Robert Coates, *New Yorker*, 17 Jan. 1948, 44. Alfieri is quoted in *Time*, 20 Nov. 1950, 71.

4. "Jackson Pollock: Is He the Greatest Living Painter in the United States?" *Life*, 8 Aug. 1949, 45.

5. *New Republic*, 25 June 1945, 871.

6. *Nation*, 13 April 1946, 445.

7. Quotes from Wright interview of Pollock, summer 1950, reprinted in JP-CR 4: 251; narration to film by Hans Namuth of Pollock painting, published in Putz, *Jackson Pollock: Theorie und Bild*, 108–09; telegram to editor, *Time*, 11 Dec. 1950, p. 10.

 To "deny the accident" could have other meanings beyond the assertion of control over medium. It might be taken as a paraphrase of the cliché voiced by a character in Alfred Hitchcock's *Rope* (1948): "Freud says there's a reason for everything." Or it might relate to the idea that "an accident is normalcy raised to the level of drama," as Alexander Cockburn has observed. "The idea of an accident is profoundly bourgeois. Newspapers, almanacs of bourgeois thought, love accidents because they ratify the idea of order" (*Nation*, 7 May 1990, 623).

8. Reprinted in JP-CR 4: 253.

9. "Inner forces" comes from Pollock's comment in Wright interview with Pollock: "The modern artist, it seems to me, is working and expressing an inner world—in other words—expressing the energy, the motion, and other inner forces" (JP-CR 4: 250).

10. Wylie, *Generation of Vipers*, 34.

11. Schmalhausen, *Why We Misbehave*, 182.

12. The book jacket, on Fromm's *Escape from Freedom* (Rinehart, 9th printing), promotes *Man for Himself* as follows: "Modern man is left the helpless prey of forces both within and without himself because he lacks faith in any principle by which his individual life and that of society ought to be guided."

13. This aspect of Pollock's work figured prominently in Sam Hunter's early retrospective essay,

written for the Museum of Modern Art exhibition that followed Pollock's death. "Pollock always saw the painting field as an arena of conflict and strife, on which, according to the stage of his stylistic evolution, recognizable forms or abstract configurations were locked in violent combat. Each picture became the representation of a precarious balance in the play of contending forces" ("Jackson Pollock," 9).

14. "Jackson Pollock's Abstraction," in Guilbaut, *Reconstructing Modernism,* 194.

15. Clark has described this as a tendency of the modernist critics to treat the dissonance in Pollock's work by looking "through it as if it were a bit embarrassing" ("Jackson Pollock's Abstraction," in Guilbaut, *Reconstructing Modernism,* 200).

16. Letter dated 7 June 1951, published in JP-CR 4: 261.

17. *Jackson Pollock,* 26.

18. Perhaps the earliest comparison between Pollock's work and jazz was drawn by Eleanor Jewett in the *Chicago Daily Tribune,* 6 March 1945, 13: "Pollock obviously is a follower of the school of the new note. His chief trouble seems to be that his trumpet has gone wild and he is sounding in all directions at once." The comparison also appears in Alfred Frankenstein, *San Francisco Chronicle,* 12 Aug. 1945: "The flare and spatter and fury of his paintings are emotional rather than formal, and like the best jazz one feels that much of it is the result of inspired improvisation rather than conscious planning. Nevertheless, for all its fury of movement, its heated color and its tangled complexity of line, this painting holds together. There is a grand swirling heave that organized the canvas" (quoted in O'Connor, *Jackson Pollock,* 38).

19. Rodman, *Conversations with Artists,* 82; and B. H. Friedman interview with Lee Krasner in Marlborough-Gerson Gallery, *Jackson Pollock: Black and White,* 7.

20. *Jackson Pollock,* 12.

21. Fried, *Three American Painters,* 14.

22. Fried, *Three American Painters,* 16. T. J. Clark has noted indications in Greenberg's early criticism that the matter of figuration/abstraction was an open question for him. The exhibition of the 1951 paintings, with their overt figuration, was seen by Greenberg as "a turn but not a sharp change of direction." For Fried, however, the reversion to traditional drawing "probably marks Pollock's decline as a major artist." See Greenberg, "Art Chronicle: Feeling Is All," 102; and Fried, *Three American Painters,* 15; and see also Clark's discussion of the issue in "Jackson Pollock's Abstraction" in Guilbaut, *Reconstructing Modernism,* 209–10.

Greenberg may have recognized the complexity of Pollock's work in this respect, but his own deep-rooted antagonism to figuration frequently colors his writing. His eagerness to embrace Pollock's early abstractions in the *Accabonac Creek* and *Sounds in the Grass* series is one such case. He wrote, "Pollock has gone beyond the stage where he needs to make his poetry explicit in ideographs. What he invents instead has perhaps, in its very abstractness and absence of assignable definition, a more reverberating meaning" (*Nation,* 1 Feb. 1947, 139; CG-CEC 2: 125).

23. "Jackson Pollock and the Modern Tradition, Part 3," 30. Rubin qualified this assertion in a footnote by distinguishing between the early pourings, which exhibit some signs of an underlayer of figuration, and the "full blown all-over drip paintings" of 1948–50, more advanced and radical works from which all figuration had been purged.

24. Fried, *Three American Painters,* 16; Rubin, "Jackson Pollock and the Modern Tradition," pt. 1, 21.

25. "Talk of the Town," *New Yorker,* 5 Aug. 1950, 16.

26. Quote from Landau, *Jackson Pollock,* 213.

27. In Marlborough-Gerson Gallery, *Jackson Pollock: Black and White,* 7.

28. Rubin made much of the fact that Krasner's original statement ended with "Well, that was that painting." Here is the sentence in context.

For me, all of Jackson's work grows from this period [the mid-1930s]; I see no more sharp

breaks, but rather a continuing development of the same themes and obsessions. The 1951 show seemed like monumental drawing, or maybe painting with the immediacy of drawing— some new category. . . . There's one other advantage I had: I saw his paintings evolve. Many of them, many of the most abstract, began with more or less recognizable imagery—heads, parts of the body, fantastic creatures. Once I asked Jackson why he didn't stop the painting when a given image was exposed. He said, "I choose to veil the imagery." Well, that was that painting. With the black-and-whites he chose mostly to expose the imagery.

Rubin's attempt to "clarify" Krasner's point in fact contravenes the import of the passage.

After citing Pollock's statement about choosing to veil the image, she carefully added, "Well, that was that picture." Indeed, which was "*that picture*"? . . . The knowledge that Pollock's remark about "veiling the image" referred to this early transitional work in which he *literally* veiled his original figures, should do much to clarify Lee Krasner Pollock's remarks. Lest questions remain, however, I have asked her to make an explanatory statement, which I quote in full: "Pollock made the remark about 'veiling' in reference to *There Were Seven in Eight*, and it doesn't necessarily apply to other paintings—certainly not to such pictures as *Autumn Rhythm, One*, etc."

Rubin ignores the fact that Krasner's original statement was an explicit challenge to the rigid stylistic periodization of Pollock's oeuvre to which Rubin himself was committed.

29. Landau, *Jackson Pollock*, 152–53.
30. Pollock gave this painting to the photographer Hans Namuth around 1950, when Namuth was documenting Pollock's painting process in photographs and films. It appears in the background of some of the studio photographs taken at this time.
31. *Three American Painters*, 17.
32. See, for example, JP-CR 4: 250.
33. *Nation*, 19 Feb. 1949, 221.
34. "Jackson Pollock and the Modern Tradition," pt. 1, 21.
35. See, for example, a review by Emily Genauer in the *New York World-Telegram*, 7 Feb. 1949, quoted in O'Connor, *Jackson Pollock*, 46.
36. The paintings, of course, were produced on the floor of Pollock's studio, so that the artist himself looked down into the pictures while making them. Occasionally this vertical orientation has been recreated for viewers by exhibiting the paintings on the floor or ceiling of a gallery. Installation photographs indicate, for example, that *White Cockatoo* was shown at Janis Gallery in December 1955 affixed to the ceiling.
37. *Abstract Painting*, 153.
38. *Arts and Architecture*, March 1954, p. 7.
39. "Jackson Pollock: The Infinite Labyrinth," 93.
40. *Art News* (Dec. 1955): 53.
41. Seiberling, "Baffling U.S. Art," 74.
42. "Pollock: Le nouvel espace," 77. Ashton quotes Stanley William Hayter:

Tout comme l'espace interstellaire, on ne peut lui trouver de références qu'avec des points extrêmement éloignés, et conçus en termes de mouvement.

43. "Jackson Pollock: The Maze and the Minotaur," 190.
44. "Jackson Pollock," *Museum of Modern Art Bulletin* 24.2, 12.
45. William Baziotes used the title earlier than Pollock. His work *The Web*, painted in 1946 and first exhibited at the Kootz Gallery in 1947, is now in the collection of the Herbert F. Johnson Museum of Art, Cornell University. The left side of the painting features a stack of close, horizontal lines which terminate at the perimeter of a dominant schematic central figure.
46. 11 Jan. 1948, sec. 2, p. 9.
47. 30 Jan. 1949, sec. 2, p. 9.

48. 27 Nov. 1949, sec. 2, p. 12.

49. *Art News* (Dec. 1949): 43; *Art Digest* (1 Dec. 1950): 16.

50. *Art Digest* (15 Dec. 1951): 19.

51. "Pollock: Le nouvel espace," 77. "Il peut aussi, comme une araignée, s'asseoir au coeur du bâti, et, à l'arrière du premier plan, demeurer à l'abri à l'intérieur de la grande trame."

52. Landau, *Jackson Pollock*, 152–53. For another recent example of a turn to web metaphor in the analysis of Pollock's painting, see Anfam, *Abstract Expressionism*, 13. Anfam quotes Henry James to illuminate the subject and structuring of Pollock's 1950 paintings, particularly *Lavender Mist:*

> Experience is never limited, and it is never complete; it is an immense sensibility, a kind of huge spiderweb of the finest silken threads suspended in the chamber of consciousness, and catching every airborne particle in its tissue.

53. "Jackson Pollock Market Soars," 132.

54. Rubin, "Jackson Pollock and the Modern Tradition," pt. 3, 30.

55. See, for example, ibid., 21, where the image is invoked four times in the space of two short paragraphs.

56. "Chaos, Damn It!" *Time*, 20 Nov. 1950, 70–71.

57. "Gorky, De Kooning, Pollock," 60.

58. "Pollock: Le nouvel espace," 77. "Le labyrinthe de lignes, croisées et re-croisées, qui en résulta, occupait un mince espace, latéralement défini. Le spectateur y pénètre et, conduit à travers le dédale magique de la trame, obéit à la succession hasardeuse des lignes."

59. "Jackson Pollock: The Maze and the Minotaur," 189.

60. "By Contemporaries," *New York Times*, 2 Dec. 1951, sec. 2, p. 11.

61. The other was *VVV*, edited by David Hare, which published only three issues (one a double issue) between June 1942 and February 1944. *View* published four to eight issues annually between September 1940 and March 1947.

62. See Cooke, "Willem de Kooning: 'A Slipping Glimpser,'" 70–72. Cooke notes that the painting "marks the moment when de Kooning is at his most thoroughly Surrealist," possibly in response to the nature of the commission.

63. An unedited typescript of the essay is in the JP Papers, AAA-SI 3048: 545–50.

64. "The Artlessness of Walt Disney," *Partisan Review* (Spring 1945): 228.

65. Tyler to Goldwater, 11 May 1950, JP Papers, AAA-SI 3046: 345. Below is the complete text of the two paragraphs deleted from Tyler's article.

> . . . a wall on which he hangs with his eyes.
>
> Perhaps the last paradox these works contain is that of death. For in being a conception of ultimate time and space, the labyrinth of infinity, Jackson Pollock's latest work goes beyond the ordinary processes of life—however these might be visualized and recognized—into an absolute being which must contain death as well as life. Hence the spatial distinctions achieved by lines and spots of color within Pollock's rectangles go as much beyond mere optical vision as seems possible to painting. They do so just as ideas of death go as much as possible beyond life as idea can go. To formulate the paradox: to reach death in any sense, one must first pass through life. In the same way, space implies existence within space, for if apprehension (visual, aural, etc.) were not differentiable, it would be absolute and unknown; so does consciousness imply unconsciousness, blindness imply sight.
>
> Jackson Pollock has put the concept of the labyrinth at an infinite and unreachable distance, a distance beyond the stars—a non-human distance. But in this, too, inheres a paradox. For how can what is man-made be "non-human"? The spectator does not experience vertigo before these works, where he is as surely anchored as though he were in front of St. Peter's in Rome or gazing at Radio City from the top of the Chrysler Building. If one felt

vertigo before Pollock's differentiations of space, then truly one would be lost in the abyss of an endless definition of being. One would be enclosed, trapped by the labyrinth of the picture-space. But we are safely looking at it, seeing it steadily and seeing it whole, from a point outside. Only *man*, in his paradoxical role of the *superman*, can achieve such a feat of absolute contemplation: the sight of an image of space *in which he does not exist*.

In being so overwhelmingly . . . (JP Papers, AAA-SI 3048: 548–49).

66. Barr, "Gorky, De Kooning, Pollock," 60; Hess, *Abstract Painting*, 153; Ashton, "Pollock: Le nouvel espace," 77 ("Il se plaça lui-même carrément et littéralement au centre de son tableau, et le spectateur fut obligé de le suivre. . . . En plaçant le spectateur au centre du tableau au lieu de le laisser en face de lui, Pollock—et les artistes qui s'intéressent au même problème— a violemment rejeté les anciennes conventions picturales, servant à délimiter un espace récessif").

67. O'Hara quotes are from *Jackson Pollock*, 29, 23. The "environment" passage is from Kaprow, "Jackson Pollock: An Artists' Symposium," pt. 1, 60. The italics are Kaprow's.

68. For example, in the most recent introductory survey of Abstract Expressionism, David Anfam describes Pollock's paintings as "webbed labyrinths" (*Abstract Expressionism*, 127).

69. For fundamental critiques from the disciplines of philosophy and anthropology, see Goodman, *Languages of Art*, and Geertz, *Interpretation of Cultures*.

70. Niebuhr, "Sickness of American Culture," 270; Wylie, *Generation of Vipers*, 41, 105.

71. Fromm, *Escape from Freedom*, 9.

72. Gage, "Reflective Eye," 4.

73. An interesting feature of this film is that it contains a subtle parody of Modern Man literature. One of the characters, a former newspaper reporter, is described as having made a fortune by writing a bestseller titled *Whither Away Mankind*, a fictitious title that evokes Charles Beard's historical study *Whither Mankind* but gives it the tenor of a Wylie-esque sermon through punning on the homonyms *wither* and *whither*. The author is represented as ridiculous, self-indulgent, and pretentious.

74. Place, "Women in Film Noir," in Kaplan, *Women in Film Noir*, 41.

75. "Jackson Pollock: The Infinite Labyrinth," 92.

76. "Jackson Pollock's Abstraction," in Guilbaut, *Reconstructing Modernism*, 201.

77. Ibid.

78. "American Action Painters," 48.

79. Quotes from *Nation*, 28 Dec. 1946, 768; and *Nation*, 6 Dec. 1947, 630. For an effort by Greenberg to advance his reading of Pollock's significance against other tendencies in Pollock criticism—an effort pitched at a mass audience—see his article "Jackson Pollock Market Soars," 42–43, 132, 135.

80. "Critical Reception of Abstract-Expressionism."

81. Tyler, manuscript for "Jackson Pollock: The Infinite Labyrinth," JP Papers, AAA-SI 3048: 548–49.

82. "Art," *Arts and Architecture*, 30.

83. "Jackson Pollock Paints a Picture," 60.

84. Typescript in JP Papers, AAA-SI 3048: 551.

EPILOGUE

1. From "Ideology and Ideological State Apparatuses," in Althusser, *Lenin and Philosophy*, 171.

2. Stella, "How Velásquez Seizes the Truth That Is Art," *New York Times*, 1 Oct. 1989, sec. 2, p. 39.

BIBLIOGRAPHY

Note: For translated works, date of publication in the original language usually is given in parentheses.

Aaron, Daniel, *Writers on the Left*. 1961. Reprint. Oxford: Oxford University Press, 1977.

Abercrombie, Nicholas, Stephen Hill, and Bryan S. Turner. *The Dominant Ideology Thesis*. London: George Allen and Unwin, 1980.

"Adolph Gottlieb." *Art News* (15–31 January 1946): 21.

Adorno, Theodor W. "Commitment." Trans. Francis McDonagh. In *The Essential Frankfurt School Reader*, ed. Andrew Arato and Eike Gebhardt. New York: Continuum, 1982. (1962.)

———. *Minima Moralia*. Trans. E. F. N. Jephcott. London: Verso, 1978. (1951.)

———. *Prisms*. Trans. Samuel and Shierry Weber. Cambridge, Mass.: MIT Press, 1981. (1967.)

Adorno, Theodor W., and Max Horkheimer. *Dialectic of Enlightenment*. Trans. John Cumming. New York: Continuum, 1982. (1944.)

Alloway, Lawrence, and Mary Davis MacNaughton. *Adolph Gottlieb: A Retrospective*. New York: The Arts Publisher and the Adolph and Esther Gottlieb Foundation, 1981.

Althusser, Louis. *For Marx*. Trans. Ben Brewster. London: New Left Books, 1977. (1965.)

———. *Lenin and Philosophy, and Other Essays*. Trans. Ben Brewster. New York: Monthly Review Press, 1978.

"Anthropology Held Essential to Victory," *New York Times,* 3 January 1943, sec. 1, p. 35.

"Artists Denounce Modern Museum." *New York Times,* 17 April 1940, p. 25.

Ashton, Dore. *About Rothko.* New York: Oxford University Press, 1983.

————. *The New York School: A Cultural Reckoning.* New York: Viking, 1973.

————. "Pollock: Le nouvel espace." *XXe Siècle,* n.s. (Christmas 1961): 75–80.

Aswell, Edward C. "American Humanism." *Forum,* August 1929, xvi-xviii.

Auden, W. H. "Purely Subjective." *Chimera* (Summer 1943): 3–22.

Auping, Michael, ed. *Abstract Expressionism: The Critical Developments.* New York: Abrams/Albright-Knox Art Gallery, 1987.

Ausfeld, Margaret Lynne, and Virginia M. Mecklenburg. *Advancing American Art, Politics and Aesthetics in the State Department Exhibition.* Montgomery, Ala.: Montgomery Museum of Fine Arts, 1984.

Baas, Jacquelynn, "Interpreting Orozco's *Epic." Dartmouth Alumni Magazine,* January/February 1984, 44–49.

Babbitt, Irving. *The New Laokoon; An Essay on the Confusion of the Arts.* Boston: Houghton Mifflin, 1910.

————. "What I Believe." *Forum,* February 1930, 80–87.

Bal, Mieke, and Norman Bryson. "Semiotics and Art History." *Art Bulletin* (June 1991): 174–208.

Barnes, Harry Elmer. "James Harvey Robinson." In *American Masters of Social Science,* ed. Howard W. Odum. New York: Holt, 1927.

Barr, Alfred H., Jr. Letter to the editor. *College Art Journal* (Fall 1950): 57–59.

————. *Painting and Sculpture in the Museum of Modern Art, 1929–1967.* New York: MoMA, 1977.

Barthes, Roland. *Mythologies.* Trans. Annette Lavers. New York: Hill and Wang, 1972. (1957.)

Baudrillard, Jean. *A l'ombre des majorités silencieuses ou la fin du social.* Paris: Denoël/Gonthier, 1982.

Baxandall, Michael. *Painting and Experience in Fifteenth Century Italy.* Oxford: Oxford University Press, 1972.

Baynes, Helton Godwin. *Analytical Psychology and the English Mind.* London: Methuen, 1950.

————. *Mythology of the Soul.* London: Baillière, Tindall and Cox, 1940.

Baziotes, William. "The Artist and His Mirror." *Right Angle* (June 1949): 2–3. (Reprinted in *New York School: The First Generation,* ed., Maurice Tuchman. Greenwich, Conn.: New York Graphic Society, 1965.)

————. "I Cannot Evolve Any Concrete Theory." *Possibilities* 1 (Winter 1947–48): 2.

————. Papers. Archives of American Art, Smithsonian Institution. Microfilms N/70-21, N/70-24, 347.

Bearor, Karen. "Gender Bias in Jungian Theory and Its Impact upon Irene Rice Pereira." Lecture delivered at the College Art Association annual meeting, New York, 1990.

Beaudoin, Kenneth. "This Is the Spring of 1946." *Iconograph* 1 (Spring 1946): 3–7.

Benedict, Ruth. "Human Nature Is Not a Trap." *Partisan Review* (March/April 1943): 159–64.

————. *Patterns of Culture.* Boston: Houghton Mifflin, 1934.

————. *Race: Science and Politics.* New York: Modern Age, 1940.

Bennett, Tony, Colin Mercer, and Janet Woollacott, eds. *Popular Culture and Social Relations.* Milton Keynes and Philadelphia: Open University Press, 1986.

Benton, Thomas Hart. *An Artist in America.* 1937. 4th ed. Columbia, Mo.: University of Missouri Press, 1983.

Bercovitch, Sacvan. "The Problem of Ideology in American Literary History." *Critical Inquiry* (Summer 1986): 631–53.

Berger, Peter. "Towards a Sociological Understanding of Psychoanalysis." *Social Research* (Spring 1965): 26–41.

Berkhofer, Robert F., Jr. *The White Man's Indian*. 1978. Reprint. New York: Vintage, 1979.

Bertine, Eleanor. "In Memoriam: Kristine Mann." *Papers of the Analytical Psychology Club of New York* 5 (1946): 11–14.

———. "The Individual and the Group." *Papers of the Analytical Psychology Club of New York* 1 (1938).

———. *Jung's Contribution to Our Time: The Collected Papers of Eleanor Bertine*, ed. Elizabeth C. Rohrbach. New York: G. P. Putnam's Sons, 1967.

Bertine, Eleanor, et al. "The Psychological Aspects of the War." *Papers of the Analytical Psychology Club of New York* 4 (1940).

Blake, Casey. *Beloved Community*. Chapel Hill: University of North Carolina Press, 1990.

Blumin, Stuart M. *The Emergence of the Middle Class: Social Experience in the American City, 1760–1900*. Cambridge: Cambridge University Press, 1989.

Boas, Franz. Letter to the editor. *Nation*, 20 December 1919, 797.

———. *Primitive Art*. 1927. Reprint. New York: Dover, 1955.

Bourdieu, Pierre. *Distinction: A Social Critique of the Judgement of Taste*. Trans. Richard Nice. Cambridge, Mass.: Harvard University Press, 1984. (1979.)

Bourgeois, Jacques. "La tragédie policière." *La Revue du Cinéma* (1 November 1946): 70–72.

Bradbury, Malcolm, and James McFarlane, eds. *Modernism, 1890–1930*. New York: Penguin, 1976.

Bradley, John Hodgdon. "Is Man an Absurdity?" *Harper's*, October 1936, 528–34.

"Brain Cells Create Electric Currents, Scientist Asserts." *New York Times*, 25 June 1933, sec. 1, p. 1.

Braque, Georges. "Testimony against Gertrude Stein." *Transition Pamphlet no. 1*, supplement to *Transition* 23 (The Hague, February 1935): 13–14.

Braun, Emily, and Thomas Branchick. *Thomas Hart Benton: The America Today Murals*. Williamstown, Mass.: Williams College Museum of Art, 1985.

Brenson, Michael. "Divining the Legacy of Jackson Pollock." *New York Times*, 13 December 1987, sec. 2, pp. 47, 53.

Briffault, Robert. "Is Man Improving?" *Scribner's*, July 1935, 8–13.

Brinkley, Alan. *Voices of Protest: Huey Long, Father Coughlin, and the Great Depression*. New York: Vintage, 1983.

Brooks, James. Statement in "Jackson Pollock: An Artists' Symposium, Part 1," *Art News* (April 1967): 31.

Bruce, H. Addington. "Insanity and the Nation." *North American Review* (January 1908): 70–79.

———. "Masters of the Mind." *American Magazine*, November 1910, 71–81.

———. "The New Mind Cure Based on Science." *American Magazine*, October 1910, 773–78.

———. "Religion and the Larger Self." *Good Housekeeping*, January 1916, 55–61.

———. "Some Books on Mental Healing." *Forum*, March 1910, 316–23.

Bruner, Jerome S. "Freud and the Image of Man." *Partisan Review* (Summer 1956): 340–47. (Also published in *American Psychologist* [September 1956]: 463–66).

Bryson, Norman. *Vision and Painting*. New Haven, Conn.: Yale University Press, 1983.

Buchloh, Benjamin. "A Concrete History of Abstract Expressionism." *Art in America* (March 1984): 19–21.

Bullard, Arthur. "Arms and the Instincts." *Harper's Monthly* January 1922: 167–74.

Bürger, Peter. *Theory of the Avant-Garde*. Trans. Michael Shaw. Minneapolis: University of Minnesota Press, 1984. (1974.)

Burgin, Victor, James Donald, and Cora Kaplan, eds. *Formations of Fantasy*. London: Methuen, 1986.

Burke, Kenneth. "The Tactics of Motivation." Parts 1, 2. *Chimera* (Spring, Summer 1943): 21–33, 37–49.

Burniston, Steve, and Chris Weedon. "Ideology, Subjectivity and the Artistic Text." In *On Ideology*. London: Centre for Contemporary Cultural Studies, 1978: 199–229.

Calas, Nicolas. "Apes, Warriors, and Prophets." *View* (December 1943): 112–14, 140–43.

———. Letter to the editor. *View* (October 1940): 1, 5.

———. "The New Prometheus." *View* (October 1942): 14–20.

———. "Notes on Liberty." *View* (May 1942): unpaginated.

———. "Painting in Paris Is Poetry." *Poetry World* (July/August 1939): 38–44.

———. "Within Good and Evil." *View* (April 1943): 12, 32–33.

Calverton, V. F., and S. D. Schmalhausen, eds. *Sex in Civilization.* New York: Macaulay, 1929.

Campbell, Mary Schmidt. *Harlem Renaissance: Art of Black America.* New York: Studio Museum in Harlem, 1987.

Carmean, E. A. "Les peintures noires de Jackson Pollock et le projet d'eglise de Tony Smith." In *Jackson Pollock,* by the Centre Georges Pompidou, Musée national d'art moderne. Paris: CGP, MNAM, 1982: 54–77. (An abridged translation appeared as "The Church Project: Pollock's Passion Themes." *Art in America* [Summer 1982]: 110–22.)

Carncross, Horace. *The Escape from the Primitive.* New York: Scribner's, 1926.

Carrel, Alexis. "For a New Knowledge of Man." *Commonweal* (30 April 1937): 13–15.

———. *Man, the Unknown.* New York: Harper and Brothers, 1935.

Carter, Betsy. "Jackson Pollock's Drawings under Analysis." *Art News* (February 1977): 58–59.

Cassirer, Ernst. *An Essay on Man.* New Haven, Conn.: Yale University Press, 1944.

Cavaliere, Barbara, and Robert Hobbs. "Against a Newer Laocoon." *Arts* (April 1977): 110–17.

"Chaos, Damn It!" *Time,* 20 November 1950, 70–71.

Chartier, Jean-Pierre. "Les Amèricains aussi font des films 'noirs.'" *La Revue du Cinéma* (1 November 1946): 67–70.

Chase, Richard. "The Armed Obscurantist." *Partisan Review* (Summer 1944): 346–48.

———. "The Huxley-Heard Paradise." *Partisan Review* (March/April 1943): 143–58.

Chave, Anna. *Mark Rothko: Subjects in Abstraction.* New Haven, Conn.: Yale University Press, 1988.

Chisholm, G. Brock. "Can Man Survive?" Parts 1, 2. *Nation,* 20 and 27 July 1946, 63–65, 93–96.

Chittenden, H. M. "Does Human Nature Change?" *Atlantic Monthly,* June 1912, 777–82.

Clark, Timothy J. "Clement Greenberg's Theory of Art." *Critical Inquiry* 9 (1982): 139–56. (Reprinted in *Pollock and After,* ed. Francis Frascina; along with "Arguments about Modernism: A Reply to Michael Fried.")

———. "Jackson Pollock's Abstraction." In *Reconstructing Modernism,* ed. Serge Guilbaut.

———. *The Painting of Modern Life.* New York: Alfred A. Knopf, 1984.

Clifford, James. "Histories of the Tribal and the Modern." *Art in America* (April 1985): 164–77, 215. (Reprinted in id., *The Predicament of Culture.*)

———. "On Ethnographic Surrealism." *Comparative Studies in Society and History* 23.4 (1981): 539–64. (Reprinted in id., *The Predicament of Culture.*)

———. *The Predicament of Culture.* Cambridge, Mass.: Harvard University Press, 1988.

Clifford, James, and George E. Marcus. *Writing Culture: The Poetics and Politics of Ethnography.* Berkeley and Los Angeles: University of California Press, 1986.

Coates, Robert. "The Art Galleries." *New Yorker,* 17 January 1948, 43–44.

———. "Assorted Moderns." *New Yorker,* 23 December 1944, 50–51.

Cockcroft, Eva. "Abstract Expressionism: Weapon of the Cold War." *Artforum* (June 1974): 39–41.

Collier, John. *From Every Zenith.* Denver: Sage, 1963.

———. *The Indians of the Americas.* New York: W. W. Norton, 1947.

Cook, Mabel Collins. *Light on the Path.* New York: Aryan Theosophical Society, n.d. (ca. 1886).

Cooke, Lynne. "Willem de Kooning: 'A Slipping Glimpser.'" Ph.D. diss., Courtauld Institute, 1988.

Cousins, Norman. "Modern Man Is Obsolete." *Saturday Review of Literature,* 18 August 1945, 5–9. (The essay was expanded and published under the same title in book form by Viking, New York, 1945.)

Covarrubias, Miguel. "Modern Art." In *Twenty Centuries of Mexican Art*. Mexico: Museum of Modern Art, New York, and the Instituto de Antropología e Historia de México, 1940: 137–41.

Cowley, Malcolm. *Exile's Return*. 1934. New York: Viking, 1956.

Cowling, Elizabeth. "The Eskimos, the American Indians and the Surrealists." *Art History* (December 1978): 484–500.

Cram, Ralph Adams. "The Mass-Man Takes Over." *American Mercury*, October 1938, 166–76.

———. "Why We Do Not Behave Like Human Beings." *American Mercury*, September 1932, 41–48. (Reprinted in *American Mercury* [August 1938]: 418–28.)

"The Crisis of the Individual." Parts 1, 2. *Commentary* (December 1945, January 1946): 1–2, 1.

Culler, Jonathan. *Framing the Sign*. Norman: University of Oklahoma Press, 1988.

Curti, Merle. "The Changing Concept of 'Human Nature' in the Literature of American Advertising." *Business History Review* (Winter 1967): 335–57.

———. *Human Nature in American Thought*. Madison: University of Wisconsin Press, 1980.

Damisch, Hubert. *L'origine de la perspective*. Paris: Flammarion, 1987.

Davenport, Russell. "A *Life* Round Table on Modern Art." *Life*, 11 October 1948, 56–79.

de Beauvoir, Simone. *America Day by Day*. Trans. Patrick Dudley. London: Duckworth, 1952. (1948.)

"Defense Post Goes to N. Rockefeller." *New York Times*, 17 August 1940, 6.

de Kooning, Elaine. "Subject: What, How or Who?" *Art News* (April 1955): 26–29, 61–62.

———. "Venus, Eve, Leda, Diana, et al." *Art News* (September 1953): 20–22, 54.

de Kooning, Willem. "What Abstract Art Means to Me." *Museum of Modern Art Bulletin* (Spring 1951): 4–8.

de Laszlo, Violet Staub. "In Memoriam: H. G. Baynes." *Bulletin of the Analytical Psychology Club of New York* 5.6 (June 1943).

———. "Review of H. G. Baynes' *Mythology of the Soul*." *Bulletin of the Analytical Psychology Club of New York* 3.5 (May 1941), supplement: 1–8.

———. "Some Dreams Connected with the Present War." *Spring* (1941): 62–80.

Deleuze, Giles, and Félix Guattari. *Anti-Oedipus: Capitalism and Schizophrenia*. Trans. Hurley, Seem, and Lane. New York: Viking, 1977.

Dell, Floyd. "The Science of the Soul." *Masses*, July 1916, 30–31.

Derrida, Jacques. "Living On: *Border Lines*." In *Deconstruction and Criticism*, ed. Harold Bloom et al. New York: Continuum, 1985.

Devree, Howard. "By Contemporaries." *New York Times*, 2 December 1951, sec. 2, p. 11.

———. "From a Reviewer's Notebook." *New York Times*, 13 February 1944, sec. 2, p. 7.

Dewey, John. "Anti-Naturalism in Extremis." *Partisan Review* (January/February 1943): 24–39.

———. *Art as Experience*. 1934. New York: G. P. Putnam's Sons, 1958.

———. "Human Nature." In *Encyclopaedia of the Social Sciences*. New York: Macmillan, 1932. (Reprinted in *John Dewey: The Later Works, 1925–1953; Vol. 6: 1931–1932*, ed. Jo Ann Boydston. Carbondale: Southern Illinois University Press, 1985.)

———. *Human Nature and Conduct*. 1922. New York: Random House, 1957.

———. Letter to the editor, entitled "Mind in the Making." *New Republic*, 7 June 1922, 48.

———. *Philosophy and Civilization*. New York: G. P. Putnam's Sons, 1931.

———. "What I Believe." *Forum*, March 1930, 176–82.

Dews, Peter. "Adorno, Post-Structuralism and the Critique of Identity." *New Left Review* (May/June 1986): 28–44.

———. "Power and Subjectivity in Foucault." *New Left Review* (March/April 1984): 72–95.

Di Leonardo, Micaela. "Otherness Is in the Details." *Nation*, 5 Nov. 1990, 530–36.

Dimnet, Abbé Ernest. "Is Man Improving?" *Scribner's*, June 1935, 321–27.

Dollard, John. *Victory over Fear*. New York: Reynal and Hitchcock, 1942.

Douglas, Frederic, and René d'Harnoncourt. *Indian Art of the United States*. New York: Museum of Modern Art, 1941.

Douglas, Mary. "Judgments on James Frazer." *Daedalus* (Fall 1978): 151–64.

Dudley, Edward, and Maximillian E. Novak. *The Wild Man Within: An Image in Western Thought from the Renaissance to Romanticism.* Pittsburgh: University of Pittsburgh Press, 1972.

Duffus, R. L. "Modern Man and His Dilemmas." *New York Times Book Review,* 26 January 1936, 2.

Durgnat, Raymond. "Paint It Black: The Family Tree of *Film Noir.*" *Cinema* [U.K.] 6/7 (August 1970): 48–56.

Dyer, Richard. "Resistance through Charisma: Rita Hayworth and *Gilda.*" In *Women in Film Noir,* ed. E. Ann Kaplan. London: British Film Institute, 1978.

Eby, Kerr. "War . . ." *Prints* (December 1935): 80–85.

Eisinger, Chester. *Fiction of the Forties.* Chicago: University of Chicago Press, 1963.

Eliot, Alexander. "Under the Four Winds." *Time,* 28 June 1954, 74–77.

Ettlinger, L. D. "German Expressionism and Primitive Art." *Burlington Magazine,* April 1968, 191–201.

Evans-Pritchard, Edward. "Lévy-Bruhl's Theory of Primitive Mentality." *Bulletin of the Faculty of Arts,* Faud I University, Cairo II. Part 2 (1934): 1–26. (Republished in the *Journal of the Anthropological Society of Oxford* 1.2 [1970]: 39–60.)

———. *Nuer Religion.* London: Oxford University Press, 1956.

Farber, Manny. "Artists for Victory." *Magazine of Art,* December 1942, 275–80.

———. "Jackson Pollock." *New Republic,* 25 June 1945, 871–72.

Farrell, James T. *The League of Frightened Philistines, and Other Papers.* New York: Vanguard, 1945.

Federation of Modern Painters and Sculptors (FMPS). Papers. Archives of American Art, Smithsonian Institution. Microfilm N/69-75.

Fellman, Anita Clair, and Michael Fellman. *Making Sense of Self: Medical Advice Literature in Late Nineteenth Century America.* Philadelphia: University of Pennsylvania Press, 1981.

Ferber, Herbert. Papers. Archives of American Art, Smithsonian Institution. Microfilm N/69-133.

Fergusson, Harvey. *Modern Man: His Belief and Behavior.* New York: Alfred A. Knopf, 1936.

———. "Taos Remembered." *American West,* September 1971, 38–41.

Fine, Reuben. *A History of Psychoanalysis.* New York: Columbia University Press, 1979.

Finkelstein, Louis. "Modern Man's Anxiety: Its Remedy." *Commentary* (December 1946): 537–46.

Fitzsimmons, James. "Art." *Arts and Architecture* (May 1953): 4–10.

———. "Art." *Arts and Architecture* (March 1954): 6–7, 30.

Folsom, James K. *Harvey Fergusson.* Austin, Tex.: Steck-Vaughn Co., 1969.

Foster, Hal, ed. *Vision and Visuality.* Seattle, Wash.: Bay Press, 1988.

Foucault, Michel. *The Archaeology of Knowledge.* Trans. A. M. Sheridan Smith. New York: Pantheon, 1972. (1969.)

———. *The Order of Things: An Archaeology of the Human Sciences.* New York: Vintage, 1973.

———. *Power/Knowledge: Selected Interviews and Other Writings, 1972–1977,* ed. Colin Gordon. New York: Pantheon, 1980.

———. "The Subject and Power." In *Michel Foucault: Beyond Structuralism and Hermeneutics,* ed. Dreyfus and Rabinow. Chicago: University of Chicago Press, 1983: 208–26.

Fox, Richard Wrightman, and T. J. Jackson Lears, eds. *The Culture of Consumption.* New York: Pantheon, 1983.

Frank, Nino. "Un nouveau genre 'policier': L'adventure criminelle." *L'Écran Francaise* 61.28.8 (1946): 8–9, 14.

Frascina, Francis, ed. *Pollock and After: The Critical Debate.* New York: Harper and Row, 1985.

Frazer, James George. *The Golden Bough.* One-volume abridged edition. New York: Macmillan, 1922.

Freke, David. "Jackson Pollock: A Symbolic Self-Portrait." *Studio International* (December 1972): 217–21.

Freud, Sigmund. "On Narcissism: An Introduction." 1914. In *The Standard Edition of the Complete Psychological Works of Sigmund Freud*, ed. James Strachey. London: Hogarth Press and the Institute of Psycho-Analysis, 1958. Vol. 14: 69–102.

———. "Psycho-Analytic Notes on an Autobiographical Account of a Case of Paranoia (The Case of Shreber)." 1911. In *The Standard Edition of the Complete Psychological Works of Sigmund Freud*, ed. James Strachey. London: Hogarth Press and the Institute of Psycho-Analysis, 1958. Vol. 12: 9–82.

Fried, Michael. "How Modernism Works: A Response to T. J. Clark." *Critical Inquiry* (September 1982): 217–34. (Reprinted in *Pollock and After,* ed. Frascina.)

———. *Three American Painters.* Cambridge, Mass.: Fogg Art Museum, 1965.

Friedman, B. H. "An Interview with Lee Krasner Pollock." *Jackson Pollock: Black and White.* New York: Marlborough-Gerson Gallery, March 1969.

Fromm, Erich. *Escape from Freedom.* New York: Rinehart, 1941.

Fryd, Vivien Green. "Two Sculptures for the Capitol: Horatio Greenough's *Rescue* and Luigi Persico's *Discovery of America.*" *American Art Journal* 19.2 (1987): 16–39.

Fuller, Robert C. *Americans and the Unconscious.* New York: Oxford University Press, 1986.

Gage, Otis. "The Reflective Eye: The Success of the Failure." *Art Digest* (15 April 1953): 4.

Geertz, Clifford. *The Interpretation of Cultures.* New York: Basic, 1973.

———. *Local Knowledge.* New York: Basic, 1983.

Gibson, Ann. "Painting outside the Paradigm: Indian Space." *Arts Magazine,* February 1983, 98–104.

———. "Theory Undeclared: Avant-Garde Magazines as a Guide to Abstract Expressionist Images and Ideas." Ph.D. diss., Univ. of Delaware, 1984.

Gibson, Ann, and Stephen Polcari, eds. Special issue of *Art Journal:* "New Myths for Old:

Gibson, Arrell Morgan. *The Santa Fe and Taos Colonies.* Norman: University of Oklahoma Press, 1983.

Giddens, Anthony. *Central Problems in Social Theory.* Berkeley and Los Angeles: University of California Press, 1979.

Gilbert, James Burkhart. *Writers and Partisans: A History of Literary Radicalism in America.* New York: John Wiley and Sons, 1968.

Gish, Robert. *Frontier's End: The Life and Literature of Harvey Fergusson.* Lincoln: University of Nebraska Press, 1988.

Glazer, Nathan. "The Alienation of Modern Man." *Commentary* (April 1947): 378–85.

Godelier, Maurice. *Perspectives in Marxist Anthropology.* Trans. Robert Brain. Cambridge: Cambridge University Press, 1977.

Goldwater, Robert. "Art Chronicle." *Partisan Review* (July/August 1947): 416–17.

———. *Primitivism in Modern Painting.* New York: Harper and Brothers, 1938.

———. *Rufino Tamayo.* New York: Quadrangle Press, 1947.

Gombrich, Ernst H. *Art and Illusion.* Princeton, N.J.: Princeton University Press, 1969.

Goodman, Nelson. *Languages of Art.* Indianapolis: Hackett, 1976.

———. *Problems and Projects.* Indianapolis: Bobbs-Merrill, 1972.

Goodnough, Robert. "Pollock Paints a Picture." *Art News* (May 1951): 38–41, 60–61.

Gordon, Donald E. "Pollock's *Bird,* or How Jung Did Not Offer Much Help in Myth-Making." *Art in America* (October 1980): 43–53.

Gottlieb, Adolph. "The Ides of Art." *Tiger's Eye* (December 1947): 43.

———. Letter to the editor. *New York Times,* 22 July 1945, sec. 2, p. 2.

———. Papers. Archives of American Art, Smithsonian Institution. Microfilm N/69-49 and N/69-50.

————. Statements quoted in "New York Exhibitions." *Limited Edition* (December 1945): 4, 6.

————. Statement in "Jackson Pollock: An Artists' Symposium, Part 1," *Art News* (April 1967): 31.

Gottlieb, Adolph, and Marcus Rothko (with Barnett Newman). Letter to Edward Alden Jewell, Art Editor, *New York Times,* 7 June 1943. Mark Rothko Papers, AAA-SI 3135: 12. (Published in slightly edited form in "*Globalism* Pops into View," by Jewell; and reprinted in full as Appendix A of *Adolph Gottlieb: A Retrospective,* by Alloway and MacNaughton.)

Gottlieb, Adolph, and Mark Rothko. "The Portrait and the Modern Artist." Dialogue broadcast over radio station WNYC, 13 Oct. 1943. (Typescript reprinted as Appendix B of *Adolph Gottlieb: A Retrospective,* by Alloway and MacNaughton.)

Graham, John D. *Exhibition of Sculptures of Old African Civilizations.* New York: Jacques Seligmann Gallery, 4–22 January 1936.

————. "Primitive Art and Picasso." *Magazine of Art,* April 1937, 236–39, 260.

Gramsci, Antonio. *Selections from the Prison Notebooks,* ed. and trans. Quinton Hoare and Geoffrey Nowell Smith. New York: International Publishers, 1971.

Grattan, C. Hartley. "Open Letters to Lewisohn, Krutch and Mumford." *Modern Monthly* (April 1933): 175–81.

Gray, Cleve. "Narcissus in Chaos." *American Scholar* (Autumn 1959): 433–43.

Green, Martin. *New York, 1913: The Armory Show and the Paterson Strike Pageant.* New York: Collier/Macmillan, 1988.

Greenberg, Clement. "'American-Type' Painting." *Partisan Review* (Spring 1955): 179–96. (Reprinted in id., *Art and Culture.*)

————. "Art." *Nation,* 8 March 1947, 284. (Reprinted in *CG-CEC* 2: 131–34.)

————. "Art." *Nation,* 6 December 1947, 629–30. (Reprinted in *CG-CEC* 2: 187–89.)

————. "Art." *Nation,* 25 December 1948, 732–34. (Reprinted in *CG-CEC* 2: 268–70.)

————. *Art and Culture.* Boston: Beacon Press, 1961.

————. "L'art américain au XXe siècle." *Les Temps Modernes* (August/September 1946): 340–52.

————. "Avant-Garde and Kitsch." *Partisan Review* (Fall 1939): 34–49. (Reprinted in id., *Art and Culture,* and in *CG-CEC* 1: 5–22.)

————. *The Collected Essays and Criticism. Volume 1: Perceptions and Judgments, 1939–1944. Volume 2: Arrogant Purpose, 1945–1949.* Edited by John O'Brian. Chicago: University of Chicago Press, 1986. (Abbreviated as *CG-CEC.*)

————. "The Jackson Pollock Market Soars." *New York Times Magazine,* 16 April 1961, 42–43, 132, 135.

————. "Pessimism for Mass Consumption." *Commentary* (October 1947): 383–94. (Reprinted in *CG-CEC* 2: 158–60.)

————. "The Present Prospects of American Painting and Sculpture." *Horizon* (October 1947): 20–30. (Reprinted in *CG-CEC* 2:160–70.)

Guilbaut, Serge. "The Frightening Freedom of the Brush." In *Dissent: The Issue of Modern Art in Boston* (Boston: Institute of Contemporary Art), 1985.

————. *How New York Stole the Idea of Modern Art.* Trans. Arthur Goldhammer. Chicago: University of Chicago Press, 1983.

————, ed. *Reconstructing Modernism: Art in New York, Paris, and Montreal, 1945–1964.* Cambridge, Mass.: MIT Press, 1990.

————, ed. *Triumph of Pessimism.* Forthcoming.

Haas, Irvin. "The Print Collector." *Art News* (October 1946): 16.

Hadjinicolaou, Nicos. "On the Ideology of Avant-Gardism." Trans. Diane Belle James. *Praxis* 6 [UCLA] 1982: 39–70.

Hale, Nathan G., Jr. *Freud and the Americans: The Beginnings of Psychoanalysis in the United States, 1876–1917.* New York: Oxford University Press, 1971.

Hale, Robert Beverly. "Stevens: A Precocious Talent Comes of Age." *Art News* (February 1946): 98–99.

Haraway, Donna. *Primate Visions: Gender, Race, and Nature in the World of Modern Science.* New York: Routledge, 1989.

Harding, M. Esther. "The Mother Archetype and its Functioning in Life." *Papers of the Analytical Psychology Club of New York* 2 (1938).

———. "A Short Review of Dr. Jung's Article 'Redemption Ideas in Alchemy.'" *Papers of the Analytical Psychology Club of New York* 1 (1938).

———. *The Way of All Women.* London: Longmans, Green, 1933.

———. *Woman's Mysteries, Ancient and Modern.* London: Longmans, Green, 1935.

Harvey, David. *The Condition of Postmodernity.* Oxford: Blackwell, 1989.

Hegel, G. W. F. *Phenomenology of Spirit.* Trans. A. V. Miller. Oxford: Oxford University Press, 1977. (1807.)

Heller, Thomas C., Morton Sosna, and David E. Wellbery, eds. *Reconstructing Individualism: Autonomy, Individuality, and the Self in Western Thought.* Stanford, Calif.: Stanford University Press, 1986.

Henderson, Joseph L. "Initiation Rites." *Papers of the Analytical Psychology Club of New York* 3 (1939).

———. "The Minotaur." *Bulletin of the Analytical Psychology Club of New York City* 2.3 (March 1940): 5.

———. Preface to *Mythology of the Soul,* by H. G. Baynes. London: Rider, 1969.

———. "A Question of Space." *Bulletin of the Analytical Psychology Club of New York City* 1.1 (February 1939): 1–2.

———. "Reflections on the History and Practice of Jungian Analysis." In *Jungian Analysis,* ed. Murray Stein. La Salle, Ill.: Open Court, 1982.

———"Review of H. G. Baynes' *Germany Possessed.*" *Bulletin of the Analytical Psychology Club of New York* 3.9 (December 1941): 9–12.

Hendricks, Luther V. *James Harvey Robinson: Teacher of History.* New York: King's Crown Press, 1946.

Herbert, Robert. "Method and Meaning in Monet." *Art in America* (September 1979): 90–108.

Herrick, Charles Judson. *Fatalism or Freedom.* New York: W. W. Norton, 1926.

———. *The Thinking Machine.* Chicago: University of Chicago Press, 1929.

Herrick, Charles Judson, George Humphrey, Joseph Jastrow, et al. *Mind and Behavior.* New York: Van Nostrand, 1929.

Hess, Thomas B. *Abstract Painting.* New York: Viking, 1951.

———. "The Art Comics of Ad Reinhardt." *Artforum* (April 1974): 46–51.

———. *Barnett Newman.* New York: Museum of Modern Art, 1971.

———. *Barnett Newman.* New York: Walker, 1969.

———. "Lam." *Art News* (May 1948): 37.

Hiller, Susan, ed. *The Myth of Primitivism.* London: Routledge, 1991.

Hills, Patricia. "Review of Serge Guilbaut, *How New York Stole . . .*" *Archives of American Art Journal* 24.1 (1984): 26–29.

Hinkle, Beatrice M. "The Evolution of Woman and Her Responsibility to the World Today." *Papers of the Analytical Psychology Club of New York* 4 (1940).

Hirsch, Foster. *The Dark Side of the Screen.* San Diego: Barnes, 1981.

Hobbs, Robert. "Confronting the Unknown Within." In *Richard Pousette-Dart,* ed. Robert Hobbs and Joanne Kuebler. Indianapolis: Indianapolis Museum of Art, 1990.

Hocking, William Ernest. *What Man Can Make of Man.* New York: Harper and Brothers, 1942.

Hoffman, Frederick J. *Freudianism and the Literary Mind.* Baton Rouge: Louisiana State University Press, 1945.

Hofmann, Hans. Letter to the editor. *New York Times,* 15 July 1945, sec. 2, p. 2.

Homans, Peter. *Jung in Context: Modernity and the Making of a Psychology.* Chicago: University of Chicago Press, 1979.

———. *Theology after Freud.* Indianapolis: Bobbs-Merrill, 1970.

Hook, Sidney. "The Failure of the Left." *Partisan Review* (March–April 1943): 165–77.

———. "Intelligence and Evil in Human History." *Commentary* (March 1947): 210–21.

———. "Metaphysics, War, and the Intellectuals." *Menorah Journal* (Autumn 1940): 326–37.

———. "The New Failure of Nerve." *Partisan Review* (January/February 1943): 2–23.

———. "The Politics of Wonderland." *Partisan Review* (May/June 1943): 258–62.

"How a Disturbed Genius Talked to His Analyst with Art." *Medical World News* (5 February 1971): 18–28.

Howells, William. "Can We Catch Up with Our World?" *New York Times Magazine,* 7 July 1946, 10–11, 19.

Huggins, Nathan Irvin. *Harlem Renaissance.* New York: Oxford University Press, 1971.

Humphrey, Zephine. "Bed in Hell." *Harper's,* June 1938, 23–26.

Hunter, Sam. "Among the New Shows." *New York Times,* 9 November 1947, sec. 2, p. 12.

———. "Among the New Shows." *New York Times,* 30 January 1949, sec. 2, p. 9.

———. "Jackson Pollock." *Museum of Modern Art Bulletin* 24.2 (1956–57): 5–13.

———. "Jackson Pollock: The Maze and the Minotaur." In *New World Writing,* Ninth Mentor Selection. New York: New American Library, 1956.

Huyssen, Andreas. *After the Great Divide: Modernism, Mass Culture, Postmodernism.* Bloomington: Indiana University Press, 1986.

Hymes, Dell, ed. *Reinventing Anthropology.* New York: Random House, 1972.

"In Defense of Man." *Commonweal* (31 January 1936): 365–66.

"Jackson Pollock: Is He the Greatest Living Painter in the United States?" *Life,* 8 August 1949, 43–45.

Jacobi, Jolande. *The Psychology of C. G. Jung.* 1942. London: Routledge and Kegan Paul, 1951.

Jameson, Fredric. *The Political Unconscious.* Ithaca, N.Y.: Cornell University Press, 1981.

———. *Postmodernism, or, The Cultural Logic of Late Capitalism.* Durham, N.C.: Duke University Press, 1991.

———. "Reification and Utopia in Mass Culture." *Social Text* 1 (1979): 130–48.

Janis, Harriet, and Rudi Blesh. *De Kooning.* New York: Grove Press, 1960.

Janis, Sidney. *Abstract and Surrealist Art in America.* New York: Reynal and Hitchcock, 1944.

Jastrow, Joseph. *The House That Freud Built.* New York: Greenberg, 1932.

Jay, Martin. *The Dialectical Imagination.* Boston: Little, Brown, 1973.

———. "Scopic Regimes of Modernity." In *Vision and Visuality,* ed. Foster.

Jewell, Edward Alden. "Art of 5 Museums to Be Seen Today." *New York Times,* 19 April 1941, 13.

———. "By Our Modernists." *New York Times,* 27 February 1944, sec. 2, p. 6.

———. "A Cuban Picasso." *New York Times,* 22 November 1942, sec. 8, p. 9.

———. "End-of-the-Season Mélange." *New York Times,* 6 June 1943, sec. 2, p. 9.

———. "'Globalism.'" *New York Times,* 27 June 1943, sec. 2, p. 6.

———. "'Globalism' Pops into View." *New York Times,* 13 June 1943, sec. 2, p. 9.

———. "Modern Painters Open Show Today." *New York Times,* 2 June 1943, 28.

———. "The 'Organized' Artist." *New York Times,* 24 September 1939, sec. 9, p. 7.

———. "'Progress' under Fire." *New York Times,* 31 May 1942, sec. 8, p. 5.

———. "Toward Abstract, or Away?" *New York Times,* 1 July 1945, sec. 2, p. 2.

———. "Where Contemporary Banners Fly." *New York Times,* 13 April 1941, sec. 9, p. 9.

Joad, C. E. M. "Is Man Improving?" *Scribner's,* August 1935, 110–14.

Johnson, Paul. *A Shopkeeper's Millenium: Society and Revivals in Rochester, New York, 1815–1837.* New York: Hill and Wang, 1978.

Jordan, Virgil. "The New Psychology and the Social Order." *Dial* (1 November 1919): 365–68.

Jung, Carl G. "The Concept of the Collective Unconscious." *Papers of the Analytical Psychology Club of New York* 1 (1938).

————. *The Integration of the Personality.* Trans. Stanley Dell. New York: Farrar and Rinehart, 1939.

————. *Modern Man in Search of a Soul.* Trans. W. S. Dell and Cary F. Baynes. New York: Harcourt, Brace, 1933.

————. "Picasso." Trans. Alda F. Oertly. *Papers of the Analytical Psychology Club of New York City* 4 (1940). (1932.)

————. "The Psychological Aspects of the Mother Archetype." Trans. Cary F. Baynes and Ximena de Angulo. *Spring* (1943): 1–31.

————. *Psychological Types, or, The Psychology of Individuation.* Trans. Helton Godwin Baynes. New York: Harcourt, Brace, 1923.

————. *The Psychology of the Unconscious.* Trans. Beatrice M. Hinkle. New York: Moffat, Yard, 1916.

————. *Two Essays on Analytical Psychology.* Trans. H. G. and C. F. Baynes. London: Baillière, Tindall and Cox, 1928.

————. "Your Negroid and Indian Behavior." *Forum,* April 1930, 193–99.

Kallen, Horace M. *Individualism—An American Way of Life.* New York: Liveright, 1933.

————. "The Twilight of the Moralists." *New Republic,* 24 May 1922, 379–82.

————. "You Can't Win." *Saturday Review of Literature,* 25 April 1936, 12.

Kaplan, E. Ann, ed. *Women in Film Noir.* London: British Film Institute, 1978.

Kaprow, Allan. "Jackson Pollock: An Artists' Symposium, Part 1." *Art News* (April 1967): 60.

Kardiner, Abram. "Western Personality and Social Crisis." *Commentary* (November 1946): 436–47.

Kasson, Joy. *Marble Queens and Captives.* New Haven, Conn.: Yale University Press, 1990.

Kavanagh, James. "Ideology." In *Critical Terms for Literary Study,* ed. Frank Lentricchia and Thomas McLaughlin. Chicago: University of Chicago Press, 1990.

Keefer, Truman Frederick. *Philip Wylie.* Boston: G. K. Hall, 1977.

Keesing, Felix M. "Applied Anthropology in Colonial Administration." In *The Science of Man in the World Crisis,* ed. Ralph Linton. New York: Columbia University Press, 1945.

Kerr, Paul. "Out of What Past? Notes on the B Film Noir." *Screen Education* (Autumn/Winter 1979–1980): 45–65.

Kirstein, Lincoln. *The Latin-American Collection of the Museum of Modern Art.* New York: MoMA, 1943.

————. "South American Painting." *Studio* (October 1944): 106–13.

Kittredge, Eleanor. "An Anthropologist Looks at the War." *New York Times Magazine,* 12 October 1941, pp. 7, 20.

Kochnitzky, Leon. "A Magic Portico." *View* (May 1946): 18–19.

Koenigswald, G. H. R. von. "Search for Early Man." *Natural History,* January 1947, 8–15, 48.

Koestler, Arthur. *The Yogi and the Commissar, and Other Essays.* New York: Macmillan, 1945.

Kootz, Samuel M. Letter to the editor. *New York Times,* 25 January 1931, sec. 8, p. 12.

————. Letter to the editor. *New York Times,* 10 August 1941, sec. 9, p. 7.

Kootz, Samuel M., and Harold Rosenberg. *The Intrasubjectives.* New York: Samuel M. Kootz Gallery, 14 September–3 October 1949.

Kozloff, Max. "American Painting during the Cold War." *Artforum* (May 1973): 43–54.

————. "The Critical Reception of Abstract Expressionism." *Arts Magazine,* December 1965, 27–33.

Kracauer, Siegfried. "Hollywood's Terror Films." *Commentary* (August 1946): 132–36.

Kramer, Hilton. "Was Rothko an Abstract Painter?" *New Criterion* (March 1989): 1–5.

Krauss, Rosalind. "Jackson Pollock's Drawings." *Artforum* (January 1971): 58–61.

————. "Reading Jackson Pollock Abstractly." In id., *The Originality of the Avant-Garde and Other Modernist Myths.* Cambridge: MIT Press, 1985. (Originally published as "Contra Carmean: The Abstract Pollock." *Art in America* [Summer 1982]: 123–31, 155.)

Kris, Ernst. *Psychoanalytic Explorations in Art.* 1952. Reprint. New York: Schocken, 1964.

Krutch, Joseph Wood. *The Modern Temper: A Study and a Confession.* New York: Harcourt, Brace, 1929.

———. "What I Believe." *Forum,* March 1931, 178–82.

Kuhn, Thomas S. *The Structure of Scientific Revolutions.* 1962. Reprint. Chicago: University of Chicago Press, 1970.

Kuper, Adam. *The Invention of Primitive Society.* New York: Routledge, 1988.

Lacan, Jacques. *Écrits: A Selection.* Trans. Alan Sheridan. New York: W. W. Norton, 1977.

———. *The Four Fundamental Concepts of Psycho-Analysis.* Ed. Jacques-Alain Miller. Trans. Alan Sheridan. New York: W. W. Norton, 1978.

Lader, Melvin P. "Howard Putzel: Proponent of Surrealism and Early Abstract Expressionism in America." *Arts Magazine,* March 1982, 85–96.

Landau, Ellen. "'A Certain Rightness': Artists for Victory's 'America in the War' Exhibition of 1943." *Arts Magazine,* February 1986, 43–53.

———. *Jackson Pollock.* New York: Abrams, 1989.

Langdon-Davies, John. *Man Comes of Age.* New York: Harper and Brothers, 1932.

Langer, Susanne K. "The Lord of Creation." *Fortune,* January 1944, 126–28, 139–54.

———. *Philosophy in a New Key.* 1942. Reprint. New York: New American Library, 1948.

Langhorne, Elizabeth L. "Jackson Pollock's *The Moon Woman Cuts the Circle.*" *Arts Magazine,* March 1979, 128–37.

———. "More on Rubin on Pollock." *Art in America* (October 1980): 59–65.

———. "Pollock, Picasso and the Primitive." *Art History* (March 1989): 64–92.

"Latin America to See Exhibits of U.S. Art." *New York Times,* 12 April 1941, 18.

Lears, T. J. Jackson. *No Place of Grace: Antimodernism and the Transformation of American Culture, 1880–1920.* New York: Pantheon, 1981.

Leider, Philip. "Surrealist and Not Surrealist in the Art of Jackson Pollock and His Contemporaries." In *The Interpretive Link,* ed. Paul Schimmel. Newport Beach, Calif.: Newport Harbor Art Museum, 1986.

Leja, Michael. "The Formation of an Avant-Garde in New York." In *Abstract Expressionism,* ed. Auping.

———. "Jackson Pollock: Representing the Unconscious." *Art History* (December 1990): 542–65.

———. "'Tragedy' and 'Terror' in Wartime American Culture." In *The Triumph of Pessimism,* ed. Guilbaut.

Lévi-Strauss, Claude. "The Art of the Northwest Coast at the American Museum of Natural History." *Gazette des Beaux-Arts* ser. 6, vol. 24 (September 1943): 175–82.

Levine, Lawrence W. "American Culture and the Great Depression." *Yale Review* (Winter 1985): 196–223.

Levy, Hyman. *A Philosophy for a Modern Man.* New York: Alfred A. Knopf, 1938.

Lévy-Bruhl, Lucien. *How Natives Think.* Trans. Lilian A. Clare. Princeton, N.J.: Princeton University Press, 1985. (1910.)

"Liberalism and Irrationalism." *New Republic,* 17 May 1922, 333–34.

Lin Yutang. *The Importance of Living.* New York: Reynal and Hitchcock, 1937.

Link, Henry C. "Man in Chains." *Saturday Evening Post,* 7 May 1938, 25, 71–76.

Linton, Ralph, ed. *The Science of Man in the World Crisis.* New York: Columbia University Press, 1945.

Lippmann, Walter. "Man's Image of Man." *Commonweal* (13 February 1942): 406–09.

Lloyd, Jill. "Primitivism and Modernity: An Expressionist Dilemma." In *German Art in the 20th Century.* Munich: Prestel Verlag, and London: Royal Academy of Arts, 1985.

Lowe, Donald M. *History of Bourgeois Perception.* Chicago: University of Chicago Press, 1982.

Lowenthal, Leo. *Literature and the Image of Man.* Boston: Beacon Press, 1957.

————. "Terror's Atomization of Man." *Commentary* (January 1946): 1–8.

Luhan, Mabel Dodge. *Edge of Taos Desert*. New York: Harcourt, Brace, 1937.

Lundberg, Ferdinand, and Marynia F. Farnham. *Modern Woman*. New York: Harper and Brothers, 1947.

Lynd, Robert S., and Helen Merrell Lynd. *Middletown in Transition*. 1937. Reprint. New York: Harcourt Brace Jovanovich, 1965.

Lynes, Barbara Buhler. *O'Keeffe, Stieglitz and the Critics, 1916–1929*. Chicago: University of Chicago Press, 1989.

Lynes, Russell. *Good Old Modern: An Intimate Portrait of the Museum of Modern Art*. New York: Atheneum, 1973.

————. "Highbrow, Lowbrow, Middlebrow." *Harper's*, February 1949, 19–28.

Mabille, Pierre. "The Ritual Painting of Wifredo Lam." *Magazine of Art*, May 1949, 186–88.

MacCabe, Colin, ed. *High Theory/Low Culture*. New York: St. Martin's, 1986.

MacLeish, Archibald. "Humanism and the Belief in Man." *Atlantic Monthly*, November 1944, 72–78.

MacLiesh, Fleming. "The Assault on Liberalism." *Common Sense* (June 1940): 10–13.

Magaret, Helene. "The Negro Fad." *Forum*, January 1932, 39–43.

Malinowski, Bronislaw. *Crime and Custom in Savage Society*. London: K. Paul, Trench, Trubner, 1926.

Mann, Kristine. "Thousands of 'Well' Women Pay for Training Health Center." *New York Times*, 1 April 1923, sec. 8, p. 15.

————. "Two Papers by Kristine Mann: The Shadow of Death, and The Self-Analysis of Emanuel Swedenborg." *Papers of the Analytical Psychology Club of New York* 4 (1940).

Marcus, George E., and Michael M. J. Fischer. *Anthropology as Cultural Critique*. Chicago: University of Chicago Press, 1986.

Marot, Helen. *American Labor Unions*. New York: Holt, 1914.

————. "American Law." *Masses*, January 1917, 25.

————. *Creative Impulse in Industry*. New York: E. P. Dutton, 1918.

————. *A Handbook of Labor Literature*. Philadelphia: Free Library of Economics and Political Science, 1899.

————. "Immigration and Militarism." *Masses*, April 1916, 21.

————. "The Play School: An Experiment." *New Republic*, 6 November 1915, 16–17.

————. "Production and the Preservation of Initiative." *Annals of the American Academy of Political and Social Science* (September 1920): 14–18.

————. "The Syndicalist Professor." *Masses*, December 1916, 14–15.

Marot, Helen, and Caroline L. Pratt. *The Makers of Men's Clothing: How They Live, What They Get*. Philadelphia: The Philadelphia Branch of the Consumers' League et al., 1903.

Martin, Everett Dean. *Civilizing Ourselves*. New York: W. W. Norton, 1932.

Mattison, Robert Saltonstall. "Robert Motherwell: The Formative Years." Ph.D. diss., Princeton University, 1986.

McEvilley, Thomas. "Doctor Lawyer Indian Chief." *Artforum* (November 1984): 54–61. (See also "Letters." *Artforum*. February 1985, and May 1985, 46–51, 65–71.)

Mead, Margaret. "Not Head-hunters, nor Appeasers, but *Men*." *New York Times Magazine*, 30 November 1941, 3, 29.

Mead, Margaret, and Nicolas Calas, eds. *Primitive Heritage*. New York: Random House, 1953.

Merian, David. "The Nerve of Sidney Hook." *Partisan Review* (May/June 1943): 248–57.

Miller, Donald L. *Lewis Mumford: A Life*. New York: Weidenfeld and Nicolson, 1989.

Mills, C. Wright. *White Collar*. New York: Oxford University Press, 1951.

Modleski, Tania. "Femininity as Mas(s)querade: A Feminist Approach to Mass Culture." In *High Theory/Low Culture*, ed. Colin MacCabe. New York: St. Martin's, 1986.

Moley, Raymond. "Man: The Unbroken Atom." *Newsweek*, 24 December 1945, 108.

Monroe, Gerald. "The Artists Union of New York." Ph.D. diss., New York University, 1971.

Montagu, M. F. Ashley. *Man's Most Dangerous Myth: The Fallacy of Race.* New York: Columbia University Press, 1942.

———. "Notes in Passing (Theories on Human Nature)." *Arts and Architecture* (May 1953): 13, 33.

Montgomery Museum of Fine Arts. *Advancing American Art: Politics and Aesthetics in the State Department Exhibition.* Montgomery, Ala.: Museum of Fine Arts, 1984.

Mooradian, Karlen. *The Many Worlds of Arshile Gorky.* Chicago: Gilgamesh, 1980.

Mosse, George L. "Two World Wars and the Myth of the War Experience." *Journal of Contemporary History* 21 (1986): 491–513.

Motherwell, Robert. "The Modern Painter's World." *Dyn* (November 1944): 9–14.

———. "Painters' Objects." *Partisan Review* (Winter 1944): 93–97.

Motherwell, Robert, and Ad Reinhardt, eds. *Modern Artists in America.* New York: Wittenborn Schultz, 1951.

Motherwell, Robert, and Harold Rosenberg, eds. *Possibilities* 1. New York: Wittenborn Schultz, Winter 1947/8.

Mouffe, Chantal. "Hegemony and Ideology in Gramsci." *Gramsci and Marxist Theory.* London: Routledge and Kegan Paul, 1979.

Mumford, Lewis. *The Condition of Man.* New York: Harcourt, Brace, 1944.

———. *Sketches from Life.* New York: Dial, 1982.

———. *The Transformations of Man.* New York: Harper and Brothers, 1956.

———. "What I Believe." *Forum,* November 1930, 263–68.

Myers, John Bernard. "Surrealism and New York Painting, 1940–1948: A Reminiscence." *Artforum* (April 1977): 55–57.

Nagel, Hildegard. "The Eranos Conference, 1938." *Papers of the Analytical Psychology Club of New York* 2 (1938).

Newman, Barnett. *Drawings by Adolph Gottlieb.* New York: Wakefield Gallery, 7–19 February 1944. (Reprinted in *Barnett Newman: Selected Writings and Interviews* [hereafter, *BN-SWI*], 60–61.)

———. "Escultura pre-Columbina en piedra." *La Revista Belga* 1.6 (August 1944): 50–59. (Published in English as "Pre-Columbian Stone Sculpture." *BN-SWI,* 62–65.)

———. "The First Man Was an Artist." *Tiger's Eye* (October 1947): 57–60. (Reprinted in *BN-SWI,* 156–60.)

———. "Las formas artisticas del pacifico," *Ambos Mundos* (June 1946). (Published in English as "Art of the South Seas." *Studio International* [February 1970]: 70–71. Reprinted in *BN-SWI:* 98–103.)

———. *Herbert Ferber.* New York: Betty Parsons Gallery, December 1947. (Reprinted in *BN-SWI:* 110–11.)

———. *The Ideographic Picture.* New York: Betty Parsons Gallery, 20 January–8 February 1947. (Reprinted in *BN-SWI:* 107–08.)

———. Letter to Clement Greenberg, December 1947. Published in *BN-SWI:* 161–64.

———. "The New Sense of Fate." 1947–48. (*BN-SWI:* 164–69.)

———. *Northwest Coast Indian Painting.* New York: Betty Parsons Gallery, 30 September–19 October 1946. (Reprinted in *BN-SWI:* 105–07.)

———. Papers. Archives of American Art, Smithsonian Institution. Microfilm 3481.

———. "La pintura de Tamayo y Gottlieb." *La Revista Belga* 2.4 (April 1945): 16–25. (Published in English as "The Painting of Tamayo and Gottlieb." *BN-SWI:* 71–77.)

———. "The Plasmic Image." 1945. *BN-SWI:* 138–55.

———. *Pre-Columbian Stone Sculpture.* New York: Wakefield Gallery, 16 May–5 June 1944. (Reprinted in *BN-SWI:* 61–62.)

———. *Selected Writings and Interviews* (*BN-SWI*), ed. John P. O'Neill. New York: Alfred A. Knopf, 1990.

———. "Sobre el arte moderno: Examen y ratificación." *La Revista Belga* 1.9 (November 1944): 18–32. (Published in English as "Pre-Columbian Stone Sculpture." *BN-SWI:* 66–71.)

———. "The Sublime is Now." *Tiger's Eye* (December 1948): 51–53. (Reprinted in *BN-SWI:* 170–73.)

Newton, Judith. "History as Usual?: Feminism and the 'New Historicism.'" *Cultural Critique* (Spring 1988): 87–121.

Niebuhr, Reinhold. *The Nature and Destiny of Man. Vol. 1: Human Nature.* New York: Scribner's, 1941.

———. "The Sickness of American Culture." *Nation,* 6 March 1948, 267–70.

"Nineteen Young Americans." *Life,* 20 March 1950, 83–93.

Norman, Dorothy, ed. "From the Writings and Conversations of Alfred Stieglitz." *Twice a Year* (Fall/Winter 1938): 77–110.

O'Connor, Francis V. *The Black Pourings.* Boston: Institute of Contemporary Art, 6 May–29 June 1980.

———. "The Genesis of Jackson Pollock, 1912 to 1943." Ph.D. diss., Johns Hopkins University, 1965.

———. "The Genesis of Jackson Pollock, 1912 to 1943." *Artforum* (May 1967): 16–23.

———. *Jackson Pollock.* New York: Museum of Modern Art, 1967.

O'Connor, Francis V., and Eugene V. Thaw. *Jackson Pollock: A Catalogue Raisonné of Paintings, Drawings, and Other Works.* 4 vols. New Haven, Conn.: Yale University Press, 1978.

Oertly, Alda F. "Jung Looks at Picasso." *Bulletin of the Analytical Psychology Club of New York City* 2.1 (January 1940): 3–5.

O'Hara, Frank. *Jackson Pollock.* New York: Braziller, 1959.

Oppenheim, James. "What Jung Has Done." *New Republic,* 20 May 1916, 67–68.

"Organized 150,000 Women." *New York Times,* 10 May 1914, sec. 3, p. 8.

Ossorio, Alfonso. *Jackson Pollock.* New York: Betty Parsons Gallery, 26 November–15 December 1951.

———. Letter to Pollock. 25 April 1951. Jackson Pollock Papers. Archives of American Art, Smithsonian Institution. Microfilm 3046: 443.

Overstreet, H. A. *About Ourselves.* New York: W. W. Norton, 1927.

———. *The Enduring Quest.* New York: W. W. Norton, 1931.

Ovid. *The Metamorphoses.* Trans. Horace Gregory. New York: Viking, 1958.

Paalen, Wolfgang. *Form and Sense.* New York: Wittenborn, 1945.

———. "Totem Art." *Dyn* 4–5 (1944): 7–37.

Panofsky, Erwin. "Die Perspektive als 'symbolische Form.'" In id., *Aufsätze zu Grundfragen der Kunstwissenschaft.* Berlin: Verlag Bruno Hessling, 1964: 99–167. (1927.)

Parsons, Betty. Papers. Archives of American Art, Smithsonian Institution. Microfilms N/68-62 to N/68-74.

Philipson, Morris. *Outline of a Jungian Aesthetics.* Chicago: Northwestern University Press, 1963.

"Picassolamming." *Art Digest* (1 December 1942): 7.

Pilkington, William T. *Harvey Fergusson.* Boston: G. K. Hall, 1975.

Place, J. A., and L. S. Peterson. "Some Visual Motifs of Film Noir." *Film Comment* (January/February 1974): 30–35.

Poggioli, Renato. *The Theory of the Avant-Garde.* Trans. Gerald Fitzgerald. New York: Harper and Row, 1971. (1962.)

Polan, Dana. *Power and Paranoia: History, Narrative and the American Cinema, 1940–1950.* New York: Columbia University Press, 1986.

Polcari, Stephen. "The Intellectual Roots of Abstract Expressionism: Clyfford Still." *Art International* (May/June 1982): 18–34.

———. "The Intellectual Roots of Abstract Expressionism: Mark Rothko." *Arts Magazine,* September 1979, 124–34.

———. "Martha Graham and Abstract Expressionism." *Smithsonian Studies in American Art* (Winter 1990): 3–27.

Pollock, Jackson. Draft of statement for *Possibilities*. Published in *Jackson Pollock*, ed. O'Connor and Thaw. Vol. 4, p. 241 (D72).

———. Interview. *Arts and Architecture* (February 1944): 14.

———. Interview by William Wright, 1950. Published in *Jackson Pollock*, ed. O'Connor and Thaw. Vol. 4, pp. 248–52 (D87).

———. Letter to James Johnson Sweeney, 3 November 1943. Published in *Jackson Pollock*, ed. O'Connor and Thaw. Vol. 4, p. 230.

———. "My Painting." *Possibilities* 1 (Winter 1947–48): 79.

———. Papers. Archives of American Art, Smithsonian Institution. Microfilms 3046–3049.

Porfirio, Robert. "No Way Out: Existential Motifs in the Film Noir." *Sight and Sound* (Autumn 1976): 212–17.

Porter, David, ed. *Personal Statement*. Washington, D.C.: David Porter Gallery, 1945. (Pamphlet prepared for the exhibition "A Painting Prophecy—1950" at the David Porter Gallery in February 1945.)

Potter, Jeffrey. *To A Violent Grave*. New York: G. P. Putnam's Sons, 1985.

Pratt, Jane Abbott. "Early Concepts of Jahweh." *Papers of the Analytical Psychology Club of New York* 3 (1939).

Preston, Stuart. "Among Current Shows." *New York Times*, 4 December 1955, sec. 2, p. 14.

———. "Early Exhibitions." *New York Times*, 18 September 1949, sec. 2, p. 12.

Prince, Morton. *The Unconscious*. New York: Macmillan, 1921.

Putnam, Hilary. "The Craving for Objectivity." *New Literary History* (Winter 1984): 229–39.

"Putting American Women 'On Another Footing'." *New York Times*, 12 October 1919, sec. 7, p. 10.

Putz, Ekkehard. *Jackson Pollock: Theorie und Bild*. Hildesheim: Georg Olms Verlag, 1975.

Putzel, Howard. *A Problem for Critics*. New York: 67 Gallery, 1945.

Radin, Paul. *Primitive Man as Philosopher*. 1927. Reprint. New York: Dover, 1957.

———. *The Racial Myth*. New York: McGraw-Hill, 1934.

Reynolds, Gary, and Beryl Wright. *Against the Odds: African-American Artists and the Harmon Foundation*. Newark: Newark Museum, 1989.

Rieber, R. W., and Kurt Salzinger, eds. *Psychology: Theoretical-Historical Perspectives*. New York: Academic Press, 1980.

Riis, Roger William. "Human Nature *Has* Changed." *Reader's Digest*, December 1941, 135–37. (Abridged from *Liberty*, 29 November 1941.)

Riley, Maude. "The Mythical Rothko and His Myths." *Art Digest* (15 January 1945): 15.

———. "Whither Goes Abstract and Surrealist Art?" *Art Digest* 1 (December 1944): 8, 31.

Robbins, Daniel. *Joaquín Torres-García*. Providence: Rhode Island School of Design, 1970.

Robinson, James Harvey. "Intellectual Radicalism." *Masses*, June 1916, 21.

———. *The Mind in the Making*. New York: Harper and Brothers, 1921.

———. "What Is the Good of History?" *Dial* (26 July 1919): 58–59.

Rockefeller, Nelson. "The Cooperative Spirit of the Americas." *Arts and Architecture* (October 1942): 23, 50.

Rodman, Selden. *Conversations with Artists*. New York: Devin-Adair Company, 1957.

———. "What's Wrong with the 'World of Tomorrow'?" *Common Sense* (September 1939): 6–7, 29.

Rorty, Richard. *Contingency, Irony, and Solidarity*. Cambridge: Cambridge University Press, 1989.

Rosenberg, Harold. "The American Action Painters." *Art News* (December 1952): 22–23, 48–50.

———. "Breton: A Dialogue." *View* (May 1942): unpaginated.

———. Introduction to "Six American Artists." Paris: Galerie Maeght, Spring 1947. (Reprinted in *Possibilities*, ed. Motherwell and Rosenberg, 75.)

———. "Myth and History." *Partisan Review* (Winter 1939): 19–39.

———. "Notes on Identity: With Special Reference to the Mixed Philosopher, Soren Kierkegaard." *View* (May 1946): 7–8, 10, 24, 28, 30.

———. "Towards the Unknown." *View* (February/March 1942): 10.

Ross, Andrew. "Irving Babbitt." In *Dictionary of Literary Biography* 63 (1988).

Rothko, Mark. *Clyfford Still.* New York: Art of This Century, 12 February–2 March 1946.

———. Letter to the editor. *New York Times*, 8 July 1945, sec. 2, p. 2.

———. Papers. Archives of American Art, Smithsonian Institution. Microfilm 3135.

———. "The Romantics Were Prompted." *Possibilities* 1 (Winter 1947–48): 84.

Rubin, William. "Jackson Pollock and the Modern Tradition." Parts 1–4. *Artforum* (February, March, April, May 1967): 14–21, 28–37, 18–31, 28–33.

———. Letters. *Artforum* (February 1985, May 1985).

———. "Pollock as Jungian Illustrator: The Limits of Psychological Criticism." Parts 1, 2. *Art in America* (November, December 1979): 104–23, 72–91.

———, ed. *"Primitivism" in 20th Century Art.* New York: Museum of Modern Art, 1984.

Ruitenbeek, H. M. ed. *Psychoanalysis and Social Science.* New York: Dutton, 1962.

Rushing, W. Jackson. "The Impact of Nietzsche and Northwest Coast Indian Art on Barnett Newman's Idea of Redemption in the Abstract Sublime." *Art Journal* (Fall 1988): 187–95.

———. "Ritual and Myth: Native American Culture and Abstract Expressionism." In *The Spiritual in Art: Abstract Painting, 1890–1985.* Los Angeles: Los Angeles County Museum of Art, 1986: 272–95.

Ryan, Mary P. *Cradle of the Middle Class.* Cambridge: Cambridge University Press, 1981.

Said, Edward. *Orientalism.* New York: Vintage/Random House, 1979.

———. "Representing the Colonized: Anthropology's Interlocutors." *Critical Inquiry* (Winter 1989): 205–25.

Sandler, Irving. Letter. *Art in America* (October 1980): 57–59.

———. *The Triumph of American Painting.* New York: Praeger, 1970.

Sawin, Martica. "'The Third Man,' or, Automatism American Style." *Art Journal* (Fall 1988): 181–86.

"Says Girls' Homes Cause Ill Health." *New York Times,* 23 October 1921, sec. 2, p. 12.

Schapiro, J. Salwyn. "James Harvey Robinson (1863–1936)." *Journal of Social Philosophy* 1 (1936): 278–81.

Schapiro, Meyer. "Blue Like an Orange." *Nation,* 25 September 1937, 323–24.

———. "The Liberating Quality of Avant-Garde Art." *Art News* (Summer 1957): 36–42. (Reprinted as "Recent Abstract Painting." In id., *Modern Art: 19th and 20th Centuries.*)

———. "Looking Forward to Looking Backward." *Partisan Review* (July 1938): 12–24.

———. *Modern Art: 19th and 20th Centuries.* New York: Braziller, 1978.

———. "Nature of Abstract Art." *Marxist Quarterly* (January/March 1937): 77–98. (Reprinted in id., *Modern Art: 19th and 20th Centuries.*)

———. "The Social Bases of Art." [Proceedings of the] *First American Artists' Congress.* New York: AAC, 1936: 31–37.

Schimmel, Paul, ed. *The Interpretive Link.* Newport Beach, Calif.: Newport Harbor Art Museum, 1986.

Schlesinger, Arthur M., Jr. *The Vital Center.* Boston: Houghton Mifflin, 1949.

Schmalhausen, Samuel D. *Our Changing Human Nature.* New York: Macaulay, 1929.

———. "Psycho-analysis *and* Communism." *Modern Quarterly* (Summer 1932): 62–69.

———. *Why We Misbehave.* New York: Garden City, 1928.

———, ed. *Our Neurotic Age: A Consultation.* New York: Farrar and Rinehart, 1932.

Schmalhausen, Samuel D., and V. F. Calverton, eds. *Woman's Coming of Age.* New York: Liveright, 1931.

Seeley, John R. "The Americanization of the Unconscious." *Atlantic Monthly,* July 1961, 68–72. (Reprinted in *Psychoanalysis and Social Science,* ed. Ruitenbeek.)

Seiberling, Dorothy. "Baffling U.S. Art: What It Is About." *Life,* 9 November 1959, 68–80.
———. "The Varied Art of Four Pioneers." *Life,* 16 November 1959, 74–86.

Seitz, William C. *Abstract Expressionist Painting in America.* 1955. Cambridge, Mass.: Harvard University Press, 1983.

Seligmann, Herbert J. *Race Against Man.* New York: G. P. Putnam's Sons, 1939.

Shelton, Suzanne. "Jungian Roots of Martha Graham's Dance Imagery." *Proceedings of the Association of Dance History Scholars* (1983): 119–32.

Sherrington, Charles Scott. *The Integrative Action of the Nervous System.* New York: Scribner's, 1906.

Shiff, Richard. *Cézanne and the End of Impressionism.* Chicago: University of Chicago Press, 1984.

Silver, Alain, and Elizabeth Ward. *Film Noir: An Encyclopedic Reference to the American Style.* Woodstock, N.Y.: Overlook Press, 1979.

Simmel, Georg. "The Metropolis and Mental Life." 1903. In id., *On Individuality and Social Forms.* Chicago: University of Chicago Press, 1971.

Sims, Lowery. "Wifredo Lam and the New York School: Filling in the Gaps." Lecture delivered at the College Art Association annual meeting, New York, 1990.

Smith, Barbara Herrnstein. *Contingencies of Value.* Cambridge, Mass.: Harvard University Press, 1988.

Smith, David. "Abstract Art." *New York Artist* (April 1940): 5–6, 15.
———. *David Smith,* ed. Garnett McCoy. New York: Praeger, 1973.

Smith, Paul. *Discerning the Subject.* Minneapolis: University of Minnesota Press, 1988.

Soby, James Thrall. *Salvador Dalí: Paintings, Drawings, Prints.* New York: Museum of Modern Art, 1941.

Sorokin, Pitirim A. *The Crisis of Our Age: The Social and Cultural Outlook.* New York: E. P. Dutton, 1941.
———. *Man and Society in Calamity.* New York: E. P. Dutton, 1942.

"Speaking of Pictures . . . Cannibals Roast a Man." *Life,* 25 March 1940, 12–14.

Stocking, George W., Jr. *Race, Culture, and Evolution.* New York: Free Press, 1968.
———, ed. *Selected Papers from the American Anthropologist, 1921–1945.* Washington, D.C.: American Anthropological Association, 1976.

Stroup, Jon. *Adolph Gottlieb.* New York: 67 Gallery, March 1945.
———. "Gottlieb and Pollock." *Town and Country,* March 1945, 86.
———. ". . . In Lyricism." *Town and Country,* January 1945, 48.

Susman, Warren I. *Culture as History: The Transformation of American Society in the Twentieth Century.* New York: Pantheon, 1984.

Sweeney, James Johnson. "Art Chronicle." *Partisan Review* (Spring 1945): 240–42.
———. "Five American Painters." *Harper's Bazaar,* April 1944, 76–77, 122, 124, 126.
———. *Jackson Pollock.* New York: Art of This Century, 9–27 November 1943.

Tagg, John. "American Power and American Painting: The Development of Vanguard Painting in the United States since 1945." *Praxis* (Winter 1976): 59–79.

Tamayo, Rufino. Statement. *Tiger's Eye* (October 1947): 62.

Thompson, Sir D'Arcy Wentworth. *On Growth and Form.* Cambridge: Cambridge University Press, 1917.

Thompson, Dorothy. "The Lesson of Dachau." *Ladies' Home Journal,* September 1945.

Thurber, James. "Thinking Ourselves into Trouble." *Forum* (June 1939): 309–11.

Tomlin, Bradley Walker. Papers. Archives of American Art, Smithsonian Institution. Microfilm 19.

Torgovnick, Marianna. *Gone Primitive: Savage Intellects, Modern Lives.* Chicago: University of Chicago Press, 1990.

Trachtenberg, Alan. *The Incorporation of America: Culture and Society in the Gilded Age.* New York: Hill and Wang, 1982.

Turkle, Sherry. *Psychoanalytic Politics: Freud's French Revolution.* Cambridge, Mass.: MIT Press, 1981.

Tworkov, Jack. Interview by Dorothy Seckler, 17 August 1962. Archives of American Art, Smithsonian Institution.

————. "The Wandering Soutine." *Art News* (November 1950): 31–33, 62.

Tyler, Parker. "Hopper/Pollock." *Art News Annual* 26 (1957): 86–107.

————. "Jackson Pollock: The Infinite Labyrinth." *Magazine of Art,* March 1950, 92–93.

Valente, Alfredo. Review of Gottlieb exhibition at Seligmann Galleries. *Promenade,* February 1949, 40.

Varnedoe, Kirk. "Abstract Expressionism." *"Primitivism" in 20th Century Art,* ed. William Rubin. Vol. 2, pp. 615–59.

Veblen, Thorstein. "The Modern Point of View and the New Order." *Dial* (19 October 1918 through 25 Jan. 1919).

Veeser, H. Aram. *The New Historicism.* New York: Routledge, 1989.

Venable, Vernon. *Human Nature: The Marxian View.* New York: Alfred A. Knopf, 1945.

Vidich, Arthur J. "Ideological Themes in American Anthropology." *Social Research* (Winter 1974): 719–45.

Wagner, Anne M. "Lee Krasner as L.K." *Representations* (Winter 1989): 42–57.

Walker, Charles R. "Anthropology as a War Weapon." *American Mercury,* July 1945, 85–89.

Warshow, Robert. "The Gangster as Tragic Hero." *Partisan Review* (February 1948): 240–44.

Waters, R. H. *"Modern Man* by Harvey Fergusson." *American Journal of Psychology* (October 1936): 701–02.

Watts, Alan W. "The Psychology of Acceptance: The Reconciliation of the Opposites in Eastern Thought and in Analytical Psychology." *Papers of the Analytical Psychology Club of New York* 3 (1939).

"A Way to Kill Space." *Newsweek,* 12 August 1946, 106, 108.

Weinberg, Jonathan. "Pollock and Picasso: The Rivalry and the Escape." *Arts Magazine,* Summer 1987, 42–48.

Weiss, Jeffrey. "Science and Primitivism: A Fearful Symmetry in the Early New York School." *Arts Magazine,* March 1983, 81–87.

West, Cornel. *The American Evasion of Philosophy.* Madison: University of Wisconsin Press, 1989.

Wheelwright, Philip. "Dogmatism—New Style." *Chimera* (Spring 1943): 7–16.

White, Harrison C., and Cynthia A. White. *Canvases and Careers: Institutional Change in the French Painting World.* New York: John Wiley and Sons, 1965.

White, Hayden. "The Forms of Wildness: Archaeology of an Idea." In *The Wild Man Within,* ed. Dudley and Novak.

White, Morton. *Social Thought in America: The Revolt against Formalism.* New York: Viking, 1949.

Wickes, Frances G. *The Inner World of Man.* New York: Farrar and Rinehart, 1938.

Wittgenstein, Ludwig. "Bemerkungen über Frazers *The Golden Bough.*" 1931. *Synthese* 17 (September 1967): 233–53.

Wolf, Ben. "Wizards and Warriors." *Art Digest* (1 May 1948): 10.

Wolf, Eric R. "American Anthropologists and American Society." In *Reinventing Anthropology,* ed. Dell Hymes.

Wolfe, Judith. "Jungian Aspects of Jackson Pollock's Imagery." *Artforum* (November 1972): 65–73.

Wood, Paul. "Howl of Minerva." *Art History* (March 1986): 119–31.

"World Fair March Is Gershwin Tune." *New York Times,* 24 April 1938, sec. 2, p. 1.

Wylie, Philip. *Generation of Vipers.* New York: Rinehart, 1942.

————. *Opus 21.* New York: Rinehart, 1949.

Wysuph, C. L. *Jackson Pollock: Psychoanalytic Drawings.* New York: Horizon, 1970.

INDEX